IT HAPPENED AT POMONA

Published with the assistance of the Getty Foundation

Organized and edited by
Rebecca McGrew

Co-organized and edited by
Glenn Phillips

Co-edited by
Marie B. Shurkus

Contributions by
Thomas Crow
Carrie Dedon
Hal Glicksman
Julie Joyce
Rochelle LeGrandsawyer
Rebecca McGrew
David Pagel
Glenn Phillips
Marie B. Shurkus
Helene Winer

IT HAPPENED AT
POMONA

ART AT THE EDGE OF LOS ANGELES 1969–1973

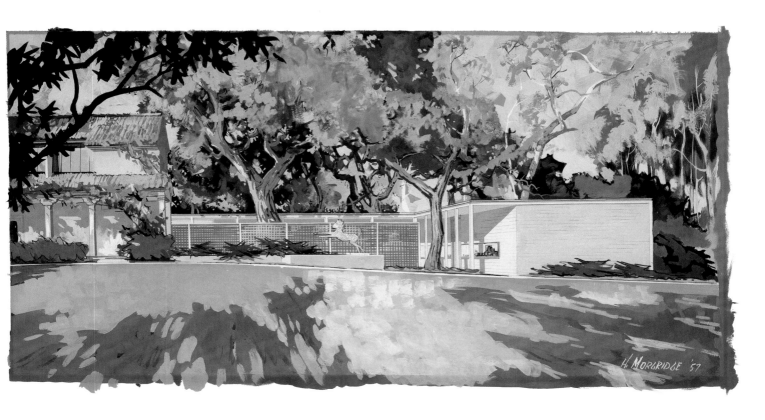

POMONA COLLEGE MUSEUM OF ART

CONTENTS

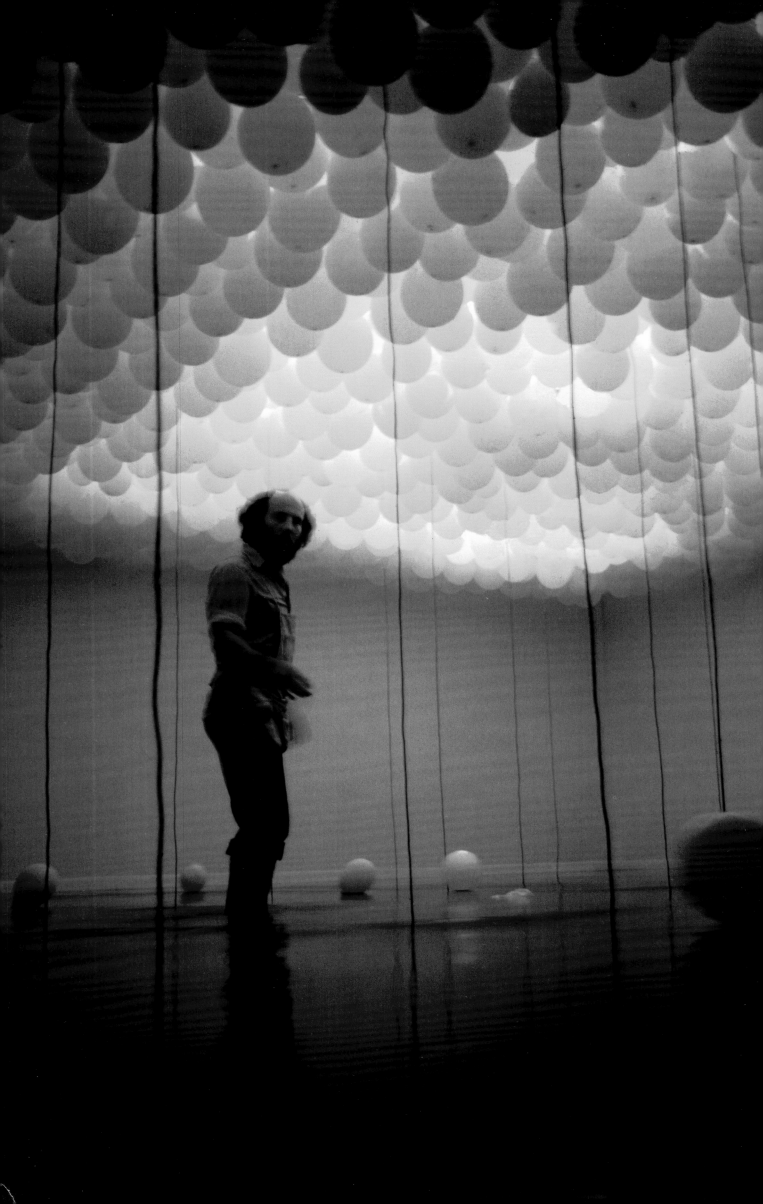

DIRECTOR'S FOREWORD

This catalogue, and the exhibitions and performance program that it accompanies, examines a complex web of experimental art practices at Pomona College and their resonance in twentieth-century art. The artworks and practices are viewed in the context of the dynamic cultural forces of the period that reshaped Southern California and the nation. The Getty Foundation's objective to recover the history of art in Southern California was pivotal in encouraging us to probe the intensely creative period at Pomona College from 1969 to 1973. Continuing support from the Getty under the Pacific Standard Time: Art in L.A. 1945–1980 initiative fostered the significant research, publication, and exhibition program at Pomona that culminate in "It Happened at Pomona: Art at the Edge of Los Angeles 1969–1973."

The driving force behind this multi-faceted project is Senior Curator Rebecca McGrew, and I want to thank her for her immense efforts in conceptualizing and organizing such an ambitious undertaking. Throughout the project, the active collaboration of the research team—Glenn Phillips, Thomas Crow, Marie B. Shurkus, Helene Winer, and Hal Glicksman—developed a synergy of intellectual, historical, and personal perspectives. We thank them for their crucial contributions.

"It Happened at Pomona" would not be possible without critical loans of artworks from private collectors, artists, and public institutions throughout the country, and I extend a special thanks to all our lenders for their generosity. Lenders to the exhibition are listed on page 374.

Just as it would be impossible to undertake such a project without artworks or intellectual investment, it would be impossible to do so without funding. We are enormously grateful to the Getty Foundation for their early and generous support, which permitted research, formulation, and realization of this project. Pacific Standard Time, which created a dynamic, multi-institutional, regional project, will stand as a landmark of collaborative research and exhibition in the visual arts. Pomona College is honored to be a participant. Additional support for exhibition, publication, and programming is provided by: The Dr. Lucille M. Paris bequest, The Matson Endowment for museum programming, The Carlton and Laura Seaver Endowment in support of the museum, The Edwin A. and Margaret K. Phillips Fund, The Rembrandt Club of Pomona College, Pasadena Art Alliance, The Philip and Muriel Berman Foundation, and private donors, including: Louise and John Bryson, David ('73) and Emily ('06) Horowitz, Janet Inskeep Benton ('79), Richard N. Frank ('46) and Mary Alice Frank ('47), and an anonymous donor.

For their ongoing support, we extend special gratitude to Pomona College President David Oxtoby, Dean Cecilia Conrad, and every member of our Board of Trustees. Without their confidence, and in many cases their active engagement, it would have been unthinkable to embark on a project of this scope. I would also like to extend our thanks to the many faculty members across disciplines who developed courses or otherwise integrated the riches of Pacific Standard Time into their curricula. Although the title of our exhibition, "It Happened at Pomona," is in the past tense, the support and participation of trustees, faculty, staff, and students at Pomona College make it clear that active involvement in the art of our time continues at Pomona College.

Ultimately the import of any project—research, exhibition, publication, and programming—lies with the audience. It is our hope that "It Happened at Pomona" will stimulate, engage, and enlighten viewers and readers.

Kathleen Stewart Howe
Sarah Rempel and Herbert S. Rempel '23 Director

Lloyd Hamrol installing *Situational Construction for Pomona College*, 1969. Gift of Hal Glicksman. The Getty Research Institute, Los Angeles (2009.M.5)

7

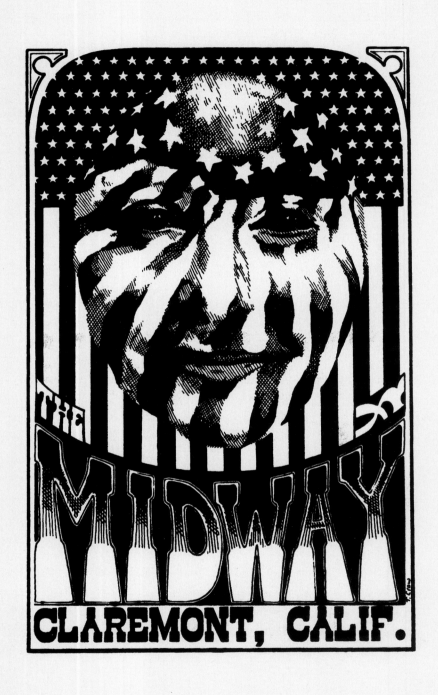

INTRODUCTION

"It Happened at Pomona: Art at the Edge of Los Angeles 1969–1973" is a groundbreaking and extraordinarily ambitious project for Pomona College. With twenty-nine artists utilizing all of the galleries of the museum for the entire academic year, this is the largest exhibition the Pomona College Museum of Art has ever mounted. The first kernel of an idea for this project took place over ten years ago, during my conversations with Mowry Baden while planning his 2001 exhibition "Freckled Gyres: Sculpture by Mowry Baden." Baden, a 1958 Pomona alumnus, relayed fascinating stories about Hal Glicksman's tenure as director and curator, Michael Asher's seminal installation in 1970, and other remarkable projects that took place at Pomona College. A couple of years later, I began working with another Pomona College alumnus, Barbara T. Smith ('53), on an exhibition, "The 21st Century Odyssey Part II: The Performances of Barbara T. Smith," that opened in January 2005. Smith, an active performance artist since the 1960s, also regaled me with stories of the Pomona College gallery and art department.

In 2006 and 2007, I had several opportunities to meet with alumni James Turrell ('65) and Peter Shelton ('73), while planning for the exhibition, "James Turrell at Pomona," and installing Shelton's sculpture *GandhiG* at the Museum. (Both projects were organized by museum director Kathleen Howe.) Baden, Turrell, and Shelton were all in Claremont during the late 1960s and early 1970s. They fondly remember their respective times at Pomona College, where they reveled in the experimental and open nature of the art department and exhibition program. More stories emerged: public nudity; urination inside the gallery; burning matches thrown at a naked woman; mind-altering excursions into a reconfigured gallery open twenty-four hours a day; lost rare videotapes; experiments with balloons, water, and broken windshields; the resignation of the entire art faculty in 1973; and many others. These tales indicated a period of such intrigue and sustained inquiry that I set out to study this era in more depth.

I knew that Pomona College had played a vital role in the history of art in Los Angeles. An early example of Pomona College's leadership in the arts is *Prometheus*, a fresco painted in 1930 by the Mexican artist José Clemente Orozco. Orozco was commissioned to paint the mural in Frary Dining Hall at the urging of José Pijoan, a popular professor of Hispanic civilization and art history at the college. Recognized as one of Orozco's great masterpieces, *Prometheus* was Orozco's first work in this country and the first piece by a Mexican muralist in the United States.

It was in the 1930s that the gallery, which would later become the Pomona College Museum of Art, began to serve as the primary visual art facility of Pomona College. Originally established as part of the art department, its programming was developed by a series of prominent scholars who served as chair of the art department and as director of the gallery. Professor Pijoan was the first director, followed by Seymour Slive (1950–54), Peter Selz (1954–58), Bates Lowry (1958–64), and Nicolai Cikovsky (1964–68).

But it wasn't until the late 1960s and early 1970s that the museum and art department at Pomona College became almost legendary. The site of ground-breaking installation and performance art work, the museum presented a number of intensely creative and innovative projects that reflected a confluence of art faculty, curators, visiting artists, and students who would go on to make significant contributions to contemporary art history. From 1969 to 1973, this era was a time of intense intellectual and artistic ferment at Pomona College.

It all coalesced in the fall of 1969, when Baden, the newly arrived chair of the art department and professor of sculpture, hired Hal Glicksman as gallery director and curator. From the fall of 1969 through June of 1970, Glicksman devised a unique series of exhibitions for a program that he called the Artist's Gallery. Under this program, the gallery functioned as a studio-residency for Conceptual artists in Southern California. Michael Asher, Lewis Baltz, Michael Brewster ('68), Judy Chicago, Ron Cooper, Tom Eatherton, Lloyd Hamrol, and Robert Irwin, among others, presented work or created different environmental situations in the gallery.

Following Glicksman, Helene Winer became the gallery director and curator in the fall of 1970. She organized exhibitions of Bas Jan Ader, Ger van Elk, Jack Goldstein, Joe Goode, William Leavitt, John McCracken, Ed Moses, Allen Ruppersberg, and William Wegman. She also presented performance work by artists such as Chris Burden ('69), Hirokazu Kosaka, and Wolfgang Stoerchle.

In concert with the innovative exhibition programming by Glicksman and Winer, the art department thrived under a unique group of faculty members: Baden, Baltz, Turrell, David Gray, and Guy Williams. In addition to Burden, other outstanding students at the time included Brewster, Thomas Crow ('69), Judy Fiskin ('66), Shelton, and Hap Tivey ('69).

This vital period ended abruptly in the spring of 1973. "It Happened at Pomona" sets out to explore this avant-garde time at Pomona College, and to shed light on a series of exhibitions and events that culminated in the mass resignation of the art faculty and gallery director, and resulted in a dramatic shift in the programmatic direction of both the Pomona College Museum of Art and the art department.

In the fall of 2007, I submitted a grant proposal to examine this history to the Getty Foundation's Curatorial Research Fellowship, which was ultimately awarded. I spent the fellowship traveling and interviewing Baden, Brewster, Glicksman, Shelton, and Winer, among others. I also began digging through the museum archives and its minimal files, which in some cases consisted of only one or two pieces of correspondence. I started sorting out a chronology of exhibitions and a record of which artists exhibited which works of art. The early stages of research involved quite a bit of detective work, as the impetus for this project was really the alumni's stories about memorable

exhibitions and my interest in uncovering the story behind the resignation of faculty, which had grown over the years into mythic status. Thus, I found myself on two different tracks— uncovering the plentitude of important exhibitions and performances that took place at Pomona and trying to find out what exactly led to the shift in the art department in 1973.

While I was conducting research for the fellowship, the Getty Foundation approached the museum about the Getty's grant program examining the history of art in Los Angeles from 1945 to 1980. In the fall of 2008, the Getty Foundation awarded the Pomona College Museum of Art a grant to conduct research into the history of fine art at Pomona College during the late 1960s and early 1970s. This grant propelled our project forward, shifting the focus from the captivating stories about the art department, art faculty, and students at Pomona College to a realization of the profound contributions and significance of the art being made then.

Finally, in fall 2009, the Getty Foundation awarded Pomona College a "Pacific Standard Time: Art in L.A. 1945–1980" grant to help realize the "It Happened at Pomona: Art at the Edge of Los Angeles 1969–1973" exhibition and accompanying publication. In totality, the support of the Getty Foundation has helped to accomplish several noteworthy goals, beginning with research into the ways in which the avant-garde practices and exhibitions at Pomona College during this pivotal period paralleled exciting developments in the art world in Southern California, which include groundbreaking advances in Conceptual art, video, performance, installation, and Light and Space work. The artists and curators active at Pomona College between 1969 and 1973 not only engaged with the developing legacies of Conceptualism and Minimalism, but also forged transformations of these ideas and concerns that ultimately became prototypes for future generations. In addition to the new scholarship and the uncovering of overlooked artists and stories, the Pacific Standard Time grant has supported the recreation of several important works of art, including Michael Brewster's 1970 installation *Configuration 010 Audio Activity*; Chris Burden's 1967 untitled sculpture; Tom Eatherton's 1970 installation *Rise*; David Gray's 1965 sculpture *L.A./5*; Lloyd Hamrol's 1969 installation *Situational Construction for Pomona College*; and the conservation of Mowry Baden's 1965 sculpture *Delivery Suite*; Peter Shelton's 1973 *Roll* and *Spread* paintings; and Guy Williams's 1972 painting *Slamfoot Brown*. The three Getty Foundation grants have been instrumental in bringing to light new works of art and scholarship and creating a permanent record of a vital and significant moment in the art history of Pomona College, and ultimately, of Los Angeles and its place in the art of our time.

With support from the Getty Foundation, the "It Happened at Pomona" project was able to bring together an impressive team of artists, critics, curators, and scholars who assisted with all aspects of this project's development. Principal team members include, as co-curator and editor, Glenn Phillips, principal project specialist and consulting

curator, Department of Architecture and Contemporary Art at the Getty Research Institute, and as research associate and co-editor, Marie Shurkus, curator of academic programs at the Pomona College Museum of Art. Key advisors and catalogue authors include: Dr. Thomas Crow, Rosalie Solow Professor of Modern Art at New York University's Institute of Fine Arts; Hal Glicksman, retired curator; and Helene Winer, owner, Metro Pictures Gallery, New York. Additional team members include Julie Joyce, Curator of Contemporary Art, Santa Barbara Museum of Art; David Pagel, writer and professor of art at Claremont Graduate University; and Rochelle LeGrandsawyer ('08) and Carrie Dedon ('10), research assistants at Pomona College.

Meeting over several years, the core research team—Phillips, Shurkus, Crow, Glicksman, Winer, LeGrandsawyer, and I—helped to select the twenty-nine artists in the exhibition and to craft the unique format of the exhibition and publication. To recreate a sense of how this era's provocative aesthetic concerns unfolded and developed, "It Happened at Pomona" has been organized into a series of three exhibitions anchored by an extensive and dynamic timeline designed by Lorraine Wild of Green Dragon Office. The timeline traces the development of significant social and art historical events at Pomona College and Southern California through words, pictures, sounds, and moving images. The first two exhibitions are designed to articulate the distinct and historically astute curatorial visions of Pomona College Museum of Art curators Glicksman and Winer. The environment at Pomona College and the successive curatorial work of Glicksman and Winer during this period frame several fascinating groups of artists whose works are rarely examined together. The third and final exhibition focuses on the extraordinary arts faculty and students at Pomona College. In addition to paintings, sculpture, video, and photography, each of the three exhibitions will feature site-specific installations and environments that have not been seen since their original presentations, including recreations of works by Brewster, Burden, Cooper, Eatherton, Goldstein, Hamrol, Tivey, and Turrell. The exhibition will also be complemented by recreations of performances by Judy Chicago, James Turrell, and John M. White.

The catalogue has likewise been organized around this guiding tripartite principle. Designed by Wild and Xiaoqing Wang of Green Dragon Office, the catalogue is a central component of this project. It brings together four newly commissioned scholarly essays, two new extensive interviews with curators Glicksman and Winer, new interviews conducted with eighteen of the twenty-nine artists, short commissioned essays on nine artists, and three reprints of rare material. To provide a context, the book also includes a detailed timeline of exhibitions at Pomona College, events at Pomona and at the other Claremont Colleges, key events in the Los Angeles art world, and concurrent social and political events in the United States. A list of art faculty and students in the art department at Pomona College from 1965 to 1974 is also included. The book concludes with artist's biographies and a selected bibliography.

Focusing on Pomona College and this moment in Southern California art history demonstrates how related sets of themes and artistic concerns develop across what are typically seen as discrete artistic movements. The book provides new insight into the relationship between post-Minimalism, Light and Space art, and various strands of Conceptual art, performance art, and photography in California, while contributing substantial new findings about lines of influence between artistic developments in Los Angeles and New York. Each of the four commissioned essays treats different aspects of this history; collectively they present substantial new scholarship dealing with this complex and transitional period of art making.

Serving as a broad introduction to the topic, my contribution sets forth a history of the visual arts at Pomona College in the late 1960s and early 1970s, drawn from my research in the Pomona College archives, interviews with students, faculty, and administrators at the college, and conversations with other artists and curators. Emphasizing the ways in which the exceptional presence of the visual arts in Claremont played an important role in activating an essentially conservative Pomona College campus, Thomas Crow's essay elucidates how the art department and gallery had a profound impact on art instruction at several area colleges and universities, and how its impact radiated out into the Los Angeles art world and beyond. Glenn Phillips's essay examines the era through the career of Wolfgang Stoerchle, a post-Minimalist sculptor and performance and video artist—about whom there has been almost no scholarship—whose time in Southern California coincided with the period covered by the exhibition. Marie B. Shurkus's essay explores how Winer's experiences as a curator at Pomona College fundamentally shaped the seminal 1977 "Pictures" exhibition at Artists Space in New York. Shurkus also establishes how theatricality was a primary aesthetic concern for artists in Southern California in the late sixties and early seventies, and she traces the influence of their examinations on the development of participatory art practices in the twenty-first century.

As a whole, this book chronicles the experimental artistic practices that emerged in the late 1960s and the role that Pomona College played in supporting and advancing these practices. Ultimately, the scope of the exhibition and the publication offer groundbreaking and thoughtful new interpretations and historical insight on the development of art in Southern California during this period.

Rebecca McGrew ('85)
Senior Curator
Pomona College Museum of Art

OPENING THINGS UP: Why and How it Happened at Pomona
Rebecca McGrew

Pomona's strong point was that there was a sense that if you really had an interesting idea, nobody was going to stand in your way. And if you wanted to be a jock and marry a princess and settle in the suburbs, you could, but if you wanted to create this new gallery situation, and show all these artworks from Los Angeles, of course, why not? It was wide open. Because of the strength of the people, the chain of associations, you didn't have an administration saying this is too radical. It sort of caught them after the fact, and they said, "Oh, wait a minute. This is too radical." But it was already done...

–Kay Larson[1] ('69)

EVERY ONCE IN A WHILE, a pivotal moment happens in the history of art. This book argues that one such moment occurred in Southern California, at Pomona College, between the years 1969 and 1973. For artists as diverse as Michael Asher, Bas Jan Ader, Lewis Baltz, Chris Burden ('69), Judy Chicago, Jack Goldstein, John McCracken, Allen Ruppersberg, and James Turrell ('65), Pomona hosted major, and sometimes radical, new directions in their art. It is a surprising story: Why would a moment like this happen in the sheltered, peaceful, and generally quite traditional environment of Pomona College, in the quiet city of Claremont?[2] This essay endeavors to answer that question and the many other "whys" of this project: Why start with 1969? Why end with 1973? And what exactly happened at Pomona?

In its most basic form, the story goes like this: Pomona College art department chair Mowry Baden ('58) hired curator Hal Glicksman in 1969, which set the stage for a series of innovative exhibitions that would continue with curator Helene Winer's arrival in 1970. Curated by Glicksman and Winer, avant-garde exhibitions by influential young artists exploring the newest post-Conceptual territories took place at the Pomona College Museum of Art. (The exhibition space at Pomona College changed names several times over the years. For simplicity's sake, we will refer to it by its current name throughout this volume.) Their innovative programming included notorious performances by Chris Burden and Wolfgang Stoerchle, which, many claim, led to the firing of Helene Winer and the restructuring of the art department. The hiring of Lewis Baltz, Michael Brewster ('68), and James Turrell in the early seventies added to the intense excitement in studio art.[3] Yet, just a few years later, with the hiring of art historian Gerald Ackerman and artist Norman Hines ('61), the department returned to a more traditional focus.

The full story of what transpired during these few short years is complex and nuanced. This moment at Pomona didn't simply appear out of nowhere. Thomas Crow's ('69) essay in this catalogue chronicles the impact of the existing art scene in Claremont and delves more deeply into the connections between artists working in Claremont and the broader art scene in Southern California.

My essay examines the dynamics specific to Pomona College, but the cultural transformations of the sixties play a huge role in this story as well. Anti-war demonstrations, the sexual revolution, civil rights, women's rights, gay liberation, the emergence of a hippie counterculture, and the rise of New Left activism all led to dramatic social shifts. For the college communities in Claremont, this was a time of turmoil, fevered protest, questioning of authority, and personal and intellectual experimentation. A new sense of freedom lifted prohibitions and created new possibilities for engaging the world. Concurrently, equally dramatic shifts and transformations in art philosophy and practice created an exhilarating sense of experimentation that dramatically expanded what was possible, allowing performance, video, installation, and other dematerialized forms of art to join the more traditional mediums of painting and sculpture. While the era initially created hope for political and social transformation, by the early to mid-seventies, the utopian promise of the sixties was overtaken by disillusionment, as the promises of social change were undercut by assassinations, commercialization, and corruption. As the sixties ground to a halt, an era of complacency settled in and many wished for a "return to normalcy." As radicalism fell from favor, the moment of "It Happened at Pomona" passed.

This essay sets forth an idiosyncratic and complex history of the visual arts at Pomona College from 1969 to 1973, drawn from research in the archives of Pomona College and the Pomona College Museum of Art, and conversations and interviews with former students, faculty, curators, and administrators. This essay explores a range of stories, knowing that many will still go untold. What follows is one version of what happened at Pomona.

1. All quotes from Kay Larson are from an interview with the author in Kingston, New York, April 7, 2010.
2. Pomona College is part of the Claremont Colleges consortium, which consists of five undergraduate colleges (Claremont McKenna, Harvey Mudd, Pitzer, Pomona, and Scripps colleges) and two graduate schools of higher education (Claremont Graduate University and Keck Graduate Institute). Located adjacent to the Claremont Village, in the heart of Claremont, the Claremont College campuses are adjoining and within walking distance of one another.
3. Baltz, Brewster, and Turrell all received MFAs from Claremont Graduate University. (*See faculty list in this volume*) Baltz and Turrell were teaching classes at Pomona College while they were enrolled concurrently as graduate students.

PREVIOUS SPREAD
Rembrandt Hall and Montgomery Gallery before addition of 1977. Pomona College Archives

The Beginning: Mowry Baden and Hal Glicksman Open Things Up

Mowry arrived...just a torrent of words...all interesting... ideas all over the place. Mowry opened the territory wide up. Mowry and Hal being here really made a big difference. [After graduating from Pomona in 1968,] I stayed in Claremont to go to graduate school because Mowry was here, and he hadn't been here for very long, and I hadn't had enough of Mowry. He was the most brilliant guy I'd ever met in my life.
–Michael Brewster[4]

Mowry was one of the few people in my life who you could reliably count on for a brilliant and original point of view. Mowry would bring a slant to something that nobody else had. I think of how germinal so much of what Mowry did was. He's someone who, when it shakes out a little bit, will be accorded a much, much more visible place than he has now. Mowry was also always sort of the grey eminence of the school as long as he was there, whether he was department chairman or not. It was really an odd little confluence of things that happened there. Everybody coming from someplace else for their own reasons. There was no plan about this school. This wasn't like CalArts, a scheme to be a certain thing, or Irvine, where they really had an objective. It didn't seem to work that way. It seemed to just happen.
–Lewis Baltz[5]

In April 1968, Mowry Baden returned to Pomona College to teach art, run the gallery, and chair the art department. His former classmate, Frank LaHorgue ('58), had contacted him at former Pomona College President E. Wilson Lyon's (President from 1941–69) suggestion. Realizing how tough it would be to take on all three jobs, Baden negotiated a three-year contract that included a single-year term as art department chair. Baden joined two colleagues in the art faculty at Pomona—painter Guy Williams, and sculptor David Gray, both of whom were well liked and respected. Baden hired Hal Glicksman as director of the gallery and assistant professor of art, in the fall of 1969, based on his reputation as an artist's preparator at the Pasadena Art Museum.[6]

Baden was a highly influential and challenging artist, colleague, and teacher. He was also a diplomat, adept at bridging the gap between artists and administrators. Speaking in 2008, former Pomona College President David Alexander (President from 1969–91) remembered with regret accepting Baden's letter of resignation in 1971. Baden thrived in the close-knit

and energized atmosphere of Pomona College, becoming close friends and remaining in contact with many former colleagues and students. Stories about Baden's life-changing influence turned up frequently in interviews with former students. Writer and critic Kay Larson, for example, returned to Pomona College in the spring of 1968, just after Baden had started working at Pomona. She remembers distinctly how different the department felt with Baden's dynamic presence.

Larson remembers "walking into Mowry's office and not knowing exactly what I wanted to do, but saying I wanted to make art about the intercession between the earth and the universe." She recounts, "I think I was talking about angels. It was about being in the middle, between phenomena and something more transcendent. And I had no idea what I was talking about. Mowry just said 'Sure!' He was able to open the doors without any effort at all...just by being so accepting."

Baden worked closely with Glicksman, collaborating with him and the artists that Glicksman invited to be part of the Artist's Gallery program, a program instituted by Glicksman in which the gallery functioned as a studio-residency for post-Conceptual and Light and Space artists. As gallery director, Glicksman (and later Winer) taught art history courses in addition to programming the exhibitions. Glicksman established a seminal series of exhibitions dealing with Light and Space art and new forms of installation.[7] He organized projects with Michael Asher, Lewis Baltz, Judy Chicago (at that time Judy Gerowitz), Ron Cooper, Tom Eatherton, Lloyd Hamrol, and Robert Irwin. After just one year, in June 1970, Glicksman left to work with Walter Hopps as associate director at the Corcoran Gallery in Washington, D.C.

Baden and Glicksman kept up a long and detailed correspondence after Glicksman left Pomona, sharing ideas about the role of art and its potential to create change. In a letter written after Glicksman's departure, Baden wrote:

I have been thinking of late that your gallery program at Pomona was a most tactful acknowledgement of some obvious truths that need facing. I'm really glad I saw you and the artists do that. Except for the aspect of impermanence, the whole program lay in that long tradition of artist and institutional patron....The only way I can see to tighten it up is in ownership. And [it] seems to me Bob Smithson said something to that effect over Walter's [coffee

4. All quotes from Michael Brewster are from an interview with the author at Pomona College, Claremont, October 2, 2008.

5. All quotes from Lewis Baltz, unless otherwise noted, are from an interview with the author in Zurich, Switzerland, June 11, 2009.

6. In the interview in this volume, Mowry Baden goes into more depth about his connection with the department and the hiring of Hal Glicksman. Characteristically modest, Baden regularly guided discussions to Glicksman, Gray, and Williams, and later James Turrell (whom he hired in 1971 to replace him), instead of mentioning his own contributions to the dynamic climate at Pomona.

7. See the interview with Glicksman in this volume for more discussion about his projects and legacy.

shop in Claremont] grease one noon. His sequence went something like this: 1) Artist makes a proposal for a specific site. 2) Artist finds a patron who must assume ownership of the site and pay for the work. 3) Because it is owned by someone it obtains instant longevity. Longevity is really a matter of memory. To have any substantial memory the work must, however brief, be public....Like Taliesin, Soleri's Scottsdale and best of all, Watts Towers and Merzbau. [8]

Both Baden and Glicksman (and later Winer) recall a strong camaraderie that united the studio faculty to the gallery, often culminating in evening parties in the gallery courtyard that also included students. Lewis Baltz, then a student at Claremont Graduate School (CGS; now Claremont Graduate University) who also taught at Pomona College, held his first gallery exhibition of his now well-known Prototype series at Pomona, at Glicksman's invitation. Baltz had taken Glicksman's course on nineteenth-century art history and developed a close relationship with Glicksman that extended beyond Glicksman's departure in 1970. Baltz recalls,

Glicksman was a great teacher and a great art historian. We laughed about this later, because he said he'd never studied nineteenth century [art history].... [H]e would read the books two days before the lecture, make the lecture, and come and give it. It was wonderful. Hal was completely convincing, completely inspiring. I assumed he'd been doing this for decades. Then he had the idea I could work a photography program into his course and that I would become his teaching assistant. In fact, what I would teach is a little photography program. I'm not sure whether that was one semester or one full year. But they asked if I wanted to do it again. And I agreed, but I said, 'I want a position.' At that moment, CGS was a young school. Everybody was sort of radicalized and now I can't imagine just coming in as a graduate student and within one year getting a teaching position. A lot of responsibility was given to me very early on, which was great. I don't think that would have happened in a more established system.

Marcy Goodwin, a CGS MFA alumnus and Guy Williams's partner for many years, lived in Claremont during this era and remembers the strong sense of cohesion among the studio faculty, students, and visiting artists. She also points out that since the art program at CGS did not have a building when she, Baltz, and Turrell were in the MFA program, Pomona became the default venue. Goodwin notes:

Pomona, despite being a small, undergraduate liberal arts college, suddenly became a mini-art-school-university, because the grads and the undergrads were mixed together, in intimate, close proximity. Inspiration was the outcome. There was no art gallery for CGS, there were no studios, there were no faculty in attendance for the grad students. It was all piggy-backed onto Pomona's faculty. Like much of that time, it was an experiment. The thing that made Pomona Pomona, as it was when we were there, was our bringing this rigorous intent to be fully international, professional artists to a completely non-professional liberal arts college. What the group brought to this small, private, slightly elitist place was an intellectual rigor about the contemporary visual world and the art world. [9]

Goodwin recounts a gathering of Baden, Baltz, Turrell, Williams, Hap Tivey, and Gus Blaisdell at the home she shared with Williams in which she and Baltz each took a memorable group photograph. She points out that in the all-male version of the photograph, she attempted to graphically characterize what being an artist was about, remarking "at Pomona, and at CGS, with Jim and Duke [Baltz] and Guy and Mowry and everybody, you were going to be an artist for all time. Being an artist is not 'looking like' or posturing as an artist-like personage, it is about fully immersing oneself in being an artist today. That is what seriousness means."

The artistic seriousness and the camaraderie, however, did not always extend to the art historians in the art department, or to the rest of the college community. As Baden's first year as chair approached its conclusion, President Alexander hired art historian David Merrill to chair the art department. Merrill stayed for a couple of years. Baden headed the search for Merrill's replacement just before leaving Pomona in the spring of 1971. Baden, and the Pomona administration, retained art historian Gerald Ackerman (who started in the fall of 1971), a hire that substantially changed the focus of the art department and which Baden and others came to regret.

The Middle: A "Pretty Hot Time"

Student life on the Pomona campus shifted dramatically in the late sixties, as it did in the rest of the United States. On November 2, 1968, Alexander's predecessor, President Lyon, gave a speech on Parent's Day addressing "The Nature of the College." This impassioned speech addressed the "deep trouble" in which American higher education found itself.

8. Undated letter from Baden to Glicksman, on Pomona College letterhead. Gift of Hal Glicksman. The Getty Research Institute, Los Angeles (2009.M.5)
9. Marcy Goodwin, interview with the author in Pasadena, California, May 15, 2009

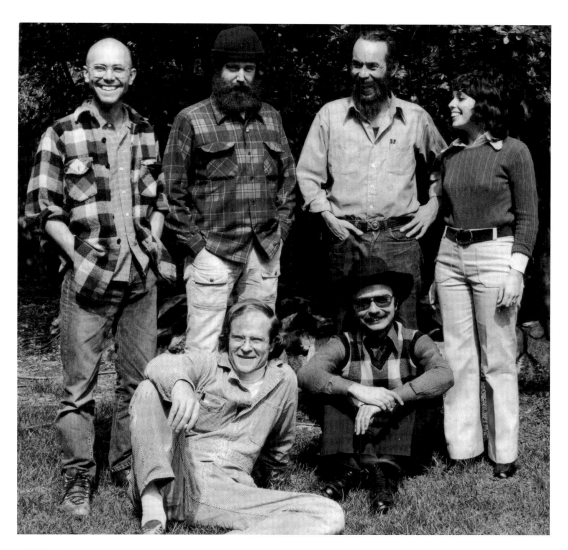

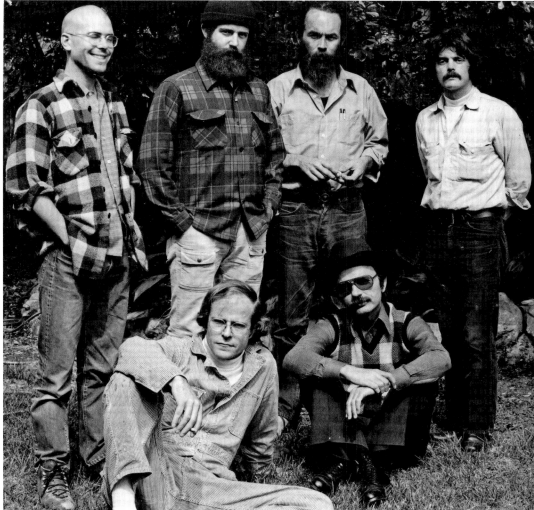

TOP / BOTTOM

Back row, from left to right: **Hap Tivey,
James Turrell, Gus Blaisdell,** and **Marcy
Goodwin**; front row, left to right: **Mowry
Baden** and **Guy Williams**; Claremont, 1972

Back row, from left to right: **Hap Tivey,
James Turrell, Gus Blaisdell,** and **Lewis
Baltz**; front row, from left to right: **Mowry
Baden** and **Guy Williams**; Claremont, 1972

1969-70 Handbook
of the
Associated Students,
Pomona College
and
Lookbook
of the
Entering Students
and Faculty

September 1969

Pomona College Bulletin

Cover of 1969–70 *Handbook of the Associated
Students, Pomona College,* and *Lookbook
of the Entering Students and Faculty,*
September 1969. Pomona College Archives

Lyon began: "The social changes affecting our national life, which we see reflected in the current presidential election, are leading to a reassessment of most American institutions, and particularly of education and at all levels." He goes on to cite statistics about Pomona College and its original mission. In his concluding statements he notes, "It is never easy to keep the present and past in proper relationship, and it has been extremely difficult in the past three years.... [F]rom my own long experience, these years seem an aberration in the American college and in national life." Finally, he pleads, "It is my fervent hope that we can at Pomona, in this time of troubles for education, keep our essential purpose and responsibility before us....[T]hat is what a liberal education is all about."[10]

Lyon's speech underscores the turmoil of the time, and only briefly mentions the presidential election of 1968, which took place three days after his speech. Richard Nixon narrowly won the election by positioning himself as a "crusader for law and order."[11] The election was a wrenching national experience, and it was conducted against a backdrop that included the assassination of civil rights leader Martin Luther King Jr., subsequent race riots across the nation, the assassination of presidential candidate Robert F. Kennedy in Los Angeles, widespread demonstrations against the Vietnam War across American university and college campuses, and violent confrontations between police and anti-war protesters at the 1968 Democratic National Convention.

Indeed, as Lyon mentioned, it was an "extremely difficult" time for America. A deep cultural divide manifested in many ways, often in shifts in dress and appearance. Writing about the rock-and-roll music scene of the era, Michael Walker remarks: "The change between 1964 and 1965 in Los Angeles was astonishing. In a photograph of a Johnny Rivers performance at the Whiskey in 1964, the patrons look like extras from an episode of *Dobie Gillis*: short brilliantined hair and skinny neckties for the boys, Doris Day-style bouffants and sack dresses for the girls. One year later, post-Beatles, the Byrds are onstage—David Crosby has grown his hair and Yosemite Sam mustache and is wearing fringed buckskin; the audience appears to have been made over by some species of hip aliens."[12] A similarly dramatic shift happened at Pomona College, although it appeared later, in 1968 and 1969. Yearbook photographs of Pomona College seniors up until 1968 show young men in suits and ties and young women in headbands and Peter-Pan collared blouses. Michael Brewster is pictured with horn-rimmed glasses and a suit and tie in his 1968 senior picture. A year later, Thomas Crow sports longish hair, just covering his ears, and a shaggy mustache, still wearing a suit and tie. By 1972, senior Paul McMahon ('72) looks the part of an artistic explorer, an almost-hippie. *(See page 367)*

Battles over more profound issues than changes in appearance were raging on campus, ranging from anti-war protests to debates over the creation of a Black Studies Center and a Mexican-American Studies Center in 1969. *The Student Life*, the Pomona College student newspaper, reflects the urgency of several of these issues. Student protest activity seems to have been spurred in 1968 by Lyon's decision that the Communist party could not recruit in the college's placement office.[13] In conjunction with rising tensions about the military draft, recruitment, and Reserve Officers' Training Corps (ROTC) on campus, Lyon's decision sparked a wave of angry protests. Several major protest actions and moratorium days were observed on campus. *(See the timeline in this volume)* Both Baden and Baltz remember participating in anti-war protests on Indian Hill Boulevard, Claremont's main street. In his freshman year, 1965–66, Crow remembers a confrontation between anti-war protestors and pro-war supporters. A few years later, the pro-war faction had disappeared and the climate on the campuses was becoming distinctly more radical. Then, on February 25, 1969, a campus building, Carnegie, was bombed.[14] Lee C. McDonald ('48 and professor of government emeritus) recounts that the bombing "severely injured the Department of Government secretary, and the simultaneous bombing of the Scripps College president's office traumatized the campuses." He notes, "the bombing culprit was never found but was thought to be a Los Angeles agitator infected with the violence of the times."[15]

The Student Life newspaper and the *Pomona Today* magazine report significant racial conflicts, reflecting that this was a major time of adjustment for Pomona students with respect to race. Civil rights movements and their attendant ideologies found their ways into local expression at Pomona: Black Panther Bobby Seale spoke at Bridges Hall of Music on December 10, 1968; a Black Studies Center and a Mexican-American Studies Center were proposed, hotly contested, and finally created; and students, faculty, and administrators frequently worried about racial diversity at the predominantly white college.[16] Dean and director of admissions William Wheaton attempted to address

10. E. Wilson Lyon, "The Nature of the College," speech for Parent's Day, November 2, 1968. Pomona College Archives.

11. Rick Perlstein, *Nixonland: The Rise of a President and the Fracturing of America* (New York: Scribner, 2008), 202.

12. Michael Walker, *Laurel Canyon: The Inside Story of Rock-and-Roll's Legendary Neighborhood* (New York: Faber and Faber, 2006), 94.

13. E. Wilson Lyon, President's Letter, January 12, 1968. Pomona College Archives.

14. According to *The Student Life*, the newspaper had already gone to press for the day when the bombing occurred, so a report was typed, mimeographed, and distributed with the paper in the evening. *The Student Life*, February 25, 1969. See the timeline for more detail.

15. Lee C. McDonald discusses this incident in a web article, "A History of Contradiction," at www.pomona.edu/Magazine/PCMWIN03/DEYears.shtml.

16. In the December 12, 1968 issue, *The Student Life* reported that Bobby Seale spoke on campus. Information from *The Student Life* was compiled by Rochelle LeGrandsawyer. In *Pomona Today* issues from April 1968 to February 1971, the editors report intense debate on campus demonstrations, on the challenges facing higher education, on "Minority Student Relations" including the formation of the Black Studies Center and the Mexican-American Studies Center (organized by the United Mexican-American students, or UMAS), on changing admissions policies, and on "Women's Liberation."

17. William Wheaton, "The Complicated, Difficult, and Sometimes Maddening Job of Admissions," *Pomona Today*, October 1964. Pomona College Archives.

18. Interview with William Wheaton, *The Student Life*, February 18, 1969, 1.

19. Ibid.

20. In "A History of Contradiction," McDonald notes, "My own class of 1948 had only one African American (her father, a New York physician, had graduated from Pomona in 1919), one student of Japanese origin, one of Chinese descent, and a handful of Jewish students."

21. See Judy Fiskin's and James Turrell's interviews with the author in this volume.

22. Larson, ibid.

23. See Chris Burden's interview with Glenn Phillips in this volume.

24. According to the Cultural Equity website, in the late sixties, Guy Carawan, and his wife Candie, moved to Hellier, Kentucky, in the rural eastern Appalachians, to support the striking coal mine workers. There, Guy and Candie worked to help the miners improve their health and dignity through community organizing. They also began to record and study in depth the music of Appalachia. They then returned to California, where Guy taught courses in Civil Rights, American folk life, and ran Appalachian field-study programs for four years at Pitzer College in Claremont. Ellen Harold and Peter Stone, "Guy Carawan," Cultural Equity, http://www.culturalequity.org/alanlomax/ce_alanlomax_profile_carawan.php, accessed January 17, 2011.

25. All quotes from Peter Shelton are from an interview with the author in Shelton's studio in Los Angeles, California, October 1, 2008.

26. All quotes from Robert Taplin are from an interview with the author in New Haven, Connecticut, April 5, 2010.

27. Kathleen Dimmick in email correspondence with the author, June 29, 2010.

the issue of a "balanced student body," including a new emphasis on racial and ethnic diversity.[17] In an interview with *The Student Life*, when he announced his retirement in 1969, Wheaton stated that the major problems facing him and the college were "establishing a racial balance at the college and offering admissions to more minority students." The article noted that the Black Studies Center and a Mexican-American Studies Center had helped to increase the number of applications from black students to eighty-one, and the number of Mexican-American applications to thirteen.[18]

In a program that became informally known as "Wheaton's Folly," Wheaton attempted to balance the student body culturally as well, saying, "the total life of the college not only demands some scientists, some social scientists, some humanists, but also some artists, some musicians, some linguists, some athletes."[19] Turrell recalls that his freshman class, in 1961, was the first class with Jewish students, while others note that "a handful" of Jewish students attended over the years.[20] Turrell and Judy Fiskin ('66) also credit "Wheaton's Folly" with the enrollment of more artistic and creative students. Both recall feeling alienated at Pomona until they located other Wheaton's Folly students. Many of the students represented in this exhibition were part of that group or gravitated to it.[21]

During this era, residential life was segregated by gender, with women living in south campus dorms and men in north campus dorms. This social arrangement slowly shifted, beginning with "open visiting hours" in Wig Dormitory and culminating in the creation of co-ed dorms as part of an academic utopian living experiment. Some social mores remained staunchly in place, while other social traditions died a public death by changes in college social policy. The annual "weigh-in," in which sophomore men weighed and measured freshmen women and published the results, was one such fatality. The time-honored (and often aggressively enforced) tradition came to a close in 1972. (*See page 342*) Larson recollects,

Basically, the Pomona administration was clueless, as far as I could see. I was in a fight with Pomona from the minute I got there in 1964 because the men could stay out all night long if they wanted. The women students had to sign in at seven or eight o'clock. Once or twice a week, you could sign out until eleven o'clock. I thought that this was such total crap. It made me furious, although I now recognize that a lot of feminist issues were making me

furious then...the attitude behind it was so patriarchal toward the conception of what a student was. That we, especially the women, had to be sheltered in some way from our own sense of who we were.[22]

Chris Burden also remembers the restrictions on women: "I'll never forget...the first or second year that I was there...you were only allowed to have women in your rooms during certain hours. The door had to be open, all that kind of stuff. Well, the faculty wanted to liberalize those rules. And the student body vetoed the faculty! And I kind of went, where the fuck am I? This is like...weird. I grew up in Cambridge, where freshmen were dating high school girls because there were not enough women to go around. So, where am I? What is this place? It came from a fundamentally very right-wing, conservative, Christian kind of ideal."[23]

In addition to the heated social dynamics, civil rights debates, and anti-war protests, the academic life of the college contributed to the intensity of the moment. Art major Peter Shelton ('73) and his close friend Robert Taplin ('73 and who created his own major in Medieval Studies), both recount the impact of several key faculty members and departments. Both vividly remember Pitzer College Professor Guy Carawan's courses in folk music and ethnographics.[24] Shelton recalls: "In my sophomore year, I went off to Kentucky with...Guy Carawan....Guy put us in these home-stay situations, and, in my case, I lived with a couple of different coalminers in eastern Kentucky."[25]

Taplin reiterates Carawan's influence: "He was a huge figure...who knew all the major figures from the folk movement....[He] was friends with Jack Elliott, and took all those people to Appalachia year after year... [to meet] those Appalachian cultural lefties, [and experience] that old thirties radical thing up in the mountains in Kentucky. It was totally incredible."[26]

Shelton and Taplin also recount that Andrew Doe, head of the theater department, and Richard (Dick) Barnes, professor in the English department, played an instrumental role at Pomona during this era. Kathleen Dimmick, a theater major ('72), credits Doe with bringing avant-garde theater companies to campus. Dimmick remembers when the Bread and Puppet Theater performed "in a tent set up on Marston Quadrangle: Mabou Mines performed *Red Horse Animation* and *Play* (by Samuel Beckett) in Holmes Hall, and the [San Francisco] Mime Troupe performed a couple of their early political pieces in the Greek Theatre and outside Frary."[27]

Professor Barnes, a poet, medieval literature specialist, and creative writing teacher, influenced many students. On October 21, 1972, he presented a highly experimental event, something like a happening or performance, in the rock quarries east of campus. Called *The Death of Buster Quinine*, this quixotic and dramatic event is one occasion that everyone I spoke with remembers distinctly. Shelton and Taplin helped build structures for the event, and Tivey and Turrell created artworks for it.

Stanley Crouch, music and cultural critic and an original member of the Watts Writers Workshop, is another name that comes up frequently. Crouch was, according to Shelton, "a poet himself, and a critic, and a jazz musician, and wrote plays. Stanley started off teaching at Pitzer College, but he got very involved with Andy Doe and later became a faculty member at Pomona teaching English and literature." Summing up the sense of energy and creativity that pervaded the theater and English departments, Taplin states:

Crouch was this brilliant, literary guy who was also a jazz drummer. He knew that crowd of musicians, David Murray and all those people who became a big deal in the eighties. Stanley was right there. Where Pomona got him, I have no idea. Crouch was notorious for classes where he talked about Moby Dick, and sometimes seemed to take on the persona of Ahab. He wrote these plays that Andy Doe in the theater department produced, which were really quite amazing. The one I remember was an incredible, ribald satire of Nixon. Stanley would be in the back of the auditorium, in the last row of Holmes Hall, which is long since torn down, playing a full set of drums. And he left, went to New York and became the jazz critic for the Village Voice *for that world of eighties jazz.*

Helene Winer remembers Crouch as a valuable ally on the faculty. Citing the conservative environment at Pomona and in Claremont, she remembers feeling that "basically no one talked to us. Not that they wouldn't have, but there was...a kind of cultural divide. We would just not be spoken to, or invited in. A bit like outsiders, judged just by our appearance. Well, there were no women on the faculty. And no Blacks, certainly, I think there was a fear of activism."[28]

In the Avant-garde, Like It or Not

Gallerist and Metro Pictures founder Helene Winer's legacy in contemporary art is now well known, but this was by no means established during her tenure at Pomona College.[29] On May 14, 1971, the new art department chair, Gerald Ackerman, wrote to President Alexander, Dean Lee McDonald, and Dean Ray Frazer, summarizing and praising Winer's first year of exhibitions:

Those who were worried about the quality or content of the exhibitions in the Pomona Gallery this past school year should be enheartened to learn that Miss Helene Winer's independent choice of artists has been backed by the staff of a major museum [LACMA] which has just included some of these artists in an important new show ["24 Young Artists"]. These artists are deeply concerned with formal matters, so deeply that anything goes for material: they see form in junk, in plaster, in the most ignoble materials....Those who were puzzled by the exhibits at Pomona may find their puzzlement ends when our artists, already familiar but hitherto seen in isolation, are enjoyed surrounded by the works of other artists of similar values. These artists are so innovative that it takes a group show (or a good eye and memory) to link them together....We can also congratulate Miss Winer that she knew how to arrange "messy" art so well: our galleries looked a little neater (without harm to the qualities of the objects displayed) than the galleries of the County Museum do today.[30]

Ackerman concludes the letter with the prophetic statement "Pomona is again in the avant-garde, whether it likes it or not."

Winer's exhibitions that first year included solo exhibitions of work by Jack Goldstein, William Wegman, Joe Goode, John McCracken, John M. White, and Guy Williams. Why did Ackerman feel the need to justify these exhibitions? Merely a year earlier, when Glicksman submitted a resignation letter to Alexander, the president replied, "Your brief stay here has already whetted our appetites for vigorous and interesting exhibitions in the Gallery."[31] Winer had been hired with a clear intention to

28. All quotes from Helene Winer are from an interview with the author at Metro Pictures Gallery in New York, October 8, 2008. Winer also noted that Crouch later became a neo-conservative critic.
29. In this volume, Marie Shurkus addresses how Winer's time at Pomona presaged more than a decade of art making in the eighties in New York. Crow also points to Winer's lasting influence in his essay. Two recent exhibitions and their accompanying catalogues prominently place Winer in a pivotal role in art of the seventies and eighties. Winer's formative work at Pomona College is not as well known as her work at Artists Space and Metro Pictures in New York. But both Douglas Eklund, in *The Pictures Generation, 1974–1984* exhibition catalogue (New York: The Metropolitan Museum of Art, 2009), and Phillip Van den Bossche, in the *In & Out of Amsterdam: Travels in Conceptual Art, 1960–1976* exhibition catalogue (New York: The Museum of Modern Art, 2009), devote significant discussion to her early exhibitions at Pomona College. Eklund lists the impressive roster of artists she worked with, and ends his discussion with the fabled story of the highly controversial performances by Burden and Wolfgang Stoerchle (with a few misattributions and errors).
30. Gerald Ackerman, letter to David Alexander, May 14, 1971. Courtesy of Helene Winer.
31. David Alexander, letter to Hal Glicksman, March 18, 1970, Pomona College Archives.

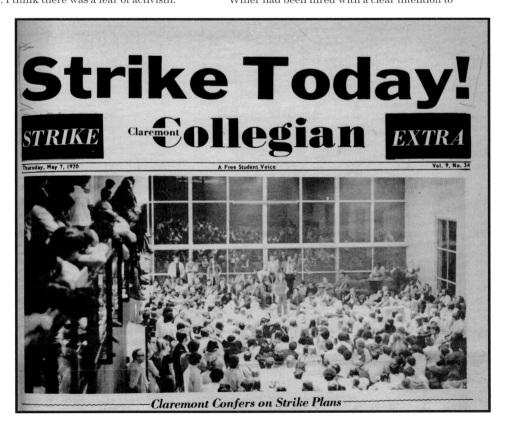

"Strike Today!," *Claremont Collegian*, May 7, 1970. Special Collections, Honnold/ Mudd Library of the Claremont Colleges

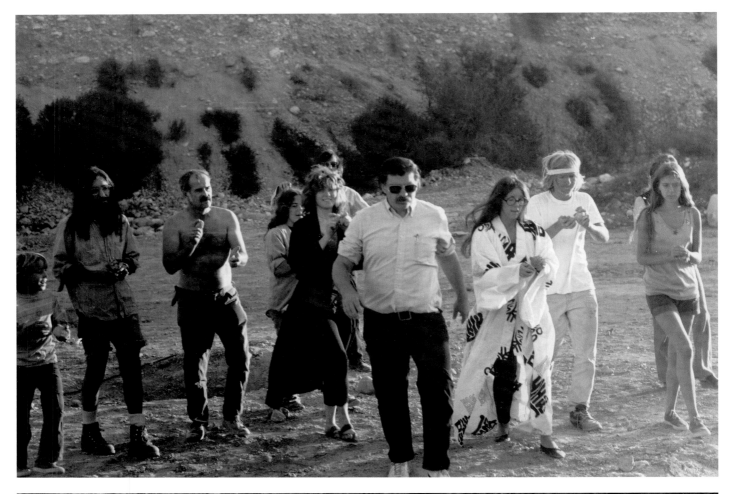

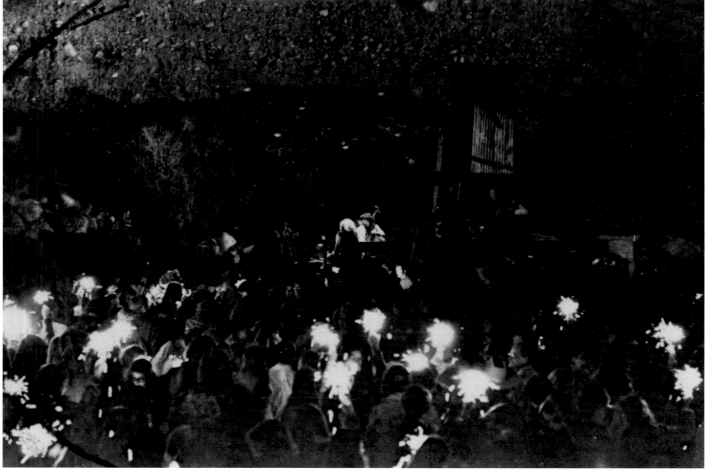

Richard (Dick) Barnes *The Death of Buster Quinine*, photographs of performance, 1972. Dick Barnes Collections, Special Collections, Honnold/Mudd Library of the Claremont Colleges

present experimental art, and in her thank you letter to Professor David Merrill, then chair of the art department, following her job interview, Winer noted, "It seems that all of the more interesting exhibition ideas and events that have taken place recently were at small museums or university galleries outside of Los Angeles, the only situations where the policy and thinking seem to be flexible enough to allow for a really imaginative program. This is of course very encouraging to me."[32] The arts faculty seemed pleased by Winer's hire. In a letter to Glicksman, Baltz sent an update on life in Claremont, including Baden's departure and Winer's arrival:

Speaking of plugging the gap, we now have a gallery director, Helene Weiner [sic], who you probably know. She was at L.A. County and the Whitechapel in London before coming to P.C. Her ideas seem parallel to your own regarding the artist-in-residence idea: she wants to put the gallery at the disposal of artists rather than merely use it to display existing works. I suspect that last year's program will serve as a model for quite a while....Mowry, as I said on the phone, is leaving. I think for Canada....I think the school will be greatly diminished by his leaving.[33]

Pomona would continue to be "in the avant-garde" as the academic year of 1971–72 got underway. James Turrell, hired by Baden as his replacement, and Michael Brewster, hired as David Gray's sabbatical replacement, both started teaching in fall 1971. During Winer's tenure, while the student body roiled with social and cultural upheavals, the art programming continued to be innovative. Winer's second year included exhibitions with Bas Jan Ader, Ger van Elk, William Leavitt, Ed Moses, Allen Ruppersberg, and performances by Burden, Stoerchle, and Hirokazu Kosaka. But apparently, by late 1971, there was a bit less administrative interest in and support for vigorous and challenging exhibitions. By the fall of 1972, Winer would be asked to resign her position at Pomona College.

In the early stages of conducting research and interviews for this project, stories turned again and again to a performance by Wolfgang Stoerchle, describing either how outrageous the performance was, or asserting that Winer and studio faculty Baltz, Brewster, Gray, Turrell, and Williams were all fired because of it. It makes a great story—a naked man urinating in the gallery on a quiet college campus. However, the performance in question took place in March 1972; Winer didn't leave Pomona until late that fall, and members of the studio faculty not until June

1973. Clearly, other issues were at play. As Brewster succinctly put it, the Stoerchle performance was really "just the straw."

One of the most thoughtful descriptions of Stoerchle's performance is by Greg Van Velsir. Van Velsir was a Pomona philosophy major ('70) and, at the time of the performance, a CGS graduate student in art:

I don't think any of us were at all concerned about the nudity. Most of us had seen each other naked on more than one occasion and after the '60s, total freedom of expression was a given. The shock value of it was zero to us and I don't think any of us were offended. However, I also left with the obvious question...was what I had seen Art? ...Of course, we discussed this as we departed and I have to admit I had trouble thinking this was art at the time. Unless art is only about defining what is or is not art, I still can't say that his performance had artistic merit to me. At best I would say I left the performance feeling flat, or let down. Despite my opinion I had no problem with the performance being sponsored by Pomona, held in Montgomery [now the Pomona College Museum of Art] (although it might have been better somewhere else), nor with the art professors there supporting it. All of that was perfectly appropriate to the time and place. It was unfortunate that the more powerful at Pomona couldn't understand that art does have to push boundaries. They supported our rights at Pomona to demonstrate, to hold peace vigils weekly on the Coop lawn, and staunchly defended all other manner of free speech in every other discipline. How could this be singled out for punishment?[34]

Apparently, the performance wasn't shocking to many people. Probably due to the nudity, many people conflate Stoerchle's performance with one by Chris Burden, which had happened a week earlier. Even Ackerman, who in some former faculty's eyes helped bring about the radical restructuring of the art department in 1973, found nothing untoward. He notes:

There was nothing students would be shocked by, in the least bit. Except the thing that was amazing was about the Chris Burden....He took matches, and by wrapping tin foil around them, when you lit them, they'd turn into rockets. There she was, beautiful body, lying cross-wise, he just lit them one after the other. The lit matches were out by the time they hit her, and just bounced off if they did. But what was so funny, is that right on either side of us were television sets. And what looked horrible in life, was just entertainment on the television. And that's what the point of it was....It really made you think. It was quite

32. Helene Winer, letter to David Merrill, October 1, 1970. Courtesy of Helene Winer.
33. Lewis Baltz, letter to Hal Glicksman, November 7, 1970. Gift of Hal Glicksman. The Getty Research Institute, Los Angeles (2009.M.5).
34. Greg Van Velsir, email correspondence with the author, June 30, 2010.

ahead of the time. And I thought, this other fellow, Stoerchle, was the least interesting of them. He spread a towel on the ground, stood in front, drank a beer, stark naked, not a bad body...not a weight lifter...drank a beer, and then stood there until he had to pee. He peed on the floor. That was sort of boring...but people did phone up complaining....And I just fended them off, one after the other. The president would turn the calls over to me.[35] *(See pages 228–31)*

The End of an Era

David Alexander began his term as Pomona College president in the fall of 1969. It must have been a difficult moment for a young president; campuses across the country were in turmoil. Early on, Alexander's support of the arts seemed clear, as implied in his 1970 letter to Glicksman. Over the next three years, however, art practice at the college and the exhibitions in the gallery would present major challenges to the administration.

In fact, the arts were a focus of conflict across the Claremont Colleges. Roland Reiss arrived in the fall of 1971 to head the Claremont Graduate School art department. Reiss stated "knowing that an art department with an important contemporary reputation was in place at Pomona and that Scripps had a solid program with a great history" helped entice him back to Southern California from Colorado. Reiss arrived at CGS at a complicated moment, and one of his first tasks was to explore how to integrate the arts across the Claremont Colleges in order to avoid duplication:

Scripps, with Millard Sheets [professor of art and art department chair for many years at Scripps College], had sort of dominated the graduate program. But the Pomona and Pitzer faculties were part of the graduate program as well. When the decision was made to make the graduate program a separate entity, a joint faculty committee appointed Douglas McClellan who had been the chair at Scripps College to be its leader. When I arrived the next year, there was no central facility in place for the program. The students were in Bridges Auditorium and various little rooms, and a few of them were over at Pomona and Scripps....There were something like twelve graduate students...[in] ceramics and painting and drawing. When I arrived there, there was no art department. There was no place."[36]

By the time Reiss submitted his report on integrating the disparate programs to the presidents of CGS and the other colleges, he was exasperated by the territorialism and protectionism displayed by all of the colleges' art departments:

All hell broke loose with my report. You see, it had turned out that they were all so proprietary. They didn't want to give up anything. Anything. So this was an exercise in futility for me...I finally realized no one was serious about it but the president of CGS. I tried to lay out a really helpful plan on different levels. But they wouldn't even take it at the lightest level. They wouldn't even share a classroom. One of the things that interested me was, under President Alexander, Pomona College did not offer tenure to its [art] faculty, which meant that they were vulnerable all the time. My major proposal was for an art department in Claremont that would service all the colleges. It was a very simple, pretty clear, straightforward procedure. You could protect the faculty with tenure. And it made sense in terms of the history of art in Claremont, which was a great history, but when I arrived its legacy was beginning to unravel.

Reiss's suggestions did not get implemented, and his assessment clearly indicated that the dissension and frustration in the art departments presented a challenge for all of the presidents of the Claremont Colleges, including Alexander. Reiss also notes that Scripps College was always seen as "fine arts/crafts" and had a very strong program in ceramics under Paul Soldner, while Pomona's art department could be seen as "more elitist, committed to Fine Arts with a capital FA." Reiss remembers that a conflict, already brewing before his arrival, centered on whether or not Pomona College should offer ceramics in its art department. In the fall of 1969, Norm Hines was teaching one ceramics class at Pomona. Reiss states:

I know that there was just a lot of bad blood. I could feel it when I was over there. The conflict between ceramics and fine art, the refusal to tenure studio faculty, the loss of Helene Winer, and the disintegration of an impressive studio faculty were all happening under President Alexander.

In addition to the conflicts at Pomona between the administration and the art department, as noted by Reiss, significant differences were brewing between Ackerman and some of the art department faculty. Tension between Winer and Ackerman seemed to accelerate after the Stoerchle incident, and both recall conflicts over the gallery's budget. Baltz, Gray, Turrell, and Williams are all on record as having disagreements with how Ackerman chaired the art

35. All quotes from Gerald Ackerman, unless otherwise noted, are from the author's interview with Ackerman, in his home in Claremont, California, July 29, 2010.

36. All quotes from Roland Reiss are from an interview with the author in Reiss's studio in Los Angeles, California, February 18, 2010.

department. In July 1972, Baltz wrote to Glicksman, voicing his dismay over the status of the Pomona College art department, saying, "since he [Ackerman] has become Acting Chairman at Pomona he has become insane and Fucked Everything Up... Helene, Jim, Guy, and me are all job hunting—or will be shortly."[37]

Artist Leland Rice recounts: "Ackerman didn't have respect for practicing artists; as an art historian he had minimal exposure to and practice with studio art."[38] In May 1973, a Pomona student, Scott Brastow ('73), published for his senior thesis a fascinating "exposé" on the departure of most of the studio faculty members from the art department. This appeared in two parts in the *Claremont Collegian*, the daily paper of the Claremont Colleges. He interviewed all of the studio faculty (including Mowry Baden, by then working at the University of British Columbia), many college administrators, and several Pomona students, including Peter Shelton. (*See pages 28–30*) Brastow's article starts with an intriguing and telling quote by former Dean Ray Frazer:

Turrell is an intelligent guy which is rare for an artist; Mowry Baden is like that too....They don't have much to do with the other faculty, they live in another world. None of these people consider themselves a teacher—that isn't what they are. They just do it to keep in food, to paint or sculpt or whatever they do... In modern times its [sic] fashionable not to verbalize, but just to grunt...the arts, music, theatre, studio art, and also P.E., are on the fringe of narrow academic thinking.[39]

The article is quite long—four newspaper-length pages—with many quotes from studio and art history faculty, administrators, and students. Ultimately, the article points to a fundamental lack of communication and the philosophical differences between several factions. Ackerman is placed in the middle, saying in the article that "the lack of commitment by the school has caused the department to suffer...it's a monster that feeds on itself, as the people change the curriculum becomes less and less stable, and the people change more."

Ackerman perhaps is referring to the lack of tenure for art faculty, which Reiss had earlier suggested was contributing to instability in the art departments. Brastow's article also highlights the conflict between contemporary studio art practices and more traditional practices, such as ceramics, as well as the differing attitudes surrounding those practices.[40] By the time

the article was published, Winer and Baltz had already left the college; Turrell, Gray, and Williams would follow shortly. Hines, who had been teaching a ceramics course at Pomona, was asked to become a full-time faculty member in 1973. Over the next year, he and Ackerman hired new studio faculty members to replace those that had left (or not been rehired).

In a September 20, 2008, phone conversation with the author about Winer's performances and exhibitions, former President Alexander first noted how he admired Winer as an "adventurous and lively person who brought a lot of energy to the department." He attended the Burden performance and thought the intention was "to see how boring he could be and how long the audience would stay." Alexander missed the Stoerchle performance the following week, but described Stoerchle as "wearing red underwear, which he took off, then urinating three seconds on and two seconds off on a piece of carpet in the gallery." Alexander recalled that on the following Monday morning, two outraged Rembrandt Club members came to his office, asking what he would do about this performance.[41] When asked about Winer's departure and the demise of the studio faculty, Alexander noted his disappointment that both Baden and Turrell left the college. He said they "both had astonished and delighted him over the years." But he also mentioned that it was very difficult to deal with the art department since they were a "dysfunctional group of folk."[42] Alexander concluded the conversation with the observation that the art department didn't stabilize until David Steadman (the next gallery director, hired to replace Winer) and Hines arrived to "restore order."

Clearly, these were challenging times. And while the Stoerchle performance may have been the "straw," or catalyst, that led to the restructuring of the art department, there were other issues at play. Thinking back to that time, Turrell speculated, "in a way, it has become something bigger in all of our minds than it actually was....You have to remember what performance was like then....It was a really wild time, and how was this supposed to fit into academia? How art fits into academia always causes trouble."[43]

It appears that Alexander—faced with Ackerman's frustration with the studio faculty, conflicts between the ceramics and fine art programs, the unpredictability of Winer's "avant-garde" programming and the "dysfunctional" faculty that were supporting her—may have decided that it might be simplest to not renew contracts for the studio faculty. Ackerman states that

37. Lewis Baltz, letter to Hal Glicksman, July 19, 1972. Gift of Hal Glicksman. The Getty Research Institute, Los Angeles (2009.M.5).

38. Leland Rice, in conversation with the author, June 16, 2010. Rice replaced Baltz at Pomona in early spring 1973.

39. Scott Brastow, "Through the looking glass: Pomona College Art Dept.," *Claremont Collegian*, May 18, 1973, 3.

40. Pomona College had an avant-garde ceramics practice under John Mason (at Pomona from 1962 to 1967), and Paul Soldner was active at Scripps College from 1957 to 1992.

41. Founded in 1905 to support the arts in Claremont, the Rembrandt Club of Pomona College sponsors monthly lectures and teas, excursions to area museums and collections, and a variety of other events. It supports the Pomona College Museum of Art through funding for publications and special programs.

42. Alexander stated that he didn't remember the particulars about Winer's departure. He was apologetic that he couldn't recollect more, but said that he had to be careful with legal issues, since this had been a serious personnel issue in the art department. He suggested looking in the college archives for the legal records. Unfortunately, no records regarding Helene Winer remain.

43. James Turrell's interview with the author in this volume.

FOLLOWING SPREAD
Scott Brastow "Through the looking glass: Pomona College Art Dept.," *Claremont Collegian*, May 18, 1973, p. 3. Special Collections, Honnold/Mudd Library of the Claremont Colleges

Through the looking glass: Pomona College Art Dept.

By Scott Brastow

The office is narrow and not very long. Overcast light enters the single window at one end. Crowded into the rectangular space is a large deep colored desk, a small bulletin board, family pictures in a cluster, a heavy old Royal business typewriter on a metal stand, and an entire wall covered with the literary texts of James Joyce, D.H. Lawrence, William Wordsworth, Albert Camus, and others. Ray Frazer, Dean of the Faculty of Pomona, sits slightly askew on a comfortable swivel chair. "Turrell is an intelligent guy which is rare for an artist; Mowry Baden is like that too...They don't have much to do with the other faculty, they live in another world. None of these people considers themselves a teacher--that isn't what they are. They just do it to keep in food to paint or sculpt or whatever they do...In modern times it's fashionable not to verbalize, but just to grunt."

"The arts, music, theatre, studio art, and also P.E., are on the fringe of narrow academic thinking. There's an attempt at Pomona College to separate what is strictly academic from what is not strictly academic. I don't think anyone in these periphery areas should be tenured."

No studio artist has been tenured at Pomona College in almost the last 20 years. There has been only one art historian tenured in the last decade. Dean Frazer feels that the turnover is generally at the option of the artist. He notes that artists are different from other academicians; it is common for them to value their profession as an artist above their teaching.

Art history professor David Merrill notes that art goes out of fashion so fast that the school appears not to want to be stuck with an outmoded artist who has no resale value. "The feeling is that if you tenure an artist it's like putting him out to pasture to vegetate. There's no more reason for this to happen in the art department than in the English department. It's a problem of tenure, not a problem of the

GUY WILLIAMS by Nick Lacy

art department." He feels a ceasing to grow might be more obvious in the art department, especially in the studio end of the program. "It's more easily discernable in a practicing artist than in an English or a biology professor."

"The department is always looking for professionals who are doing what is being done now. Some move into a better position, some fall out of mode and are let go," Said Norman Hines, the recently hired Pomona College ceramics professor.

This sort of behavior by the school breeds little commitment on the part of the artists. Most in the administration and in the department believe that a periodically rotating staff helps to keep the faculty fresh, but if there is a history of no commitment to the artist it does not seem unreasonable to expect the same treatment to be reciprocated.

Ray Frzer notes, "Artists haven't had security since the beginning of time," but Gerald Ackerman, Acting Art Department Chairman, feels that the lack of commitment by the school has caused the department to suffer. He said, "It's a monster that feeds on itself, as the people change the curriculum becomes less and less stable, and the people change more. No person has consciously developed a curriculum that will survive due to the coming and going of the staff."

Pomona alumni faculty

Ackerman believes that Pomona graduates on the staff can help to stabilize the department. At present there are two alumni out of seven on the art faculty. "What we want here are people who genuinely want to teach, to build up the curriculum in the department. But every artist is torn between his work and teaching. Pomona graduates already have a commitment to the department. Too many people have just gone through here as a stepping stone."

"It can only be a stepping stone," projected Jim Turrell, visiting artist and a Pomona graduate in psychology.

"i don't actually like tenure, I don't think it's a good idea. We can see what happens. But I like this college. The only reason I stayed here last semester is because I went here and I have some sort of bizarre allegiance. But I really don't think that the situation is tenable."

According to several members of the department, both past and present, there is an unwritten rule by the administration not to tenure studio faculty. Helene Winer, Montgomery Gallery director until the middle of fall semester 1972, has been lead to believe that President Alexander flatly refuses to tenure studio artists. David Gray, the sculpture professor, feels that there is "no chance to be anything but transcient if there is no chance of tenure."

No tenure policy

Alexander states that there is absolutely no policy, written or unwritten, to withhold tenure from studio teachers. He feels that a compromise of the Irvine Plan is the best course that the college can follow. The Irvine plan provides for a studio staff to be hired on non-renewable contracts, running from 1-3 years. Its main advantage is a consistently contemporary staff. But according to Norman Hines this is not a good policy for a small liberal arts college since it minimizes any possibility of dedication or commitment by the studio staff. The compromise proposed by Alexander and Ackerman is to have two permanent members of the staff to maintain stability in the curriculum and keep one slot open for a visiting artist; someone who could bring fresh ideas to the department every two or three years.

This plan may have the approval of the majority of the administration and the art department, but it does not explain why no studio artist has been tenured for 20 years. Whether it is the artist's personal commitment to his work, his contract not being renewed, or the mere untenability of teaching, the only artist who has remained at Pomona long enough to be considered for tenure is Guy Williams. His position is presently under review.

Williams was initially denied tenure earlier this year and chose to appeal. He solicited support from faculty, other colleges and universities, museums, and artists who know him personally and by reputation. Altogether he submitted 30 letters of recommendation to the faculty Grievance Committee over two mongths ago. There has not yet been a decision made.

When pressed for what criteria are used to determine tenure for a studio artist Alexander stated that there is not a great deal of difference between the consideration of an artist up for tenure and a member of the academic faculty. He said, "It depends on the individual, some are more central to the faculty than others." Alexander concurs with Frazer that credentials do not have a large bearing on a tenure decision for studio faculty. One art-practice senior asked Frazer what criteria were being used to evaluate Williams and discovered that no students' opinion had been sought--inspite of the Pomona College **Handbook for Faculty Members**, Section VI, "Procedures and Policies on Appointment, Promotion and Tenure," which reads: "In making faculty nominations the President relies on the assistance of the Administrative Committee. Members of the Committee from the Division of the appointment constitute a subcommittee to canvas members of the candidate's department, other colleagues in related fields, **and where it is possible without jepordising the student-teacher relationship, the students or recent graduates.**"

No time for student opinion

Though the Grievance Committee has taken over two months to review Williams' appeal, Frazer informed the inquiring student that there had been no time to solicit the opinion of any of the artist's students. Frazer has previously stated that when Williams' case came up it would be a very crucial decision, one that had to be reviewed very carefully. Similar treatment, Helene Winer believes was given to David Merrill. "He (Merrill) had a great deal of support from the students, which whatever anyone else thought at the time, he did have that support and it certainly should have been considered. My opinion aside."

Do the administration and faculty have a language with which to interpret the art department? How can they judge a discipline that denies many of the standards of "narrow academic thinking?" Or does it deny those standards?

Dean Frazer feels that the artists are hurt by not being known by the other faculty. Ackerman concurs, believing that there is "not a great deal of understanding from the outside." Norman Hines stated that there is not much credability or interaction between the art personnel and the rest of the faculty. He doesn't feel it is reasonable to expect much participation from the artists in their present situation: Gray, terminal; Turrell, terminal; Merrill, terminal; Williams, in question. "Unless the art department becomes a part of the college and the faculty a part of the faculty it's going to continue this way."

Academic faculty snobbish

David Gray believes that the rest of the faculty are a little snobbish; uptight about no credentials, although "a sizeable group is knowledgable about arts and support the art department, which is the studio department." Ackerman agrees saying, "The rest of the faculty just don't know how to judge an artist's credentials...people don't know how to judge contemporary art."

Where has the communication broken down? Why is it so difficult for an artist to be accepted by faculty of the college? Carl Hertel, art professor (tenured) at Pitzer College, states that there is an unwillingness on the parts

DAVID MERRILL by Nick Lacy

of many members of the academic community to "really take the arts seriously as an essential sector of the educational enterprise here at Claremont." Hertel believes the Claremont Colleges, under the guise of supporting the arts, subtly exploits them in catalogs and alumni publications to "infer that indeed there is a cultural environment here at Claremont. They just want to play with it, use art for purposes of status, for the mild titillation of the social environment." He cites as an example the publicity of the Pomona College Theatre Department in a recent issue of **Pomona Today**, and the lack of actual financial support that the department receives from the college.

Communication broken down

"I don't know where things have broken down," said Guy Williams, "Not at this college particularly, but at this college as well, where the artist is not held--well, he's held in low repute somehow. It's been pointed out several times that people who teach calisthenics are given tenure, whereas artists are a special category. That, in itself, will philosophically divide a department immediately, saying that we have one class of men here who have Ph.D's, who write about the work of artists, yet the people who are the makers aren't qualified because they are thought of as mechanics. Somehow artists are really not taken seriously . . . If a liberal arts college really wants excellence then they should treat art with some dignity. If they don't want excellence they can hire anyone and have anyone teach those classes using some 'how-to-do-it' book run on a lesson plan week by week. Maybe that's indeed what's required. I don't know what the adminstration is thinking about at this time. However, if they want people who think about art 24 hours-a-day, may I say they are going to have people like Jim Turrell and myself."

Turrell does not think that there ought to be much distinction between the faculty comprehending the work of a studio artist and the work of, for instance, a professor

—continued on page eight

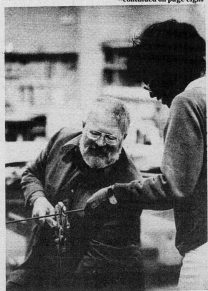

DAVID GRAY by Nick Lacy

PC Art Dept. under glass

NORMAN HINES by Nick Lacy

--from page three

of astronomy or physics. But, due to the accepted technicality of the latter the professor is considered to be an expert in the field; few people are inclined to enter his ranks. However, because art is viewed by many as simple craft everyone is willing to enter its arena. Because it is believed to be not as esoteric as many other disciplines it is held in lower repute.

If it is impossible for the faculty to be knowledgeable about every discipline offered at the college is it possible for them to judge accurately an area about which they do not have sufficient knowledge to know what standards to apply?

"I do think Pomona has a definite problem in its communication system," said Helene Winer. "I would have been very pleased with some direct criticism about the gallery because I did, of course, get it through the grapevine in every case. There was never any kind of official opinion or official expression of concern or any kind of active attempt to understand what was actually going on there. They certainly didn't make any attempt to understand the gallery shows or gain any information from them. It's real fault of the college not to have that communication as a part of their system.

"Where there is an unpleasant or unfortunate situation, where someone is likely to get axed, they certainly should have the opportunity to change the way they're operating, to defend their position, or to confront the person who is, in a sense, accusing them or saying they are not an adequate teacher ..." Dr. Merrill reports that he did not receive a "syllable of criticism" about his teaching before his dismissal. Ms. Winer, who was an assistant professor of art history, also reports, "I never received any comment pro or con." When asked if she would have appreciated reaction from the art history staff, Ms. Winer replied, "No ...maybe someone who was experienced in teaching (art history), but not the particular people who were available to make comments ... My field is specifically twentieth century art, or modern art, and the areas of the two ther art historians were not twentieth century art ... and of course I had my own particular approach. I would assume unless they were cirticising my methods of communicating with the students their comments would not necessarily have been valid. But certainly," she added, "I would have been open to their comments, and would have liked to know what they felt or thought."

How can an instructor's teaching methods be examined if there has been no primary observation done by the people who are resonsible for judging them? Furthermore, if no students' opinions have been sought how cna the quality of a professor's classroom information be considered, or for that matter any aspect of the quality of his student-teacher relationships?

Artist-student relations

When asked about his feelings toward student-teacher relations Guy Williams replied, "For myself, I don't have the view that some historians have of the pupil-master relationship. I don't feel that way. I feel that I'm just older, unfortunately older. I want to deal with students on a one-to-one basis, and there is an opportunity in a small college to do that. When somebody has a spark or feeds back something to me and gives something I'm wide open for that. But if the student is obedient and behaves in my classes as he would probably behave with the master in another class then that person is almost impossible to communicate with. First of all he's not interested in art that much, he just wants to get through and not concern himself with those problems."

It's worthwhile pursuing a student like that, to try to show him that there is a value in art?

"Yes, I do that by pointing out examples among their fellow students and say-- 'look at what this person is doing. Look at what he's thinking about. He has some audacity, he's thinking; whatever it might be,' I try to go to that person, to that idea, to that work that's pinned up on the wall possibly, and say, 'Notice this, you should behave this way because it's a starting towards excellence." Even as a non-art major you can recognize excellence."

Dr. Merrill thinks that the instructor primarily ought to respond to what the student shows him and use that response to direct the student in the most beneficial direction. He describes the method as "interaction without impedance." David Gray believes the whole creative experience in an art course comes merely from working with an artist in a classroom. Of course how the artist approaches the student is important, but the association of the student with the process that the artist goes through in approaching the novice's work and his own work is more important.

A great deal of tension has arisen between the artists and the administration as to the role artists should take with students. The artist themselves feel that after hiring them to be artists, the administration now wants them to be art educators, a kind of proctor with illustrative skills. "We believe in what we're doing," said Jim Turrell. "We've been hired to come here as teachers. For some reason they've decided to hire artists as opposed to art educators. If you want art educators then you should buy art educators."

Studio personnel agree that a dialog must necessarily occur, an interaction that cannot take place if the artist if the artist has to assume the unnatural role of art educator. They do not wish to exalt themselves and remove themselves even further from the student. Most of the studio faculty do not accept the precept of Dr. Ackerman that a student is a student, and an "artist is a person of great achievement in skills and craft." Put very simply by Mowry Baden, former instructor of studio art now at the University of British Columbia, "The best that can be said is that when young artists hang out with seasoned artists they become more critical of their own production." To this David Alexander warns of the danger of imposing a style on the student. To be sure, there is a great deal of style in the methods that the studio artists use, but no one encourages mere imitation, and all agree the potential rewards to the students are far greater than those offered by an art educator.

PC restricts art majors

Art historian Merrill believes that additional tension is produced between the department and the colege because the admissions policies of the school automatically restrict the number of potential art majors. "Qualification for admittance to a school like this is seriously closed down to a student who is going to develop a primary and quality interest in the vision of art . . . A genuine artistic capacity correlates with a questioning skepticism of a system for its own sake." The kind of student Pomona College enrolls generally accepts the feeling that "academics are the sole measure of achievement at this school."

Helen Winer comments that, "All of the important art that has occured in this century has been done by intellectuals, academics so to speak. They certainly were attracted to art not merely because it is something to do

with your hands to make beautiful objects or because it's a satisfying physical activity, but because of its intellectual content. Unless students are exposed to that aspect of art they certainly are not going to be attracted because it then appears to be merely a craft."

Practice students "bastards"

Peter Shelton, Pomona College studio art senior, thinks that creative pursuits here are considered to be of spurious intellectual value. "Practice people are always the bastards of this school...though even non-academic pursuits require an awareness." Moreover, because the administration insists on repeatedly interfering with the curriculum and the methodology in the art department, maintaining their foothold by playing musical chairs with the art faculty and never allowing a coherent staff to develop, an exceedingly unhealthy tension is created at the student's expense.

"With all the tension it's necessary for the art faculty to get it out-- anywhere to get it out, so they get it out on the students because they represent the least risk and danger and they'll take it." Shelton said he is very bitter about the lack of community between the studio professors and the students. The social situation is divorced from the student, "Personally I feel many of the inadequacies of the department, but I'm willing to excuse that and take a lot of shit because Guy's that valuable to me."

Some art history students do not feel that the present situation is at all tenable. One student describes the faculty as "a slap dash department, they really don't care...Ackerman prepares his lectures, gets up and gives them. You can get the same thing out of a book...Merrill's philosophy is purely his own."

This student feels that it is inadequate for an art historian to be directing the operations of the studio faculty. "They just don't know how to handle the creative aspect of art." The student further describes departmental communication as a "memo war...apparently they don't talk to each other, they don't have anything to say to each other." When asked what would be necessary to rectify the situation the student commented, "I would demand that the professors get their shit together, both personally and scholastically...they are so immature and whisical."

Defective Communication

Communication defects between the Art Historians and the students epitomize the situation as it now exists. Little effective communication exists between the majority of Pomona's academic facuty and the art department or between the faculty and the studio staff. The artists are themselves estranged, not only from the college which denies them tenure given even to a Phys-Ed teaher, but also from the administration and faculty committees who seem to continually invent excuses for firing them before tenure is imminent. Moreover, the defective communications between the studio artists and the art historians, or between the artists and the Chairman of the art department have set up tensions that cannot continue, without tearing the whole department apart. This is ironic, for the tension exists among people who are all, it would seem, involved in the same quest : to attract and inform the student about th value of art ; to try to cause the student to see the potential intellectual and emotional satisfaction that can be derived from art. But , with further inquiry this notion will prove to be incorrect. Though the goals are common, there is little agreement over the correct materials and methods to be used to meet them. Much of the tension, if not the majority, lies among the colleagues of the same department.

Three to appear 'On Campus'

Three Pomona seniors who have been awarded some of the nation's most coveted scholarships, were interviewed by David Horowitz, KNBC education editor, for "On Campus", airing at 3:30 p.m. Saturday, May 19, on Channel 4.

The half-hour, entitled "$7,000 to Learn," will feature Sandra J. Ott and Garrett Kauru Hongo, both winners of $7,000 Thomas J. Watson Foundation fellowship grants for a year of independent study and travel abroad, and Carl E. Garcia, who was awarded a Ford Foundation fellowship, which will provide him with full tuition and fees, plus funds for books and living costs during each of four years while he is in pursuit of a Ph.D.

"On Campus" is sponsored by KNBC and the 15-member Independent Colleges of Southern California, and is produced in cooperation with Dave Bell Associates, Inc., Hollywood.

The program opens with a brief introduction by Dean of the College Lee C. McDonald. Horowitz will interview each of the three students, who describe their goals, objectives and how they intend to enhance their career potential with the scholarships.

Ott, an anthropology major, spent eight months last year in the Hebrides Islands off the coast of Scotland studying folk practices and beliefs.

Under the Watson Fellowship, she will extend these

studies in the Hebrides and then make cross-cultural comparisions in Ireland, Wales, the Inner Hebrides, Nova Scotia and Cape Breton Island.

Ott also has been accepted to read for the postgraduate Diploma in Social Anthropology at the Institute of Social Anthropology at Wolfson College at Oxford University, and later to studey the Gaelic Otherworld as a doctoral candidate.

Hongo will use his Watson Fellowship to undertake "an almost complete circumambulation of the Japanese Islands" which was "inspired by the journey described by the 17th century Japanese poet, Matsuo Basho, in his travel-diary, "Oku no hosomichi" ("The Narrow Road to the Deep North").

While traveling, Hongo, an English major, will keep a journal of his own, composed of original poetry and prose sketches, that would eventually result in a completed work of novel length.

Garcia, 21 of Los Angeles, is a foreign language major who has mastered French, Spanish and Italian while a student at Pomona.

Whith the assistance of the Ford Fellowship, he will pursue master's and doctoral degrees in comparative literature at the University of San Diego.

Garcia hopes to teach both French and Spanish literature and the history of the theater at the college or university level.

Cracked servant's mirror: Pomona College Art Dept.

Second of two parts.

By SCOTT BRASTOW

"We can run down a week by week summary of what could be done in the class -- methods of drawing and techniques, manners, all of those things, but what's at stake is something that's much more important: is art an important activity now or are the students here brought into a liberal arts society only to learn to play the violin a little bit so they can get on with the real stuff -- managing the society?

"Art is not very highly thought of, so if you can learn to play the violin a little bit and get through a tune maybe that's all a liberal arts education requires.

"However, if you think about it as something authentic and real, rather than hobbyist or recreational or therapeutic "Mickey Mouse" courses, then you start facing very difficult problems -- philosophical problems, religious problems, problems of man. . .

"Leonardo, for instance, in all the things he undertook in his genius, including agriculture, as a poet, as a writer; with all his inventions, he said that painting is the highest sensibility that a man can cultivate.

"That's really been forgotten, hasn't it? He meant that it was the hardest thing to do; that it was the most challenging, the toughest thing to do of all his undertakings. He was ultimately a painter.

"I'm not waving a flag for painting as such, I'm just saying that the visual arts, which have been belittled locally, have a long tradition of being regarded as a noble activity. It is no longer regarded as a noble activity here."

GUY WILLIAMS

How can the Pomona College Art Department elevate the status of the arts in Claremont? What do the members of its faculty regard as their role in the school?

Guy Williams believes that 99% of the people who take art courses are not art majors. "Basically, they just want to come and have a little fun with clay--get their hands in it. They don't want to deal with anything further than that, and that's fine."

Those 99 people out of a hundred play a very important role in the life of the arts; their role as a patron, a connoisseur. An important task for the art department is to develop an aesthetic sense in these people, so they may have what President Alexander describes as "artistic literacy."

GERALD ACKERMAN

Carl Hertel, Pitzer professor of art, maintains that, "Education in art is education in perception." The art department can set up the coherent relationship between the eyes and the hands that is necessary to every person.

Tension important

"Art confronts the tension between the flesh and the spirit more immediately than the other humanities areas," said David Merrill. Art therefore has the greatest contribution to make to the reconciliation of this tension, but not its elimination. "The tension must be maintained without deadlock or softness...Art is one of the important means, perhaps the most important means, of the integration of the human personality. Not making it into a homogeneous mass, but a complete, rounded, and balanced entity."

Merrill believes that the college has made a mistake by ignoring the value of tension in the department, and that Gerald Ackerman, Acting Chairman, is attempting to eliminate all the creative tension in the curriculum and the faculty. "It is a safe, but very dull course to take," said Merrill, "And Ackerman has the college's approval to do it."

Dr. Merrill states that the communication in the department is very poor. He has been told next to nothing about the department's operations, "nor consulted, I might add."

Williams said he knew of no possible way to restore the artist's role in the department because they were powerless. "We have no role any longer in the decision-making about choosing our colleagues or anything else for

that matter. We are simply given memos and told what to do."

Do they resist this?

"Yes!"

In what way do they resist it, by not fulfilling the memos? "Oh, no, we do our jobs, but communication has broken down pretty much between history and practice at this point."

"Memo war"

Williams pointed out as an example of this "memo war" a letter concerning instruction methods in studio art which Chairman Ackerman sent to all studio faculty on May 15, 1973. The memo noted that "The present studio curriculum is unorganized and unsatisfactory...The courses are a part of their liberal education, not professional training...The problem should be discussed and decided upon by all the studio faculty in agreement with me." Williams said he was struck by the impersonal and dictatorial tone of the communication.

Tone of Chairman

What should be the tone of the chairman of the art department? What role should he perform? Ackerman feels that the chairman should guide the curriculum, but that he must take his impetus from the staff. Studio people, he says, have resisted this guidance. Differences in opinion on the philosophy of undergraduate work exist. But, he maintains, practical economics have to be considered: Are the classes full? Are there enough majors? Student enrollment in the department is down, Ackerman thinks, because students do not 'identify with the curriculum. He worries that if enrollment is not bolstered, the administration can feel free to limit the number of teaching positions. Ackerman is trying to revise the curriculum, "but it's hard to dictate a curriculum if people don't want to do it."

Dr. Merrill feels that the major duty of the chairman is to maintain tension among the faculty to insure a dynamic learning situation. He adds that in a department and a school of this size it is inappropriate for a chairman to be autocratic.

Others feel that there are nuances to the chairman of an art department; that he is not a director or a guider of the curriculum, but a representative and a balancing agent of the rest of the faculty.

David Gray, sculpture professor, said, "Ackerman wants to control the whole thing, he doesn't have a good idea of what the word faculty means." Gray maintains that Ackerman is trying to get other people into the department and create his own domain.

Former Gallery Director Helene Winer comments at length that a chairman should be a liaison between the department and the administration, taking their democratic decision of the faculty and being their spokesman. If he has a strongly opposing opinion, he is obligated to present not only his own opinion, but also the democratic opinion of the department.

Chairman "a catalyst"

A chairman, she says, should be "more a catalyst than a director. Mostly it's based on the personality of that chairman.

"Obviously a very powerful personality, a very impressive, dignified person, that everyone else in the department can respect and feel well about, could have a great deal more power and more say than another type of chairman. There are very few of those amazing personalities that everyone simply allows to get and do whatever he has to do.

"I think for a chairman to assume automatically that that is the role he is going to take is a mistake because that is something that has to be somehow granted him by the people in the department. He simply can't demand it from other adults that they are going to allow him to make all the decisions that affect their lives, their teaching, and their opinions so strongly, unless they quite approve.

"And someone like Mowry Baden, who had very substantial support from the department when he was there, would be able then to just get on with whatever he was doing because they feel they could trust his opinions and his choices.

"I don't think this is the case with Dr. Ackerman, and wouldn't often be the case, although I think a very good chairman should have those qualities. It's a matter of leadership and personality. Some people are just incapable of operating that way."

Some persons involved in the conflict made guarded statements. Others felt the situation to be grave enough to require complete candor.

Jim Turrell demanded, "What is this historian doing? Why is he entering into this? What has he got to do with this? Why doesn't he teach art history? Why is he entering into the artist being there--their presence? Why is he trying to put something between that presence and the student?--in other words, an artificial way of dealing, which is 16th century fundamentals!"

"Art is made now"

"First of all, the artists are involved in making art, historians in talking about it. As far as whether one exists without the other, well that's irrelevant, especially here where there is art history to be taught and art practice to be taught.

"In a way they are very different, but they involve the same thing. So I think it's important for art historians to be involved with the fact that all art is made when it's now, or it was all made when it was now, and that art is made now."

JIM TURRELL

"As to how that affects the teaching and what has arisen as far as schools of art history--you can get more and more removed from the actual art object and what it really is.

"The reasons for its being made can be very different from the reasons that award it a great place in the history of man. That may have little to do with why it was even made. I think the people who are interested in the making of art are very interested in that aspect--the involvement of the artist with what he's doing."

Dr. Merrill adds that many studio artists and art historians are too discipline-oriented, not art oriented. He feels there should be a "balance between theory and practice. It's important to bring them to bear on each other."

He reiterates that the tension between the practice and history of art is potentially the most creative in the humanities. If the tension were to be removed a condition of stasis would occur.

"One ignores the conflict at one's own peril. A perfect organization is a dead organization."

"Fundamentals" laughable

The teaching of fundamentals is an extremely volatile issue in the department at this time. Dr. Ackerman states that the faculty are "responsible to teach people an established set of tools."

Mowry Baden believes, "Anyone even remotely acquainted with the diversity of artistic standards generated over the last 80 years in Europe and the United States would find the notion of 'fundamentals' laughable, to say the least. There are no 'fundamentals', no 'standards', and there is certainly no codified 'process' for making artists."

Dr. Ackerman maintains that all that can be taught in an introductory course of the art department are fundamentals, "skills, imagination, coordination between skill and the imagination...they are a definite set of techniques that have been set up since the 15th and 16th centuries, they're classic techniques.

"It is necessary to learn about materials, outlines, shadows...drawing is at the bottom of all art, it is best to aim the student at the fundamentals, skills, so he has something to draw from." Basically, Dr. Alexander concurs with Dr. Ackerman, calling this curriculum a "service-oriented studio practice program...one that would do the total novice the most good."

David Merrill says the question of fundamentals is a problem in both areas. If you do not have the mechanics under control, he agrees, it is very difficult to work in the chosen medium. The problem of fundmentals becomes acute in the areas of interpretation rather than the mre orientation or manipulation of the material.

David Gray takes a more subjective viewpoint of the definition of fundmentals, but nevertheless admits their importance. He feels that fundmentals taught in an introductory class, before the student is capable of operating on his own, are "what the professor thinks the student must have to satisfy the professor's concept of art."

He continues, "he (Ackerman) thinks there's a hierarchy. It's not that at all. A growth, not step-by-step, can go full speed at start and get faster or reach a peak and/or go down. A musician doesn't become a musician just by learning scales. Some insight is needed, some vision."

Peter Shelton, Pomona art practice senior, feels that to ask a student what a fundamental is, is a Duchampian question. "The attitude at Pomona is to find out about what you want to paint and then start painting...There are a lot of ways that I've gotten the specific tools. Guy says to me, 'If you need to know how to draw, Peter, go learn how to draw. Anything you want to do you can.' Guy facilitates these things to happen."

Get tradition at Scripps

A senior art history major says that the student can get the traditional approach at Scripps. She feels that Scripps and Pomona should complement each other in their methods and courses. "The art classes at Pomona are valid, too."

Williams and Turrell upheld the importance of fundamentals, but disagreed with Ackerman's definition and dictatorial manner of application. They eventually concluded that, indeed, the Art Historians give students inadequate preparation for advanced classes.

"It seems to me," says Williams, "if an artist is going to

--continued on page four

"when [the studio faculty contracts] came up for renewal, I just didn't lift a finger....I just didn't want them there because their classes were nonsense. The artists and the art historians never understood each other. They had a different vocabulary."

Brastow's article concludes with the lament, "men and women of position at Pomona are making policy decisions in terms of the careers and livelihoods of the art department's faculty using incomplete information and an inadequate language to apply that information." In the last line of the article, Brastow asks, "Can traditional teachniques [sic] satisfy contemporary needs?"

Kay Larson echoes this refrain, noting what a major shift of perspective was required in order to comprehend what the artists were doing. She states, "It took a whole new intellectual sub-structure, and a whole new way of thinking and being in relationship to art, in order to understand what the artists of the sixties were doing." Larson suggests "everything was wide open at Pomona...[because] nobody in the administration was catching on to what was happening. And, therefore, anything was possible. But had they known, had they been paying more attention from the beginning, the attitude that was prevalent in other parts of Pomona—this deep conservatism—really would have clamped down right away."

In fact, one of the common outcomes of the turmoil of the late sixties was the desire to return to conservative and traditional values in the arts, as well as in the wider social context. In his 1968 talk, President Lyon alluded to this very thing—exhaustion with the constant cultural and social upheavals and the concern that traditional educational norms were being lost. With Pomona College as an institution seemingly threatened by radical pressure—epitomized by the obstreperous art studio faculty—and unable or unwilling to see value in the sorts of avant-garde experimentation taking place in the art galleries and studios, the outcome was practically inevitable. The combination of the art studio faculty pushing beyond the bounds of traditional values of scholarship and teaching, and the perception that the gallery's emphasis on experimental work was at the expense of art historical scholarship mirrors broader societal cycles of revolution and reaction. The manifestation of this wider pattern in the Pomona art department also speaks to the unease of the liberal arts academy with art that had as its focus the deliberate disruption of traditional definitions and forms.

A Final Twist

This would appear to answer several of the questions this essay started with: Why did it happen at Pomona, beginning in 1969, and why did this era end in 1973? However, one final twist remains, and that involves collector Norton Simon. Simon, as a prominent art collector and benefactor of the college, may have played a role in the reconfiguration of the art department and gallery. Simon had been a benefactor of Pomona College since the late 1950s, when he donated significant art works to the college: Auguste Renoir's *Andrée en Bleu* (1917), Henri Matisse's *Jetty at Collioure* (1906); two Jean Dubuffet collages, *Jardin de Bibi Trompette* and *Jardin des Illes* (both 1955); Fritz Winter's *Tension* (1952); and an etching by Rembrandt, *Diana at the Bath* (1631).

Given the tumult of the era, it would be logical for the college to look to a previous supporter, one associated with traditional forms of art scholarship and aesthetic values, to enlist his advice and his financial support in structuring a college gallery that would be a traditional teaching resource. Thus, it may not be unexpected that in the midst of all the departmental and gallery turmoil, Alexander was in contact with Simon. On March 23, 1973, Simon wrote to Alexander, evidently responding to a request from the college, that he had no objection to the college selling five of the works of art that he had donated.[44] On March 28, 1973, Alexander wrote Simon, thanking him very much for giving Pomona College permission to "sell the paintings which you gave the College....Thank you for all the concern you have shown in our discussions about a pace-setting program in the Arts at Pomona College." How did this "pace-setting program" effect the gallery and art department in 1973? Several former faculty and students have suggested that Alexander took this moment, with the financial support realized from the sale of Simon's earlier gifts, to reconfigure the Pomona gallery and to refocus the art department toward a more traditional art historical focus, and away from Conceptual art and other forms of contemporary art practice.

Several letters and documents in the Pomona College Museum of Art archives suggest as much. The archives include correspondence between Alexander and Simon's representatives, as well as contracts and budgets that indicate that the new program in the arts would be funded by the sale of the five paintings. On March 30, 1973, Alexander wrote Simon's representative, Robert S. MacFarlane Jr., letting him know that

44. In a letter dated March 23, 1973, Simon wrote to Alexander: "I have no objection to your selling the Renoir, *Andrea en Blue*, which was given to Pomona College in 1956; the Winter, *Tension*, and the two Dubuffet oils, *Jardin de Bibi Trompette* and *Jardin des Illes*, given in 1957, and the Matisse, *The Jetty at Collioure*, which was given in 1957 and 1958." Pomona College Museum of Art Archives.

Scott Brastow "Cracked servant's mirror: Pomona College Art Dept.," *Claremont Collegian*, May 21, 1973, p. 3. Special Collections, Honnold/Mudd Library of the Claremont Colleges

Pomona College agreed to the sale of the paintings. In a letter dated October 12, 1973, from MacFarlane to Alexander, and copied to David Steadman, who would become the next director of the gallery program, MacFarlane advises that the two Dubuffets and the Winter had sold. He continues, "Pomona College will realize $18,500 net from the sale."[45]

MacFarlane, with Simon, Steadman, and Alexander, hoped to set forth a "four year program of cooperation between The Norton Simon Foundation NSIMA, and Pomona College."[46] A contract lists a series of objectives, including:

1. To provide for the purchase by Pomona of a collection of graphics which focuses on the work of three or four significant artists.
2. To encourage alumni interest in and support of Pomona College Gallery and the graphics collection.
3. To leave Pomona College, at the end of the four year program, with a collection of graphics which will stand on its own for both exhibition and undergraduate education.

The list continues with nine more items; the document also contains a budget that includes the renovation of the Montgomery Art Center and salary and benefits for a gallery director (Steadman), among others. Both the contract and the budget lay out a commitment to developing a teaching collection of graphic art—a collection focus that continues to this day—and specify Francisco Goya as one of the significant artists to collect.[47] During Steadman's directorship, he organized several print exhibitions, including "The Graphic Art of Francisco Goya" and "Works on Paper from Southern California Collections, 1900–1960."

In an August 2010 conversation, David Steadman agreed that as director of the Pomona College gallery program, his primary mission as stipulated by Alexander was to consolidate the galleries of the Claremont Colleges, to integrate the galleries with art history and other departments on campus, and to teach art history.[48] Steadman remembers that, at the time he arrived, the graduate school, under Reiss, was very active, and that the focus on contemporary art in Claremont had moved to CGS. Asked what he knew of the departmental turmoil preceding his arrival, he stated that when he began working he wanted to "look forward, not back"; that he was interested in printmaking; and that he had heard that "at a performance series there were nude bodies on campus."

Would the nude bodies be those of Stoerchle and Burden's wife? When asked if the Stoerchle performance contributed to the downfall of the art department, Baltz replied that he didn't know if it was hearsay or not, but he "thought everyone knew... the Norton Simon print collection was offered to the Claremont Colleges with an acquisition budget to acquire more prints." Baltz noted, "Simon detested contemporary art." He continued: "The problem with the gallery was [also] what was good about it...it attracted a lot of attention. Helene and Hal got lots of reviews...so Pomona College had this very public face of espousing radical contemporary art...it was an image problem."

Pomona English major Robb Scott ('73), who served as gallery assistant to Winer in 1970 and 1971, took classes with Baltz, Turrell, and Williams, and worked as Ackerman's teaching assistant, remembers the situation similarly. Scott recalls, "I came to understand that Pomona sacrificed its art faculty in a failed attempt to negotiate a gift of the Norton Simon collection, and as a condition of the gift, to assume responsibility for his curators. This ambitious but hard-edged plan failed, after the faculty resigned, when the Pasadena Art Museum became insolvent and offered a more convenient home for Norton Simon's art."[49]

Suzanne Muchnic, in her book *Odd Man In: Norton Simon and the Pursuit of Culture*, mentions Simon's long-term support of education and educational institutions and his legendary passion for arranging complicated billing and art-trading agreements with dealers and other figures.[50] While she does not mention his dealings with Pomona College, Muchnic discusses the prolonged negotiations Simon underwent with individuals and nonprofits, including both the University of California, Los Angeles, and LACMA as possible showcases for his collection. Muchnic notes, "The primary mission of Simon's art foundations—and the rationale for their tax-exempt status—was to make the collections available for educational purposes....[H]aving abandoned his plan for a museum in Fullerton and becoming increasingly disenchanted with the County Museum, he needed other showcases."[51] Simon was looking for a home for his collection.

The story of the Pasadena Art Museum's fall and its subsequent takeover by Norton Simon is a well-documented story, but the timing of Simon's takeover of the Pasadena institution is relevant to our story. The

45. Robert MacFarlane letter to David Alexander, October 12, 1973, Pomona College Museum of Art Archives.
46. NSIMA stands for the Norton Simon, Inc. Museum of Art.
47. The contract in the archive shows that all budget items were supported by both Pomona and the Simon Foundation. The document includes other items as well, including a section describing acquisitions, where it claims "the goal of the purchasing is to build the Pomona College Collection so that with the completion of the program's funding at the end of four years, the Pomona Collection will be strong in two or three areas in its own right."
48. Another section in the contract discusses Steadman's schedule, and specifies that "25% of David Steadman's time will be allocated for preparation of exhibitions including the Norton Simon Foundation's collections, graphics, and the administration of the exhibition net work. The remainder of his time will, of course, be allocated to other purposes at the Claremont Colleges."
49. Robb Scott, email correspondence with the author, July 20, 2010.
50. Suzanne Muchnic, *Odd Man In: Norton Simon and the Pursuit of Culture* (Berkeley: University of California Press, 1998), 68.
51. Ibid., 122.

Pasadena Art Institute was founded in 1922. It subsequently underwent a series of programmatic, location, and name changes, finally coming to reside in its current location in Pasadena, on the corner of Colorado and Orange Grove Boulevards, in 1969. By the early sixties, the Pasadena Art Museum, with Walter Hopps and James Demetrion in various capacities as curator and director, had a renowned contemporary program. In 1963, Hopps curated the legendary Marcel Duchamp retrospective, and he later presented exhibitions of the work of Joseph Cornell, Jasper Johns, Larry Rivers, and Frank Stella, among others.

The downfall of the Pasadena Art Museum coincided with a controversial, and financially risky, project to build a new facility. The costs proved insurmountable, and finally, much to the chagrin of the institution's many supporters of contemporary art, Simon was the only person who offered to take over the debt and run the museum. According to Muchnic, "in summer 1972 the Pasadena facility opened a year-long exhibition of thirty-five pieces of modern sculpture from the Norton Simon, Inc. Museum of Art and the Norton Simon Foundation." This was devastating news to supporters of contemporary art, for Simon's dislike of contemporary art was well-known, and the Pasadena Art Museum was the best known public institution in Los Angeles to exhibit contemporary, avant-garde art. On April 22, 1974, Simon "drafted a letter outlining an agreement to combine his collection with the museum's collections."[52] Pasadena Art Museum supporters felt this was "just another step in the disappearance of L.A. as a contemporary art scene."[53]

Contemporary art supporters at Pomona College had reason to be disappointed as well, as the avant-garde art scene there was also disappearing. By April 1974, the Pomona College Gallery had changed course, "at which time an agreement was reached between the trustees of Pomona College and Scripps College to join the administration of each college's gallery into a new unit called the Galleries of the Claremont Colleges."[54]

In 1988, the Galleries of the Claremont Colleges published *Art at Pomona 1887–1987: A Centennial Celebration*, authored by former Pomona College Museum of Art director Marjorie Harth, who ran the museum from 1981 to 2004. In this laudatory book, Harth details a long history of the gallery and arts at Pomona College. One section stands out:

From 1964 to 1968, Nicolai Cikovsky directed the gallery, organizing a number of significant exhibitions. These included "Recent American Painting," 1965, "The Baroque," 1966, "Kandinsky," 1966, which celebrated the hundredth anniversary of the artist's birth, and "Impressionism," also in 1966. In 1968 Cikovsky left to teach at Vassar College where he became director of its gallery in 1971.

In 1973 David Steadman came to Pomona from Princeton. It was under his administration, in 1974, that Pomona and Scripps entered into an agreement whereby their two art galleries would henceforth be joined administratively, creating a new entity to be known as the Galleries of the Claremont Colleges.

The book jumps from 1968 to 1973, and fails to mention Glicksman and Winer—two of the most influential and significant Pomona College Museum of Art curators and directors. It skips this avant-garde moment entirely. During our interview, I showed the centennial book on Pomona and the arts to Thomas Crow. He observed, "Around the time that I went back [in 2006], in conversations then with people including President Alexander, it was clear the historical memory had lapsed. People just didn't know how important art had been to the culture of Pomona at the time that I was there."[55]

It is my hope that this catalogue will help rebuild the lapsed historical memory of what happened at Pomona from 1969 to 1973, by elucidating both the avant-garde practices that developed at Pomona and the complicated role that Pomona College played in advancing these practices. The confluence of influential curators, artists, and innovative projects, for a brief, pivotal moment in the history of avant-garde art, resonated throughout Southern California and beyond, as the other essays in this book reveal. The "It Happened at Pomona" project demonstrates how important visual art once was to this institution, and how important it can be again.

52. Ibid., 212.
53. Ibid., 213, 215–16.
54. In a press release issued by Pomona College on July 25, 1973, this agreement was "approved by Dr. David Alexander, president of Pomona College, and Dr. Mark H. Curtis, president of Scripps College," and is considered "a milestone." Pomona College Archives.
55. Thomas Crow interview with the author in New York, New York, March 12, 2009.

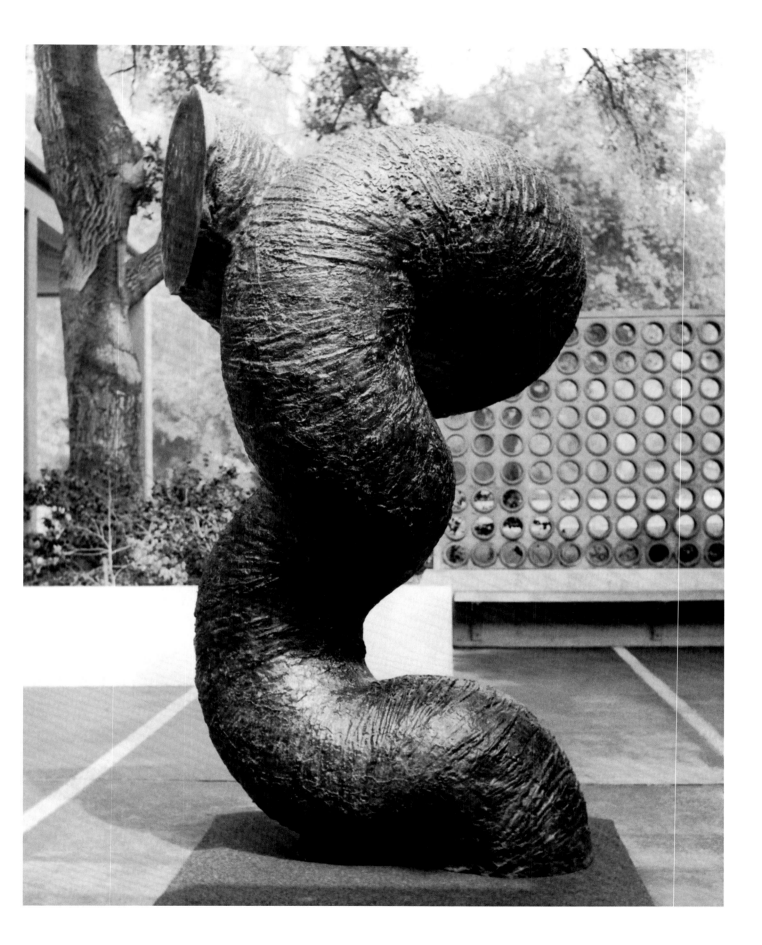

IT IS A CREDIBLE PROPOSITION to assert that the art being made and shown at the Pomona College Museum of Art between 1969 and 1973 was as salient to art history as any being made and shown anywhere else in the world at that time. Then a quiet, socially conservative college, surrounded by sister institutions of similar description in a tranquil, distant suburb of Los Angeles—one still semi-rural in its environs of mountains and lemon groves—the Pomona campus attracted some of the most distinctive artists working anywhere in the world. It also gave them, for that brief historical moment, an exceptionally sympathetic platform and showcase that succeeded in inflecting the terms of serious art making across a vastly wider terrain.

John Baldessari, the Conceptualist mentor of a generation from his teaching post at California Institute of the Arts (CalArts), recalls, "In my VW bus, I would take students out to see Helene Winer's shows at Pomona College....She would show work no one else was interested in. For every one of her shows, I would load up students and take them out to Claremont."[1] Matt Mullican, then among the magic circle of Baldessari's CalArts students, likewise remembers both the need to keep up with the Pomona scene and the effort it took to get there: "We went out to Claremont a bunch of times; it was a long trip. I had an old BMW, which was breaking down all of the time, ...so I would drive out there with Jim [Welling]."[2]

Names like Mullican and Welling most readily call to mind the so-called Pictures Generation, which formed as a loose cohort of young artists in New York at the end of the 1970s. And Winer was there with them, first at the nonprofit Artists Space and then as partner in Metro Pictures Gallery. She has rightly been celebrated for recognizing and sponsoring other major names associated with that moment—Cindy Sherman, Louise Lawler, Robert Longo, and Sherrie Levine, among others. But her earlier moment as director of the Pomona College Museum of Art from 1970 to 1972 brought into focus a body of art just as significant but less amenable to labeling or theoretical categorization.

While some of the names attached to this earlier California moment have become retrospectively renowned, their reputations have grown detached from the Claremont-centered network of students, teachers, and curators that shaped their initial careers. While Pomona's museum served as its principal venue, that constellation extended from the college's own faculty and students to counterparts elsewhere in the associated Claremont Colleges: ceramicists at Scripps College were key to wrapping art in an aura of counter-cultural glamour, while the master's-degree students, who worked under the rubric of the Claremont Graduate School, brought their more seasoned ambitions to the teaching studios, along with a set of connections to other institutions in the region. It was the force of this convergence—in process well in advance of Winer's decisive arrival on the scene—to which Baldessari and Welling pay tribute. In those years, the CalArts post-studio program was not yet the professional juggernaut that it would shortly become; at this juncture, the program of exhibitions and performances staged at Pomona gave its principals—faculty and students alike—a picture of where they themselves wanted to go. How and why it occurred in this ostensibly improbable location entails the telling of story yet to enter the common history of art in our time.

PERHAPS THE BEST PLACE TO BEGIN would be to ask what planted the seed and to look literally into the earth or, more precisely, in the clay for an answer. When Rebecca McGrew recently asked James Turrell whether he had artistic ambitions when he entered Pomona as a freshman in 1961, he answered succinctly: "I wanted to work with clay....There was really this clay thing going on, and that had a lot to do with Claremont."[3]

A particularly rich vein of art history in Southern California lies behind that remark, one that links the incubation of the first recognizable Los Angeles avant-garde to the artistic possibilities that drew Turrell as a young applicant to Pomona. At its core was the figure of Peter Voulkos, who arrived in 1954 at the Otis Art Institute in central Los Angeles as head of its new graduate program in ceramics. He was fresh from a summer teaching at Black Mountain College in the company of John Cage, Merce Cunningham, and Robert Rauschenberg, and his pedagogical ideas continued the famously experimental ethos of that institution. He imposed no schedule as such, no lectures, no critiques, no grades. In his words, "We'd all go to class, then the first thing we'd do is go off to see whatever there was to see in galleries, drinking coffee, and talking. We'd look at a new building going up or a show at a museum. Then we'd talk some more. Then we'd go to work. My purpose was for the students to become aware not only of everything around them but of themselves, to find themselves, to get to the point where they felt

1. John Baldessari, quoted in Richard Hertz, ed., *Jack Goldstein and the CalArts Mafia* (Ojai, Calif.: Minneola Press, 2003), 62. Hertz's savvy compilation of oral histories has been indispensable to the present study.
2. Ibid., 157.
3. James Turrell, interview with Rebecca McGrew in this volume.

PREVIOUS PAGE
Mowry Baden *Augur*, 1967. Fibered polyester resin. 96 in. (244 cm) high. Collection of Felicia Kuen

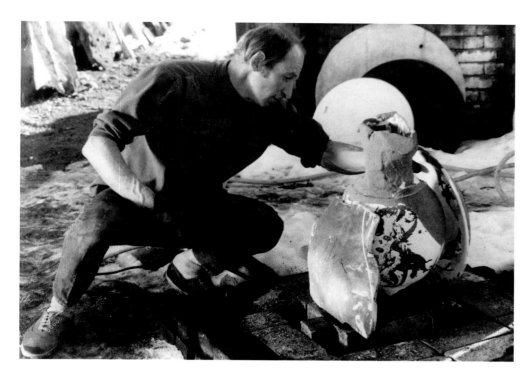

that they were the complete center of the universe and everything worked around them."[4]

Every individual body in the studio thereby took on a heightened salience, most of all Voulkos's. To maneuver hundred-pound masses of clay into shape on the wheel, Voulkos would throw his whole body into the task; indeed he transformed the process of forming the clay into performances for his students and entourage, wearing flamenco boots, telling jokes, and moving with musical and theatrical flourishes.[5] Clay may have been the beginning and end of the process, but between raw material and fired finished product lay the elaboration of a different, round-the-clock way of life: throwing sessions fueled by caffeine and nicotine until dawn, accompanied by a charismatic model of the artistic vocation centered on the body and every ephemeral action of the creator.

Voulkos's improvisatory approach to manipulating clay both on and off the wheel has been linked to Zen notions of No-Mind; his abstract painterly decoration and the unprecedentedly large scale on which he worked have been likened to Abstract Expressionist painting. But his most significant impact on the emerging Los Angeles ethos lay in the way he personally worked and taught. His manner of teaching formed a salient core of Southern California artists, among them Billy Al Bengston, Ken Price, and John Mason. His very first student at the start of the 1954

academic year was Paul Soldner, who marveled at the atmosphere and camaraderie of the Otis pot shop (as the ceramics studio was called): "People began dropping in. They did not enroll. They just worked. It was dynamic. It never happened like that before."[6]

Fresh from that heady experience, Soldner was hired as the ceramics teacher at Scripps College immediately after receiving his Otis MFA in 1956. And not long afterwards, his satellite studio came to stand in the place of his teacher's. The Otis ceramics experiment came abruptly to an end in 1958 when Voulkos was asked to resign his position; the stated reason was "ideological differences with the administration," and he soon decamped for Berkeley.[7] Bengston and Price migrated west to the coastal strip between Venice and Malibu, with Bengston applying Voulkos's epoxy pigments to metal supports and Price using delicate clay vessels as props for luminous glazes. Both thus found themselves drawn into the orbit of the other Venice artists crafting highly finished, artificial surfaces. But the two artists who stayed closest to a gestural and organic approach to the ceramic medium, Soldner and Mason, found a new base in Claremont.

At Scripps, Soldner was evolving his own version of an improvisatory, way-of-life approach to ceramics in adapting Japanese *raku* techniques to an American sensibility. He set out to ground his practice in the local landscape and in the manual skills he imparted

4. Quoted in Rose Slivka, "The Artist and His Work: Risk and Revelation," in Slivka and Karen Tsujimoto, eds., *The Art of Peter Voulkos* (Oakland: Oakland Museum of Art, 1995), 40. See also Andrew Perchuk, *From Otis to Ferus: Robert Irwin, Ed Ruscha, and Peter Voulkos in Los Angeles, 1954–1975* (New Haven, Conn. and London: Yale University Press, forthcoming).

5. See Perchuk, *Otis to Ferus*; and Slivka, "The Artist and His Work," 57–62.

6. Quoted in Slivka, "The Artist and His Work," 40.

7. Slivka and Tsujimoto, 163.

Paul Soldner demonstrating American *raku* in 1970

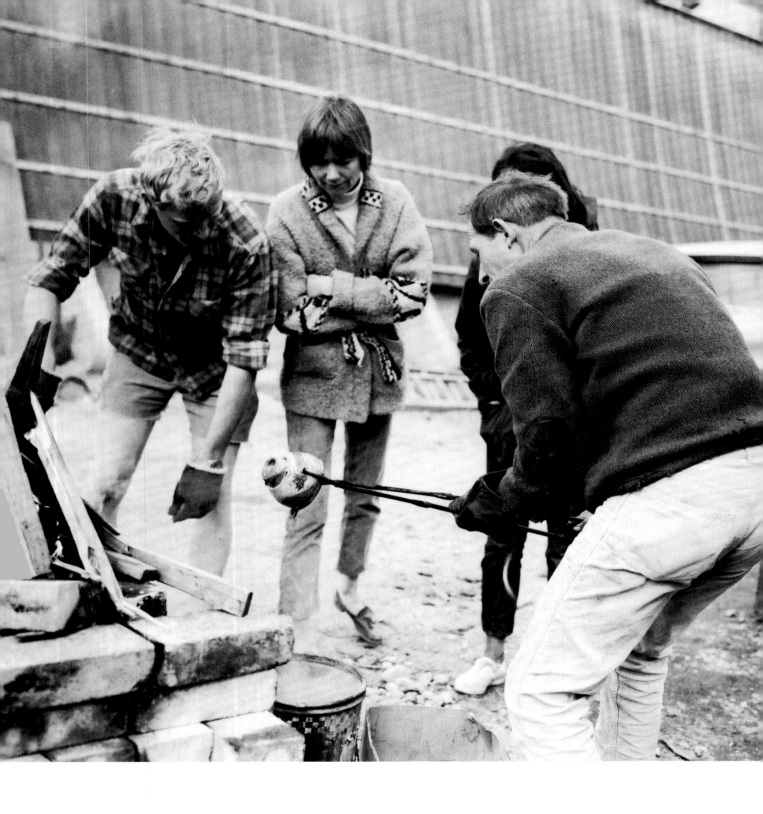

Paul Soldner teaching students American *raku*
in the mid-1960s

to students through building kilns and wheels, mixing glazes, making quick aesthetic decisions and courting accidents, occasionally catastrophic ones, in the firing and sudden cooling of the vessels. The college had been seriously teaching ceramics since the 1930s, but Soldner's infusion made that medium a sign and vehicle for the most up-to-date artistic sensibilities in the Los Angeles basin. His older students colonized the Midway Inn on Foothill Boulevard, a rough-hewn tavern built out of native boulders, to give Claremont its own artists' bar.

That incipient formation of a scene—a self-reinforcing sense of artistic community—echoed the process taking place in West Hollywood around the newly founded Ferus Gallery, which was the undertaking of a young Walter Hopps with artist-provocateur Ed Kienholz. Before his appointment at Pomona in 1961, Mason played a significant part in defining the Ferus scene and sensibility. Hopps had solicited both Soldner and Mason for a 1957 exhibition, though their durable ceramic pieces found themselves relegated to an outdoor alleyway. Mason received a more ambitious solo showing at the relocated Ferus in 1959. That exhibition included the massive, multipart relief *Blue Wall* (1959), a consummate challenge to the hegemony of paint in terms of both scale and embodied energy. *Blue Wall* remained on the patio wall at Ferus for some two years afterward, as a swaggering emblem of the gallery's unruly spirit. When Hopps moved to the Pasadena Art Museum as curator in 1960, he devoted one of his first exhibitions to Mason's work; the installation juxtaposed *Blue Wall* with a forest of precariously towering, vertical sculptures. (Mason and Voulkos had shared a walk-in kiln seven feet in height.)[8]

Mason's move east to teach at Pomona perhaps was made easier by his having kept a certain distance from the Venice-based core of Ferus artists. Mason worked close to downtown Los Angeles and steered clear of their freewheeling, extracurricular activities. He thus brought with him the aura of Ferus glamour, but projected at the same time a quieter authority more suitable to a placid collegiate setting. In keeping with the previous trajectory of his work, Mason kept pushing the limits of clay in terms of both its potential grandeur and structural complexity, while Turrell arrived at Pomona as a student simultaneously with Mason's appointment. More mature and worldly than his typical classmate, he had just returned from serving as a pilot in Southeast Asia (duty performed as a Quaker conscientious objector to the military

draft). His tour entailed flying Buddhist monks out of Tibet in the wake of the Chinese invasion. Not the easiest student to impress, Turrell credits Mason with a strong power of example: "[In the] way he conducted himself...you really got a feeling of what it was to be an artist."[9]

IT IS DOUBTFUL, however, that the resonance of art making in Claremont would have projected itself very far had it been circumscribed by work in ceramics. In the eyes of established critical opinion, the medium itself would always be a problem. Rosalind Krauss, one of the most influential critics of the era, would later pronounce Mason's clay work ultimately wanting on account of the material alone: "Ceramics retains too much of the landscape (in its material) and too much of the architectonic (in its usage) for 'sculpture' to find it acceptable."[10] For the art that was beginning to gather around Claremont, however, it proved to be exactly those axes of unmediated nature (from the physiology of the living human body to the surrounding semi-desert landscape) and of enclosing architecture (from the simplest shelter to monumental alteration of the terrain) that provided the defining coordinates of an alternative aesthetic.

None of these themes will come as a revelation to anyone even cursorily acquainted with the most influential art of the past forty years or so. But in the mid-1960s, they were incipient at best, if not still invisible. The ceramics orbit had incubated the terms of an emerging aesthetic; what was next required was a translation of the same basic nature-architecture coordinates into another medium. Enter Mowry Baden, appointed to the Pomona faculty in the fall of 1968, whose work and teaching practice enabled the bodily and architectural implications of the Claremont artistic ethos to emerge explicitly out of their former matrix in clay.

Known to the administration as a Pomona alumnus, he had been asked to step in and steady the art department after the sudden departure of its chair. Under other circumstances, it is doubtful that the kind of art he was making would have secured him the job. A visitor to the Pomona College Museum of Art in the first weeks of Baden's new chairmanship, encountering a recent sculpture titled *Augur* (1967), might at first have been reminded of a roughly stacked, Voulkos-style ceramic tower. But Baden had engineered the shape of *Augur* by carving into a block of polyurethane foam from the inside, blindly feeling his way as he entered its volume. "I didn't know what

8. Information concerning Mason's dealings with Hopps, the Ferus Gallery, and the 1960 Pasadena exhibition can be found in Kristine McKenna, ed., *The Ferus Gallery: A Place to Begin* (Göttingen, Germany: Steidl, 2009), 70–71, 163, 197, 210–11.
9. Turrell interview with McGrew.
10. Rosalind Krauss, *John Mason: Installations from the Hudson River Series* (Yonkers, N.Y.: The Hudson River Museum, 1978), 12–13.

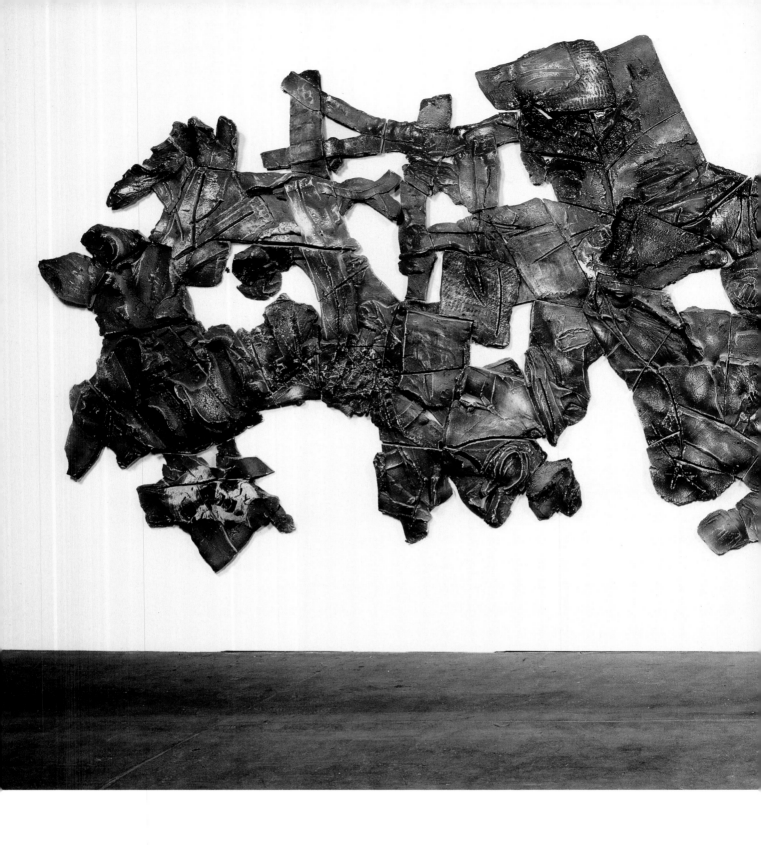

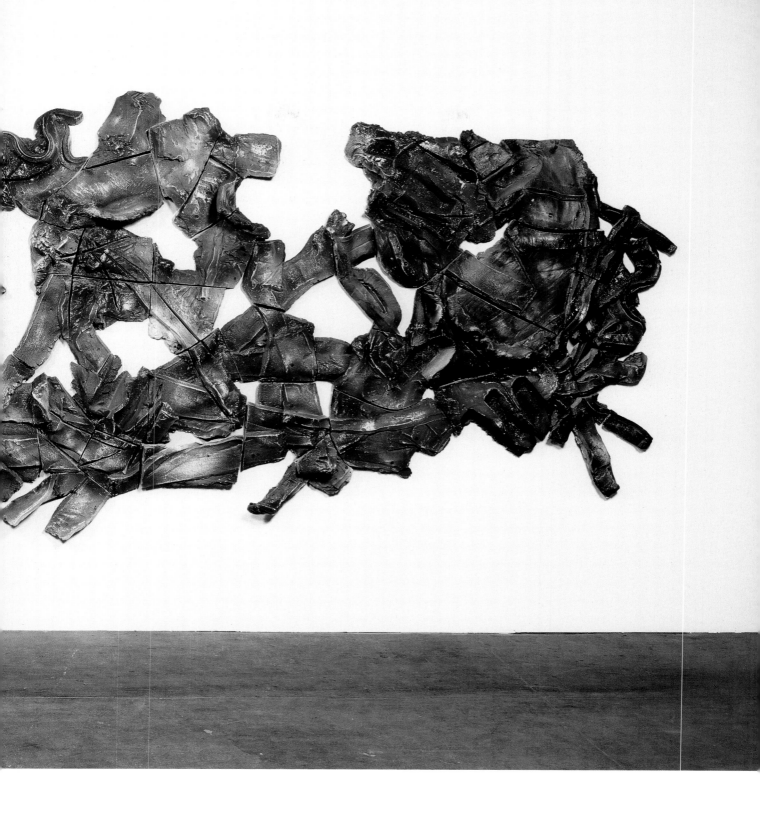

John Mason *Blue Wall*, 1959.
Ceramic relief with blue glaze. 84 × 252 × 5 in.
(213.3 × 640 × 12.7 cm)

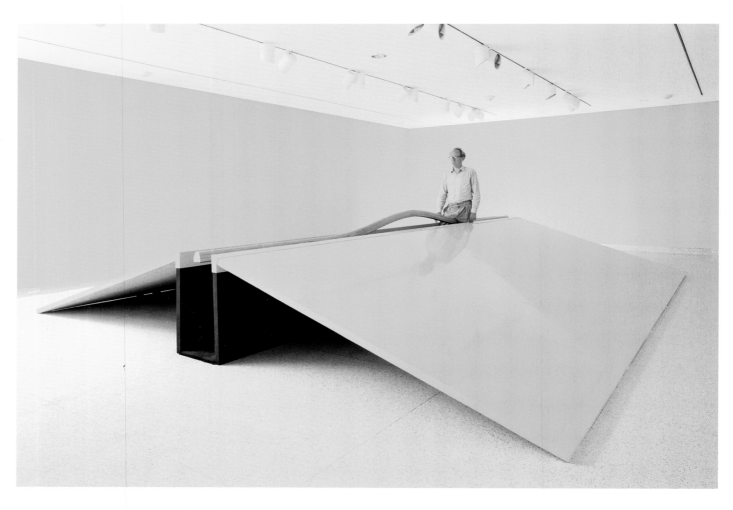

it would look like," he told a student reporter, "and I didn't much care. I was more interested in the experience of generating my own physical space."[11] From the resulting cavity, he cast *Augur* in a light, fiberglass-resin composite as its negative remainder.

The logical corollary of the heightened visibility of the artist in the throes of creation is the concealment of the artist in the throes of creation. Baden's procedure removed vision from its position of sensory mastery; and it rendered the formal outcome of the exercise a secondary and somewhat pathetic residue of the main event, that is, the act of blind tunneling itself. As he told critic Jack Burnham, "Boring my way through…urethane foam may not have been the most reflective way to confront my body, but it certainly removed all the usual stand-off-and-look-at-it attitudes, which to me are irrelevant."[12]

His next step was to bring the body out of hiding, but reduce even further the salience of contemplative vision. The cleanly fabricated pieces of apparatus that

Baden made in a period of intense activity coinciding with his move to Pomona—*Phantom Limb* (1967), *I Walk the Line* (with its deft Johnny Cash allusion, 1967), and *Stop Gap* (1968)—enlisted the bodies of the artist or gallery visitors only to put them through paces that rendered any external witnessing more or less nugatory. The pieces only communicate by the pressures they place on the sensitive parts of the body that come into contact with their surfaces. Sculpture is possibly the wrong word for tunnels or elevated bars that resemble some species of eccentric playground equipment; the space they define lies in the physiological responses of anyone who submits to their built-in regimen.

But there were two quite distinct aspects to this transformation of viewer into living art object. As Baden made plain, the dimensions of each piece were configured to the measurements of his own body: "I am the laboratory," as he put it, "and, by extension, the art."[13] So anyone else traversing the pieces became forcibly aware of the greater or lesser resistance that

11. May Beth Jackson, "PC Profs Display Their Own Things," *Claremont Collegian* (October 9, 1968), 4. Baden states further, "The qualities that we generally associate with sculpture are a priapic aspect and impenetrability. It may be that we don't have to make sculpture anymore and only to give a set of direct and precise instructions for action."

12. Mowry Baden, quoted in Jack Burnham, "On Being Sculpture," *Artforum* (1968): 44.

13. Ibid., 45.

Mowry Baden / *Walk the Line*, 1967.
Wood, steel, and carpet. 41 × 240 × 204 in.
(104.1 × 609.6 × 518.2 cm). Collection
Museum of Contemporary Art San Diego,
Gift of the artist

right word) plunged into the narrow passage between the frames, changing air pressure induced by the body's own movement caused the suspended plastic sheets to close around it, thereby shutting out the view both ahead and behind.[14] From the outside, the concealed bodies inside the structure appeared like elongated peas in an undulating pod. (Racing from one end to the other quickly became a favorite pastime for kids from the adjacent Claremont barrio.)

The scale and symmetry of the piece might conceivably be traced to Burden's earlier vocational aspirations toward architecture. (Baden's arrival in his junior year helped make art practice the more intriguing alternative.) Consequently, in place of architectural school, Burden moved on to the MFA program at the University of California's new campus at Irvine, the Orange County site of which lay on a direct commuters' route from the Pomona valley. By pursuing this path, Burden was retracing the one that Turrell had taken four years before—though the latter had lasted only one year at Irvine before leaving to set up his first studio in the Ocean Park neighborhood of Santa Monica. Then, just as Burden was departing for Irvine, Turrell would return to the Pomona campus as an instructor.

Over the intervening years, Turrell had achieved both precocious recognition and a precipitate forfeiture of influential patronage. At Irvine, his curiosity and strong intellectual formation (mathematics and psychology in his undergraduate years) led to a close relationship with John Coplans, who both taught art history there and held a curator's position at the Pasadena Art Museum. Under Walter Hopps's charismatic sway, the Pasadena Art Museum had emerged as without rival in its receptivity to advanced art, famously giving Marcel Duchamp his first museum retrospective, while extending a museum imprimatur to young artists such as Roy Lichtenstein and Frank Stella. In 1967, only two years after Turrell's Pomona graduation, Coplans organized a Pasadena show of the first light pieces: luminous rectangles that appeared to hang in space independently of the physical corners onto which they were projected. The simultaneously coherent and uncanny character of those pieces, seen in such a prestigious venue, engendered strong expressions of interest from major galleries in both Los Angeles and New York. Turrell largely spurned such entreaties in order to pursue a new series of non-portable (and non-saleable) works based on the controlled release of ambient light into his bare, darkened studio—titled the

by implication imposes the shape of the absent creator on his or her awareness. The presence of the artist could thus be made more forcibly evident to the senses when missing from the scene than if he were acting out some routine before the comparatively jaded sense of vision alone.

ONE BASIC PERMUTATION from Baden's example would have been somehow to combine the exposure of the participating body with the concealment of *Augur*. In the spring of 1969, Chris Burden could be said to have accomplished something like this with a senior project constructed on an athletic practice field east of a rustic part of the Pomona campus called the Wash. Suspending black plastic sheets from two parallel metal frames two hundred feet in length and eleven feet high, he created what might have seemed like an enlarged, open-air equivalent to one of Bruce Nauman's stud-and-plywood corridors. The animated effect of Burden's piece, however, diverged significantly from the experience induced by Nauman's rigid enclosures. Once a visitor (viewer does not seem the

14. For the artist's description of this effect, see Robert Horvitz, "Chris Burden," *Artforum* (May 1976): 26.

James Turrell, *Mendota Stoppage*, 1969.
Outside night lights into prepared space

Mendota Stoppages after the previous identity of his studio building as the Mendota Hotel.

By the summer of 1969, Turrell found himself without any of the promised exposure in New York (and reportedly owing the Pace Gallery $13,500 in the bargain).[15] But downtown Manhattan art entrepreneur Willoughby Sharp, a key underground opinion maker, wrote that, "Turrell's refusal to show after invitations from Nick Wilder and Leo Castelli, and vague reports of works with natural light constructed in the walls of his studio have made him a heroic figure for a younger generation of Los Angeles artists."[16] For an artist whose very medium was visual response, it was his invisibility in the normal venues of art, a controlled vanishing, that made for this heroic reputation—part and parcel of which was having spent time behind bars for allegedly encouraging draft resistance while counseling young conscientious objectors in 1966.[17] But on the Pomona campus, his commanding physical presence—a long-limbed Western figure with cowboy boots and thick nimbus of dark hair, anti-war martyr, and ace pilot who had once landed and taken off on the college's central quadrangle—was fully and visibly in evidence.

IF TURRELL HAD BECOME his own embodied ideal of the artist, much as he had regarded Mason in his own student days, he differed from his predecessor in lacking evident work or workplace in Claremont to accompany the persona. All of that lay for him fifty miles away on the other side of the Los Angeles basin. But new Pomona gallery director Hal Glicksman's exhibition program during the 1969–70 season supplied the Claremont audience with a vivid sampling of work by artists whose approach was cognate to Turrell's. Glicksman had been working as a preparator under Hopps at Pasadena; Baden recalls hiring him on the recommendation of painter colleague Guy Williams, who had worked with Glicksman there. Having acquired his curatorial acumen while working in this capacity had instilled in Glicksman a heightened awareness of the gallery as a physical apparatus. At a time when the idea of site-specific sculpture was still in its infancy, he set out commissioning sympathetic artists to take over the entire gallery in a series of comprehensive installations.

In March 1970, he staged what was perhaps the most uncompromising of these endeavors to the design of Michael Asher, then an unheralded young Los Angeles artist with few realized works to his name.

Asher's plan was to create a parasitic interior architecture that would nest inside and conceal the two offset rectangles that constituted the whole of the exhibition and office space. He drew the shape of the new space as two opposed right triangles meeting to form an hourglass shape, the narrow throat of which lay within the old opening between the two galleries. The low-ceilinged, pristinely white interior—hammered together and finished largely by Glicksman and Baden themselves—was illuminated only by the light that entered from the outside during the day or by a dim artificial substitute in the entryway at night. The main entrance doors of the museum were removed so as to permit round-the-clock access to the space.

As the fame of the piece has grown with Asher's subsequent reputation, it has come to be aligned—on account of its masking the normal display, security, and administrative functions of a gallery—with a critique of art institutions.[18] But such issues were minor preoccupations among the first (and only) actual witnesses to the installation's effects. Baden speaks of a "whiteout" visual overload and of the startlingly amplified sound of the trains passing a few blocks to the south.[19] Virtually all of Baden's recollections liken the piece, not to any inanimate construction or sociological experiment, but to parts of the human body. He calls the opening passage "a permanently open esophagus." The wide interior variation in light intensity approximated the widening and narrowing of a pupil; its acoustic effects made the space function like a superhuman ear canal. Baden describes Asher bringing a device into the space that released a coherent ball of smoke, the movements of which enabled him to track the currents of air moving through an interior, functioning now as a kind of lung: "The gob of smoke took off, went down the wall where we were standing at chest height, turned the corner, went along the opposite wall ahead of us and into the first room, went around two walls there and then went out the door. And then Michael said, 'It's working.'"[20]

The magnified physiological analogies engendered by the piece had as their objective correlative the actual and necessary presence of real bodies inside it. A gallery is a container for art; any body inside the container takes on the volume of sculpture much as Baden had earlier imagined his devices subjecting their users to re-description as art. The figurative and literal descriptions of the piece thus nested one within the other. There was no possible way to experience the piece, still less to "see" it, without

15. See Craig Adcock, *James Turrell: The Art of Light and Space* (Berkeley and Los Angeles: University of California Press, 1990), 87, 237.

16. Willoughby Sharp, "New Directions in Southern California Sculpture," *Arts* (Summer 1970): 37.

17. See David Pagel, "Turn on the Light," *Los Angeles Times* (October 21, 2007).

18. For the author's own discussion along these lines, see Thomas Crow, *Modern Art in the Common Culture* (New Haven, Conn. and London: Yale University Press, 1996), 136–41.

19. Mowry Baden, interview with Rebecca McGrew in this volume.

20. See ibid.; also Barbara Munger, "Michael Asher: An Environmental Project," *Studio International* (October 1970): 162.

simultaneously being one of its components—the spectator was not just in it, but of it, overtaken by an art condition without temporal boundaries.

In one sense, Asher, Baden, and Glicksman could be seen to have taken the typically opaque container of Minimalism and simply turned it inside out. But that achievement carried with it a more far-reaching challenge to dominant aesthetic assumptions than they themselves may have realized in that moment. The only significant contemporaneous comment on the Asher piece came in fact from one of the prime inventors of the Minimalist container, New York artist Robert Morris, writing in *Artforum*—which is to say, in the leading American journal of the period.[21] Two photographs and a plan of the Pomona installation appear prominently on the opening page of Morris's essay, which begins with a premise sympathetic to Asher's ambitions: "It seems a truism at this point," Morris asserts, "that the static, portable, indoor art object can do no more than carry a decorative load that becomes increasingly uninteresting."[22] But the remainder of the essay contains no explicit reference to Asher or any other actual artist. Instead Morris contrived an entirely invented account of visits to two sites in California, where he discovers immersive structures designed to isolate and manipulate the senses. Each of their creators entices Morris's fictional narrator into enclosed spaces where he is subjected, in one case, to high-energy radio frequencies and, in the other, to an array of noxious gases, administered by a scarred, monocle-wearing "artist" fond of Auschwitz comparisons. While Morris concedes the exhaustion of the New York scene in which he was formed ("next season's polished metal boxes, stretched tie dyes and elegantly applied liquitex references to Art Deco"), a decisive alternative emerging from the West Coast fills him with ambivalence and anxiety. He applauds, on the one hand, the "suppression of an objective source of stimuli that can be located externally and separately from oneself" and a consequently "new plane of experience...qualitatively different from the possible responses to external objects..."[23] At the same time, he cannot concede this achievement without suppressing the actual work in question in favor of Gothic grotesqueries out of a Roger Corman B-movie.

THE IMPLICIT THREAT that Morris perceived in Asher's large but reticent sculpture lay in its negative implications for the traditional mastery enjoyed by both the form-giving artist and the self-possessed spectator. Simultaneously resident in Claremont was the artist who, perhaps more than any other, made this emerging vulnerability the dominant theme of his career. Since 1965, the Dutch expatriate Bas Jan Ader had maintained a relatively unobtrusive presence in the community, living quietly in a 1920s shingled bungalow just southeast of the Pomona campus. A disaffected and semi-successful student in his native Netherlands, he had emigrated to the United States on a yacht helmed by a film-studio artist who had once worked for MGM (after a mishap-filled voyage that ended with the U.S. Coast Guard towing their disabled vessel into San Diego bay).[24] Settling in at the Otis Art Institute, he had completed his undergraduate degree and married the dean's daughter and fellow student, Mary Sue Andersen. When his wife began teaching art in San Bernardino, the couple settled in Claremont, and Ader began working toward a Master of Fine Arts at the Claremont Graduate School. His degree show in 1967 consisted of large paintings and reliefs in a Pop mode, some with eye-catchingly iridescent surfaces, which he arranged as an interconnected installation. In a foretaste of the work to come, however, the photomontage illustrating the poster for his degree show depicts him sitting precariously in a chair resting on the crest of his bungalow's roofline. He leans back against a painted cartoon sky, nonchalantly smoking a cigar.

In the course of the Claremont degree program, Ader had found a close friend and ally in fellow student William Leavitt. After graduation, Leavitt drew their shared attention back towards downtown Los Angeles when he took a day job in the dean's office of the venerable Chouinard Art Institute. A neighbor to Otis, Chouinard possessed considerable residual cachet, a stature comparable to the newly minted prestige of the Irvine program. Mason had been enrolled there during his formative days in the neighboring Voulkos studio: Ed Ruscha and Joe Goode followed around 1960. The latter two had been featured—alongside Roy Lichtenstein and Andy Warhol—in Walter Hopps's groundbreaking 1962 exhibition at the Pasadena Art Museum, "The New Painting of Common Objects." Their exposure in what stands in hindsight as the first Pop exhibition, enhanced by the support of the Ferus Gallery, lent significant 1960s glamour to the school from which they had emerged. But that very cool factor had also engendered considerable dissension within the student body by the time Leavitt went to work there.

What might be called the dominant student faction at Chouinard consisted of male artists—among them

21. Robert Morris, "The Art of Existence, Three Extra-Visual Artists: Works in Progress," *Artforum* (January 1971): 28–33. Morris's article alludes as well to Turrell, Bruce Nauman, and Larry Bell, but discusses no actual work by any of them. Morris's elaborately indirect commentary also includes a rural Ohio character who disdains the name "artist" and is said to have built an archaizing facsimile of a burial mound with a narrow passage to an interior chamber. At the equinox, the rising sun projects a hovering luminous rectangle against the rear wall (its maker, notes the narrator, was unaware of James Turrell). The first of the Californians, located in San Diego, operates inside a large hourglass-shaped chamber that amplifies ambient radio-frequency transmissions capable of exciting human neurons and inducing palpable and generally unpleasant effects outside the normal range of sight, hearing, and touch. (He is described as admiring Asher's work but finds it "'too estheticized.'") In Sacramento, Morris's narrator encounters an artist left largely blind and facially disfigured by earlier experiments with acid, who subsequently builds a labyrinth of gas chambers that work both on the smell and color vision of any visitors he can induce to enter them. Head shaven and sporting a monocle, this character is fond of analogies to Buchenwald and Auschwitz. Undeterred, the intrepid narrator plunges in and finds all of his senses and general equilibrium unpleasantly disturbed in "an exhausting afternoon."

22. Ibid., 28.

23. Ibid., 33.

24. "STORM-BEATEN KETCH TOWED TO SAN DIEGO," *Los Angeles Times* (January 6, 1963).

Charles Arnoldi and the brothers Guy and Laddie Dill—set on a suave, formally accomplished manner in both art and style of life. For their models of success, they looked to the Ferus Gallery artists of Venice Beach and to visiting stars from New York, such as Jasper Johns and Robert Rauschenberg, who regularly visited the Gemini G.E.L. print studio. The view of dissenters is aptly summed up by then-undergraduate Jack Goldstein: "People in their group... wanted to be important artists. They became more like decorators, but that was not their intention. They were striving to be famous artists."[25] Hirokazu Kosaka, Goldstein's closest friend at Chouinard, puts the matter more starkly: "There were painterly beauty artists and there were the Post-Studio Conceptual artists. The two sides didn't cross over.... It was like Vietnam—there were the long hairs and the short hairs. It was a cultural and social dynamic that we may never see again."[26]

As with the forced break-up of the Otis ceramics circle a decade before, turmoil and disintegration within a central Los Angeles institution propelled its innovative elements outward to the receptive boundary location of Claremont. This was a dynamic into which Leavitt and Ader eagerly inserted themselves. Using scrounged materials, they started up a parodic art journal they dubbed *Landslide*, in its title an uncanny anticipation of the art sheet *Avalanche* that Willoughby Sharp and Liza Béar were shortly to launch in downtown New York. In its pages, they were no kinder to the posing worker-artists of Minimalism than Goldstein and Kosaka were to the "beauty" boys. To that end, they invented a California artist called John Grover, "mustachioed carpenter-turned-sculptor" complete with portrait pose decked out in *Easy Rider*-style fringed suede, love beads, shoulder-length hair, and shades. "I knew Bob Morris, Don Judd, Sol LeWitt pretty well," the fatuous Grover is made to say, "But I never gave much thought to their influences....I was always struck by the beauty of the mass-produced home and the myriad structures possible with very simple materials. It goes to the core of our culture. This system of putting things together serially."[27]

John Grover represented an end of the line for the model of art as way of life in the incipiently counter-cultural mode that had taken root in Los Angeles during the late 1950s. In the intervening years, the artist's body more rigorously conceived as perceiving mechanism or mechanical volume had taken over. The overriding question then became: How does one articulate the human body in its indivisibility, when production of meaning in any field depends upon systematic internal differences? Already suggested in Baden's *Augur* and Burden's outdoor senior project was concealing or removing the body from view as the equal and opposite requirement to putting it on display or subjecting it to some stipulated regimen. The body taken as a whole carries only rudimentary signifying possibilities unless it can also be cancelled or negated.

In Ader's studio installation of 1969, *Please Don't Leave Me*, the spot-lit words scrawled on the wall in crude capitals gave voice to the absent artist subject protesting his abandonment from vision. The staged photograph *All My Clothes,* of the following year, laid out the social signifiers of the artist's self across the roof of his increasingly iconic Claremont bungalow, the container that presumably shielded him from sight. A certain intimation of remains and dismemberment also attends the piece, though it comes couched in a kind of slap-stick reminiscent of Buster Keaton's silent-movie stunts. Both peril and comedy converge in the filmed performance *Fall 1, Los Angeles* of 1970, where he descends from the chair on the peak of the roof—the spot where he had perched for his MFA poster—to disappear from view into the overgrown shrubbery beneath the porch.

As famous as these works have since become, they were barely visible to anyone outside Ader's intimate circle during the years in which they were made. Kosaka described the neglect that all of them felt keenly at that moment: "Art in L.A. was about making objects that were beautiful and that you put on the wall. Decoration. All of a sudden there was space, a small space, for a different kind of work that dealt with more important issues. There were a small number of people doing this new kind of work: Bas Jan Ader, John Baldessari, Chris Burden, Jack Goldstein, Bill Leavitt, Bruce Nauman, Al Ruppersberg, Wolfgang Stoerchle, Bill Wegman.... There were maybe a dozen people, you could count them on your fingers, and we were outcasts, complete outcasts...separated from the Venice artists...not known by anyone."[28]

They were not known by anyone, that is, until Winer arrived as Pomona gallery director in 1970, after which this roster, including Kosaka himself, became the ready-made core of her exhibition program. Unlike the appointments of Baden and Glicksman (who resigned in 1970 to accompany Hopps when he

25. Jack Goldstein, quoted in Hertz, 20.
26. Hirokazu Kosaka, quoted in Hertz, 34–35.
27. See *Landslide* IV (1969).
28. Kosaka, quoted in Hertz, 34.

was appointed director of the Corcoran Gallery in Washington) no previous Pomona associations preceded her. Though a University of Southern California graduate, Winer's key formation as a young curator had taken place while working at the Whitechapel Gallery in London—a city that had arguably surpassed New York in the later 1960s as a place to encounter and learn about advanced international art. Under Robert Townsend and Charles Harrison, *Studio International* had outdistanced *Artforum* as a vehicle for both information and ideas. In 1969, Harrison had been instrumental in adapting Harald Szeemann's watershed exhibition "When Attitudes Become Form: Works, Concepts, Processes, Situations, Information" for its London iteration. "When Attitudes Become Form" was perhaps the most thoroughgoing summation to date of art's possibilities as the primacy of the "beauty" object disintegrated. But her return to Los Angeles presented her with a palette of curatorial possibilities, courtesy of Kosaka's outcasts, just as advanced as any she had left behind in London.

ONE COULD SAY that the group remained outcast in a more literal sense, that is, cast out from a deteriorating core to a new and far more receptive location on the geographical periphery of the metropolis. By this date, the old Chouinard had effectively disappeared, absorbed into the new, multidisciplinary CalArts, which was destined for its own remote, exurban site in the new town of Valencia—a location as far from the center of Los Angeles as Claremont, but without the latter's developed roots as an art community. The unreflective culture of the old Chouinard was to undergo a profound change as the CalArts ethos came together, from a defiantly pragmatic attitude verging on anti-intellectualism towards, as Goldstein put it, "a whole new attitude about what art could be, not expression but investigation." But he also observed, "When I was there in the early 1970s we didn't know what it would become."[29] In those intervening years, the intellectually sympathetic environment of Claremont offered perhaps the only venue where art making could engage formal learning without apology. Ader's preoccupation in these years with Ludwig Wittgenstein's *Philosophical Investigations* exasperated some acquaintances; Turrell's scientific and mathematical training, carried more lightly, undergirded all of his investigations of light and space. Baden thought simultaneously like a physiologist, psychologist, and engineer. And a new standard for such endeavors had been set in the spring of 1971 by Chris Burden's *Five Day Locker Piece*, a Pomona piece by proxy performed as his MFA exhibition at Irvine. Taking Baden's investigation of bodily parameters to a place that was persuasively his own, Burden's self-imposed ordeal of confinement in a standard-issue student's locker diverted standard avant-garde devices of the ready-made and Minimalist container into the most thoroughgoing concealment of the artist to date, acted out, what was more, over that unbroken, round-the-clock continuity of time that Asher's installation had made manifest the year before.

Though Burden can be said to have remained within a physical-mechanical set of operations, an unintended excess of meaning arose among the parade of visitors drawn to the bank of lockers during the days of his occupancy. Some strove to make themselves recognized, frequently through self-revealing confession, by the invisible but reciprocally vocal presence on the other side of the metal barrier.[30] The kinds of performances associated with Los Angeles—Burden's and Ader's in particular—can readily attract imputations of narcissism and self-aggrandizement; yet that tendency is always tempered by the implications of loss and melancholy, which necessarily shadow these complementary actions of self-erasure. Burden discovered these as they were reflected back to him from the supplicating visitors to his locker; Ader, literary-minded European that he was, found more representational means to figure that light and dark chiaroscuro of the self. Over the two years preceding his exhibition at Pomona in January 1972, he had been honing, alongside the falling scenarios, a filmed performance called *I'm Too Sad to Tell You*, which featured his sobbing face in theatrical close-up. As he had staged his falling episodes as a kind of Keatonesque comedy, the haunting of the performance artist by his negated double here takes on the aspect of exaggerated, silent-movie melodrama. Seen in public for the first time in that exhibition, that installation has been probed by many for psychological clues leading as far forward as his 1975 death in a risky, solo sailing voyage across the Atlantic—despite the traps of sentimentality and incorrigible conjecture that lie along this path of interpretation. In a terse statement solicited by *Avalanche* early in 1971, he batted away the charismatic reading that his works might attract: "I do not make body sculpture, body art, or body works. When I fell off the roof of my house, or into a canal, it was because gravity made itself master over me. When I cried it was because of extreme grief."[31] Following his lead, the firmer path lies with the demonstrable, that is, the observable interplay between the artist's presence and withdrawal,

29. Goldstein, quoted in Hertz, 3, 55.
30. See artist's statement in Horvitz, "Chris Burden," 27.
31. See "Rumbles," *Avalanche* (Winter 1971): 2.

between self-possession and loss of control, a dynamic broadly shared among his network of Claremont-oriented peers.

Baldessari, more senior (he was then forty) but still years away from his current renown, joined his younger colleagues and students in mounting a Pomona show that linked themes of absence reckoned in ephemeral traces with the erasure of the work of art as surrogate or stand-in for its maker. As he has described his negotiations with Winer: "At the time I was into police photography and when she came to the door I gave her a bowl, which she grabbed. I dusted it for prints and said, here, show this, which she did. I had burned all my paintings and had the ashes. I gave them to her and said, 'Scatter them in the corner; after the first person walks in, rope off the area.'"[32]

That negation of self carried, it must be recognized, dire real-world connotations in this period for Baldessari's pupils at CalArts and for the decidedly male coterie that dominated the Pomona exhibition program. As early as 1967, Ader began to be pressured by American immigration authorities to apply for United States citizenship, which would have made him eligible for the military draft.[33] For a generation of young men under threat of being involuntarily enlisted in a futile war that few if any of them endorsed, infusing the work of art with themes of the artist's hidden, fugitive, or even entombed condition carried inescapable implications of genuine legal jeopardy and physical peril.

A remarkable series of performances that Winer organized in March 1972 included a contribution by Kosaka that drove these dark implications to the fore. Lying on the floor of the Pomona gallery, he encased himself in an electric blanket turned up high, over the top of which was shoveled a thick covering of earth, such that the shape of his body and his individual features were lost to view. The performance consisted of his enduring the weight and oven-like heat for its duration, while a subdued audience hung back against the walls of the space uncertain as to whether humanitarian intervention was required. But even here, a certain comic leavening remained latent in the work, the intimation of a stunt designed to induce a theatrical *frisson* of alarm in the gulled spectator. Such was the stock in trade of the historical escape artist Harry Houdini, the specialist in live burial, around whom Chouinardian Allen Ruppersberg built his Pomona exhibition. The show opened with an appropriate flourish on Halloween night in 1972, the forty-sixth anniversary of the magician's death. Among the conjuring paraphernalia on display was a recently minted piece Ruppersberg called *Missing*, consisting of overdue notices for five books by or about Houdini checked out from the Los Angeles Public Library. The artist's responsibility for the fugitive status of the books was left to the viewer to infer.

Also mounted at Pomona was Ruppersberg's consummate comedy on the theme of the elusive artist, *Where's Al?* (also from 1972): 160 casual instamatic photographs of a beachside reunion among friends interspersed with bits of laconically pitch-perfect dialogue typed on 110 index cards like these:

he: Why didn't Al come?
he: Too busy maybe. He's been working a lot.
he: Yeah, could be.
he: Was Al coming by himself?
she: Usually does.
he: Somebody ought to check.

Needless to say, Al is never spotted.

Winer observed that the physical matter of the entire exhibition was so slight that he could carry it anywhere in a small brief case.[34] *Where's Al?* traveled that same year to the Stedelijk Museum in Amsterdam, which had lately emerged as a nodal point in the international dissemination of advanced art, marking an accelerated, centrifugal momentum within this circle of artists—one that Claremont could not have contained for long. Indeed that event helped inaugurate the longstanding historical pattern whereby Los Angeles artists frequently leapfrog the East Coast of the United States to achieve their first wider recognition in Europe. When Ader staged what would be his final artistic gesture in 1975, he was among other things mapping that link. Having installed the first iteration of *In Search of the Miraculous* at the Claire Copley Gallery in Los Angeles, its projected culmination was to have taken place, had his voyage succeeded, at the Art & Project Gallery in Amsterdam, "possibly to continue," he noted.[35] That same leading-edge space, with its attendant journal, had welcomed Leavitt and Ruppersberg as well, placing them among a constellation of luminaries that was bound to obscure their earlier Pomona moment. Winer's precipitate departure in 1972 (in administrative retribution over Stoerchle's publicly urinating in the course of a performance) closed that experimental episode altogether.

32. Baldessari, quoted in Hertz, 62. The official title of the piece is *Cremation Project* (1970), which he also manifested in public with a paid, notarized notice of his action in the newspaper (July 27, 1970).

33. See Paul Andriesse, *Bas Jan Ader* (Amsterdam: Openbaar Kunstbezit, 1988), 87.

34. See Christophe Cherix, *In & Out of Amsterdam: Travels in Conceptual Art, 1960–1976* (New York: The Museum of Modern Art, 2009), 118–19.

35. Hand-written note, Bas Jan Ader Archives.

Chris Burden *Five Day Locker Piece*, 1971. Photograph of performance at the University of California, Irvine, April 26–30, 1971. Typed text by Burden accompanying performance: "I was locked in locker number 5 for five consecutive days and did not leave the locker during this time. The locker measured two feet high, two feet wide, and three feet deep. I stopped eating several days prior to entry. The locker directly above me contained five gallons of bottled water; the locker below me contained an empty five gallon bottle."

Closer to home, CalArts began to find its independent center of gravity, as its first student cohort continued in Valencia the lines of endeavor initially launched in Claremont. Perhaps the most extreme manifestation of the artist's self-erasure occurred in 1972, at the MFA graduation performance by Jack Goldstein on the CalArts campus. For his Pomona outing, Goldstein had shown—in a distant dialogue with Richard Serra, he admits—sculptures composed of stacked sheets of unsecured wood.[36] Finding no affirmation from Baldessari for this direction, he concluded his formal art training by subjecting himself, over an entire night on a hill above Interstate 5 in Valencia, to perhaps the most perilous act of Houdini-like self-immolation to date. Baldessari offers this recollection: "The work of Jack's that sticks in my mind is when he buried himself underground and got his air from plastic tubes; it was one of the most risky pieces I have ever seen. It took place at CalArts and Wolfgang Stoerchle was there; it was in the evening. The sun was setting, and Jack had a stethoscope, which measured his heartbeat from about twenty feet away. It was connected to where he was buried and where he was symbolically dead. What a terror being buried like that must have induced. Jack said that he was trying to give up something organic to make a symbolic statement."[37]

Well might it have stuck in the mind of a mentor. And well might he have discerned a symbolic intent whereby the presence and absence of the artist finds itself reduced to the simplest on-off binary, converting, in Goldstein's words, "subjectivity to anonymous objective impulse."[38] By Goldstein's estimation that performance helped launch his mature trajectory as an artist: "I tried to disappear by hiring actors and by hiring others to manufacture my paintings. The movies and performances became symbolic of my disappearances, just as in my final show at CalArts I was buried. All anyone saw was the blinking light, which was symbolic of my heartbeat."[39]

That nearly forgotten blinking light can be likened as well to the faint signal from a pulsar in deep space, a figure for the temporal distance and near-invisibility of the Pomona moment with which this exploit so plainly resonated. Goldstein's early CalArts performances, though a break-through in the artist's self-knowledge, have likewise receded in retrospective consciousness, overshadowed by the films and then the paintings that made his name in New York by the end of the decade. As these were annexed to the notion of a Pictures Generation, so too the fame of CalArts established

itself around the production of portable objects that quoted and reframed found imagery. But faint signals can lead the searching astronomer to consequential fields of force. In this case, an attractor was centered in the village of Claremont around 1970 around which works of varying historical renown—from Ader's and Burden's at the more visible end of the spectrum to Baden's, Kosaka's, and Goldstein's at the other (with Asher's and Ruppersberg's somewhere in between)—grasped a truth imperfectly recognized in other times and places, that is, the artist's body and persona can credibly occupy the work only under the sign of their vanishing.

36. Goldstein, quoted in Hertz, 25–26, 55.
37. Baldessari, quoted in Hertz, 65.
38. Goldstein, quoted in Yves Aupetitallot and Lionel Bovier, *Jack Goldstein* (Grenoble, France: Le Magasin, Centre National de l'Art Contemporain, 2002), 154; see also Goldstein's remark in an interview with Philip Pocock, *Journal of Contemporary Art* (Spring 1988), 37 (reprinted in Aupetitallot and Bovier, *Goldstein*, 105): "The beacon flicked on and off to my heartbeat and consequently lit up the side of this hill to my pulsation. My physicality as a body or whatever was not to be seen. Now this pulsating beacon indicates its own presence since it is displaced from its source of origin or location. This beacon of light follows after the thing that it represents and consequently we have something called representation. I became this origin without any existence. That one performance defines and exemplifies my body of work up until today." My thanks to Rebecca Lowery for her help with this material.
39. Ibid., 93.

OVERDUE NOTICE

TITLE AND COPY NUMBER	TRANS. NUMBER	AG	DUE DATE MO	DAY	YR	ITEM PRICE	AMOUNT DUE IF RET'D FINE	IF LOST TOTAL
793.5 H836CA ILL HOUDINIS ESCA 002	0265	31	08	29	2	650	80	730
						650	80	730

3920917 00
ALLEN R RUPPERSBERG
7507 SUNSET BL
LOS ANGELES CALIF 90046

PLEASE BRING THIS NOTICE WHEN RETURNING ITEMS.
FOR IMPORTANT INFORMATION, READ THE REVERSE.

9/14/1972

AS OF_____OUR RECORDS SHOW THE ABOVE
ITEMS CHARGED TO YOUR LIBRARY CARD HAVE NOT BEEN
RETURNED TO ANY **LOS ANGELES PUBLIC LIBRARY.**

IF THESE ITEMS HAVE BEEN RETURNED AND/OR FINES
PAID, PLEASE DISREGARD THIS NOTICE.

Allen Ruppersberg *Missing*, 1972. Los Angeles
Public Library overdue book notice for
Houdini's Escape. 3½ × 7 in. (9 × 18 cm).
Courtesy of the artist and Christine Burgin

UNTITLED CRITICAL PROJECT: Wolfgang Stoerchle's Brief Career
Glenn Phillips

IN 1971, WOLFGANG STOERCHLE was asked to complete a survey consisting of three simple questions:

1. Which artists, without restriction to where they work or worked or whether they are living or dead, would you want to exhibit with in a group show?
 Stoerchle's answer: Joseph Beuys, Robert Morris, Dieter Roth, Eberhard Schmidt.
2. Which living West Coast artists would you want to exhibit with in a group show?
 Stoerchle: Bill Leavitt, Jack Goldstein, Al Ruppersberg, Bill Wegman, John Baldessari.
3. List as many artists as you can think of working in the Los Angeles Basin Area.
 Stoerchle: [John] Altoon, [John] Alberty, [Billy Al] Bengston, [Paul] Brach, etc. (I am new to the area.)[1]

THE SURVEY WAS ADMINISTERED to several hundred artists as part of a project by the Market Street Program. Market Street was an innovative arts organization run by Josh Young from 1971–73; it began operating out of Robert Irwin's studio space on 72 Market Street in Venice, California, after Irwin moved away from creating discrete objects. For Young, the important question on the survey was the second one, as he wished to use a computer to compile artists' answers in order to statistically determine local group shows based on the artists' own desires to be exhibiting together.

Stoerchle never managed to exhibit simultaneously with Leavitt, Goldstein, Ruppersberg, Wegman, and Baldessari during his short life.[2] However, his wish is being realized forty years later as a consequence of the exhibition "It Happened at Pomona," because Stoerchle's answer on the Market Street survey was both an abridged summary and prediction of curator Helene Winer's exhibition program at Pomona. Stoerchle has become irrevocably intertwined with Winer's program, as his performance at Pomona on March 13, 1972, which concluded with Stoerchle urinating on a strip of carpet in the galleries, is said to have sparked a chain of events that led to the firing of Winer and the mass resignation of the entire art department faculty. The reality, of course, was far more complicated than this, but in the collective memory of the Southern California art scene, many remember Stoerchle only as the man who pissed in the gallery at the Pomona museum, bringing a brilliant period in the arts programs there to a close.

Stoerchle was a rising young artist by 1972, though his career faltered during his last few years, and his work fell into almost complete obscurity following his untimely death at the age of thirty-two in 1976. Few, aside from those who knew him personally, have remembered his work or included it in narratives of postwar art in Los Angeles. With Stoerchle, then, one has an artist whose work has been mostly detached from the intervening decades of scholarship that have placed trajectories behind the careers and affiliations of Stoerchle's peers. Where does Stoerchle belong? Looking at his body of work today one finds an artist who was asking himself that same question, and constantly testing the waters—particularly between 1969–1973—as he looked widely at the work of other artists and current debates, and produced an eclectic body of work as he attempted to find his own voice as an artist. What results is a body of work that intersects with many of the major developments of Los Angeles art without fully being a participant in any of them, allowing us to find some alternate points of entry into the developments of Los Angeles Conceptual art at the beginning of the 1970s. Looking concurrently at the adjacent curatorial visions of Winer and Hal Glicksman at Pomona in the years leading up to Stoerchle's performance there, one finds an advanced and productive context against which to gauge Stoerchle's own coming into being as an artist, although there is ultimately little in the narrative conventions of art history that can compete with the drama of Stoerchle's own constructed narrative of self.

1. Wolfgang Stoerchle survey for Market Street Program. Market Street Program Records, 1970–74. Archives of American Art, Smithsonian Institution. Reel 3979. Many thanks are due to Matthew Simms for bringing this document to my attention.
2. He came close on several occasions, exhibiting with combinations of these artists in various group shows. For his Market Street exhibition he was paired with William Wegman and John Alberty, whom he had listed in his answer to question three.

PREVIOUS PAGE

Wolfgang Stoerchle *Plaster Drop*, 1970.
White casting plaster. Dimensions variable.
The Getty Research Institute, Los Angeles
(2009.M.16)

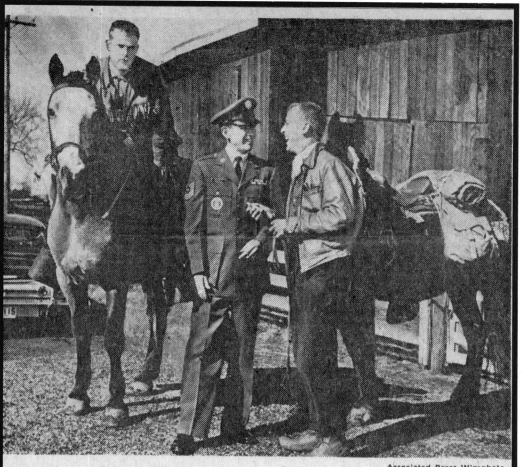

Associated Press Wirephoto

CHRISTMAS IS COMING . . . And that's when two brothers from Toronto, Canada, hope to reach Los Angeles by horseback. One of the brothers, Wolfgang Stoerchle, offers a cigarette to M/Sgt. Ernest Nicely, Lexington, who provided a night's lodging for Wolfgang and his brother, Peter Stoerchle, who is on horse.

Canadian Horse Riders
Reach Bluegrass Area

AS HE WOULD COME TO CRAFT THE STORY AROUND 1970, Wolfgang Stoerchle's first work of performance art was a grand one, unprecedented in scale. In 1962, eighteen-year-old Stoerchle and his older brother Peter began a ten-month trek across the United States on horseback, covering more than four thousand miles while trading odd jobs for provisions and lodging. The two brothers—German by birth, though the family had immigrated to Toronto, Canada, in 1959—formed a memorable pair, and local papers sometimes tracked their progress. In reality, the cross-country trek was not performance art at all, but a youthful road trip undertaken by two adventurous siblings. Their ultimate goal was to reach Los Angeles, where two of their brothers and Peter's fiancée all lived. As the trip progressed, they began to look more and more like cowboys, enacting a fantasy about the American West and westward expansion.

Unidentified newspaper article about **Wolfgang** and **Peter Stoerchle's** horseback trip across the United States, 1962. The Getty Research Institute, Los Angeles (2009.M.16)

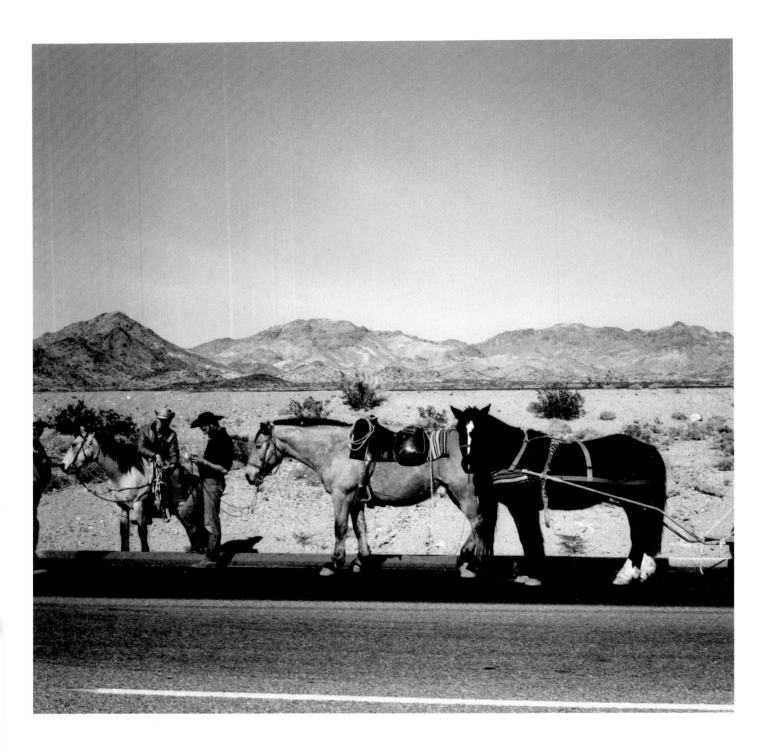

Wolfgang and **Peter Stoerchle** during their
horseback trip across the United States, 1962.
The Getty Research Institute, Los Angeles
(2009.M.16)

Stoerchle lived in Los Angeles for all of 1963 and part of 1964, and he got a job working in the art department at a pulp magazine, gaining experience with designing layouts and learning the printing process. In the fall of 1964, he moved to Norman, Oklahoma, where he enrolled at the University of Oklahoma. He had met the dean of the university, Dr. Glenn Couch, during his horseback trip, and the two had stayed in touch. He majored in art with a focus on painting, and in 1966 he married Dr. Couch's daughter, Karen. He graduated in 1968, and then enrolled at the University of California, Santa Barbara (UCSB), where he had been accepted into the MFA program.

The paintings Stoerchle was producing at this point were unremarkable, though revealing, showing a conflicting set of approaches to being "current." A rendering of folded mattresses and pillows, polka-dotted and floating on an undifferentiated field of blue, appears to be an amalgamation of influences, taking cues perhaps from Claes Oldenburg's soft sculptures and Wayne Thiebaud's colors. The surface itself strives to be smooth, almost looking airbrushed, and one could venture that Stoerchle had seen the Finish Fetish surfaces of Billy Al Bengston and was trying to reproduce them by hand.

The painting may have arisen in part from Stoerchle's observation of recent sculpture. In April of 1968, a few months before Stoerchle would begin his mattress painting, Robert Morris had published his famous "Anti-Form" essay in *Artforum*. Noting a new tendency for artists to work with softer materials and more inchoate forms (in contrast to the strong geometries of Minimalism in which "process is not

visible"[3]), Morris described a process-oriented sculptural practice in which composition was becoming de-emphasized:

In these cases considerations of gravity become as important as those of space. The focus on matter and gravity as means results in forms which were not projected in advance. Considerations of ordering are necessarily casual and imprecise and unemphasized. Random piling, loose stacking, hanging, give passing form to the material. Chance is accepted and indeterminacy is implied since replacing will result in another configuration. Disengagement with preconceived enduring forms and orders for things is a positive assertion. It is part of the work's refusal to continue aestheticizing form by dealing with it as a prescribed end.[4]

At UCSB, Stoerchle turned almost immediately towards performative and process-oriented sculpture, moving through a wide array of materials and techniques that were becoming associated with post-Minimalism and "anti-form" sculpture. He produced sculptures composed of paper and melting ice, and experimented with polyurethane, Styrofoam, polyester resin, and inflatable structures. He also began to feel his way into live performance, starting with some simple, Fluxus-style performances, such as his *Clothes Exchange* (1969), an unannounced performance at UCSB in which he and another artist stripped down and exchanged clothes in public.

By his second year at UCSB, Stoerchle had arrived at his first mature project, a series of sculptures known as the Plaster Drops (1969–70). Using slabs of non-reinforced, white casting plaster, Stoerchle made

3. Robert Morris, "Anti-Form." *Artforum* 6, no. 8 (April 1968): 35.
4. Ibid., 35.

Wolfgang Stoerchle *Untitled*, 1968. Oil on canvas. Private collection, Santa Barbara

Wolfgang Stoerchle Untitled experiment with ice and paper, c. 1968–69. The Getty Research Institute, Los Angeles (2009.M.16)

controlled drops of these slabs at locations throughout the UCSB campus, allowing the slabs to shatter when they fell, and making no other compositional choices aside from choosing where and how the slabs would be dropped. Stoerchle described the idea behind the series as a "minimum chance concept,"[5] which was meant to be a rebuttal to Morris's ideas about anti-form. Stoerchle was taking his lead from Allan Kaprow, who had published a biting critique of "Anti-Form" in the summer 1968 issue of *Artforum*. Titled "The Shape of the Art Environment," Kaprow argued that the concept of an "anti-form" was impossible for the human cognitive process, noting that "we may prefer this pattern to that one—say a pile of shit to a series of cubes—but they are equally formal, equally analyzable."[6] Kaprow quickly added that he quite liked Morris's piles of felt, but he noted

that nothing in the appearance of these works clarified whether their composition was achieved through scrupulous arrangement or, as Morris asserted, a chance encounter between material and gravity.

Stoerchle's Plaster Drops were meant to maintain the notion of chance composition, while also resulting in a sculpture that was a coherent product of its making. Looking at the plaster forms, one can clearly see what the object is but also what it *was*, and one would never question whether these dozens of plaster fragments had been arranged: they were simply a product of the process that made them.

Kaprow's most important point, however, was that the uncomposed state of "anti-form" art means little when considered within the overall shape of the art environment:

5. Wolfgang Stoerchle, "Thesis Project," University of California Santa Barbara, Department of Art, 1970, n.p.

6. Allan Kaprow, "The Shape of the Art Environment: How antiform is 'Anti-Form'?" *Artforum* 6, no. 10 (Summer 1968): 32.

Wolfgang Stoerchle *Plaster Drop*, 1970. White casting plaster. Dimensions variable. The Getty Research Institute, Los Angeles (2009.M.16)

Morris's new work, and that of the other artists illustrating his article, was made in a rectangular studio, to be shown in a rectangular gallery, reproduced in a rectangular magazine, in rectangular photographs, all aligned according to rectangular axes, for rectangular reading movements and rectangular thought patterns....[S]o long as we live in a world dominated by this and other part-to-whole geometrical figures, we cannot talk about antiform or nonform except as one type of form in relation to another (rectilinear) type.[7]

Kaprow's counterexample was the environmental Happenings of the late fifties and early sixties, which "tended to fill...their entire containing areas, nearly obliterating the ruled definition of the rooms."[8] At the time he wrote "Shape of the Art Environment," Kaprow was just beginning his transition to the West Coast,[9] and he would not have been thinking about Los Angeles artists as an alternative to Morris's anti-form. However, the points of his critique were applicable to the many artists in Southern California who had recently begun producing a type of perceptual installation and sculpture now commonly referred to as Light and Space art, and which was a primary focus of Hal Glicksman's curatorial program at Pomona College in the fall of 1969 and spring of 1970. Rather than focusing on the strong figural and material presences found within Minimalism and post-Minimalism on the East Coast, artists such as Robert Irwin and Tom Eatherton aimed to destabilize vision, producing works that often operated at the fringes of human perception.

A "disc painting" by Robert Irwin remained on view for the entirety of Glicksman's tenure at Pomona College, conceptually presiding over the Artist Gallery program. Irwin's hovering convex disc was painted with an imperceptible concentric fade, protruding from the wall from an armature; upon directed viewing, it appeared to disappear amidst the concatenation of overlapping shadows cast from the four spotlights illuminating the work from above and below. The piece arose from Irwin's desire to create "a painting that does not begin and end at an edge but rather starts to take in and become involved with the space or environment around it."[10] Irwin's disc paintings aimed to dissolve the distinction between the art object and its container, but other artists exhibiting at Pomona College aimed to dissolve the container itself. Ron Cooper's *Ball Drop* (1969) performance—where an electromagnet dropped a heavy ball bearing onto a large sheet of glass in the Pomona Museum—bore the most resemblance to

Stoerchle's Plaster Drop works. But the four broken windshield sculptures displayed in the gallery were lit to cast their webs of cracks across the walls of the otherwise dark gallery, creating a play between the objects and their shadows, and like Irwin's disc, confusing the distinction between object and wall. Other artists in Glicksman's program created more radical transformations: Tom Eatherton's *Rise* (1970) produced glowing and edgeless walls that appeared to be made of pure light, and Lloyd Hamrol's *Situational Construction for Pomona College* (1969) appeared to vertically extend the gallery into unknown dimensions. Judy Chicago's *Snow Atmosphere* (1970), which encased a large swath of Mt. Baldy under a shroud of smoke, abandoned the gallery altogether. Michael Asher's untitled installation (1970) remade the "container" of the museum entirely, opening it to the outdoors and, in the process, calling into question its function. In their focus on environmental installations and perceptual processes, the artists featured in Glicksman's program at Pomona College were several steps ahead of Stoerchle, although the same acquisitive tour that led Allan Kaprow, as the new associate dean of California Institute of the Arts (CalArts), to visit Lloyd Hamrol's installation at Pomona College, also led him to visit Stoerchle's Plaster Drops in Santa Barbara. Kaprow offered both artists teaching positions at CalArts for its opening semester in the fall of 1970.

Stoerchle met Robert Morris in late February or March of 1970, when Morris (at the time a visiting faculty member at the University of California, Irvine) produced a large-scale Timber Spill work at UCSB's art museum. Taking the chance component of anti-form sculpture to a scale that could be competitive with Richard Serra (who had exhibited eighty tons of giant redwood logs at the Pasadena Art Museum that January), and clearly ignoring Kaprow's criticisms, Morris stacked fifty 20-foot timbers into a 5-by-40-foot mass and then wedged them off the ground until they spilled across the gallery.

While in Santa Barbara, Morris agreed to pose for some photos with Stoerchle in which the two artists, both shirtless, squared off in an arm wrestling match. A newspaper clipping in Stoerchle's archive bears the headline "Call to Arms at the Butler Gallery" and describes an exhibition that consisted of Stoerchle sitting in the gallery challenging visitors to arm wrestle. A caption beneath the image notes that Stoerchle and Morris are engaged in "'artistic' combat." Another clipping shows a different image

7. Ibid., 32–33.
8. Ibid., 33.
9. In the spring of 1968, Kaprow was commuting regularly from New York to Berkeley, California, for his position as co-director of Project Other Ways. In 1969, he moved to Los Angeles, following his appointment as associate dean at the newly formed California Institute of the Arts.
10. Robert Irwin quoted in Lawrence Weschler, *Seeing is Forgetting the Name of the Thing One Sees: A Life of Contemporary Artist Robert Irwin* (Berkeley and Los Angeles: University of California Press, 1982), 99.

of Stoerchle and Morris and a caption that reads: "...the fingers numb, the wrist aching as the soul; the neck cricked from months of horizontal labor... (Michelangelo Buonarroti)." The clippings are, of course, fake, a product of the design and production skills Stoerchle had gained when working at the pulp magazine during his first stay in Los Angeles. A second set of clippings, titled "Minimalist Anti-Pollution System at Work," describes Stoerchle's exhibition of invisible art at the non-existent Knagge Gallery in Los Angeles. An image shows gallery visitors peering at rectangles of masking tape on the wall—a contrived concession, the article notes, to the visitors who needed an indication as to where they should look. In a 1974 article about Stoerchle in *Studio International*, Miles Varner describes a third fake clipping announcing that Stoerchle had won a print competition, which Stoerchle in turn submitted as his print to that very competition. Varner viewed these newspaper works (collectively titled *Untitled Critical Project*) as a variation of process art, noting that "the artist's role as stimulus for the review is retained, the object is eliminated, and the process with a perceptive use of media is presented directly. The process includes an illegitimate history, its own existence, anticipated reaction to it, and this description, as elements of itself."[11]

Despite the "critical" stance of Stoerchle's news clippings, they also clearly show that Stoerchle was becoming fascinated with larger-than-life notions of the artist, and they reflect his own attempts at self-mythologizing. In June of 1970, Stoerchle produced a plaster drop event at UCSB that abandoned his previous principles of clarity in favor of a raucous

performance that focused attention on Stoerchle himself as the star and maestro of the evening. Stoerchle, clad in a jumpsuit and knit cap and wearing sunglasses for much of the performance, leapt onto stacked rows of plaster slabs, crashed through a plaster wall by swinging through the gallery on a rope, was smashed through plaster slabs while being run through the gallery carried by six men, and teetered through the gallery balancing plaster boxes on his head, aiming to fling them onto a growing pile of broken plaster. A gymnast smashed a series of raised slabs by performing precision somersaults along the floor. Titled *Event*, the spectacle was staged for the local NBC television station, and the debris from each segment of the evening was swept into a sculptural heap before setting up more plaster for the next performance. Though it was clearly great fun for everyone who attended, the event was also a play for attention, and an attempt to craft a macho public persona, as artists such as Morris and Serra had done so successfully. It was around this time that Stoerchle proposed that his earlier horseback trip, with its own attendant news clippings, was a grand and originary work of performance art. He also began to manipulate photographs to depict fictitious events. *R.R. Event* (1970) appeared to document Stoerchle arm wrestling with California governor Ronald Reagan in Sacramento (*High Performance* magazine would later run this image as its cover following Reagan's inauguration as president in 1981). An untitled and undated image in Stoerchle's archive depicts the artist outdoors hovering in mid-air, as if levitating—an idea that he would further pursue later in his performance at Pomona College.

11. Miles Varner, "Wolfgang Stoerchle," *Studio International* 183, no. 943 (1974): 160.

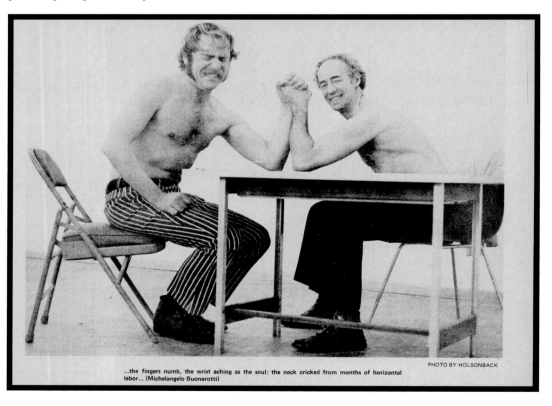

...the fingers numb, the wrist aching as the soul; the neck cricked from months of horizontal labor... (Michelangelo Buonarotti)

PHOTO BY HOLSONBACK

Wolfgang Stoerchle *Untitled Critical Project (Call to Arms at the Butler Gallery)*, 1970. Newsprint. The Getty Research Institute, Los Angeles (2009.M.16)

NEXT PAGE, LEFT / RIGHT

Wolfgang Stoerchle *Untitled Critical Project (Call to Arms at the Butler Gallery)*, 1970. Newsprint. The Getty Research Institute, Los Angeles (2009.M.16)

Wolfgang Stoerchle *Untitled Critical Project (Minimalist Anti-Pollution System at Work)*, 1970. Newsprint. The Getty Research Institute, Los Angeles (2009.M.16)

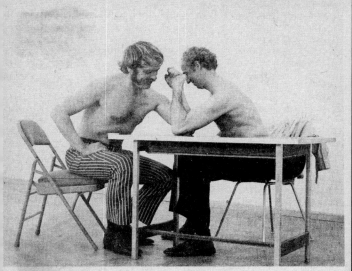

'Wolfgang Stoerchle' and Robert Morris ("artists") locked in "artistic" combat at the Butler Gallery.

Visitors to the Stoerchle exhibit contributing essential forms of non-comprehension.

CALL TO ARMS AT THE BUTLER GALLERY

There is some pretty agressive and challenging art at the Butler Galleries this week. Arm-wrestling, and for real. An artist for whom we have learned to expect something new every time, Wolfgang Stoerchle, just sits there, in the middle of the gallery, and challenges the public, individually, to arm-wrestle him. No doubt at all that the show generates considerable excitement — as long as the public responds, as it certainly should if it has any taste at all. Since the A new form of art demands new critical standards, and since the best form of criticism is criticism from the inside, I can do no better than describe how I personally fared in this new Art Exterience.

I engaged my opponent with a regular, four-square, minimal overlap grip. I outlined a few preliminary manoeuvres, then threw in some heavy reds and umbers, straight from the tube. My opponent went down at least three inches, but I was overdrawn, my compositional energy flagged, and the other arm came up in a trenchant rising diagonal, which tipped back into the middle-ground again. For a moment I was really worried; I detected a fanatical Supremacist glint in the eye opposite me, and my hand was sinking as fast as the Santa Barbara sun on a winter's evening. I summoned up the battle-slogan which had served me in previous critical situations: Per — spective! In I zoomed, sending (as it seemed to me at the time) at last the enemy arm ceded a fraction, the elbow lifted an inch, abandoning the corner repoussoir where it had been anchored for so long. Two backs arched in symmetry; eight fingers and two thumbs tightened until the knuckles turned complementary shades of blue and orange. By this time my elbow, too had lifted, so that the whole composition of the contest hung in dynamic balance. A space-time continuum, brachial eternity: then the vanishing-point upon which the mind-sights had been fixed melted away in the dust of a distant horizon-line, my vision dissolved into impressionist flecks, post-impressionist dots and cubes, and expressionist distortions; until, at last, my wrist flailed over, my arm crashed down, and my consciousness rothk.o.ed into black on black.

The artist appeared to have defeated the critic; but I later discovered that, once more, the dice had been leaded against the critic; why, that fellow had been trained as an action painter!

MINIMALIST ANTI-POLLUTION SYSTEM AT WORK

In an atmosphere polluted by smog and the four-letter inanities of our campus Mussolinis, it is refreshing indeed to breathe the pure air of arch-minimalist Wolfgang Stoerchle's exhibit now showing at the Knagge Gallery, 6001 La Cienega. With so much art tagging desperately along in the wake of fake-liberalist 'social relevance', with Kinetic Art whoring after the gods of Instant Structural Change, Op Art unnaturally coupled to the organs of 'psychedelic' retinal orgasm, and Pop Art sophomorically dedicated to the proposition that all Bananas were not created equal (Oldenburg's plastic versions, costing around $20,000 a time, being obviously more equal than others), and as I pointed out in this column recently, after Op and Pop there can only be Stop Art -- the art-movement to end all art movements; the art movement which takes art to the people, out of the galleries into the streets, where an identical monument, incorporating a novel intermittently shining red light effect, is to be erected at every busy intersection. But to return to the subject in hand without further beating of the critical breast -- since all art-movements after abstract expressionism have been charging with fixed bayonets up the blind alleys of 'objectivity', the art of Stoerchle appears as just marvellously pure, cerebral in the highest degree, spiritualised to the point of supremely metaphysical non-being.

DYNAMIC PLASTIC KNOBS

Stoerchle creates upon the gallery wall rectangular spaces by means of thin strips of opaque scotch tape. These spaces reach so extreme a point of the intangible, as perforce to enter (by the back door, or from the other side, as it were) the realm of metaphysical tangibility. Visitors to the exhibit (see photograph), by trying to establish a literal rather than metaphorical physical contact, failed totally to grasp the meaning of the show. This is exactly as the artist intended. Non-comprehension of his work is essential to its success, because non-comprehension means non-participation, which is essential to it if its purity is to remain uncontaminated by the spectator. Even this review is a form of contamination, which could be excused only by the possibility (denied me, alas, by my friends) that no-one reads my column. I have accordingly offered an alternative minimalist review, conceived in the spirit of Stoerchle's work, which the editor will refuse to print (Wrong. See space to right -- ED). Even if this alternative review were printed, it could not do justice to the art of Stoerchle: for any process of extraneous duplication, especially a process of critical superimposition so exact that the mind and eye are deceived, must appear as nothing less than the most grotesque form of parody.

YULETIDE COLORING

Stoerchle has made the ultimate sacrifice an artist of integrity can make in this day and age: in his attempt to prevent spectator-comprehension- contamination, he has not exhibited the work as originally conceived. The work was planned to be shown without the thin strips of opaque scotch tape. This last-minute addition was connived at by Stoerchle, but the exhibition catalogue (which is by the way lavishly illustrated and was already out of print before the show opened) pretends taht it was forced upon the artist by the gallery owner, who felt obliged to make this 'concession to popular taste'. Such a transparently implausible fiction serves the artist's purpose in ensuring maximum non-comprehension; and it is, finally, in the spirit of calculated non-comprehension that I append the following comments:

"Stoerchle's Minimalist art appears pretentious compared with the genius of John Eod, who shows us empty galleries entirely devoid of any extraneous symbols or objects with emotional associations or tangible properties. Eod thus deprives us mercilessly of anything perceptual, creating a mindlessness characteristic of the art of the mid-Sixties, that, despite its detachment, has an aggressive vacuity capable of establishing a tremendous intimacy with the patient viewer. This vacuous intimacy Stoerchle is, as yet, unable to master." —DMK

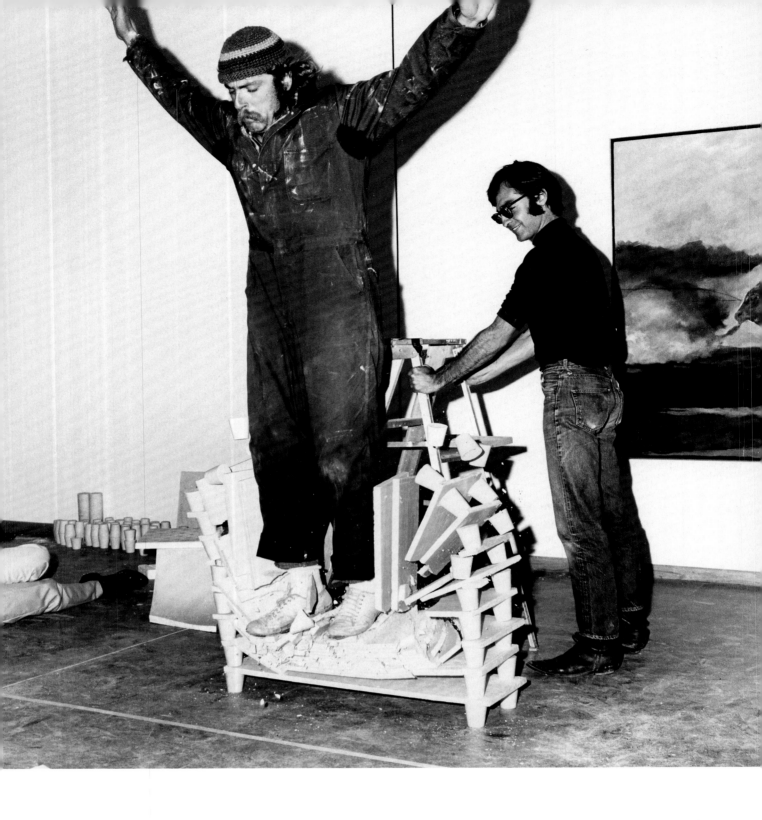

Wolfgang Stoerchle *Event* performance
at the University of California, Santa Barbara,
June 1970. The Getty Research Institute, Los
Angeles (2009.M.16)

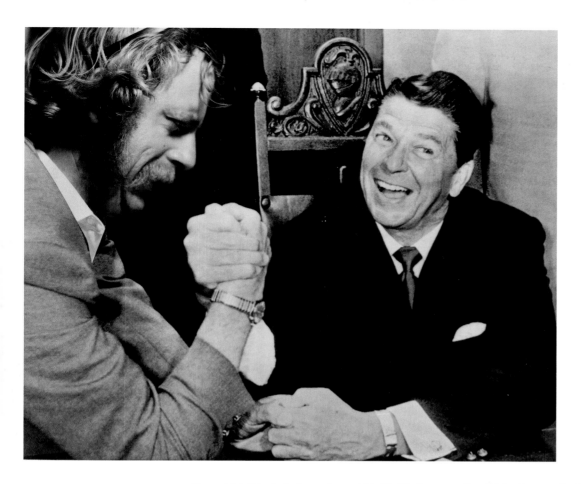

Stoerchle's faked photographs and his *Untitled Critical Project* bear affinity with the parodic journal *Landslide*, which was produced in 1969–70 by William Leavitt and Bas Jan Ader.[12] Distributed as anonymous mailings to friends and art world figures, *Landslide* presented a comical series of fictional artists and critics (such as "John Grover" and "Brian Shitart") while also poking fun at current trends with bogus performance scores and fake multiples, such as the packing peanuts sent with issue three as "expandable sculpture," or the McDonald's hamburger sent through the mail as the entirety of issue six.[13] Leavitt and Ader produced a number of "fake" artworks to be photographed as illustrations in *Landslide* (including some hilarious knockoffs of Morris's canonical *L-Beams* [1965]), while also producing some large-scale outdoor perfor-mance works as *Landslide* events, including a "landslide" of traffic flares sent down a Los Feliz hillside in 1969 (perhaps unintentionally spoofing Judy Chicago's *Atmosphere* performances that had begun earlier that year). Still based in Santa Barbara and with few contacts in Los Angeles, it is highly unlikely that Stoerchle would have known about

Landslide when producing his own fake articles. But upon moving to Los Angeles for his teaching position at CalArts in the fall 1970, Stoerchle was introduced to a number of people familiar with the project.

At CalArts, Stoerchle found himself in the midst of one of the most exciting artistic environments anywhere in the world. He was one of the youngest teachers amidst a radically avant-garde faculty that included figures such as Kaprow, John Baldessari, Nam June Paik, and Alison Knowles. Stoerchle got along fine with the faculty, but his friendships were more with the graduate students, such as Jack Goldstein, who were closer to him in age and sensibility. Winer's tenure at Pomona College began that same fall. Stoerchle probably met Winer through Goldstein, and he most likely would have visited Pomona at the latest by January of 1971, when Goldstein exhibited his own play on the timber spill— neat but precariously high stacks of wooden blocks that continually threatened to topple over. Stoerchle also met a number of Goldstein's former undergraduate classmates at Chouinard, many of whom, such as Allen Ruppersberg, Leavitt, and Hirokazu Kosaka,

12. Though one might naturally assume *Landslide* was poking fun at *Avalanche* magazine, it in fact preceded the publication of *Avalanche* by more than a year.

13. For more on *Landslide*, see Erik Bluhm, "Minimalism's Rubble: On William Leavitt's and Bas Jan Ader's *Landslide* (1969–70), ArtUS 10 (2005): 14–17.

Wolfgang Stoerchle *R.R. Event*, 1970.
The Getty Research Institute, Los Angeles
(2009.M.16)

would later feature in Winer's curatorial program at Pomona College. Stoerchle had mixed results being introduced to this circle. He became fast friends with Kosaka, though an early meeting left Leavitt and Ader unimpressed.

Stoerchle began to work with the new medium of video, which was abundantly available for faculty and students in the fine arts program at CalArts. With video, Stoerchle began to truly come into his own as an artist, intuitively grasping the complexities of the new medium, and producing an imaginative and dynamic series of works between 1970 and 1972. Among his earliest experiments is an attempt to create an anti-form video. Focusing the camera on a small, carefully formed cube of dirt, Stoerchle repeatedly blew on the cube until it was reduced to an uncomposed scatter of dirt across the screen. More typically, however, Stoerchle set up situations in which his body was forced to struggle. In one piece, he rolls across the floor amidst two rolls of paper that he is trying to unroll on one side and allow to re-roll on the other. Another work (later incorporated into his Pomona College performance) saw the artist squirming himself out of his sweatpants, and then his sweatshirt (each held in place by an assistant) until the garments were turned inside out and Stoerchle was nude. Other works capitalized on the fragility of the recording apparatus. By setting off a series of flashes in a darkened room, Stoerchle was able to temporarily "burn" images of his nude body into the camera's sensitive picture tube, creating a series of ghostly photograph-like images that appear and then fade to black. Several works focused specifically on Stoerchle's penis—bouncing around upside down, urinating, and most infamously, extruding a series of small Disney figurines from his foreskin, poking fun at Disney's bankrolling of CalArts (whose equipment he was using to produce the piece).

Stoerchle's best work occurred when he was using multiple cameras, or multiple passes through the recording apparatus. Creating a time-delayed live feed by stringing together two video recorders, Stoerchle played with the infinite recession of monitors that appear when pointing the live camera towards the monitor to which it is broadcasting, creating a sequence in which two hands appear to successively drape fabric around each receding monitor, moving from the inside outwards. A humorous work shows

Stoerchle, pictured from the neck down, sitting on top of a television set. A second camera broadcasts live footage of Stoerchle's head to the television, and Stoerchle struggles to keep a black paper strip positioned over the television image of his eyes. This work was also performed as a semi-live event as part of an unlikely video called *A.T.E. Dinner Party* (1972), produced by Stoerchle and Daniel Lentz, in which Stoerchle, Kaprow, Winer, Lentz, and artists Pauline Oliveros and Emmett Williams and journalist Clare Loeb enacted a conversation about contemporary art over a staged dinner in a television studio.

Stoerchle's first exhibition at Pomona College was supposed to happen in March of 1971, in conjunction with his participation in the *Pier 18* exhibition in New York City. Organized by *Avalanche* magazine editor Willoughby Sharp, *Pier 18* consisted of projects by twenty-four artists (including, from the West Coast, Baldessari, Wegman, Goldstein, and Ruppersberg) that were performed over a two-month period in the winter of 1971. Wegman turned the pier into a one-shot bowling alley; Ruppersberg filled a suitcase with a brick from Houdini's home, wrapped it in chains, and cast it into the water (it floated); Baldessari used his fingers to frame pictures of ships visible from the pier. As perhaps a final dig at Robert Morris (who was also in the show) or as a dig at Goldstein, Stoerchle had his arms stacked high with wood, and he stumbled along the pier until he spilled the timber. All of the projects were photographed by Harry Shunk and Janos Kender, and the photographs were scheduled to be exhibited at Pomona. But the exhibition was cancelled after being scooped by the Museum of Modern Art, who wished to be the premiere venue that July.

One year later, Winer invited Stoerchle to present a performance as part of a three-week series that would feature new works by Kosaka, Stoerchle, and Chris Burden on three successive Mondays in March 1972. Stoerchle performed second in the series, on March 13, and his announcement featured an image of him jumping on a stack of plaster slabs from his final Plaster Drop event in Santa Barbara. At Pomona College, Stoerchle presented five short works that were strung together as a continuous sequence. The evening began with Stoerchle standing in front of the audience straddling a mirror that obscured one leg. Lifting his exposed leg created an illusion, with

Wolfgang Stoerchle *Untitled Video Works*, 1970–72. Stills from single-channel videos. Black-and-white, sound, 62 min., 30 sec. The Getty Research Institute, Los Angeles (2009.M.16)

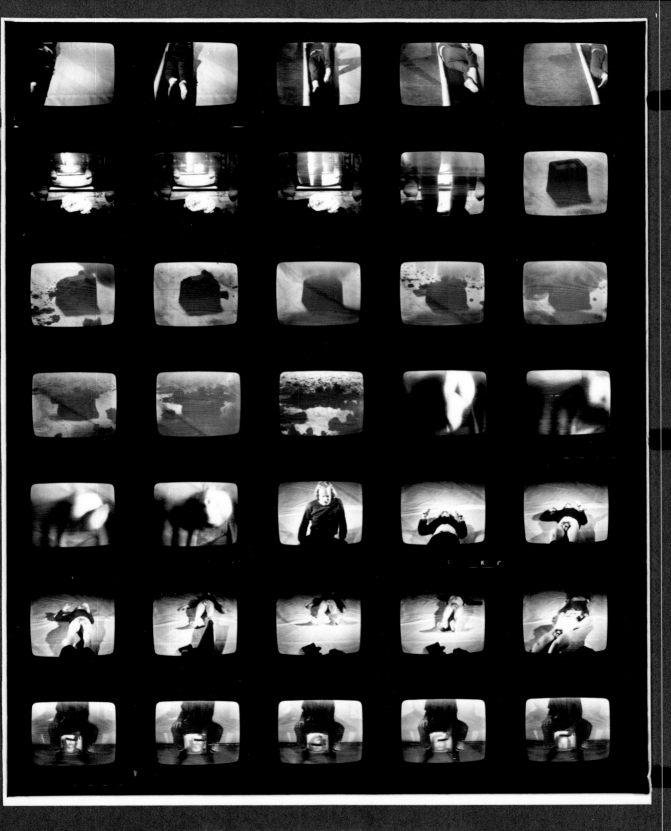

Untitled Video Works, 1970-1972

the mirror reflection, that he was levitating. He proceeded to move sideways across the room—lifting his exposed leg, shifting his weight as he settled into a wide stance, and sliding the mirror-obscured leg back to normal posture—until he reached a strip of carpet that had been brought into the gallery. He stood on the edge of the carpet as an assistant pulled it out from under him, causing him to fall face-forward on the ground. He flipped over on his back and, repeating his earlier video, squirmed out of his sweatpants and sweatshirt, leaving him completely nude. He was handed a toothpick and tissue, and he began inserting the toothpick up his nose in order to agitate his sinuses and provoke sneezing. With each sneeze, he moved closer to a vertical position, trying to move only by means of the energy from each sneeze. Finally, he moved back to the edge of the carpet, and urinated on the carpet in a series of short spurts.

While the action would have certainly offended some members of the audience, it is hard to find evidence of any immediate uproar stemming from Stoerchle's performance. *The Student Life*, Pomona's college newspaper, featured a lengthy and mostly positive review of the performance by undergraduate student Paul McMahon, inset with a short, pseudonymously submitted complaint by an audience member who noted: "I realize that rapidly changing times and new values must lead me to condone publicly certain activities in fraternities and various ill-advised names for "rock-and-roll" combos, but to advertise and review such activity as I witnessed in Montgomery Art Gallery is, in my view, in egregious bad taste."[14] An article in the *Los Angeles Times* later that month about overall trends in performance art mentioned no scandals associated with Stoerchle's performance, but described the ending of the performance by saying, "He then faced the audience and reportedly performed a public nuisance."[15] Winer, in turn, continued working at Pomona College for almost eight more months following Stoerchle's performance. While it is likely that Stoerchle's actions may have been an easy point of reference for those within the Pomona community who were critical of Winer, there was certainly not an immediate cause-and-effect relationship between Stoerchle's performance and Winer's dismissal.

Stoerchle, for his part, continued pissing in galleries. He developed a performance, repeated on several occasions, in which he stood nude in front of the audience and attempted, without using his hands or otherwise touching himself, to achieve an erection. During the performances, he never managed to achieve this goal more than partially, and a related video from this period depicts Stoerchle in the midst of the performance, describing in detail his visits with a therapist who was attempting to help him work through these issues and achieve his goal in the future. Stoerchle concluded each failed erection performance by urinating on and off in short spurts, as he had done at the end of his Pomona College performance. When speaking with people who remember attending Stoerchle's performance at Pomona, several describe not the piece presented as part of Winer's program, but Stoerchle's erection performance. From April 23 to May 6, 1973, the Libra Gallery at Claremont Graduate School (CGS) presented a project called "Art Forms and Ideas: Exhibition of Conceptual Art." Although organized by CGS, Pomona also acted as a host for the event, which featured not only an exhibition but also several days of lectures and performances. Stoerchle's name is listed among the artists included in the exhibition, and it is possible that, although Stoerchle was living in New York by this point, he presented his erection performance as part of the exhibition. This event had no connection with Winer, but its closer proximity to Winer's dismissal and the resignation of Pomona College's art faculty, along with its more "scandalous" nature than Stoerchle's Pomona performance, could also help explain the association in so many memories between Stoerchle and the end of Winer's tenure. At the same time, the fact that Stoerchle was invited back to participate in a project that took place at a fellow member of the Claremont Colleges consortium, and was partially hosted by Pomona, implies that the original performance could not have been seen as that offensive. One can only imagine that Stoerchle would have loved the afterlife of this work, and its circulation as a legend amongst stories of the life and death of arts programs at Pomona College.

Postscript

PAUL MCMAHON'S REVIEW of Stoerchle's Pomona performance described the work as being essentially about vulnerability. Though the points of McMahon's interpretation are overwrought in their details, vulnerability is persistent throughout Stoerchle's work, and the arc of his career shows that vulnerability continually creeping to the surface. (*See pages 229–30*) Underneath a public persona that was intensely macho, bawdy, and romantic stood Stoerchle with his shattered sculptures, naked for the world to see, dribbling piss, impotent, emasculated. Stoerchle's

14. "Stoerchle Decried: Outrageous," *The Student Life*, March 21, 1972, 4.
15. William Wilson, "This is Art— These People Are Artists," *Los Angeles Times*, March 24, 1972, G15.

Wolfgang Stoerchle untitled "levitation"
photo, n.d. The Getty Research Institute,
Los Angeles (2009.M.16)

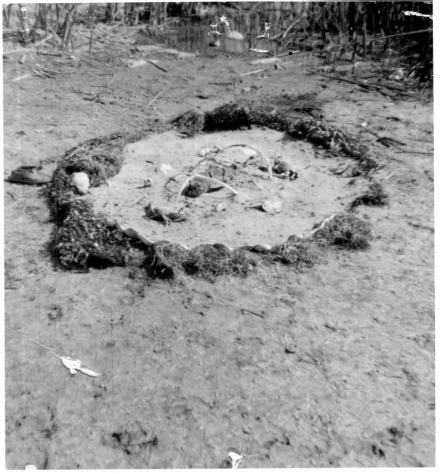

teaching position at CalArts ended in the Spring of 1972, and he decided to take the advice that Baldessari had been giving to the exiting graduate students and move to New York. Finding himself in a far more competitive environment than Los Angeles, and without the stream of contacts provided by working at an institution like CalArts, Stoerchle's career failed to take off as he had hoped, and few complete works survive from his time in New York. In July 1973, he received a fellowship to be part of the first Dance/Television Workshop during the American Dance Festival at Connecticut College. He produced a startling, masterful work there, one that in other circumstances could have become firmly established as one of the very best works of early video art. Instead, the work remained almost completely unknown for thirty-five years.[16]

Stoerchle became increasingly disillusioned with his minor role in the art world, and following his residency he left New York and headed to Mexico, where he spent the next six months hiking and living in a rural area. For the last two years of his life Stoerchle was frequently on the move, back and forth between Southern California, Mexico, and New Mexico. He had developed a fistula that required him to undergo a series of unsuccessful operations in Mexico City and Santa Barbara, and he became obsessed with his diet, subsisting much of the time on only oatmeal and milk. In November of 1974, he married his second wife, Carol Lingham, whom he had known since graduate school in Santa Barbara, and the two of them went back to Mexico in 1975 for another extended period of camping and hiking.[17]

During this period, Stoerchle produced simple, almost primitive, artworks using materials he had on hand: he produced shrines and mounds of rocks, and drew fiery, agitated sketches that are suggestive of wounded or excised landscapes. It was as if, harking back to his earlier mythical trip across America as a cowboy, Stoerchle was now trying to summon a more primitive fantasy of a native North American mythology.

In the fall of 1975, Stoerchle made a brief trip back to Los Angeles, where he produced his final performance

16. See my detailed description of this work, posthumously titled *Sue Turning*, in *Record > Again! 40yearsvideoart.de Part 2*, Peter Weibel and Christophe Blase, eds. (Ostfildern, Germany: Hatje Cantz, 2010).

17. This period of Stoerchle's life, as remembered by Miles Varner and Carol Lingham, are recounted in the exhibition catalogue *Wolfgang Stoerchle* (Grenoble, France: Le Magasin—Centre National d'Art Contemporain, 1996), n.p.

Wolfgang Stoerchle untitled sculptural arrangement produced while hiking, c. 1974–75. The Getty Research Institute, Los Angeles (2009.M.16)

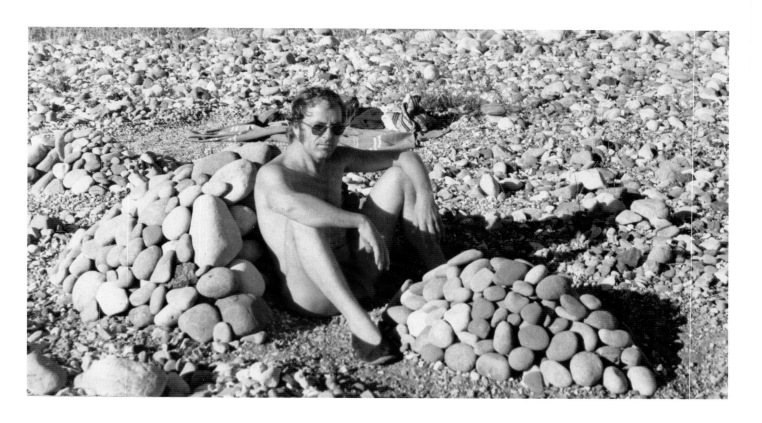

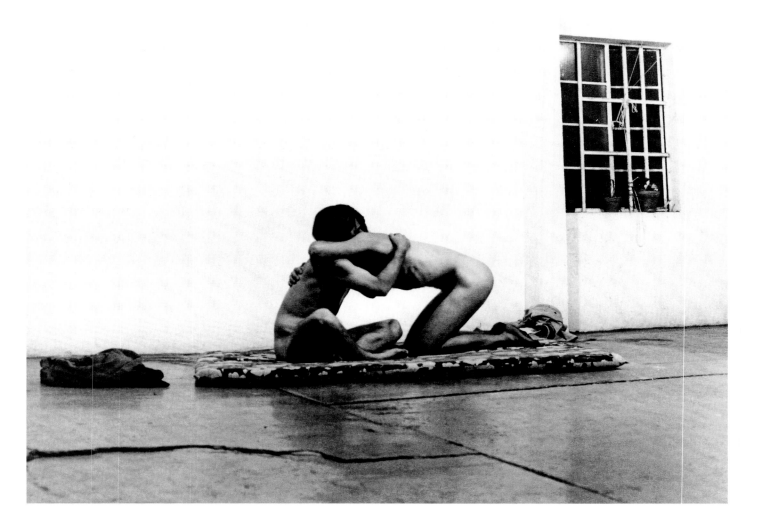

TOP / BOTTOM

Wolfgang Stoerchle untitled sculptural
arrangement produced while hiking,
c. 1974–75. The Getty Research Institute,
Los Angeles (2009.M.16)

Wolfgang Stoerchle final performance
at John Baldessari's studio, 1975.
The Getty Research Institute, Los Angeles
(2009.M.16)

in Baldessari's studio. Around seventy-five people attended the performance, which involved Stoerchle standing in front of the audience and describing a series of fantasies that had fascinated him throughout his life. In the midst of the performance, Stoerchle stated that he might be attracted to men. He said that if there were a willing male volunteer in the audience, he would like to try performing oral sex on him. He repeated these stories and this offer over and over again, until finally a volunteer emerged from the audience.

In October of 1975, Stoerchle and Lingham moved back to Santa Fe, where he worked at the Dell Weston Bronze Foundry. His job was to cast scenes of western Americana—literally cowboys and Indians, and other fantastical American myths. He became more and more fascinated with dream therapy, astrology, past life regression and other trappings of West Coast new age-ism, and trips to the doctor revealed that he was suffering from malnutrition. In the winter of 1976, Stoerchle began telling Lingham that he had foreseen his death. On March 14, 1976, a speeding car that had run a red light struck Stoerchle and Lingham. Lingham was mostly uninjured, but Stoerchle suffered massive head injuries, and a broken rib impaled his heart, killing him instantly.

Many thanks are due to the people who have shared their memories of Wolfgang Stoerchle with me over the course of this research, including John Arvanites, John Baldessari, Barbara Bloom, Chris Burden, Peter Kirby, Hirokazu Kosaka, William Leavitt, Carol Lingham, Paul McCarthy, Sue Pfaffle, Allen Ruppersberg, Ilene Segalove, Miles Varner, and Helene Winer.

Wolfgang Stoerchle untitled drawing,
c. 1974–75. Private collection, Santa Barbara

Wolfgang Stoerchle untitled drawing, c. 1975.
Private collection, Santa Barbara

LESSONS FROM POST-MINIMALISM:
Understanding Theatricality as a Pictorial Value
Marie B. Shurkus

BICEPS BRACHII

"Swinging high above the jungle floor, with Jad-bal-ja,
the golden lion, leaping along beneath him, Tarzan heard a
shot and the wailing of Little Nkima. Tarzan leaped thirty
feet, caught a high vine that swung him a hundred feet in
a swishing arc at the end of which he sailed through the
air for another breath-taking space only to unerringly
catch a limb which he scampered along at top speeds towards
the sounds.

It was not two minutes after the shot before he dropped
silently to the ground before the cruel hunter. When Ja-ba-
ja, racing at full speed, arrived, Tarzan needed no help.
He had already torn the gun from Malevich's hands, and in
terrible anger, he had bent the cold steel into a quarter
circle."

witnesses. Approximately thirty years later, Ruppersberg's more performative approach to art making would be dubbed Relational Aesthetics.[2] In the late sixties, however, his work was seen as part of a larger shift that was transforming art making in the name of Conceptualism. In fact, Ruppersberg was one of the youngest artists to be featured in Harald Szeemann's 1969 landmark exhibition "When Attitudes Become Form," and thereafter Ruppersberg's work became a standard feature in most of the era's Conceptual art exhibitions. Nevertheless, as Winer recently recalled, even then there was something mysteriously different about Ruppersberg's work that separated it from the more language-based approaches of Joseph Kosuth, Lawrence Weiner, and other artists whose work was also central to the development of Conceptual art.[3]

Expanding upon Winer's metaphor, it might be argued that "Detective" Ruppersberg was investigating the case of Representation, which certainly appeared to be missing from his first solo exhibition, simply titled *Location Piece* (1969). When visitors arrived at the Eugenia Butler gallery exhibition, they encountered a mostly empty space; empty, that is, except for a few store-bought fish aquariums that Ruppersberg had repurposed. The aquariums had inspired Ruppersberg because of their unique references to Minimalism. Their transparent walls were reminiscent of Larry Bell's formal geometric cubes, and the lights installed in their metal tops transformed the internal space of the aquariums into miniature stage sets. With this sense of theatricality built in, the aquariums provided Ruppersberg with the perfect form in which to conduct his initial experiments with staging representation. In a few months, the glass walls would come down and the stage sets expand to become common public spaces in which culture and representation perform. As Ruppersberg explained, "Al's Café was just a giant aquarium that you entered." (Drawing on the insights garnered from the aquariums, in 1969 Ruppersberg rented a storefront and set up an "all American" café. With waitresses to take orders from a printed menu, *Al's Café* (1969) looked and operated like any other café. Yet, there was one exception: instead of prepared food, the kitchen produced inedible assemblages that were partially composed of material representations.) During the *Location Piece* exhibition, the aquariums only pointed to this theatricality, while the rest of the exhibition enacted it. For the primary focus of Ruppersberg's "Location" exhibition was a written street address, a theatrical prompt designed to direct

WHEN HELENE WINER compared Al Ruppersberg to Los Angeles' fictional Detective Philip Marlowe, she was referring to his itinerate approach to studio practice.[1] In fact, shortly after graduating from the Chouinard Art Institute in 1967, Ruppersberg replaced his easel with an old desk that resembled Marlowe's and set up his studio practice in an office building on Hollywood's Sunset Boulevard. Significantly, Ruppersberg's decision to abandon painting and pursue a more performative approach to art making was not motivated by a rejection of the medium per se; rather, it emerged from a sense that representation originated and developed through cultural exchanges more than aesthetic objects. Ultimately, Ruppersberg recognized that representations convey more than pictures; they also leave behind traces or imprints on the landscape of the world and in the bodies of

1. Helene Winer, "Scenarios/Documents/Images II," *Art in America* (May–June 1973), 69.
2. Ruppersberg's work was included in the 1991 exhibition "No Man's Time," curated by Nicolas Bourriaud and Eric Troncy. Also see Cheryl Donegan's interview with Ruppersberg in *BOMB* (Fall 2009), 80–87.
3. Helene Winer, conversation with the author, October 24, 2009.

PREVIOUS PAGE

Allen Ruppersberg *Muscles on the Run* (detail showing *Biceps Brachi I*), 1972. Seven chromogenic color prints: 7⅝ × 7⅝ in. (17.78 × 17.78 cm) each. Seven typewritten sheets: 11¼ × 8½ in. (27.94 × 20.32 cm) each. Edition of 3. Collection of The Museum of Modern Art, New York

Allen Ruppersberg *Al's Grand Hotel*, 1971. Installation view of aquariums mounted on shelves

viewers back out into the world, to Hollywood's Sunset Boulevard, where they "located" Ruppersberg's rented office filled with nostalgic paraphernalia garnered from popular culture, much of it referencing Hollywood's fading glory.

Like many of his artist peers, Ruppersberg grew up outside of California, and when he moved to Los Angeles in 1961, he became instantly fascinated by the city. At the time, Hollywood was in the process of a major transformation. This was evident in the streets, where the famous nightclubs of Hollywood's glamorous heydays—Ciro's Le Disc, the Mocambo, Cafe Trocadero—were being reinvented as venues for rock concerts or strip clubs, while hoards of young people were roaming the streets, claiming this social space as their own with expressive, often politically motivated, actions that frequently resulted in violent clashes with police. Equally significant for Hollywood's transformation was the growing popularity of television, which became a major factor contributing to the demise of the studio system. Overall, North American film production and attendance at movies declined as the number of homes in the United States with televisions sets dramatically increased from 34.2 to 90 percent in 1962.[4] Unlike films viewed in the darkness of a movie theater, television was broadcast directly into the otherwise private space of the home, infiltrating everyday life with news reports, entertainment, and advertising. Ruppersberg was part of the first generation to grow up with televised media as a normalized presence in their lives, and it dramatically influenced how many of them understood representation. Ultimately, the destination of the televised image is the body; indeed as choreographer and filmmaker Yvonne Rainer once observed, the body retains the images that media conveys long after the television has been turned off.[5] Inherent to Rainer's astute observation is the sense that pictorial images operate in a manner that is similar to sound: as rhythmic forms of physical energy that convey both subject matter and physical sensibilities.

Rainer, Ruppersberg, and many other artists of their generation were tuned into this "theatrical" effect of representation, for they realized early on that media representations create "live" experiences that viewers witness and retain as actual experiences, which then shape how we understand and participate in the world. In fact, Ruppersberg's piece *Muscles on the Run* (1972) illustrates this effect quite literally. In this piece seven chromogenic color prints are placed above seven sheets of paper with typewritten text. Each image depicts a naked body part—such as the upper chest (*Pectoralis Major*) or the inner thigh (*Semimembranosus*)—the muscles of which serve as titles for the text typed below. This conjunction between image and text is doubled yet again in the photographs, for other images have been projected on top of the nude model's body parts. Thus, for example, *Biceps Brachi I* depicts a flexed bicep on top of which an image of Tarzan and a hunter had been projected. Ruppersberg appropriated the projected images from a 1950s View-Master reel of "Tarzan of the Apes."[6] Likewise, the appropriated typewritten text recounts the episodes of Tarzan's rescue of "Numa the Lion." Significantly, the gestures of the depicted naked body parts echo Tarzan's gestures in the projected images. Therefore, "Muscles" not only illustrates how media images construct certain male subject positions, but also how this occurs through the body. Seen as a whole, *Muscles on the Run* presents the body as both the destination for media imagery and its container. In fact, once contained within the muscles of the body, Ruppersberg's work suggests that media images acquire a life force, which the body carries and maintains, literally performing the power of media images within the larger cultural arena of social exchanges.

Muscles on the Run was one of several pieces featured in Ruppersberg's solo exhibition at the Pomona College Museum of Art. Scheduled near the end of the 1972 fall semester, Ruppersberg's show was one of the last exhibitions curated by the young Winer at Pomona College. For Winer, Ruppersberg's work exemplified a larger shift that was developing among contemporary artists in Southern California. In 1970, when Winer returned to Los Angeles after spending two-and-a-half years at London's Whitechapel Art Gallery, she began to notice a new direction that was developing in the practices of several young artists who were transforming Conceptualism. "At the time, I couldn't have told you what it was, but I always recognized it when I saw it," Winer recalled.[7] In fact, the insightful Winer was so impressed by this new direction that she dedicated almost her entire two-year exhibition program at Pomona College (from 1970 to 1972) to artworks that explored it. Over the course of the seventies, this direction would continue to develop and culminate in the semiotically informed critique of media representation that has come to define the Pictures Generation.

4. Quoted in Pamela Lee's *Chronophobia* (Cambridge, Mass.: The MIT Press, 2004), see 183–92.
5. Yvonne Rainer, "Statement," from program for *The Mind Is a Muscle*, Anderson Theater, New York, April 1968, reprinted in Rainer's *Work 1961–73* (Halifax: Press of the Nova Scotia College of Art and Design, 1974), 71.
6. Allen Ruppersberg, email exchanges with the author, October 6–7, 2010.
7. Winer, conversation with the author.

Now, almost forty years later and in the wake of a major retrospective exploring the historical development of the Pictures Generation, questions remain: What exactly did Winer recognize developing within young Los Angeles artists' works? How did these changes relate to what preceded it in Southern California? And how did these changes influence what later developed among the Pictures Generation artists in New York? Somewhat central to the answers to these questions is Winer's presence in both Los Angeles and later New York, where she became the director of Artists Space and was instrumental in organizing the 1977 "Pictures" exhibition. Through an exploration of some of the artists and artworks that informed Winer's curatorial vision at Pomona College, this essay suggests that the critical trajectory that has shaped our historical understanding of "Pictures" actually emerged from a much broader terrain than art history has accounted for thus far. When the installation and film work of Bas Jan Ader, Jack Goldstein, William Leavitt, and Allen Ruppersberg are considered alongside of Michael Asher's somewhat unique approach to Institutional Critique, an expanded understanding of this history begins to take shape. Looking back to these artists, whose work developed in the wake of what has come to be called the California Light and Space movement, this essay locates another trajectory that not only informed "Pictures," but was also specifically investigating how theatricality operates as a pictorial value.

Winer became the director of Artists Space in the fall of 1975. One of her major innovations there was to introduce curated theme-based exhibitions into what had previously been a system of artists choosing other artists to exhibit. The 1977 "Pictures" exhibition developed as part of this new structure. Thinking back on that moment, Winer told an interviewer: "Of course, we had no idea the show would be a sort of marker. I really thought there was a particular type of art being formulated and I wanted to have a serious look at it. I raised some money to do a catalogue and travel the show and invited Douglas Crimp to be the curator."[8]

Shortly after moving to New York, Winer met Crimp, and they often attended exhibition openings together, swapping ideas about contemporary art practices.[9] Essentially, the exhibition grew out of a collaborative effort between the two. When Winer approached Crimp about curating the exhibition, he had returned to graduate school and was studying under Rosalind Krauss. "When Douglas first started working on the show," Winer said, "we talked about the ideas and the artists. It got fairly serious in relation to postmodern concepts he was involved with critically."[10] As Crimp recalled, "I wasn't someone who went around making studio visits. So I took my lead from Helene, who gave me a list of artists she thought were interesting."[11] Winer in turn pointed Crimp to artists who were expanding upon the new direction that she had first noticed developing in Los Angeles.

As has been well reported, Crimp's "Pictures" essay changed over the course of several years and a few different iterations.[12] Nevertheless, Crimp's consistent focus was on a shift in "the phenomenon of representation itself." To elaborate on this shift, Crimp's initial essay cited the influence of Minimalist theatricality and offered two precedents: Sol LeWitt's untitled open cubic structures, from 1966, and Joel Shapiro's *Untitled (house)* from 1973–74.[13] These precedents help to explain some of the confusion that developed later, for they actually demonstrate two very different approaches to representation, both of which operate in the Pictures Generation's work but only one of which the critics focused on.

Effectively, the diminished size of Shapiro's tiny iron house enhances its function as an iconic symbol whose meaning is derived from our experience of culture. In other words, viewers understand the significance of Shapiro's work by reading it as a linguistic sign that references home and shelter. LeWitt's cube, on the other hand, performs the information it presents in a more theatrical manner that is similar to Ruppersberg's *Location Piece*; that is, it enacts rather than points. Crimp describes LeWitt's cube as presenting a "network of interlaced bars," which he then interprets as a grid that makes a symbolic reference to perspectival representation.[14] However, unlike Shapiro's house, LeWitt's cube does not engage representation symbolically as much as it simply performs the image of a grid through its physical composition (a network of interlaced bars). Crimp seems to recognize that a different approach to representation is operating within LeWitt's sculpture, for he says that LeWitt's work refers "to the process of converting the complex data of sensory experience into the schematic representation of it that is captured by the notion *cube*, but it does so not by making an image of a cube but by making the cube itself."[15] Nevertheless, Crimp does not distinguish this more theatrical approach to representation as being different from Shapiro's symbolic approach. Instead, he claims both as precedents for the Picture's Generation. Crimp is not wrong here, for both approaches are

8. Winer, "Helene Winer interviewed by Matt Mullican, Cindy Sherman, and Valerie Smith," *5000 Artists Return to Artist Space*, Claudia Gould and Valerie Smith, eds. (New York: Artists Space, 1998), 60.
9. Winer, conversation with the author.
10. Winer, "Helene Winer interviewed by Matt Mullican, Cindy Sherman, and Valerie Smith,", 61.
11. Douglas Crimp, *5000 Artists Return to Artist Space*, 89.
12. See Howard Singerman, "The Myth of Criticism in the 1980s," *X-TRA* 8.1 (Fall 2005); and Doug Eklund's *The Pictures Generation, 1974–1984* (New Haven, Conn.: Yale University Press, 2009).
13. Crimp, "Pictures," exhibition catalogue, (New York: Artists Space, 1977), 4.
14. Ibid.
15. Ibid.

Double-page spread, *RealLife Magazine* 3, 1980. Top left advertisement depicts "Pictures" exhibition opening. Collection of Thomas Lawson and Susan Morgan

functioning in the Pictures Generation's work, but what's important to note is how they present information differently. In actuality, Troy Brauntuch, Barbara Kruger, Sherrie Levine, and Philip Smith made works that were more similar to Shapiro's symbolic approach; whereas Jack Goldstein, Robert Longo, Richard Prince, and Cindy Sherman's works were closer to LeWitt's theatrical approach.

Two years after the "Pictures" exhibition closed, Crimp said that there was still "enough buzz around the show to warrant that I write about it for *October*."[16] By 1979, however, Crimp's ideas about "Pictures" had evolved, so Crimp opened the *October* essay by citing his curatorial essay as his point of departure from which to "address an aesthetic phenomenon" evident in the work of "many more artists than the original exhibition included."[17] Accordingly, Philip Smith's work (which was included in the exhibition) was now relegated to a footnote, and Cindy Sherman's work (which was not in the exhibition) was touted as being exemplary of the phenomena under investigation. In addition to this replacement, Crimp's second essay dropped all references to LeWitt and Shapiro and focused on newer works that the exhibited artists created after the "Pictures" exhibition closed. The displacement between Smith and Sherman and Crimp's analysis of Levine's newer work help to locate a subtle but significant shift in focus between the two essays that dramatically shaped how the Pictures Generation's work was later interpreted.

Both of Crimp's essays are primarily concerned with investigating how the featured artists use appropriated imagery to demonstrate that visual representations convey meaning beyond the mimetic figurations that they depict. Crimp's first essay locates a meta-narrative effect in the fragmentary nature of appropriation, whereas the second essay shifts it to the structural operation of reading that the frame provides. Thus, for example, Crimp's initial essay describes Smith's 1977 drawing *Bring* as a "kaleidoscope of pictures" that "look as if they were intended to be read, like a storyboard." However, Crimp goes on to point out that Smith's appropriated images refuse to produce a coherent narrative. Crimp compares this refusal to the psychological process of a fetish, arguing that the fragmented images (which appropriation creates) activate desire, specifically a desire for the missing narrative references that the lost context would have provided. Similarly, he says that Levine's *Sons and Lovers* (1977)—a suite of thirty-six paired drawings of silhouetted heads executed in fluorescent tempera

on graph paper—prompts the desire for a specific narrative, which is absent. Although Crimp's second essay abandons any discussion of Smith's work and focuses on Levine's newer projection piece, he continues to describe the narrative effects of appropriation in terms of fetish. This is evident in his analysis of Troy Brauntuch's 1978 work *Untitled (Mercedes)*, which features an appropriated image of Hitler sleeping in a car. Since the picture is shot from behind, it is impossible to recognize the figure as being the Führer. Thus, Crimp argues:

The picture is an object of desire, the desire for significa- tion that is known to be absent. The expression of that desire to make the picture yield a reality that it pretends to contain is the subject of the work by Troy Brauntuch. But, it must be emphasized, his is no private obsession. It is an obsession that is the very nature of our relationship to pictures.[18]

Nevertheless, by 1979 Crimp's insight into this process had developed considerably; beyond the effects of fetish, his second essay addressed how framing controls the narratives that representations convey. This occurs primarily through the introduction of Sherman's work, followed by his analysis of Levine's newer work. Speaking first of Sherman's 1978 *Untitled (Film Still)*, Crimp points to the manner in which her photograph captures a "staged performance," whose narrative lies outside the frame.[19] Although Sherman's *Film Stills* have since been widely celebrat- ed, in the late seventies her black-and-white photographs of herself performing female stereotypes appropriated from Hollywood films were essentially unknown. Yet, as Crimp noted, they were nevertheless recognizable as staged presentations. In his essay Crimp says that this theatrical effect brings attention to the frame, which is where he says that meaning resides. Building on this insight, Crimp turns to Levine's newer work—a slide projection, presented at The Kitchen in February 1978. For this performance Levine projected images of women, which she had appropriated from magazine advertisements, through silhouettes cut in the shape of the presidential heads that appear on United States coins. Accordingly, Crimp argues that Levine's compositions force viewers to interpret each image through the frame of the other:

The confrontation of the two images is structured in such a way that they must be read through each other: the profile of Kennedy delineates the picture of mother and child, which in turns fills in the Kennedy emblem. These pictures have no autonomous power of signification

16. Crimp, *5000 Artists Return to Artist Space*, 89.
17. Crimp, "Pictures," *October* 8 (Spring 1979): 75.
18. Ibid., 83.
19. Ibid., 80.

(pictures do not signify what they picture); they are provided with signification by the manner in which they are presented.[20]

Here, Crimp effectively articulated what would become the standard interpretation of the Pictures Generation's strategic use of appropriated imagery. In describing Levine's work as reading constructions of female identity through the frame of economic currency, Crimp defines appropriation as a tool for critiquing the meta-narratives embedded within social discourses. As noted, Crimp's second essay omits any discussion of Shapiro and LeWitt, yet it does not abandon the significant influence of Minimalism. In fact, quite the opposite, Crimp's second essay opens by squarely positioning his argument against Michael Fried's critique of Minimalist theatricality. This latter change was in part a response to the rise of Neo-Expressionism and an overall renewed interest in painting that characterized the late seventies and the early eighties. Yet, it also speaks to the shift in address that Crimp recognized in Goldstein's films and had struggled to define in LeWitt's sculpture.

According to Fried, the problem with Minimalist theatricality was located in its address; he argued that the dramatic unfolding of these artworks through time prevented viewers from having a more contemplative and transcendent experience of the work. In a word, the problem was their "liveness."[21] Conventionally, "the live" event is presumed to describe a category of activities that resides outside of representation.[22] As noted earlier, however, this perception of liveness relies upon a limited understanding of representation, one that a number of artists were beginning to question in the late sixties and seventies. In fact many of the artists whose work Winer showed at Pomona College were specifically investigating how theatricality re-defines our encounter with representation as a live experience in which the image leaves a physical trace on the body. This was not only evident in the reflexive manner that LeWitt and Ruppersberg's works performed representations, but it was also evident in the manner that artists—such as Ader, van Elk, Goldstein, and William Wegman—were using photography and film to literally stage performances of representation. For example, Wegman's *Duck/Crow* (1970) offers a humorous rendition of Plato's famous parable of the cave by presenting an image of a stuffed crow that casts the shadow of a duck. Likewise, van Elk's *The Reality of G. Morandi* (1971) engages the documentary authority of photography. The central image of van Elk's triptych depicts one of Giorgio Morandi's untitled still-life paintings. This appropriated image is flanked by two other photographs documenting props (eyeglasses as well as other bottles and vases) that van Elk imagined to exist beyond the frame of Morandi's painting. By recreating Morandi's picture with an expanded perspective that includes items not in the original painting, van Elk transforms viewers' perceptual understanding of Morandi's work, and thereafter viewers will always encounter Morandi's painting with the reference to van Elk's imagined picture-plane in mind.

Significantly, Crimp's second essay sets up Fried's opposition to theatricality in order to define the "Pictures" artists as being grounded in a similar exploration of how theatricality functions as a pictorial value. Thus he explained:

The extent to which this [temporal] experience fully pervades their work is not, however, immediately apparent, for its theatrical dimensions have been transformed and, quite unexpectedly, reinvested in the pictorial image. If many of these artists can be said to have been apprenticed in the field of performance as it issued from minimalism,

20. Ibid., 85.
21. Here, I am borrowing the term "liveness" from Philip Auslander who uses it to refer to the "live" experience of recorded representations. See Philip Auslander, *Liveness: Performance in a Mediatized Culture* (New York: Routledge, 1999). Also see Rick Altman, ed.. *Sound Theory Sound Practice* (New York: Routledge, 1992).
22. Steve Wurtzler, "She Sang Live, but the Microphone Was Turned Off: The Live, the Recorded, and the *Subject* of Representation," *Sound Theory Sound Practice*, Rick Altman, ed. (New York: Routledge, 1992), 88–90.

Announcement card for **Sherrie Levine** exhibition at The Kitchen, New York, 1979. Postcard. 6 × 4 in. (15.2 × 10.2 cm). Collection of Thomas Lawson and Susan Morgan

they have nevertheless begun to reverse its priorities, making of the literal situation and duration of the performed event a tableau whose presence and temporality are utterly psychologized; performance becomes just one of a number of ways of "staging" a picture.[23]

Despite Crimp's powerful recognition that many of the Pictures artists were investigating how the image not only conveys symbolic information but also stages or performs sensual data, his discussion of theatricality in the name of "presence" became tangled up (in both essays) with his analysis of how narrative structures operate. In the end, his concern for narrative and symbolic meaning led him away from fully exploring the profound impact of the theatrical register on viewers.

To a large degree this confusion revolves around Goldstein's work. Goldstein's 1978 film-loop *The Jump* depicts a diver performing a somersault from a high board. In the first essay Crimp takes pains to elaborate on Goldstein's process of isolating the image from its context through the use of the animation technique of rotoscoping, explaining:

He does this in order to impose a distance between the event and its viewers because according to Goldstein, it is only through a distance that we can understand the world. Which is to say that we only experience reality through the pictures we make of it.[24]

Crimp's paraphrase actually subtly misinterprets Goldstein's comment. The reference originates in Morgan Fisher's interview, where Goldstein actually said:

Making films instead was a way of creating distance and removing the audience. The phonograph records are one more step to create more distance, getting more abstract. Film is one step away from an object in real life, and one

23. Crimp, "Pictures," *October* 8: 77.
24. Crimp, "Pictures," exhibition catalogue, 3.

Jack Goldstein *The Jump*, 1978. Film still

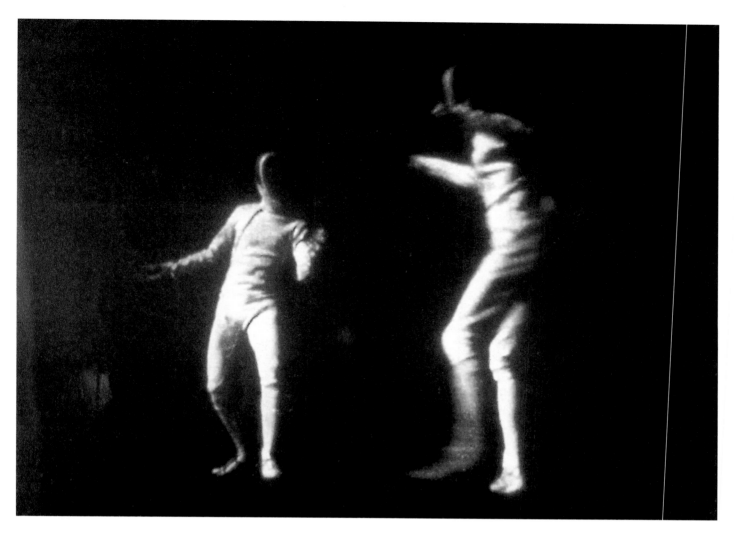

step beyond that would be a record, because the sounds are very real, and that thing is very real, except that a distance is created.[25]

In the statement above, Crimp interprets Goldstein's as saying that the meaning of representation is the absence of the referent and the distance that this absence creates, which allows for a more symbolic and culturally informed experience of the world. Yet, Goldstein is also referring to representation as a phenomenon. Thus, he describes how images—both audio and visual—function as "real" elements that not only exist separately from the "things" they reference but also from the material substrates (the vinyl of the records or the celluloid of film) that present them and allow them to appear as representations. As Goldstein points out, sounds are real and exist separately from the events or objects that cause them as well as from the vinyl material that presents them. Goldstein's comments also suggest the progres-

sive refinement of his *oeuvre* from sculptural and performance works to films and phonograph records. In part driving this development of his work is his effort to isolate the image as an abstraction and demonstrate how it operates through sound or light waves that address audiences directly as a kind of theatrical force. In fact, this was evident early on in Goldstein's sculptural work, which he first exhibited at Pomona College.

Functioning somewhat like Richard Serra's Prop pieces (1967–87), Goldstein's five untitled wooden sculptural towers teetered on the verge of collapse in the Pomona College Museum. Almost nine feet tall, their imposing physical presence was further animated by audible cracks emanating from their freshly cut wooden components. As a result, Goldstein's sculptures seemed to hold danger in suspension, giving viewers a powerful experience of its theatrical presence as a threat that was not actualized. When

25. Morgan Fisher, "Talking with Jack Goldstein," reprinted in *Jack Goldstein* (Köln: Daniel Buchholz Galerie, 2003), 69.

Jack Goldstein *Two Fencers*, 1977.
Performance still

Goldstein's work developed into other media, he continued to hone this investigation of how the theatricality of the visual image addresses viewers physically as a presence or invisible force that exists separately from its material presentation. (*See my essay "Jack Goldstein's Sculpture: Image Before Its Consequences" in this volume.*) In fact, Crimp was responding to this aspect of Goldstein's work when he described his performances as engaging theatrical effects to transform the physical presence of his performers into "spectral" images.[26] Here, Crimp was specifically referring to Goldstein's performance at The Kitchen, which featured a lone contortionist performing moves on an empty stage that was cast entirely in a green light. Similarly, his 1977 performance *Two Fencers* was drenched in red lighting, an effect that Crimp said caused the performers to appear as "virtual" or "dematerialized" forms.[27]

Crimp compared the ghostly sensibility of Goldstein's performers to the "nebulous images of holograms." Yet, he might also have compared them to the disembodied images of Robert Irwin's disc paintings, for like Goldstein after him, Irwin was also investigating the immaterial condition of the image. As Klaus Kertess has pointed out,

Unlike Stella and the minimalists of the sixties whose painting configurations are interdependent and co-extensive with the shape and materiality of their support, Irwin sought to break the frame of the support in order to make the painting not only more interactive with the space it is in but co-extensive with it.[28]

Inherent to Irwin's phenomenological appeal to viewers is an understanding of the image as a temporal form that appears through the material substrate of the artwork, but that is never fully contained by its physical structure. Fundamentally Irwin and many of the California Light and Space artists' works from the late sixties were concerned with exploring how the temporal form of an image continues to move beyond the reflective material substrates of physical objects or architectural installations to address spectators directly and in terms of the body's perceptual mechanisms. Yet, where Irwin's work only demonstrates this immaterial aspect of the image, Goldstein was actualizing it in order to show his viewers how the immaterial or theatrical register of the image operates on the body as a force that conveys information. Here again, Crimp's observations about Goldstein's performance *Two Fencers* offer insight. After the performers exited the stage, the lights went

down and the soundtrack that accompanied their performance repeated. As Crimp notes, when the soundtrack is replayed, it awakens the "dematerialized" presence of the fencers, which has moved from the bodies of the performers to reside in the memories of the audience as a non-visible sensibility. Significantly, Crimp describes this effect as a "quality of representation, providing that kind of sensation that we experience as *déjà vu*."[29] Yet, *déjà vu* is not a form of representation; it is the apprehension of a sensation, a virtual quality that we recognize perceptually because we have physically experienced something like it before. Herein lies the power of the theatrical register of the image, which Ruppersberg's *Muscles on the Run* also referred to. The theatricality of the image appeals to the body's capacity to be impacted by the world's invisible forces, what Crimp referred to as the production of "presence" and what the philosopher Gilles Deleuze has called, after Baruch Spinoza, "affect."[30] The theatrical register of the image not only leaves a impression on the body, but in doing so it calls forward past sensibilities deposited by other representations, creating associative links that help to shape our perceptual understanding of what is being presented.

While Crimp seemed to recognize that the theatrical register of the image addressed viewers differently from the more symbolic register of representation, he did not fully articulate and analyze its effects. Instead, he resorted to the term "presence," which became a different kind of ghost that haunted him until he redressed it in *October* in 1980:

Their [Goldstein and Longo's] performances were little else than presences, performed tableaux that were there in the spectator's space but which appeared ethereal, absent. They had that odd quality of holograms, very vivid and detailed and present and at the same time ghostly, absent.[31]

Once again Crimp invoked a comparison with a disembodied holographic image, but now he focused on the symbolic meaning of this ghostly effect. Accordingly, Crimp's new essay maintained that the artists specifically constructed this effect to indicate the absence of an original and the impossibility of authenticity.[32] In doing so Crimp further argued that Longo and Goldstein's performances demonstrated how representations and commodities alike rely upon such notions of authenticity and originality to convey ghostly fictions. In the end, Crimp reduced the theatrical appeal of these artists' works to a symbolic narrative about the ideological effects of representation.

26. Crimp, "Pictures," *October* 8: 78.
27. Ibid.
28. Klaus Kertess, ed., "The Architecture of Perception," *Robert Irwin* (Los Angeles: The Museum of Contemporary Art, 1993), 115.
29. Crimp, "Pictures," exhibition catalogue, 6.
30. See Gilles Deleuze, *Expressionism in Philosophy: Spinoza*, trans. Martin Joughin (New York: Zone Books, 1992), 83–95.
31. Crimp, "The Photographic Activity of Postmodernism," *October* 15 (Winter 1980): 92–96.
32. Ibid.

The critical analysis of representation that finally developed around the Pictures Generation's use of appropriated imagery brought a semiotic analysis of representation together with the Marxist notion of historical materialism.[33] As a result, appropriation was recognized as a form of theft that usurped ownership and blatantly demonstrated a rejection of originality and Modern notions of authorship. Instead of being generated by the artist, meaning was determined to be a function of reading that was accomplished by viewers and directed by the effects of framing. As noted earlier, this analysis of appropriation was evident early on in Crimp's second "Pictures" essay. Three years later Hal Foster would echo Crimp's analysis, identifying appropriation as "re-coding" and specifically aligning this practice with "the special attention to site, address, and audience" that developed in the name of "situational aesthetics" and not "its minimalist antecedents."[34] Writing in the same year (1982), Benjamin Buchloh fully endorsed Crimp's analysis of appropriation and further underscored its connection to Institutional Critique:

The precision with which these artists [Michael Asher, Marcel Broodthaers, Daniel Buren, Hans Haacke, and Lawrence Weiner] analyzed the place and function of esthetic practice within the institutions of Modernism had to be inverted and attention paid to the ideological discourses outside of that framework, which conditioned daily reality. This paradigmatic shift occurs in the late '70s in the work of such artists as Dara Birnbaum, Jenny Holzer, Barbara Kruger, Louise Lawler, Sherrie Levine, and Martha Rosler, where the languages of television, advertising, and photography, and the ideology of "everyday" life, were subjected to formal and linguistic operations that essentially followed Roland Barthes' model of secondary mythification that deconstructs ideology.[35]

As a result of these and other similar critical assessments, the Pictures Generation's use of appropriation was primarily understood as a meta-textual practice that was strategically designed to engage viewers in the critical process of reading the ideological content of media imagery. Gone was any discussion of presence or Minimalist theatricality. Instead, Institutional Critique's analysis of discourses became identified as the historical precedent informing the Pictures Generations' critical analysis of the media apparatus. According to Andrea Fraser, Institutional Critique is always site-specific. However, rather than an architectural structure or particular location, Institutional Critique defines a site as a social field of discursive relations.[36] A similar definition can be applied to the

Pictures Generation's interpretation of media representations, which were understood as a field of discursive relations framed by ideological concerns that directed viewers' interpretation of the depicted information. Indeed, it was this particular aspect of representation that the Pictures Generation's strategic use of appropriation was designed to reveal. Nevertheless, the critical link between Institutional Critique and the development of the Pictures Generation must be considered in light of the fact that the term "Institutional Critique" appears in print for the first time in the mid-eighties, which is to say almost twenty years after the era associated with Conceptual Art and on the very coattails of the Pictures Generation.[37] In other words, the historical connection between the Pictures Generation's use of appropriation and the Conceptual art practice of Institutional Critique is partially a product of a historiography whose vantage point is located in the eighties, when visual representation was fundamentally understood as a meta-textual practice. I raise this point not to dismiss this legacy or somehow dislodge Institutional Critique's influence from the history of appropriation art; rather my goal here is to complicate the relationship between Institutional Critique and the development of the Pictures Generation.

For Fraser, who has been credited with being first to use the term in print, the radicality of Institutional Critique lay in its methodology, which does not result in an object or even necessarily a picture but rather a critical analysis. Thus she wrote:

To the extent that a site is understood as a set of relations, Institutional Critique aims to transform not only the substantive, visible manifestations of those relations, but their structure, particularly what is hierarchical in that structure and the forms of power and domination, symbolic and material violence, produced by those hierarchies.[38]

Fraser's comments considerably update Victor Burgin's 1969 observations about Situational Aesthetics, the original moniker for works engaging Institutional Critique. While Burgin concurred that the product of Situational Aesthetics was not a concrete object but an experience of relations, he situated this understanding in terms of the perceptual processes of the body, which he described as "a constant to our reception of perceptual experience which shifts freely between sensorial and psychological data."[39] Arguably, this shifting process moves between a reception of dematerialized imagery, such as the impression of the fencers that Goldstein's

33. Isabelle Graw "Dedication Replacing Appropriation Art", *Louise Lawler and Others*, Ed.: George Baker, et al. (Ostfildern-Ruit, Germany: Hatje Cantz, 2004) 59–64

34. Hal Foster, "Subversive Signs" *Art in America* (November 1982) 88–92.

35. Benjamin H. D. Buchloh, "Allegorical Procedures: Appropriation and Montage in Contemporary Art" *Artforum* (September 1982): 48.

36. See Andrea Fraser, "What is Institutional Critique?" in *Institutional Critique and After*, John C. Welchman, ed. (Zurich: JRP/Ringier, 2006), 305–09.

37. For more on the history of the term Institutional Critique, see Isabelle Graw's "Beyond Institutional Critique" in *Institutional Critique and After*, 137–51.

38. Fraser, 306.

39. Victor Burgin, "Situational Aesthetics," *Studio International* 178, no. 915 (October 1969): 119.

performance left in the bodies of his audience members, and a more symbolic interpretation of what an image references. To better explore how this shifting process operates, it is worth considering Asher's somewhat unique approach to Institutional Critique.

Unlike what Fraser has suggested about Institutional Critique in general, Asher's work is always intimately tied to the physical architecture of the sites in which he stages his interventions. This is not to suggest that Asher equates "Institution" with the building or architectural structure that houses it, but that Asher understands that the physical conditions of a site play a significant role in determining how discursive relationships shape our understanding of artworks and their role within culture. For example, Asher's work in "It Happened at Pomona," *No Title* (2011) involves no material objects or physical adjustments to the space; it simply alters the museum's hours of operation, making it possible for the public to visit the museum and see the artworks on display there at any hour of the day or night. Through this seemingly benign act of generosity, Asher demonstrates how museums across the globe contain our access to art within certain prescribed hours, which are generally the same hours that most people are obliged to be at their places of employment. As a result, museums end up somewhat controlling the role that art plays within our daily lives. In other words, Asher's piece demonstrates how the institutional regulation of our access to artworks has become internalized as a social norm, which in turn crafts expectations about the role of art within society at large and individual's daily experience. Significantly, Asher's work activates this awareness not by pointing to or deconstructing the institutional discourse behind it. Rather, he simply institutes a new structural operation that restates the institutional discourse differently. The significance of this performative effect was brought to Asher's attention over forty years ago, when he created a different installation at Pomona College.

In 1970, as the final installation of Hal Glicksman's Artist Gallery program, Asher transformed the Pomona College museum space into an instrument for conveying sound and light. While all museums manipulate lighting and sound to varying degrees, they usually do so in as an unobtrusive manner as possible. Asher's installation on the other hand moved in the opposite direction. He lowered the ceilings and reconfigured the walls into the shape of two triangles intersecting at their apexes. Removing the exterior doors of the museums, Asher thus reconstructed the space to emphasize the presence of light and sound, which flooded the exterior triangle. Meanwhile, in the interior space visitors experienced filtered lighting and amplified sounds. With twenty-four hour access, these experiences also fluctuated according to the time of day and the activities outside the museum. During one such evening visit to the space, Asher recognized the presence of another institutional force operating and he began to contemplate the piece that he has now realized as part of the 2011 "It Happened at Pomona," exhibition. (*See my essay "Michael Asher: Familiar Passages and Other Visibilities" in this volume.*)

By enacting new hours of operation, Asher's latest intervention at Pomona College creates a new temporal configuration of the museum space and its societal role as the caretaker of our most prized cultural artifacts. Through this new configuration, different expectations can develop for museum visitors. Central to this piece and Asher's entire *oeuvre* is the recognition that structural systems of operation, which Michel Foucault described as *visibilities*, develop social norms through time and repeated exposure.[40] For it is only through repeated exposure and regular use of the new hours of operation that individuals will develop new expectations and social norms about the function of museums and art within our daily lives. Thus, unlike the more linguistic gesture of pointing or the critical act of reframing, Asher creates environments, situations, and encounters that provide his audiences with an opportunity to experience a physical manifestation of alternative institutional discourses that may in turn cause different expectations and normative behaviors to develop.

As Foucault's profound analysis of the architectural structure of the panopticon demonstrated, visibilities are produced through institutional forms of operation that architectural structures actualize and literally perform.[41] In other words, institutional operations create ways of seeing and understanding the world, which in turn structure our behaviors. Thus, in much the same way that Foucault demonstrated how the invisible surveillance operations of the panopticon produced a form of self-policing in prisoners, Asher's piece demonstrates how the operational systems of art institutions construct social behaviors and attitudes toward art. Foucault called these institutional structures non-discursive visibilities, which construct meaning literally by performing actions. However, unlike what the linguist J. L. Austin

40. See Michel Foucault's *The Archaeology of Knowledge*, trans. Alan Sheridan (New York: Pantheon, 1972), and *The Birth of the Clinic*, trans. Alan Sheridan (New York: Pantheon, 1973).
41. See Foucault, *Discipline and Punish: The Birth of the Prison*, trans. Alan Sheridan (New York: Pantheon, 1977).

has said about performative illocution, the effect of these visibilities is NOT the result of a speech act.[42] In fact, Foucault is careful to separate non-discursive visibilities from what he referred to as "the articulable."[43] While visibilities are structural actions that perform and thereby instill normative behaviors, *articulations* translate the meaning of objects (such as artworks) by associating them with terms that are often located in other discursive fields.

Asher's works, almost without exception, intervene with institutions at the level of visibilities, whereas the legacy of Institutional Critique that informs the critical assessment of the Pictures Generation derives primarily from representational models that operate within the regime of "the articulable." Marcel Broodthaers's 1968 *Musée d'Art Moderne, Département des Aigles* is a case in point. Using reproductions of artworks, Broodthaers's fictional museum demonstrates how museums classify, label, and present artworks in terms of the categorical identities and stylistic concerns that art history has articulated. To paraphrase Crimp, Broodthaers's work uses parody to draw attention to the manner in which museum discourses read artworks through the frame of art historical discourses. Engaging the more complex ramifications of Foucault's insights about the process in which articulations impact the world, Hans Haacke's *Manet-Projekt '74* (1974) detailed the provenance of Edouard Manet's 1880 painting *Bunch of Asparagus*. In doing so, Haacke demonstrated how this individual artwork passed through the hands of various collectors, including those of Hermann J. Abs, a former Nazi and, in 1974, a current board member of Cologne's Wallraf-Richartz Museum, which had invited Haacke to create a project based on their collection. Effectively, in cataloging the history of Manet's painting, Haacke revealed how the meaning of the painting developed and shifted by its movement through the frames of these different institutional discourses and ideological belief systems, including those of the Third Reich and the Cologne museum. In the end, the associations that Haacke unearthed were too disturbing for the museum to accept and Haacke's project was rejected, while the painting and Abs remained in place.

As the above examples demonstrate, Haacke's and Broodthaers's works primarily intervene at the level of the articulable, while Asher's work intervenes with institutions at the level of visibilities. Neither approach is necessarily more effective, but they entail different representational strategies. Asher's work looks at how institutional discourses regulate behav-iors, while Haacke's and Broodthaers's works look at how art objects presented within one institutional discourse simultaneously participate in other discourses, which in turn shape our understanding of those objects. Visibilities focus on how institutions actualize systems that develop and sustain normative behaviors, while articulations focus on how institutions construct identities around objects by drawing upon terms located in other fields of expression. Both approaches to representation engage discourses differently, but where one focuses on regulations that are primarily conveyed through statements and the tools of language, the other focuses on behaviors that are primarily conveyed performatively through repetition. Simply put, articulations operate more within the symbolic register of representation, whereas visibilities engage what might be called the theatrical register of the image.

Thinking retrospectively about this difference, Asher partially attributes the development of this aspect of his work to certain critics' phenomenological claims about the theatricality of Minimalist sculpture, which supposedly caused viewers to become more consciously aware of their physical experience of viewing artworks. In a recent interview, Asher recalled his frustration with this assessment of Minimalist sculpture because for him this phenomenon seldom occurred. "The presence of the object was so great that it was impossible to become self-aware of the relationship you as a viewer had with the sculpture."[44] Somewhat inspired by this failure, Asher proceeded to create works that used tools, such as industrial air blowers and tone generators, to make his audience's embodied experience of a specific space impossible to ignore. As Asher's work developed into the early seventies, he proceeded to infuse these physical experiences with other insights about the social behaviors that institutional discourses construct.

In response to his doubts about the theatricality of Minimalist sculpture, Asher developed works that were undeniably theatrical. In doing so he demonstrated that at the level of non-discursive visibilities every encounter with representation is a "live" event that physically addresses viewers separately from whatever a picture might articulate symbolically. It is not that one form of address ever occurs without the other; on the contrary, the theatrical and symbolic registers of representation operate differently but concurrently. However, unlike what has generally been concluded about the Pictures Generation's artworks, the theatrical register of representation does

42. See J. L. Austin, *How to Do Things with Words* (Cambridge, Mass.: Harvard University Press, 1962).

43. See Foucault's *The Archaeology of Knowledge* and *The Birth of the Clinic*. Also see Deleuze, *Foucault*, trans. Sean Hand (Minneapolis: University of Minnesota Press, 1988), 23–69.

44. Michael Asher, conversation with the author, May 22, 2010.

not function meta-textually; it is operational.[45] Moreover, as Asher's work further demonstrates, this operational approach to representation is also part of the historical legacy that comes through Institutional Critique and the work of several Southern California artists to influence the development of the Pictures Generation.

As noted earlier, Crimp recognized this more theatrical approach to "staging representation" operating in Jack Goldstein's work: "The psychological resonance of this work is not that of the subject matter of his pictures, however, but of the way those pictures are presented, *staged*; that is, it is a function of their structure."[46] In fact, Goldstein was fully aware of the theatrical register of the image and its power to address viewers directly. As noted earlier, this was evident early on in the sculptures he installed at Pomona College, which directly influenced his later film work.[47] However, Goldstein's understanding of the powerful way in which theatricality conveys information to viewers was finally made clear through his use of film loops. Goldstein's film *The Jump*—prominently featured in both of Crimp's essays—offers a powerful example here. The momentarily stunning figure, moving through space almost like a living arabesque, quickly disappears, only to return again. Despite the regular looping return of the image, viewers never really see a picture of the diver or even the "jump." In fact, most people know this image best from its representation as a film still that has been reproduced in publications. But its appearance in the actual film loop never occupies the stable condition of a picture; it's always moving, visible on the screen only long enough to register some form of intensity, the trace of its movement through space, which is to say the flow of its theatrical force. As a result, this theatrical force or affective content leaves the screen and enters viewers' bodies in a manner that is similar to the way in which our bodies capture and preserve the rhythm of a song.

The movement of the looping image functions according to what Deleuze and Félix Guattari have called a *technology*. Citing the example of a bird singing, Deleuze and Guattari say that refrains have an organizing effect; they function as technologies that build territories.[48] Likewise, the movement of the diver builds a territory within viewers' bodies as a presence, a rhythmic pattern that waits to be reactivated by the next appearance of the diver's image. This is the affective content that the theatrical register of the image, particularly media images, leaves

behind. Goldstein's use of repetition allowed him to draw attention to this residual effect of media and thereby enhance our awareness of its insidious presence in our lives and our bodies. Thus, he explained to Jean Fisher, "This is where duration is important. I want the image to become a memory of the object."[49] Inherent to Goldstein's comments is a recognition of the power of the theatrical register of representation to move like sound waves through boundaries—be it the boundaries of architectural walls or those of bodily skin—depositing forms of energy that have the potential to operate like visibilities and construct behaviors and social norms.

Like Goldstein's work, Bas Jan Ader's 1970 photographic works *Fall I, Los Angeles*, and *Fall II, Amsterdam*, demonstrate a similarly profound understanding of the theatrical address of imagery. Engaging a strategy—documenting staged performances—that was popular among many artists in the late sixties and that would continue to be employed by many of the Pictures Generation artists[50]—Ader's photographs suggest a simple "before and after" narrative about falling down. *Fall II, Amsterdam*, for example, depicts the artist riding his bike into an Amsterdam canal. This slapstick content belies the artists more serious concern with demonstrating how forces (physical as well as social and political) operate on us and impact our lives. Arguably, falling down—a theme that obsessed Ader—can be defined as the behavioral effect of the persistent presence of a non-discursive force, namely gravity. Indeed, as Ader famously explained to a reporter: "When I fell off the roof of my house or in the canal, it was because gravity made itself master over me."[51] Ader's observations about the power of gravity resonate with a more personal narrative in his 1971 work *Untitled (Sweden)*. Here again, the force of gravity is made visually apparent by the physical behavior it causes; accordingly, one image depicts Ader standing upright while the other shows him prone, facedown on the forest floor. Yet, Ader's personal history suggests another interpretation. Ader's father, a resistance fighter in World War II, was caught, taken out to the woods, and executed by Nazi soldiers. Seen from this perspective, *Untitled (Sweden)* becomes a re-enactment of Ader's father's death. However, it does not articulate the narrative details of his death, nor does it convey its symbolic meaning; rather it performs it. In doing so, Ader's piece demonstrates how political forces are ever present in our lives; operating on us like gravity, they are always shaping and defining our experiences, even into future generations.

45. See Francois Lyotard's *The Postmodern Condition: A Report on Knowledge*, trans. Geoff Bennington and Brian Massumi, (Manchester: Manchester University Press, 1984).

46. Crimp, "Pictures," *October* 8: 79–80. (Emphasis made by Crimp in original text)

47. Winer, conversation with the author.

48. See Deleuze and Félix Guattari, *A Thousand Plateaus: Capitalism and Schizophrenia*, trans.: Brian Massumi (Minneapolis: University of Minnesota Press, 1987), 233–350.

49. Jack Goldstein, quoted in Jean Fisher, "Jack Goldstein," *Jack Goldstein: Feuer, Körper, Licht* (Erlangen, Germany: Städtische Galerie Erlangen, 1985), 71–72.

50. Performances or installations staged for the camera are evident in the work Ger van Elk, James Welling, Robert Longo, Laurie Simmons, Cindy Sherman, and others.

51. Bas Jan Ader, "Rumbles," *Avalanche* A (Winter 1971): 3.

View of backyard landscaping, Anthony Swimming Pool Company catalogue, 1970

Significantly, Ader's chosen medium, slide projections, reinforces this understanding of time as a spatialized presence that brings the past into the present as a force contained within the memory of the body. Depicted through slides, Ader's images appear to be moving in the light that animates them, but they never change. Instead, presented side-by-side the two events become simultaneous: Ader appears at once standing upright and facedown on the ground, both gestures ever present. This spatialization of the temporal image repeatedly and consistently points to the absent narrative located between the images, which is the actual falling of Ader's body and the invisible presence of a violent execution that exists within the personal history that Ader physically embodies. The unchanging but seemingly animated images that appear in the gallery simultaneously invoke and inscribe a reference to this behavior of falling within viewers' bodies. Thus as happened with Goldstein's looping film, the invisible image of actually falling becomes a presence that resonates like a rhythm in viewers' bodies long after they have exited the gallery.

Formally, Ader and Goldstein's works both move temporal events into two-dimensional representational formats that are displaced and seem to unfold abstractly in the space of the gallery. In doing so, they hone in on the theatrical register of image that appears, unencumbered by a physical, material body. William Leavitt's *California Patio*, which was made for his 1972 exhibition at Pomona College, somewhat reverses this formula, creating a three-dimensional, materialized representation of a two-dimensional media image. Through this somewhat different methodological approach, Leavitt's work opens up a direct dialogue with the appropriation strategies that will develop later among many of the Pictures Generation artists. Moreover, Leavitt's work engages both the performative and symbolic registers of the image.

Leavitt constructed *California Patio* in response to a series of images he found in the Anthony Swimming Pool Company catalogue, which advertised outdoor patios.[52] Yet, Leavitt did not produce an exact replica of any of the catalogue images, instead he actualized a sculptural representation of the general idea that each of the catalogue images was expressing. Installed in the gallery, *California Patio* confronts viewers with double sliding-glass doors, framed by curtains, that presumably would lead outside to a fieldstone patio lush with plants. Thus, Leavitt's work captures and re-iterates the identity that the catalogue patio images expresses, namely a 1970s upper-middle-class patio. Significantly, Leavitt re-presents this identity in a deadpan manner that avoids any sense of exaggeration or parody. In this regard, *California Patio* operates in a similar manner to Cindy Sherman's Untitled Film Stills, a series of black-and-white, untitled, numbered photographs that she produced from 1977 through 1980 and that Crimp discussed in his second "Pictures" essay.

As their persistent subtitle implies, Sherman's Untitled Film Stills recall the cinema. Although her images are not direct quotes, Sherman's work—like Leavitt's—relies upon a sense of recognition. She constructed the Untitled Film Stills to be vaguely reminiscent of many well-known Hollywood films. Some even seem to portray specific scenes: #20 appears to be a scene from Alfred Hitchcock's *Rear Window*, #54 recalls Marilyn Monroe in *Seven Year Itch*, and #35 is surely Sophia Loren in *A Special Day* or is it *Two Women*? In fact, Sherman told an interviewer that the images "… should trigger your memory so that you feel you have seen it before. Some people have told me that they remember the movie that one of my images derives from, but in fact I had no film in mind at all."[53] Rather than rephotographing pictures, Sherman—like Leavitt—recreated the images or identities that media representations expressed. Thus,

52. William Leavitt, conversation with the author, January 21, 2010.
53. Gerald Marzorati, "Imitaiton of Life," *Artnews*, (September 1983): 77.

just as Leavitt demonstrated how advertisers were marketing products aimed at constructing a certain economic identity, Sherman demonstrated how Hollywood movies from the 1940s and 1950s were constructing models for female identity. Sherman's Film Stills achieve this outcome by including certain visual incongruences that caused the illusions of Hollywood to break down. For example, shutter cords are visible in #6, 10, 11, 34, and 35; close scrutiny of the bed in #6 reveals that it is actually a sheet propped up as a backdrop, and a contemporary-looking phone book is visible in the background of #4. These bits of visual information undermine the illusions that the pictures otherwise construct. Moreover, by articulating this through the discourse of Hollywood, Sherman invites viewers to consider how these discourses enter our everyday lives and thereby shape how we understand female identities. Likewise, Leavitt's *California Patio* appears only as a façade—for when seen from a side view, *California Patio* readily reveals the scaffolding holding it up. The scaffolding is designed to inform viewers that the image and its inherent identity are only constructed representations that reference an upper-middle-class identity. Yet, unlike Sherman's pictures, which make clear references to Hollywood film, Leavitt's does not point to his catalogue source.[54] He simply invites viewers to recognize the *California Patio* as representing a certain class identity. Inherent to this recognition is the question that Sherman's work asks and answers but that Leavitt's only poses: how do such ideas about class and identity enter our lives?

Sherman's work stood out from many other Pictures Generation artists because her process was more involved with staging and recreating representation rather than appropriating it directly through rephotography. As noted earlier, rephotography was critically celebrated for the sameness it preserved and the inherent rejection of originality this implied. Nevertheless, this understanding of rephotography relied upon a rather casual interpretation of the Pictures Generation artists' photographs. Richard Prince, for example, regularly cropped and reframed most of the pictures he rephotographed, as did Barbara Kruger.[55] Similarly, Levine's pictures of other artists' photographs never matched the dimensions of their presumed sources. In fact, Levine worked from reproductions, producing pictures of pictures that were at least three to four times removed from their sources.[56] In actuality, all of the Pictures Generation artists subtly altered the pictures they reproduced in order to point to their condition as representations that expressed coded identities.

When understood as reconstruction, rather than re-photography, Leavitt's work provides an important precedent for this approach.

Despite the strong similarities between Leavitt's and Sherman's works, a subtle but important difference remains. Sherman, like many of the Pictures Generation artists, used photography to recreate her images in terms of the distance that the media relies upon. Leavitt, on the other hand, recreated the images he appropriated from the media as three-dimensional representations that physically occupy the same space as viewers, literally operating as theatrical presences. Accordingly, *California Patio* presents both an objective referent that we encounter as an installation in the gallery and the symbolic identity that the advertisement of the patio in the catalogue points to. In doing so, Leavitt undermines a fundamental tenet of advertising formulas, which are designed to confuse a representation with its referent at the level of reception. Admittedly, this confusion between representation and referent is also the basic illusion of all figurative sculpture. Yet, when Leavitt stages this confusion, he not only underscores how commercially this confusion constructs the illusion of an identity, but he also demonstrates how such constructed identities actually enter our daily experiences through the commercial products that we purchase.

Leavitt realized that when the confusion between a referent and its symbolic references is enhanced through the theatrical register of representational objects, something much more powerful happens. For when commercial objects become possessions that populate our lives, these commercial objects continue to express the symbolic identities that the media has embedded within them and continues to reinforce through advertising. Ultimately, Leavitt's work demonstrates how advertising stages representational ideas that through repetition become transferred into the actual products that enter our homes and become normalized presences in ordinary, everyday activities, such as backyard barbecues. In this regard, Leavitt's work also demonstrates how commercial products function as institutional structures or visibilities that norm-alize identities by presenting them repeatedly through our regular use of these objects in our daily experien-ces. Accordingly, as consumers, we continue to receive and participate in the symbolic messages of media representations.

54. Ibid.
55. See Lisa Phillips, "People Keep Asking," *Richard Prince* (New York: Whitney Museum of American Art, 1992), 21–53.
56. Singerman, "Sherrie Levine, Richard Kuhlenschmidt Gallery," *Artforum* 22 (September 1983): 80.

Cindy Sherman *Untitled Film Still #35*, 1979.
Black-and-white photograph. 8 × 10 in.
(20.3 × 25.4 cm)

While both Leavitt's and Sherman's approaches to representation encourage viewers to recognize and confront media-constructed images as commercial forces operating in our experiences of culture, Sherman's does this by intervening at the level of media's articulation of these discourses. Leavitt's work on the other hand shifted the site of this discourse, locating it in the structure of commercial objects that enter the privacy of our homes, where the expressions that they carry become normalized. Leavitt demonstrates that these objects do not simply articulate these messages; they also convey them through their non-discursive but ubiquitous presence in our lives. Historically central to this more theatrical approach to representation is the demise of theater's proscenium arch and the violation of the "invisible fourth wall" that performance artists actualized and that the theatricality of Minimalism introduced into the gallery space. Where Ed Kienholtz in particular advanced this move of Minimalist theatricality by staging actual tableaux in the gallery space, Leavitt's *Patio* took one step farther in this direction by creating installations that invite viewers to fully occupy the same space as his façades. In doing so, Leavitt demonstrates how the messages of commercial media continue to perform in our daily lives through the objects that we purchase. Leavitt demonstrated this effect in the gallery, but his friend Al Ruppersberg pushed this investigation of how theatricality functions in commercial imagery even farther by locating his installations directly within the terrain of cultural exchanges.

Open only on Thursday evenings, *Al's Café* appeared in 1969 like any other unremarkable American diner with checkered tablecloths and decorative memorabilia—calendars, picture postcards, felt-pennant souvenirs, and autographed pictures of movie stars and sports heroes—all giving the impression of a place "nurtured for forty years by a caring café-owner," as Allan McCollum recalled.[57] Despite this impression, there remained one significant difference: instead of food, *Al's Café* served up representations. The menu offered patrons entrees such as "Simulated Burnt Pine Needles," which took on a gritty sense of heartbreak and bad luck with the added stylistic description of "a la Johnny Cash." Similarly, the $2-burger was seductively dubbed the "Patti Page Melt." As the café's provocative menu suggested, the meals were described as representations infused with entertainment references and clever puns that were specifically designed to appeal to the imagination and, like advertising, call forward desirable associations.

Yet, Ruppersberg was not only interested in pointing to the presence of these discourses in our daily lives; he also wanted to demonstrate how their performative statements fail to materialize in actuality. Therefore, what came out of the kitchen was exactly what the menu's extended written descriptions promised, for example the less appetizing and gooey "Patti Page photo (or reasonable facsimile) covered with toasted marshmallows." In this inedible fashion, these assemblages demonstrated the impossibility for material foods to actualize the promises and implied messages conveyed by the linguistic associations that the menu invoked. *Al's Café* demonstrated how advertising draws on terminology located in another institutional discourse—the discourse of Hollywood glamour and passion—to transform the meaning attached to referents, in this case restaurant food.

Ruppersberg recreated the café as a recognizable type or identity in order to activate its function as an institutional form through which other economic discourses operated and addressed audiences. Accordingly, his patrons' physical participation was a central component. For Ruppersberg realized that media representations not only make symbolic references, but they also perform actual translational effects. In fact, whatever came out the kitchen under the rubric of "a la Johnny Cash" moved in two directions at once. It simultaneously transformed what the symbolic identity of "Johnny Cash" called to mind while also altering the café patron's experience of the meal that had been cloaked in this terminology. Inherent to this understanding of representation is the realization that every encounter with imagery leaves behind residues or sensibilities that the theatrical register can activate through appeals to the imagination. Where *Al's Café* constructed meals that successfully undermined the performative strategies of advertising articulations, it did not specifically address how the theatrical register of the image could be calibrated to call forward specific sensibilities from our bodies, which effectively complete the picture. Two years after *Al's Café* closed, Ruppersberg would take up this challenge in his project *Al's Grand Hotel* (1971).

Located at 7175 Sunset Boulevard, a street that at the time was dotted with other legitimate hotels, *Al's Grand Hotel* offered guests a choice of seven theme-based rooms, ranging in price from $15 to $30 per night. Although the hotel's official brochure advertised rooms "for your sleeping comfort," in fact most were uncomfortably appointed. The "Day Room," for example, was crowded with pails filled

57. Allan McCollum, "Allen Ruppersberg: What One Loves About Life Art the Things that Fade," *Allen Ruppersberg: Books, Inc.* (Limoges, France: FRAC Limousin, 2001), 9–10.

Ruppersberg's hotel recreated advertisements themselves as materialized objects that had an overwhelming physical presence, and which could neither be avoided nor easily forgotten. In doing so, Ruppersberg gave his guests an opportunity to experience first-hand how their personal lives, in fact their very bodies, were being addressed and ultimately occupied by immaterial but highly commercial images. For while most guests recognized that when they entered the hotel, they were becoming part of its operation as a representation, they did not realize that aspects of this public representation would virtually hitch a ride out of the hotel through the sensory imprints left in their bodies.

At their most basic level, *Al's Café* and *Al's Grand Hotel* actualized the next step in the development of a task-oriented approach to performance that Kaprow's Happenings had initiated and many Fluxus artists, active in Ruppersberg's milieu, expanded into a more collaborative process of interpretation that was orchestrated through the audience. (Yoko Ono's infamous *Cut Piece*, performed in 1965, comes to mind here.) Drawing insight from these and other precedents, Ruppersberg situated his performative practice directly within the volatile arena of commerce. For his audiences at *Al's Café* and *Al's Hotel* all were required to pay cash for the meals and rooms they experienced. This economic exchange was a vital component of Ruppersberg's projects, for it clearly situated his representations within the discourses of capital and demonstrated how media representations operate as vehicles for circulating capital. In this regard, Ruppersberg's projects find another important precedent in Claes Oldenburg's 1961 *The Store*, which was also directly installed in a social space whose functions were regulated by economic exchanges. Yet, unlike *The Store*, Ruppersberg's café and hotel did not sell objects for consumption; rather they sold experiences of representations as products. In making this departure from Oldenburg's store, Ruppersberg's projects thus underscored the movement of capital through representations that occupy our everyday experiences.

Theodor Adorno and Max Horkheimer have argued that the culture industry as a whole molds men into types or subjectivities that are unfailingly reproduced in every product.[58] Many of the Pictures Generation produced artworks that critically addressed how advertising constructs and reproduces these subjectivities. Marx also argued that capital strives "to annihilate space with time to break down barriers and create a fluid transition from one form to

with newspapers, comic books, and packaged food, such as large boxes of coco puffs cereal. The sheer number of pails made any movement in the space of the room challenging at best. Likewise, a fifteen-foot wooden cross vertically bisected the space of the "Jesus Room," and guests in the more expensive "Al's Room" found their bed surrounded with life-size paper cuts-outs depicting Ruppersberg cloaked in stereotyped identities, such as a blue-tuxedoed groomsman or a shirtless cowboy. As a result of these outlandish decors, those who spent the night (and typically there were no vacancies) were forced to cozy up and share the space of their room with physically imposing representations. Thus, instead of undermining the false promises of advertising as *Al's Café* did,

58. Max Horkheimer and Theodor W. Adorno, *Dialectic of Enlightenment* (New York: Herder and Herder, 1972), 53.

Allen Ruppersberg *Al's Café*, 1969. Menu

FOLLOWING SPREAD
Brochure for **Allen Ruppersberg's**
Al's Grand Hotel, 1971

AL'S GRAND HOTEL guests have nearby access to freeway network which puts all Southern California points of interest within minutes of easy driving.

AL'S GRAND HOTEL

7175 SUNSET BOULEVARD
HOLLYWOOD, CALIFORNIA 90046
PHONE 656-5500 (CODE 213)

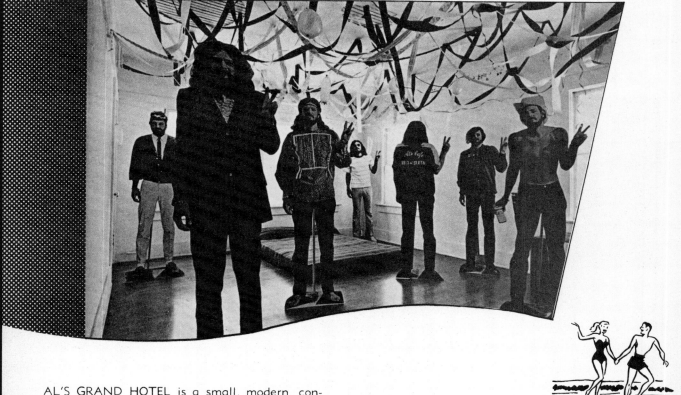

AL'S GRAND HOTEL is a small, modern, convenient, comfortable and friendly resort hotel which offers the finest accommodations at most reasonable rates. Conveniences offered are live entertainment on selected evenings, free television, bar, continental breakfast, free ice cubes and daily maid services.

Hollywood's famous Grauman's Chinese Theater, Lawrence Welk's Palladium, Hollywood Blvd. Shopping, Ralph's Market, excellent department stores, fine restaurants such as Denny's, Tiny Naylor's and the Carolina Pines, motels, theatres, churches, bowling, psychedelic shops, all within walking distance from AL'S GRAND HOTEL. You can easily walk to famous Hollywood and Vine where the stars meet. Any westerly street in Los Angeles leads to exciting Hollywood and AL'S GRAND HOTEL on Sunset Blvd.

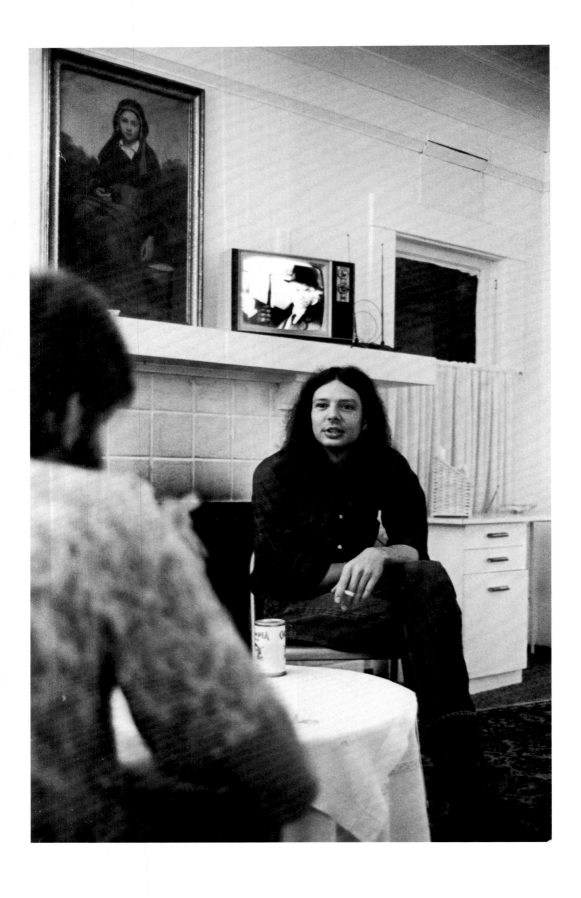

Allen Ruppersberg in *Al's Grand Hotel*, 1971

another."[59] Here, Marx suggests an expanded understanding of subjectivity that is actualized through an ongoing movement of exchanges. In this model the body becomes a container with permeable boundaries that the discursive images of capital can enter and operate through. Artists such as Ader, Goldstein, Leavitt, Ruppersberg, and van Elk were beginning to map how this temporal movement operates through the theatrical register of the image to address viewers at the level of the body and thereby shape our perceptions of the world. Ultimately the new direction that the young curator Helene Winer recognized developing in Southern California in the late sixties and early seventies was this effort to investigate how theatricality operates as a pictorial value.

I would like to thank Michael Asher, William Leavitt, Al Ruppersberg, Ger van Elk, and Helene Winer for their thoughtful conversations, all of which helped to give shape to the ideas about representation expressed in this essay.

59. Karl Marx, quoted in Jonathan Crary, "Capital Effects," *October* 56 (Spring 1991): 123.

Allen Ruppersberg *Al's Grand Hotel*, 1971.
Installation view of "Jesus Room"

PART 1

HAL GLICKSMAN AT POMONA

MICHAEL ASHER
Exhibition: "Michael Asher,"
February 13–March 8, 1970

LEWIS BALTZ
Faculty: 1970–73
Exhibition: "Lewis Baltz," May 25–June 1, 1970

JUDY CHICAGO
Performance: *Snow Atmosphere*, February 22, 1970,
Mt. Baldy, San Gabriel Mountains, California

RON COOPER
Exhibitions: "Ron Cooper," December 12–20, 1969;
"Monoprints," December 5–26, 1970

TOM EATHERTON
Exhibition: "Tom Eatherton," May 1–27, 1970

LLOYD HAMROL
Exhibition: "Lloyd Hamrol,"
October 25–November 2, 1969

ROBERT IRWIN
Exhibition: "Robert Irwin,"
October 20, 1969–June 6, 1970

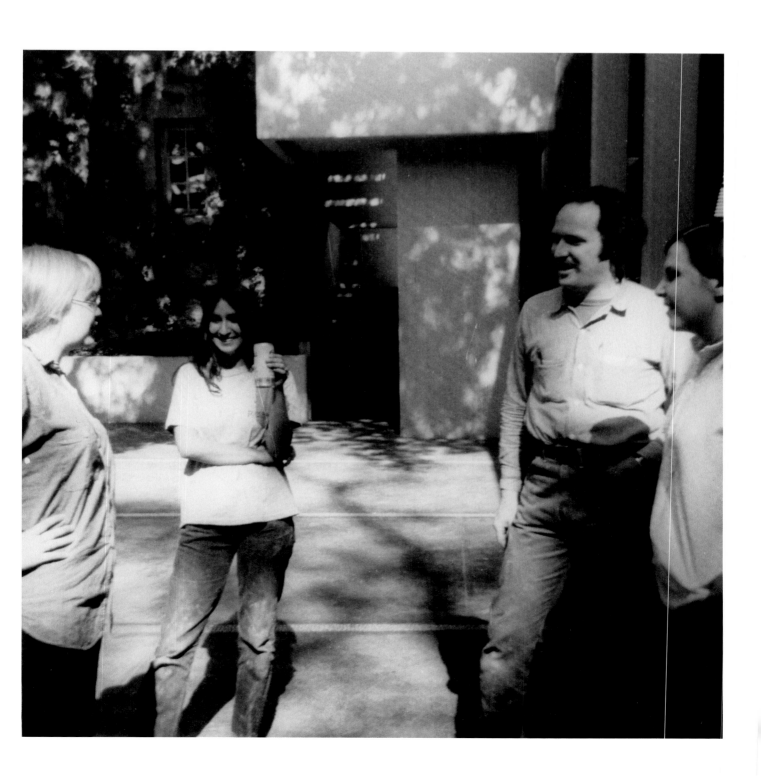

REBECCA MCGREW Let's start by talking about how you got the gallery director's job at Pomona College. Did Mowry Baden contact you?

HAL GLICKSMAN Yes, he did. Mowry came to me and he basically offered me the job. I told him that I wasn't a museum director; I was a preparator. I said, "I hang the shows," and he said, "Well, the artists don't seem to think so. You're always the one that gets everything done." So he just offered it to me.

RM Where were you working at that time?

HG I was the preparator at the Pasadena Art Museum from 1963–69. And my wife Gretchen Taylor [died 2009] was the registrar. Walter Hopps was the director at Pasadena and he had six people doing all the work. It was unbelievable; Walter would pick up the phone and say, "We're going to do a show and..." So in the end I did a lot more than hang pictures. I built a room for Bob Irwin, and solved a lot of problems. We did the first [James] Turrell show. John Coplans was the curator, but he didn't know anything about how it came into existence physically. I remember Jim Turrell asking, "Do you have a soldering iron? Do you have a VTVM [vacuum tube volt meter]?" That was a little meter for electricity. And every time I said, "Yes," I got really proud because I'd accumulated all of these tools that people needed. Then he says, "Do you have an oscilloscope?" And I had to say "No," I didn't have an oscilloscope. To which he says, "When you're in this long enough, you'll have one of those, too." [Laughs.] Anyway, Mowry had heard stories like this because he asked the artists and they said, "Hal Glicksman knows how to do this and that."

RM Then you started at Pomona in September of 1969. Did you initiate the Artist's Gallery immediately when you started?

HG I was director for only one academic year. The summer before coming to Pomona I visited Lloyd Hamrol. He had this beautiful artwork installed in his studio. It was a cube made of red vinyl thread, kind of like a Fred Sandback piece. It was a drawing in space made out of red tubing, and the corners of it were held by almost invisible, clear monofilament from the ceiling, walls, and floor. All you saw was a red cube about the size of a room, floating in a much bigger space. I said, "Oh, you should show that." And he said, "Well, you never have any time with these shows, there's two days to install, and they don't have anybody to help, and you know, it's just impossible. And besides, I like to do things for the space."

So he gave me the idea for the Artist's Gallery, and I gave him the first show. I said, "Well, why don't we have a gallery that functions like an artist's residency? And you could come and take all the time you need to do the piece. So, out of the six weeks he did four or five things that he took down the next day.

RM When you conceived of the Artist's Gallery, you scheduled the installations for about six weeks per artist?

HG I think it was six weeks, but it might have been a little more. You know, it was always dependent on the school's breaks and things. And some artists had projects that they wanted to do that took many weeks just to construct, like Tom Eatherton's piece and Michael Asher's. So it depended.

RM How did you select the artists?

HG There was no formal selection process. Artists knew me as someone who was interested in the processes and technology of creating art and showing it properly. I was able to see the correlation of the materials and the aesthetic goals of the work. The artists that I showed were friends, and there did not seem to be any conflict of interest because there was no special prestige or advantage to showing at Pomona College at the time. The artists expected that only other artists and art students would make the trek to Claremont to see their work. They wanted to show because otherwise the work would not be created, or even conceived.

RM Did you let the public observe what the artists were doing?

HG No, only the students. You see, there were three galleries. So I could always have something up while the artists were working on their projects in a separate gallery. People couldn't go into the Artist's Gallery space, but there would be another exhibition that they could see.

RM So Lloyd's was the first Artist's Gallery installation, and at the same time you invited Robert Irwin to exhibit one of his discs?

HG Yes, Irwin came for a half a day. He didn't need to experiment, because we knew exactly what we wanted, and I had already installed a disc at the Pasadena Art Museum. I knew what Bob wanted, and he knew I knew, so he trusted me.

RM There are no photos of that in the files.

HG He didn't allow photos at the time...I might have an installation shot, but I really respected his wishes. I have to digress. After Irwin did the show at the São Paulo Biennial in Brazil (1965), his painting was returned to the National Collection of Fine Arts in Washington, D.C. And I came back with it to install it because I'd installed it in Brazil. Well, Irwin's piece was an orphan in this museum. They had like half a floor for the entire museum. So Irwin's piece was supposed to fit in among the stuffed elephants and what not. There was a hallway next to a huge room with two smaller, square galleries on either side. We placed one of Irwin's curved paintings with the little dots on them in each of the smaller rooms, so he could light them and do what he needed. But the rooms had had molding that went three feet up the wall. They had taken it off and put a piece of Masonite over the lower part of the wall to cover the space where the molding had been. So it was cloth above and Masonite below, and they painted the whole thing white, hoping it would disappear and at least visually become a white wall. But it didn't. A little beveled edge of the Masonite created a bright line that skewered the painting from each side.

So Bob mixed gray paint, and he painted the top edge of the Masonite with exactly the amount of gray needed to make the bright line disappear. He'd paint a small section, then mix more gray and carefully feather it out, so it wasn't the same gray all the way, because the light fades out unevenly as it falls. It took him two days but he made that line disappear. And when he got his painting up there and lit, it was perfect. Then he put a barrier across the door so people couldn't come in, because the works had been vandalized in Brazil.

Hilton Kramer came down from New York to review the show. And Bob was on one side of the barrier, just a foot away from Kramer. They talked for half an hour. The painting was on the opposite wall. When they were through, Hilton Kramer said, "Well, I'd love to see it when it's hung." It had been there the whole time, but it was invisible to Kramer. He didn't even see the painting!

RM That's a good story! Let's get back to Hamrol's installation. After you saw the red cube, did you invite him to create something at Pomona?

HG I didn't even say that. I told him to just use the artist's space as his studio for six weeks. And that's when he did the pieces that no one saw. [Laughs.]

RM Were they documented?

HG I don't think so. Because he didn't think they were successful. I remember two rows of heat lamps, pointing straight down. That was funny.

RM With just the red glow?

HG Just the red glow and the heat. For the final piece the whole gallery had a sea of water about four inches deep. We put black vinyl on the floor to contain the water, and it acted like a mirror. The ceiling was filled with balloons lit from above. It was almost like a sunset burning through the clouds.

RM Were they regular museum lights?

HG Yes. Judy Chicago [who was married to Hamrol at the time] helped Lloyd position the lights and put colored gels over some of them to create the feeling of late afternoon sun through billowy clouds. A grid of nylon strings held the balloons up. There were also lead wires hanging down from the balloons and into the water, like frozen streams of rain. Once they touched the water, they were reflected perfectly. The wires appeared to continue through to the reflection of the clouds deep within the water. It was gorgeous.

We had a long discussion about how people would view it. At first, Lloyd wanted to make a little dock that you'd walk out onto the water, but he figured people would be splashing around in there. So we ended up with a little booth structure that you'd walk into and look at the installation through a glass, which created another layer of remove. It made it really romantic, like a painting almost.

RM I'm curious about Michael Asher's installation from 1970. How did that come about?

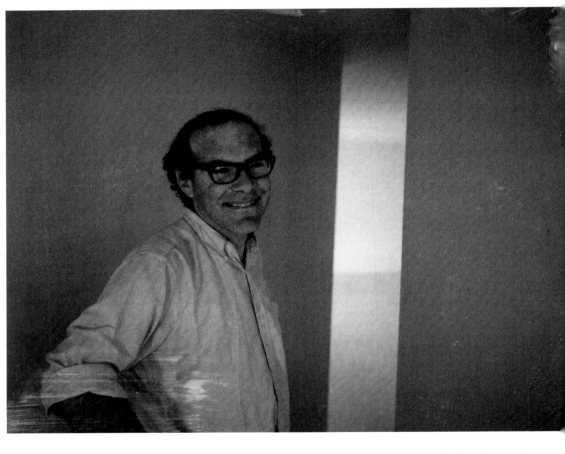

Michael Asher in his installation at Pomona College Museum of Art, February 1970. Gift of Hal Glicksman. The Getty Research Institute, Los Angeles (2009.M.5)

HG Oh yes, before Pomona, Michael did a piece for a very important show called "Spaces" (1969–70) curated by Jennifer Licht at the Museum of Modern Art. Michael created a room that had doors situated in opposite corners of the room. It also had state-of-the-art soundproofing, so the walls were very thick. I remember the floor was sloped a bit so you actually had to walk up a slight incline. Then, once you were in the room, your voice just fell. It was uncannily quiet in there; the room just ate up the sound. When you left the room, you realized that the sounds of traffic penetrated the entire museum, but you were only made aware of the sound after staying a while in Michael's space.

Michael took the idea of contrasts that he had explored in the MoMA piece and built on it at Pomona. Originally, the Pomona installation was constructed with an open door at the very end of the gallery that went out into the courtyard. The exit created a wind tunnel effect. The air passing over the courtyard created a suction that drew quite a strong current of air through the gallery. At the last minute, Asher covered up the exit door and it became very still in the gallery. Because of that last-minute change, the piece was entirely transformed. It is important to know about the closing of the exit, because it shows the evolution of the piece based on the earlier MoMA project, and the artist's way of making decisions about the work based on interacting with the space.

RM Mowry told a story of Michael coming in and bringing a little measuring device or something that would shoot puffs of smoke around the room.

HG Yes. The T.T. Smoker.

RM According to Mowry, Michael would send off a puff of smoke, watch it, and then nod his head as the smoke followed the walls through the room.

HG [Laughs.] The name of that device—the T.T. Smoker—stands for titanium tetrachloride, which is a chemical that forms smoke when it meets air. Since the smoke is not hot, it doesn't rise. The smoke just sits there and lasts a long time. Air follows walls, so architects and heating and air conditioning engineers use the smoker to search for drafts, which are really hard to chase down. The smoker also makes sure that the air-flow in a room is even, that there are no spots where the air doesn't circulate, and things like that. Michael used it to see where the air movements were.

Unpublished note from Michael Asher to Hal Glicksman, 1970. Gift of Hal Glicksman. The Getty Research Institute, Los Angeles (2009.M.5)

RM So was part of the piece about visualizing the airflow, or enhancing the viewer's perception of the air itself?

HG Asher did a piece at the Whitney the year before in "Anti-Illusion: Procedures/Materials" (1969). That was a landmark show. Michael's piece consisted of directing an air duct to blow down on the visitors.

Once Michael closed the rear door to the Pomona space, air movement became barely perceptible. Other contrasts were now more important: a small lit space contrasting with a large dark space; a closing in of space to form a narrow corridor, then opening up again; and the angle of the walls creating a new axis for the building. Finally, on exiting, you saw the park through the doorway: art framing nature.

Michael Asher (right) and **Mowry Baden** (left) with students, 1970. Gift of Hal Glicksman. The Getty Research Institute, Los Angeles (2009.M.5)

RM Was the door open 24/7?

HG We removed the doors so that the steps and the entry were a seamless part of the space. Asher put a blue gel and diffuser in the square light fixture over the door to soften the light. The campus was quiet and safe at night. We considered the students to be the main audience for the piece, and they soon were gathering in the space late at night.

RM Michael's installation at Pomona opened in mid-February of 1970, which means that the project by Judy Chicago was presented while Michael's installation was up. It was number 9 or 10 from her Atmosphere series. After all this talk about the T.T. Smoker, I have to ask, was there any connection between Judy's and Michael's pieces?

HG I showed the T.T. Smoker to Judy and she used it to visualize some smoke effects. A photo of her hand blowing a puff of smoke with the T.T. Smoker became the announcement for her show.

RM Prior to Pomona, didn't Judy present one of the Atmospheres at the Pasadena Art Museum?

HG Yes, the one at Pasadena was gorgeous, with color and billowing clouds by the reflecting pool of the new museum building (*Multi-Color Atmosphere*, 1970). Her piece for Pomona was called *Snow Atmosphere* (1970); it was ephemeral art created as an event.

RM You didn't invite Judy to do a project in the Artist's Gallery. Instead, her piece for Pomona was presented on Mt. Baldy. Was there significance to presenting it outside, in a natural setting?

HG The snow made possible an aesthetic of white on white. Her piece needed a steep canyon with a convenient overlook, lots of snow, access to Los Angeles, and forest rangers who would understand her project and accept her credentials. Judy was studying to be a licensed pyrotechnician.

RM Were people reluctant to go outside to see art?

HG There was a new type of audience and a new type of event that grew out of E.A.T. [Experiments in Art and Technology] and other organizations that had project demos and ephemeral installations. Judy did pieces at Caltech [California Institute of Technology] for Elsa Garmire, and she collaborated with Sam Francis to propose that NASA add colors to the missile tests and time them to color the sunset.

RM Do you think that Judy's Atmosphere performances were created in dialogue with the other L.A. Light and Space artists?

HG Judy was very connected to the formal/minimal art that gave rise to Light and Space art. She had a studio next to Larry Bell in Ocean Park around 1960, and was living with Lloyd Hamrol on Raymond Avenue in Pasadena later in the 1960s when Irwin, Turrell, and Doug Wheeler had shows at the Pasadena Art Museum. Bruce Nauman lived nearby in Pasadena. I don't know about specific collaborations, but she followed closely the perceptual and formal investigations of artists around her.

RM One thing I noticed when I was getting this show together was that Judy was the only woman artist who was part of this period, from 1969 to 1973, at Pomona College Museum. How did you come to invite Judy to work with you?

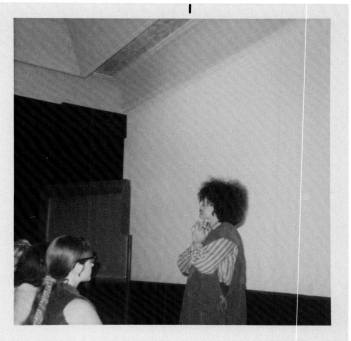

Judy Chicago presenting a lecture at Pomona College, 1970 (reprinted in this volume). Gift of Hal Glicksman. The Getty Research Institute, Los Angeles (2009.M.5)

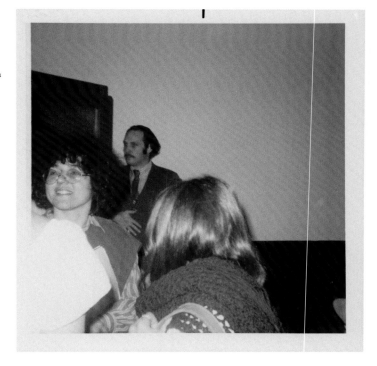

HG I had known Judy for a while. We were students together at UCLA. I knew her when she was Judy Cohen, Judy Gerowitz, and Judy Chicago....I became a feminist because of her. The next year after Pomona, when I was associate director at the Corcoran, we hosted the first conference on women in the visual arts. Of course, Judy was part of the conference. She and Miriam Schapiro were the main contingent from California.

Gretchen, my wife at the time, was working at the National Collection of Fine Arts with traveling foreign exhibitions. But Judy and Miriam wanted her to come back to California. They were organizing a professor-curatorial project at CalArts [the Feminist Art Program] dealing with women's studies, and they wanted Gretchen to be a part of it.

So Gretchen and I came back to Los Angeles. I took the job as the director of the art gallery and lecturer at UC Irvine [from September 1972 to June 1975]. Judy and Miriam convinced Gretchen to open Womanspace Gallery in 1972. Before the Woman's Building opened, Womanspace was this wonderful little gallery on Venice Boulevard, just like a storefront. It was a wreck of a building. I remember I worked very, very hard doing painting and drywall. I was the men's support group, and Gretchen was the director.

> **RM** Let's get back to what was happening at Pomona. Lloyd Hamrol's exhibit was over in November 1969; the next show was "California Abstract Expressionism," from the collection of Mr. and Mrs. Monte Factor.

HG Oh yes. Monte and Betty Factor were part of a small group of collectors who supported West Coast artists. They became close friends of Ed Kienholz and bought many works from the Ferus Gallery when it was partly run by Kienholz. The first exhibition I was able to curate on my own, outside of the Pasadena Art Museum, was "Assemblage in California" as a guest curator at the University of California, Irvine, in 1968. I had asked the Factors to lend us *The Illegal Operation* (1962) for the show, but they very nicely declined. The whole controversy over the exhibition of Kienholz's *Back Seat Dodge '38* (1964) at Los Angeles County Museum of Art [LACMA] in 1966 was still fresh in everyone's mind, and *The Illegal Operation* was particularly tough. They kindly called Sterling Holloway and encouraged him to lend me Kienholz's *John Doe* (1959).

The Factors greatly enjoyed "Assemblage in California," so when they later heard that I was the gallery director at Pomona, they offered to lend work to the gallery. Half of the paintings exhibited in "California Abstract Expressionism" at Pomona were from the Bay Area and half from Los Angeles. The artists included John Altoon, Kienholz, Frank Lobdell, Nathan Oliviera, Hassel Smith, and Emerson Woelffer. They all shared abstract expressionist roots and were very consistent in style. The Kienholz painting had projecting pieces of wood; it was a pivotal transition from abstract expressionism to assemblage.

> **RM** The next show after "California Abstract Expressionism" was called "Movie Palace Modern: Drawings of A. B. Heinsbergen," which opened in December 1969, right?

HG Yes, that show has a good story attached to it. While I was still working at the Pasadena Art Museum, Maurice Tuchman asked me to be a guest curator for LACMA's "Art and Technology" exhibition, because again, he had heard from artists that I knew quite a bit about the technological side of art installations. But when I first got to LACMA, I didn't have projects to work on right away. To keep busy, I went to the library to do a little detective work on Los Angeles history, looking at art deco architecture and things like that.

I found a run of *Art + Architecture* magazines, which came out of Los Angeles in the thirties. I had an idea to put the magazine and the phone book side-by-side and call every ad in the magazine. I would look in the phone book to see if the company was still in business, call them, and ask, "Do you have anything from the thirties?" I called heating companies and glaziers, any company that had taken out an ad at that time.

I struck gold when I called up Heinsbergen Decorating Company. They said, "Oh, yes, we may have something, come down." So I went, and found this little Romanesque chateau on Beverly Boulevard. Anthony Heinsbergen had bought an old chateau in Carennac in the Lot in southern France, and he reproduced it here in Hollywood. The thirties were a time in Hollywood when they reproduced everything. So he had this little chateau with the tiny little moat and bridge and everything. He had a vault installed to protect against fire with those big steel doors that you slide open. In there were books and books of watercolors from every project he had ever worked on.

Front cover of exhibition brochure for "Movie Palace Modern: Drawings of A. B. Heinsbergen," 1969. Pomona College Museum of Art Archives

MOVIE PALACE MODERN

RM Was he an architect?

HG No. He was a painter, a decorator. He painted all of the ceilings of Los Angeles: City Hall, all the art deco movie theaters. He painted angels on the ceilings of opera houses, and things like that. He was "The Decorator of L.A." There in the vault were all his drawings and designs. It was a fantastic collection of stuff. So I showed those at Pomona College. Using the same detective method, I found a photographer, Bernard Merge, who had five-by-seven-inch negatives in his file of images from the thirties. I had him reprint a selection of them, enough to fill the gallery.

RM Didn't the show travel to the Corcoran?

HG First it went up to the Oakland Museum of California. Then, the Smithsonian Institution Traveling Exhibition Service picked it up. It traveled for years. That was a great show, and old man Heinsbergen was a wonderful character.

I have to tell you about his notebook. He had a great hatred for Modern Art. I remember he showed me a notebook that he made, one of those fancy leather binders with gold lettering. His was stamped: "Frauds in Art." It had three artists in there that he thought were examples of fraud. Picasso was at the top of his list, followed by Paul Klee and Yves Klein! I was fascinated! I had to bite my tongue to not tell him that I loved Klein. He went to every Klein show, clipped every Klein notice in the paper. He had photographs of work that I didn't even know Klein had done. There was a photograph of a canvas tied to the front of a Renault that Klein had driven through puddles to splash mud on the canvas. He knew everything about Klein! Better to hate him knowledgeably.

RM So that show was conceived when you were working at LACMA, and you brought it to Pomona?

HG I found the stuff and kept it in my brain, then I took it to Pomona.

RM Ron Cooper's show was immediately after that one, in December 1969, right?

HG Yes, he was in the Artist's Gallery.

RM And how did you know about his work?

HG Oh, I knew him forever. We were all in a little neighborhood together in Venice [California]. Peter Alexander, Jim Ganzer, and Cooper were all in the building next door.

RM Now for Ron's installation, didn't you write to a steel company to get—? What was it?

HG Well, this is very interesting. I don't know if you remember your high school physics. Ron wanted four rocks, and he wanted to use the park that was across the street from the museum. Ron wanted four boulders the size of a table with a sheet of steel approximately fifty feet square, and he wanted to drop one of the rocks in the middle to make the steel bend. People were doing things like that at the time. He was inspired by Robert Smithson; in fact, Smithson came to his performance. Anyway, Ron started thinking à la Smithson and Michael Heizer. It would have been ridiculously expensive to do that project of bending the steel; it would have cost much more than we had. Besides the costs, we called up Owl Crane and Rigging and asked if they could lift a rock up and drop it on this metal sheet. Well, they said, "No, you can't because, according to Newton, [for every action] there's an equal and opposite reaction. And when, God forbid, a cable breaks on a crane, the crane flies up." So it turned out to be physically impossible to drop a rock in the middle of this thing.

RM So then what?

HG Dropping a metal ball on a piece of glass.

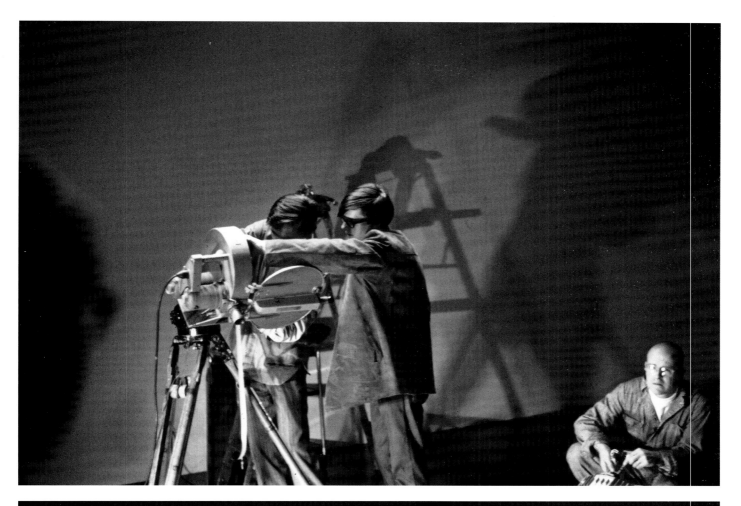

TOP / BOTTOM

Preparing to film **Ron Cooper's** *Ball Drop*,
1969. Gift of Hal Glicksman. The Getty
Research Institute, Los Angeles (2009.M.5)

Camera set-up for documenting **Ron Cooper's**
Ball Drop, 1969. Gift of Hal Glicksman.
The Getty Research Institute, Los Angeles
(2009.M.5)

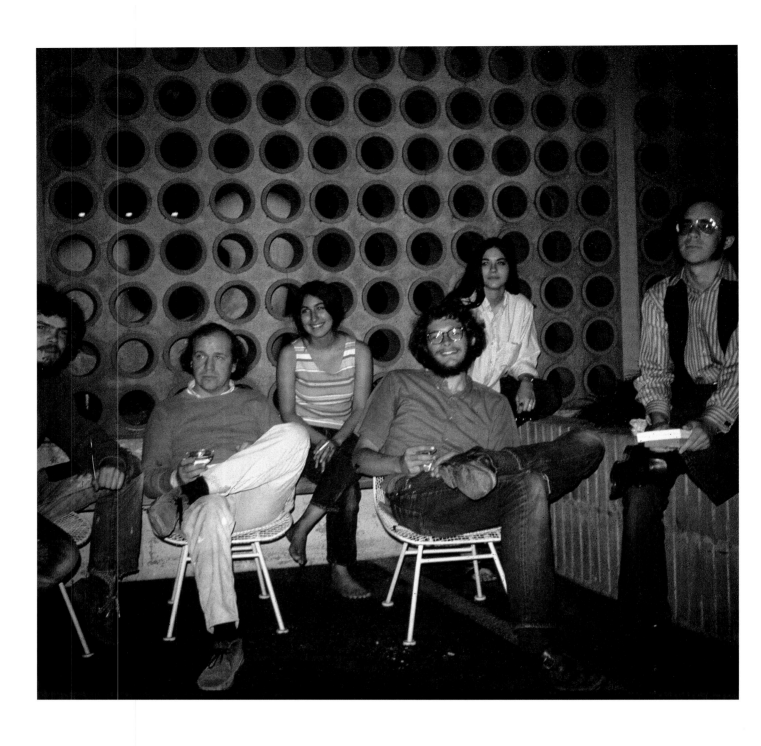

Tom Eatherton and students in Pomona
College Museum of Art courtyard, 1970.
Gift of Hal Glicksman. The Getty Research
Institute, Los Angeles (2009.M.5)

RM In the gallery space?

HG Yes, it was fantastic. Ron used a high-speed movie camera—the kind that takes pictures of bullets going through light bulbs—and he made *Ball Drop* (1969), which is really, really beautiful.

RM So the film was part of the exhibit.

HG Yes, we showed it a few times. I don't remember the schedule, maybe it was just to the students.

RM Then the glass and the ball were left in the exhibition. Was the drop a performance that people were invited to?

HG Students. By the way, people didn't come to the gallery much then. Two or three people a week would come out, more on the weekends. It was not the place it is now. It was just a place for students, really, to see the stuff...Anyway, that film of the ball dropping was fabulous. It takes a couple of seconds or so for the ball to appear on the screen. In the beginning you look for quite a while, but you don't see anything because the glass is translucent; you can't see it when it's not cracked. You don't even realize that you're looking at a piece of glass; it just looks like the floor. So you look and look and wonder what's going to happen. And then you see this ball come down like the setting sun, so leisurely, right? Then it hits the glass. Ron wanted to show the cracks propagating, but actually the camera still wasn't fast enough. You see some of that for a second or so, then very leisurely these pieces of glass start moving around. Then the steel ball goes back up and disappears out the top of the frame, because it actually bounced. The glass is flying and cracks are happening, and things are sparkling into the lens. And you look and look, and they start to calm down a little bit, and then the ball comes back! After you think it's gone, it goes *thunk*. Oh, it's beautiful.

RM You also hosted an MFA exhibition by Michael Brewster and the first solo show by Lewis Baltz?

HG Yes, Michael's was a graduate show. But he was a real artist by then. Brewster's exhibit was for three days in May 1970.

RM Lewis Baltz was next, right, with the Prototype works?

HG Yes. Baltz was older, in his thirties. He told me about his interview to come to Claremont Graduate School. They told him, "We don't teach photography." Baltz said, "I'm not interested in photography. I want to be an artist. I happen to do photography. That's my art form." And they said, "We don't have labs." And he said, "I don't need a lab. I want to be with artists. I want to discuss art." You could look at his work and see that he was an artist right off.

RM Did you see his photographs before you agreed to do the show?

HG No.

RM You just said, "Yes, I'll just take the show?"

HG Well, yes. Because Mowry and everybody agreed he was an important artist. Then I saw the work, and I picked up the phone and I called Irving Blum. I said, "Irving, I know you don't show photography." And he says, "No." I said, "I've never sent you an artist to look at his work, have I, ever?" And he says, "No." "I just want you to look at this guy's work!" Irving immediately called John Szarkowski at the Museum of Modern Art! He said, "You've got to look at this guy's work."

RM Right away.

HG Yes, I mean anyone who looked at it at the time didn't need to be convinced. It wasn't that I did anything for him; anyone who saw that work knew it was different. You knew it was very special. It didn't look like any other photographs you'd ever seen. Yet it was solidly in the tradition of photography. It was Donald Judd in a photograph. Unbelievable. Gorgeous.

RM I also wanted to ask you about the 1970 show, "Chicano Graffiti." How did that come about?

HG While I was working on the LACMA "Art and Technology" show, I had an old Volkswagen. I didn't like to go on the freeway, so every day I'd explore different ways to go from my house in Pasadena to LACMA and back. And I started noticing all of the graffiti.

I fell in love with some of it. At the time, graffiti was definitely a local phenomenon. Most of it was more or less indecipherable lettering. And I figured out how to read it. That was my interest in it. You know, it was real calligraphy; graffiti artists were inventing whole new alphabets and ways of writing. So I started documenting it. I ran into Robert Allikas who had also made a bunch of photographs of graffiti. We decided to do a show. People hated the idea of glorifying graffiti. I wrote a letter to the Los Angeles Board of Education. You know, every year they burn a lot of old textbooks, and I said "Can I get those?" Because on the inside of the jackets, there's all this graffiti. And they thought that was horrible. They absolutely refused. Anyway, that turned out to be a really interesting show.

RM Was the Pomona show one of the early exhibitions of Chicano graffiti?

HG Yes, I think it was the earliest Chicano graffiti exhibition. They were starting to discover graffiti in New York; Norman Mailer's book *The Faith of Graffiti* was published in 1974. But it didn't become a huge thing until a few years later.

RM That's interesting. So was there an exhibition in the Artist's Gallery during the graffiti show?

HG Tom Eatherton.

RM How did Tom's exhibition come about?

HG I knew Tom was interested in doing an installation because he had done a Light and Space piece in his studio. But no one ever saw it, only a few friends. I felt confident that he could do a large, complicated piece. But when he got to Pomona, he actually had no idea how to do it. He knew what he wanted, and he could communicate it to me, but I had to solve all the technical problems. That was fine, that was my job. We worked day and night. But you know that's what you do. [Chuckles.] My principle the whole time I was doing exhibitions was to show artists who needed something that I could do for them—that the art wouldn't exist without the opportunity and without the technical expertise that I could give to it. I didn't see any justification for the existence of curators just to be arbiters of taste. If you didn't do something for the art, for the artists, for the art world, I felt that you didn't really have a justification for your work. I wasn't interested in just being a power broker or whatever. I didn't like that. As a result, I didn't have a collector base. Most curators had collectors they could go to for money and for support. I rarely had anything to do with collectors because I always thought that what I liked couldn't be collected.

RM You supported some of the early Light and Space artists.

HG Back then I didn't know it was "Light and Space"! But I knew right away that it was the direction that the artists were going. And it ended up that I showed all of them. It was an amazing time really.

Tom Eatherton (left) and David Gray (right) in the offices of the Pomona College Museum of Art, 1970. Gift of Hal Glicksman. The Getty Research Institute, Los Angeles (2009.M.5)

Hal Glicksman preparing Tom Eatherton's *Rise*, 1970. Gift of Hal Glicksman. The Getty Research Institute, Los Angeles (2009.M.5)

1. See Allan Sekula's "Michael Asher: Down to Earth," *Afterall* (Autumn/Winter 2000); and Miwon Kwon's "Approaching Architecture: The Cases of Richard Serra and Michael Asher," *Yale University Art Gallery Bulletin* (2000): 22–33.

2. See Michael Asher, "Galleria Toselli, Milan, 1973" in *Situation*, Claire Doherty, ed. (Cambridge, Mass.: The MIT Press, 2009), 30–32.

3. See Victor Burgin's "Situational Aesthetics," *Studio International* 178 (1969): 118–21; Benjamin H. D. Buchloh's "Michael Asher and the Conclusion of Modernist Sculpture" (1980), in *Neo-Avantgarde and Culture Industry: Essays on European and American Art from 1955 to 1975* (Cambridge, Mass.: The MIT Press, 2000), 1–39; and Kirsi Peltomäki's *Situation Aesthetics: The Art of Michael Asher* (Cambridge, Mass.: The MIT Press, 2010).

4. See *California Perceptions: Light and Space: Selections from the Wortz Collection* (Fullerton: California State University, Fullerton, Art Gallery, 1979).

5. Sandy Ballatore, "Michael Asher: Less is Enough," *Artweek* 5.34 (October 12, 1974): 16.

6. Gilles Deleuze, *Foucault* (Minneapolis: Minnesota University Press, 1988), 59.

7. Walter Benjamin, "The Work of Art in the Age of Mechanical Reproduction," in *Illuminations* (New York: Schocken Books, 1969), 239–41.

8. Kwon, 31–33.

LIKE MANY ARTISTS OF HIS GENERATION,

Michael Asher took his lead from Minimalism's theatricality, which was designed to enhance viewers' perceptual awareness of their role within the exhibition space. Yet where many of Asher's peers responded by expanding their practice into the more temporal realms of film and performance, Asher focused on the temporal as a condition of the spatial, which aligned his work more specifically with architecture.[1] Overall, Asher's entire *oeuvre* has investigated how viewers encounter specific sites, primarily spaces dedicated to the presentation of visual art. As a result, Asher's work is typically associated with the Conceptual art practice of Institutional Critique.

Historically, the placement of Asher's work within the discourse of Institutional Critique was cemented with his 1974 project at the Claire Copley Gallery in Los Angeles. For this work, Asher removed the wall separating the exhibition and office spaces, revealing the otherwise hidden gallerist working at her desk. With all physical traces of Asher's intervention repaired, visitors to the gallery encountered a space whose only apparent focus was the administration of business. This intervention not only opened the discourse of the gallery to issues of labor and economic exchange, but also invited the participants—both Copley and the gallery visitors alike—to re-examine their understanding of what constitutes an artwork and how visual art functions within the larger social domain.

While not Asher's first manipulation of a gallery space, his intervention at the Copley Gallery was certainly one of his first to bring attention to the larger social discourses that inform the production of art—be it an aesthetic object or a system of exchange. Yet, Asher's attention to the discursive functions operating within an exhibition space was already evident the year before in his project at Milan's Galleria Toselli. Here, Asher sandblasted the gallery walls and ceiling, stripping away the neutral white paint and pristine surfaces to reveal the underlying brown plaster. The effect physically recreated the gallery as a site under construction, rather than one engaged with the conventions of display.[2] For visitors the transformation was as stunning as the encounter with Copley was awkward. Together, Asher's interventions at the Toselli and Copley galleries marked a significant transition that clearly positioned his work in terms of the more analytical, site-specific approach that has come to define Institutional Critique. Victor Burgin described this approach as a shift in focus from material effects toward a concern for the more immaterial effects of content, which he dubbed Situational Aesthetics.[3]

Like many other artists in the mid-seventies, Asher took the opportunity of the Copley exhibition to publicly distance his work from the more purely perceptual environments that have come to be associated with "Southern California Light and Space."[4] Thus he told a reviewer: "I don't deal with environments. I do situational work. I'm not interested in manipulating perception."[5] In part, Asher's declaration referred to the more critical direction that had been developing in his work for several years and was clearly articulated in the Copley installation. In fact, prior to this articulation, many of his installations could be described as minimal environments primarily designed to address viewers at a sensory level. Yet, by the early seventies, Asher was specifically expanding his practice to concentrate on other extra-sensory but equally intangible forces that shape and impact viewers' expectations and interpretations of art. In this regard Asher's interventions at the Copley and Toselli galleries were designed to produce what Michel Foucault has called "visibilities," which "are not defined by sight but are complexes of actions and passions, actions and reactions, multisensorial complexes, which emerge into the light of day."[6] In other words, Asher's works allow a complex network composed of historical traditions and economic discourses to become more readily apparent within the physical structures of the exhibition site. Significantly, viewers who witnessed Asher's interventions and returned to the Toselli or Copley galleries after their walls had been restored did not lose "sight" of the surface below or the business behind the walls. Thus, in contrast to the Light and Space environments of his Southern California contemporaries, Asher's work connected perceptual experiences of the specific locations with the actual social discourses flowing through those contexts. Inherent to this conjunction in Asher's work is an understanding of how architecture creates an immersive environment. Less apparent is Asher's highly logical and analytical methodology, which ultimately revealed to Asher how these environments convey discursive functions performatively, through observers' physical encounters with actual spaces. As Walter Benjamin observed, our reception of architecture operates at the level of habit; we acquire its information gradually and through our physical use of it over time.[7] Unlike many other artists associated with Institutional Critique (for example, Marcel Broodthaers, Daniel Buren, and Hans Haacke) Asher's approach relies upon a physical experience that cannot be fully captured through photographic documentation.[8]

MICHAEL ASHER
FAMILIAR
PASSAGES AND
OTHER
VISIBILITIES

Marie B. Shurkus

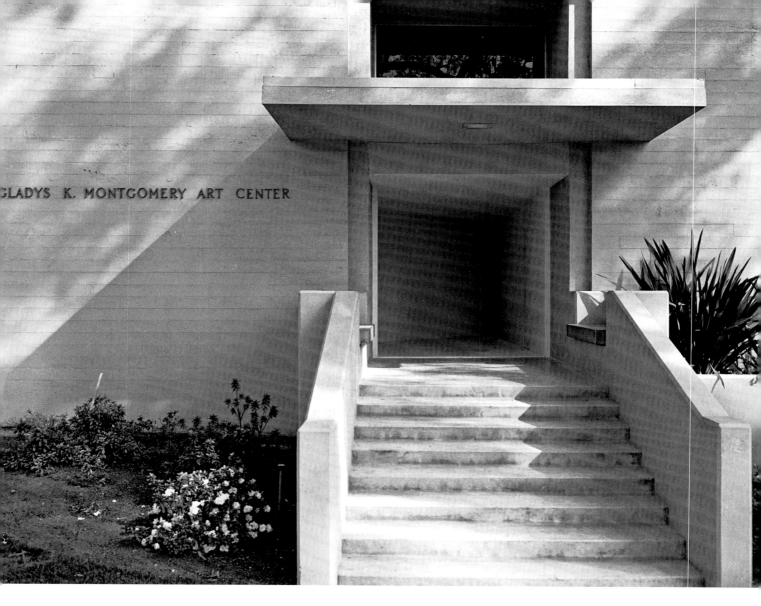

GLADYS K. MONTGOMERY ART CENTER

9. Michael Asher, conversation with the author, May 22, 2010. Asher's piece in the current exhibition at the Pomona College Museum of Art was also featured in the Whitney's 2010 Biennial as "Open: Day and Nite." However, where costs forced the Whitney to limit the duration of the piece to three days, Asher's installation at Pomona follows his original design of being operational for twenty-four hours per day throughout the run of the exhibition, from August 30–November 6, 2011.

10. Ibid.

Asher's understanding of how spaces address viewers physically and construct visibilities emerged through a number of works that culminated in his 1970 exhibition at Pomona College. (*See Asher's detailed description of the piece in this volume.*) In fact, Asher's contribution to the exhibition at Pomona College in 2011 was first inspired by his 1970 installation.[9] Nevertheless, Asher admits that the significance of his original intervention at Pomona did not occur to him until after the logistics of recreating the space were complete. Initially, Asher was too consumed with solving a problem that had emerged a few months earlier during his first solo exhibition at the La Jolla Museum of Art.[10]

For the La Jolla exhibition, Asher installed a tone generator in one of the gallery walls that effectively cancelled out all sound waves in the room, creating a dead zone in the center of the gallery. Accordingly, "viewers" experienced sound as a physical force operating through the gallery space. Similarly, in the months prior to the La Jolla exhibition, Asher had employed industrial air blowers to create first a "wall" of air at the Newport Harbor Art Museum, and then the less intrusive "curtain" of air, exhibited in the Whitney's 1969 "Anti-Illusion: Procedures/Materials" exhibition. Moving on from these and other sensory-based installations, Asher confronted the problem of how to organize light and sound at Pomona without introducing any outside equipment.

The solution he found was as simple as it was insightful: recompose the walls. "I was fascinated that architecture alone could amplify light and sound,"

Michael Asher installation, 1970. Main entry / exit viewed from street during exhibition. Pomona College Museum of Art

11. Ibid.
12. Ibid.
13. Asher with Benjamin H. D. Buchloh, *Michael Asher: Writings 1973–1983 on Works 1969–1979* (Halifax: Press of the Nova Scotia College of Art and Design; and Los Angeles: The Museum of Contemporary Art, 1983), 1–2.
14. Asher, conversation with the author.

Asher recalled.[11] Ultimately, Asher reconfigured the space into two intersecting triangles so that in order to move from one space to the other viewers were required to pass through a narrow passage where the two triangles met. With the ceilings lowered, this narrow passage addressed visitors physically, punctuating their movement from one space flooded with the light and sounds of the exterior street to a more interior space, where these sensory elements continued to exist but in either an amplified or filtered manner. Thus, the passageway demonstrated in real time how the traditional white cube constructs artificial effects and "false neutrality."

Asher's solution at Pomona reflects what has become a fundamental principle of his site-specific methodology: use only the pre-existing elements of a space. In fact, as a result of this basic principle, architecture has become both the primary tool and the material that defines Asher's practice.[12] Although his 1970 installation at Pomona College was instrumental in establishing this principle, this insight first occurred to Asher the year before, during his 1969 exhibition at the San Francisco Art Institute. Using only the museum's temporary modular walls, Asher effectively installed a geometric plane down the center of the gallery. This illustrative "misuse" of the modular partitions allowed Asher to underscore the otherwise invisible "structural ambiguity" that the transitory walls conveyed. For when properly installed, Asher noted, "they appear to be architectural surfaces when they are really planar objects."[13] Functioning in a similar manner, the reconstructed physical structure of the Pomona College gallery drew attention to other, less visible forces constructing the gallery space, namely light, sound, and the movement of air.

The significance of Asher's site-specific methodology led him to a steadfast commitment to working with the actual and a refusal to add decorative features—be they figurative or metaphorical. This discipline defines Asher's work, and it helps him to recognize how extra-discursive operations flow through spaces, and how the physical constructs of a space facilitate the operation of these discourses. At Pomona, Asher's decision to use only what was present led rather organically to the idea of removing what was unnecessary. He explains:

I got to a point where I'd figured out the installation and how these two triangular spaces were going to work. Since I was looking at everything that pre-existed, I finally wondered about the doors. Why do I have to use the doors? Because in fact, all the elements that I wanted to use in the work were coming through the passageway anyway, why not have basically a work which truly merges to the out of doors, and yet is defined by the indoors? So I took them off... As a matter of fact, I really liked the idea of accessibility day and night because I was interested in how the air was changing, the sounds were changing, and the light was changing. And if one really wanted to follow it, like I wanted to follow it, they would come back at night to see what shifts were taking place in those three elements.[14]

Ultimately, Asher's decision to remove the doors followed his methodology to its logical conclusion. However, much more was at stake in seeing this logic through than Asher initially realized. Having solved the problem of how to amplify viewers' experience of the exhibition space without using extra equipment, Asher realized during an evening visit to the reconstructed space that art institutions were also controlling access to culture. Embedded within his decision to remove the doors was the immaterial presence of institutional regulations that had prescribed certain hours of operation and limited public access. Moreover, these institutional conventions had been somewhat uniformly adopted across the field, thereby constructing certain perspectives about the role of art within our daily lives. By removing the doors, Asher revealed that much more than light, sound, and air was moving through the passageway to the outside that he had created at Pomona.

Perhaps his simplest yet most daring work to date, Asher's current intervention at the Pomona College Museum of Art is a response to his previous work forty years earlier. His current work creates another passageway into the museum that is open twenty-four hours a day. This time, however, the passageway is not a function of the physical structure; rather it has been cut through the structure of the institution such that throughout the run of the exhibition viewers may enter the museum any time of the day or night and view the other works on display. Significantly, Asher decided not to recreate his 1970 installation because, he explained, to do so would effectively transform his intervention into an object that could be put on display for consumption. Instead of creating an object or even an environment, Asher's current work intervenes at the level of social assumptions. His goal for the piece is to have it function like any other mundane museum operation, so that over time the passage of art into our daily lives might become familiar and even expected.

Lawrence Kenny documentation drawing
of Michael Asher's 1970 installation at the
Pomona College Museum of Art. Drawing
produced for the publication *Writings 1973–
1983 on Works 1969–1979* (Halifax: Press
of the Nova Scotia College of Art and Design;
and Los Angeles: The Museum of
Contemporary Art, 1983)

IN 1969, Hal Glicksman, the curator of the Gladys K. Montgomery Art Center at Pomona College, offered me the opportunity to stage a work in the center's large exhibition gallery. After visiting and inspecting the center, I considered using a location in the building that was outside of the area normally allocated for exhibition purposes.

Only after I had taken up residence in a dormitory at the college to plan and install the work did I decide to use the large exhibition gallery, the lobby, and the main entrance from the street.

The art center is situated at one end of the campus. There is an intersection of public streets on its south and west sides. The main entrance is on the west side of the gallery. On the northeast side, the gallery is open to a patio that is surrounded by other college buildings.

A portico at the front entrance leads into the gallery lobby, which is flanked on the south by an enclosed office space. The lobby is 27 feet square with an 11-foot-8-inch ceiling. At the southeast corner of the lobby a corridor of 6 feet wide opens into the large exhibition space. The dimensions of the space are 41 feet 3 inches in length and 25 feet 9 inches in width with a ceiling height identical to that of the lobby.

For this exhibition, three walls were constructed, one in the large gallery and two in the lobby. The wall in the large gallery, a three-part construction incorporating two already existing walls, delineated a triangular area. One wall was adjacent to the west edge of the passageway and extended 43 feet 4 inches across the gallery to its southeast corner. The other two already existing walls measured 28 feet 5 inches on the north side and 25 feet 9 inches on the east side.

A second constructed wall, adjacent to the east edge of the passageway, ran parallel to the first wall and extended 27 feet into the lobby. I had a third wall constructed adjacent and perpendicular to the existing north wall of the main entrance. It ran parallel to the gallery's west wall and extended 8 feet 9 inches, joining the end of the second constructed wall at an acute angle.

Together with the two constructed walls, another existing wall measuring 21 feet 4 inches on the south side of the lobby and main entrance completed a smaller triangular area. A flush door construction was added to the office door of the existing wall for a smooth, unbroken wall surface.

The two glass doors that normally partitioned the main entryway and lobby, and which were hinged to the north and south walls at a point 5 feet 2 inches from the outer wall, were removed for the duration of the exhibition, leaving an open entry/exit 6 feet 4 inches in width. The doorjamb and hardware were covered.

A 6 foot 10 inch-high ceiling was constructed that totally covered the two triangular areas, and turned the 6 foot 4 inch wide entry into a perfect square. It extended through the main entry passage and ended outside, flush with the exterior front wall of the gallery where the gap was boxed in with a drywall panel. The constructed ceiling and walls were drywall mounted on wood framing. All drywall surfaces were finished with off-white paint. The linoleum floor, which had been covered with a protective tape, was painted the same off-white color.

The ceiling, lowered to a height of 6 feet 10 inches, became as integral a part of the work's spatial continuity as the walls and the floor. As such, the ceiling directed the viewer's awareness to standard architectural usage within an exhibition space, similar to the way in which the constructed walls altered perception of the standard rectilinear areas.

As the ground plan indicates, each triangular area was positioned in reverse of the other. Each side of one triangular area had a corresponding parallel wall in the other. Therefore, both triangular areas had a right angle and two identical acute angles. Finally, the parallel hypotenuses of each triangular area overlapped for a distance of 5 feet, resulting in a corridor 2 feet in width.

The interior of the architectural container, housing the office and additional gallery space, could be reached from a courtyard behind the gallery building. From this area the viewer could see the construction and the support of the smaller triangular space, including structural details (i.e., the two-by-four framing, the sandbag props that were used to stabilize the walls, the joists holding the ceiling and walls together, and the back of the drywall panels).

While in the office/gallery space, viewers could observe the backside of the construction and at the same time the front side and the outdoor elements in their formalized context.

FEBUARY 13 MARCH 8, 1970 GLADYS K. MONTGOMERY ART CENTER, POMONA COLLEGE, CLAREMONT, CALIFORNIA

Michael Asher with Benjamin H. D. Buchloh
Reprint from *Writings 1973–1983 on Works 1969–1979*. Halifax: Press of the Nova Scotia College of Art and Design; and Los Angeles: The Museum of Contemporary Art, 1983, pages 31, 34, 38, and 42.

Michael Asher installation, 1970. Camera in
small triangular area facing passageway into
large triangular area. Photo taken with artificial
light. Pomona College Museum of Art

FOLLOWING PAGE, TOP / BOTTOM
Michael Asher installation, 1970.
View from large triangular area towards
passageway to small triangular area.
Pomona College Museum of Art

Michael Asher installation, 1970.
Small triangular area facing toward
passageway. Pomona College Museum of Art

In this case, as in many others, the architectural site did not exclusively determine how the work was structured or perceived. However, it did give the viewer an opportunity to see what could be accommodated within the parameters of a museum's architectural structure.

With the two glass doors removed, the installation was open to anyone twenty-four hours a day. Exterior light, sound, and air became a permanent part of the exhibition. Daylight saturated all the surfaces of the first, small triangular area. It condensed in the corridor and gradually dispersed over all the surfaces of the large triangular area. Only the back wall facing the corridor was fairly evenly lit by the projected daylight from the corridor. Light intensity, color, and shadows varied, depending on the sun's position in the sky. Reflected light had a yellow tint due to the off-white color of the interior.

Nighttime light entered from streetlights, which cast a low, tinted blue light into the installation. Also, a 75-watt bulb in the lobby ceiling, which was covered with a clear blue Plexiglas sheet and several layers of fiberglass diffusers in order to match the color of the streetlights, cast a dim, tinted blue light into the triangular areas, producing an extent and degree of illumination similar to that of daylight.

Sound was generated from such sources as street traffic, people walking past the gallery, and people within the installation. Exterior and interior sounds were collected and amplified in the smaller triangular space and transmitted through the corridor. Channeled and intensified in the corridor, sound was further amplified in the larger triangular space, reaching its highest level at the back wall. With the removal of the main entry doors, the installation was also directly ventilated from outdoors and therefore subject to varying climatic conditions.

I originally intended the installation at Pomona College to deal with air movement generated from natural, outdoor sources rather than mechanical means, and to direct that air movement through the gallery. In this regard, the installation was an amplification and variation on my early air works and, specifically, my more recent air works at Newport

Harbor Art Museum and the Whitney Museum of American Art, all of which had employed mechanical devices to generate airflow into the exhibition area. The Pomona work was similar to the installation at the Museum of Modern Art in that it collected and structured given exterior elements and integrated them into the work.

While working on the Pomona installation, I realized that it was impossible to focus on one singular element such as the movement of air. All of the various elements, once the space had been literally opened to them, had to become inherent determinants in the production and reception of the work.

The installation shifted formal control from a singular object to a seemingly neutral given architectural structure previously containing that object. The induced and false neutrality of the object had been dependent upon the false neutrality of the container.

The triangular shapes were defined in opposition to the usual architectural context surrounding a work of art. As right triangles, they simultaneously adapted and referred to the conditions of the architectural container.

The arbitrary way in which the exterior elements entered the triangular spaces was as important to the work as the material construction of the installation, if only as a contradiction of the installation's formal control over those elements.

Entering and moving through the installation, the viewer became increasingly removed from the exterior reality, at the same time perceiving gradual abstractions of that reality within a formally determined and controlled space.

Gradually walking back through the two triangular areas, the viewers reconstructed what had previously been abstracted, reaching the point of total reconstruction at the moment they returned to the outdoors. This view of exterior reality was framed by the square entry/exit, which was combined and juxtaposed with the final element of the installation's formal abstraction: the 6-foot-4-inch-by-8-foot-9-inch wall panel to the right of the entry/exit square.

PREVIOUS PAGE, TOP / BOTTOM
Michael Asher installation, 1970. View from front (small) triangular area with constructed office door on the far right, viewing into passageway. Pomona College Museum of Art

Michael Asher installation, 1970. Photo taken from back wall of large triangular area viewing onto front wall of small triangular area. Photo taken with artificial light. (Note: electric cord not part of installation. Used here for photodocumentation.) Pomona College Museum of Art

The twenty-four-hour time order, a popular structure in the Los Angeles community, was transposed to the operation of the work. This time structure introduced a temporal configuration of reality, opening the work temporally as the entry structure had opened it spatially. Some of my earlier works had also developed a formal temporal structure through the use of sound: sound as a temporal structure determined by its mechanical generation within the work (as in a work at the La Jolla Museum of Art), or by the viewer's limited access to the work, which was ultimately determined by the museum's operating hours (as in the work at the Museum of Modern Art).

The sound in this work was the sound of the activity of the community surrounding the work as well as that of viewers who entered it. Because of the twenty-four-hour time structure, viewers activated the work by entering at a time determined by them, rather than according to the museum's usual daytime schedule. The three-week duration of twenty-four-hour accessibility focused on a more generalized understanding of temporal experience.

The visual, spatial, and formal continuity of the installation was dialectically in opposition to the actual continuity of time, sound, light, and climatic conditions. To stage a work that would express these oppositions with ideal clarity, it seemed that certain facets of the reality of the work—its various levels of support, for example—had to be suppressed. The work's specific reality—what it shares with the institution that contains it—remained elusive. This apparent absence derived from conditions created in the work's construction: the demarcation of the existing space and the partial concealment of the activities within that space.

TOP / BOTTOM

Lewis Baltz *Laguna Beach 1970*.
Gelatin silver print. 5 9/16 × 8 ½ in.
(14.13 × 21.59 cm). Pomona College Collection

Lewis Baltz *Gilroy 1967*. Gelatin
silver print. 5 × 7 15/16 in. (12.7 × 20.1 cm).
Pomona College Collection

1. Lewis Baltz, interview with Rebecca McGrew, June 11, 2009, Zurich, Switzerland.

2. Baltz interview with McGrew.

3. Though Baltz's course was officially listed as a studio class, he dedicated a large portion of time to the theory and history of photography, exposing students to key theorists and current debates about the nature of the photographic act. Building from the work of semiotics, French structuralism and phenomenology, Baltz—along with others, including John Berger, Victor Burgin, Allan Sekula, and John Tagg—became part of a vanguard movement in developing the critical apparatus of photography as such.

4. Baltz interview with McGrew.

5. Unpublished letter from Lewis Baltz to Hal Glicksman, November 7, 1970; Gift of Hal Glicksman. The Getty Research Institute, Los Angeles (2009.M.5).

6. Matthew Witkovsky, footnote 3. *Lewis Baltz: The Prototype Works* (Göttinagen, Germany: Steidl Verlag, 2010.)

7. Lewis Baltz, quoted in *Landscape: Theory*, ed. Carol Digrappa (New York: Lustrum Press, 1980), reproduced in Deborah Bright, "Of Mother Nature and Marlboro Men: An Inquiry into the Cultural Meanings of Landscape Photography," in *The Contest of Meaning: Critical Histories of Photography*, ed. Richard Bolton (Cambridge, Mass.: The MIT Press, 1989), 132.

8. Adam Weinberg, *Lewis Baltz: The Tract Houses* (Los Angeles: R.A.M Publications, Steidl Verlag, and Whitney Museum of American Art, 2005), 6.

PROGRESSIONS OF A NOT PHOTOGRAPHER LEWIS BALTZ 1969–1973

CLAREMONT GRADUATE SCHOOL (CGS) was not an obvious choice for the young artist Lewis Baltz, as there was no program in photography there or at any of the five undergraduate colleges in the Claremont Colleges consortium at that time. After an informational meeting with Guy Williams and Mowry Baden in the summer of 1969, Baltz was admitted to CGS, but not before defending his case against a good dose of skepticism surrounding a photographer's place in the program. Baltz recalls, "I wanted to do graduate work. I wanted to do more, meet more interesting people in the art world...and I absolutely did not want to go to a school that had photography, because I didn't like photography very much....I think mostly what they needed to be convinced [of was] that I didn't need any physical equipment, I didn't need any technical advice. Which I didn't. But I needed aesthetic advice. I needed people to read things with and discuss them with."[1] Aesthetic advice and an intellectual community is precisely what Baltz found in the Claremont art faculty. A relationship that began with some hesitance from both parties soon dev-eloped into a healthy exchange of artistic and professional support.

Three men were especially influential in Baltz's development during his time in Claremont: Guy Williams, Mowry Baden, and Hal Glicksman. Guy Williams, Baltz's academic advisor, met weekly with Baltz to discuss the development of his work. Meanwhile, Mowry Baden offered Baltz a consistently unique intellectual perspective. Baltz remembers Baden as someone he could "reliably count on for an original point of view. Mowry would bring a slant to something that nobody else had."[2] Learning from Williams's and Baden's intensely analytical process, Baltz further developed the ethos of intellectual inquiry that underlies his incisive photographic style. Of Baltz's three key mentors, Glicksman would have the largest direct impact on Baltz's burgeoning career. Glicksman—then director of the Pomona College Museum of Art—immediately recognized not only Baltz's extraordinary technical skill in producing photographs, but the unusually critical approach with which Baltz supported his work.

After his initial interactions with Baltz in his history of nineteenth-century art course in the fall of 1969, Glicksman quickly made Baltz his teaching assistant, asking him to introduce a section on photography into the course. Glicksman then invited Baltz to teach a studio photography course. Baltz accepted, but requested an official position with the college.[3] Glicksman followed through, not only securing Baltz a teaching position at Pomona in the spring of 1970, but also inviting him to show his photographs in the Pomona College Museum of Art.[4] Baltz's show

(May 25–June 1, 1970) was the final exhibition of Glicksman's tenure at Pomona, and Baltz's first solo exhibition. The two continued their relationship long after Glicksman left Pomona for the Corcoran Gallery. Indeed, it was Glicksman who would act, according to Baltz, as "Prime Mover in a process of steps leading from Claremont to the [Museum of] Modern [Art]."[5]

The photographs Baltz exhibited in the Pomona College Museum that spring were part of an ongoing series that he came to refer to as Prototypes. Baltz began this work as an undergraduate in 1967 and continued adding photographs until 1973.[6] While the Prototypes were not a formal series in the strict sense of much of Baltz's later photographic works, they served to establish the artist's characteristic approach to the medium: crisp, quiet, luminescent, black-and-white photographs of urban and suburban locales. Always devoid of people, the Prototypes present tightly controlled, visually restricted views of shop windows, walls, parking lots, cars, signage, and other urban structures. The photographs are accompanied by equally restricted titles comprised of a place name and a date: *Gilroy 1967, Laguna Beach 1970*, and *Claremont 1973*, for example. The Prototypes are filled with what might best be termed strategic abstraction—the photographs' subjects are removed from their typical contexts, but not so much as to lose reference to their standard use.

The Prototypes allowed Baltz to enter—via photography—into several larger discourses of art. The historical moment of Prototypes coincides with two major shifts: an intellectual shift in the critical dialogue about photography as a medium, and a physical shift in the make-up of the American landscape. The Prototypes emerge at the intersection of these shifts, positing original discussions of photographic meaning against the backdrop of similarly new developments—suburban and ex-urban sprawl. Baltz reframed the object of inquiry, while also reframing the attitude with which he made that inquiry. He described his approach in the following terms: "I want my work to be neutral and free from aesthetic or ideological posturing."[7] Baltz's attentive handling of banal objects and spaces revealed their uncommon qualities, but without an agenda about the meaning or value of those qualities. As Adam Weinberg aptly notes, "Photography for him is an appropriate, utilitarian language with which to address interests and conduct inquiries."[8] The Prototypes offer physical evidence of an ongoing conversation between Baltz and the shifting environments he encountered.

Baltz's photographs also entered into dialogue with sectors of art production not typically related to photographic practice—in particular, Minimalism.

Rochelle LeGrandsawyer

9. Ibid., 4.
10. Baltz interview with McGrew.
11. Ibid.
12. Unpublished letter from Baltz to
 Glicksman, November 7, 1970.

Whereas the standard Minimal object was based on industrial materials and methods, Baltz's photographs echoed the Minimalist aesthetic with neither purely industrial process nor purely industrial content. Instead, the vocabulary of Minimalism is transposed into photographic and sub-industrial space. The Prototypes stop short of true Minimalism, retaining traces of human influence. This human inflection is detectable both in the artist's too-attentive-to-be-standard views, and in the clearly human-tainted irregularity of the photographs' locales. In the Prototypes, Baltz helped build an important bridge between divergent art practices; his photographs were among the first works to, in the words of Weinberg, "transform the high language of Minimal aesthetics into the vernacular."[9]

After his first year as a graduate student in Claremont, Baltz applied for transfer to Yale, in search of a "heavier ticket."[10] At Yale, Baltz would have been able to work with renowned photographer Walker Evans. Baltz was accepted, but he ultimately declined the offer, opting instead to complete his MFA at CGS. Baltz recalled his reasoning along the lines of, "I'm here. I'm working here. I have these great people, and they know me. I haven't even scratched the surface, much less exhausted it."[11] Ultimately, Claremont offered Baltz a freedom in his approach to art making that he was unlikely to find in a more established program.

If the Prototypes began Baltz's exploration of the built landscape, Baltz's 1971 series the Tract Houses, which focused specifically on the synthetic domestic habitat, tightened the inquiry. Though presented together, the series' twenty-five photographs of Southern California tract houses represent Baltz's first attempt to create a series of stand-alone works that held up when viewed both individually and collectively. Whereas the Prototypes depict generic structures temporarily uninhabited by human users, the Tract Houses capture empty, lifeless buildings whose lack of people and personality leave an eerie vacuum of narrative content. Divorced from their human use, Baltz's tract houses take on a formal beauty of their own; the houses become sumptuous structures of sharp line and soft, diffuse light and shadow. The formal beauty of built elements had been previously explored by photographers such as Walker Evans, Paul Strand, and Charles Sheeler, but always with structures that bore the trace of human handiwork. In the Tract Houses, Baltz foregrounds the elegance of the impersonal.

The photographic alchemy that created the Tract Houses series resonated with some very influential viewers. In the fall of 1970, Baltz made his first networking trip to New York (after Glicksman arranged a few referrals). His impressive itinerary included meetings with Henry Geldzahler (curator, Metropolitan Museum), Jennifer Licht (curator, Museum of Modern Art [MoMA]), Michael Hoffman (executive director, Aperture), and David Whitney (curator and collector), among others. The trip proved highly successful: David Whitney connected Baltz to influential gallerist Leo Castelli, and the Tract Houses series was acquired by MoMA in a matter of weeks.[12] Word of the talented young photographer spread quickly, and in the spring of 1971, Leo Castelli presented

Lewis Baltz *Tract House #24*, 1971. Gelatin silver print. 6 × 9 in. (15.24 × 23 cm), mounted on 11 × 11 in. (28 × 28 cm) archival board. Norton Simon Museum, Gift of the artist

13. Unpublished letter from Lewis Baltz to Hal Glicksman, May 29, 1971; Gift of Hal Glicksman. The Getty Research Institute, Los Angeles (2009.M.5).

14. Witkovsky, 11–20.

the Tract Houses in New York at Castelli Graphics. Remarkable by any measure, Baltz's blue-chip debut with Castelli doubled as his MFA exhibition. In anticipation of his Castelli show, Baltz wrote to Glicksman: "A great step for me, a small step for mankind. If this comes up, I'll be the first photographer to show north of 63rd St., and I relish the distinction."[13]

Baltz's unfettered welcome into the upper echelons of the art world as a young artist signaled his exceptionality and uniqueness of vision, which many subsequent curators, gallerists and collectors would quickly recognize. After his exhibition at Castelli Graphics, Baltz went on to show the Tract Houses series at the George Eastman House in Rochester, New York, in 1972. By 1973, Baltz had already won a National Endowment for the Arts award. During these years, Baltz also worked with curator Walter Hopps (another Glicksman referral), who arranged an exhibition of the Tract Houses at the Corcoran Gallery in 1974. By the time Baltz participated in the landmark 1975 group exhibition "The New Topographics" at the George Eastman House, he was a firmly established mainstay in contemporary art and photography.

Despite his remarkable success as a photographer, Baltz maintained an ambivalent relationship with his chosen medium. What is clear from even the earliest pieces in Baltz's *oeuvre* is that his work both is and is not about photography. His work indicates his participation in the era's discourse surrounding photography, yet it also points to Baltz's wider concern for social and conceptual issues that extend beyond a discussion of photographic practice. Even as he draws the viewer

into intimate yet abstracted spaces, Baltz refuses to envelop the viewer in the world captured in the photograph. As Matthew Witkovsky observes of the Prototypes, "The paired sheets were glued to the mount, a Strathmore board of an off-white tone that was noticeably warmer than the prints and warmer, too, than most white frames or exhibition walls. Prepared in this way, the works were guaranteed not to 'sink in' to their surroundings."[14] Baltz forces viewers to deal simultaneously with the emptiness of the subject, the abstraction of the image, and the object of the photograph itself.

In walking the line between a disinterested photographic inventory and framing the poetic, abstracted beauty of the minimal and the mundane, Baltz distinguished his approach from many major photographic trends of the era. Baltz's stark, mid-distance views locate his work in what was then a sort of photographic no man's land. Unlike Aaron Siskind's peeling curls of paint, Baltz's views are too far away to allow the abstraction of form to take precedence. At the same time, Baltz's views do not give enough space to properly survey or romanticize the landscape. Baltz's work lacks the grandeur of Ansel Adams's epic landscapes, and the typologic register of Bernd and Hilla Becher's photographs. Instead, Baltz presents his spaces with a controlled aesthetic eye, a cool disinterest that is nonetheless evocative. Set somewhere between documentary photography and strategic abstraction, Baltz's photographs seem to hover as oscillating objects that in their quietness allow meditations on the place captured and the place of images.

Lewis Baltz *Tract House #5*, 1971. Gelatin silver print. 6 × 9 in. (15.24 × 23 cm), mounted on 11 × 11 in. (28 × 28 cm) archival board. Norton Simon Museum, Gift of the artist

1. Judy Chicago presented this lecture as Judy Gerowitz several months before changing her last name to Chicago.

HI. HAL TELLS ME HE ALREADY TOLD YOU THAT I'M GOING TO TALK ABOUT CUNTS...well, I want to talk to you first a little bit about me, and about some of the things I'm trying to do. Then you can ask me questions.

First of all, I was brought up with the idea that I could do what I wanted. At the time I didn't understand that that was a fairly radical way of bringing a kid up, especially a girl. But as I've become an adult, I've discovered that's pretty far out. I didn't really understand that I was going to encounter any kind of problems until I got into college. Now, there were problems that I encountered when I was growing up, but I didn't understand that they had anything to do with the fact that I was a girl; I just didn't think in those terms. And until I was in college—I'm sure a lot of girls understand this—I never encountered anyone saying anything to me overtly about the fact that I couldn't do something, or my ideas weren't valid, or my thoughts weren't important, because I was born with a cunt. It just never penetrated my consciousness until once when I was arguing with some guy about Hamlet. He proceeded to tell me that my ideas about Hamlet were obviously wrong, not because they were incorrect, but because I was a girl and obviously didn't know what I was talking about. I was shocked; I mean shocked. I didn't even know how to cope with it at the time. I got outraged. Those things started to happen to me, but it still didn't really affect me, because I had all those years behind me of being able to do what I wanted.

Then, I must have been about twenty the first time I got used sexually. I was irate. I couldn't believe it. I mean, the idea of me being used like that, just like I was some turd on the ground. My ego was just someplace else. All these things started to happen to me. I began to confront a whole structure of reality that was totally out of context with the way I was brought up. Somehow or other, though, I kept on thinking that everything was going to be okay. I thought that I was still going to be able to do what I wanted, that I was going to somehow get by. I didn't want to believe that things were this way. This kind of thing was creeping into my head, and I began to be aware of it, but I still wanted to push it away. I didn't want to believe it; it wasn't going to affect me. Somehow I was different. Somehow I was going to slip by. I was going to get to do what I wanted.

I wanted to make art from the time I was a little girl. I have had no other aim in life since I was three years old. By the time I was twenty-one, I had developed some attitudes that I think a lot of young women develop, like putting down other women, and saying, "I don't really like women very much; I like men better." And "Most women aren't very interesting..."

What was happening to me—which I understand now—was that I was beginning to see the world as if I was a man. I was talking like I was a man, putting down women, saying the things that all the boys said, "Women aren't very...blah, blah, blah," so that I could be accepted by a bunch of boys. They were the ones that I was trying to get recognition from, because they were the ones that were doing things. I got into that whole trip, not recognizing that on its fundamental level it was perverted and unhealthy and destructive. I went along like that for four or five years, still thinking somehow that I would just do what I wanted to do, despite the fact that there were no women on any level in society above menial. There are no women in Congress; you look at Congress, there are no women. There are no women running anything. There are no women running the country. There are no women in power in administration. There were no women generally teaching art, and the ones who taught art in universities were just unimportant. There were two when Hal and I were in school, and they were both put down. I mean, they were laughed at as little old ladies.

But that was the way the world was, and I was not prepared to question it. Then I get out of school, and I was alone with myself in my studio for five years. That was a very important time because, during that time, I was in the process of creating myself, defining myself. And that meant my ego was of central importance. I was the one who was important. What I felt, what I believed, the way I saw the world, those were the things I used and dealt with in my artwork. Every day I walked out of my studio and saw women on billboards with their tits stuck up and their asses stuck out, and there was a direct contradiction between what I was discovering about myself and the image that I kept coming up against outside my studio. And I had a whole series of hassles over the years, enormous hassles with men in the power structure. I sort of knew, yeah, they don't dig women too much. There are hardly any women artists. Still, I was not under-

standing what that meant, until one day it dawned on me that the way in which my work was perceived was totally conditioned by the facts that I had not wanted to accept, the facts that existed in the society. Women are not important. We live in a male-oriented society where men are more important than women.

The entire structure of our society is based on the idea that men are more important; you can see it in two very evident ways. The first way is in names. The most degrading thing you can say about a man is that he's Mister Judy Gerowitz. But nobody gets uptight at all if I'm called by my husband's name. That's perfectly okay, because my ego is not important; only his ego is important. And for you to really understand that—if you're male—is to try and imagine how you would feel about being called by your girl-friend's name. Those feelings that you would have are the feelings that you ask every woman to accept without even thinking about it. Which means that you do not even recognize her humanity; you don't even recognize her ego. That's what's so terrible. But what we're talking about, what I'm talking about, are the ways in which we function without ever giving it a second thought—the assumptions we make, the ways in which men deal with women and we deal with each other, without ever thinking about it.

The other way you can see this whole thing operating about needs is in our sexual attitudes. Twenty years ago, in sexual books, marriage manuals, and all that stuff—even ten years ago, when I was growing up— it said women didn't need to have orgasms. Only men had to have orgasms. What that means is that it's men's needs that are important. Then the next stage was, "Okay, women need to have orgasms, but they have to have orgasms simultaneous with men." Which means that a woman's needs have to be exactly the same as a man's needs. She's still not an independent creature with her own sexual needs, even though we know, for example, that women are multi-orgasmic, that their rate of sexuality is very different from men. But this wasn't even established as scientific fact until two years ago, with the printing of the Masters and Johnson book. Before that, Freudians were still talking about some weird transference from your clitoris to your vagina. I means that's serious. Even now there's an assumption that goes through the entire society that ejaculation for the male is out of his control. What that means is that men are not brought up with the idea that it is their responsibility to stick their hard cock out there for women's needs, because women's needs aren't important. It pervades our whole way of seeing.

How does that affect me? Well, if I'm not important, and my feelings aren't important, then how can the art that I make be important? If it is only important to write about war, and not important to write about childbirth, then how can I write about my experience in life? If it is important to have a hard-on, and not important to have a contracting cunt, how can I deal with the experience of my life, and how can anybody perceive it? So that means that half of my work goes unseen. It isn't real. A man who looks at my work has no criteria for evaluating female experience. None. He has only the history of art, which is the history of the white male ego; and he measures my work by how it projects the image of the white male ego. Now, if I'm being true to myself, it's not going to do that very well, is it? So then my choice is to make art that looks like it was made by a man. That's a compliment, you know. That's fantastic! Everybody is supposed to make art that looks like it was made by a white man. If you're black, you're not supposed to show that you're black in your work; that's a no-no. It's not supposed to show in your work that you're a woman either. That means I have to deny who I am. That's sick! That's profoundly sick, and I'm not going to do it. However, I understand that for me to be perceived means that what must exist is a power structure of women who evaluate each other's perceptions, ideas, and revelations. It's girls who have to measure my experience, not boys. It's women who have to say, "Yes, that's honor; that's not honor," and "Yes, that reflects my experience in life." But that requires a fundamental change in the basis of society, because women do not have power. They have no power to determine their own lives. They can only live covert lives; they can do what they want as long as nobody notices.

Let me talk a little about how I see, before I go on to my particular plans in this area. Let me talk a little bit about how I see the situation of women in relationship to the rest of the revolutions that are taking place in society. I think there's a fundamental problem in our society; it's the problem between the sexes. I think that all the issues of racism, pollution of the landscape, rape of the natural resources, and lack of respect for the species, are tied up and linked directly to the fact that the whole basis of our society is non-egalitarian. That is, in order for a man to be able to not perceive the humanity of his own sister or his own wife—to be able to use her as a sexual object, demand that she do work that he is unable, unwilling, and absolutely would flip out if he was asked to do—a man must be cut off from the wellsprings of his own feeling. Once he is cut off from those wellsprings, once he can deny

the humanity of his own wife, it's easy to deny the humanity of a black person, or of a Vietnamese. As long as we have revolutions that are just a change of power from one set of hands to another, we're going to keep on having the same shit we have. It's ludicrous to see Dr. Spock marching for the self-determination of the Vietnamese, while writing articles saying that it's women's duty, and actually that their fundamental happiness is derived from having babies and staying home. Well, having babies and staying home is a wonderful part of life. But that's what it is; it's a very small part of life. For a woman, there is much more in the world than being with a man; there are so many other things in the world, it's unbelievable. To try and force yourself to this little narrow confine will just fuck your whole being up. At any rate, I find it ludicrous that the leaders of the revolution demand that the women make coffee while they write manifestoes about the Vietnamese. But people don't even recognize what's going on, they just make these assumptions.

But the fact is, a fundamental change is necessary. It's a change of attitude, a change of self-perception, and a change of reality framework in the society, so that we all know that very sophisticated, sensitive men cannot go to war. They cannot go to war, they cannot kill, not because they don't have the same potentials as all those other guys out there, but because they have realized themselves more fully as beings and feel themselves sufficiently. They see other people as human beings, and that prevents them from killing them as if they were objects. Now, until all men see each other in that way, and all women see each other in that way, there will be no revolution. There will be no change, and there will be the same old shit.

Well, how do you accomplish that change? You don't accomplish it by violence, because as soon as you pick up a gun you have made yourself the same person who is opposing you. It is not whether it's effective that is the issue; it's what you have to do to yourself in order to shoot a gun. To be human is to not allow yourself to see other human beings as less than yourself; that's the meaning of being human. The problem with the revolution of minorities is that they are minorities, and therefore they are forced ultimately to make a stand that leads them to violence. The only revolution that's capable of making that kind of change is the revolution of attitudes and perceptions between man and woman. That's a confrontation on the most intimate level, absolutely down the line, until man and woman stand looking at each other naked and together. And we're a long way from that.

My own aims involve first my own liberation as a human being, as an artist. I will not make art that looks as if it was made by a man; I want to make art that looks as if it was made by a woman. I want to be proud that I'm a woman. I want to use everything about me that's a woman and put it right out there, with my cunt right out there on the line. In order to do that, I feel it necessary to do a few of the following things: I'm changing my name. I'm going to not use a name that was given to me by a man. I'm going to choose my own name. I'm going away for a year; I'm going to teach a class only for women. After next year, I will never teach again, except women. Because I need to be with women as much as women need to be with me. I need to help girls feel secure so that they can realize themselves, they can be aggressive, they can be assertive, they don't have to step back, and they don't have to hide all the pressures that all women, all girls, feel as long as a man is in the room. I would like to try and help myself and girls realize ourselves and feel proud of ourselves, and begin to make images out of our femaleness. I would like to see the beginning of a criticism by women about women. I would like to see women beginning to be peers for each other, support each other, help each other, reflect each other.

When men friends of mine say, about other men, "He's a cunt," you know, I really get uptight.

That's all I have to say. Now I'll answer any questions, but only from women. I'm sorry; I won't answer questions from men.

AUDIENCE Where are you teaching next year?

GEROWITZ Fresno State College.

AUDIENCE What kind of course are you going to teach?

GEROWITZ I'm teaching three courses. I'm teaching one class that's an all women's class, for twelve women who are seriously interested in being artists, or art critics. I'm teaching an earth class that involves working outdoors, working directly in a very large scale. And I'm teaching a seminar class that has to do with seeing and looking.

Judy Chicago *Snow Atmosphere*, 1970.
Performance on Mt. Baldy, San Gabriel
Mountains, California

AUDIENCE Do you know if people in other places are teaching courses like that?

GEROWITZ Probably not. I don't know. There's no woman who's teaching a course like I am, no.

No questions?!

AUDIENCE How do you define what makes art look like it was made by a man?

GEROWITZ First of all, it's a very hard question to answer because there's very little art that's made by women. That's very important art. But there are a lot of books that are written by women. Now, one of the things I've been doing the last couple of years is reading books by women, almost exclusively. And one thing I'm discovering is that when I look at work, or read books that are by men, there's always some kind of an emotional gap for me, like I can't completely identify. Generally, in men's books I can't identify with the women at all, because they're usually just objects in the books. Think about it. Or they're incomplete human beings. It's always the men in the books who are really the major figures, the ones who are doing things; and since I see myself as doing things, I always have to identify with the men in books. So that leaves a gap for me, an emotional gap in terms of my experience in reading a book.

It's the same thing in looking at art. I think that there's a fundamental difference in form organization between men and women. That is, my body is organized around a central core; I don't have any cantilever things. An erection is a cantilever; it's a physical and emotional experience of a cantilever. That's very foreign to me. No, it's true! See, men have this idea that art is asexual, that it doesn't in any way reflect their bodies or their limitations. But that's because they think that their perception of reality *is* reality. It never occurs to them that there's some other form of reality where they are perceived differently than they perceive themselves. There's this whole myth about art being asexual and a-racial. Do you follow what I'm saying? Okay. Men would never admit that their work is at all conditioned by their bodies; they would get outraged. Most men get outraged at that suggestion, but the fact is true. And one of the ways in which I've seen it operate is between my husband and me. We've talked a lot about it; we've seen a lot of things, such as moves that he would make and moves that I would make, that are very different.

I think also that it's very different experientially to be soft. I think it's very different experientially to have a sensation of going this way, of your body going this way, which I think women have. I think you can see it in Georgia O'Keeffe, you can see it in Lee Bontecou, and you can see it in my work very clearly. Lee Bontecou did a tremendous thing. I think there's very little recognition of what she did, but she did something fantastic. The concept of the cunt is of a passive organ, and Bontecou took that framework of a cunt—that's what those images are—and she made them a two-fold image. It's an aggressive image; it's a going-out image and it's a coming-in image. That's a profoundly different concept of a woman, that your cunt is not a passive hole. And it's not! It expands, it contracts, it tears, it bleeds, it has children, it opens, it closes, it comes, it does all kinds of things. It can fuck a cock. But nobody ever thinks about all of that because our concept is just some passive hole, and that's because we're thought of like that. And all that comes across in a work. For a woman to be able to put out another concept of herself depends upon her being able to see herself independent of the social demands of how she sees herself. You can see it in Bontecou, O'Keeffe, and you can see it in my work. And you can see it in a lot of writing by women, for example in Flannery O'Connor, Carson McCullers, Mary McCarthy, and Hortense Calisher. It has not just to do with the image of reality; it also has to do with how form is organized. Does that answer your question?

AUDIENCE How did a man-dominated society become so established?

GEROWITZ Well, I think it was a historical necessity. You see, I think it was a historical necessity for the planet to be tamed. And in that place, men have an advantage over women because they're stronger. There was also a historical necessity for population growth, so women had to have children. That was their main function in life because the race needed children. Men had to go out in the field because the race had to have the planet tamed for their habitation. But now we're carrying around a whole carload of historical baggage that grows out of what was once a historical necessity that no longer is necessary. In fact, we need to reverse all our trends. We have to stop having so many children; we have to begin to understand that raising children is a very important thing, and we have to begin to devote some energy to raising children in an intelligent way, and not raising more children than can be accommodated

Judy Chicago *Snow Atmosphere*, 1970.
Performance on Mt. Baldy, San Gabriel
Mountains, California

by the planet. We have to redefine ourselves as men and women. We have to stop raping the planet. We have to stop exploiting; we have to stop doing all the things that we've been doing. And that's what the revolution is all about. It's changing the entire path of human beings, because we are going towards destruction. It's time to re-focus, rearrange our priorities, and rearrange the society, in order to go another way.

AUDIENCE You say that what is needed is more real communication between men and women and a redefinition of roles; why is it then that you're cutting yourself off from the world of men after Fresno State?

GEROWITZ Because women aren't ready for a real dialogue with men. We'll come back when we're strong and we have something to say. When we know who we are and we can be ourselves, then we can have a dialogue. But not until we're in that kind of shape. Do you really think we're in that kind of shape?

AUDIENCE Well, maybe not as, not as–.

GEROWITZ I'm not. Are you? I'm not. Are you?

AUDIENCE I mean–.

GEROWITZ Can you not give in to a man?

AUDIENCE No, admittedly I do, not necessarily every day of my life.

GEROWITZ That's the reason. It doesn't matter if it's every day. That's the reason.

AUDIENCE So you mean that a person should redefine their own role until they're sure of it?

GEROWITZ You see, we have a slave mentality. We have to get approval from men. As long as we have to get approval from men, we reinforce the idea that they are really better than we are. We believe it. We believe it in our whole beings. I mean, you wouldn't ever say to yourself that they like what we're doing, or not like what we're doing. We can't have a dialogue, because they don't give a shit. And that's the truth and you know it. If you don't like it that your husband's moving somewhere, too bad. If you don't like it that he's taken some kind of job, too bad. You can divorce him, but too bad otherwise. We women care profoundly all the time.

AUDIENCE I see this whole revolution as a redefinition of roles. One thing that bothers me about your whole approach is that it seems like you have to separate men and woman completely. But it's not like a male couldn't decide that he likes childrearing, and that a woman, his wife or whatever, likes executive work, and why not completely switch roles and never think about, "As a man I have to do this."

GEROWITZ Because we can't. We're not in that place. I agree with you, that's where we should be. Where we should be is a complete breakdown of roles, where anybody can do anything on the basis of what they want, not on the basis of what they should. Men don't have to go out and be heroes; they can be soft and quiet if they want. And women don't have to stay home and make babies. It's a breakdown of all roles. We all could do everything, but we're emotionally not up to that. I don't think very many women are equipped to really, first of all, be aggressive or assertive about what they want.

AUDIENCE Well, how do you deal with reactions you get from men when you assert yourself?

GEROWITZ I've been getting used to tension. I really have. It used to wipe me out, because I was being a bad girl. I was not being a good girl; I was not getting patted on the head. But you want to know something really weird? I'm going to tell you something. I always used to be afraid all these terrible things would happen if I really said what I believed, really terrible things. But you know, I have more friends now than I ever had in my life. And I don't know exactly why that is, but maybe it's because I don't care so much about what other people think. Maybe it's because I'm not so frightened, and then other people who are around me don't have to be frightened either, so maybe everybody ends up feeling better. I haven't quite figured it out. All I know is it's a really remarkable, delightful surprise to me. But at first, when I first started, the tension that's in this room, or was in this room, would just wipe me out. I mean, I just backed down, all the time, and ran away because I couldn't handle it. But I just got to the point where I figured, "Look, all men are sexists; all whites are racists; that's the way it is. We don't even mean to be that way. That's how we're brought up to be; it's nobody's fault." And as soon as I began to realize that, I began to feel okay. "So everybody's going to get uptight. So what?"

AUDIENCE So your idea of not talking to men is, actually what you're doing is just cutting their balls off, is that right?

GEROWITZ No.

AUDIENCE You're castrating the shit out of us.

GEROWITZ Is it really? Well that's your problem. Your balls are your problem.

[FIGHT.]

Have you noticed the difference between the way the men are addressing me and the way the women are addressing me? You are not yet worthy.

AUDIENCE Getting back to art, what do you believe is the role of traditional art history, like 20ᵗʰ-century American artists, in a female art student's education, given the fact that most 20ᵗʰ-century American art is made by men?

GEROWITZ I think the message is very heavy; it's like, "Forget it, baby!"

AUDIENCE In terms of a specific work that women can relate to.

GEROWITZ Oh, wait. Rephrase your question. I didn't understand.

AUDIENCE Like, what can a female art student gain from looking at the works of 20ᵗʰ-century men artists?

GEROWITZ Well, obviously you can learn a lot about perceptions of reality, and that's the only art history we have. However, I think you have to understand that it's biased history, and if you approach it from that point of view, then you can take what's worthwhile from it. Which is a lot; artists learn about making art from other artists. But you have to recognize the limitation in what it can help you do, and you have to fight against the underlying message, which is: "This is the true reality."

AUDIENCE Aren't you sometimes accused of being unfeminine when you become aggressive and assert yourself?

GEROWITZ Uh-huh. I don't pay any attention to it; I think it's bullshit. It used to wipe me out, but not anymore because I know it's just a bunch of shit. Just another excuse why you shouldn't be human.

AUDIENCE What do you mean by feminine?

GEROWITZ I don't have any definition. I think the whole concept of masculine-feminine is ridiculous. I'm a female because I have a cunt; men are men because they have cocks; that's it. However, it conditions your perceptions of reality. Other than that, it should have nothing to do with anything you want to do.

AUDIENCE How do you justify your marriage?

GEROWITZ I love my husband and I want an emotional bond. That's what our marriage represents. We use different names, we live separately; our marriage accommodates the needs of both of us. We got married at the point where we knew that there was nothing that either of us would ever want to do in our lives that couldn't be accomplished in the framework of our marriage.

Any other questions? No? Okay, that's all.

REBECCA MCGREW Your exhibition for Hal Glicksman's Artist's Gallery program at Pomona was from December 12 to 20 in 1969. How did it come about that Hal invited you?

RON COOPER Let me tell you how I knew Hal. When I was in art school at Chouinard, in the early sixties, there was a guy who was making really cool paintings that had a show at Ralph Stewart Gallery on La Cienega, named Michael Olodort. Through him, I met Phil Hefferton, who was also a pop painter. Through Olodort and Hefferton, I met Hal and Gretchen Glicksman in Pasadena. They knew all the artists living downtown in those lofts.

RM Were you working on your MFA at this time?

RC Ah, no. I got pushed out of Chouinard by John Dean. It was the period, around '64–'65, when Chouinard was going to become CalArts. And Ed Reep, who was the head of the California Watercolor Society and definitely a fifties kind of painter, was the dean of painting at Chouinard. He began to fire cool people like Bob Irwin and John Altoon, and limit the input that we young students had. So we formed a student body organization. I was the representative for the junior year, and we had a meeting in the library. And Disney had six three-piece-gray-suited lawyers walk in. And we said, "Look, we're very happy to take classes from Ed Reep and the old school, but we want young, vital people as well." Anyway, Dean was one of those attorneys, and he said: "Look, we know what's good for your education. You limit yourselves to school dances and art sales. We'll take care of the rest."

And I stood up and gave everyone the finger. I said, "Fuck you. This is the end of my formal education."

RM What year was that?

RC In '64 or '65. I had been working eight hours a day at Chouinard, five days a week, and eight hours a day in my studio. After this incident with Dean and the Disney people, I was exhausted. It was just before lunch, and I collapsed on the sidewalk, sitting against the wall. All the teachers came out and shook my hand and said, "You did the right thing."

I went back to my studio and I took stacks of all the work I had done up to that moment and put it out on the sidewalk for the trash pick-up the next day. I decided that the things that were the most personal to me were a sense of scale; I grew up in a small town—Ojai, California. Instead of the abstraction of the city, where you go north four blocks and then you go east a block, and then north another half block, I grew up where you could see everything. I wanted to deal with a scale that was real, rather than abstract. Ojai is basically a bowl, just like James Turrell's crater.

RM That's right, Ojai is in a valley.

RC And it's filled with this incredible light. I wanted to deal with space, a sense of scale, and light.

When I was a teenager, I was really into hotrods; I was going to be the greatest car customizer in the world. Then, when I was eighteen, I went to Europe for a year. I saw all the great work in the museums, and realized that what I really wanted to be was an artist. But what was most personal to me were the materials and techniques of my time—the custom lacquer paint, nacreous pigment, surfboard resin.

RM Was this when you were working on the Vertical Bars?

RC Yes, and the Light Traps. The Vertical Bars had a scale the size of an American four by four (which are really 3 5/8 by 3 5/8 inches) and were seven to eight feet high. I thought a lot about the materials of construction and the tract housing in Southern California, that kind of density and volume. So I began making pieces that related to all these things.

RM Don't the Vertical Bars have many layers of pigment?

RC Yes, of nacreous pigment, lacquer, and transparent pigment, sanded many times, then more layers. Close to thirty layers of transparent pigment. At that time, I began to meet another group of artists. I shared my earliest work with Bill Petit, Terry O'Shea, who's dead, and Doug Wheeler. We hung out in each other's studios. And then Ron Davis became a part of this group of artists.

RM Where was your studio when you were part of this group of artists?

RON COOPER
INTERVIEWED BY
REBECCA MCGREW

*Ron Cooper's studio, Taos, New Mexico,
December 17, 2009*

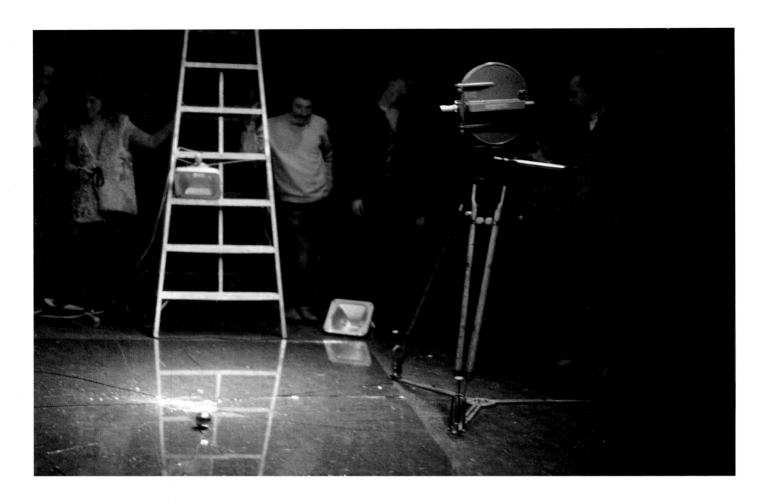

RC My studio was down on Figueroa and Pico. It was this beautiful, 6,000-square-foot loft. For a year, I locked the door and put a sign out that said: "Working, please call first." I started seriously working: days, nights, around the clock. The studio had that pebbled factory glass that lets only light come in. You can't see through it. It faced directly west, and I would sit down every day at sunset and just experience the change of the light. It was like a meditation, but it was before anyone used the word "meditation." There was a transition, the moment when it became absolutely dark or almost totally dark, but it was always hard to pinpoint it exactly. I lived that way for a year.

RM So this would have been 1967?

RC Yes, or '68. Somehow, another space opened up in Venice at Pacific Ocean Park, the old entertainment pier. I left downtown and moved to Venice. It was a great year. I was invited to be in a show in Europe called "Prospect 69" in Düsseldorf, Germany. The show was incredible, it included Donald Judd, Robert Smithson, Michael Heizer, Joseph Beuys, Wheeler, and me. It wasn't a big show, but it was a totally cool show to be invited to.

Before leaving for the show, Hal asked me if I would be an artist-in-residence at Pomona. Trying to get out of it, I said, "Sure, if you get me a cabin at the top of Mt. Baldy." Well, he did. So I couldn't say no.

When I left for Europe, I had to move out of my studio at Pacific Ocean Park and put everything in storage. Pacific Ocean Park was scheduled to be demolished, so I had nothing. I had no space. Coming back from Europe, the next thing I was going to do was go to Pomona. I had to fulfill this promise.

RM The artist-in-residency was in December of 1969.

RC Yes. What I had in mind was to get some giant boulders in the park across the street from the gallery. I wanted to set up a steel plate that was welded together—the biggest steel plate you could possibly get, about twenty by twenty feet—and have a crane drop a giant boulder onto this steel plate. I wanted to use the physics department to calculate what altitude, what wave, what strength steel, so that it would deflect the steel and bend it, and stop just before touching the ground. That was the vision that I had.

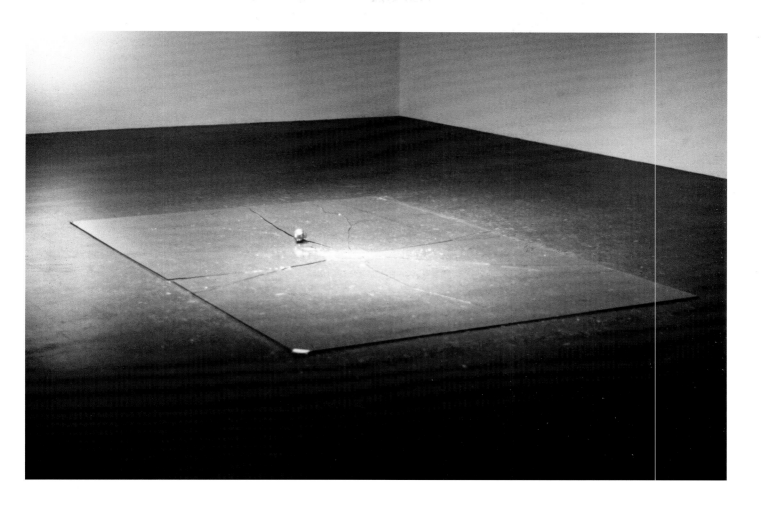

I was driving down from Mt. Baldy four days a week, hanging out and scheming on how to make this thing work. On the drive down from Baldy, along Baseline Road, were rock quarries. One day I saw this broken car windshield on the side of the road. Obviously, there'd been an accident, and the windshield had popped out. It was tinted from black to purple to blue to clear. It was just totally destroyed, but it caught my attention. When it became obvious that this thing was not going to happen with the steel, I switched over to glass. I had been working with big sheets of glass as molds for the resin pieces.

RM Was it disappointing not to realize your original idea?

RC I think making things happen is half of it, and I remember Hal and I both being disappointed. The other part of this was that Bob Smithson and his wife Nancy Holt came out to visit.

RM And that must be Smithson in the photo of you doing the *Ball Drop*.

RC He and Nancy came to hang out with me for four or five days. Anyway, with regards to the windshields' impact, I remembered that my art school buddy, Boyd Elder, hit his head on his windshield. I decided to work with the physics department to make these football helmets that were built-up with masking tape, kind of like skin. We mounted the windshields in a wood frame, holding them like a car windshield. We impacted them with a helmet to break them and get this drawing made from the cracks in the glass, which I really like.

RM In the installation were four windshields and *King City*, which was the floor piece. What was the relationship of *King City* to the *Ball Drop* film?

RC For the film, we had a metal ball hanging from an electromagnet, which was attached to a circular air conditioning louver on the ceiling. A wire went across and down the wall to one of those old-fashioned breaker switches. It broke the electricity—the current—and the ball dropped.

Ron Cooper *King City*, 1969. Glass and steel ball. 96 × 120 × ¼ in. (244 × 305 × .6 cm)

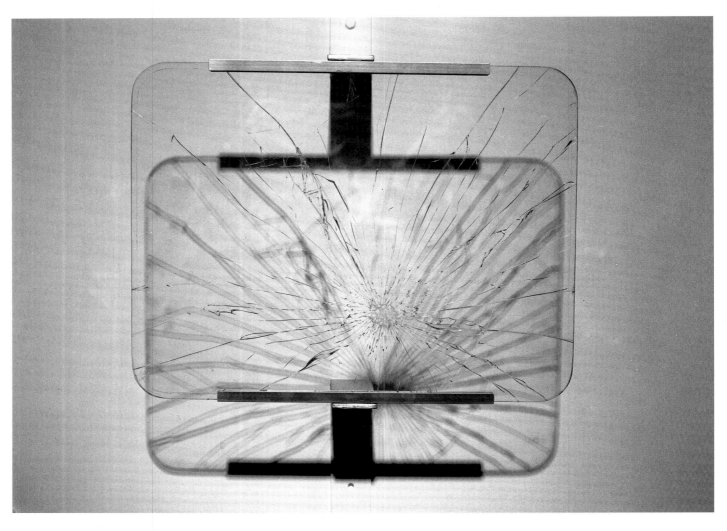

RM What a setup!

RC It was like a public performance.

The night of the Pomona opening event, Gretchen, Hal, and I had dinner at this steakhouse out on Baseline Road. At the end of the dinner, they went down to the opening, and I headed down in my pick-up. I looked through the glass front of the gallery and I could see all these people in blue blazers and khaki pants holding plastic wine glasses. And I said: "They're in there, and I'm out here. Adios, motherfuckers!" And I just headed off to Valentine, Texas, to hang out with my friend Boyd Elder. I didn't go to the opening. I drove out into the desert, spent the night in the back of the truck in a sleeping bag, and eventually got to Texas. I hung out down there for a while. Eventually, I headed up to New Mexico. I ended up staying in Truchas, New Mexico, for a year. I didn't even bother with Los Angeles. I didn't even bother with all that shit I had stored back there.

Basically, the whole experience liberated me—the whole course of losing the studio, going to Europe and having a wonderful time, and then coming back and doing this extemporaneous thing with Hal. So, for the year in New Mexico, I broke a horse, plowed with a one-man plow, watched the sun go over in the daytime and the Milky Way at night, and thought about making art. I was planning to build a studio there. I bought land.

But, I had a show at the Pasadena Art Museum; I had a show in Europe. And I had a show at Ace Gallery in Venice [California]. I had to go out there. Then we got this big studio in Venice. It was Jim Ganzer, Guy Dill, Michael Balog, Peter Alexander, and me. And I ended up stuck in Los Angeles again, and I fell in love.

RM But you kept your property out here in New Mexico?

RC Yes. And meanwhile I did these shows, Vertical Bars at Ace, large resin pieces in Germany. Then I did an installation at the Pasadena Art Museum that was called *Four Corners*. After that, I said, "Okay, I've done my commitments. Now, I'm not going to do this any more." I want to have an adventure, and that means I want to be free to make art in any way, shape, or form that is art to me. So, that's what I've lived. And it started right there at Pomona. The whole residency at Pomona was really a life-changing event for me. It was a radical time.

Ron Cooper *Rick Griffin B*, 1969. VW bus window. Approx. 16 × 18 in. (40.6 × 45.7 cm)

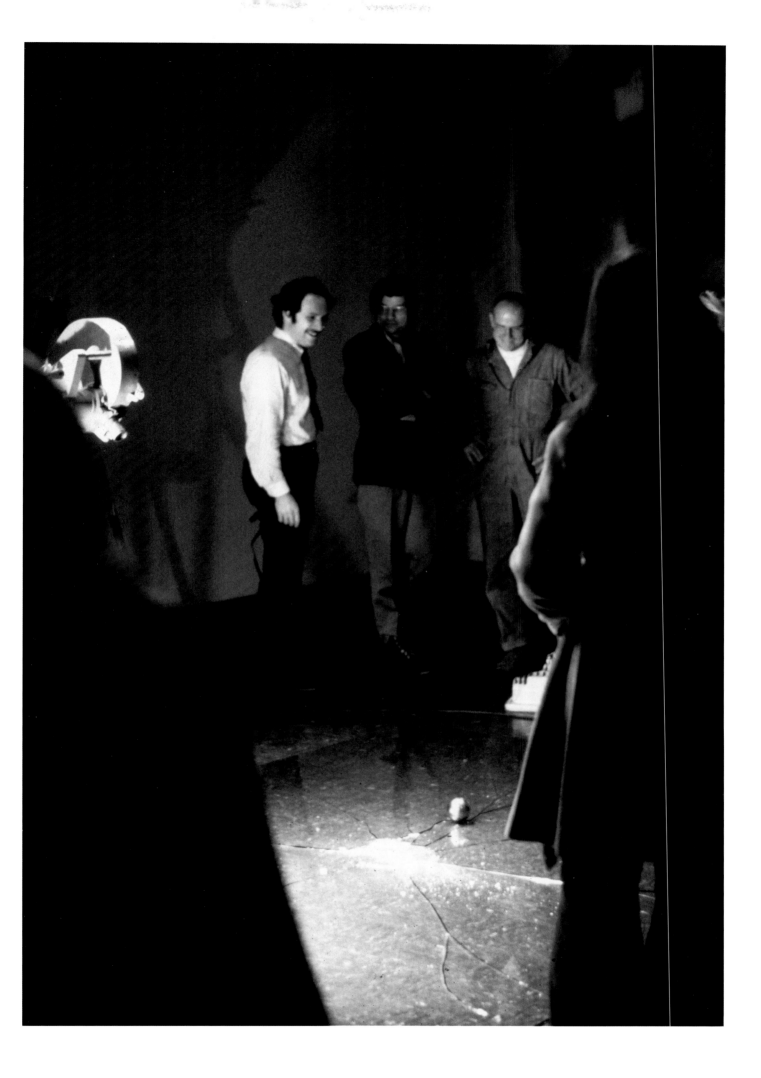

Ron Cooper *Ball Drop* (film set), 1969.
Pomona College Museum of Art. Depicted
in the photograph from left to right:
Hal Glicksman, Robert Smithson, and Mowry
Baden. Gift of Hal Glicksman. The Getty
Research Institute, Los Angeles (2009.M.5)

DAVID PAGEL I understand that you went to Pomona High School with Roland Reiss.

TOM EATHERTON Well, actually, he graduated before I got there, but we knew each other. I remember both of us drawing the model at a night-school class. I think it was in a park in Pomona. He was a friend of my family, too. When I was in high school, I went to Claremont a lot, to night-school classes at different colleges.

DP Just to sit in on them?

TE Oh, no. I was enrolled in extension courses. I was in a drawing class with Roger Kuntz and a painting class with Bob Frame. Other people, too. When I went to the University of California, Los Angeles (UCLA), which is where Roland also went, Craig Kauffman and Ed Moses were there, too. They were graduate students. I was an undergrad.

DP But at that time you already knew that you were an artist?

TE Earlier. Always.

DP Did you think of yourself as a painter or a sculptor? Or simply an artist?

TE Only as a painter. I still do.

DP Even with the installation work?

TE Yes. I think painting is a tradition. Even calling it painting is kind of slighting it, you know. Paint is what you make it with. But it's much greater than that. It's a whole dialogue across the centuries.

DP A way of looking or thinking about things?

TE Well, you know people made those things. When you make a thing, an object, it's not like acting or performance. It's not like writing, where you may have several editions. Most often it's unique. You make it, and it goes out in the world. It has its own existence.

You are its first viewer. You have a vision. And you try to make the artwork as close as possible to that vision so that it will trigger a response—an experience—so that hopefully the viewer will have that experience as well, or something very similar. And I just think that's too profound to be called painting. It's like calling writing typing.

DP Before you made *Rise* at Pomona in 1970, you made more traditional paintings?

TE Yes. In 1958, I actually did some Abstract Expressionist paintings, and they really meant a lot to me. Abstract Expressionism...those artists just really totally turned my head around. Because all through high school and college I was grappling with lots of figurative art attempts, trying all kinds of different solutions, experimentations, and so on. And then about a year or two after I got out of UCLA, I did this series of Abstract Expressionist paintings.

I'd been trying to understand that ethos. Those guys were so committed, and they were so rigorous. For me, it was very clarifying. It burned away the irrelevancies. So, I actually got brave and did some myself.

DP Your paintings from that time strike me as being structural, as stubbornly built.

TE It was conscious. They were consciously made on the grid, but with the painting gesture. That's just where I was at, at the time. Later, I did clearly formalist paintings, geometric abstractions, and works of that sort.

DP And these led to works like *Rise*?

TE In 1966, I was doing another series of paintings. Most of them were four-by-four feet. A few were six-by-six feet. And I did one that was only about two-feet square. It was painted on unbleached muslin that I didn't size. I didn't paint it white first; I masked the points right on the muslin and I painted an opaque black or dark blue surround.

It was little and I was playing around. For some reason, I took it home. I was married at the time, and I took it to our apartment. We had a breakfast nook and I propped it up on the table in the breakfast nook. I went away and I came back later. The sun was shining through the window and it was shining through that muslin. And these points were lit up in my painting.

DP An epiphany?

TE Until then, I didn't know what I wanted to do. Besides making these paintings, I had been making these little corrugated cardboard maquettes. They were just geometric forms. I said, "You can see that form clearly because you're looking at it from the outside." After looking at these things for a little while,

Tom Eatherton's studio, Santa Monica, California, June 4, 2010

OPPOSITE

Installation views of **Tom Eatherton**'s *Rise* at Pomona College Museum of Art, 1970. Gift of Hal Glicksman. The Getty Research Institute, Los Angeles (2009.M.5)

FOLLOWING SPREAD

Tom Eatherton *Rise*, 1970. Light environment consisting of incandescent bulbs, two layers of nylon diffusion material, and wooden support structure. 122 in. high × 432 in. long (310 × 1097 cm); width extends from 36 in. (91 cm) at opening to 192 in. (488 cm) at widest part. Collection of the artist

TOM EATHERTON INTERVIEWED BY DAVID PAGEL

I realized, "I don't want to look at them from the outside. I want to look at them from the inside."

DP And the painting in the breakfast nook suggested a way to do that?

TE I was looking at that light coming through those points, and I thought, "That's it. I can make those pieces. I can get inside them. If I bring the light in, that's it, that's the information."

And then I did this other thing that really blew my mind. I took the painting down, a simple gesture, and I looked at the window. It didn't have curtains; curtains were too middleclass and too much trouble. Ever since we were college students, we just took old sheets and stapled them around the window frame. That's what was in the breakfast nook. All this light was pouring through this white cloth. And I said, "No, not the points—"

DP It was already there and you didn't see it.

TE That's it. That's the light. And the next day, I started to make *Home* (1967), my first piece in which light was the primary aesthetic component, and the viewer was completely surrounded by the artwork.

It was a considerable breakthrough for me. I hadn't even considered anything like this before.

DP But you still think of it as painting?

TE I still think of it as painting because, as I said, I think that painting is a tradition that touches on so many things. I went to Washington, D.C., to see the Vermeer exhibition. I felt like he was talking to me.

DP Right in the present.

TE Yes! Right there. I'll never forget that experience. Claes Oldenburg said the same thing. He said that he was a painter. Even though his things were in three dimensions, he still considered that to be an extension of painting. So what I thought is that I had taken those geometric abstractions to a point. The points got smaller and smaller; the lines got thinner and thinner. And the way I think about it is that I pushed through the picture frame, and invited the viewer to walk around in the painting.

DP You didn't want the viewer to be looking at an image.

TE From the outside.

DP You wanted the viewer to be in the painting, looking out, seeing painting everywhere.

TE Yes. Everything they look at when they're inside is the art.

DP What happened next?

TE Well, the first problem I had was that it had to be big enough to get a person in there. And after I made three, more-or-less on the scale of a solitary viewer, I realized that they were too small.

DP Claustrophobic?

TE Not for me, but I thought it might be for others. And just at that point, Hal Glicksman said, "I'm doing this series of exhibitions at Pomona. Take the gallery and do whatever you want to it." I had done three; I was ready. The problem was getting some kind of industrial material that was big enough. In 1967, all I knew about was photo background paper. That's what I had used for *Home*. I lit it from the outside. But photo backdrop paper has these little marks that you see when it is brightly lit from outside. So I kept lowering the light until it got to be sort of low, gray, and uniform. Still glowing. And then I thought, well as long as it has to be dim like this, why not use blue light, because I love blue light. I bought the bulbs and was very pleased with the results. The second one, *Float* (1968), had an octagonal footprint. Its floor and ceiling were black, like in *Rise*. And because its panels were narrower, I could use this white plastic that I'd been experimenting with.

DP Plexiglas?

TE No, it was a shower curtain material. It had this beautiful, polished surface when it was stretched taut. It allowed me to work larger. And in 1969, I made a curved piece, *Arc*, which was sixteen feet long, eight feet high, and about five feet wide. I lit it with blue on one end and red on the other, and then interspersed blue and red at the top so that it blended. All of these three works were a size that I could do in the studio, take apart and put back together again.

DP So *Rise* was a breakthrough in terms of scale.

TE Oh, *Rise* was definitely a major piece. The earlier ones were fascinating to me because of the development they provided.

DP They were almost like prototypes?

TE No, they were independent artworks, but I learned everything from them at the time. Like the last one with the curve, I was thinking, "I could turn this thing on its side, and the curve would go this way, and mimic our visual screen." So when I got this opportunity [at Pomona], I thought, "I'll take that and I'll double it, and have them face each other." And that was basically how I came up with *Rise*. And it just worked out really well.

DP And is that the first time you did it that way?

TE I had been experimenting with all sorts of things. I stretched different kinds of materials, to see what their properties were, reflective as well as translucent, even aluminized Mylar, which is a mirror, basically.

But mostly what I got out of doing this was that I built a framework that fit inside another one so that there was a space between their two surfaces. It was white but also translucent. And when I lit that, I really had something. The double diffusion makes the quality of light that means an awful lot to me.

DP How did it work?

TE For *Rise*, all we needed was a little negative air pressure behind where the lights were. The air goes through the cloth front surface, which is this beautiful nylon, but it does not go through the plastic behind. It makes a big balloon, a big tube that goes all the way around that curve. Nobody can see that. All they can see is the quality of light, and people go up to that cloth and—

DP It's magic.

TE It's moving. I mean I wasn't trying to trick anybody. But an old girlfriend of mine took her six-year-old son to *Rise*, and he reached down to feel the floor he was standing on, to see if it was there.

DP Perfect.

TE I don't think anybody was ever disoriented or anything like that. There is a sensory deprivation quality, but it's not bothersome. If anything, these pieces are very calming. That was my intention, to show the light without distractions, to make it, I don't know, meditative. I spent a lot of time in those little pieces I made in the studio and I got a pretty clear idea of what I was after.

DP Whom were you talking to at the time?

TE I was sort of an urban hermit. I was lucky to show in public venues, in university galleries and museums, but seldom at galleries.

DP But in those days, many artists didn't think about careers or sales. They focused pretty exclusively on the art.

TE Yup. That was me.

DP When I interviewed Michael Brewster and John White, they expressed similar sentiments. Neither was interested in making art that merely documented something that happened somewhere else. You were putting people inside paintings, a first-hand experience if ever there was one.

TE It's really about perception and experience. And those are the two things I think about when I'm working. You know, I don't think that geometric abstraction is that remote. First of all, it led me to working with light. But it's about perception as well. It's not about reference. It works on you. It's direct.

DP What came after *Rise*?

TE After *Rise*, I did *Trip*, in 1972, because I wanted to make a piece that was on the interface between the inside of the studio, where things get made, and the rest of the world—without galleries or museums or anybody coming in between or interfering. But the next major piece I did was at the Pasadena Art Museum. *Move* (1972) was sixty feet long and twenty feet wide.

DP The structure was similar to the curved one from 1969?

TE When I made the small one in '69, the overhead part was sixteen feet long. I actually did another proposal for Pasadena, but Norton Simon was moving in. He took over the biggest room. I couldn't do the piece that was going to be fifty feet across, which was a big circular cone that had sections. I've got a lot of proposals I never got to build. I keep wanting to do the next thing, or another thing. If I had the opportunity, if there had been venues and budgets available to me, I would never have stopped. I would have just kept doing these things. Anyway, *Move* worked out fine. I custom-dyed the lamps to create blue incandescent light. I clustered the lamps in the center of the ceiling because I wanted the light to blend from dark

to bright and back to dark. *Move* also had the double diffusion setup of *Rise*—a cloudy layer and a white layer and light behind. And that—

DP Softened it.

TE Oh, yes. It gets me. And I've seen it get other people.

DP That's why you called it *Move*?

TE Actually, the curves in these pieces are associated in my mind with the curvature of the earth and its rotation, the orbit of the earth around the sun. Big curves, you know. At Pomona, when we got that piece done and were walking around in there, Hal said, "What do you want to call it?" I said, "I don't know." And he said, "Well, it reminds me of a sunrise." And I said, "Well, it reminds me of a moonrise." So we called it *Rise*.

DP The blue is lunar, quiet.

TE Sometimes when you're in there, you can't see color. But when you look at other people, they're all pink. Your eye is actually compensating. When you cut down on the information that people get, like in a room like that, the eye compensates. The camera can see things that the eye can't, but the eye can see things that the camera can't. And the pieces are made for the eye, so the photographs don't get it. The photographs are just approximations. Standing in front of the painting or whatever is the real thing. It's the real deal. These kinds of pieces are made for that circumstance. I'm working with people's perceptions in order to create an experience.

DP Did people talk about Light and Space art at that time?

TE That term came from Jan Butterfield, as far as I know. I wasn't in on it. I don't know all the history. To call some kinds of art Light and Space is just like calling it a painting. You're identifying it by what it's made with physically. And that's limiting. I mean, the experience I had in Washington, D.C., with Mr. Vermeer, it couldn't be any better than that. Experiences like that are not defined by materials.

DP Material is the vehicle.

TE The art experience touches, I think, on lots of things, lots of other disciplines—physics, philosophy, and the enlightenment experience. It's emotional, it's intellectual, it's intuitive, and it's physical. Personally, I think that your whole nervous system—your intestines, everything—is involved and activated by that experience.

You remember the Norton Simon Museum when it was the Pasadena Art Museum? They had an Abstract Expressionist exhibition, all kinds of marvelous stuff. I'd been through the whole exhibition. There weren't many people there that day. I was having a great time. And I thought, "I'm going to get tired pretty soon, I'd better go and look at those Clyfford Stills again." So I started walking down this hallway and out of the side of my eye, I must have seen—but I wasn't conscious of seeing—this Jackson Pollock. All of a sudden, I lost my balance. I almost fell on the ground. It was because I had seen the Pollock out of the side of my eye! It grabbed me and I very nearly fell on the floor.

Long after that, a psychologist, Ed Wortz, told me that your right brain controls the center of the vision of your right eye. And your left brain controls the center of the left eye. But that the right brain controls the right peripheral vision of both eyes, and the left brain controls the left peripheral vision of both eyes. So when I was passing that Pollock, I was seeing it with the right peripheral vision of my left eye, and the right peripheral vision of my right eye, and if [I was seeing] anything with the front, it was with the right eye. That means it was only my right brain that was getting this image.

DP An overdose?

TE Something I didn't have a chance to label or analyze.

DP Pure experience?

TE Yes.

Tom Eatherton *Rise*, 1970. Light environment consisting of incandescent bulbs, two layers of nylon diffusion material, and wooden support structure. 122 in. high × 432 in. long (310 × 1097 cm); width extends from 36 in. (91 cm) at opening to 192 in. (488 cm) at widest part. Collection of the artist

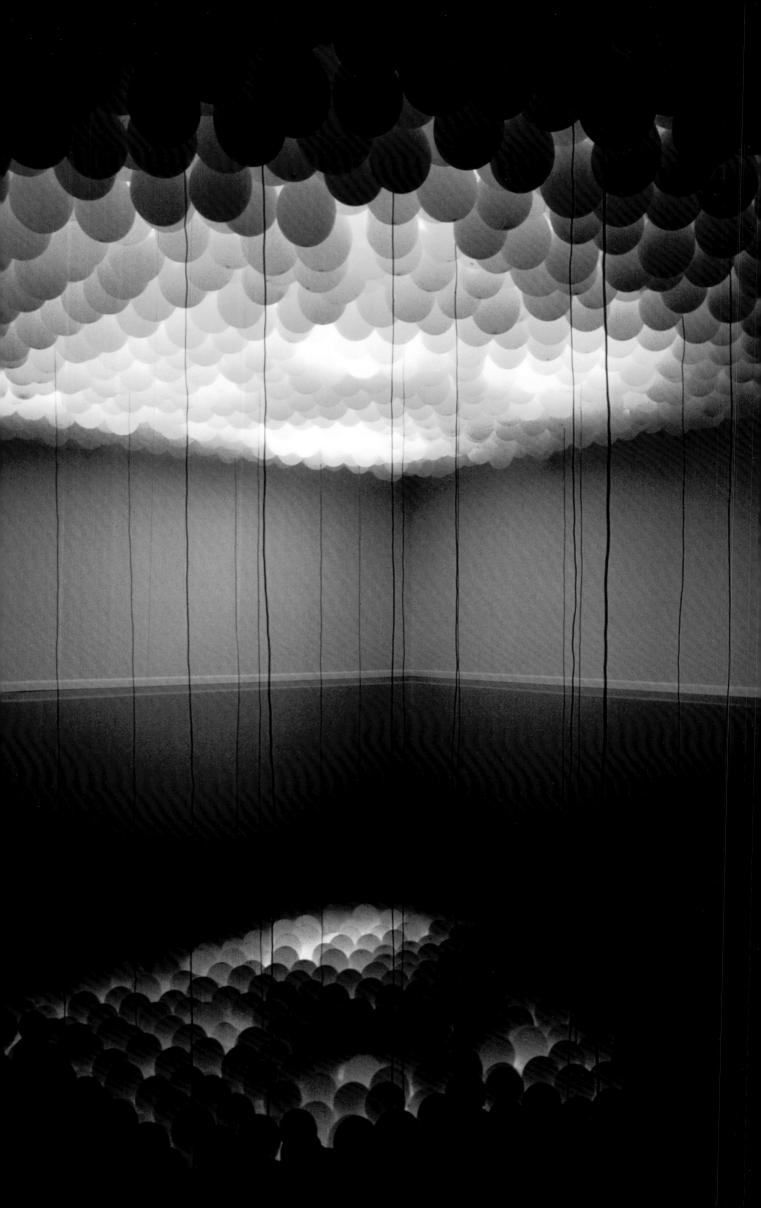

GLENN PHILLIPS You studied art at the University of California, Los Angeles?

LLOYD HAMROL I did, and then I went back and spent four years in graduate school there for a master's degree. I think I was probably one of the most difficult people for them to eject from the program. I don't know anyone else who spent four years in that program. When I graduated with a BFA, one of my teachers, Jan Stussy, said, "So what are you going to do now?" I said, "I don't know." He said, "Don't go out there. It's scary out there; you should come back to school."

GP What did your sculpture look like around the time you were finishing the graduate degree?

LH Well, I wanted to cast, but I had some disasters with casting. We didn't have a casting facility at UCLA then. I had done these wax pieces, and I looked around town for someplace to cast them in bronze. I found a foundry out in the valley, but they really weren't lost wax casters. They did a piss poor job of burning them out, and when they poured it, there was an internal conflagration between the wax and the molten bronze—things were shooting around. I thought I was embarking on something that would be my thesis show, and I got half a piece. I was so depressed after that. I said, "Okay, no more hot industrial processes." So I started making these laminated polychrome constructions out of plywood, cut with a scroll saw, nailed together, and glued up.

John Coplans saw what I was doing, and he was very supportive. He was involved with Finish Fetish, the refinement, that sort of elemental geometry, and he told me that I was going to have to learn how to spray paint. Judy [Chicago] and I—we were neighbors at the time—enrolled together in an auto body finishing school in downtown Los Angeles, and we learned about spray painting. I realized that I couldn't really build a spray booth in the studio I was in, so Judy and I decided to move together into the same place in Pasadena. This was in late 1964. We turned that studio into a paint factory.

Then I sort of lost interest in the spray painting thing. When I made *Goodboy* (1965), the canvas and plywood triangular sculpture that Los Angeles County Museum of Art owns, I simply used paint rollers. Then, when I was making *5 x 9* (1966), a set of adjustable, modular sculptures I showed at Rolf Nelson in 1966, I started looking for craftsmen to make it. So within a

year I moved from doing everything myself to beginning to employ other people to make the things I wanted to make.

GP Was that about getting the level of finish you wanted?

LH When I was in school, we were looking for signature and authenticity—the artist's hand, and that sort of thing. Then the whole paradigm shifted from expressionism and individuality to the artist removing himself or herself from the work by degrees.

GP Were you watching what was happening with Minimalism and with developments on the East Coast?

LH Kind of. We were all reading *Artforum* at the time. Bob Morris was beginning to pound away at his philosophy. But then also around that time there were other things going on that had to do with participation. So I had an impulse to make these discrete forms, and I had this other impulse to go out and do stuff that disappeared. That's how we got into those dry ice environments in 1967. Before that, we did a feather environment at Rolf's gallery.

GP Where did you get the feathers?

LH From a chicken plucker! There was a place down in South Central. A guy used to pluck chickens for the bedding and pillow industry.

GP And the gallery walls were covered in plastic.

LH It was inflated. They were bags that we blew up, so they became pillows. We had a drop plastic ceiling, convex pillow walls, and the floor was covered in feathers.

GP The reviews from the time say that it was this incredible, ethereal kind of environment—but then the smell—

LH It was a killer. You couldn't stay in there for very long. It was just the aroma of hundreds of pounds of chicken feathers and talcum powder. The smell factor. It was dynamic in there. [Laughs.]

GP What about the dry ice environments, which you collaborated on with Judy [Chicago] and Eric Orr?

Lloyd Hamrol's home, Los Angeles, California, June 15, 2010

LLOYD HAMROL INTERVIEWED BY GLENN PHILLIPS

Lloyd Hamrol *Situational Construction for Pomona College*, 1969. Balloons, lead wire, plastic sheeting, water, and colored light. Dimensions variable. Gift of Hal Glicksman. The Getty Research Institute, Los Angeles (2009.M.5)

LH Well, the whole thing came about from the efforts of a group called Aesthetic Research Center. It was a collection of like-minded people, including Oliver Andrews, Charles Mattox, and a few other people. We got Alcoa Aluminum to sponsor us. They were investors in the development of Century City. All of the artists were able to use sites within Century City. It was approaching the holiday season in 1967, and we wanted to do something in the context of this development that was rising around everybody. We also took into account the season, since in Los Angeles you never really have the cold. We wanted it to be the inverse, in a kind of satirical way, of the positive energy that was going into the construction. So as their construction went up, ours disappeared. Union Ice Co. donated all the dry ice that we needed, and Stanley Grinstein lent us his forklifts. We designed two pieces. The first one was a set of parallel but staggered walls in an undeveloped lot, adjacent to a new, rising building. These rows were like hedgerows of dry ice. They felt like footings or foundations for something, and the sublimation would come up at different times of the day in different densities. Eventually the nice, uniform, regular blocks began to soften and shrink, until at the end they were just these little imprints or retinal afterimages on the ground. It was a fun thing, and it made the whole space cold.

The second venture was a series of step pyramids in a shopping mall in another part of Century City. We would finish one, which would take an afternoon, and then go on to the next one. This happened over a series of days, so by the time we got to the last one, you had a succession of changes in form. We really liked doing those things. We liked the building process, and then the kind of anti-building process.

GP What about your *Raymond Rose Ritual Environment* (1969)?

LH It was kind of the alternative to the Rose Parade. It took place the night before. Our building was on the corner of Raymond Street and Colorado Boulevard in Pasadena. It was a 5,000-square-foot space, and we had this perfect view of both Raymond and Colorado. We put this piece together with Barbara Smith, and with these guys who used to work with Sam Francis. They were liquid light people.

GP Single Wing Turquoise Bird?

LH Yes! That was them. We went to the city and got permits, and we commandeered the street for the evening. We had to get rent-a-cops. We fabricated these helium-filled polyethylene arches that went across the street, and from the roof of a building across the street we dropped an enormous screen fabric. It came all the way down and covered up the windows of the building. Then, from my studio, Single Wing Turquoise Bird projected their stuff. It was very New-Agey. Did we have "New Age" then? It was hippie stuff. [Laughs.] Lots of unclad women in yoga postures, lots of music blasting in the street. Then, as night descended on Pasadena, we had our crew go out with these smoke machines and we fogged the whole street. People walked through the crowd with roses, handing out roses in the fog. It was a raucous thing. The street was absolutely jammed with people. And then the motorcyclists showed up. And then the cops had a good time, you know. But it was beautiful chaos. It was totally atmospheric.

GP How did you meet Hal Glicksman?

LH Hal Glicksman lived up the street from us on Colorado Boulevard. He had this wonderful old second floor space in the old Elks Hall. It was absolutely huge. It was a whole environment of Hal and Gretchen's treasures, exquisite things. Phil Hefferton was nearby, and Clark Murray was around the corner, and Ron Davis. Bruce Nauman had moved to a studio a couple blocks away. It was a community.

Lloyd Hamrol with balloons and Polaroid photographs, 1969. Gift of Hal Glicksman. The Getty Research Institute, Los Angeles (2009.M.5)

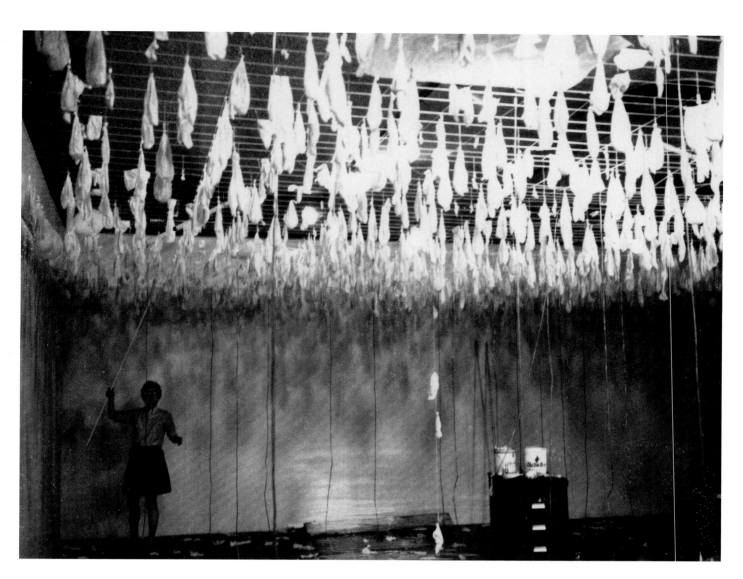

GP Let's talk about the piece that Glicksman invited you to do at Pomona. Could you describe how that piece, *Situational Construction for Pomona College*, looked?

LH It looked like the ceiling and floor had been opened up—ripped out, somehow—and this land-scape-like condition was running through them. Pendulous white balloons were packed closely together, behind which were floodlights and theater gels that colored the balloons. There was a crepuscu-lar, sunset-like quality in the light coming through. The light was uneven, and there was a sense of some light source beyond or above. Coming from spaces

between the balloons were a discrete number—not too many—of 1/4-inch lead wires that had little wrig-gles in them. They were slightly irregular rather than being mechanically straight lines, and they felt like rivulets of rain running down. Two inches of water flooded the entire floor, filling a black polyethylene liner. You really couldn't tell how deep it was. And the sky above was reflected in the water, as were the little lead wires, so the whole thing popped vertically. It went from being a room with given and known dimen-sions to a room with some unknown dimension in the vertical axis. And there it sat.

Gretchen Glicksman de-installing
Lloyd Hamrol's *Situational Construction for*
Pomona College, 1969. Gift of Hal Glicksman.
The Getty Research Institute, Los Angeles
(2009.M.5)

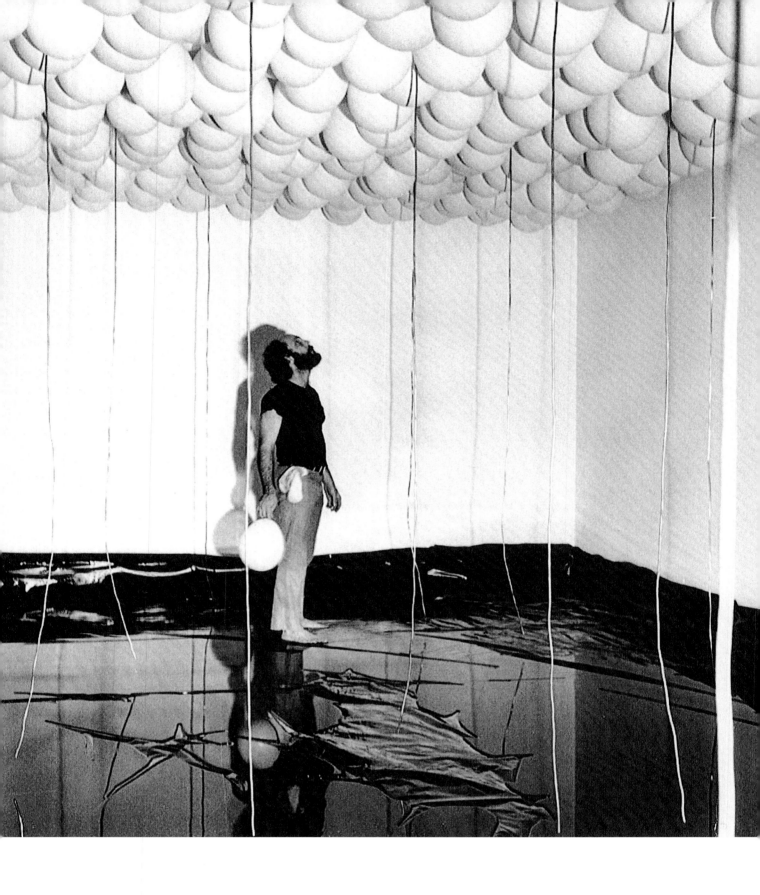

Lloyd Hamrol installing *Situational
Construction for Pomona College*, 1969.
Gift of Hal Glicksman. The Getty Research
Institute, Los Angeles (2009.M.5)

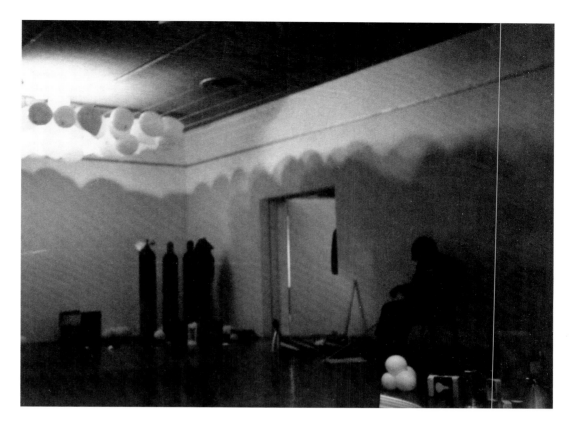

When I first started working on the show with Hal, I didn't have this piece in mind. I think that the site and circumstances had a lot to do with the resulting work. Rolf Nelson had shown a Georgia O'Keeffe painting once. It was one of the cloud series, and it really grabbed me, the recession of those clouds. I think that O'Keeffe was somewhere in the back of my mind, and the largest way that I could imagine doing it was to fundamentally establish a landscape. But if this is going to be a landscape, how do we expand the space? A mirror would work very well, but how do you do that in there? I started thinking about water, but it was all very iffy. Is it just going to look like a room with a wet floor, or can we actually make it feel like something else?

Hal was supportive without hesitation there. He didn't voice concern about any of the problematic issues with using water, etc., so I just started looking around, going shopping. In those days, the Internet didn't exist. The Yellow Pages was my bible, and that's how I found everything. At a certain point, it became clear to me that you would have to approach this work from the outside.

GP Viewers could only see the piece through a window, right?

LH I wanted the sense of surprise, that you round the corner and come to this window. What's that on the other side of the glass? It's another world. It reinforced the kind of specialness of it. You can only have it through this one channel of perception. You can't walk around it, or into it. It was like a dioramic peephole Easter egg. In doing that, I set up a kind of desire and frustration with the spectator. It was about a longing. It was a very romantic kind of thing. And clearly, if people had gone in there, the piece would have been destroyed. It was entirely fragile.

GP Did it feel as if you had maybe captured, for a moment, the same type of ephemeral performances that you had been doing?

LH Probably, yes. Many things played into finally pulling this piece together. The window was also like a car window. You know, I've driven through Southern California, the Central Valley, and I was used to looking out at certain times of day over that landscape. You get a kind of longing. You have that for certain landscapes. You know that it's a fiction--it's a momentary realm—but it's that romantic idealization that's the fun part. The Pomona piece was kind of like driving past the landscape. It's as close as you get.

Lloyd Hamrol installing *Situational Construction for Pomona College*, 1969. Gift of Hal Glicksman. The Getty Research Institute, Los Angeles (2009.M.5)

ROCHELLE LEGRANDSAWYER In the fall of 1969, you worked with Hal Glicksman to install a disc in the Pomona College Museum of Art, which was up for the 1969–70 school year. When you started making the discs, did you have a particular effect in mind?

ROBERT IRWIN Well, yes, I had very specific things in mind when I made the discs. It was a very simple set of questions, really, because I'm a very simple person. The question was, if something is in the painting that doesn't actually contribute to the painting in a way that merits it being there, then is it actually a distraction? I started taking out those things that were not really contributing, and in that process things kept becoming more and more sparse. My first breakthrough was realizing that when it's working, two and two don't make four. They never make less than five. All the actions and interactions may not actually be there in the concrete sense, but they're there in the perceptual sense.

For me, that was a big deal. I wondered, "Could I paint a painting without a mark, without a line?" Because I realized that in some way or another all marks are part of a sign system. So I made these stretcher bars. They were six-by-six feet and very slightly curved in all directions. It took me a year just to build these stretcher bars. And they worked, in a way. They had a kind of energy to them. But being a painter, I couldn't just leave it at that. I still had to do something. I made a series of dots on them, bright red dots, very carefully put on, not too ordered, not too disordered. And they went out all the way to the edge and slowly became less and less. Then I put a bright green dot in between every red one, and they canceled each other. What you had was like a field of energy, but slightly circular. In that interval, while they were manifesting themselves for the first time, I saw the frame. And then I looked around at the world and said, "There are no frames in the world, in that sense." That's not how we see at all. How can we carry on the entire dialogue about art within something that is, in fact, arbitrary? We see the world with all of our senses; we're wrapped in an envelope of it, which is a continuum. Well, that blew my mind. How do you deal with that? How do I paint a painting that doesn't begin and end at the edge? Now the square, of course, is rather demanding, because of the corners. So I took off the corners, which made it round and more neutral, and I stood it off from the wall slightly. The key was for the edge to become lost in its own shadows. The painting didn't begin and end at the edge. The discs were a beginning of one kind.

They broke the magic of the frame. The idea that we can actually conduct everything within that frame is a highly stylized, learned logic. You realize that the frame is very limiting. Look around—that's not how the world presents itself at all.

RLG You talked about taking the mark away, so that there wasn't so much of a sign. Were you able to find any way to disengage people from "I see 'x' and it means 'y'"?

RI You know, the thing about something like that is that you don't do it for that reason. There are two big myths in the art world. One is the idea that the purpose of art is to communicate. And the other is the idea of expression, that I'm expressing myself in some way. In terms of expression, there's nothing that I can think of that is not an expression. If that's true, then obviously that can't be a real reason for the whole enterprise of art. The other is communication, and my questions are: What? How? And to whom? It's not about me telling them "how," or "what." I'll assume I've got something of value to contribute, and the best I can do is put it in the world.

I do have one responsibility, and that is, if you ask me a question—no matter how simple and naïve, or how complicated and sophisticated—I have the obligation to try and answer that question. But whatever my answer is, it only has value for that specific question. It's not universal. It's a specific answer for a specific question in a specific set of conditions. And so, on the basis of that principle, I said I would go anywhere, at any time, for anybody, for anything. And basically I did that. Over the last forty years, I have spent time in at least one university in every state but two. In California, I've been to every single campus of the University of California and every campus of the state colleges.

They say, "We would like you to come and we'd like you to do this and this." I say "fine," with one caveat: I won't do studio visits and critique work. And the reason is simple: On what grounds can I walk into somebody's intimate life space, where they're struggling with something, and make comments on it? Do I know what art is? I don't. For me, teaching was always a very intimate kind of thing. You basically deal with the person, essentially trying to understand their strengths and weaknesses. The key is that you don't teach somebody something; instead, the name of the game is to work with them. Not teach them, but work with them to develop that sensibility.

ROBERT IRWIN INTERVIEWED BY ROCHELLE LEGRANDSAWYER

Robert Irwin's home, San Diego, California, May 22, 2010

Robert Irwin *Untitled*, 1968–69.
Acrylic lacquer on formed acrylic plastic.
Diameter: 54 in. (137.2 cm). The Museum
of Contemporary Art, Los Angeles.
Gift of Lannan Foundation, 97.56

RLG Does this mean your role as an educator is similar to your role as an artist?

RI Yes, my art, anything I say, my opinion, is only another topic for discussion. You don't know what a student is going to do in ten years. And they don't know what they're going to do in ten years. So if I give you some kind of critique, I, in a sense, become really helpful for the moment, but restrictive in the long term. So you have to put all that aside and attend to the students. Chris Burden is a perfect example. The first thing I had to decide was: Is this guy crazy?

RLG That's a good first question. You taught Burden at the University of California, Irvine, from 1969–71?

RI Yes. And the second question was: Is he danger-ous? In fact, when it was time to get him out of school, they didn't want to graduate him. I'm the one who said, "You graduate him." Because the first thing I realized was that he's not crazy at all. He very carefully thinks everything through. Completely controlled. Once I knew that, we spent a lot of time talking and working with what he was doing.

RLG Did living in Los Angeles affect your work?

RI I remember when I first went to New York, every-body said, "L.A., there's really no history there." I thought, they're actually right. But if you want to play the game I'm playing, which is breaking out, changing, putting stuff up for grabs, it's not a bad place. We don't have all that stuff to break through.

RLG Absolutely. Places like Paris and New York are very invested in preserving their history. Whereas in Los Angeles, the whole point is that you're making it up. It really does breed a certain kind of work.

RI It does. It's very fluid. People in New York can't understand it. And it really irritates them, for example, that I had a happy childhood. [Laughs.] They have all this angst. Man, I say, how about joy? Give joy a try. It's corrupting, but it's no more corrupting than angst is. At fourteen years old, I bought a car, a '34 coupe. When I was sixteen, [claps hands] the world was my oyster. It was fluid, and I was mobile. I'd get in the car, get a Coca-Cola, and drive on. Whew! I'm in seventh heaven! I still do it. My car is like a 1940s big band, you know. I put my sounds on, I get my Coke, and just go.

RLG You can't do that in New York.

RI No, you can't. New York is terrific. You can do all kinds of stuff. But I'm L.A. through and through. I have all the bad habits, or good habits, whatever you want to call them, and I have no shame about it at all. In fact, I think it really was why the Ferus Gallery be-came the Ferus Gallery. We were the first generation to not go to New York. I flirted with it. We all sort of flirted with it. If you want to think in terms of career, staying definitely did not service our careers very well. But we all had a sense that we were doing some-thing we were after, so we all stayed here. We were the first generation to stay home.

Robert Irwin *Untitled*, 1965. Sprayed acrylic
lacquer on shaped aluminum. Diameter: 60 in.
(152.4 cm). The Museum of Contemporary Art,
Los Angeles. Gift of Lannan Foundation, 97.54

PART 2

HELENE WINER AT POMONA

BAS JAN ADER
Exhibition: "Bas Jan Ader, William Leavitt,
Ger van Elk," January 18–February 20, 1972

JOHN BALDESSARI
Exhibitions: "Monoprints," December 5–26, 1970;
"ArtForms Abstract Activities Ideas: Exhibition of
Conceptual Art," Pomona College Museum of Art
and Libra Gallery, Claremont Graduate School,
April 23–May 11, 1973

GER VAN ELK
Exhibition: "Bas Jan Ader, William Leavitt,
Ger van Elk," January 18–February 20, 1972

JACK GOLDSTEIN
Exhibition: "Jack Goldstein," January 7–31, 1971

JOE GOODE
Exhibitions: "Monoprints," December 5–26, 1970;
"Wall Reliefs," February 9–March 7, 1971

HIROKAZU KOSAKA
Performance: March 6, 1972

WILLIAM LEAVITT
Exhibition: "Bas Jan Ader, William Leavitt,
Ger van Elk," January 18–February 20, 1972

JOHN MCCRACKEN
Exhibition: "John McCracken: Wall Pieces,"
February 10–March 7, 1971

ED MOSES
Exhibition: "Edward Moses: some early work,
some recent work, some work in progress,"
November 16–December 17, 1971

ALLEN RUPPERSBERG
Exhibition: "Allen Ruppersberg," October 31–
November 22, 1972

WOLFGANG STOERCHLE
Performance: March 13, 1972
Exhibition: "ArtForms Abstract Activities Ideas:
Exhibition of Conceptual Art," Pomona College
Museum of Art and Libra Gallery, Claremont
Graduate School, April 23–May 11, 1973

WILLIAM WEGMAN
Exhibition: "William Wegman," January 7–31, 1971

JOHN M. WHITE
Exhibition: "John M. White," March 29–April 16, 1971
Performances: *Preparation F* and *Wooded Path*,
April 16, 1971

PART 2

HELENE WINER AT POMONA

BAS JAN ADER
Exhibition: "Bas Jan Ader, William Leavitt,
Ger van Elk," January 18–February 20, 1972

JOHN BALDESSARI
Exhibitions: "Monoprints," December 5–26, 1970;
"ArtForms Abstract Activities Ideas: Exhibition of
Conceptual Art," Pomona College Museum of Art
and Libra Gallery, Claremont Graduate School,
April 23–May 11, 1973

GER VAN ELK
Exhibition: "Bas Jan Ader, William Leavitt,
Ger van Elk," January 18–February 20, 1972

JACK GOLDSTEIN
Exhibition: "Jack Goldstein," January 7–31, 1971

JOE GOODE
Exhibitions: "Monoprints," December 5–26, 1970;
"Wall Reliefs," February 9–March 7, 1971

HIROKAZU KOSAKA
Performance: March 6, 1972

WILLIAM LEAVITT
Exhibition: "Bas Jan Ader, William Leavitt,
Ger van Elk," January 18–February 20, 1972

JOHN McCRACKEN
Exhibition: "John McCracken: Wall Pieces,"
February 10–March 7, 1971

ED MOSES
Exhibition: "Edward Moses: some early work,
some recent work, some work in progress,"
November 16–December 17, 1971

ALLEN RUPPERSBERG
Exhibition: "Allen Ruppersberg," October 31–
November 22, 1972

WOLFGANG STOERCHLE
Performance: March 13, 1972
Exhibition: "ArtForms Abstract Activities Ideas:
Exhibition of Conceptual Art," Pomona College
Museum of Art and Libra Gallery, Claremont
Graduate School, April 23–May 11, 1973

WILLIAM WEGMAN
Exhibition: "William Wegman," January 7–31, 1971

JOHN M. WHITE
Exhibition: "John M. White," March 29–April 16, 1971
Performances: Preparation F and Wooded Path,
April 16, 1971

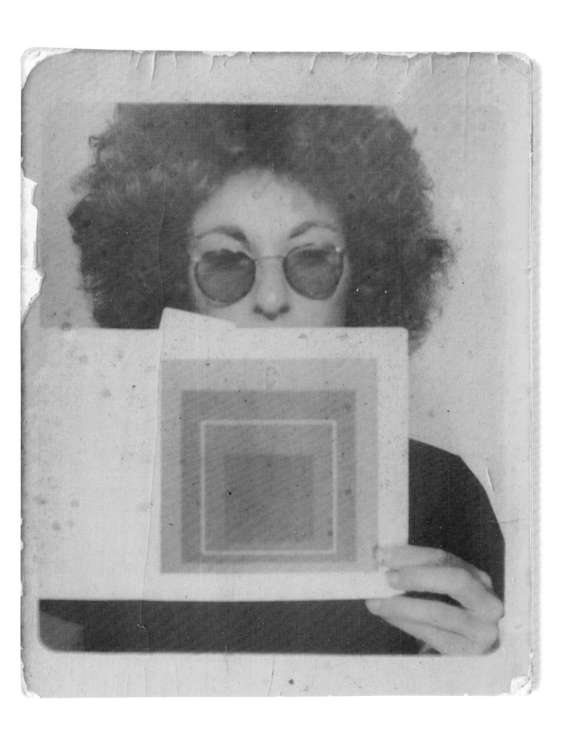

REBECCA MCGREW Let's begin with a discussion about your background and how you came to Pomona College. You were previously at Whitechapel Gallery in London; what brought you back to Los Angeles?

HELENE WINER I was away from Los Angeles for about three years. Most of that time I was in London working at the Whitechapel Gallery as assistant director. I started at Pomona a few months after returning to Los Angeles in the fall of 1970. I grew up in Los Angeles, in Westchester, and I studied art history at USC. After college, I landed what for me was a prize job at the L.A. (Los Angeles) County Museum of Art (LACMA). Jim Elliott, chief curator, and curator of modern art, hired me as part-time assistant. I think I told him that I would do anything, even empty ashtrays, if he would just hire me. I vaguely intended to do graduate work at the UCLA, but quickly dropped that idea.

RM What did you do at LACMA?

HW I was an all-purpose, curatorial/exhibition assistant until I was assigned to American Art. For the prints and drawings department, I catalogued prints and assisted on Pablo Picasso's eighty-fifth birthday print survey for which I drove around Beverly Hills with a Polaroid camera documenting prints in collectors' homes. I helped in the decorative arts/costume department, sometimes getting my photo taken in period costumes. In the American art department, I worked on a watercolors show. I organized a very small show of the Ash Can school from the collection, and produced a brochure. I worked with the preparators installing exhibitions, which I loved doing, and did odd jobs like making wall labels.

I quickly gravitated to contemporary art, as I became acquainted with artists and curators. Through them I discovered the galleries that were active in Los Angeles at that time, like Dwan Gallery, which had shows of Minimalists such as Carl Andre and Sol LeWitt, and Irving Blum Gallery, where the Pop artists and Ferus artists showed. I remember seeing Warhol's Mylar pillows [*Silver Clouds*, 1966] at Irving Blum. The most prominent new artists showed at either Irving Blum or Nick Wilder. This immersion into an art-based community that I knew little about made an enormous impression on me. The idea of a community of artists such as those I had studied about in Paris or New York existing in Los Angeles never occurred to me.

At twenty-three, of course, I naturally became acquainted with all of the younger, and all male, artists. I got to know Ed Ruscha because he designed catalogues for LACMA and designed for *Artforum*. I was there when Ruscha unveiled his *Los Angeles County Museum on Fire* [1965–68, now owned by the Hirshhorn Museum in Washington, D.C.] on the museum patio. I posed for his famous "Ed Ruscha Says Goodbye to College Joys," his January 1967 *Artforum* ad/marriage announcement. I was bartender for Jim Elliott's parties for friends, like Robert Rauschenberg and Claes Oldenburg, at his apartment above the merry-go-round on the Santa Monica Pier. These are some of my most vivid memories of that time, along with buying my first artwork—two paintings by Richard Pettibone for $15 at his annual studio sale.

RM Why did you leave Los Angeles and move to London?

HW My job at the museum was tremendously valuable, but it was also a very loosely defined, entry-level job. So when friends of mine went to Croatia (then Yugoslavia) to shoot a film, I joined them with no real purpose but to spend some time in Europe. It was certainly not a career move. After visiting Croatia, Greece, and Italy, and spending several months in Paris, I moved to London. Bryan Robertson, who had just retired as director of Whitechapel, told me of the assistant director job there. It was very fortunate timing, and I stayed for two years. It was the peak of Conceptual art activity for both American and European artists, with London as a hub. My introduction to that work, and the often intense, serious talk around it, was in stunning contrast to the mute, wry stance adopted by the artists I had known in Los Angeles. But I left London, primarily because I was unable to adapt to the dark and damp weather, or survive on the impossibly low pay.

PREVIOUS PAGE
Helene Winer photo booth self-portrait, c. 1969

RM Tell me about what the Los Angeles art world was like in 1970, when you came back and started working at Pomona College.

HW Los Angeles had changed dramatically during the few years I was away. When I left, it was the late sixties, and the Finish Fetish artists were prominent in L.A. The counterpoint group was the "assemblage" or Topanga artists. I respected both groups of artists and admired what they did.

Los Angeles in the 1960s was still fairly isolated and had developed a kind of parallel universe where the main artists had careers that were serious and active locally, and included shows in New York and Europe. But I cannot think of one artist who was fully embraced outside of Los Angeles. I believe this problem for L.A. artists really did not change substantially until the 1980s.

When I returned in 1970, Chouinard, where I took painting classes as a teenager, was closed, the Finish Fetish artists were now firmly established, CalArts had opened, and UC Irvine had an ambitious art program.

RM Was your position at Pomona College similar to Hal Glicksman's before you?

HW I was hired as gallery director and assistant professor. Other than some secretarial and very part-time student help, the gallery had no staff. Director then meant curator, registrar, PR, transport, preparator, etc.

RM What courses in art history did you teach?

HW I taught "Art Since 1945," and a contemporary art seminar. I recently found a stack of file cards that I used for one of the classes, with a list I had compiled of major modern artists, organized chronologically by birth date. So many of the figures who were the foundation of Modern art were, remarkably, still alive in 1970. What is astounding to me is that the era from 1970 until the present—forty years—is the same amount of time as the period from 1930 to 1970. When my time at Pomona is viewed today, it may seem as distant as the Depression, prohibition, and the WPA were to me.

It seemed incredible when I was at LACMA that Picasso was going to visit Los Angeles for his print show; that I visited Igor Stravinsky at his house; that I met Man Ray when he was a house guest at a Los Angeles collector's home. With the students, I used the idea of artist interactions to contemporize and humanize the art history. In the seminar, I assigned the students to interview an artist. One of my students interviewed Bruce Nauman. This was one of Nauman's first interviews, and it was referenced in his first museum exhibition at the Whitney Museum and LACMA.

"Montgomery Center Director Appointed," undated newspaper clipping

Montgomery Center Director Appointed

CLAREMONT—Miss Helene Winer, former assistant director of Whitechapel Art Gallery in London, has been named director of Montgomery Art Center and assistant professor of art at Pomona College.

A native of Los Angeles and a graduate of USC, Miss Winer served as curatorial aid for the Los Angeles County Museum of Art for three years.

As assistant director for the Whitechapel Art Gallery, she was responsible for the organization of contemporary exhibitions and for the administrative aspects of the gallery.

Miss Winer has written articles for newspapers, magazines and art brochures on the "History of Whitechapel Art Gallery," George Bellows and John Sloan," and "Art and Community."

HELENE WINER

RM I'm interested in hearing you speak about your exhibitions at Pomona. You were quoted once as describing the artists that you worked with at Pomona College as "defining a new direction in Conceptualism." What did you mean by that?

HW I wouldn't describe the artists I showed in that way now, but this was when Conceptual art was narrowly defined by a core group of artists, including Robert Barry, Douglas Huebler, Sol LeWitt, and Lawrence Weiner. Their work was language-based and not focused on producing objects of any permanence or visual interest. The Los Angeles artists whose work I became interested in were doing work that was both closely allied to but made striking departures from this Conceptualist orthodoxy. The new work that I found utilized imagery, humor, cultural references, and wide-ranging content in varied mediums, including painting and drawing. I made a fairly deliberate effort to locate artists whose sympathies were Conceptual but who were bringing in something new. It was the first time that I looked for artists whose work I did not know, who did not have reputations that preceded them, artists at the beginning of their careers.

RM How did you go about finding newer artists?

HW I began to visit studios and seek out group shows of newer art. Jack Goldstein was one of the first artists whose work I saw in a group show in an exhibition titled "Temple Street Artists," at the Long Beach Museum of Art. The work was very minimal and made of paper; it was not yet the work he would later become known for. It was through Jack that I met Bill Leavitt, and through Bill, I met Bas Jan Ader, and so on. Quite soon I began to identify other artists whom I had an interest in, like Bill Wegman, Al Ruppersberg, Wolfgang Stoerchle, Chris Burden, and the artists around them.

Postcard with **Bill Leavitt, Jack Goldstein,** and **Gary Krueger**

RM Did these artists identify loosely as a group, or recognize each other as being part of something new?

HW Not at all. Chris Burden was living and working near Irvine, where he went to graduate school, and I don't think he knew the others. The same applies to Bill Wegman, who came to Los Angeles for a teaching position at Cal State Long Beach. When I met him, he was living fairly isolated in San Pedro.

RM Do you remember what was in Wegman's show, in January 1971?

HW Yes, very distinctly. I thought then, and still do, that the work in that show was remarkable. The small gallery room held his black and white photographs. Several of his earliest videos played on a reel-to-reel tape deck borrowed from Pomona's audiovisual department. The tapes were brief, absurd, comical compositions using sight gags or perceptual tricks and art-related puns. They were really brilliant, very independent of the videos that others were doing at that time. Tragically, one was erased by accident when someone came and took the equipment with the tape still in it. Even though he had no other copy of the tape, Bill was not as upset about this as I was.

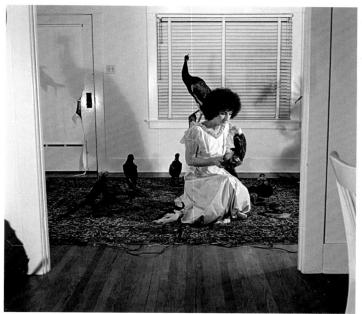 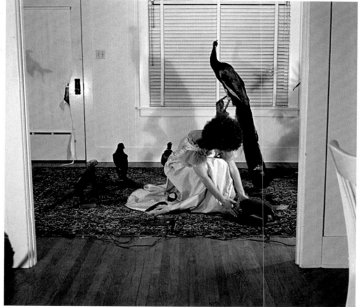

HW Yes, the Goldstein and Wegman shows were simultaneous, though there were separate announcements and small catalogues. I am not sure why I chose to do this, since only one of the two gallery rooms was a good exhibition space.

RM Interestingly, like Wegman's erased videos, the sculptures Goldstein exhibited at Pomona don't exist anymore. Do you know what happened to the sculptures?

HW The materials for the sculpture, the wood blocks, were retained for a time, but I think it was a space issue that determined their preservation. The individual works consisted of blocks of wood stacked to a precarious height, with black or white cards inserted in the corners between the blocks. I thought of these as ironic gestures reflecting the oppositional stability of the forms and rendering the precarious and potentially danger-ous stacks with the physically purposeless cards somewhat comic. The pieces often tumbled over during the colder nights and had to be restacked in the morning. The work Jack became known for is quite different, but certain qualities were evident in this early work, such as their performative quality, their temporary nature, and the ominous precariousness that was also in the early films and performances. But primarily, it was the aspect of a proposition that first drew me to the work.

I recently read a quote in an article by Howard Singerman, where he quoted Richard Hertz's book *Jack Goldstein and the CalArts Mafia*. Apparently, when Jack showed slides of his sculpture to John Baldessari's class, Jack noticed that John was unimpressed. Jack said that if John was that uninterested in the work, it must be really bad. So Jack never made sculpture again. I believe Jack was referring to work like what he showed at Pomona.

RM Let me jump ahead to 1972, and ask about the performance series you organized with Chris Burden, Wolfgang Stoerchle, and Hirokazu Kosaka. Did a theme tie them together?

HW No theme, just that they were young artists doing performance, which was not so prevalent then.

William Wegman untitled photographs of **Helene Winer** in Wegman's San Pedro studio with still life props from California State University, Long Beach art department, 1970. Collection of Helene Winer

RM I have heard from some attendees that Chris Burden's *Match Piece* not only entailed throwing lit match "rockets" at a nude woman (his then-wife), but also that it felt like an endurance event, that the intention was to bore the audience so much that they would just leave and the performance would end when the gallery was empty. Is that what happened?

HW It was somewhat of an endurance event because of the repetitive nature of the activity and the perversity of waiting ghoulishly, for a long time, to see if one of the lighted matches would ever hit or burn the woman. Chris had wanted a student to volunteer, but no one did, and he recruited his unhappy wife, who really did not want to do it. There was something disturbing about the situation, where the audience had to sit and witness this malicious and juvenile act.

RM Did he tell you what he was going to do in advance? He had just done *TV Hijack* (1972) a few months earlier. Were you worried at all about what he might do at Pomona?

HW No. It never crossed my mind to be concerned about what he might do. Chris just said he had an idea, and would show up and do it. I was so interested in his work, and this aspect of fear and danger, that I didn't view it as a concern.

RM Do you remember if there was any fallout from this performance because of the nudity or the implied violence, especially in light of one of the other performances—by Wolfgang Stoerchle, the prior week— which caused quite a stir?

HW I don't believe so, although I seem to have been fairly oblivious to institutional concerns. I didn't consider that the college would be concerned about what I did, *their interest seemed so low*. I was never called upon to explain, defend, or accept any criticism. During my interview for the job, I think I made it clear that I wanted to show things that weren't otherwise being shown. I didn't see any reason to show art that was already being seen in museums, or to take traveling shows, or to do anything but originate contemporary exhibitions by fairly young artists. I thought that would be most valuable to the students and the college environment, and of course, to the artists themselves.

RM Stoerchle's performance became notorious. Apparently, he incorporated a number of different elements that he used in other performances, and then urinated on a carpet in the gallery. What do you remember of this night?

HW I really only remember him doing a kind of movement around the room, with his movements directed by the controlled stopping and starting of his urinating. It seemed like the piece was designed as a kind of formal dance. There is a good description in the review by Paul McMahon in the school newspaper, and in the *Los Angeles Times* review. (*See pages 229–30*) Before the performance, Wolf explained to me that it was very difficult for a man to start and stop urinating; it required great control. I thought it was so funny that he assumed this fact outweighed or had greater bearing than the reality of a naked man urinating in public.

RM The performance series immediately followed the exhibition by Bas Jan Ader, William Leavitt, and Ger van Elk in January and February 1972. Can you talk a little about how that exhibition came about?

HW Bas Jan and Ger were sharing a studio in Pomona and they suggested I come over. They more or less proposed the three-person show with Bill Leavitt. I agreed because they really wanted to do this show, but I would have preferred at that time to do bigger shows by Bill and Bas Jan. I didn't really know Ger's work.

RM It's strange that Ader was underappreciated for so long, but is now incredibly popular among younger artists. What do you think makes his work so relevant to artists today?

HW I think he is being romanticized, partly because of his disappearance at sea, but also because his small body of work wasn't well known. His early work was very beautifully conceived and has a special kind of emotional impact. His work was both philosophical and slapstick, with an elegant formalism and pathos. The later work was more romantic and operatic.

RM Can you talk a little more about Bill Leavitt's work? You showed his *California Patio* (1972). What did that piece capture that made it so significant at the time?

HW Possibly it was the isolated clarity of this iconic California image, done so lovingly, celebrating its role in people's lives and others' minds. The text that accompanied it sets the tone. I would say this work, which Bill created for the Pomona show, is one of the most successful of his theatrical, tableau-like stage sets. The theatrical fragments have the content of recognition and meaning, without irony, without critical position.

RM After this exhibition, in April and May 1972, the next show you organized was "Los Angeles Painters of the Nineteen Twenties," which you co-curated with Nancy Moure, who was working at LACMA.

HW Yes. These artists were of interest to me in part because standard Southern California landscapes were almost unknown at that time. Also, most of the painters worked at Disney or other Hollywood studios painting backdrops, like the big skies for Westerns, as the announcement of the exhibition shows. This cultural aspect, which is peculiar to Los Angeles, was a resource and reference for many artists then, and for generations of artists since.

RM The Allen Ruppersberg exhibition, which opened on October 31, 1972, came shortly after.

HW Al Ruppersberg was, for me, the ultimate Los Angeles artist. He was one of the few artists who was already well known at the time of his Pomona show. He had done his famous *Al's Café* (1969), which happened before I got back to Los Angeles, and he had just done *Al's Grand Hotel* (1971). His use of the city for his work, and his ability to move around, without a standard studio, was unusual. His show included many extraordinary works. The show opened on Halloween, which is the date of Houdini's death. Many of the works in the show dealt with sleight of hand or visual trickery.

Allen Ruppersberg, Jack Goldstein, and Wolfgang Stoerchle at LAX for flight to New York, 1971

RM Ruppersberg was part of this new direction that you saw emerging in Los Angeles art. Would you say that many of the artists that you showed at Pomona fit into this program?

HW That was true of the younger artists, but certainly not for the more established artists, such as Joe Goode, John McCracken, or Ed Moses.

RM Do you remember what was in the John McCracken exhibition in February and March 1971? The archives only have a press release and one photograph.

HW He showed three new wall sculptures that were a departure from the leaning planks. I recently found an article I wrote for *Studio International* in 1971, wherein I described the type of work shown at Pomona. I said, "McCracken has lately moved away from this surface perfection in some of his sculpture, which is occasionally wall hanging. These pieces are constructed of wood beams painted directly with hard, resilient marine paint."

LEFT / RIGHT

Helene Winer pouring tea at Pomona College Faculty Tea at Pomona College Museum of Art, c. 1971

Helene Winer and **James Turrell** pouring tea at Pomona College Faculty Tea at Pomona College Museum of Art, c. 1971

RM What was the environment like at Pomona College when you were working there?

HW I was the only woman on the Pomona faculty. Stanley Crouch taught writing at Pomona then, and he was likely the only black faculty member. At my first faculty meeting, two women who were part-time faculty, seated at the ends of a long table with a silver tea service, poured tea. It was so archaic and comical. The president later asked me if I would pour at the next faculty tea, and I said, "absolutely not." Some in the art department were unhappy that I had done that, considering the art department's shaky position. I asked the studio faculty if one of them would do it in my place. Mowry Baden, who was an extraordinary person, volunteered. When the faculty arrived, Mowry was there at one end of the table, in overalls, and was setting up a very male system of pouring tea into cups lined up on the table, as opposed to picking up a cup and saucer in one hand and pouring with the other. In hindsight, my walking papers were probably drawn up by this act. I was later warned that President Alexander was very angry about this. Somehow, either in a note or in person, I explained about the inappropriateness of having women faculty perform this sort of "women's work." Later, as a mutual peace offering, Jim Turrell and I did it together. He got all dressed up in a top hat and tails, and I wore a long skirt of some sort.

Curiously, no women were included in the shows I did at Pomona, nor was I aware of their absence, though I was certainly aware of feminist issues. I did not see myself as contributing to the problem, and I did not see that my position gave me an opportunity to contribute to a change. It did not occur to me, or to many others, until later to make specific corrective efforts in order to address the problem.

RM In addition to a new feminist consciousness slowly coming to campus, do you remember other social and political situations? For example, I know there were Vietnam War protests and sit-ins on the campuses. What was your perception of that?

HW My impression was that Pomona was surprisingly straight and preppy, given the radical and activist climate elsewhere. Among artists there is a kind of automatic assumption of liberal politics, indifference to certain conventions, and some degree of oddness. I was surprised at how conservative the students were in their dress and demeanor. They conducted themselves, at least in my courses, in a strangely well-programmed way that I couldn't relate to. I did not live in Claremont, so it's entirely possible that I missed whatever was really going on. I do remember I had a part-time gallery assistant who was very attractive, preppy, and nice. He was engaged to be married, and an excellent student, but he almost never showed up. It turned out that he was a very troubled druggy.

It was just a very strange time. I remember that when I first came people were somehow suspicious of me. In fact, during my interviews for the job, someone asked me if I was involved in radical politics. That, I imagine, was due to my appearance and age. In London, my hair, which was an Afro, was just fashion, as opposed to a Black Power statement. When I started at Pomona, in October of 1970, Angela Davis was a high-profile fugitive thought to be in California. I was stopped a few times by the police, who were on the lookout.

RM In Claremont?

HW Yes, after getting off the freeway, twice that I remember.

RM Your leaving Pomona College was a very complicated situation, and I've heard so many versions of the end of your tenure. Given how important your curatorial vision was historically, it's really amazing that the college essentially fired you, or asked you to resign.

HW Thank you. I did feel at the time that I was providing a worthwhile program for the students and others, as well as something of value to the artists and larger art community. The only open disagreement I can remember having with anyone was concerning the gallery budget. I had a very small budget, and the expenditures were well accounted for, but there was a disagreement about whether the department chairman or I controlled this budget. I printed small catalogues for some of the shows, which I felt were important for the understanding of such new issues in art, and they were very much appreciated by the artists. The Ruppersberg catalogue was the trigger for the resigning/firing events.

RM This was the fall semester of 1972, during the Ruppersberg exhibition. Lewis Baltz, Michael Brewster, David Gray, James Turrell, and Guy Williams all resigned or were terminated on or near June 30, 1973, at the end of that academic year. So, basically, the whole studio department quit after you left.

HW The studio faculty were very good artists who took teaching seriously and together generated a lot of energy and camaraderie amongst the Pomona College and Claremont Graduate faculty and students. It was an unusually interesting and desirable atmosphere for artists and art students. I was surprised to learn of the problems that occurred after I left.

I think the college's attitude toward the art faculty was one of distress. There was the notion that the department did not enhance the standing or reputation of the college.

RM What was the actual reason for your firing? Do you think it was over the catalogues exclusively? Or do you think it also had something to do with the kinds of programs and artists you were presenting, like the controversial Stoerchle and Burden performances?

HW For the official firing, I really don't know what the reasons were. I had a contract that made it difficult for them to fire me, which was what I more or less forced them to do after a standoff over the tiny gallery budget. That, of course, wasn't the core problem. There were a number of reasons why the administration was unhappy with my performance or existence. Foremost were aspects of the program that caused the administration some discomfort, like some of the exhibitions, as well as incidents separate from the exhibition program.

Helene Winer with **James Turrell** reflected in cable car window on a faculty/student trip to San Francisco, 1971

I believe it was a cumulative situation, beginning with the tea pouring and including my dealings with a women's group associated with the gallery. The Rembrandt Club raised a small amount of money each year to donate to the gallery by holding an annual print sale. I had a painfully uncomfortable lunch with some members at the Cucamonga Country Club. I objected to the greeting card level of the print sale. I don't think I ever heard from or saw them again. Another occasion I remember was a lunch meeting with potential corporate donors, where someone objected to my wearing pants to the lunch.

After Ackerman threatened to stop the printing of Al's catalogue, thinking the exhibition would go one without it, I said I would resign and the exhibition would not proceed if the catalogue was not printed. After a few hours, I realized that they should have to fire me, and I withdrew my resignation, but not the threat to cancel the show. Ackerman was furious; I was fully prepared to depart, but I would not resign. I got a lawyer, Gerry Rosen, a labor lawyer, who was bucking convention by wearing head-to-toe black leather and rode a motorcycle to his meeting with Alexander. Forcing the firing and a settlement of my contract gave me some satisfaction in an otherwise really unfortunate situation.

> **RM** After you left Pomona, you moved to New York. Did you move to New York because of the Artists Space position, or did that come later?

HW Immediately after leaving Pomona College, I wrote a column and did some reviewing for the *Los Angeles Times* and then moved to New York a year or so later. I did freelance work for the New York State Council on the Arts and the National Endowment for the Arts for a few years and, in 1975, I became director of Artists Space.

> **RM** When you started at Artists Space, it seemed they didn't have a defined mission. How do you think your knowledge of post-Conceptual art in Los Angeles influenced your curatorial decisions?

HW The lack of identity at Artists Space had been purposeful, since it was conceived to provide some ideal of a democratic exhibition program and a site for meetings of artists' groups. In the effort to avoid curatorial prejudice, a supposedly neutral method of organizing exhibitions was devised with uninspired results. I initially found ways to do something resembling a democratic selection of shows, but soon ignored the impossible issue. As at Pomona, my biggest concern was to show the most interesting art developments, and my preferences followed the course set at Pomona. Alternative spaces were essential in those years for artists early in their careers; there were no small galleries available to them as there are now, and the established galleries were relatively few and inaccessible.

> **RM** What led to your founding of the gallery Metro Pictures in 1980?

HW I had been at Artists Space for five years and wanted to make a change. The public funding was changing so that it would be necessary to spend time fundraising and reorganizing the Artists Space board from its advisory role to a financially supportive role.

I had never entertained the idea of starting a gallery, and in fact, I had the usual antipathy of what was perceived by outsiders as a very elite and unwelcoming environment. Janelle Reiring, who was director at Leo Castelli Gallery, and I talked about founding a not-quite-standard gallery that would operate only at night and include artists I had been associated with, but we quickly shifted to the idea of a more conventional and serious gallery. The artists' needs, and their lack of options, were the reason for opening the gallery. It is hard to imagine now, but there were virtually no galleries for new artists to show in.

> **RM** Why the name Metro Pictures?

HW Metro Pictures was just the solution for not using our names, i.e., Janelle Reiring Helene Winer Gallery. We weren't trying to be clever or to send a particular message, but we did think it suited the work we would be showing.

1. Jan Verwoert, *Bas Jan Ader: In Search of the Miraculous* (London: Afterall Books, 2006), 7.
2. Brad Spence, "The Case of Bas Jan Ader" (2008), www.basjanader.com/dp/Spence.pdf. Verwoert, cited above, also notes this phenomenon.
3. Erik Beenker, "Bas Jan Ader: The man who wanted to look beyond the horizon," in *Bas Jan Ader: Please Don't Leave Me* (Rotterdam: Museum Boijmans van Beuningen, 2006), 15–16.
4. Ibid.
5. Jörg Heiser, "Curb your romanticism: Bas Jan Ader's slapstick," in *Bas Jan Ader: Please Don't Leave Me*, 26–27.
6. Beenker, 12.
7. Bas Jan Ader, "Rumbles," *Avalanche* (Winter 1971): 3.

BAS JAN ADER'S SHORT LIFE and even shorter career are often overshadowed by the circumstances surrounding his tragic death. On July 9, 1975, Ader began what was intended to be the central component of a tri-part work entitled *In Search of the Miraculous*: a solo crossing of the Atlantic Ocean from Cape Cod to England in a thirteen-foot-long sailboat. It would have been the smallest vessel ever to make that journey. Before departing, he had gone on a nighttime walk from the eastern edge of Los Angeles to the ocean. He exhibited the photographs documenting this performance, along with the printed lyrics of *A Life on the Ocean Waves* and a live performance of students singing sea shanties, at the Claire Copley Gallery in Los Angeles in 1975. He intended to repeat this night walk and mirror the pre-voyage exhibition at the Groningen Museum in the Netherlands following his safe arrival in Europe. But Ader lost radio contact three weeks into the trip, and eight months later his empty boat was discovered by Spanish fishermen off the coast of Ireland. Ader had disappeared, and what happened in the middle of the Atlantic remains a mystery.[1]

Ader's sudden death during his most ambitious performance retrospectively shaped the reading of his earlier work. He became understood as a tragic romantic hero, on a quest for an unobtainable and unidentifiable quality that ultimately cost him his life. As Brad Spence, the curator of Ader's first United States retrospective (at the University of California, Irvine, in 1999), noted, "In considering the work of artist Bas Jan Ader, there is an almost irresistible temptation to lapse into speculative narratives of the sensational and popular variety. This is perfectly understandable, since his story climaxes with the artist lost at sea in a risky performance....Responses to his work are rife with personal projections and detective-style sleuthing as to his psychological state and artistic intent."[2] In particular, Ader's famous Fall pieces were reinterpreted in this vein, as the prophetic preludes of the hero's final downfall, the desperate and self-destructive acts of a man questing for something that even he could not define. Indeed, Ader's entire body of work became redefined as his lifelong search for whatever "the miraculous" might entail.

In 1965, Ader's "search" brought him to Claremont, California. While he originally moved to this apparently un-miraculous location to obtain his MFA, and later an MA in philosophy, at Claremont Graduate School (CGS), it quickly became an important site for the development of his work and career.[3] This was evident in Ader's 1967 MFA thesis project, entitled *Implosion,* one of his earliest works exploring the concept of falling.

Thematically and physically, *Implosion* consisted of many complex components. Ader filled the exhibition space with two large, multimedia constructions containing six smaller works and a book filled with poems and lithographic drawings. Ader described the entire installation as an "environment" that was subdivided into three thematic categories: part and whole, real and illusionary, and rise and fall. This final theme, which was to become so essential to Ader's later work, was evident in paintings, linens, films, and photographs with titles like *Niagara Falls, Humpty Dumpty,* and *Plan for a Dangerous Journey* (all three works, 1967). The poster for the project showed a photograph of Ader smoking a cigar and sitting in a chair on the roof of his Claremont home, surrounded by Pop-art–styled cartoon clouds. Ader titled the poster *The Artist Contemplating the Forces of Nature* (1967).[4]

In 1970 Ader gave into these forces of nature by pushing the theme of falling—and literally pushing himself—over the edge of the same house in Claremont. In his first Fall film, *Fall I, Los Angeles,* Ader sits in a chair on the roof of his home before falling and rolling off the roof, into the bushes below. Reminiscent of the slapstick humor of Buster Keaton and Charlie Chaplin, the film hovers between the realms of the comic and the tragic, as the viewer wonders about the fate of the artist.[5] (In fact Ader's wife, Mary Sue Ader-Andersen, once implied that he was badly hurt in the filming of *Fall I, Los Angeles*.)[6] But the viewer is not given any information about the outcome of the fall, nor told why the artist was on the roof in the first place. The beginning and end of the fall are not made significant by Ader—only the act of falling itself. The artist provides no personal narrative, nor is he the subject of the film; rather, his body becomes a passive object used to illustrate the force of gravity, and the inevitable result of succumbing to nature. Ader once famously declared, "I do not make body sculpture, body art or body works. When I fell off the roof of my house, or into a canal, it was because gravity made itself master over me."[7] It is clear that his apparent failure to maintain control over his body was not simply a premonition of his death or a tragically self-destructive quest, but a conscious exploration of the natural gravitation of any object towards the earth.

BEFORE THE MIRACULOUS: BAS JAN ADER IN CLAREMONT

Carrie Dedon

TOP
Bas Jan Ader *Fall I, Los Angeles*, 1970.
Photograph

BOTTOM
Bas Jan Ader *Fall II, Amsterdam*, 1970.
Photograph

Bas Jan Ader *Untitled (Sweden)*, 1971.
Projection of two color slides

8. Helene Winer, *Bas Jan Ader, Ger van Elk, William Leavitt* (Claremont, Calif.: Pomona College Museum of Art, 1972), 1.

9. *Bas Jan Ader: Please Don't Leave Me*, 74–80.

10. Winer, 1.

11. Beenker, 20–23.

12. Ibid, 14.

13. Betty van Garrel, "Bas Jan Ader's tragiek schuilt in een pure val," *Haagse Post*, January 5–11, 1972.

14. Text fragment by Bas Jan Ader, probably autumn 1974, as quoted in Beenker, 16.

Fall I, Los Angeles, along with other films and photographs exploring physical and emotional falls, was first seen in the United States in the city of its creation, in a January 1972 exhibition entitled "Bas Jan Ader, Ger van Elk, William Leavitt," organized by Helene Winer at the Pomona College Museum of Art. In the catalogue introduction, Winer wrote that the exhibition "issue[d] not only from an interest in the artists' individual work, but more specifically, from their mutual respect, friendship, and wish to show together."[8] Indeed, the three artists collaborated closely throughout their careers, and both Leavitt and van Elk directly helped Ader create many of his Fall pieces. (Leavitt took a series of unused photographs during the filming of *Fall I, Los Angeles*; van Elk took photos of *Broken Fall (Geometric)* (1971) and both were on site to document *Fall II, Amsterdam* (1970).)[9] That his Fall series should be exhibited in this city with these artists was therefore an appropriate debut.

Ader's works at the Pomona College exhibition were, as Winer wrote, "specifically concerned with physical or emotional 'falls' and their varying literary, psychological, and philosophical connotations."[10] Many critics have argued that this fascination with the act of falling is rooted in Ader's personal experiences and history.[11] His parents were both preachers, and it is likely that Ader and his brother were taught the biblical implications of falling: the fall of Babel, the fall of the walls of Jericho, the Fall of Man. Another highly personal layer of meaning to the fall is the death of Ader's father, who was arrested and executed in a forest during the Nazi occupation of the Netherlands.[12] The two-part photographic work *Untitled (Sweden)* (1971) (which has only been exhibited once in the United States, during the 1972 Pomona College exhibition) is the piece that is perhaps most often read in relation to this background. The first photograph depicts Ader standing in a forest; the second shows him lying on the ground, "felled" along with several trees.

But in a 1972 interview, Ader rejected such an autobiographical interpretation of this and other works. He said: "I have always been fascinated by the tragic. That is also contained in the act of falling; the fall is failure. Someone once said to me: 'I can well imagine that you are so obsessed with the fall; that's because your father was shot.' That is obviously a far too anecdotal interpretation. Everything is tragic because people always lose control of processes, of matter, of their feelings. That is a much more universal tragedy, and that cannot be visualized from an anecdote."[13] The universal implication of the fall, of the giving in to the forces of nature contemplated by the artist on his roof, fascinated Ader. He felt its allure perhaps most keenly in Southern California, of which he once wrote: "I really love Los Angeles. I love the surrounding wilderness of ocean, desert and mountains. I feel belittled by its enormous scale…. Even disasters, enormous bushfires and earthquakes have strengthened my attachment to the city rather than chased me away. I must admit to being fascinated by the constant threat that nature has over us here. I love this wild romantic metropolis of extremes."[14]

Whether his inspiration was personal or universal, rooted in his family's tragic past in Europe or potential future disasters in Los Angeles, Ader's Pomona College exhibition thoroughly embodied his exploration of falling. *I'm Too Sad to Tell You* (1971), a film consisting of a close-up of the artist weeping, confronted the viewer with a personal psychological fall, apparently too devastating even to describe. *Fall II, Amsterdam* depicts another physical fall, in which the artist attempts to steer his bike while holding a bouquet of flowers, fails, and crashes into a canal. *Nightfall* (1971) records the artist's destructiveness as he lifts a large brick, in a visible struggle against the heavy pull exerted on the object by gravity. He then drops it on two light bulbs on the ground, one after the other, crushing them and shrouding the entire scene in darkness. Visitors to the Pomona College Museum saw a kaleidoscope of failures— of physical and emotional inevitabilities as the artist succumbed to forces greater than himself.

After Ader disappeared in the middle of the Atlantic Ocean three years later, the works that were shown at Pomona College were subsumed by the larger Bas Jan Ader legend: that of the tragicomic hero whose fateful quest for the unidentified "miraculous" would lead to his untimely death in his final submission to nature. But when they debuted together as a group in 1972, the Fall pieces stood on their own as a remarkable body of work, filled with complex commentary on the forces of nature, on man, and on the tension between the two. In the Pomona gallery, before his last "search," Ader was not the romantic character that he is considered today, but a young artist with a seemingly promising career ahead filled, paradoxically, with failures and falls.

LEFT AND TOP RIGHT

Bas Jan Ader *I'm Too Sad to Tell You*, 1970–71. Photographs

BOTTOM RIGHT

Bas Jan Ader *I'm Too Sad to Tell You*, 1971. Black-and-white, 16 mm film transferred to DVD, silent, 3 min., 34 sec. Edition of 3

A POTENTIAL PRINT

Most prints are on paper. What is used as ink might vary more, but
not a lot. What is seen here is an attempt to avoid both ink and paper,
but also the ACT, or at least delay the act or stretch it out in time.

Having just completed a piece in which I had cremated a body of my
paintings; reducing them to ashes, I was struck by reading the
following account:

"Ashes were often used in divination, one of the strangest examples
being in Yorkshire where, on the eve of St. Mark's day (24 April)
the ashes were riddled in the hearth and left overnight, and in the
morning carefully examined for any mark ressembling a footprint.
Should this be found, the member of the family whose foot fitted
the print was doomed to die within 12 months."

While I say that I am not superstitious, I must admit that to consider
some other substance seems to be not as effective. To use ashes seems
to give the piece more power, and to use the ashes of my burnt
paintings seems even morerpowerfull.

Still, the main point of this piece is more formal, the setting up
of conditions for something to happen, or that might happen
rather than an act accomplished. The superstition just gives it
overstones.

 John Baldessari
 November, 1970

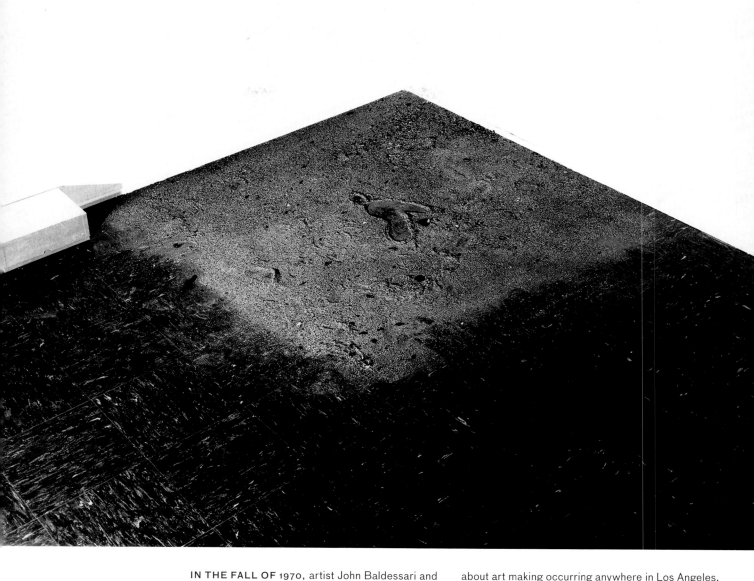

EVIDENCE: JOHN BALDESSARI AT POMONA

Glenn Phillips

IN THE FALL OF 1970, artist John Baldessari and curator Helene Winer each began new jobs: Baldessari as a professor of "post-studio art" at the newly formed California Institute of the Arts (CalArts), and Winer as director and curator of the Pomona College Museum of Art. CalArts operated its first year out of temporary quarters in Burbank, as it finished the construction of its new campus in Valencia, California, a small town near the expansive northwestern edge of Los Angeles County. Pomona College is sixty miles away from Valencia, at Los Angeles County's southeastern edge, in the town of Claremont. As Baldessari and Winer both settled into their jobs, these two unlikely communities on the outer fringes of Los Angeles County would become host to some of the most radical and advanced ideas

about art making occurring anywhere in Los Angeles. Winer's first exhibition of (mostly) Los Angeles artists at Pomona took place in December 1970. Titled "Monoprints," the exhibition aimed, according to the press release, to present "original work that can, in a loose interpretation of the term, be considered a print." "Monoprints" included work by Baldessari, Billy Al Bengston, Ed Ruscha, Sol LeWitt, and Joe Goode, among others. While many works in the show took the notion of a print loosely (LeWitt, for instance, folded and unfolded paper to produce a textured grid), Baldessari produced two works that challenged nearly every notion of what a "print" might mean. *Evidence: Bowl Handed to Helene Winer Dec. 1, 70* (1970) consisted of a wide white bowl that had been dusted with graphite powder to reveal

John Baldessari *Evidence: A Potential Print*, 1970. Typed text, ashes. Typed text: 12 × 9 ½ in. (30.5 × 24 cm). Collection of the artist

Photo documentation of installation of ashes for *Evidence: A Potential Print*, 1970. Photograph: 8 × 10 ¼ in. (20.3 × 26 cm). Collection of the artist

1. John Baldessari, "Paintings 1966–68," *John Baldessari: Works 1966–81* (Eindhoven, The Netherlands, and Essen, Germany: Municipal Van Abbemuseum, Eindhoven, and Museum Folkwang, Essen, 1981), 6.

fingerprints. *Evidence: A Potential Print* (1970) took the form of ashes scattered in a corner of the gallery, with a footprint in their midst.

Baldessari had struggled as a painter for more than a decade before moving, in the mid-1960s, to a Conceptual practice that examined the process of art making and its reception as a system of rules and relationships. In 1966, he began a series of text paintings that aimed to remove his "hand" from the artwork by separating him from the work's process of fabrication. Baldessari chose simple texts, often derived from art books and instruction manuals, and then hired out production of the canvas: "Someone else built and primed the canvases and took them to the sign painter, the texts are quotations from art books, and the sign painter was instructed not to attempt to make attractive artful lettering but to letter the information in the most simple way."[1] Many of these works also included banal or compositionally awkward photographs that were transferred to the canvas using a photo-emulsion process. *Wrong* (1966–68), for instance, includes an image of the artist standing in front of a palm tree, illustrating a "bad" composition that makes the tree appear to be growing from his head.

In July of 1970, Baldessari conceived to make his painterly self-effacement retroactive by burning in a mortuary crematorium all of his pre-1966 paintings that were still in his possession. He published a death notice in his hometown San Diego newspaper, and he began to repurpose the cremated ashes for new works. Some, for instance, were sealed into an urn as part of the documentation of the *Cremation Project*; others were baked into cookies. The ashes sprinkled in the corner at Pomona for *Evidence: A Potential Print* were also, of course, from the cremated paintings.

In a statement published alongside the Pomona works, Baldessari noted, "What is seen here is an attempt to avoid both ink and paper, but also the ACT, or at least delay the act or stretch it out in time." That is, Baldessari was trying not only to separate the printmaking process from the use of ink and paper, but also from the "act" of printing at all, substituting in its place the often inadvertent act of leaving "evidence"—footprints, fingerprints—as marks of one's presence. Production of the works required a bit of trickery: under the guise of a friendly dinner, Baldessari invited Winer to his home, making sure to hand her the white bowl during her visit so that he could capture her fingerprints. The footprint in the ashes was more mysterious and unidentified, but it pointed to a previous presence within the gallery, while also tempting gallery visitors to leave their own surreptitious marks within the powder. Together, the works pointed to art making as a larger system of relations: the curator has a literal "hand" in the process, providing opportunities and occasion to produce new work, and viewers form a constant, though often unacknowledged, backdrop to an artwork's life on view.

Baldessari's tendency to use appropriated photography and text, and to focus on how images circulate in society and the ways in which they produce meaning, was predictive of the dominant artistic concerns of the later 1970s and early 1980s, when Postmodern artists interrogated the dominant role images and media play in constructing our beliefs and perceptions of reality. At the forefront of this group of artists (the Pictures Generation) were a number of former Baldessari students and/or CalArts grads, including Jack Goldstein, Troy Brauntuch, James Welling, Barbara Bloom, and David Salle. Baldessari always urged his students to move to New York during this period, as it seemed to offer better opportunities for young artists—and indeed so many CalArts grads found success that they began to be referred to as the "CalArts mafia." After departing Pomona, Winer herself played an instrumental role in this new generation's rise to prominence in New York, as her work at Artists Space and Metro Pictures offered significant avenues of support for younger artists. It was as if, for a moment, New York in the later 1970s became the outermost fringe of Los Angeles, separated in both space and time from the crucial and mostly overlooked developments of Los Angeles art at the turn of the 1970s.

John Baldessari *Evidence: Bowl Handed to Helene Winer Dec. 1, 70, 1970.* Typed text, bowl, tape, and lamp black. (Bowl was later destroyed.) Photodocumentation: black-and-white photograph, 8 × 10 ¼ in. (20.3 × 25.4 cm). Collection of the artist

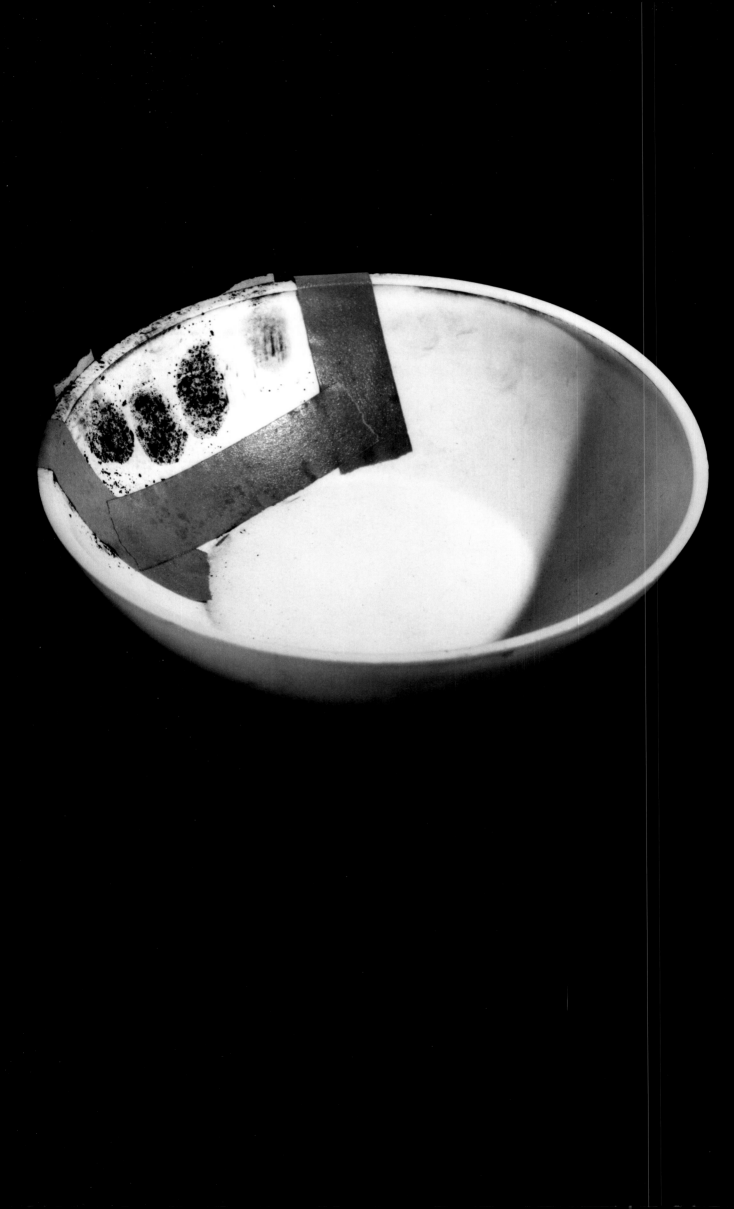

MARIE B. SHURKUS My research revealed three different stories about how you first came to the States. So let's start there.

GER VAN ELK Mine is the classic story of an immigrant. My father flew back and forth between Holland and America. In the late fifties, he was living in Cheshire, Connecticut, but he was planning on moving to Los Angeles, where he was an illustrator for Hanna-Barbera cartoons. So on one of his trips back to Holland he confronted me, saying something like: "What the heck are you doing in Holland; it's such a provincial place. It's not good for you. You should be out in the world. You should come see me in Los Angeles." So I decided to go to America.

MS Was that in 1959?

GVE Yes, I immigrated to the United States, and got a job in a pastry shop with my father's friend Louie Cavalier. I earned $90 a week punching holes in Connecticut donuts, and it was great! I learned to speak English, got to know American culture. And then, after eight or nine months, I took the train from New York to my father's place in Los Angeles.

MS Once in Los Angeles, you enrolled in Immaculate Heart College. Why there?

GVE Because I have always been difficult. [Laughs.] At that time, any self-respecting contemporary artist went to Chouinard Art Institute. But I thought, how can anyone possibly learn to make contemporary art? I found that ridiculous, plus I was intrigued by this nun place. It was unheard of to have nuns dressed in habits teaching contemporary art! I thought this is really one misunderstanding after the other, and decided that it would be more interesting for me to go see the nuns than to go to Chouinard.

MS Did you get a degree?

GVE No, before coming to America I went to art school in Amsterdam at the Kunstnijverheidsschool, which is where I became very good friends with Bas Jan Ader, though we lost touch right after school. You see, Bas traveled south, through Spain and onto Morocco, where he signed on with an English crew sailing west, across the Atlantic, through the Panama Canal, and on to San Diego. At that point I was already living on Sunset Boulevard, and one day I got a phone call: it was Bas looking for a place to stay. The sailboat had sunk, and the U.S. Marines had fished him and the crew out of the water. He had lost everything, his passport, everything lost at sea again, or for the first time. Anyway, I convinced him to join us at this funny place with the nuns. Mary Sue, whom he later married, was also taking classes at Immaculate Heart. We ended up living together for about a year, but then it was my turn to be a sailor. It's not that I wanted to be a real sailor, but I thought I've got to go through that experience. So I signed on to an oil tanker for about nine months. When the tanker stopped in Rotterdam, I got off and spent more time making art in the Netherlands.

MS Is that when you organized the International Institute for the Re-education of Artists?

GVE I organized that group with Jan Dibbets and Reinier Lucassen in 1967. Back then international art schools were becoming a very popular phenomenon; it was like McDonald's, something that was spreading everywhere. So we thought we could make it even more ridiculous by starting an international school for the re-education of artists in Conceptualism. We advertised classes on how to become an artist, tips on how to be a successful collector, or how to run your own gallery.

MS Did anyone try to enroll?

GVE Some people took it seriously, but most knew it was a joke. A few people got really annoyed. They didn't like us making fun of people who were trying to start galleries, but we were against that kind of amateurism. I was very contrary back then.

MS What do you mean?

GVE Oh, I was constantly questioning myself and whatever was going on in the art world. For example, in the early sixties, it was forbidden to like Salvador Dalí. The general feeling was that Dalí couldn't paint! I saw that he couldn't paint in the manner that people think of as good painting. But I didn't care, because I liked his concepts. Of course, I understand the phenomena of artists making pieces about painting, like Ad Reinhardt or Robert Ryman. In fact, I really appreciate their work. But I have always made work that functions as a witness to thoughts, a witness to things happening in the world and my relationship with society.

MS Does this notion of witnessing have anything to do with the projection pieces that you started making in 1969? For example, in the *Self-Portrait behind a Wooden Fence* piece, there is an actual wooden

Margo Leavin Gallery, Los Angeles, California, October 6, 2009

Ger van Elk *The Return of Pierre Bonnard*, 1971. Two color photographs between Plexiglas and mirror in wooden frame. 24 × 28 in. (60 × 70.4 cm); and mirror, 21 × 24 in. (53 × 60.5 cm). Collection of the Stedelijk Museum, Amsterdam, The Netherlands

fence hanging on the gallery wall, but you also project a film of the same fence on top of it but slightly off register. As the film unfolds, we see your head emerge slowly from behind the fence, but of course you are only behind the fence in the film, not the actual fence hanging on the gallery wall. It's hard to tell what we are really witnessing here. What were you trying to convey with this doubling of the image and the actual referent?

GVE It's about comparison, making comparisons. It's sort of like stating a proposition and saying, if this is the truth, then the other statement cannot be true. But maybe the other is the truth and the first one is not accurate. I've asked questions like that my whole life. When you look at my work, especially these early works, it always has a sort of schizophrenic element about struggling to make decisions. The projections also provide a strategy for adding information because the film pieces were always projected onto something concrete. So, if you have a film, you add something to reality: a story. You open the present up to another possibility.

MS After 1972, the film projections and the slide projections just stop. What happened?

GVE No, I started again in 2001. The newer ones are presented on flat screens. I started these because I wanted to show some of the earlier films I had made that weren't being shown because of the challenges of showing film in galleries, so I recreated them as framed video pictures in the gallery. For example, I made a film in 1971 that is called *The Flattening of the Brooke's Surface*. It features me in a little rubber boat floating on a small brook. The movement of the boat makes small waves, leaving a trace from the boat, and you see in the film I'm trying to smooth that out; I am using a trowel to smooth the surface of the water. But the theoretical idea behind it was to use the water as a sculptural material, because it's a body of material. But of course you cannot really sculpt it, it's a liquid that's moving.

MS *The Well-Shaven Cactus* piece, from 1969, was presented as both a film and in photographs. Which came first?

GVE Let me see. First, I sent the Queen of England a telegram, asking for permission to clean a square meter of the mall outside Buckingham Palace. You see, on the right side of the mall is the exhibition hall where "When Attitudes Become Form" was shown in London, after it had opened in Bern. I didn't show *The Well-Shaven Cactus* in Switzerland, but I made it for the London presentation of the show.

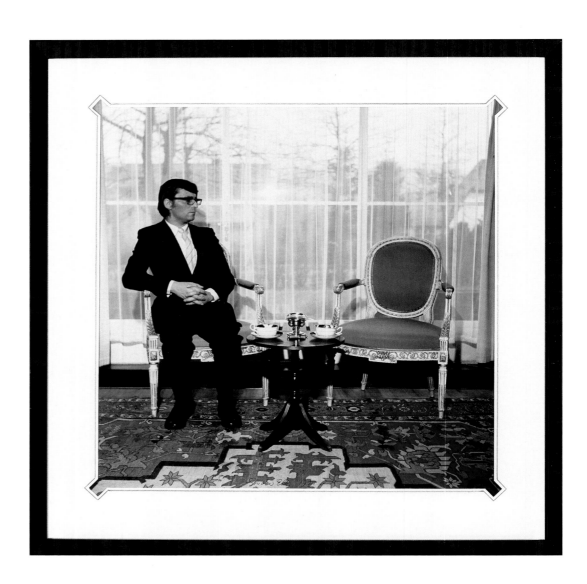

MS It sounds like you're suggesting that *The Well-Shaven Cactus* was inspired by *The Well Polished Floor Sculpture* (1968–69). But to return to my initial question, did you show the *Well-Shaven Cactus* as film or photographs?

GVE Neither. It was an action, a performance. Someone from the British weekly newspaper *The Observer* photographed it and pictures of the performance appeared on the front page. About a month after I saw these pictures I made the photo version of the piece as more of a remembrance, like a souvenir of the action.

MS Many of your works set up a specific dialogue with certain art historical works. In fact, one of the pieces that you showed at Pomona College in 1972 was *The Return of Pierre Bonnard* (1971).

GVE Yes, that piece is about reading art history. Bonnard made a painting of the French Riviera, a very wonderful little painting of a white sailboat moving along the rocky coast. I saw that painting in the collection of the Stedelijk Museum, but they rarely show it. So I thought since it was such a wonderful piece, I should bring it back into history and somehow initiate a discussion with it, because that's exactly what I wanted to do, to have a discussion with Pierre Bonnard. Of course, I couldn't do that, so instead I made a "mirror-image" of this

wonderful painting; I mean, literally a mirror that reflected a copy of the painting. Seen in the mirror, the boat is going in the other direction, and so is the piece. It was painted in 1917, but the mirror reverses the date, which appears on the painting after Bonnard's signature. It becomes 1971 and that's the year I made that piece!

MS One of the other pieces that you showed at Pomona was titled *The Reality of G. Morandi*, which sets up another dialogue with a past artwork.

GVE The Morandi piece is composed of a photograph of the actual painting and another photograph of what I imagined his studio to look like, beyond the frame of the painting. [Giorgio] Morandi was always setting up still lifes. Bottles and little pill boxes or things like that. And I was always curious about what was on the other side of the table that he didn't paint? So I tried to imagine it. In those paintings he always concentrated on the mystical atmosphere surrounding the objects, but I thought he must have some earthy things too, like a bowl of soup or something. So I made these fantasy photographs about what was on the other side of the table that he had left out of the painting. Amazingly enough, my friend Rudi Fuchs visited Morandi's studio in northern Italy and sent me a postcard that revealed that my fantasies weren't far off the mark!

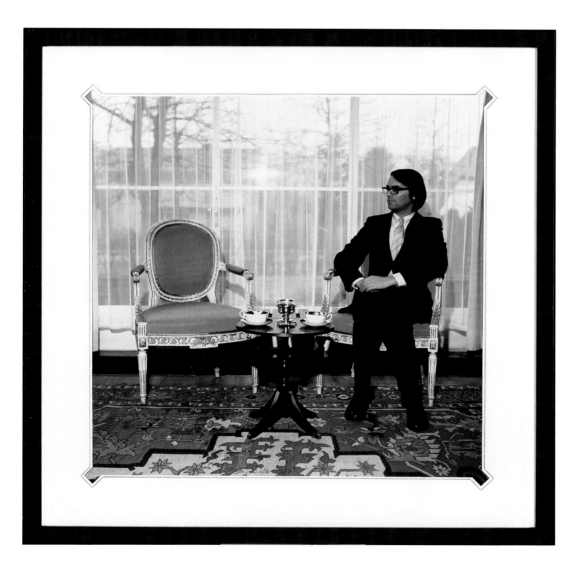

Ger van Elk *The Symmetry of Diplomacy I*, 1971. Two color photographs. 27 × 28 in. (68.5 × 70.4 cm). Collection of the Stedelijk Museum, Amsterdam, The Netherlands

JACK GOLDSTEIN

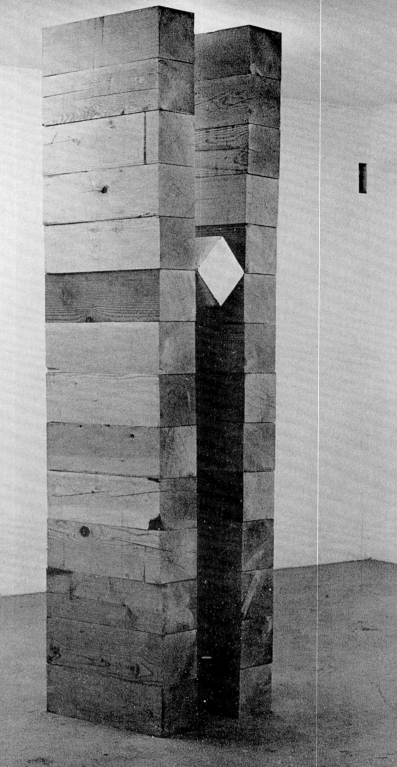

**POMONA COLLEGE
ART GALLERY**

1. In addition to the five towers, the exhibition also included three more sculptures, which were horizontally oriented.

2. Hirokazu Kosaka, conversation with the author, March 5, 2010.

3. Helene Winer, *Jack Goldstein* (Claremont, Calif.: Pomona College Museum of Art, 1971), n.p.

4. Jack Goldstein, "Aphorisms," in Jack Goldstein, John Miller, Daniel Buchholz, and Christopher Müller, *Jack Goldstein: Films, Records, Performances and Aphorisms, 1971–1984* (Köln: Daniel Buchholz Galerie, 2003), 22.

5. Chris Dercon, "An Interview with Jack Goldstein, 1985," in Jack Goldstein, Susanne Gaensheimer, and Klaus Görner, *Jack Goldstein* (Frankfurt: Museum für Moderne Kunst, 2009), 167.

6. Kosaka.

7. Goldstein ended up using a few nails because the polished gallery floor was so slippery. See Laurie Anderson, "Exhibition Reviews, OK Harris Gallery," *ARTnews* 72 (January 1973): 83.

8. Four were reconstructed for the 2002 Jack Goldstein exhibition presented at Magasin Centre National d'Art Contemporain in Grenoble, France.

9. Helene Winer, conversation with the author, October 24, 2009.

10. Morgan Fisher, "Talking With Jack Goldstein," [1977] reprinted in *Jack Goldstein: Films, Records, Performances and Aphorisms, 1971–1984*, 26.

IN JANUARY 1971, the Pomona College Museum of Art became a very dangerous place. Entering the gallery meant sharing space with five Jack Goldstein sculptures, which were constructed of eight-by-eight-inch blocks of wood stacked approximately nine feet high.[1] The wooden blocks were freshly cut and mostly unpainted. Accordingly, the wood dried and shifted over the course of the exhibition. The effect enhanced the sculptures' instability while also animating them, as the invisible forces of heat and humidity announced their presence with audible cracks. In short, the sculptures confronted viewers with a palpable sense of danger.

Since the only armature holding these towering structures in place was gravity, the danger was neither imagined nor symbolic, but rather a potential held in suspension like the deadly weight of Richard Serra's Prop pieces, initiated only a few years earlier. More to the point, Goldstein's friend and roommate Hirokazu Kosaka recalled, the danger was real; they fell down in the studio almost every day.[2] During the actual exhibition, however, they only teetered. In fact, the height of the vertical sculptures was determined by the size of the components and their ability to remain upright and maintain balance; taller stacks would have required larger blocks, Pomona curator Helene Winer explained.[3] Pushing toward the impossible, Goldstein's sculptures marked the edge of gravity's power over composed shapes as well as the edge between actual violence and its threat. Like a video image placed on pause Goldstein's physical objects thus contained and held both movement and danger in suspension. Indeed, as Goldstein once observed: "An explosive is beauty before its consequences."[4]

Violent imagery and other forms of implied danger and overt spectacle populate Goldstein's entire *oeuvre*, which encompassed sculpture, performance, film, photography, sound, painting, and prints. Nevertheless, Goldstein repeatedly insisted that his work was never about violence. Instead, Goldstein treated danger as a material that he used to craft a sense of anticipation and thereby enhance his viewers' awareness of how representation operates. As Goldstein explained, "If there is a dangerous aspect, it's because of what happens to an image when it anticipates, and so that moment before its fragmentation is gonna be violent, no matter what it is."[5] Goldstein's 1972 film *Rocking Chair* specifically depicts this effect: after building a tense rhythmic rocking, the figure abruptly gets up and in one swift movement exits the frame, leaving the deserted chair to continue rocking wildly in his wake. Where *Rocking Chair* demonstrates the fragmentation of the image, Goldstein's sculptures dramatize the moment before departure, when it appears in the violent tension of rocking or teetering, as only a threat, calling viewers to anticipate the potential consequences.

Although Serra's Prop pieces offer an insightful precedent, Goldstein's inspiration primarily came from Carl Andre's "stacks."[6] This influence becomes especially apparent in Goldstein's next series of sculptures, exhibited at New York's OK Harris gallery in December 1972. Like those at Pomona, these sculptures relied entirely upon a balance negotiated between the material components and the ever-present force of gravity. However, the newer sculptures were composed of long, two-by-four planks that presented more complex and elegant forms. One critic even described their spiraling shapes as "miraculous"; for once again they seemed to defy gravity without the assistance of nails or other bindings.[7] Nevertheless, one strong vibration—like a fist pounding on a table or some one jumping nearby—and these sculptures would crumble, their elegant shapes fragmenting, leaving a heap of planks scattered across the floor. In fact, Goldstein demonstrated as much in his films—*A Glass of Milk* and *Some Plates*—produced during the almost two years that elapsed between the Pomona and Harris exhibitions.

Although Goldstein's work has been the subject of numerous exhibitions and essays, little has been written about his sculptures. None of the originals exists anymore, which partially accounts for this critical reticence as well as their absence in the recent retrospective mounted at the Museum für Moderne Kunst.[8] Moreover, after 1972, Goldstein gave up making sculpture to focus on his better-known film work, which Winer said was a direct outcome of the sculptures he exhibited at Pomona.[9] Nevertheless, Goldstein always situated his artistic practice in terms of Minimalist sculpture. His focus, however, was not on the medium per se; rather, he latched onto Minimalism's theatricality, which appeared initially in his sculptures as a dangerous discourse with gravity, and was later developed as a more pictorial value.[10]

In the gallery space, Goldstein's control over the events that developed was limited; film on the other hand provided a space in which Goldstein could enact the events his sculptures only threatened. Thus,

JACK GOLDSTEIN'S
SCULPTURE:
IMAGINING ITS
CONSEQUENCES

Marie B. Shurkus

Cover of **Jack Goldstein** exhibition catalogue with image of *Untitled*, 1969–71. Pomona College Museum of Art Archives

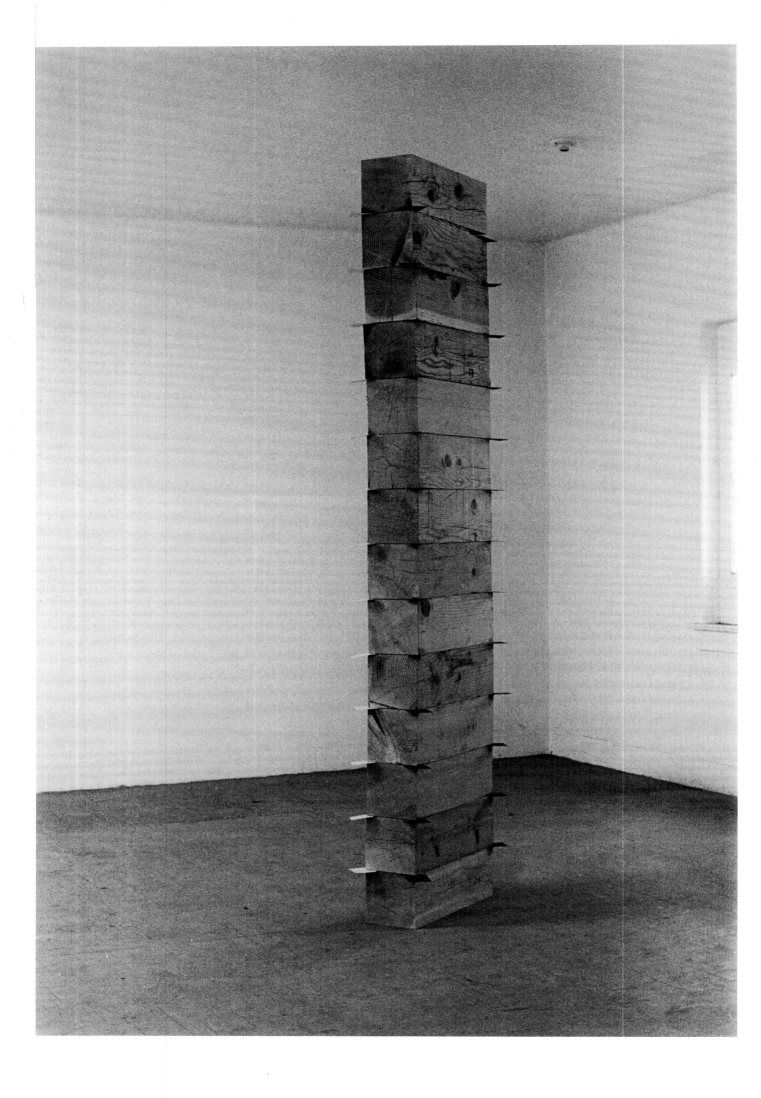

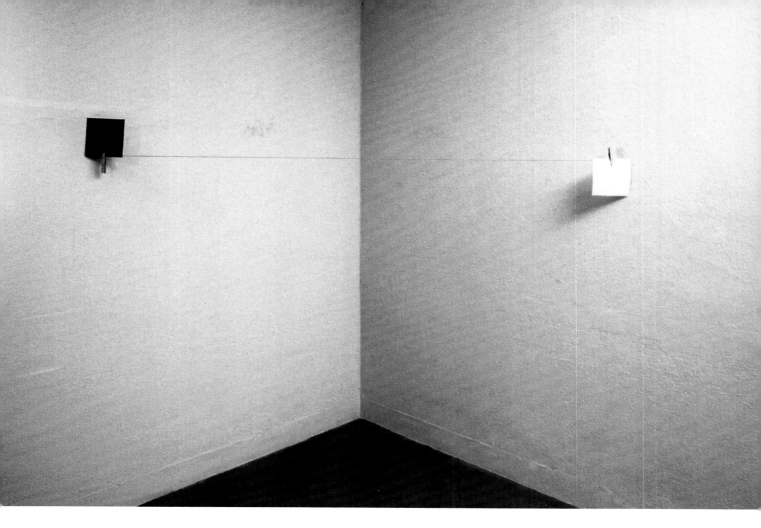

Some Plates (1972) opens with a static camera monitoring a stack of over one hundred plates towering in what appears to be an empty room. Shot through a blue gel at a dramatic angle, the space acquires a mysterious, dreamlike quality that vaguely references horror films. Without explication a booming sound suddenly echoes from a corner outside the film-frame. A few seconds later, closer now, it booms again. This process is repeated with the stack of plates wobbling more each time and threatening collapse. As the sound advances, a shadowy figure enters the frame and is seen jumping up and down at regular intervals. With the source of the noise now revealed, fear dissipates but anticipation remains, for the task at hand has become clear. When the stack finally topples, viewers experience a discernable sense of relief. Unlike the sculptures, there is no violence or danger in viewers' experience of this film, only the theater of anticipation. In film Goldstein found a tool for extracting this theatrical quality and manipulating it as a pictorial value that images could convey directly, separated from the material constraints of his sculptures.

For Goldstein the medium of an artwork was simply a tool for constructing distance between images and viewers.[11] In this regard, the sculptural towers exhibited at Pomona mark the beginnings of an effort to control and specifically manipulate this distance for the purposes of his more pictorial concerns. Ultimately, the Pomona sculptures were designed to confront viewers with a sense of danger and thereby engage them in a manner similar to the suspense of a theatrical drama. Like theater, Goldstein's sculptures were capable of sustaining the presence of danger over an artificially extended period of time. In other words, by suspending movement and keeping it on hold, the sculptures specifically increased the temporal, as opposed to spatial, distance between viewers and the transmission of events. The films on the other hand reversed this formula; they increased the spatial distance by occupying a separate, inaccessible space. Accordingly, the films followed the simple formula of television, which is a one-way transmission. As Brian Massumi once observed about a soccer game, "Through the TV audience the

Jack Goldstein *Untitled*, 1969–71. Wood and paper. 101 ½ x 24 x 7 ¼ in. (258 x 61 x 18 cm). The Estate of Jack Goldstein

Jack Goldstein *Untitled*, 1969–71. Paper, string, tacks, and clothespins. Dimensions variable. The Estate of Jack Goldstein

12. Brian Massumi, *Parables of the Virtual* (London: Duke University Press, 2002), 80.
13. David Salle specifically associated Goldstein's work with the presentational effects of television; see his "Distance Equals Control," in *Jack Goldstein: Distance Equals Control* (Buffalo: Hallwalls, 1978), 1–11. Bruce Grenville extends this discussion to technology in general; see his "The Spectacle of Technology," in Bruce Grenville, Jack Goldstein, and Fiona McLeod, *Jack Goldstein* (Saskatoon: Mendel Art Gallery, 1992), 6–19.
14. Kosaka.
15. Ibid.
16. Goldstein, "Performances," *Jack Goldstein: Films, Records, Performances and Aphorisms, 1971–1984*, 67.
17. Michael Brewster, email exchange with author, June 6, 2010.
18. For a discussion of how desire and dread operate throughout Goldstein's *oeuvre*, see Jean Fisher, "Jack Goldstein," in *Jack Goldstein: Feuer, Körper, Licht* (Erlangen, Germany: Städtische Galerie Erlangen, 1985).
19. Goldstein, "Performances."

play folds out of its own event space and into another. The televised game enters the home as a domestic player."[12] Home viewers, however, cannot affect the events broadcast through their television. Goldstein's recognition of this basic condition of media transmission was apparent as early as 1972, when he literally recreated his sculptural towers in the form of a stack of plates and enacted the drama that the gallery space had only allowed him to present as a threatening potential.[13]

Occurring one semester into his graduate studies at California Institute of the Arts (CalArts), Goldstein's first solo exhibition at Pomona College marked a significant turning point in the development of his artwork and career. In Winer, the young, new curator at Pomona College, Goldstein found an intellectual partner who would facilitate the development of his career. Together the two hosted dinners, organized exhibitions, and helped strengthen a growing sense of community among a younger group of artists who saw themselves as distinctly separate from the more established "Venice Beach" crowd.

"We were Downtown Boys," Kosaka proudly recalled.[14] Friends for life, Goldstein met Kosaka at Chouinard, where they worked as janitors under the supervision of another undergrad—Al Ruppersberg. According to Kosaka, Ruppersberg's obsession with collecting Americana greatly inspired Goldstein's use of imagery; in fact, when Kosaka first saw Goldstein's films from the mid-seventies (*White Dove*, *Bone China*, etc.), he thought Ruppersberg had made them.[15] By all accounts, Kosaka also had a major impact on Goldstein, exposing him to ideas of duration, Japanese aesthetics, and the traditions of Noh theater. Kosaka specifically recalls explaining to Goldstein how Yves Klein's work was influenced by his study of judo, which entails throwing bodies on mats that momentarily retain visible imprints. This insight informed Goldstein's 1971 performance *A Flight of Steps*, staged on Pomona College's campus. Goldstein directed his collaborator (Kosaka) to climb the stairs and leave a footprint on each step, including one atop Goldstein's white-clad body, lying prostrate across one step. According to Goldstein, the footprint became an image that left the residue of a presence.[16] However, much more than defining representation as an indexical imprint, Goldstein was investigating how images function as forces that transmit energy from one body to another.

Goldstein's understanding of the image as a transmission of energy becomes particularly evident in what was no doubt his most dangerous work, namely his untitled "burial" piece (1971), staged on the CalArts campus. For this work, Goldstein was interred in a box with a red light installed above ground that was supposed to pulsate in tandem with Goldstein's heartbeat throughout the night. In actuality, Goldstein was dug up not long after the performance started. According to Michael Brewster, who built the gadget that was supposed to convert Goldstein's heartbeat into the pulsating light, the mechanics didn't quite work. Too many other bodily sounds interfered with isolating Goldstein's heartbeat. Brewster explained, "We settled on some EKG skin sensors running through an amplifier...[but] Jack was hyper-nervous and squirmed around a lot, loosening the sensors."[17] Some critics have interpret-ed the pulsating red light from this performance as a symbolic representation of Goldstein's life, but from a strictly mechanical perspective it was a transmission that was specifically designed to translate a beating sound into a pulsing visual image that appeared in a new context, transformed and detached from the body that had generated it.

Prior to his "burial" piece, Goldstein had created a series of nine performances that along with his films specifically developed this notion of the image as a transmission. Following in the task-based approach established by Happenings, Goldstein's performances operated within specific parameters, such as extinguishing a row of lit candles by running back and forth. In a related, more harrowing performance, *A Street at Night* (1972) Goldstein ran back and forth across a busy street at night. Dressed in a white T-shirt, his visibility was determined by the lights of passing automobiles, an effect that seemed to articulate his presence as if it were an image. As happened with the Pomona sculptures, the audience's encounter with this "image" was fraught with apprehension, a combination of desire and dread that recognized the potentially dangerous consequences of this event.[18] Yet, unlike what happened with the sculptures, this "image" was not suspended on hold. "The action itself takes precedence over the body," Goldstein explained, "locating intervals or spaces within the stream of traffic through which it develops its own internal almost mechanical rhythm."[19] Thus, where the sculptures relied upon a towering accumulation of components to create apprehension, the

Jack Goldstein *Untitled*, 1969–71. Plywood, nails, and glass. 108 × 108 in. (274 × 274 cm). The Estate of Jack Goldstein

20. Morgan Fisher, 28.
21. See Michael Newman, "Michael Newman Talks to Jack Goldstein," (1981) reprinted in Jack Goldstein, Yves Aupetitallot, and Lionel Bovier, *Jack Goldstein: 03.02–28.04.2002* (Grenoble: Magasin, Centre National d'Art Contemporain, 2002), 87.

performances engaged a temporal composition based on repetition, which conjoined apprehension with expectation (a combination that informed his later use of the film-loop format).

Central to Goldstein's use of repetitive actions is its effect on the fragmenting image, which does not disappear as much as it transforms. *A Glass of Milk* (1972) offers an early example of this insight. The opening scene depicts a full glass set atop a folding card table. A fist comes down on the corner, shattering the still silence of the image. The pounding itself is not loud but it reverberates on the soundtrack, enhancing the sense of its force. Repeated regularly, the pounding fist eventually causes the milk to splatter across the artificial wood-grain laminate of the tabletop. As Goldstein noted about his performance in traffic, the repetitive force of the pounding fist creates a temporal rhythm that enters viewers' bodies like the backbeat of a familiar tune, causing viewers to anticipate its next impact on the table. In fact, Goldstein strategically controlled the duration of his films such that when they concluded, viewers were "left with this thing in [their] head[s] afterwards."[20]

Significantly, the milk spilt on the tabletop creates a white pattern, effectively another image that not only references abstract expressionist painting but also causes the image of the faux wood-grain to recede

and seemingly disappear into what now appears as a black background. Despite this visual effect, Goldstein was acutely aware that images are never composed of concrete materials—be it milk, wood, or paint; rather images are a form of light and energy moving through matter—the matter of wooden sculptures, ceramic plates, and even viewers' bodies.[21] Inherent to Goldstein's work is an understanding that visual representations convey more than subject matter or signification; they also transmit energy, which like music adds temporal qualities to the other subject matter being conveyed. His sculptures provided a first glimpse of his effort to investigate how this "virtual," more theatrical register of the image operates; his films and later audio recordings develop this investigation much further.

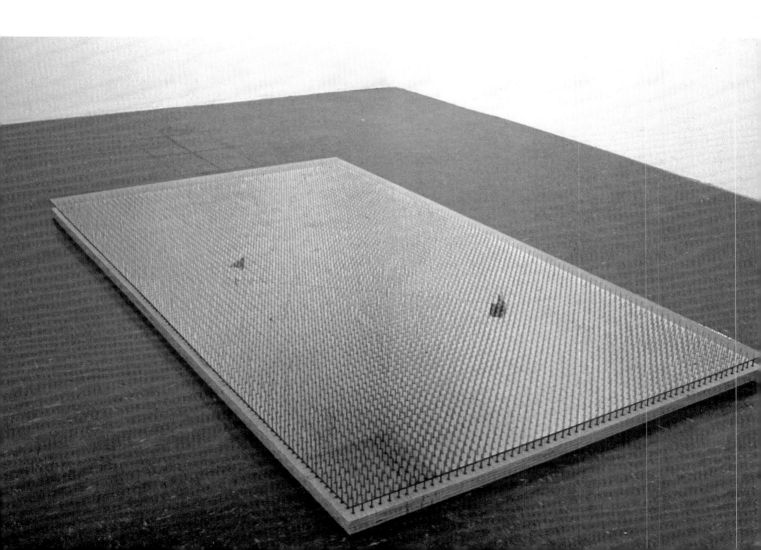

1. Joe Goode, quoted in Sue Scott, "Basic Elements: Paintings, Drawings, and Prints by Joe Goode," *Joe Goode, Jerry McMillan, Edward Ruscha* (Oklahoma City: Oklahoma City Art Museum, 1989), 14.

2. Joe Goode in conversation with the author, May 19, 2010.

3. Ibid.

4. Ibid.

5. Ibid.

6. Joe Goode in conversation with Henry T. Hopkins, in "Bengston, Grieger, Goode: 3 Interviews," *Art in America* 61, no. 2 (March/April 1973), 52.

7. William Wilson, "Art Review: Southlanders' Pomona Show (Joe Goode and John McCracken at Pomona College)," *Los Angeles Times*, March 3, 1971.

8. John Coplans, "The New Paintings of Common Objects," *Artforum* 1, no. 6 (November 1962). (Review of the exhibition of the same title at the Pasadena Art Museum.)

9. Philip Leider, "Joe Goode and the Common Object," *Artforum* 4, no. 7 (March 1966), 24.

It seems every image I have used since completing school has to do with seeing through something, whether it is glass, water, skies, fires, trees...everything. What I am doing is projecting a way of seeing, essentially the same way through a different avenue, through a different image, in a way you don't normally see.
—Joe Goode[1]

"WALL RELIEFS" BY JOE GOODE featured a group of five sculptures designed and produced specifically for the main gallery at Pomona College. The Staircases (as this series of works was called) were indeed as named—replicas of actual staircases, positioned in profile and sunken into the wall at varying depths. Integral to the installation were colors and shadows cast through the strategic positioning of ceiling lights colored with filters—blue, red, yellow— that bathed these objects in variations of purples and oranges. Goode's installation exists now primarily as anecdote or hearsay: vibrant for the viewer who had the good fortune of experiencing it, yet vanishing almost as quickly as it appeared. The artist hasn't elaborated much on this series or this particular exhibition, at least in comparison to his other works. And their appearance in print is most often just as fleeting; they are discussed by Helene Winer in the modest exhibition catalogue that accompanied his Pomona exhibition, but they appear briefly or not at all in other publications. Enhancing their elusiveness is the fact that only three of the sculptures reportedly still exist.[2] However, this installation has a lasting significance, not only for the artist and the program at Pomona, but also in the exploration and expansion of art in Southern California.

Goode began working on the Staircases in 1964. Prior to the Pomona show, he exhibited a group of them in a 1966 solo exhibition at the Nicholas Wilder Gallery in Los Angeles. In this earlier manifestation, they projected from the wall to meet the viewer frontally, in contrast to the Staircases at Pomona, which were experienced primarily from their sides, where they existed "on the same plane"[3] as the wall. This was an important distinction for Goode, who, then early in his career, was embarking on what was to become a life-long exploration of the physical and phenomenological aspects of spatial relationships. Other than the Staircases, he primarily explored these issues via conventional two-dimensional formats: painting, drawing, and collage. Thus, a large part of what distinguishes the Staircases from the rest of the artist's *oeuvre* is the fact that they extended into the actual third dimension.

Goode's Staircases were preceded by his Milk Bottle series (1961–62)—large monochrome paintings juxtaposed with an actual milk bottle painted the same color and positioned on the floor in front of the canvas. Goode recently recalled, "The idea to do stairs was from the same idea that inspired the Milk Bottle paintings."[4] Upon arriving home at the small dwelling in Highland Park that the artist shared with his first wife and new baby, he would often find a glass milk bottle sitting on the steps near the door. Goode's fascination with the way the bottle "floated in space"[5] was a part of the inspiration for these paintings, as was the way he could utilize this phenomenon toward the portrayal of expanding space, in this case by using the floor to reach beyond the canvas. The artist's House paintings (1963)—reductive renderings of typical California bungalows on a monochromatic background—synthesized Goode's use of the quotidian with his interest in metaphysical space. Goode explains: "If a house is typical enough, you always have an idea about what's inside....It was the idea of intellectual transparency that fascinated me.'[6] In the Window paintings, begun at the same time as the Staircases, Goode depicted a view of the sky through a window, and overlaid that with a sheet of transparent Plexiglas. This deceptively simple device acted to disrupt the view out the window while simultaneously reflecting the viewer's space, thus taking his explorations of space even further.

The Staircases, and even more prominently, the Wall Reliefs, appear to function like normal staircases, but in fact they go, quite literally, nowhere. As such, the Staircases convey denial to an emphatic degree, perhaps even more so than Goode's other works (or the works of his peers). This point was certainly not lost on the critic William Wilson, who, in his review of Goode's exhibition at Pomona College (and of John McCracken's exhibition on view there concurrently), struggles to reconcile the evasive character of the work. Positing both Goode and McCracken in what he calls "Neutrality-style art," the writer acknowledges that the work "makes some observers feel tricked, put on."[7] A similar reticence towards Goode's work can be found in reviews of the artist's Milk Bottle paintings, which John Coplans described as "the loneliest painting imaginable."[8] Philip Leider addressed their "unsettling quality," or more specifically, their "intrusive moral overtone which set them apart from the inscrutably noncommittal presentations of his fellows."[9]

WALL RELIEFS BY JOE GOODE

Julie Joyce

Joe Goode Untitled (*Staircase Series II*), 1971. Wood and carpet. 64 ¼ × 64 ¼ × 8 ¾ in. (163.2 × 163.2 × 22.2 cm). Collection of Ed Ruscha

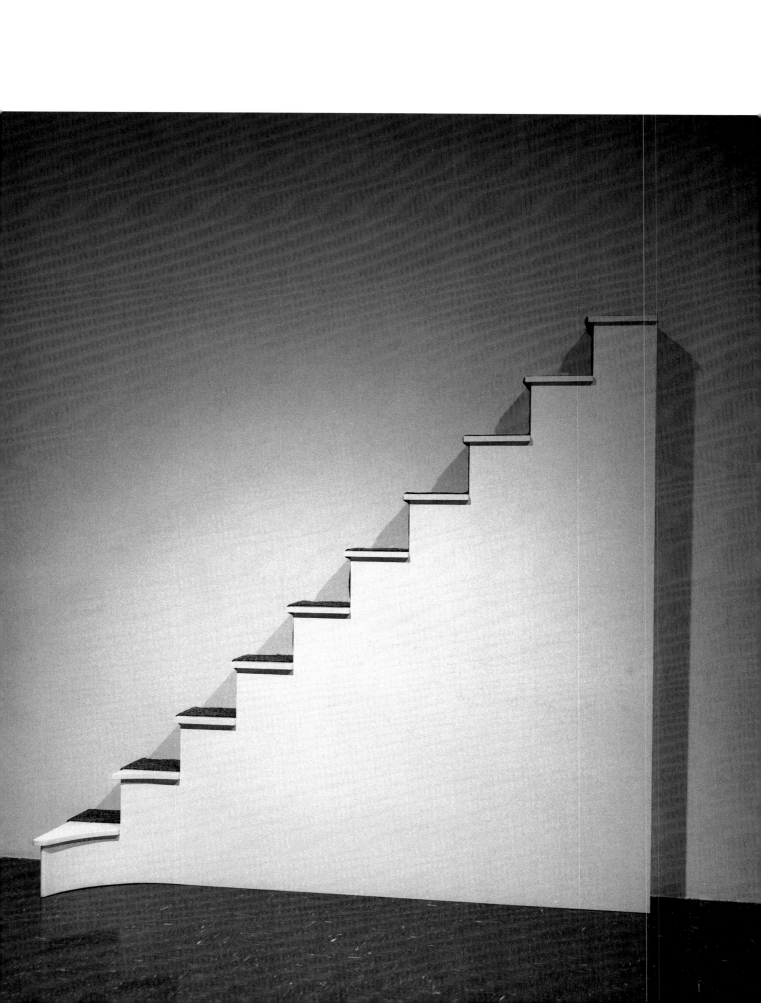

TOP / BOTTOM
Installation view of **Joe Goode** exhibition at
Pomona College Museum of Art, 1971

Joe Goode *Untitled (Staircase Series II)*, 1971.
Wood and carpet. 64 ¼ × 64 ¼ × 8 ¾ in.
(163.2 × 163.2 × 22.2 cm)

10. Joe Goode in conversation with the author, May 19, 2010. See also: Oral history interview with Joe Goode, January 5, 1999–April 12, 2001, Archives of American Art, Smithsonian Institution.

11. Joe Goode, conversation with the author, May 19, 2010.

12. Helene Winer, "Introduction," *Wall Reliefs by Joe Goode* (exhibition brochure) (Claremont, Caif.: Pomona College Museum of Art, 1971).

Goode's works rose out of the artist's observations and experiences of the everyday. This factor, as well as the inclusion of his work in Walter Hopps's landmark 1962 exhibition "The New Paintings of Common Objects" at the Pasadena Art Museum, linked him early on with Los Angeles Pop art. But the fact that Goode was at odds with this early association can be seen throughout his *oeuvre*. Goode has always viewed himself as a painter. He came out of an undergraduate education at Chouinard, during an era when abstract expressionism was preeminent through the teaching of Emerson Woelffer and Richards Rubens. His classmates included Ed Ruscha, Jerry McMillan, Llyn Foulkes, and Larry Bell.[10] Goode considered the Staircase sculptures along the lines of painting, comparing them to his early Milk Bottle paintings. "The staircases are like paintings...they go in and out and up and down, but here you're doing it all at the same time."[11]

Even more important than his alliance with Pop art and any discourse of painting, however, was Goode's interest in perception. During his early years, he felt more closely aligned with Robert Irwin and James Turrell than with other artists to whom he was frequently compared. While the Staircases projected what many felt was equivocation and rejection—elements often associated with Pop and Minimalism—much more can be learned from the artist's ongoing engagement with the experiential. What is most prescient in Goode's Staircases is the dynamism and tension introduced by the work, particularly between that which is visible and that which is perceived. These

sculptures suggest on an immediate level an imperative of form and function, but their deeper meaning lies beyond the knowable and visible—in an *other* dimension.

Essential to any understanding of Goode's Staircases is the rhetoric surrounding its formality; even its context—the experimental and volatile period that this work rises from—is secondary. Winer states:

As an image, the staircase connotes greater romantic fantasy than Goode's other images, while still retaining the sense of familiarity present in his other work. Duchamp, De Chirico, Magritte, Sheeler and many other artists have demonstrated an interest in the concept and formal possibilities of staircases. Theater and film have used the staircase as a dramatic device for staging entrances, exits, falls, duels, speeches, etc. An acknowledged encouragement to Goode's use of the staircase as an isolated object was Busby Berkeley extravaganzas, where the dance sequences incorporated destinationless [sic] staircases on which countless dancers tapped up one side and down the other.[12]

It is indeed rewarding to imagine not just the Staircases themselves, but also what they propose, which is an unending realm of options: physical, rhetorical, mnemonic, fantastical, phenomenological, and more. Goode's works introduce another dimension, both physically and metaphysically. And these dimensions project a new way of seeing that is no less than panoramic.

Joe Goode *Untitled (Staircase Series I)*, 1964. Mixed media. 48 × 70 × 36 in. (122 × 178 × 91.4 cm). Private collection

GLENN PHILLIPS How did you first come to Los Angeles?

HIROKAZU KOSAKA I came in 1966 to go to Chouinard Art Institute. My parents insisted that I receive an American education. When I came to the United States, I brought fear; there was a language problem, a cultural difference. During the occupation in Japan in the 1940s and '50s, I met American soldiers. Seeing American soldiers with rifles coming into the house with their boots on was very scary. I came from Kyoto, the ancient capital of Japan. You see thousand-year-old homes there, and merchants that go back hundreds of years.

I never knew the word "art." In Japan, it's called craftsmen or artisans. The Chinese ideogram is three symbols: ear, sound, and ladder, to support it. We have to hear it, the sound of the crafts. That's how I grew up: I thought brush-makers were artists. Paint-makers were artists. We didn't have museums. The museums were Buddhist temples, and the walls were screens that were painted five or six hundred years ago. Japanese gardeners were artists. I thought, coming to Chouinard Art Institute, that I would be learning something in that line of craftsmen. But Chouinard was very different.

GP What were the other students like?

HK The first year, I met many non-Americans: people from Mexico, people from Europe, one or two Japanese. The students were very diverse. I always thought Americans were six feet tall, blue eyes. I was surprised. It was nothing like what I imagined. Most of my teachers were draftsmen in the lineage of Rico Lebrun. The first year was figure drawing for eight hours a day. I think there were thirty students in the class. We drew with charcoal. That's all we did that first year.

GP And then you studied painting after that?

HK It was general studies: We had drawing class, painting class, sculpture class. I had an incredible handicap with language, but one of my interests was art history. Our teacher was a writer for the *Los Angeles Times*.

GP Jules Langsner.

HK Yes. He was showing some Chinese and Japanese paintings, and one of the paintings was from my neighbor's temple. I told him this, and he was very surprised that I'd seen this painting. He

asked me to sit around on the patio, talking about these paintings. He was also very fascinated with experimental art. The name Gutai came up. And I said, Jules, I know these guys.

GP So you had known some of the Gutai artists in Japan.

HK Yes, I knew some of them as a teenager. There was a publication that came out around 1956–57, which I had. My high school teacher was very experimental, and he was showing these photographs. I had collected a lot of photographs of that period.

GP And what did you think of that work? Did you think of it as performance, or photography, or was it just another approach to art making?

HK I think when I came to Chouinard, Allan Kaprow's book on Happenings had already been printed. There were Gutai photographs in that book. That was very surprising. The word "Happening" was a kind of fashion for that period, not so much the word "performance." I don't think Gutai group called them happenings or performances. The word Gutai means concrete forms. That's what's Mr. [Jiro] Yoshihara, the leader of the group, was concentrating on. He painted circles all his life. The circle connotes Zen *ensō*, meaning empty. I think that's the word Gutai was trying to say something about, this Buddhist notion of emptiness. I don't think Allan Kaprow knew that. I talked to him a couple of times about that, and he just said, "I don't understand." But John Cage was profoundly moved by *ensō*. He did a lot of pieces about that.

I think my potential for making art was just seated in certain periods. I did well at drafting, and I did well in painting, but I think there was a limitation. The Gutai artists really influenced my work after my junior year. I started to see pictures of Joseph Beuys's work in *Art International* magazine, and I saw Conceptual art, like Douglas Huebler. I saw pictures of earth art—[Robert] Smithson, [Dennis] Oppenheim, people like that. But when it became body art—that really brought back the Gutai group. Especially [Saburo] Murakami going through paper, or [Kazuo] Shiraga in the mud, looking for his art.

At the same time, I came from a very traditional background, and there was a conflict. I think the conflict was the Vietnam War. I was seeing the Vietnam War and looking at the images of bodies, just piling up. That also went back to Rico Lebrun's drawings for Dante's *Inferno* from the early sixties.

Getty Research Institute, Los Angeles, California, June 2, 2010

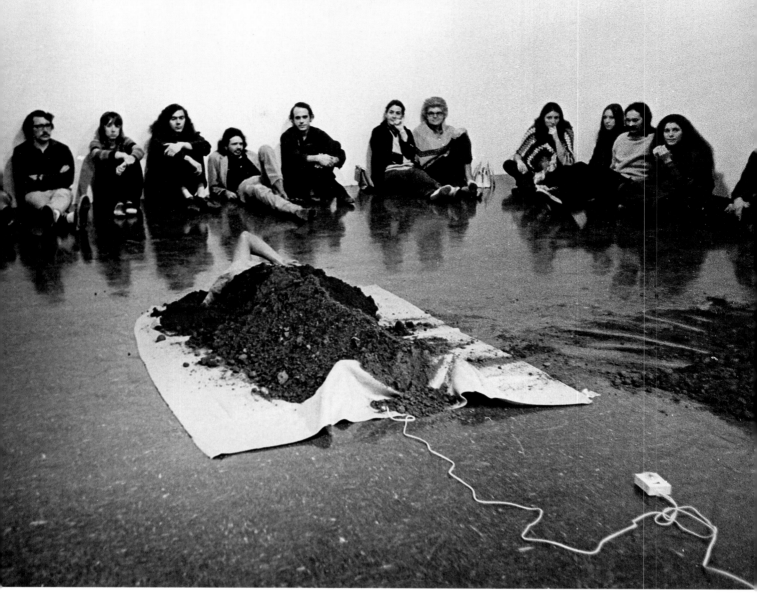

He was an artist in the army, and he went to death camps and drew all these incredible bodies. I also knew the photographs of Hiroshima and Nagasaki. But the first image that really blinded me was the Vietnamese monk who burned himself. I think it was in Saigon, and he just poured gasoline over himself and burned himself. He was so stationary. It was like meditation in a way, in this posture, and then he just collapsed. And I thought: I could do it. I wanted to do it. But...I couldn't do it.

But I wanted to do something. The word "perception" comes back. When *Avalanche* magazine came out, I think it melted into my mind a kind of a perception. *The Primacy of Perception* by [Maurice] Merleau-Ponty. That book was very popular. And [Claude] Lévi-Strauss. Jack [Goldstein] and I were hitting the bookshops constantly, trying to catch up.

GP How did you meet Jack Goldstein?

HK I met him at Chouinard, probably around 1967. We became good friends. He had a studio with Jim Morphesis, and I used to go to his space. Senior year, he moved into Ron Cooper's studio, and he asked me if I would share. It was $100 per month for ten thousand square feet. We shared it 50/50. We thought maybe we could do some kind of a business, so we created GK Frames (G = Goldstein, K = Kosaka). It was a big fashion in that period to have a Plexiglas frame—clean and minimal—so we were doing a lot of Plexiglas.

In our studio, *Avalanche, Artforum,* you name it, the current issues were always on the coffee table, and we had intense conversations. Jack was just intense. It's forty years ago, but still, I live that moment. It's really sentimental, good old days.

Hirokazu Kosaka *Untitled*, 1972.
Photograph of performance
at Pomona College Museum of Art

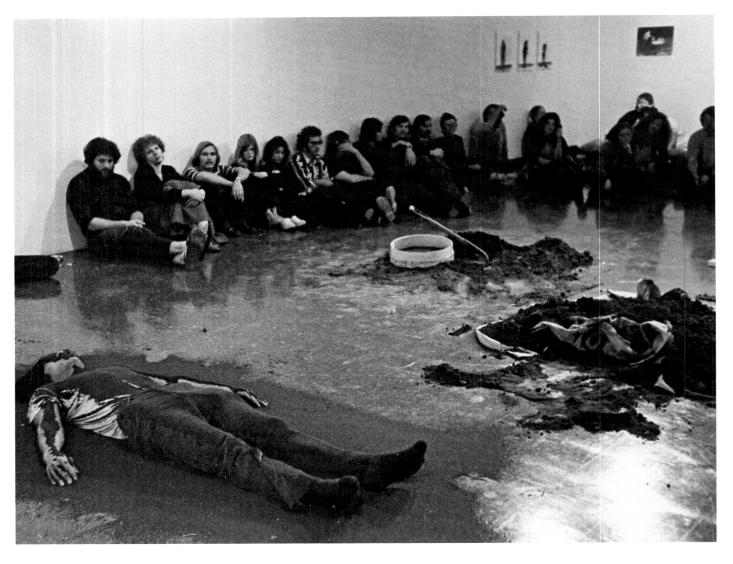

I don't know where Jack met Helene Winer. Jack was kind of a romantic guy. One day, he said he met a very smart woman. Helene saw my work through Jack, and coming to our studio. She wanted to curate something, so she called Wolfgang Stoerchle, Chris Burden, and me, and said, "Let's do a performance every week for three weeks in March 1972." The first piece I did with an audience was for Pomona.

GP Oh, that was the first one?

HK I think it was.

GP Before we talk about that piece, maybe you should describe some of your earlier performances, ones that didn't have an audience.

HK Let's look in this book. [Opens a book of his artworks.] This piece was much earlier. I was in a forest.

GP This piece is called *Pineapple Juice*?

HK It's in 1970. I got a can of pineapple juice and poured it all over my body, and then I became an entomologist. [Laughs.] This was one of the first pieces.

The second one was this electric blanket with feathers on it. This was not so much a performance, but more an installation piece. It's almost similar to Allen Ruppersberg's work. He would install something, take photographs, and that is the piece. But why an electric blanket? Electric blankets had been really important in my life. When I came to the United States, the apartment person gave me an electric blanket, and he said, "Put this on." I didn't know what it was, but I was fascinated. We had never seen this in Japan. We had huge cotton blankets over us. I was just amazed by the electric blanket. It was so warm! I had a dream the first night, with this incredible floating sensation. Ever since then, I've had this notion of America being an electric blanket.

Hirokazu Kosaka *Untitled*, 1972.
Photograph of performance
at Pomona College Museum of Art

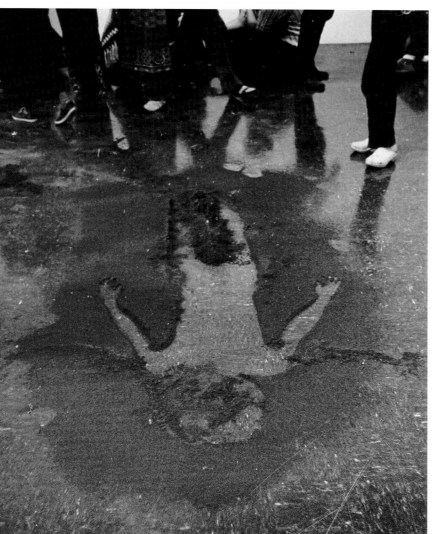

GP *Condition* (1970) shows an image of your feet?

HK This is a film. The feet go up and down, as if levitating. This is a forty-five-minute piece, just levitating back and forth.

GP Wolfgang also made levitating pieces.

HK With the mirror, going back and forth. Levitation and astral projection was a fashion of the period. That word "projection" came up many times. I didn't know the word. I looked in the dictionary, what is a projection? What does that mean? "Astral projection," what is that? Then the words became familiar to me in both languages, Japanese and English.

GP What about *Music Box* (1971)? You're crouched inside a tunnel.

HK When I was fourteen, I went to Spain to learn flamenco guitar. I knew flamenco music, Persian-Indian music, Moorish music, and Japanese Gagaku, the traditional court music. So I created a kind of Silk Road music, and there was a guy who built the music boxes for me, five of them. I would go to different places to play the boxes. There was a mile-long tunnel in downtown [Los Angeles]. It was owned by the Department of Water and Power. It was gated, but I asked them if I could do something, and they said okay. There was no audience, except for the guy who opened the tunnel. I had a tripod, and I took this photograph.

GP Let's talk about your performance at Pomona. Why don't you describe the performance?

GP What about this piece, *Stage* (1970)? You set up all these objects on a stage, and you're manipulating them for the sound?

HK Yes. Firecrackers, an air pump, rolling marbles on the ground. This is also a walking place. People will walk different textures. When you approach a Japanese garden, the architecture will provide you with different textures for your feet or even the surroundings. It's about axial orientation. Wolfgang Stoerchle was also interested in this. I told him about textural kinds of perceptions—not just in looking, but how we approach different places. We talked for maybe three or four days about this. He was working with plaster of Paris. He would drop plaster slabs on the steps of University of California, Santa Barbara. He said he approached the steps with this same kind of premise.

HK I went back to the electric blanket. I wanted to do a projection piece, to astral project my body. I had the electric blanket on really hot. I was under the blanket, and on top of that I had a couple hundred pounds of dirt over me. When the audience came in, they saw me lying on the floor. I was trying to project my body to someplace else. About forty minutes later, I got out of the dirt and the blanket, and I lay down in another location. An assistant, I think a student, used a big industrial sifter to sift that same dirt over my body. I laid there for another ten minutes or so. Then I got up, and I had projected myself to a different place. I had a line of my body to a different space. That was the piece. About a week later, Wolfgang called me. He said, "We've gotta talk. I want to know what you did there." It was just prior to his performance [at Pomona]. He said he saw a photograph

Hirokazu Kosaka *Untitled*, 1972.
Photograph of performance
at Pomona College Museum of Art

of the atomic bomb in Hiroshima. Someone was standing in a bank, and the atomic bomb blasted, and the shadow was there, burned onto the wall. He said it reminded him of that. I said, "Yes." He said in Germany, there was a guy who jumped from a thirty-story building onto the cement, and it just flattened him. The image of his body was still on the concrete asphalt. He said, "That was a very powerful thing that you did," sort of congratulating me. I think that conversation made me really happy.

I think Helene really gambled, in a way, to do something like that in a traditional university. I remember talking to Jack, "Is she going to get fired doing this kind of stuff?" If it were an art school like CalArts that would be okay, but Pomona? Jack and I talked about it, and he said, "Oh, I think it's okay." Chris's piece and my piece were kind of conservative, but I think Wolfgang's piece—pissing in the gallery—upset a lot of people.

GP *Five Hour Run* (1972) was another powerful work.

HK This was at a gallery called Mori's Form. This was the first opening at the gallery. My friend Kikuo Mori was the owner of the gallery, and he told me that Mr. Shimamato Shozo from the Gutai group was coming to do a performance. He said, "I want you to do something to purify the space." So I laid down lines of string. I nailed down the lines, and I ran for five hours in the gallery. I had water, and I was running, running, running. Five hours came, and I went home. I was exhausted. Then the audience came. In fact, Jack and Helene came by. The only thing they saw was a string. "Where's the art?" The gallery director told them: "You're breathing it."

GP And that was the inaugural show at Mori's Form?

HK The next week, Shimamato Shozo came. Many Gutai people came. We did what was probably the first Southern California exhibition of Gutai photographs. I still have them. [Pulls out photographs.] This was the exhibition.

GP When was this?

HK This was 1972. These are the original photographs. Not too many people have these photographs, even the Gutai members. Many of these are different views than what you see in books.

GP These are amazing.

HK It's shocking, that these guys were doing these things in 1956.

GP It's so early.

HK And for me it's amazing because Osaka was devastated in the war. I can't believe these guys were making art, and their wives were working. These kinds of solutions, around Gutai, it changed my entire life about how I looked at art. That's Mr. Jiro Yoshihara; he did the circle. These are pieces at the Expo in 1970, the Osaka Expo. They did a huge performance of Gutai members. Many of the photographs are black-and-white. I asked them, what color was this? It was red!!! All kinds of colors. I can't imagine. For a twenty-year old kid looking at this stuff—. I thought: I'd better not paint any more decoration art, you know? They really taught me how to see different things, not just art. Especially Mr. Murakami. In 1973, I went back to Japan, and I stayed with him. His mother and wife were still living, and they took me in as their son.

Mr. Murakami was part of a gallery in Kyoto, in an old neighborhood. "Hiro," he said, "I want you to do something." I was feeling so bad about the Vietnam War. My girlfriend left me alone, and I was feeling very bad. I said "Okay." And Kikuo Mori had moved back to Japan from Los Angeles, and he asked me to do something, too. In two weeks, I went to the space. I had white paper on the floor, and one chair. I came in and a hundred people were in the audience sitting on the floor. I took a guitar. I embedded a razor blade into my index finger, and I played almost forty-five minutes of flamenco music. I was so excited, the blood just kept pouring. The entire floor was blood. But the fiery flamenco music excited everyone, too. After that, I just walked away. I took a train to Kobe, and then from Kobe I took a ferry to Shikoku Island. I went to the temple, and the next day, two priests and myself began walking around the perimeter of the island.

The gypsies play this incredible music influenced by the Moorish and nomadic people from Punjab, India. They came all the way to Andalusia, Spain, around the fifteenth century. They brought many things. So, I was doing something like that. I was a gypsy, nomadic. I traveled for three months around the perimeter of the island, a thousand-mile walk. When I came back, there was no such thing as art any more. I became a fully ordained Buddhist priest after that. I learned something that was totally different from art; to kill the self was the idea. And I lost it; I lost the egoism of making something.

GP How did you reconcile body art and Conceptual art with your studies to become a priest?

HK It was a polar opposition for me: there's the egotism of making art and aspiring to become famous, and the opposite is non-ego. That was really a conflict at the beginning, but I pursued a form of

meditation called standing meditation, which includes Zen archery. The notion of hitting the perfect shot is the action without intervening thought. No thinking; just do it, forget it. That was very important. In my study of Buddhism, the teachers who taught me the old script, incredibly, I think they knew where I came from. Some of them asked me what I did. And they would take that piece, *Five Hour Run*, for example, and put that into an historical context, and immediately I said, "God, these guys were doing this in the fifteenth century in a rock garden, or even a circle painting." They were doing exactly what I was doing. So I was sort of awakened to a certain level of human nature. Archery had a lot to do with that. It's an instrument, a vehicle that awakened me. It's not about hitting the target, it's about letting go of your ego, of *not* hitting the target. That kind of teaching really defined what I am rather than who I was in the past tense.

At the temple, I was one of the monks who attended a huge gong outside. It weighed a couple of tons. I would hit it when it was six o'clock. And it echoes. Immediately, it is disappearing. And I thought to myself, everything is impermanent. That's what it signifies, that gong. That was my job; every day at 6 p.m. I hit that gong fifteen times to feel the impermanence of all things. I read *The Tale of Heike*, a twelfth-century novel, and the first line is about hitting the gong, and the impermanence of all things. And then, after three years in the monastery, the head priest said, "Time to get out of here." And so I left.

GP When did you come back to Los Angeles?

HK In 1977, when the headquarters of this particular denomination was looking for a minister in Los Angeles. But during that time I was also going back and forth to Boston, New York, taking classes with senior ministers. My study was in esoteric Buddhism, mandala, and Sanskrit. Finally, I ended up in the Harvard-Yenching library, and assisting the curator at the Museum of Fine Arts, Boston, on an exhibition of Japanese Buddhist treasures. So I lived in Boston for a while, from 1980–82. At that time, Los Angeles was already creating the Japanese American Cultural & Community Center (JACCC), where I am now artistic director. The curator there asked if I could help, so I came back and they hired me as a preparator. I liked it. It was physical and not too academic.

Then, in 1983, Julie Lazar from MOCA [The Museum of Contemporary Art, Los Angeles] asked me if I would like to do a new performance as part of the Exploration series. It was going to be in the theater at JACCC, and all these young people were part of it.

I was so out of it—performance art—but I nonchalantly said, "Okay, I'll do something." I did an archery performance, *The Contemplations on the Asymmetry of a Bow*. Chris Burden came to see the performance, and Barbara Smith, Mike Kelley, Paul McCarthy, those guys. That brought kind of an inertia to me. I thought I should do something more creative. So from academics, I started to do grandiose performance. Then I started to bring the Buddhist congregation into the performance. Not just performance art, but small gatherings of Buddhist music and things like that.

It intermingles, but it's independent of each other, my personal life. The monastic versus Chouinard Art Institute—it's very similar, but bi-polar oppositions. If it weren't for Chouinard Art Institute, I would never have been awakened into certain levels of Buddhist teachings.

I'm very lucky. I had great teachers to show me the path. But I think that path—I don't know if it's bad or good. To find the answer—that was never in monastic life. Once you question, you have to have an answer, and that answer affirms your ego. It's an appetite, a dessert, the idea that the answer is going to be affirmed. So, I had to let that go. I asked: What is art, who is this, who is that? That, too, I think I let it go. That was one of the teachings. It was very hard to let it go. Even today—can I let go my bow and arrow? No, I can't. [Points to the Gutai photographs.] Can I let go of all this stuff? No, I can't. But I've seen people let go and, I don't know. Jack let himself go in certain ways. I'm kind of envious. There was a period of my life when I wanted to imitate the Vietnamese monk who burned himself. How can I do that? To be *so* still but *so* angry. God, it was an incredible meditation; just an inferno, you know? I don't think I could do it.

So in the meantime, I've been doing like Bruce Nauman said, "I do my art because it kills my time." I think about my kids, I've got to get these guys in college! I'm artistic director at JACC. That is a full-time job. I own my Japanese archery club, which is very heavy. It started in 1916, and I have to keep it going. I have little jobs to do, and it's hard work. My social boundaries still linger, you know?

So I can't think about the monk who burned himself. Occasionally, I think, wow, it would be nice. But the maintenance of all this work I have to do, it keeps me busy.

MARIE B. SHURKUS Your work really seems to stand out in the context of the late sixties. Who were some of your influences?

WILLIAM LEAVITT Ed Kienholz was a really strong influence because his tableaux were narrative and narrative was something I was very sympathetic to. Also Ed Ruscha. He did a show at Ferus Gallery in 1965 that was important for me, but I haven't seen any of those paintings since. They depicted birds, pencils, and fish; and if I remember correctly, the bird was a Baltimore oriole. He used those three elements in different arrangements as figures on a black background. And these paintings were in line with my interest in the absurd. Ruscha didn't really make much of those paintings later, but they did have an influence on me in terms of their presentation of the image as icon without its usual connection to meaning.

MS A similar sensibility seems to be operating in your piece *Random Selections* from 1969.

WL Yes, I used three-by-five-inch cards that had pictorial elements on them. I think there were maybe twenty different items such as smoke, wire, photo, cage, fish, and sand. They were just banal things from the world. I shuffled the cards and dealt three, then made a little drawing of the set, and then took a photograph of the actual objects in the combinations given by the cards. I think I only made three or four different photos of the various combinations, though I used that technique later on to generate material for scripts.

MS In 1969, you also collaborated with Bas Jan Ader, right?

WL I met Bas at Claremont Graduate School in 1965, where we were both students. Later we worked together on a publication and some outdoor installation performances; one we did at Immaculate Heart College was called *A Hillside Work* (1969). It was a waterfall of highway flares, laid out with one at the top, two, three…until it spread out at the bottom of the hill. All these flares were lit sequentially from the top to the bottom, creating a sense of movement unfolding. We amplified the sound of the flares with a microphone, so that you heard the hissing of the flares as they slowly burned out and the sound faded.

MS Audio is also a significant part of the work you showed in your first solo exhibition at Eugenia Butler Gallery in 1970.

WL Yes, I installed three pieces at Eugenia Butler. *Forest Sound* was composed of seven artificial plastic trees set on a sand hillock. A yellow spotlight lit the trees from below so you could see the concrete bases of the trees. There was also a tape recorder playing a looped recording of mockingbirds, which came from a speaker in the trees. The second installation, *Garden Sound*, was a clump of plastic vegetation, a wooden box with microphone and amplifier, and a speaker buried in the plants. A pump circulated water in the box, so you heard the sound of running water coming from the plastic plants. Each piece had its own room. *Wind Sound* was in the office area of the gallery. On one wall of the room was a tape player with a looped recording of the wind going through a radio transmitter—built from a little Radio Shack kit. On the other wall was a radio that received and broadcast the sound of the wind. Actually, the wind sounded a lot like static, but you also heard a whishing sound. I was mostly interested in the absurdist idea of broadcasting the sound of wind over a radio ten feet away—a wind environment in the office. I was interested in creating something that was illusionistic in terms of mood, or story, or place, or situation.

MS That sense of creating the illusion of a mood or a place also seems to describe your approach to narrative. The last time we spoke about narrative, you mentioned an influence coming from soap operas as well as from the author Alain Robbe-Grillet.

WL The banality of soap operas fits in with my interest in suburbia. I thought the style of soap operas was marvelous in this absurd way. It wasn't that I wanted to disparage it; I just wanted to hold it there and think, What is this? I wanted to look at it not through a plot sequence, but through how it was presented. It does seem kind of opposite to what Robbe-Grillet was creating—this very reduced description of a place, a situation, pared down to a point where there was just this repetition of the language and a kind of blankness that he created, sometimes with a layer of dread underneath, but not giving you too much. He kind of left you to fill in the spaces yourself. So I was interested in how he did that. I was also interested in the philosophy of phenomenology, which asks that we look at things before judgment, and try not to assign any value to our investigations of the world, but just look at it and bracket it to see if something else will come up.

William Leavitt's home, Los Angeles, California, January 21, 2010

WILLIAM LEAVITT
INTERVIEWED BY
MARIE B. SHURKUS

William Leavitt Typed text exhibited with *California Patio*, 1972. Collection of the artist

A Summer evening in the backyard and garden of a contemporary
hillside home in Southern California. There is a swimming pool,
a flagstone patio, a redwood fence, some lawn, and the usual
tropical landscaping of succulents, ferns, leafy plants and
flowering shrubs. The beauty of this setting is most evident
at this time of day when the combination of lighted pool, soft
garden lights, black sky, and the lights of surrounding houses
comes into play.

On this particular evening a small cocktail party is being held
on the patio adjoining the house. The guests are all close friends
of the host and hostess. Their presence adds the elements of motion
and sound to this scene; the men standing near the edge of the
patio engaged in relaxed conversation, while the women sit in a
loose circle of lawn chairs arranged on the lawn. Now the hostess
comes out through the sliding glass doors on to the patio to
announce that a light buffet supper is ready inside.

MS In interviews, Robbe-Grillet has talked about wanting to create a new structure for the novel that doesn't rely on plot. That seems to resonate with what you were doing. Critics have described your work as creating scenes that only suggest narrative. It's almost as if you were trying to occupy the gap between a story and its telling. Is that what you mean when you referred to some of your works as "Theater Objects"?

WL *The Silk* from 1975 was a kind of Theater Object. It was a one-act play and had actors, speech, movement, some kind of plot line. But it didn't have any of the drama or metaphor that a play would have. It went through the motions of a play, but it wasn't really theater. I thought of it as a play separated from the world of theater, outside of the world of drama, comedy and so forth, as a kind of element on its own. I thought of it as a kind of object.

MS Was it scripted?

WL Yes, scripted and directed. It wasn't random at all. As I said, I was very interested in soap operas and how uncondensed soap operas are, because soap operas take years for any plot point to really develop. They are always in a state of suspension; nothing is ever realized. In *The Silk*, I condensed it into thirty minutes and something actually changed. But the situations that were presented felt like soap opera situations.

MS So are Theater Objects a kind of performance art?

WL I don't think of it as performance art because it was imitating theater. There are other established styles of performance—cabaret, stand-up comedy— all these things that got folded into performance art in a raw form. So maybe I was doing something similar, imitating theater in a kind of raw, unpolished way. It was kind of parallel, but I wasn't interested in acting out these things myself as a performer. I was more interested in it as a distanced process or event that I could do theatrically.

MS By calling it an object, there's an implied reference to sculpture.

WL Well, I think that's interesting, because one thing I liked about live theater was that it was a kind of moving 3-D. You had these very strong sculptural elements that you could use spatially. I thought it was a kind of spatial sculpture. Some of these ideas I picked up from Bill Shepard, who taught theater at Immaculate Heart College. He had studied with Jerzy Grotowski and brought some of these techniques to Immaculate Heart's theater department. I sat in on their workshops and productions, so I was aware that there was another style of theater developing, another point of view in terms of how one could do a theater piece.

MS We kind of jumped ahead with the discussion of Theater Objects. Getting back to 1969, Ger van Elk and Al Ruppersberg were both included in the "When Attitudes Become Form" exhibition [curated by Harald Szeemann at Kunsthalle Bern].

WL Yes, for our group it was kind of a coup for Al to be in that show. Plus, the title of that show was very leading, as it validated the explorations and experiments we were engaged with here in Southern California.

MS Do you feel like there was a different flavor of Conceptual art going on in Los Angeles than in New York?

WL Oh, definitely. When you think about Ruscha's books—*Royal Road Test* (1967) or *Every Building on the Sunset Strip* (1966)—they had a very absurd element, and they weren't concerned with academic language. I'm not sure the East Coast really was either, but what was happening out there seemed a little more minimal. It seemed like the work here brought in the real world more, what was actually going on in the city.

MS Did you consider yourself a Conceptual artist?

WL No, I didn't think that was exactly what I was doing. I read Conceptual art rather narrowly. When I consider Conceptual artists like Douglas Huebler, Lawrence Weiner, and Robert Barry, I think about how they usually used only language or photographs to create their works. I didn't feel like I was doing that. I felt that I was doing something more material, that I was using material to create a mood, or a social situation. For me, Conceptual art was really a doorway into narrative. I was interested in creating the situation that could result in a story. I wanted to lay the ground for a story, but not actually tell it.

TOP / BOTTOM
William Leavitt *California Patio*, 1972. Mixed media construction. Dimensions variable. Collection of the Stedelijk Museum, Amsterdam, The Netherlands

MS In 1972, you, Bas, and Ger had your show at Pomona. You showed *California Patio* (1972), which seems to capture that sense of narrative. How did that piece come about?

WL It's interesting when one gets asked how a certain piece came about. When viewed from the present, these things almost seem to be autochthonous, like they just sprung out of the ground, fully armed, like the Titans. You don't even know where they came from. I do know that I was fascinated by suburbia. I had a catalog of swimming pools that was put out by a big swimming pool company in Los Angeles, and it had these great shots of people's backyards with their pools. I would just study it, as a kind of amateur sociologist. I was looking at all the different possibilities, and I was also interested in what was generic, or reduced. I wanted to see what I could do in terms of not being particular, maybe take from all of those backyards and present something that embodied all those middle-class patios. So I think I wanted to recreate something of that backyard suburban feeling, which was *California Patio*.

MS Helene [Winer] described your work as creating a space in the gallery that was actually quoting another space. Did you want people to look at *California Patio* and recognize it as something that was quoting suburban patios?

WL Well, I don't think I thought of it as quoting. I wanted it to have that direct reference to suburbia, but I also thought of it as an object in the gallery, that from one point of view, it could have a very illusionistic reference. If you just looked at the curtain and through the door, there would be something quite illusionistic about it. But, as a whole, it would be somewhat awkward, and you would see that the whole thing was really just this clunky wall with supports; it had a back, where it wasn't an illusion, it was just material. I liked it that you saw all the seams and the parts of it, what went into making the illusion.

MS Your approach of working from a magazine or catalogue and creating a general composite of what you saw makes me think of Cindy Sherman's work. It seems like your approach is related to what developed later in New York under the name of the Pictures Generation.

WL Yes, I think there's a correspondence—mostly with Cindy because she created her own scenes. They were called appropriated images, but they were actually pictures that she created herself in reference to the movies or some other popular media source. I didn't directly appropriate either. There was a lot made of John Baldessari and CalArts, and the whole idea that these images were lifted from existing publications. But that wasn't so important to me. Somehow I would arrive at the image, using those sources in some way, but not by copying them directly. I think too much was made of rephotographing. It's really just part of the tool kit, you know? Of course, theoretically it deals with the idea of authorship, which is interesting, but sometimes you want more from what's being rephotographed. I think John Baldessari and Cindy Sherman really supplied that; they put it into their own realm, added their personal interpretations of it, and twisted it enough so that it came alive again. They kind of recreated it.

Set for "The Tropics". William Leavitt '72

William Leavitt *The Tropics*, 1972.
Pencil and watercolor on paper. 22 ¼ × 30 in.
(56.5 × 76 cm). Collection of Marc Selwyn

1. Melinda Wortz, "Spiritual Dimensions in the Art of John McCracken," in John McCracken, Edward Leffingwell, and Anne Ayres, *Heroic Stance: The Sculpture of John McCracken, 1965-1986,* exh. cat. (New York: P.S. 1 and The Institute for Art and Urban Resources, 1986), 20.
2. John McCracken quoted in "Interview: John McCracken and Matthew Higgs," in *Early Sculpture: John McCracken* (New York: Zwirner & Wirth, 2005), 9.
3. James R. Mellow, "Up Against the Wall? Or Floored?" *New York Times,* June 7, 1970, 107.
4. Helene Winer, press release, Pomona College Art Department, February 2, 1971.
5. Mellow, 107.
6. McCracken, as quoted in "Interview: John McCracken and Matthew Higgs," 10.
7. Wortz, 22.
8. Anne Ayres, "Connecting Heaven and Earth: The Angelic Madness of John McCracken," in McCracken, Leffingwell, and Ayres, *Heroic Stance,* 32.
9. McCracken, as quoted in "Interview: John McCracken and Matthew Higgs," 7.
10. Ibid., 11.
11. Wortz, 20; and Ayres, 36.
12. Ayres, 28–30, 34–36.

JOHN MCCRACKEN WAS WELL ESTABLISHED in the art world by the time of his exhibition at the Pomona College Museum of Art in February 1971. His work, associated with Minimalism in New York and with the "Los Angeles aesthetic" of Finish Fetish,[1] had been featured in solo shows on both coasts and internationally. McCracken was best known for his planks—tall, thin structures that were brightly colored with meticulous, high-gloss finishes. These finishes are a distinctive feature of McCracken's work; highly labor intensive, they require hours of work and layers of varnish, and are almost always entirely handmade by McCracken. Although they contain what he calls "subtle reflections of the maker's energy," the final product appears to be industrially manufactured.[2] Reminiscent of surf-boards, the planks are exhibited leaning against the gallery wall at an angle. *New York Times* critic James R. Mellow described them in 1970 as "brightly colored Platonic slabs of lumber—ideally nonfunc-tional structural forms."[3] The planks propelled McCracken's art world success; in 1970, they were already regarded as his signature pieces.

At his Pomona College exhibition, however, the planks did not appear. Instead, McCracken exhibited what the press release for the show described as "the first works by the artist that hang on the wall, bringing the pieces closer to painting problems that have always been integral in his sculpture."[4] The three rectangular works shared the same bright colors and glossy finish of McCracken's earlier work, but they abandoned the floor altogether. Mellow described the planks in 1970 as "not quite sculpture and not quite painting."[5] McCracken's works are considered sculptural for their three-dimensional presence in the viewer's space; they are simultane-ously considered as paintings for their bright colors, which McCracken described as an actual medium of the work itself, and their glazed, two-dimensional surfaces.[6] Less than a year after Mellow's comment, McCracken's exhibition at Pomona College moved his body of work even closer to painterly issues. One of the three untitled pieces was a long, horizontal, red work that abandoned the planks' smooth finishes in favor of a surface that, while still glossy, clearly distinguished the boards underneath, evoking both the texture of painting and the medium of sculpture. This and the other 1971 wall works seemed to be sculptures, by design and by fabrication, that were displayed and viewed as if they were paintings.

Despite the claims of the press release, the Pomona College works were not McCracken's first wall pieces. He began his career, as Melinda Wortz recalls in the catalogue for McCracken's 1986 retrospective, "with painting on canvas and gradually incorporated other materials, such as lacquer, on the canvas; then he produced reliefs that hang on the wall, and finally allowed the work literally to come off the wall and stand freely in space."[7] McCracken's early sculptures echoed their predecessors, which were highly polished slabs with recessed "slots" that allowed them to be considered relief sculptures even before their departure from the gallery wall.[8] The step from one to the other seemed to be a natural one, as simple as removing the pieces from the wall and placing them on freestanding pedestals.

McCracken describes this development of his work as a natural push towards a more reductive and radical form. He notes in a 2005 interview that "the earliest works were composed of many elements, then the elements coalesced and simplified, and then they got to the point where they turned into different materials, and then what had been paintings became reliefs with hard surfaces, and then the reliefs got deeper, and jumped off the wall in the form of sculp-tures. The whole development was unconscious and intuitive enough that I was surprised when I fully realized what had been happening."[9] The push to further reduce the forms of his work could be read as an embrace of the Minimalist esthetic, but McCracken was striving to do something more com-plex with his pieces: he was attempting to create "beings." He said in the same interview, "I went kind of full tilt with my ideas. I was purely inventing as much as I was thinking, but I was mainly trying to make things that had strong existence. They had to be inter-esting, beautiful, have the right scale and bearing, and have obvious, convincing *being.*"[10] This associa-tion of his works with anthropomorphic beings (he describes them alternately as "heroic" alien beings and the creations of a future UFO traveler)[11] differentiates McCracken from his Minimalist con-temporaries. The planks represent more than the tangible and imposing presence felt by viewers of Minimalist sculpture. They represent an alternate reality, a strange and unidentifiable presence that is at once foreign yet literally reflective of our own world, as the high-polished surface mirrors and distorts the viewer and his/her surroundings.[12]

BACK TO THE WALL: JOHN MCCRACKEN'S WALL WORKS

Carrie Dedon

John McCracken *Black Resin Painting I*, 1974.
Polyester resin on plywood.
32 ¼ × 48 ¼ × 2 ⅜ in. (82 × 122.6 × 6 cm).
Collection of Orange County Museum of Art;
Gift of Mr. and Mrs. M. A. Gribin

13. Ibid., 34.
14. Edward Leffingwell, "Heroic Stance," in McCracken, Leffingwell, and Ayres, *Heroic Stance*, 9.
15. Wortz, 24.

The wall works at the Pomona College Museum further blurred the distinction between painting and sculpture, as the flat sculptural surfaces were mounted and viewed like traditional canvases within the gallery. They presented an "insouciant refutation of the formalist separation of painting and sculpture," a merging of the most distinct elements of each medium.[13] Typical art viewers approach paintings in a different way than they approach sculptures. They face the canvas directly, to contemplate its surface, and to immerse themselves within it. The highly reflective and brightly colored surfaces of the Pomona wall works therefore presented a unique viewing experience. Because they were displayed like paintings, viewers were invited to immerse themselves more deeply in the reflective surfaces and study more thoroughly the deformations perceived there. This experience heightened the potential for viewing an alternate reality and being which may be, as McCracken muses, the product of time travel, UFO visitations, or could be "just sculpture."[14]

Ultimately, McCracken returned to the form for which he is best known. Indeed, the planks most successfully represent his attempt to create "beings"; their form is often anthropomorphized as a metaphor for the human condition—standing freely, but dependent on external support.[15] Although McCracken ultimately moved back off the wall, the Pomona wall works were an important step in the exploration of surface and form that characterizes his work. They represented a simplified version of the sculpture/painting blend that further intensified the glimpse into an alternate reality and a foreign vision of ourselves.

Installation view of **John McCracken** exhibition at Pomona College Museum of Art, 1971

John McCracken *Think Pink*, 1967.
Polyester resin, fiberglass, and plywood.
102 3/8 × 19 3/4 × 2 3/4 in. (260 × 50.2 × 7 cm).
Courtesy of the artist and David Zwirner, New York

DAVID PAGEL What was your relationship to the Pomona College Museum of Art when Helene Winer invited you to exhibit there in 1971?

ED MOSES I never paid any attention to it. I met Helene, one way or another, and she was fairly attractive, and I was always interested in attractive women.

I was also interested in materials, in drawing, in rawness. I was aware of resins and plastics through Craig Kauffman and De Wain Valentine. I had this idea that I wanted to wrap a painting in plastic. By un-stretching the canvas it has the extra edges I like, the raw edges. So I made a huge Mylar table, put rain gutters around it, placed the canvas face down, and poured resin all over the back of the canvas until it bled out to the edges. The excess was swept off into the gutters. I worked outdoors because of the fumes. I poured paint into the wet resin, squirted it in there and when it dried I lifted the whole thing off the table. What happened was that the resin bled through irregularly, so there were shiny and matte surfaces. Then I nailed the whole resin-embedded canvas to the wall. It didn't exactly look like a laminated driver's license, but it was a primitive attempt. It was contrary to the modus operandi of the resin and plastic art of the time, which was shiny and finished and polished. Being the contrarian that I am, it suited me. There, on the wall, was this big strange thing that looked like leather. In order to keep the edges from curling up, I used old stirring sticks, anything that had a history, to add to the natural aspect of the situation. The process was important. I like moving things around without an end result in mind, of finding out through the process things I couldn't have thought of. When I do things that I think of it's just the same old story. I do things that I know and use my somewhat experienced eye in editing and correcting. I wanted to free myself from that and just take it as it comes.

DP So for your show at Pomona, "some early work, some recent work, some work in progress," in 1971, you made some of the works in the galleries?

EM Yes. I planned to do some of the pouring of the resin in the gallery. But I was concerned about the fumes and the toxicity, so I didn't pour any resin there. Instead, the gallery functioned as a place to build the resin paintings, marking them with chalk lines, snap lines, and masking them out. I had them in various stages of development. First I drew with snap lines, chalk lines, using pigment powders. I put tape over the canvases in irregular diagonal configurations. The designs came from Navajo blankets, second-phase chief blankets: diagonals, crisscross patterns, and lazy lines. Strips of paper went across, allowing for chance markings. I had various stages there to be seen and any of the stages could have been finished paintings. In fact, some of them I just left on the panels. They looked pretty nice. The two largest ones hung from long wooden sticks and looked as if they had been loomed. I put strings going vertically, horizontally, and diagonally. They made highly irregular patterns and let you see the substructure and the final construct.

DP You wanted something unfixed? In flux?

EM Right. I wanted the unpredictability. I had this feeling that to be an artist was to be a shaman. I believed, and still believe, that man leaves his mark as a response to his existence. I think there's a genetic factor that makes certain people object makers. I never thought it was about making money. Who knows where that idea came from? There are different realities. When you're drunk there's a reality; when you're in love there's a reality; when you're making love there's a reality. So how do I respond to that and demonstrate that out of these compulsive lines? A handprint, a painting, or what?

DP What else was in the show?

EM Many of my small works on paper from that time involved cutting, folding, and compulsive coloring in, almost like 3-D architectural studies or abstract, shallow relief sculptures. To echo their format, I mounted them on eight-by-four-foot sheets of Celotex, a fragile composition board. I just push-pinned them in loose clusters, sort of salon style. I also built a platform with Celotex to keep people from taking the drawings off the wall or touching them. It was a barrier. At the opening a young guy stepped up on the platform and stepped right through the Celotex. He whirled around and ran out, leaving a puncture in the platform. It was a kind of on-the-spot performance that added to the environment of accidents, chance, and discoveries.

DP And that was the "some work in progress" component of your show?

ED MOSES
INTERVIEWED
BY DAVID PAGEL

Former Ferus Gallery, Los Angeles,
California, June 7, 2010

Ed Moses *Hegeman #195*, 1971. Resin and
powdered pigment on canvas, 120 × 96 in.
(305 × 244 cm). Collection of the artist

Ed Moses *ILL. 245 B*, 1971. Resin and
powdered pigment on canvas. 96 × 132 in.
(244 × 335.3 cm). Collection of the artist

Installation view of **Ed Moses** exhibition
at Pomona College Museum of Art, 1971

EM Yes. Those works were all very compulsive. I was trying to see if I could fill the space they occupied with energy. It was like filling a mold. You squeezed everything you could into it and pressed it harder and harder. I thought that if you pressed hard enough, something might give, something might move out and become something more than the sum of its parts or materials. I have this theory about the black hole. Back then, the popular theory was that all of this gravitational energy went in and when it got compacted enough, it exploded. I think that notion has changed. Anyway, my thought is that it doesn't explode, it just turns inside out. So you have a whole new dynamic. It's expansive, not compressed; infinite, not limited. And that's what happens with art. If you press, and the right factors come in, there might be ignition. Ignition is the magic that we all depend on. It may happen and it may not. I explore that territory.

DP When did you discover that you would spend your artistic life exploring that territory?

EM Well, I don't know about *artistic*. I did like exploring from the very beginning. When I was in high school I took drafting. I loved lines. I was very much into lines. But I had no aesthetic ambitions. It was all intuitive. I was raised in Long Beach, very square. My mother was born in Hawaii of Portuguese descent. My father did the Moses genealogy to see if there were any Jews in the litter. The genealogy went back to Cornwall, England, by way of St. Augustine, Florida, and Nova Scotia, Canada. My dad was teaching English in Nova Scotia and Joseph Conrad was his favorite writer. So, my dad and another guy sailed around Cape Horn to the Sandwich Islands and then to Hawaii. I was born on a ship sailing from Hawaii to San Pedro.

In the Navy, I was a surgical technician. After I got out of the service, I did pre–med for two years. I was getting Cs, maybe Bs. To get into medical school you had to get As. So I knew that wasn't going to happen. A friend of mine said, "You've got to see this art teacher, Pedro Miller." He was an eccentric, a bohemian. I'd never seen one of those guys before. I'd always lived in a very bourgeois environment. Artists were considered pansies or psychos. I went into the class and was absolutely riveted. He talked about Picasso and he talked about Cezanne. He said, "I don't want to see any Norman Rockwell. I hate that shit." He set up a still life, showed us how to mix paint, and everybody started in, holding their pencils up and making measurements. I didn't know what to do. I was so embarrassed. My friends kept looking to

see what I was going to do. They had hoped to do advertising, and they had some experience in drawing and painting. Here I was exposed, not knowing what to do or how to do it.

We straddled these little benches with easels that held our first canvas boards. He kept getting closer, insulting everybody as he went along. I thought, "Oh, my god. I just better get the hell out of here." At the last minute, when he's almost there, I dipped my fingers in the tempera paint and just drew across the surface of these canvas boards with the different colors. Sort of like finger painting. Sort of a primitive attempt to make a mark. I didn't know how to paint. When he got to me he looked down at what I'd been doing, looked at me, looked at the board again. Then he took my canvas and leaned it up on the shelf in front of the whole class and looked around the room and said, "Now this guy is a real artist." He changed my life. For a long time, I thought that he had ruined it.

DP And that's kind of a method to the madness of being an artist?

EM Yes. And it leads to another thought, to Susan Sontag's wonderful idea in *Against Interpretation*, which is that you don't interpret. You view and you acknowledge what's there. If you can write about it or talk about it, so much the better, without projecting your own expectations, conditionings, and beliefs on it. This very much fits into my Buddhist training, of being in tune with the natural world, the phenomenal world, without making use of it, but watching it. And if you watch it long enough, you may become aware of things that you had not been aware of before. You might even get in tune with this kind of phenomena rather than control. To be in tune. Ahhh. That's the rub.

DP There's something very basic, even primal, about those works at Pomona.

EM Right. The more primal I could be, the truer I could be. And the less sophisticated, the better. Unfortunately, in time, you learn, you view, and you talk yourself right out of that primal stage. That development or refinement often comes with success, with careers, with professionalism, and over-intellectualizing art. The show at Pomona was an attempt to be free of that control, that knowing. I never know what I'm doing. I'm always in freefall.

MARIE B. SHURKUS Your work changed significantly after you graduated from art school in 1967.

ALLEN RUPPERSBERG I came out of Chouinard as a painter with a minor interest in sculpture. But once you come out of school, you have to start over again—or at least in those days you did. I had some savings bonds that my dad had put away for me, and so I had a year or so where I could just paint and get started. Somewhere in that period, I went to see Frank Stella's show at the Pasadena Art Museum. Looking at his Protractor series, I realized that he really knew what he was doing, and I didn't. So that's when I decided, I have to find my own language, my own voice. And that's when I *really* started over.

MS Is that when you started working on the aquarium pieces?

AR The aquariums that you bought then were almost minimalist objects, like a Larry Bell box. (*See page 74*) They had chrome sides, and tops with little lights in them. They were like 3-D canvases and a ready-made all at once. So they fit formally very well into my transition toward making more sculptural work. But what went inside the chrome aquariums became a much more personal kind of beginning. The whole idea of what an artwork could be was up for grabs, and that became my question, actually not just my question, but the question for my whole generation.

MS Your work *Al's Café* from 1969 really took that question and ran with it.

AR Well, it began with the aquariums. You can look at the café as just a giant aquarium. And *Al's Grand Hotel* (1971) is an extension of the café. The café is an extension of all the pieces that preceded it, beginning with the aquariums.

MS They seem like tableaux, three-dimensional images that people entered.

AR Well, what precede it are tableaux. And those indeed are images. When I made the three books—*23 Pieces*, *24 Pieces*, and *25 Pieces* (1968, 1970, and 1971)—those are about images, but they're also tableaux.

MS How did you decide what places to include in *23 Pieces*, for example?

AR I spent a lot of time driving all over Los Angeles, and California in general. Being from the Midwest, this was a great place to explore. Jack Goldstein and I would drive around town, look at things, and say: "That looks like a Robert Morris, or that looks like this other sculpture or earthwork."

MS Were you specifically looking for tableaux? I ask because a lot of the scenes have a dramatic emptiness to them, as if something is about to happen.

AR Well, I was looking for essences, kind of the essence of indescribable atmospheres, or whatever you want to call it. So, it's not only in the photographs, but it's in the aquariums. It's trying to capture something outside of art objects.

MS In 1970, you published *24 Pieces*, which focused more on empty hotel rooms, but you would alter them slightly. For example, in one of them, there's a picture taken off the wall.

AR There's a trace of something taking place, but it's only to indicate to the viewer that you can find traces like that anywhere. Anybody who walks into one of those places can find something like that.

MS In addition to location, there's often a clue that suggests a narrative that's left incomplete.

AR Yes, that really comes later, but it begins in those pieces.

MS Ed Ruscha also made books about locations.

AR Certainly, but almost everybody was making books at that time, because it was a way to make something that was not a museum piece or a gallery object. What I liked is that you could make something that could be distributed in a completely different way, and yet it was still art.

MS "The Location Piece" was your first solo exhibition, at the Eugenia Butler Gallery in 1969. When people arrived at the gallery—

AR They didn't encounter an empty gallery. That wasn't the point. There were a couple of minor pieces lying around, but the point was that they had to travel again. To go to see the real work—the show, really—they had to drive up La Cienega and come over to Sunset and Gardner, where I had rented offices much like this. Inside one office was the show,

Allen Ruppersberg's studio, El Segundo, California, February 16, 2010

he: Where's Al?

she: I don't know. Nobody's up yet.

she: Where's Al?

he: Holed up in his room probably.

she: I suppose.

she: It's nice everybody could make it.

he: Except Al.

she: Yeah, where is he?

he: I don't know. He said he would call.

she: You never heard from him?

he: Nope.

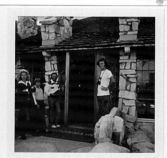

he: Where's Al?

she: Who knows.

he: I thought he was coming with you?

she: That was three weeks ago. I haven't
 seen him since.

he: Huh.

ere?

she: Was Al in town when you left?

he: No. I think he went to Texas.

she: Yeah.

he: Has anybody seen Al lately?

he: Not me.

Allen Ruppersberg *Where's Al?* (detail), 1972.
110 typed index cards; 3 × 5 in. (7.6 × 12.7 cm)
each. 160 instamatic prints; 3 ½ × 3 ½ in.
(9 × 9 cm) each. Edition of 3. Collection
Jill and Peter Kraus, New York

Allen Ruppersberg *Where's Al?*, 1972.
110 typed index cards, 3 × 5 in. (7.6 × 12.7 cm)
each; 160 instamatic prints, 3 ½ × 3 ½ in.
(9 × 9 cm) each. Edition of 3. Collection
Jill and Peter Kraus, New York

which was a room environment that you walked into. It was like walking into one of the aquariums, only it was real life, at its real scale, and it was located in a place where you would not expect to find such a thing.

MS Some critics suggested that the location—an old office rather than a gallery or artist's studio—created a relationship with detective novels and film noir. Helene Winer even once compared you to Los Angeles's fictional Detective Philip Marlowe.

AR I was very much influenced by Raymond Chandler and all of that stuff. People still say the same thing when they come to my current studio—it looks like an old detective office. And it is. It's from 1928, and all the details are still here. I like this kind of atmosphere. When I came out to Los Angeles in 1962, that sensibility was still around, in the post-war environment of the early sixties. I loved living in Hollywood. Part of it was the romance of old Hollywood; it was the time when Hollywood was being reinvented. I remember the curfew riots on the Sunset Strip; I was a participant in all of that, so that became part of my influences, too.

MS In 1969, when you opened *Al's Café*, were you afraid that people wouldn't get it?

AR Well, I was almost sure they wouldn't get it. And they didn't at first. I remember the opening night; everybody was looking around, wondering: What do we do? What is this? Everybody had to go through their initiation period, when they first came in, but word spread and people began to know what was happening. But the most significant reactions came from outside the art world. The LAPD [Los Angeles Police Department] infiltrated it with undercover cops. They saw people out on the streets, and you know, we were all hippies back then. They thought it was a drug ring or something. So they sent in undercover cops to try and mix in, but of course you could spot them instantly. That was the precursor to shutting it down. Because they found out what was going on in there—although they never really knew what was going on. The only thing that they knew was that I was selling beer without a license. So that's what shut it down.

MS Did you see *Al's Café* as having a relationship with Allan Kaprow's Happenings?

AR Absolutely. Happenings, combines, surrealism, dada, hippie culture, civil rights culture, drug culture, rock 'n' roll music, art, history—it was all mixed up at that time, which was a good thing. It's part of Southern California art history. Out here you have the history of George Herms, Wallace Berman, Ed Kienholz, and many others of all stripes. Assemblage seems in general very much an indigenous Los Angeles form. That's how it resonated for me.

MS Two years later you opened *Al's Grand Hotel*, which took the café one step further.

AR Well, it was just a bigger experience in many ways. It was located in a part of Los Angeles where there were lots of motels at the time, so it fit in to its surroundings more than the café. But, you know, when you ask somebody to spend the night somewhere, that's very different from inviting them for a cup of coffee. So, it's different at that level of experience.

MS The catalogue for *Al's Grand Hotel* is a kind of brochure.

AR It's a brochure because I thought I could sell some of the stuff and make some money, but I didn't. A lot was tossed out; but there are some objects that still exist, like the neon sign. Some of the objects got bought; they're out there, somewhere.

MS One of the things that comes through with the café, as well as the hotel, is a focus on economic exchange as a kind of discourse.

AR Yes, I'm offering something as an artwork that costs the same as its equivalent in the real world, not an art object with a high price tag. It's the same with the books later on. The books were produced in order to sell something at a normal price and put them in a normal environment, like a bookstore.

MS Getting back to 1969, you were in the "One Month" exhibit that Seth Siegelaub organized, and you were also in the "When Attitudes Become Form" exhibition [curated by Harald Szeemann], which must have been a big deal for you, being only twenty-five at the time.

AR Well, it didn't have the historical significance it does now. I mean, everybody certainly recognized that it was an important show, but its importance also grew. If you look at the "When Attitudes Become Form" catalogue, it's a big tent. There are a lot of people in there underneath the same umbrella that a few years later would never be under the same umbrella. It was a very brief moment in time.

MS Let's talk about your exhibition at Pomona College. It opened on Halloween in 1972. Several pieces make reference to magic; how did you get interested in this?

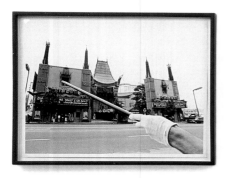 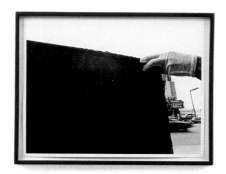 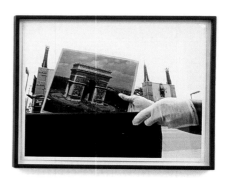

Allen Ruppersberg *The Disappearing Chinese Theatre*, 1972. Three black-and-white photographs. 11 × 14 in. (28 × 36 cm). Edition of 3. Collection of Marc Selwyn

AR I don't know. I first got interested in Harry Houdini as a person, as a performer, and as an artist. That led to an interest in magic, and then to friendships with other people who were interested in that. So it was a subject for a while, yes.

MS This is evident in your work *The Disappearing Chinese Theatre* (1972), where Grauman's Chinese Theatre disappears and then seems to reappear as a picture of the Paris Arc de Triomphe.

AR It's a fake magic trick. I mean, it's a magic trick where you see the wires. [The work] *100 MPH* (1972), also shown at Pomona, uses special effects, tabletop photography and that kind of stuff.

MS So, representation as magic. One of your most famous works, *Where's Al?* (1972), was also featured. Did you make that for the Pomona exhibition?

AR No, it was made for the occasion of my friend Terry Allen's tenth wedding anniversary. Terry and his wife, Jo Harvey, decided that Pismo Beach would be a great place for everybody to come and

hang out for the weekend. It was cheap, and we took over the hotel. It was like an extension of *Al's Grand Hotel*. I installed the work with pushpins at Pomona, so all of the cards with text and the images could be con-stantly rearranged. There was no set way to look at it, and it was never meant to be put up the same way twice.

MS Did that happen?

AR No, people are afraid to touch things, but the idea was that's what could happen to it. Of course, it doesn't get touched any more.

MS Another piece in the show was a return to painting called *Greetings from California* (1971).

AR Oh, that painting was there too! I forgot. I knew the book *Greetings from LA* was there because I made it just around the time of the show. Well, the painting was made the same year, but earlier. I remember having the book come out. It's connected to the Hollywood novel, a genre unto itself, so it's my kind of concrete version of living in Los Angeles.

Installation view of **Allen Ruppersberg** exhibition at Pomona College Museum of Art, 1972

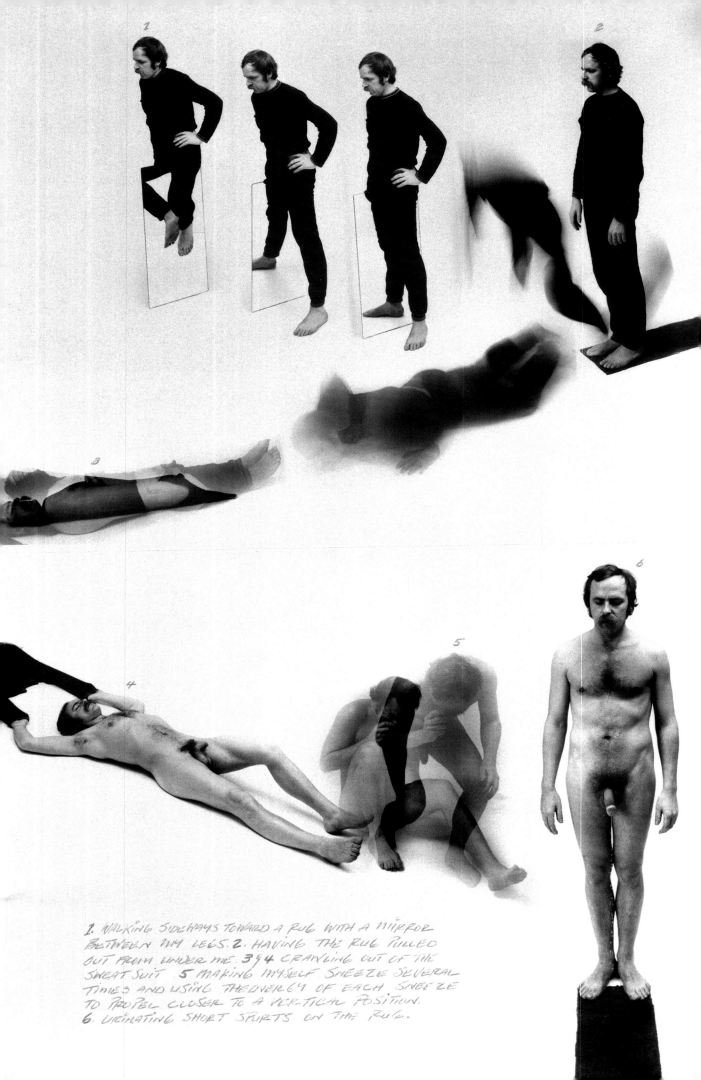

1. WALKING SIDEWAYS TOWARD A RUG WITH A MIRROR
BETWEEN MY LEGS. 2. HAVING THE RUG PULLED
OUT FROM UNDER ME. 3 & 4 CRAWLING OUT OF THE
SWEAT SUIT 5 MAKING MYSELF SNEEZE SEVERAL
TIMES AND USING THE ENERGY OF EACH SNEEZE
TO PROPEL CLOSER TO A VERTICAL POSITION.
6. URINATING SHORT SPURTS ON THE RUG.

WOLF STOERCHLE'S SHOW contrasted in many ways with Hiro Kosaka's of a week earlier, notably in the way it was presented. While Kosaka to some extent ignored the audience and just did his piece, Stoerchle worked very closely with the audience at all times. Kosaka's piece was in progress when the first spectators arrived. Stoerchle intentionally started about twenty minutes late to make sure that the audience would see the whole show, to avoid people missing the start and coming in while the show was in progress. Kosaka created an enigmatic situation for the audience in terms of how they should respond. Stoerchle provided a rug for the audience to sit on, lit only the performance half of the room (leaving the audience in darkness), and with masking tape marked off a boundary line between the performer's space and the audience.

Stoerchle's performance consisted of five different pieces done together as one show. There was strong continuity from one piece to the next, to the point that one really could not be sure whether it was one big piece or several small ones. The only demarcation between pieces was a short pause by the artist. Stoerchle cleared up the question somewhat in the short statement he made when he was finished by thanking the Once Group (a group of artists from Ann Arbor) "for the second piece."

The way the performance was conducted was considerably closer to a sort of standard (if that word can be used) theatrical format than I expected from a contemporary artist. There seems to have been a certain amount of general criticism of aspects of the theatrical medium floating around in contemporary art for a while and perhaps an unwillingness on the part of some artists to commit themselves to a theatrical format. The use of this structure, however, seems to have been quite appropriate to the pieces Stoerchle performed. The pieces probably could not have been as effectively performed in a less formal situation.

All of the works dealt with vulnerability of different kinds. In the first piece Stoerchle straddled a mirror, which faced the audience, and raised the leg between the audience and the mirror, giving the illusion that he was sitting on the mirror and balancing, raising both legs at once. The audience, however, was aware that it was only an illusion and was faced with a case of illusion for the enjoyment of illusion.

The vulnerability in this piece was also quite clearly an illusion. The illusion that Stoerchle was balancing all of his weight on the mirror gave rise to the illusions that the mirror might break and that he might lose his balance.

The second piece, borrowed from the Once Group, was an "acting out" of the idea of "having the rug pulled out from under you." (An interesting recent development is that some artists are openly performing others' pieces, much like musicians playing each other's pieces. Besides being a friendly gesture, this practice acknowledges the fact that many works can be "redone" by others.)

The acting out of phrases that evoke images has been widely used recently and can often be done as well by one artist as another; Stoerchle is making explicit reference here to the fact that one is always vulnerable to having the rug pulled out from under him.

In the third piece Stoerchle stripped, shedding his navy blue and red sweatsuit. While his assistant held his clothes stationary, Stoerchle, on his back, moved out of first his pants and then his shirt. He moved sort of like an inch-worm out of his shirt and wriggled out of his pants. The fact of his nudity seems to me to be the kind of vulnerability being used here, and as Stoerchle remained nude for the rest of the show, the sense of vulnerability remained at a high level.

In the fourth piece, Stoerchle, lying flat on his back, irritated his nose with a toothpick until he was forced to sneeze. As he involuntarily tightened his stomach muscles in sneezing he sat partly up and propped himself on his elbow, where he stayed after the sneeze was over. In the following eight or so sneezes, all forced by picking at his nose, Stoerchle stood all the way up, step by step, never moving voluntarily until he was already set in motion by the involuntary contractions of sneezing. At times this piece seemed a little contrived just because it was obvious that his intention was to eventually stand up, as opposed to going where the sneeze took him, and this did not seem quite right somehow. This piece points out a person's vulnerability to his involuntary processes.

The final piece consisted of Stoerchle urinating on the small rug his assistant had pulled out from under him in the second piece. Standing nude, facing the audience, he concentrated for a short while and then

ARTIST PERFORMS IN MONTGOMERY: STOERCHLE REVIEWED BY PAUL MCMAHON

Reprint of Paul McMahon, "Stoerchle Reviewed: Artist Performs in Montgomery," *The Student Life* (March 21, 1972): 4.

Wolfgang Stoerchle untitled print documenting performance at Pomona College, 1972. Private collection, Santa Barbara

peed, stopping himself immediately by tightening his muscles. He then relaxed his muscles and urinated again, stopping himself immediately again. This process continued until he was out of urine, about twenty spurts of urine, a lapse of about thirty seconds as the muscles relaxed, followed by another spurt, and so on.

Pieces four and five contrasted voluntary and involuntary physical reactions. Standing nude and urinating is in itself a very vulnerable position to be in, in front of an audience. This vulnerability was threatened at one point when a girl in the audience started clapping in the middle of this piece. If the audience had decided to start clapping it would have ruined the piece and left Stoerchle in an embarrassing position. In conversation later he mentioned to me that he had particularly enjoyed that point in the performance because it emphasized his vulnerability and because the audience, by not clapping, indicated a kind of support for the performance.

Stoerchle has a sophisticated and rich imagery, which has probably moved some to call him decadent, but I find it both pleasant and emotionally challenging. An example of this richness can be seen on the posters advertising the series of the three shows (organized by Helene Winer) of which this was one. The structure that Stoerchle is jumping on is made of plaster parts.

Stoerchle emphasized in a conversation I had with him a day after the performance that he did not intend to insult or anger members of the audience. He hoped to perform for an audience that would not be offended. Even if it was accidental, he did anger some in the audience, made up mostly of artists and students. A few walked out and several students have indicated disapproval in other ways.

The show initiated many interesting arguments, including one of the most honest and important discussions I have heard among a medium-sized group of art students.

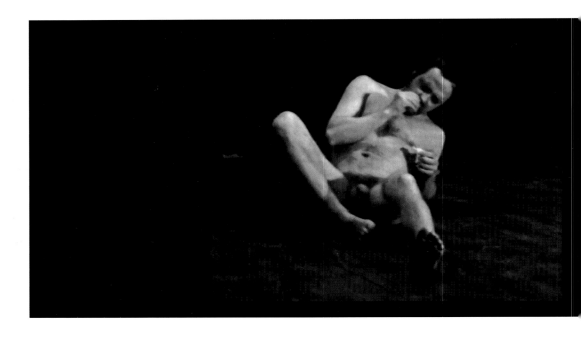

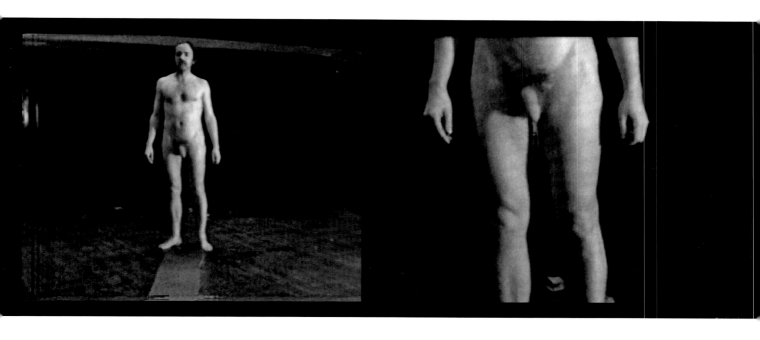

Wolfgang Stoerchle *Untitled* (video fragment
from rehearsal of performance), 1972.
Stills from black-and-white video. The Getty
Research Institute, Los Angeles (2009.M.16)

GLENN PHILLIPS How did you come to Los Angeles?

WILLIAM WEGMAN I was teaching in Wisconsin, at Madison, in 1969. It was a pretty amazing position: I was a visiting artist with Malcolm Morley, Richard Artschwager, Robert Morris, and John Chamberlain—all that year at Madison! It was a phenomenally interesting year, and that's when I started working with video and photography. But it was just a one-year position. So I moved out in 1970 to teach beginning watercolor and life drawing at California State University, Long Beach. This was right after teaching Conceptual art and sculpture to graduate students at Madison.

So that was my first Los Angeles experience. I lived in a charming little house in San Pedro and significantly, I guess, I got a dog, and he started appearing in my videos right off the bat. I had a second studio space about a block away, and I used both of those sites for the videos, which appear in what became known as *Reel 1* (1970–71). One space has a very normal-looking wooden floor, with a door and windows and so forth, and another is more of a loft-type space, sort of like a forgotten plumbing shop. I believe the house was at 921 Center Street. You might want to landmark that.

GP Definitely. Who were some of the first artists that you met out here?

WW Well, I met several of them about a year later. I wasn't rehired for that Long Beach job, so I moved from San Pedro to Santa Monica. John Baldessari lived around the block, and I used to have coffee with him every morning. I was in a show called "24 Young Artists" at LACMA [Los Angeles County Museum of Art] in 1971, and I met a lot of young artists through that. There was Chuck Arnoldi, Laddie Dill, David Deutsch, and a gazillion others. Well, twenty-one others. And I met Ed Ruscha. I also used to play basketball in Venice with a group of Los Angeles artists.

GP I heard about that group. That was on Sundays, right?

WW Yes. It was Bruce Nauman, Doug Wheeler, and a few others.

GP Cynthia Maughan—who was a student at Cal State Long Beach when you were there—always made her video art pieces on Sundays when her husband was playing basketball with you guys.

WW I was a terrible basketball player. I also met Van Schley. Do you know him? He called himself a leisure artist, and he did some funny pieces. One was called *World Run* (1976), where he had himself photographed at every Olympic stadium as he ran around the world.

GP I was actually just looking at that book the other day! It's made to resemble a charming little coffee table book.

WW Van became a close friend of mine. He was interesting to hang out with. My neighbor in Santa Monica was Gary Weis, who ended up doing films for *Saturday Night Live*. He went out with Sharon Peckinpah, one of Sam's daughters. I met Lorne Michaels then, and I did some pieces for *Saturday Night Live* in the mid-seventies.

GP That was after you moved to New York.

WW It was after, but I had several meetings with Lorne back then when he was describing this idea for a live comedy show that would bridge the new comedy with art.

GP You and John Baldessari traded studio spaces at a certain point, right?

WW We didn't trade, because he didn't give me his. I gave him mine. So it wasn't a fair trade at all, was it? I left it for him when I moved to New York. He's barely changed that space, except there are a million more objects in there than when I lived there. I visited John this year, and he gave me a chair I'd left in that space—one that appeared in several of my works.

GP Was it the same chair you used in the massage chair video, the one you hit with the stick?

WW Exactly! I have that in my little home museum. You can come and sit in it, and try out the vibrations.

GP Let's talk a little bit about some of the works that were in the Pomona exhibition. You were showing photographs, video, and some sculptural assemblages, all together. The photographs were dealing a lot with doubles, or this idea of twinning, or identical situations.

WW Those little "find the difference" puzzles often fascinated me. I came to photography rather late. I never studied it in school. I borrowed my wife Gail's

Via telephone, June 9, 2010

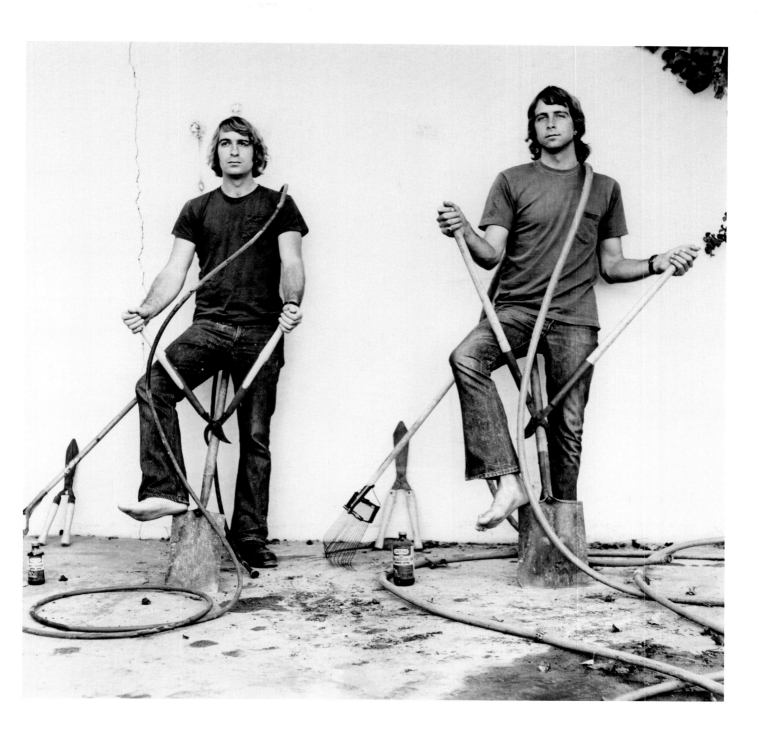

William Wegman *Big and Little*, 1970.
Gelatin silver print. 8 × 8 ¾ in. (20.3 × 22.2 cm).
Collection of Atlas Wegman

WW I was teaching still life at Cal State Long Beach, and I just raided the still life department.

GP Oh, so the taxidermy all came from the still life classes!

WW Yes, for the students to paint. I also made a fantastic connection at Long Beach. One of my favorite students looked like me, but he was bigger. Tim Owens was his name, and he was married to an identical twin. So I really used that a lot. I used the twins, and I used Tim in a lot of these works. One of my favorite photographs from that time was *Big and Little* (1970). We found a location in Palos Verdes. I can't remember whose house it was, but it had all these garden tools in two different sizes, like gigantic snippers, and one size down. A hose, and then another hose that was twice as big. It just sort of fell into place. I photographed myself with the smaller tools, and Tim with the bigger ones. It had this uncanny sense about it. The other work that I did at that time was photographing the identical twins, and then overlapping the photographs. It made a third—somewhat more attractive—girl, actually.

GP What about the videos that you showed at Pomona?

WW Well, they would have been from 1970, I believe. The first ones were made with a camera that I think was more like a surveillance camera. There was kind of a wide angle to it, but it's hard for me to remember the pieces. I think the works were probably pretty similar to works that became known as *Reel 1*, but they had—let's call it a tragic ending. We had borrowed a deck for the show and we left the only copy of the tape in it. The person who picked up the deck recorded over it. I can only imagine how great they were. I'm certain that they were short, and they had beginnings and ends. That was sort of my deal: that the videos had to complete themselves. They weren't just something repetitive going on in the corner for the length of the reel. They really had an entrance and an exit.

GP What about the sculptural installations that you had in the show. What were those like?

WW I think I was just hanging on to something that I blithely left. Those were the things I was doing in Wisconsin, and I still did a few of them when I moved to Los Angeles. Just look at *Artforum* in 1968 and you can sort of put me in there, I suppose.

camera when I was documenting some things in Wisconsin, and I came to the conclusion that I should be making work for the camera rather than just documenting sculptures. The idea was that the photographs should be the size that you would see in a magazine. At the time, photographs were being brought back to the studio as relics of earth art, and I wanted to distinguish myself from that side of the photo world. I didn't want the photos to be documents, but the actual work. At the time, I thought I was really on to something that was mine. It had strength because it could be reproduced without changing the sense of the work, whether it was here or there. It didn't have to be attached to a place. It wasn't like, "Gee, if you were here, you would have seen this."

GP You were playing with some taxidermic animals for a while.

William Wegman *Duck/Crow*, 1970.
Gelatin silver print. 12 × 11 in. (30.5 × 28 cm).
Pomona College Collection. Museum
purchase with funds provided by the Estate of
Walter and Elise Mosher

William Wegman *Basic Shapes in Nature:*
Square (Variant), 1970. Gelatin silver print.
14 × 11 in. (35.5 × 28 cm). Collection of the artist

GP How did you meet Helene Winer?

WW It was Willoughby Sharp who connected me with Helene. I think I remember having a meeting with Helene and Willoughby together. They were looking at my little photographs and some of the videos I was doing. But Willoughby lived in New York, so he may have just written to her. What I clearly remember, though, is my first review in the *Los Angeles Times* of that show. It was supposed to be a one-person show, and then suddenly Jack Goldstein slipped in to share the space with me. Jack was doing sculpture with wooden beams at the time—before he moved to his more signature work. And the reviewer confused my work with his: Jack Goldstein does these funny videos with his dog, and William Wegman does these big wooden sculptures. It was not exactly a jump start.

I got to like Jack, though. I didn't at the time. I thought that he was really moving in on my big moment. Helene said, "No, he's at CalArts [California Institute of the Arts], he'll bring all these famous people with him; it's going to be good for you." And it did turn out to be that way, because he brought everybody. It was a good opening.

GP Well, setting aside the mix-up in the review, did the show at Pomona start anything off for you?

WW It must have, because I followed it up with a one-person show at LACMA, which Jane Livingston put together. And then Ed Ruscha bought fifty of my photographs. I was living on food stamps and I couldn't get a teaching job, and Ed bought every photograph I ever did up until that time. I lived for a whole year on what he gave me for that.

GP One of the interesting things to me about the Pomona show is that it captures this transitional moment for you: it's the sculptures, right when you're moving past them; it's the photography, right when you're about to move it in another direction; and it's— well the videos were destroyed, but we can imagine that it's the videos, right before they became the videos that we're familiar with. It's a moment when all of the ideas are in the air at the same time.

WW Yes, everything that I think of as a significant component of my work was there, except the drawing, which happened about two years later. If I had keeled over at twenty-eight it would have been perfect, because I had the drawings, the video, and the photos. I don't think you would have needed anything more to establish me as a James Dean type. I had the hair, the look. Or maybe Jim Morrison. But unfortunately I blew that opportunity. Now I'm sixty-six and still plowing away here.

GP Well, there's something to be said about still plowing away.

WW I'm having a blast, that's for sure. My Los Angeles period was also really fun. I felt like I was William Bendix in *The Life of Riley*. Kind of an ordinary person in a land of really bizarre folks. I just plodded through in my everyday, dopey way, with these "Bob and Ray," New England-type, straight works. I think I was really a straight man, in a way. William Bendix with a video camera.

GP Los Angeles in 1970 was such a strange time. So many of the stereotypes that we have about Los Angeles were really in motion then—the pop architecture, the freeways, the mobility, the smog, and all the travelers coming in to find their fortune. What did Los Angeles seem like to you then?

WW When I first got there I was blown away, because I couldn't find it. You have an idea of what it looks like, I guess from TV shows, that image of Malibu or whatever. And I just could not find it. I did lots of pushing and looking around. I went up to Big Bear, to Ensenada, to the Sierras. It seemed like I was in Los Angeles for twenty-five years. I've lived in New York since 1972, but it seems like I lived in that building at 2001½ Main Street in Santa Monica for longer than that. There is something static, stable, and timeless in my mind about it.

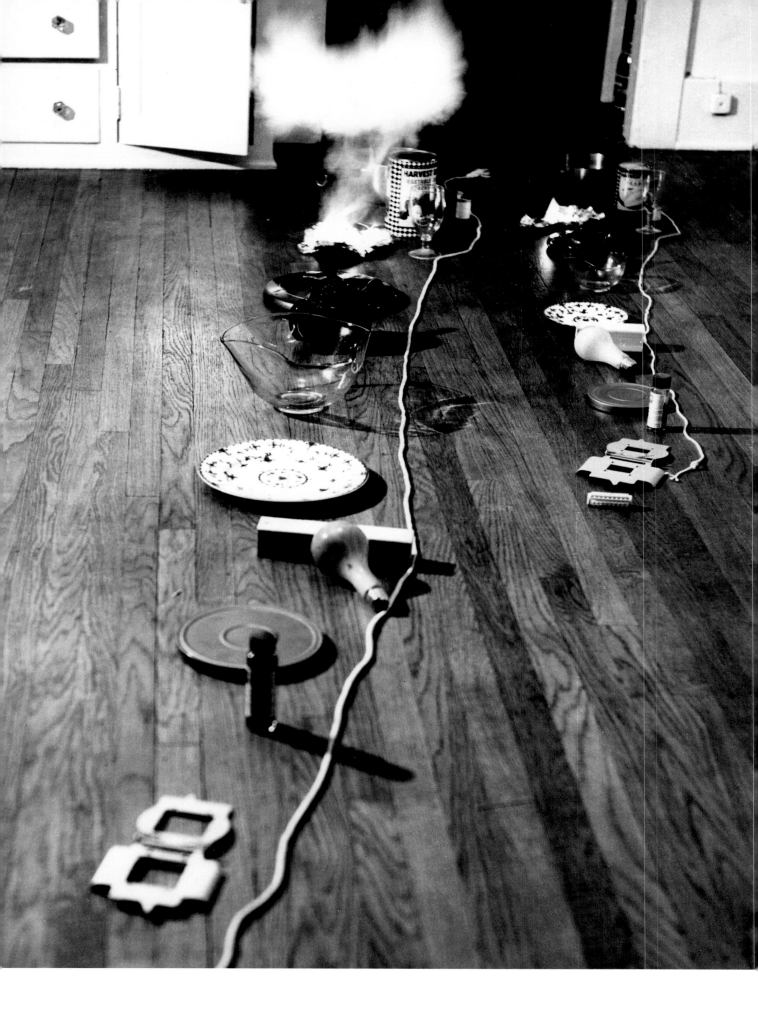

William Wegman *Untitled (Arrangement View 1)*, 1970. Gelatin silver print. 7 × 5 ½ in. (18 × 14 cm). Collection of the artist

DAVID PAGEL When did you figure out that you wanted to be an artist?

JOHN M. WHITE After the first three months of art school, where I had gone for all the wrong reasons.

DP What were some of those reasons?

JW The main one was to get a job. I was a brewer, making beer in a San Francisco brewery. My dad was a brewmaster. I'd flunked out of Cal Poly [California Polytechnic State University], San Luis Obispo, and I went up to San Francisco State [University], played on their golf team, and flunked out of there, too. So, I was a mess. My dad said, "Let's get you back on track. You'll become a brewmaster like me, and I'll help you out. But you have to go to school, okay?" He was real disappointed that I was flunking out because he wanted me to be the first one in the family to get a college degree. Anyway, I traced a bunch of drawings, a skier from a ski magazine, a golfer, things like that, and put them up in my dad's room. He didn't know I traced them and thought I had talent. So he said, "I've got somebody from Allied Industries, a chemical corporation, and they'd like to meet you because they're hiring. They're looking for a guy who's white, knows how to play golf, has had some education, and knows the brewery business." So I met this guy and he said, "You've got the job. But you have to go to school and learn single-line drawing because one of your jobs will be to draw the floor plans of breweries you visit in Argentina and places like that. You'll have to walk in to the brewery, draw its floor plan quickly, and then be able to take everybody out to play golf, lose to the bosses, and schmooze."

DP That was in 1962?

JW In 1961 or 1962. I was twenty-four or twenty-five. So I open up the yellow pages, and it says "The Patri School of Art Fundamentals, For the Absolute Beginner." I call this guy up and he says, "Bring your portfolio down Wednesday, and I'll see what you've got." This was Monday, so I called a couple of girlfriends and I told them my situation. They said, "Let's all meet tonight over at Judy's house."

DP And they made your portfolio?

JW I paid for the pizza and the beer and had a portfolio by the end of the evening. On Wednesday I walked into the Patri School. Giacomo Patri was a well-known illustrator, trained by [László] Moholy-Nagy of the Chicago School of Design [now Illinois Institute of Technology] and the Bauhaus before that. He looked at my portfolio all of five seconds and slammed it shut. I had gone out and bought a nice heavy one. And he said, "Did you do this?" I said "Well, that's my portfolio." He said, "I don't need to see it. Sit down and start drawing."

DP And you were hooked?

JW It was a wonderful place. I lived there from 1962 to 1964. I said to hell with the brewery job. My dad stopped talking to me. I got an AA degree. By my last year, I was teaching drawing at the Patri School.

DP You fell in love with the scene?

JW Boom! I fell in love. I had no fucking idea what was going on. But it was just that you could smell it. I just felt it. I just sensed it. I gave up everything and moved in. I met these drunk guys who would paint for three days and then collapse in their rooms. They took me in! I was this raw material. Monday was sketching, Tuesday sculpture, Wednesday big drawing, Thursday design, and Friday you take all that and make something out of it. And Patri ran all the classes. Absolutely fantastic.

DP Then you went to Otis to get your BFA?

JW My BFA and MFA, from 1965 to 1969.

DP How was it different?

JW At Otis, students were channeled toward academic drawing or the design department. It was nothing like the Patri School. It was actually more old-fashioned, rigidly structured. Performance was not taught. But that school was good for me because I had everybody hating me—the students, the teachers. It made you tough with your own ideas and you had to fight for yourself. All in all, it was a way of knowing what I didn't want to do. So in some odd, ass backwards way, it worked as an education.

DP You had assignments?

JW Yes. I made paintings that I thought were acceptable for Otis, and I did my own work for myself and my friends. I'd go home at night to do them, or I'd wait until after the faculty had gone home and then paint what I wanted at Otis.

DP Your secret work.

John M. White's Studio, Ventura, California, June 3, 2010

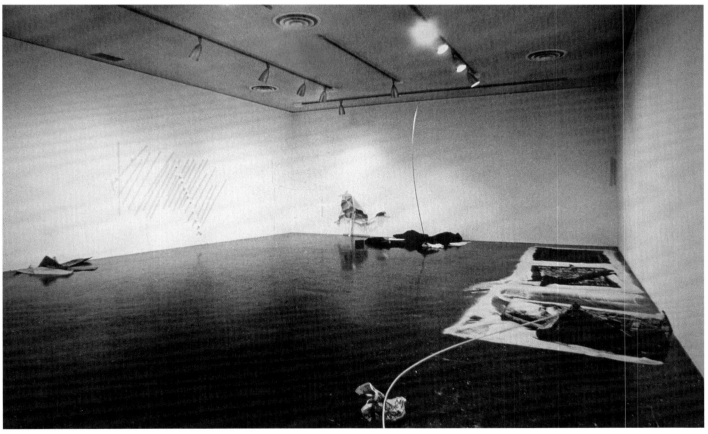

Installation views of **John M. White** exhibition
at Pomona College Museum of Art, 1971

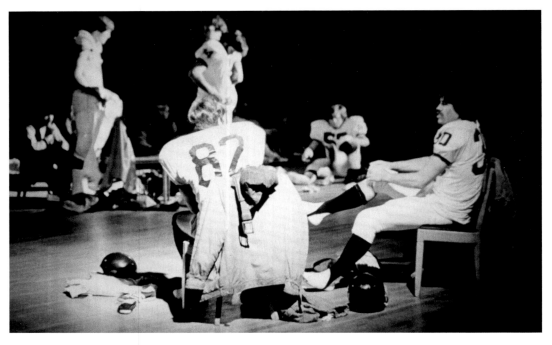

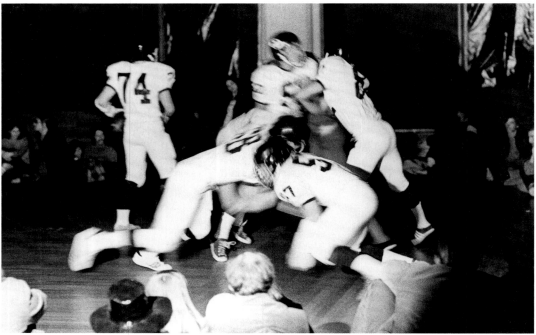

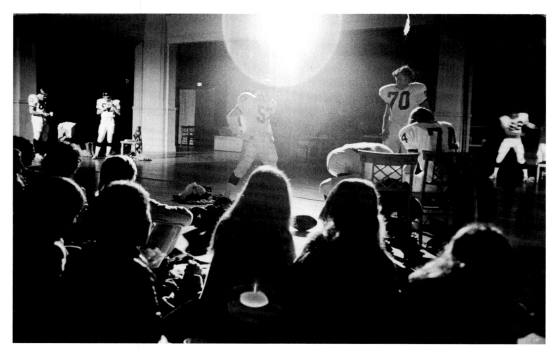

John M. White *Preparation F*, 1971.
Photographs of performance at
Pomona College Campus Center

JW Yes, which wasn't so secret when it came time for my MFA thesis show. On hollow-core doors, I did floor plans from the brewery, schematic drawings that I'd made into big paintings. Down at the bottom I had written various phrases, like "performance notations" and "dance notations." I brought these works down to the gallery for my thesis exhibition and Wayne Long, the lead faculty member on my committee, said, "What's this?" I said, "It's about performance art." But I was told, "No, this is not art, this has to do with theater. You're not going to get away with this for your master's show!" He fucking freaked out!

So I had one of those devices retail stores use to affix price stickers to merchandise. It was called a Dymo. I printed out "Untitled #1," "Untitled #2," and so on, and stuck those tags over the words at the bottom of my paintings. That placated the faculty. And then, the night before the show opened, I snuck in through the basement with my studio mate and we tore off the stickers. By the time the faculty saw them, too many people were already at the show. They couldn't do anything. My timing wasn't bad.

DP You graduated?

JW Yes. I think they just wanted me out of there.

DP Where did you go?

JW I rented a studio for fifty bucks a month on Pacific Avenue at Brooks Avenue in Venice [California]. I had had a place up in Highland Park on Avenue 64 with three other artists, and we were paying fifty bucks a month total for all four of us. But I came out to Venice because I heard that was the place to be. Maurice Tuchman was a curator at the county museum [Los Angeles County Museum of Art], and he was connected with a group called the "June Street Crowd." They would come out to Venice, buy artists' work, and this would lead to a museum

show. They checked me out but didn't buy anything because I was a performance artist. I had paintings, but at the time you were either a performance artist or you made objects. You couldn't do both, and I did both, so that kept me way out in the wilderness.

DP What led you to performance art?

JW There was no single moment of conversion. It happened gradually, naturally. Joan Hugo, the librarian at Otis, was a big influence. At the time, I was painting abstractly. For each painting I had a theme in mind, but I would never reveal it. I was using lots of masking tape in those works, pulling it off and sticking it on my studio walls. Sometimes I made notations on it. Joan came by and thought that the tangles of tape were interesting. She related them to the floor plans in my paintings. That got me thinking. And when Yvonne Rainer and Steve Paxton came to Otis and enlisted students to be in their perfor-man-ces—as bodies moving through space—I thought, "This is how I paint." So lo and behold, I did both.

DP What did you do for money?

JW I worked in a psychiatric hospital up on Olympic Boulevard and Barrington Avenue. It was very much like the setting for *One Flew Over the Cuckoo's Nest*. To get the job I had lied about having a brown belt in judo. My job was to make sure all the patients stayed in their rooms at night. During the day, it was to make notes about their behavior and pass the notes on to the therapists. On weekends I rehearsed perform-ances with some of the patients on the open unit. They loved it. Some stopped taking their weekend passes, so they could stay for the performances. One of the psychiatrists there said, "I don't want to know what you're doing, but you have done so much for my patients." Westwood Psychiatric is where I met Sylvia, who was employed in the same capacity I was. We eloped in 1973 and are still married.

SEQUENCE:
I appear from bandstand with saw going at same pitch as orchestra. Performers come from audience, gather wood lengths and position themselves for first cut-through. After final cut-through, perform-ers invite remaining audience to

join and hold sawn wood(making path narrower and longer) for second and final cut-through. After final cut-through, audience and performers return to their seats. Performers sweep up sawdust which is gathered on floor revealing foot prints and motion tracks.

I return to orchestra, turn off saw and music ends as sweeping ends

Time: 30-40 mins.

4. (b) In Progress

Pomona College, Pomona 1970 Cal of

/71

John M. White script for *Wooded Path*, 1971

Performance Score
Pomona College 1971
— Wooded Path + Saw —

Basic Structure I

| 1 | 2 | 3 | 4 | 5 | 6 | 7 | 8 | 9 | 10 | 11 |

Basic Structure II

1 2 3 4 5 6 7 8 9 10 11 12 13 14 15 16 17 18 19 20 21 22

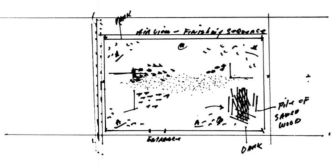

Air View — Finishing Sequence

Pile of sawed wood

Entrance

Dark

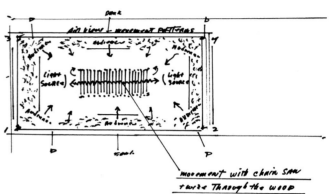

Air View — Movement Patterns

Dark

(Light Source) (Light Source)

Audience

movement with chain saw
twice through the wood

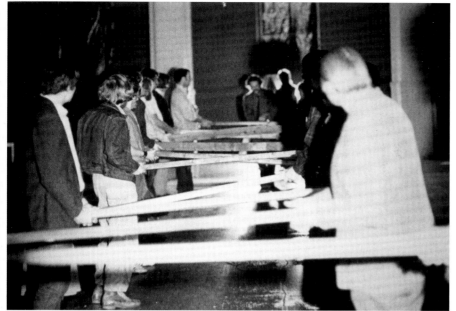

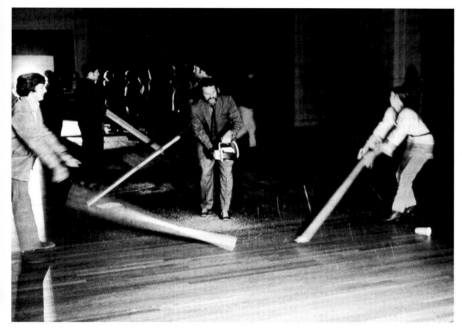

DP What about the performance scene?

JW Rainer and Paxton would come in and do workshops and things like this. They picked us up, drove us to empty storefronts and abandoned lots downtown, and I performed with them. Lots of different little venues from Santa Barbara to Irvine and San Diego. It was really wonderful. Robert Rauschenberg and Jasper Johns showed up at one of my performances. A nice little chill. They talked to us all. It was great. Chris Burden was doing his thing about risk and manipulating the media. I was doing a much calmer type of thing. As a performer, I use stuff that everybody else throws out. I'll take the mistakes and turn them into something else.

DP Did you think of yourselves as performing for an outside audience, or for yourselves?

JW We didn't really think, we just did it. We had places where we could perform, Cal State [California State University] Northridge, Cal State LA [California State University, Los Angeles], the Brand Library, Occidental College, and Pomona College. Helene Winer was very, very sharp. She wanted me to come down.

DP She invited you to do a performance?

JW I think somebody had cancelled; I think I was a fill-in. But I was ready to go. I had the Pomona College football team come out in street clothes, undress, and change into their football uniforms, as if they were getting ready for a game. It was called *Preparation F*, for football. Then they started pounding and whacking one another, and they loved it. We had practiced once or twice. At first their attitude was, "We don't do anything for you, you fucking fruit." But I told them I had been a professional golfer (lie) and that I had played football. They slowly came around and got into it. The audience went bananas. And so did these guys. They just loved it.

DP And the performance with the lumber?

JW For the other part of the evening, I had brought ten pieces of wood. Each was ten feet long. I had audience members hold the ends. With a chainsaw, I cut my way through all ten pieces. Then I turned around and brought the rest of the audience down to five feet. I sawed my way through that. The audience screamed, "More!" I wasn't ready for that. But they were fearless. They would have kept going closer and closer. To my relief, the saw ran out of gas. It's called *Wooded Path* (1971).

DP What was the atmosphere like at Pomona?

JW It was good. Lovely. You were left alone. It was contemporary, conceptually oriented. The campuses were the places to do things. There was freedom. And then Helene got fired and it just went…boom.

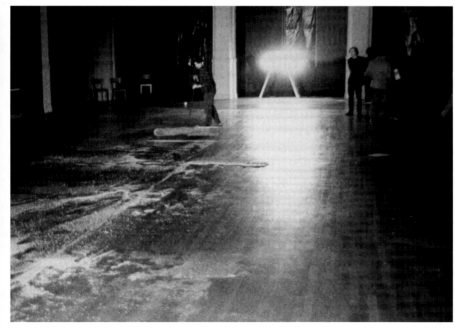

John M. White performance score for *Wooded Path*, 1971

John M. White *Wooded Path*, 1971. Photographs of performance at Pomona College Campus Center

PART 3

AT POMONA

MOWRY BADEN
Alumnus: Class of 1958
Faculty: 1968–71
Gallery Director: 1968–69
Exhibition: "Faculty Show," September 30–
October 31, 1968

MICHAEL BREWSTER
Alumnus: Class of 1968
Faculty: 1971–73
Exhibition: "Configuration 010 Audio Activity,"
May 29–31, 1970

CHRIS BURDEN
Alumnus: Class of 1969
Exhibitions: "Pomona Student Show,"
May 20–26, 1969
Performance: *Match Piece*, March 20, 1972

JUDY FISKIN
Alumna: Class of 1966
Exhibition: "Alumni Exhibition," March 19–
April 13, 1973

DAVID GRAY
Faculty: 1967–73
Exhibitions: "Monoprints," December 5–26, 1970;
"Faculty Show," September 30–October 31, 1968

PETER SHELTON
Alumnus: Class of 1973
Exhibition: "Senior Art Show," May 30–June 10, 1973

HAP TIVEY
Alumnus: Class of 1969
Exhibition: "Pomona Student Show," May 20–26, 1969
Performance: Untitled flare performance in conjunc-
tion with Dick Barnes's *The Death of Buster Quinine*,
October 21, 1972

JAMES TURRELL
Alumnus: Class of 1965
Faculty: 1971–73
Performances: *Burning Bridges* flare performance
on Pomona College campus, 1971; *Silver Cord* flare
performance in conjunction with Dick Barnes's
The Death of Buster Quinine, October 21, 1972
Curated "Revolution in a Box from 1839: A Histori-
cal Survey of Photographica in Two Parts," Pomona
College Museum of Art and University of California,
Riverside, January 8–March 11, 1973

GUY WILLIAMS
Faculty: 1967–74
Exhibitions: "Recent Paintings by Guy Williams,"
April 20–May 16, 1971; "Faculty Show," September 30–
October 31, 1968

TALKING AT POMONA
David Antin

Reprint of David Antin, "Talking at Pomona" *Artforum*
(September 1972): 38–47.

TALKING AT POMONA

Michelangelo, *Pietà*, marble, 69'' high, 1498-99.

Matthias Grunewald, Crucifixion (Isenheim Altarpiece), oil on panel, 8'10'' x 10'1'', c. 1512-15.

DAVID ANTIN

what i would like to talk about really is a
subject that probably doesnt have a name if i
were to give it a name it would sound kind of
pretentious and it might be misleading
 so let me begin by reminiscing slightly last
quarter we have a trimester system that
has quarters it is an absurd system i set about
to ask myself out loud with a group of
students who were ostensibly concerned with art
 what we could do to make a discourse
situation in art meaningful or comprehensible
 now that sounds a little vague but what
i really wanted to know was this how can you
think about making art and i use the word
art as an undefined at the moment how can you
talk about it in such a way that it will lead
to making more art and the making of more art
will itself be rewarding rather than a
diminishing return now how do you set about
looking at art making as something that will be
 valuable to do and the value of which
will increase as you proceed to do more of it
 im afraid this sounds like an absurd thing to say
because people who normally come to a
graduate school or to undergraduate school to
be art majors or graduate students normally
assume that it is valuable to make art whatever
that is and typically they have in mind
the things that people have always done when
they made art and you know there is a kind of
consensus a low level consensus about
what art making is i mean without placing a
utilitarian role upon what it does to you say
 there is a kind of function that people seem to
attribute to it nevertheless they know
what it is beforehand people think they want to
make paintings or they want to make
sculpture now this is a commonplace and
obvious idea of course very few people have
any clear idea of what it is that a painting
ought to be that somebody should want to have it
 for example if any of you or all of you
are graduate students or artists or whatever or
art makers and i say to you "you want to
make paintings and youre really interested in
making furniture right? i mean you want
something to hang on the wall right over the
sofa and they have a persimmon colored sofa
 and you want one that will give them
pleasure so that they will buy it?" and at that
point you will either say "what is he coming
on?" or you get up and start trying to get out
the door or show me the door you mean i
make furniture what do you think thats
a very offensive thing to say "what do you
think i am an interior decorator? no im not an
interior decorator im an artist!" i said
"well i thought you were an artist and you
wanted to make paintings" paintings you
know what paintings are in the art scene theyre
seven feet by seven feet and the important
thing to know is that a painting is big it is very
important to know that a painting is large

and not easily portable a painting is a flat
nonportable object frequently covered with colors
and usually stretched canvas over a support
 and the important thing is to realize that when
people look at it automatically in the beginning
uninitiated people walk into a place to see
it they dont think of it as a painting i said "oh
thats a painting?" "no you dont understand
painting is about " and then theres a
dead end painting is about something that
is not easy i mean theres a kind of feeling a
great consensus that its not easy its never
easy the one thing you know from painters who
paint is that painting cant possibly be easy
 they struggle about it because it would be easy
if lets say the little lady the proverbial
and mythical little lady who down in our area
around san diego we think of the little
lady from la jolla the little lady of la jolla has a
gold frame painting and thats not what
you want to make and she bought it in balboa
park and you say "but whats the matter
with buying a little painting in balboa park with
a frame she hangs it there she looks at it
often it gives her pleasure" and thats not what
you want to make because what you want
to make means something else and i say "but
that doesnt mean anything?" no what that means
is that that woman has a set of historical tastes
that she loves and she is attached to her taste and
she wants to stick to those ideas that she
knows very well and she will be satisfied by
it the way she will be satisfied by
having a particular dish served to her once a
week by her cook lets say her spanish
speaking cook to whom she doesnt speak because
she doesnt speak spanish but this
 particularly peculiar dish that she expects
regularly her taco dinner and she knows
what she wants in art it tastes a particular way
 now my young artist or old artist
doesnt want to make that kind of art because hes
not making food hes not making a consumer
item so all right youre not making a consumer
item youre making a painting and its a big
painting and what else is there in the painting
that is why are you carrying out this unnatural
act say with respect to a large piece of canvas
 stretched on a support? i mean what is
this all about i mean there is this thing and its
heavy its nonfunctional it acquires dust
and you put colors on it and theres a sigh a
tremendous sigh and they point to other
paintings that is to say its like with other art
 and it turns out after a while that this art this
painting relates only to other paintings that is
to say it relates to other paintings in the minds
of the people who relate to other paintings there
are a set of people who are painting relators
and these painting relators relate your painting to
other paintings which is how you know these
are paintings now in order to make a painting
of the sort that is related to other paintings
by painting relators you have to find painting

relators thats very important painting relators
are essential to artists sometimes these
painting relators are other artists and sometimes
theyre people who do nothing else but
relate paintings they have sometimes been
thought of as critics sometimes theyre hustlers
called dealers and sometimes theyre people
who are just sort of wandering around
with nothing else to do but relate paintings they
sometimes relate sculpture which is about
the same business that is sculpture has a similar
career i didnt pick painting because i think
of it as less or more than sculpture that is in
sculpture for example there will be a man who
will have a theory of sculpture and he will
relate things that other people will for example
 im giving a parallel example that is im
not leading into greater depth here what im
assuming is that a man publishes an
announcement in some accessible place saying
that he will pay a reward for the capture of
this notoriously nondangerous criminal who is
among the twenty most or least wanted men
by the united states government the name of the
man who published this is douglas huebler
 and he offered a reward of a thousand dollars
for the capture of this notoriously nondangerous
man who the police also wanted and he
was going to pay a reward for the capture on the
basis of selling the documentation that is to
say he was going to sell the documentation
involving the apprehension of the criminal and his
offer to pay the thousand dollars and when
he did this he set a kind of diminishing reward
 if the capture was effective within so
many days a thousand dollars was paid if not
 it was reduced gradually over a period of about
a year i believe and the thing was worked
out very carefully because as the time elapsed
between the offer and the capture the price of
the art work i believe was being reduced to
keep it equivalent so that the whole thing
operated so that the cost of the art work would be
paid to the men who apprehended the
criminal by the man who bought the art work
now you say to yourself what was that
 what was this kind of creepy work I
mean what was this man doing intervening
 was he as it were an auxiliary policeman? he
says "no im not an auxiliary policeman im
a sculptor" and you say "youre a sculptor"
"yes yes im making a piece of sculpture"
 "why are you making a piece of sculpture?"
"im making a piece of sculpture because
this work doesnt mean anything see basically
this work is a solid that is to say it is
noncommittal there is no meaning attributable
to this solid object" and you say "wait a
minute solid object?" "it is as it were
nonreferential or nonsymbolical what it is
 is that there is an offer made by me the work
has an offer and it pays i pay this man a
thousand dollars if he catches the criminal and i
pay it with the money i receive from my art

buyer its a perfect system it is a sculptural
system" "say why is that a piece of sculpture?"
and it turns out to be a piece of sculpture
because and im not putting the work down
it turns out to be a piece of sculpture because
a piece of sculpture becomes defined as a
self-enclosed system referring to nothing and in
doug huebler's case not occupying physical
space hes advanced over the work that was
noncommittal and occupied physical space that
is to say several years before that there was a
fashion in presenting objects which were
intended as noncommittal now to say it is
noncommittal that is a man fashioned oh a
cube and the cube might be a piece of
fiberglass and the fiberglass was placed in
the room and somebody came into the room and
he looked at the fiberglass and then he
went out having seen his piece of sculpture now
he may not have known it was a piece of
sculpture he may have thought somebody was
doing something modifying the room in some
manner providing it with some sort of
architectural modification but had he been a
member of the sculpture relating community he
would have come to the astonishing conclusion
that an advance had taken place in
sculpture that is to say that up to then there
had been a theory of sculpture relations that went
like this sculpture consists of the coupling of
elements in space now nobody ever says that
that is to say three-dimensional elements
arranged in three dimensional space people
don't say that sculpture had the idea of adding
part to part in such a manner as to energize
differentially various parts of the space but
they used to say "sculpture articulates space"
it was one of the great lines i remember
everybody since about 1910 to about 1960 said
sculpture articulates space they said it about
architecture too nobody knows exactly what that
meant what it meant was apparently
that shapes were placed in a three-dimensional
continuum and apparently emphasized for
certain people who were remarkably sensitive to
these emphases various parts of the continuum at
the expense of other parts of the continuum
so that the continuum was reduced to a
noncontinuum now if that was a sculptural idea
the idea of presenting a noncommittal
cube in the same three-dimensional space might
have been considered by sculpture relators
a move after all you take a cube and its so big
and you place it there it also articulates
space in the sense that say in this poem by
wallace stevens wallace stevens talks about putting
a jar in tennessee now putting a jar in
tennessee is after all an odd idea merely
because the scale of the jar and the scale of
tennessee is discrepant that is as soon as you
say i put a jar in tennessee you have an
idea of a relation between a geographical entity
that isnt visible and something that is trivially
handleable that is to say you have created a kind

of conceptual nexus between the jar and a
state of the union now this peculiar activity
might as it were be extended to the career
of sculpture one might say that sculptures
proceeding was to create a conceptual relation
between spaces of a sort now you say "what
sort?" and theyd say "well of an interesting
sort" well whats interesting about space
itself? and you could think of a lot of things that
are interesting about space but to a sculpture
relator space being interesting that is real space
being interesting lets take sculpture relators
and painting relators separately sculpture
relators are interested in relations in real space
in three-dimensional space and painting
relators are involved in in nonreal space
whatever they are involved in is involved on a
surface that is imagined to be separated from the
space you walk into that is it is not typical for
paintings to be placed in a doorway such that you
walk through them and that thats intrinsic
to your experience i mean people dont take a
painting put it here and you know the gallery
door is there and as you open the door you smash
the painting in half and go through thats
not the way of painting one could conceive of
somebody doing that he would then be
treating painting as a kind of entrance way
that is to say painting is an obstacle to your
entry into the art gallery when you wind up in
the art gallery you turn around and look at the
hole youve made and they say that was the
painting you know and that may well be a
way of dealing with painting im not putting it
down as a matter of fact there are things
to be said for painting producing that effect but
typically painting has been regarded as living
in a sacred space of its own sacred and inviolable
that is to say it is a virtual space no matter
what they do with it its what happens
on a picture plane by itself or inside on the other
side of the picture plane if it comes out
and hits you like in those rube goldberg cartoons
you look at it come up to it close and a little
fist goes bang then you regard it as a
cryptosculpture that is to say there was sculpture
lurking in that painting you know like the
man who comes around wearing gardenias or
something like that and you walk up close to him
and he goes squirt and hits you because
he had an inviolable visual object a gardenia
here which then turned out to be a fountain
to your regret now the point that i would like
to make is essentially that painting had been
imagined to be something that was interesting in
a conceptual space that was not really physical
whatever it was it wasnt really physical now
you may say that it was perceptual and in
that sense physical but the perceptual triggered
the painting and there was a career of
painting and triggering activities triggering
mental activities in relation to something that as
it were was marked off behind some kind of
sacred barrier sculpture occupied a place lets

say on the floor that is to say the intrinsic
thing about sculpture is that its in your world
it can fall on you you can trip on it it
could be a terrible disaster as there was recently
dick serra killed somebody recently the
melodrama surrounding serras lead sculptures
that is there was always a great deal of
melodrama largely provoked by dick and his
own style of how the works were leaning against
the wall and how they were likely to fall down
and cripple people and if you walked alongside
of it you were taking your life in your hands and
there was this feeling that it could in fact
do these things and anyone who knew anything
about leaning metal on other pieces of metal had
a very bad feeling about what would finally be the
outcome but one of them finally fell and killed
someone now he doesnt make them that way
anymore and he in fact hadnt made that one
so that it should fall it had been made so that it
shouldnt fall and they put it up incorrectly and
it killed someone but the point that im
making here is that sculpture is intractably part of
your space in that sense it even cohabits
the world with you or its an invader and
sculpture has always done this now when you
talk about painting painting has never as
it were inhabited your space in the same manner
now those are limiting definitions theyre
not exhaustive and they are not entirely
descriptive within those areas theres no reason
why those should be the art career theres
nothing intrinsically interesting about making
painting or making sculpture those are merely
arenas what we have described are two
arenas one arena is in a sacred space one arena
is not in a sacred space now you say why
should someone be concerned with operating
in this arena and what sort of operation
has he got in mind in this arena well painting
as we all know has a history of presenting
in some manner beginning from an art of
representation that is to say representing some
aspect of reality in a perfectly ordinary
manner that is presenting to a visual inspection
some encoded message concerning the
nature of a visual reality now thats a very cagey
statement but i want to be very cagey about it
that is i dont propose that painting was
intending to simulate the real world at any given
time it was intending to present a representation
a representation is a model a model is
not a real object and a model may always be
counted upon to neglect certain features
of the thing that it is a model of otherwise its
not a model its the thing that is to say
you make a painting of a man there are many
features of the man you undoubtedly leave out if
you couldnt leave out any feature you wouldnt
know that you didnt have the man youd have
the man now this representational basis was not
only art it was also a function that is to say
there were functions of representation
and it is a history that painting is stuck with

40

sculpture had other things it was stuck with
there were these careers but those careers are
way in back of us that is there are these
careers so far in back of us not because people
dont do them any more but we dont even think
about them any more because they are so banal
that is that there were these careers of making
sculpture lets say as it were sculpture to
adorn the wall of a temple that everybody took
for granted that is to say you narrated a story
in sculpture on a frieze say you narrated
something or you encoded a god in an
appropriate place well thats pretty functional
and people would know why you did it but
no one would agree that that was the art function
and everybody is aware that theres an art
function and it started from some area back
there and that were here making art in an
arena that was not necessarily set up to be the art
arena well thats because were not sure what
we mean when we say the art arena we
mean something ineffably pure apparently now
what is this art arena what do we do in this
art arena and this is very curious i mean to me
it seems curious because as a poet and artist
ive always felt secure that what i was doing was
valuable to be doing that if someone
should be doing it i should be doing it
that it needed doing other artists
feel secure that there is something going on
and you say to yourself well what is it that
people want to do in this arena having started
with this background this absurd background
of art which in certain cases in the case of
the visual arts was a commodity at one point it
may have been sacred and another point
it was a commodity certainly from the renaissance
on art was a commodity now i dont know
how many of you people here are artists but if
all of you are artists or even a fairly large
number of you are artists there are probably very
few of you who are concerned with art making
as the making of a merchandisable commodity
primarily i mean everybody figures if youre
going to make art as a commodity your going to
use that as an out as a method to get by while
you do your thing you know what you
have in mind youre going to go to a gallery
and the gallery owner is going to be a jerk
and what you're going to do is youre going
to convince this jerk that what youve got there
is a sellable commodity in spite of the fact that its
a piece of art thats one attitude another attitude
is that you think the guy is really smart and
you say to him you say to the smart man "nick i
want you to look at this" you say "nick
youre a smart guy dont you think this is very
meaningful?" and then you wait and if nick
thinks its very meaningful it means he thinks he
can sell it to rowan than hell think its
very meaningful but your main concern is
no matter how you feel about it you feel rather
ambiguous with relation to the hustling of
merchandise and its fairly evident were all here

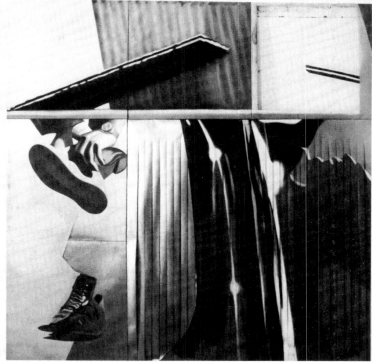

James Rosenquist, *Wall Dog* (detail), oil on mylar and canvas, 132'' x 264'', 1966.

and like there are no spies so i think that
basically we can say that here we will feel that the
selling of the thing is secondary that its
merchandisable relations to the rest of the
community are secondary to what we want to
do so if theyre secondary to what we want
to do they may in fact become an obstacle but
they may not the point is how do you manage
with some piece of merchandise that
youve got there with something that can function
as merchandise to do something else you want
to do what what do you want to do with
this piece of merchandise? now think of all the
kinds of merchandise that people have
people sell old merchandise all the time many
things are merchandise for various reasons
there are people who hustle it and there are
people who buy it now think of people buying
art objects buying a painting what does
a man buy a painting for there are a lot of buyers
there are people who buy art that is in a
sense they like the art theyve seen before and
presumably they think that your work is related to
it or maybe they dont maybe they consume
they look at a work and it gives them pleasure
now you say do i really want to make a
pleasure giving machine that is to say am i

essentially in the business of trying to provide a
universally human pleasurable experience
relatively durable for an average human being?
not on your life you know you dont think
about that for a second i mean thats ridiculous
i mean its an honorable career but you
dont think about that that is to say the honorable
career of providing consumer value is not
something that immediately occurs to you as a
matter of fact if you think about how you
go about making art you have a taste for things
that people will find somewhat difficult that
is to say somewhat uncomfortable you know if
they said yeah they saw your painting
and said id love to hang it right over my sofa
youd get very nervous you know and maybe
if you got enough money for it you wouldnt
be too nervous but on the whole you dont start
out with taking a survey to find out if you
really wanted to sell presumably youd find out
what people wanted to buy and youd find out
what it is people like what houses they had
how big their houses were where you wanted
to put the thing a person has only so much
wall space but you make seven by seven
paintings and you havent figured how many
people have seven by seven wall space rooms

41

Dennis Oppenheim, *Guarded Land Mass*, 1971. (Museum of Fine Arts, Boston.)

how many people can hang a seven
foot painting have you got any idea there are
really not too many considering the way they
make houses nowadays and when you consider
that they use plasterboard rather than regular
lath and plaster how do they support this thing?

you dont care because youre image is of getting
it into a museum you know perfectly
well that there are only certain places that you
want that painting to go because you want it to
get into a museum which is what one might
call the first stage of getting into history

that is in a certain sense you have a very funny
relation to this art work you dont really
want the man to put it in his home you dont care
if he puts it in his home but you hope its
the kind of man who lends paintings to traveling
shows you hope its the kind of guy who
if he gives a painting to a museum they wont
throw it out the door you know there are plenty
of people who call up museums every day in the
week and say "boy have i got a painting for
you" it happens all the time it happens
all the time you know as a matter of fact my
school specializes in having an administration
which is very lovable we have some of the most
lovable scientists in the country and outside
of science theyre really very astonishing people

i received a phone call from a member
of the administration who said "id like you to
come over and look at a painting to evaluate it"

and i said "why should i come
look at it to evaluate it whats the problem?"

they said "well its being donated to the school"
i said "do we want it?" and they said
"well yes you do its" and they named the
name they said its bob rhinestones painting
i said "what do you mean its bob rhinestones
painting did he paint it?" they said no

he bought it i said "well whos painting is it?"
and they said "its a spaniard he bought it in
spain" and i said "what possessed him to
buy a painting in spain? why would he go to spain
to buy a painting? you know where did he
buy it? estramadura?" you know and he said to me
"i dont know the name of the painting"

they dont know the name of the painter they
dont know anything i should go down there
and put a price tag on it and they had a very
strange idea why should i put a price tag on it

"why youre the chairman of our art department
surely you can put the value on this painting"

and i said "but i dont know anything
about estramaduran painting at this time of the
year" i mean how do i know what its selling
for in estramadura and the answer is

this person thought that there was an arbitrary
scale of consumer values that is fixed that is
to say maybe not an arbitrary maybe a natural
scale of consumer values that is instantaneously
apparent to us art connoisseurs we can go
down and find the cost of a painting we say that
painting is worth two thousand three hundred
and thirty-nine dollars and forty-three cents
and next week it will be worth three thousand four
hundred and seventy-four cents you know
and so forth and it will be based on quality

that is to say i will go over to that painting and
i will say yes brush strokes fifteen hundred
color and i will put together the components
of painting and i will lay a value on it now
while it is perfectly evident to me that
this is absurd it is not perfectly evident to the
vice chancellor of the university of california that
this is absurd and its for a very good
reason artists have worked very hard to convey
the illusion that paintings are very important
in a way that should carry financial reward with

them that is usually part of our conspiracy

that when we go out into the world we as it
were say yes thats a terrifically important
painting what do you mean its important? its
important financially? that is to say if it were
stolen the insurance companies would have
to lay out a lot of money everybody knows
the game of insurance and paintings and
what would happen finally with testimonies

a curator will be called in and he will say
yes thats a painting of a particular sort and
they pay two thousand dollars for paintings
like that but nevertheless everybody knows
perfectly well that a painting has no intrinsic
value that is to say monetarily its very hard
to establish a monetary value on a painting
because nobody knows what anybody wants to pay
for it nobody knows what anybody wants
to pay for it because nobody knows what
it is theyre paying for now take either an
old painting old art take old art like a
cézanne what you have is a picture and what
it costs is a peculiar accident undoubtedly
but the art world tries to convey an image of
importance in the art activity but they are
not willing to say what the art activity is now
cézannes mentality i mean if cézanne was
working on let us imagine that cézanne
had an idea i will not say that he did
have this idea but let me assert what cézannes
idea is if cézanne was an impressionist

which he was and impressionism involved
a number of people with different attitudes
but one of the most astonishing attitudes
they had was the liberation of painting
from its darkness that is to say of opening up
the possibility towards a tremulous sunlight
being rendered in paint treating everything
under a kind of trembling veil of sunlight and 42

that this was one of the most exciting ideas
for about four or five years in painting and
that cézanne was one of the people who was
intoxicated with this possibility and
cézanne finally looked at it and said "yes im
intoxicated with sunlight but im not intoxicated
with what sunlight seems to do to
volume i mean its ridiculous you look at what
the sunlight is doing to my sense of voluminous
reality and i cant stand it" and so he
invents a style which presumably is intended
to render voluminousness and luminosity
all at once and it does it lets say and it
does this and it does this for example at the
expense of annihilating mass cézannes
mountains always look like tablecloths they
always look like a tablecloth thats been crumpled
 and theres a reason for it you cant get
everything you know its like gambling art
is like gambling you pay your money you
take your choice you cant have everything
at once because there are certain things that are
contradictory in the late painting by cézanne
theres no mass no sense of mass because by
the time he got through rendering volume
and luminosity he has no room for mass
 that is the characteristics that he has to
sacrifice finally destroy the idea of weight well
thats fine now lets say he has this idea now
he may not have had that idea very long
but there is a period during which he had that
idea what is that idea worth to a gentleman
who made himself ten million dollars in the
movie business and hes in a position to buy
it or to some gentlemen who ran for office not
so long ago and didnt succeed what is this
idea worth to this man why should he care
about cézannes concern for improving or
shifting the emphasis of an impressionists
passion what difference could it possibly make
to him whether cézanne managed to achieve an
image of pure configuration and luminosity
 it doesnt make any difference to him in
fact it has never occurred to him that this was
the idea nor does he think the idea is
meaningful if the idea were given to him he
might say "and thats what the cézanne is?
im turning it back in i thought it was great
art the point is i thought this great art was
relatively eternal you know this man was
working on something that had a dense drive
a drive that was universally clear and was
always to be found in art" but its not always
to be found is it an interesting idea? does
it interest you? i dont know if its interesting
i mean i dont know why i dont start from
an assumption that art has to be dealing with
luminosity now it may be that thats not
interesting anymore but it was very interesting
for cézanne for a while if cézanne lived longer
it might not have been interesting to him
much afterwards you know it might have
been another ten years and cézanne didnt
care now in which case if he didnt care what

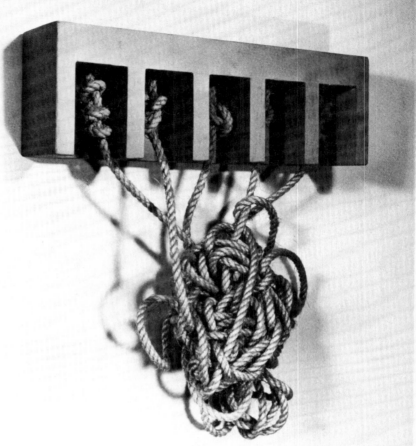

Robert Morris, *Untitled*, wood and rope, 1963.

if cézanne decided he didnt care anymore
about those early paintings who cared? his
dealer? its a very funny situation if art is
about this set of ideas that cézanne was
dealing with at the time that they were
interesting theres no inherent way of a thing
holding its value if the ideas lose their
interest now museums are there largely
to capture and embalm ideas that were once
interesting that is to place an idea that was
once interesting in a place where you can stumble
over it and for reasons that are humanly
valuable reconsider the idea that is it may be
that any idea ultimately that is no longer
available that is any set of ideas and passions
and concerns that one may call the art idea when
they disappear may still be as valuable
intrinsically as any other past idea which is gone

and that there is something valuable about
considering it from the human point of view
but thats a museums problem its not a problem
of absolute value it is an exercise in humanly
reevoking the world its like an exercise in
shamanism the way a shaman evokes the
presence of the dead person that is to say
someone who is very real and had a very real
effect upon his wife and his children and
the tribe and the shaman draws upon his
reality and brings him there long enough for
people to recognize an anterior person who
stood once fully alive and it may very well be
a terrific role that the museum should play it
very often doesnt play it at all and that art history
should play that is to say to play this kind of
 intellectual human shamanism and i would say
thats a very respectable role but its not about value

nor is it about the art youre making now the careers that van gogh or cézanne were embarked upon seemed to them perfectly reasonable careers that is to say what it was that they wanted to do always seemed plausible to them and were in an art world where the things that were doing for some reason dont immediately seem plausible now i dont mean by this that there is no art that is meaningful being made in the world that is for some reason there was a consistent series of moves that seemed available to people like cézanne

and so that cézanne always knew what he wanted to do in a sense that is he knew that there was something about delacroix that he thought delacroix did right and there was something delacroix didnt do right that is to say if he thought that delacroix did everything right he wouldnt have wanted to borrow some delacroix if he thought that he did everything wrong he wouldnt have wanted to borrow it either there was a funny relation he had to delacroix that is to say for delacroix maybe it was right but there is something he is not doing right now but who is doing something for us that is not quite right that will clarify for us what we should do today i mean its a funny problem if there was a continuous career in which youre involved and your friend over here who just died or whos aging is just missing the point of whats really important

you want to correct it for me you know you want to rescue whats going wrong now what is this sense that you want to rescue? you want to rescue a sense something of importance in this sense painting has a historicity or art making has a historicity that is to say it is a historicity of common career he was doing something and something has gone out of the beer its faded somewhat something is not quite right now i can give you an example of a situation that i feel has faded very significantly i mean in a very realistic sense so far we have been talking in general terms but when in 1965 when there appeared in new york galleries certain very simple looking work particularly at the green gallery certain very simple shapes thrust into a room and having no other justification that was obvious the shapes were placed before you there was something

apparently very exciting in being confronted with the idea of simplicity simplicity being offered to you as a significant enough object to respond to it was in virtue of its simplicity that it accused people like disuvero of being absurd

now disuvero was a very reasonable sculptor who made things by knocking things together in a very amiable way a tire a chain and something that hung on something else and there was something very likable about disuvero and there was something very likable about people like george sugarman who put gay little shapes together all over the place and they sprawled out over the floor and people liked it

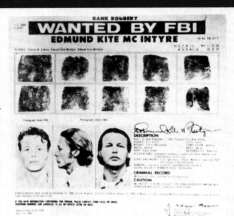

Douglas Huebler, *Duration Piece #15—Global*, 1969.

Duration Piece #15

Global

Beginning on January 1, 1970 a reward of $1,100.00 will be paid to the person who provides the information resulting in the arrest and conviction of Edmund Kite McIntyre wanted by the Federal Bureau of Investigation for Bank Robbery (Title 18, U.S.Code, Sections 2113a and 2113d). On February 1, 1970 $100.00 will be reduced from that first offer making it $1,000.00; it will be reduced another $100.00 on the first day of each subsequent month until there will exist no reward at all on January 1, 1971.

I, (Douglas Huebler), guarantee (by my signature below) the full payment of the reward offered above. In the event that this piece has been purchased from me at any time between September 1969 and January 1971 the then owner will have assumed responsibility for payment of such a reward.

(The price for this piece is $1,100.00: from that sum I will reimburse its owner any amount that he pays as a reward in completing the destiny of its design)

This statement and the "Wanted" publication (FBI No. 342,327) will constitute the finished form of this piece on January 1, 1971 unless Mr. McIntyre is apprehended and convicted in which case copies of all attendant documents concerning his conviction will join altogether to form the piece.

September, 1969

and they said its kind of interesting see how im not saying why i liked it but people said gee it was kind of nice but on the other hand it was kind of obvious it was obvious in that it was a lot of movement and you said well its a lot of movement but to no end i mean what does he need all this machinery? why all this coupling all this moving around? if its possible to energize a space which people thought was interesting to do if its possible to energize a

space maybe its possible to energize a space without all that obvious sign of being an art maker maybe just one cube in the room what is putting a cube in a room? or how high a cube? that is to say any cube? is any cube exactly the same as the other cube? consider the possibility a room is a cube make believe the room is a cube it may not be imagine that the room is a cube twenty feet by twenty feet and you say to yourself the first kind of cube that i put in that room thats going to make that room very difficult is a cube nineteen and a half feet by nineteen and a half feet by nineteen and a half feet i assure you that that cube is going to have a very grotesque effect and will certainly articulate the space of that room that is if you can put that cube into the other cube you will have articulated the space to such a degree that almost nobody can get in there and this is one way of articulating the space in this sense sculpture is an invader that is to say sculpture then occupies space but it calls attention to an idea something is represented

that is the possibility of art as an invader and an aggressor and this is meaningful

now you may not want to be aggressed upon nevertheless in going into an art gallery that is twenty feet by twenty feet by twenty feet and when you encounter a cube within it that is nineteen feet by nineteen feet by nineteen feet you still have to open the door to get in there however difficult it may prove to be once youre in so that its aggression is relatively limited

you open the door you thought there was going to be an art experience and it turns out you can hardly get in the door thats your first experience on the other hand you have other experiences which were presented earlier because that in fact was not the kind of thing that was done you were presented lets say with an empty room where a slab say three inches off the ground and five feet wide and five feet long was presented

a square slab and it was perhaps twelve inches thick and it was three inches off the ground and you see a few of them lets say three of them or four of them and you came in thats all there was and the peculiar problem is there was this large shape it appears to be too low to look at head on it appears to be peculiarly lifted off the floor for no purpose

that is to say you cant see under it so that its lifting off the floor is largely obvious from the light that falls on it you could put your foot under it if you wanted to but on the whole you are apparently aware that its off the floor yet its off-the-floorness appears trivial because

youre damned if youre going to get on your hands and knees and look under it because it only has this much space under it so a lot of things begin to become apparent once youre in this kind of work once you take for granted that people will question the moves that were made that is to say if there is a question

44

concerning why it is that these things were done why it is that this thing was three inches off the floor and why it is that it was this size in relation to a presentation that you would normally imagine to expect it begins to assume a certain kind of meaning but only if you were going to inspect it notice that this all hinges on your assuming some relation to a presentation in that space up to then everybody has validated that presentation everybody says you come into the room and you expect to be presented when you come in you are presented

youre presented with something which is different from what you intended to be presented with and the manner in which its a different thing than you expected is the meaning of the work

in a sense but notice the meaning of the work only to the degree that it is a modification of the preceding work that is it modifies the other work in terms of general conditions imagined to be imposed upon presentation by the preceding history of art in that sense there is a historicity there too notice theres a live discourse sculpture was this series of shapes in a room now you come in and there is only one shape and you wonder why its presented so low or why its so high or why it takes up so much room which makes you ask a question is that an adequate rationale for doing the work at all is that discrepancy that discrepancy which is like a move in a chess game is that next move is that the meaning of the work then you say to yourself what about the game itself that is thats a move in a game thats older and longer and a game which has had previous moves and this is just one move now the move has maybe changed the nature of the overall game to some degree but on the whole it makes you wonder about what is necessary or what is possible and to be sure there were people in the new york art scene who quickly saw that if you could present a cube let us say or a slab three inches off the floor and people would in fact respond to it that is the people whom you cared about would respond to a lot less than this now you say what do you mean a lot less than this this is still merchandise this stuff can sell i have a set of four slabs and somebody comes into the gallery and says "you know i thought that was kind of terrific the way that operated I have a living room thats not unlike the living room in which this was in or i can lower my living room or i can raise it im a serious art collector ill raise my living room to an auspicious size and ill put it there in the same way" now he may very well have found a way to house it and try the same experience if thats what hes really interested in but notwithstanding all that how much concern is it for the artist to be able to produce this experience again and again once its been done that is is he producing a reliable experience for people

45 to enjoy regularly that is is he going to be

happy about the taken home work which will be there will he bring his friends to come look at it will he say here is my art work? the logical thing is that he probably wont that on the whole there is a feeling that once this was done it opens up a new opportunity now theres a funny opportunity for something else that is to make a new theory a new theory of what you could make with the next move and the new theory of the next move might be that you saw so much less in this move than in the last move you see that the morris that im describing is a lot less meaningful in any other sense than as a modification of previous experience well now what if we modify this in the direction of even greater simplicity now theres no need that it should have to go in the direction of greater simplicity but let us say supposing that we even operate with a less objectlike thing

supposing what we do is introduce a situation that forces questioning which this does the slabs did force a questioning as to what they were the first time you saw them and the second time perhaps and maybe for about two or three years but by the third year by 1967 there was nobody terribly concerned with whether a cube was off the ground or a slab was up in the air it didnt matter anything like that was not only acceptable but what you expected now if you expected this this isnt what the artist intended to do he was furthermore going to modify the situation in such a way that you would receive an experience

that occupied your mind for a certain length of time perhaps with the same amount of intensity mainly because it wasnt like this so then let us say that you take the doug huebler as if the doug huebler were the next work it isnt the the next work in my mind but imagine a doug huebler piece in which doug huebler operates a system he operates a system in which he proposes that you apprehend a criminal and he offers the closed system if the work is bought if the criminal is apprehended the buyer pays for the apprehension now what kind of work is that? is it a piece of sculpture? its an art work to the degree that it occupies your mind? perhaps its not an object and its a piece of sculpture to huebler

now huebler sees it hes chipped away a certain amount of the physical materiality of sculpture and yet retained the kind of displacement character of minimal art that is the work is entirely displaced spatially i mean forgetting all the other aspects of it the sociological and humanitarian about which one might raise some very interesting questions but there is a displacement the work itself involves history and geography there is someone who has been identified by documentation as a committer of a crime somewhere in the past whatever crime and his name is known and a photograph is given of him in order to capture him

somebody would have to go out and find such a person to conform essentially to the photograph and to the history that is ultimately someone who conforms to the photograph will be supposed to conform to the history

and then other tests will be invoked to find out whether the person conforms to the name as well as the history now that will be done and then this particular situation will invoke a necessary reward or initial outlay of money by huebler say a thousand dollars that huebler will have to put up because the art work hasnt been sold yet and then this whole thing will be sold as an art work this is a comical idea you notice the comedy now you say to yourself "but huebler thats not physical space" and huebler says "no but its real space" its very real space police action only occurs in real space sculpture occurs in real space its a sculpture sculpture is real space this is real space real space is experience space its not physical space its not three-dimensional twenty by twenty space its not the space of this room as a three-dimensional manifold that is metrically determined thats not human space human space is experiential space i dont experience the part of the room that those six people are sitting on though it is metrically possible i could refer it to axes that are arbitrarily there but thats not a space i recognize i may recognize the people i may move from part to part with my mind but not all of this room is experienced humanly by me at any given time and i only refer to the room as a conceptual continuum i think thats fairly obvious to everybody its almost banal

on the other hand human space is a kind of conceptual manifold that is not continuous its the space of experience that is the space of all kinds of experience tactile social literary acoustical olfactory i mean its a very complicated operation huebler presents a piece that operates or could conceivably operate in real space there is a danger of it becoming real space now there is the danger of it occupying moral space if you picked out i think that with deliberate malice huebler picked out a criminal whose criminality first of all is neither clear nor significant that is he happened to wind up on a wanted list despite the fact that his crime seemed to be publically real though he may not have committed the crime he looked marvelously innocent that is the photograph of a man who looks terrifically unlikely as a criminal and what youre being invited to do is participate in what one might call a potential obscenity that is to say youre being invited to take part in the apprehension of the human being only on the faith that the wanted poster is accurate this raises the question about the accuracy of the documentation of the first part and it offers this problem as a temptation it offers the art work as a temptation

to crime of its own sort so that it evokes this moral space a very curious moral space is invoked by this work now you say this art work is an interesting art work for a very good reason its not an interesting art work because its a work modifying art history its an interesting art work because it raises the question about the meaning of art it raises the question about what sort of space a work of art could possibly occupy and huebler is in a certain sense paradoxically suggesting what about occupying this insane moral space i mean consider it

huebler always presents it as if it were a formalist scheme everything is beautifully presented that is you capture the man youre paid the thousand dollars huebler receives a thousand dollars from the buyer of the art work the buyer of the art work is thereby the man who finances the whole operation and there is neither gain nor loss as a matter of fact huebler is not profiting the piece was aimed at nonprofit its a nonprofit art work now take the structural piece which is very curious and regard it as formalist sculpture the work itself from the historical and abstract art point of view is very ironic what the work does is create a kind of total irony with respect to formalist concerns in sculpture it raises the idea that formal concerns applied to things that might be interesting in human space

would turn out to be obscene on the other hand thats very interesting it raises the issue essentially of what i would call pornography now art has always played with pornography in the west i mean pornography has been a very significant concern of art in the west its been significant because it has always been the challenge of the artist that art is informal because one responds pornographically the most cheerful aspect the most heartening aspect of western european art was its possible pornographic concerns because it was always the specter of the human however formal an art work was if it played with pornography as an idea not because the pornography was beautiful or cheerful but because it was a reminiscence of human maneuver within the work now if hueblers work is an assault on it there are many works in the art world that are not i picked hueblers work because hueblers work is an art work of a rather odd kind he presents it as a formalist nonrepresentational piece and what it is is a rather bizarre model of reality that is it is a representational piece of sculpture if it is sculpture it is representational sculpture but there are many sculptural works that are not consider take a dennis oppenheim work dennis oppenheim did a piece of work in which he managed to get some things harvested in a field i dont remember if it was wheat or corn or what it was but he harvested it he harvested it he arranged the field in such a manner as to correspond to the route between there and the place he was

shipping the grain to he harvested the grain by making this contour pattern in the area and when he harvested the grain he sent it to an art gallery and the grain was sold now big deal i mean thats formal there was a task an arbitrary relation between field and grain which was there and the natural environment and the removal of the grain into an art context where it became a commodity that is it was labeled art and it was sold now theoretically the works look like they have the same structural center that is to say they work in human space the oppenheim harvests corn or wheat and it goes through a situation in which the activity the costly labor of oppenheim and the people are then paid for by the purchase of a patron say say rowan whats the difference theyre paid for by the pasadena museums large backer and you know he buys the grain he wont because it doesnt look like an olitski but thats not the point the fact is he pays for it and that makes it a complete cycle its a perfect system now you say to yourself they did a perfect system of the same order as the heubler i mean is it interesting the way the heubler is interesting the huebler verges on obscenity and triviality and the huebler is a very violent piece thats why huebler is one of the best conceptual artists and there are very few good conceptual artists i mean that is why heubler is a profoundly disturbing artist and oppenheims not disturbing theres nothing disturbing about an oppenheim piece not of the type now consider other kinds of work now i dont remember if it was oppenheim or heizer who did this piece and there is a very interesting and very violent conceptual work that is done by one of them which was the police dog piece that was done in boston its a different kind of piece than the huebler piece the huebler piece verges on social structures and sociology in a way what im talking about is a social art that doesnt work within an arbitrary formalist frame but this piece which was either oppenheims or heizers and if i dont remember which one it is its because I begin to think of them as the bobbsey twins at times involved the placement of police dogs in front of the museum near the entrance to the the museum and these police dogs were chained they were chained down in such a way that if you walked a straight line between them the police dogs however violent they got would not be able to reach you but they would come very close now i would say that articulated the space rather clearly the space was articulated very well you walked down the space the animals lunged at you and you found that the space was very narrow there were three inches on either side which were not dog and you got into the museum to get into the museum you had to go by these rather peculiar animals now theres something interesting about that and amusing a kind of witty idea but now this

dog work occupies a space somewhere between the oppenheim canceled crop operation and the huebler piece the violent relation this sort of funny special path to the museum now you think about the piece itself as a model of art structure that is the art structure being represented as a model path into a museum it is an amusing idea and kind of terrifying in a funny way theres something interesting and peculiar about its operation its trivial in a sense

that you know the animals are not going to kill you its trivial oh you may not believe in the secure technological assurance of those chains one knows of those mistakes made by industry before i mean one knows that lockheed exists if lockheed exists its possible that the chains may not exist all the time

lockheed has planes that dont exist very well i mean why should the chains hold up all the time still youre toying with fear in a more or less pornographic sense i mean this kind of work shares a pornographic character with the huebler what youre offered is a kind of *frisson* a kind of chilling quality in the work and youre setting up the chilling quality by trying out the art work in a way this piece questions art making too in relation to pornography that is it questions it because the art itself handles human feelings toys with human feelings in a situation that is ultimately rather protected which is pornography and it is self-provoking you enter into it now apparently to the degree that both pieces are rather melodramatic

i dont mean to advocate only melodramatic operation but youll notice that both of these operations are about pornography in art they are about art as it were opportunizing over social human activities now it seems one of the problems here thats raised is the kind of conflict that exists between human values and the idea of art making itself as a career that is

what art making is about or what it has often been about take the nude say the female nude from the renaissance on it has always offered something of an entrance to the painting through human sexual feeling the consumer the art looker was always assumed to be a man now everyone knows that men dont get excited when they see a painting of a beautiful naked woman not a gentleman or an art lover relator not now anyway that we have photographs and movies still who can deny that there is that momentary flicker of of interest sure its more complicated than that

this feeling is surely diverted or suspended by some conflict of interest in painting say or antiquity nostalgia still its a naked woman youre looking at in a titian or a renoir or a wesselmann it isnt a wine bottle or a mountain though the feeling the flicker of sexuality is protected from its consequences by its surrounding attributes its props the case is may be clearer with suffering than with sexuality the painter has painted a picture of

a human being in torment you are filled with an honorable ennobling sympathy for his exquisite torment you look at grunewalds christ and are filled with pleasure youre masturbating at the crucifixion we are back to vito acconci

what is the point of all this self-stimulation if you are the viewer or why all this generosity if you are the artist this sexual assistance? what are you masters and johnson? at least for vito the pleasure is reciprocal he sits under a plank concealment and knows that you the audience are only a few feet away from his trivial but scandalous pleasure he knows that you are nearby and he is pleased to be so close to disclosure his *frisson* you are close to his sexual act about as close as you are to it any time you walk by the door of somebody elses apartment but you know that your being there gives him pleasure and his being there gives you pleasure this is a little fairer than pornography as it is usually practiced in the arts but what if you are not especially interested in or in need of masturbation for an artist who gets no *frisson* from exposing himself or pretending to do so what is there to do?

supposing art making is like a kind of knot making if youre a knot maker youve got an idea about what is a knot and what is a mess a legal way of proceeding what is a legal knot and what is a snarl? all knots involve some kind of double reversal you start out going somewhere go back and take some of the past with you to wherever you were going to go and you find a way to mark off some memorial to where youve been a node well there are two kinds at least of knot makers

one knot maker knows how to proceed making his knots and watches himself proceeding in the end he arrives at a knot he approves for some reason if hes been watching the way he has been knotting all this time he wont be surprised at the outcome and though he may be satisfied he will walk away and forget it then hes a process knot maker or he might not walk away but place it in front of you in the hope that you will be bettered thereby in which case hes a therapeutic or didactic knot maker

or say he is a forgetful knot maker as soon as he finishes a loop he forgets it because all the time he is only attending to the node he is working on at any given moment at some time when hes tired or interrupted by a phone call he will look up and hell be surprised by his knot because hell have no idea how he got there hes a kind of magical knot maker but with all of this and i think we should not underestimate the pleasures and surprises of knot making why in the world should we bother making knots who cares about rope? in a way this is a lot like playing chess and you can say someone has played it well or played poorly but why should you care about this game? it seems ridiculous to spend all this time pushing little pieces of wood about on a board havent

you got better things to do? but it was not always this way with chess chess is a depraved game it represents the world as a struggle for dominance between two sides that have no choice but conflict there is no clear demarcation or boundary that cuts off one side from the others hostilities and there is no bound to human abilities it is an arrogant fantasy of war in which the greater ability will surely win by annihilating his opponent what sort of paradigm is this? no experience on earth corresponds to it so it is a game of no relevance it is a fundamentally trivial representation of reality but it wasnt always like that according to most authorities chess derived from an indian game called *shatrandji* which was supposed to represent the state of the world the social classes into which people were arbitrarily divided

and it was a game invaded by chance the best player the best plan could as easily be defeated as the worst by luck and this was thought to teach humility to rulers *shatrandji* was the game of which chess is the trivial example

and it doesnt seem that we have to be especially impressed with *shatrandji* either but as *shatrandji* was a game built up out of the human experiences of its time arbitrary inequities among people the facts of unavoidable war and the absurd circumstances of luck lying under the feet of ability it is possible to construct make our art out of something more meaningful than the arbitrary rules of knot making out of the character of human experience in our world ■

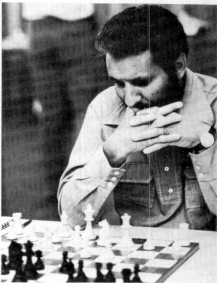

"It seems ridiculous to spend all this time pushing little pieces of wood about on a board."

Afterthoughts

p. 39 and p. 46 *it's a nonprofit art work*
I seem to have misremembered here. Huebler is not notably philanthropic — and why should he be? *Global* was not a nonprofit piece, it was a gambling piece. Huebler's asking price for the documentation was $1000 and the offered reward, which he guaranteed to pay until the piece was bought, was $1100. On purchase of the piece the buyer was to assume responsibility for the reward. Huebler was gambling that he could sell the piece before Edmund Kite McIntyre was apprehended. The reward was to be reduced $100 a month until there was no reward to be paid. A bold buyer stood to pay anywhere from a maximum of $2100 to a minimum of $1000 for the work.
p. 40 *the gallery door is there and as you open the door you smash the painting in half & go through*
James Rosenquist did exhibit a painting that hung in strips across a doorway like the entrance to a Hong Kong whorehouse. It was something of an image-painting and the conceptual integrity of the painting was to some degree established by the depicted image. Even a fragmented or partially deteriorated image will effectively maintain its integrity as long as it is recognizable as an image at all, because an image exists in a conceptual space not in a physical one. But the work was slightly more complicated than this because it involved a conflict between two images: the pictorial image cut into strips and the image of a curtainlike object that could be walked through, since coherent objects also represent themselves as conceptual images.
p. 40 *a model is not a real object*
Obviously a model is a real object but it is not a real object in respect to its role as a model. The conflict between the model's status as an object and its status as a signifier has been one of the most fruitful confusions in the history of representation.
p. 46 *either Oppenheim's or Heizer's*
The piece was Oppenheim's *Guarded Elements* and seems to suggest it is harder than one may think to get into a museum, though people exposed to the piece for a considerable length of time tell me the dogs were usually sleeping.
p. 47 *who cares about rope?*
I suppose Alexander's solution was a reminder of this sort.

David Antin is on the faculty of the University of California, San Diego. This text is his transcription of a talk given to the art students of Pomona College, California, in April, 1972. It will be included in his forthcoming book, *Talking*, which will be published by the Kulchur Foundation in October.

47

Mowry Baden *Phantom Limb*, 1967.
Fibered polyester. 54 × 96 × 45 ³/₈ in.
(137 × 243 × 116 cm). Collection of University
of Lethbridge, Lethbridge, Alberta

REBECCA MCGREW Mowry, you know I am just starting research looking into the history of the art gallery and art department in the late sixties and early seventies. When we did our show in the spring of 2001, our conversations about this era planted a seed that has grown into this big project. Today I'd like to talk about that era; in the future, we'll meet again to talk in more detail about your work. You graduated from Pomona in 1958, and later went to Stanford University for your MFA. When did you come back to Pomona to work?

MOWRY BADEN The fall of 1968. The president was E. Wilson Lyon. And I left in May 1971, at the end of spring term.

RM How did you end up back at Pomona?

MB An advisor to the president, a young guy my age named Frank LaHorgue, brought my name to the president's attention. I think the department was in some disarray. The department chair was an art historian, Nick Cikovsky, and I believe that Nick left without much warning and they were scrambling to replace him. I'd gone to school with Frank LaHorgue, so Frank said, "Let's try Mowry. He can do this."

RM Nick was department chair and also the gallery director.

MB That was the style in those days.

RM They hired you as department chair, professor of art, and as the gallery director. That's a huge job.

MB Completely undoable. So when President Lyon offered me a three-year contract, I said, "I don't want to be chair of this department any longer than I have to." So we worked my term as chair down to one year. I think he figured that he was buying another year during which he could set up a proper search for a chair, hopefully an art historian, because they're perceived as so much more responsible than artists. And he found one in David Merrill. And David was chair for the remaining two years of my tenure there.

You know, in those days they prided themselves on not giving any kind of tenure to artists, arguing that it would be unwise to offer tenure to an artist because fashions change, and then you would be mired in an anachronism, which suggests that artists are slaves to fashion. It was an impossible position for a school to take when they were happily giving tenure to art historians and people in other departments.

Anyway, I did a few shows while I was chair, because I had to. I had to get something in the gallery.

RM Tell me about hiring Hal Glicksman. How did you know of him?

MB Through Guy Williams. He knew Hal from before Hal worked at the Pasadena Art Museum. So I connected with Hal, and I liked him a lot. We talked about what he might do for the school. He looked like a perfect fit. And he had great ideas.

RM So at this point, it was President Lyon that allowed you to hire a curatorial position.

MB Yes, it was my single shining administrative achievement. [Laughs.] To get those two jobs—the chair and the gallery director—separated!

RM Were you good friends with Hal then?

MB Totally. We were very tight. In fact, it was a very tight department. There were Guy, David Gray, and me. David was a sculptor. They didn't actually hire me to teach sculpture. They hired me to run the department, and they found something else for me to do and that was teaching drawing and painting, because they had more enrollment in those classes than they did in sculpture. But David Gray was the guy on deck teaching sculpture when I arrived and he was doing a great job.

After I left, David was badly injured. He was helping a student do an earth-rammed mold with wooden supports out there in the wash. They were filling it with a front-end loader, dumping the sand in and then ramming it. David got out to cut the straps that were holding this whole thing together. The sand was inadequately packed, and all that tonnage came down on him and crushed him. Fortunately, the student knew how to run the front-end loader and lifted the form off of him. He came out alive, but I don't think he ever taught again.

RM That's tragic.

MB But David made a huge contribution. I don't think that anybody really had as good a grasp on what Minimalism meant as David did.

MOWRY BADEN INTERVIEWED BY REBECCA MCGREW

Part I: Mowry Baden's studio, Victoria, British Columbia, August 12, 2008

Part II: Pomona College Museum of Art, December 21, 2009

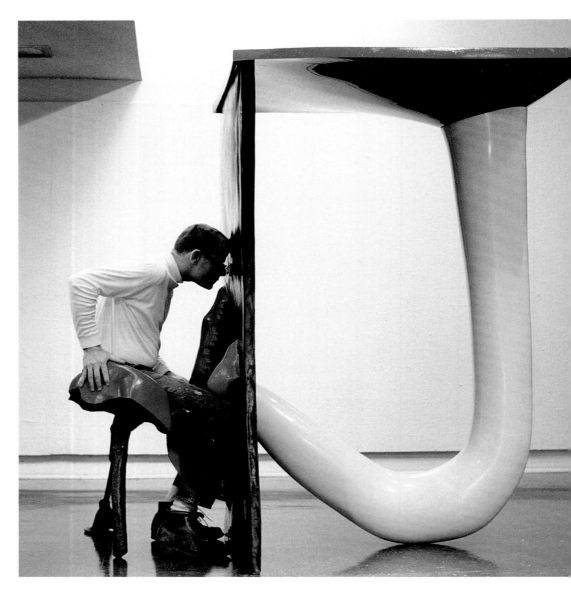

RM Did you work with Hal on any of the exhibitions he organized?

MB Oh, did I! Hal had this group of students who didn't know which end of the hammer to hold. So Hal and I pitched in. For Michael Asher's piece, as I recall, we worked from Michael's drawings. He maybe made one or two visits at the beginning, and then once we had it all built, dry-walled and painted, and the floor finished with MACtac—a sticky-backed paper that you could lay down and then paint white—he came back.

RM To give it the thumbs up?

MB But in an interesting way. We had been going there regularly. I would go in there with the students at all hours of the day and night because the gallery/museum was always open. That's what's written about so much by people who never experienced it. Here's Michael Asher putting a permanently open esophagus into what is normally an intact body. But it had other properties as well. It delivered a "whiteout" sensation, because the walls and ceiling were white and the floor was white. And it seemed strange in there acoustically, too. You couldn't quite put your finger on what the hell it was.

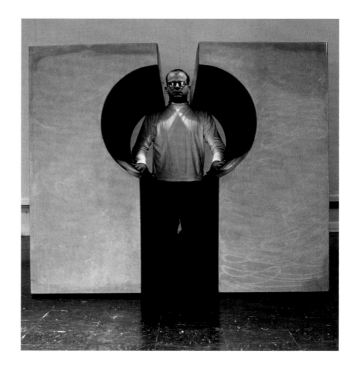

TOP / BOTTOM

Mowry Baden *Delivery Suite*, 1965.
Steel and fibered polyester resin. 49 × 77 × 75 in.
(124 × 195 × 190 cm). Collection of Theresa
Britschgi, Seattle, Washington

Mowry Baden *Phantom Limb*, 1967.
Fibered polyester. 54 × 96 × 45³⁄₅ in.
(137 × 243 × 116 cm) Collection of University
of Lethbridge, Lethbridge, Alberta

And then he shows up, and he's got this little glass pistol—one of those things that professionals use to check the efficiency of an air handling system that they have just installed, or to test one that is faulty or ineffective. It's a little pistol that you fill halfway with acid. Then you drop in an alkaline pellet, and it makes a dense white smoke. It has a bulb on it, like an atomizer. You squeeze that, and out of the barrel of the gun comes this gob of smoke that doesn't disperse. It stays together in a ball, and you can watch the way it moves. It's a very sensible way of tracking air currents.

So we went into the second room and stood against the wall—Michael, Hal, and I. And Michael fired the pistol. This gob of smoke took off, went along the wall at chest height where we were standing, turned the corner, went along the opposite wall in front of us and into the first room, went around two walls there, and then went out the door. And then Michael said, "It's working."

What's working? And, you know, Michael Asher has this booming laugh. And that's all we got, just this laugh. So the next time we're in there, we're more attentive, just looking for anything, any other phenomena. And then I suddenly realized what was enhanced: the sound of the train crossing that's south of the campus. Not only the sound of the train moving but also the change in the sound as the train passed the level crossing. The sound was hugely enhanced in that room.

RM Sort of amplified?

MB Amplified. He pulled the sound right in and served it up.

RM So do you think that's one thing that he was going for?

MB There's no question about it, because the relationship between air movements and sound is well known. That's often the way acoustics people test for the effectiveness of sound delivery in a given space.

RM What kind of channels did you have to go through to get this piece approved [by the administration]?

MB That was the thing about Hal, he'd just do it without approvals. We'd just take a lot of heat and say, "I won't do it again."

RM In your tenure, was this one of the more memorable installations for you?

MB The best. Yes, the best.

RM What were some of the other ones?

MB Oh, the Lloyd Hamrol installation was interesting. He put balloons on the ceiling and reflective water on the floor. Michael Brewster, too. Michael made these little clickers that were transistor-powered. So they had a life span long enough to last for the length of the exhibition. And they were tiny. He cut holes in the drywall and dropped these things in, and then with the kind of paper you get in model airplane stores, he covered over those cavities and painted the paper the same color as the gallery walls. Per wall, I don't know how many there were—a dozen here, a dozen there— and it was an amazing experience, because you went in there and it was like taking a shower in sound. The sound came from everywhere. It was all around you. And the clicks were completely random and unpredictable. It was very, very sophisticated work for a very young man.

RM What other events do you particularly remember?

MB My resignation from the department and the arrival of Jim [James] Turrell, who replaced me.

RM Now, James was only there for about a year; did you overlap with him?

MB No, but I was still there when he came to Pomona to interview for my job.

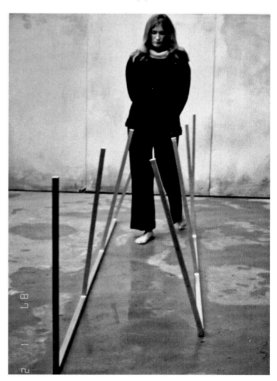

Mowry Baden *K Walk*, 1969. Aluminum. 116 × 24 × 35 in. (294 × 60 × 88 cm). Pomona College Collection. Museum purchase with funds provided by the Estate of Walter and Elise Mosher

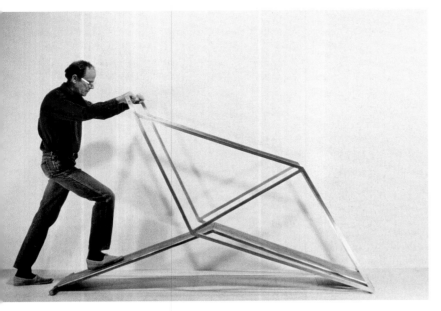

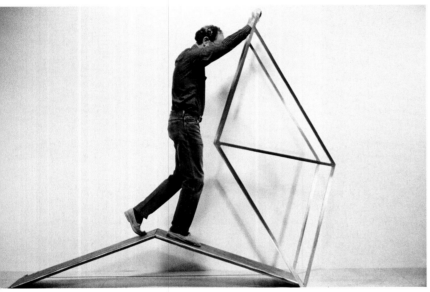

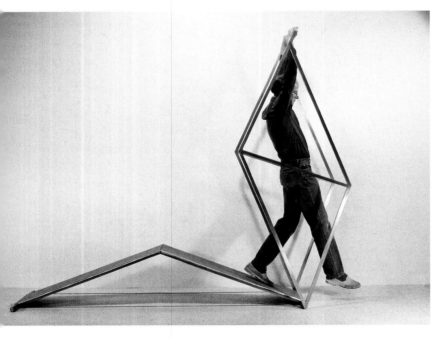

And Willoughby Sharp showed up and gave a talk at Pomona. Now there's a guy who couldn't be more of a hippie. In the same week, or within a couple of weeks of one another, we had visits from Larry Weiner and Willoughby Sharp. What a pair! [Laughs.]

RM Who brought them there?

MB I think Guy brought Lawrence Weiner. Guy Williams was connected with so many scenes, notably writers and poets. He was a treasure as a colleague. And he brought people like [Charles] Bukowski.

RM How do you think teaching at Pomona affected your work? Do you think your work changed from teaching there?

MB Yes, it did. Not so much the institution, but people like I've been just talking about, and the enormous flood of new information. I saw my first Samuel Beckett play at Pomona College, for instance. Andy Doe staged a Beckett play; Mike Devine did the sets, and Dave Gray welded all the metal together. I mean, seeing Samuel Beckett for the first time in your life—it's staggering.

But, you know, what really turned my work around were my previous experiences teaching at Raymond College in Stockton. Raymond College was an experimental school where students got a degree in three years. It had a ferocious core curriculum of twenty-one courses that every student had to take. And this curriculum was serviced by a faculty of perhaps only twenty-two of us. We all had to teach outside our disciplines. I taught studio, I taught art history, and occasionally I'd be asked to teach a course in world civilizations, or world literature, or western literature. Or, on occasion, I had to teach psychology—you know, something that I didn't know anything about, really. And the students were completely accustomed to this condition. The professor stands up and says, "I don't know anything about this, but the guy who does gave me this reading list. Let's start."

RM [Laughs.] Let's learn together.

MB Yes. And it worked! It worked on them, and it worked on us. And I wouldn't be the artist that I am today had that not happened to me. I started reading in perceptual psychology, and I just jumped into that like a fish into water. But had I not been in that place, it would not have happened. It changed my life, and

Mowry Baden *Shortfall*, 1969. Aluminum and steel. 26 × 166 × 89 in. (66 × 422 × 225 cm). Collection of the artist, Victoria, British Columbia

[it happened] at a critical moment between my twenties and early thirties, at a time when things should begin to stabilize, when you discover the problems you can't solve in your lifetime or a hundred lifetimes. These problems gave me a platform of investigation. That rarely happens later in life because you don't have that drive of youth behind you. You don't have the steam to say, "Yes! I believe in doing this. Yes, I give myself to this investigation completely."

But now, [laughs] students don't think like that. I remember meeting not so long ago with some Claremont graduate students after my lecture. They invited me for coffee and we sat down on the lawn. And I said to them what I just said to you. And they had this look of total bafflement on their faces. I could tell I'd treaded into *terra incognita*. And I said, "Well, yes, if you don't have a platform of investigation by the time you're in your late twenties or early thirties, it's very difficult to proceed. It's really hard to go forward."

RM As an artist or in any field?

MB As an artist. Because it's at that very point that you're supposed to be having some exhibition success, and the temptations of simply moving from one trend to another are very strong. "But believe me," I said to them, "the galleries and museums can dump you in five minutes. You can go out with what you think is a pretty trendy deal and it *will* be, and it can all be over like [snaps fingers] that," I said. "Then what will you do? How will you go back into your studio?" And, you know, they said to me, "Nobody's ever said that to us before."

PART II

RM *Delivery Suite*, from 1965, represents your earliest work in the show and provides a nice sense of your artistic development.

MB A window of furious activity.

RM Right! Where were you working when you built *Delivery Suite*?

MB Stanford University. And the person to whom the work is dedicated, and who owns it, is my daughter, Theresa. It celebrates her birth. She's that yellow force. Of all three of my children, she was the only one whose birth I was allowed to witness.

RM Oh! Why?

MB Because the hospital where my other children were born wouldn't allow anybody in the delivery suite except the staff and the mother.

RM Is she your youngest child?

MB Yes. So you can think of me sitting in that seat, observing this birth. It was made at Stanford and underwent modifications and changes in Stockton. So, I actually finished the work while I was teaching at Raymond College.

RM How did *Delivery Suite* address your sculptural questions at that time?

MB Well, I was suspicious of part-to-part sculpture. I found it profoundly unsatisfying. For someone like Anthony Caro, part-to-part sculpture can sustain a thousand practices, but to me it seemed like a pointless exercise of setting out different elements and adjusting them in relation to one another and giving some of them a tensile relationship and some of them a merely plastic relationship. It was just meaningless. And I knew I couldn't go back to painting. So, I began to make sculptures that I could get into, physically. That doesn't seem like a very elaborate organizing principle, does it?

RM No, but it makes complete sense, given the time and the context.

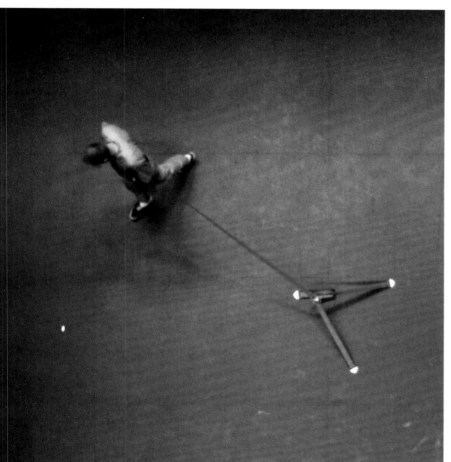

Mowry Baden *Seat Belt Three Points*, 1970.
Steel and nylon. 168 in. (426 cm)
diameter × height of viewer. Collection
of Steve C. Young, Lopez, Washington

MB It was brutally simple. But in 1965, you could probably count on the fingers of one hand the other practitioners who took that small premise as an organizing principle in their work. I think the architect and artist Frederick Kiesler was still alive in 1965. Anyway, I'd seen his work and admired it deeply. And also Herbert Ferber, whose sculpture I saw in New York. It's kind of a restricted pedigree, because there are so few players.

And then later, I saw Mark di Suvero's work—the ones with rides in them—that the spectator, the viewer, could physically participate in. One—*Praise for Elohim Adonai* (1966)—had a big triangular beam structure that you could just barely reach and set in motion by touching it with your fingertips. But of course people were climbing on it, getting themselves pushed around. Riding on all that tonnage moving through space was pretty exciting.

RM When was he doing those?

MB Oh, in the sixties. It was after his accident. I think he became a different artist after he got hurt, and I think a more revolutionary one, because the sculpture became load-bearing, like architecture.

Irish Position in 1967 was the first gimbal-cast sculpture that I ever made. And *Phantom Limb* (also 1967) was gimbal-cast as well. These are juvenilia. They're works made by a pretty young guy, but still, trying to get the artist—body and all—into the art. They were made in the gimbal box in my studio. And *Augur* of 1967 was made the same way.

RM Mowry, could you explain what a gimbal box is?

MB It was a box filled with urethane foam the size of a phone booth and mounted in a rotating gimbal. While the box was stationary, I opened a hatch in the bottom and carved a void up into the foam. I later used the gimbal to coat the surface of the void with fibered polyester. I wanted to make a big form without knowing what it looked like while I was making it.

Irish Position truly surprised me. I had no idea what the thing was going to look like, because I made it blind. When I broke the foam off from around the form I had made, I was truly surprised. But then I learned how to predict even the trickiest inversions and was able to imagine while inside what the positive form

would look like from the outside. So I stopped doing it because I couldn't surprise myself any more. The other thing, too, was that the end product was no-where near as interesting as the process of making it.

Then later, the sculpture *Phantom Limb,* which I also made using the gimbal box, allowed the viewer to experience the inside.

RM It is a sort of transitional piece, then. *Delivery Suite* is an example of your earlier practice, and *Phantom Limb* is a transitional work.

MB Yes. It's not uncommon for an artist to make a tool and use that tool to make something like *Irish Position*, and then continue using the tool to produce different outcomes. And then I quit using it. It was too limiting.

RM So then were *K-Walk* and *Shortall* (both 1969) made when you were at Pomona?

MB Yes, and I made the seat belt works here, too.

RM Can you tell me more about these works?

MB The guy in the photo of *Phantom Limb* is me, and the dimensions of that keyway are the dimensions of my body—the distance from one side of my skull to the other, the distance from one of my shoulders to the other, and the distance from the shoulder to the elbow for a person my size who is kneeling and mov-ing forward through that eight-foot long space. So, I'm the laboratory for the work. And the same is true of—

RM *Shortall.*

MB *Shortall*, yes. The sculpture is built to my size. As I walk forward, up the ramp, I get taller and taller and more and more in command of the frame I'm holding, which is pivoted. But then, if I continue for-ward and down the ramp, I get smaller and the frame gets taller—a challenging experience. At first, I didn't intend for other people to move through these things, but I began to see that they might, so I began to think more globally, and my work became less about using *my* body to develop the experience and more about using the bodies of others. So, for ex-ample, my former wife Gretchen helped me develop *K Walk*. I was looking at her stride and wondering if I could make a sculpture that would match the move-

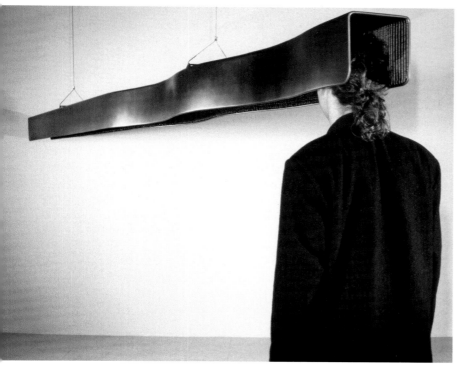

MB The seat belts emphasize the tactile, all proprioceptive senses. They leave the viewer with what I call a "body print." I began to realize, back in the late sixties, that this would be a completely different territory for exploration.

Like so much of my art, the seat belts downplay vision. In *Seat Belt Three Points*, you can know that the path you're traveling is not a pure circle, but only after you've made multiple journeys. It is the subtlest of them all. You can walk around for ten minutes before the geometry begins to click in. So that's good. The other thing you can say about this work is that the needle swings over to the non-visual senses gradually. The viewer progressively discovers where the sensory challenge is. And the experience is complex. Personally, I can't exhaust it. Even today, I can't wear it out.

The other thing is, back at Raymond College, I had a blind student. She came to me one day and wanted to join my studio class. She wanted to make sculpture, and in particular, she wanted to make portraits in clay. So I gave her a twenty-five-pound block of clay, and for want of another model, I said, "Why don't you make a portrait of me? And while you do that, I'll make one of you." And I took off my glasses, fortunately, because in no time, my face was smeared with clay. She worked for maybe an hour or so, and she said, "I'm done." She said, "Does it look like you?" and I lied. I said, "Yes, it does," because I didn't want to dis-courage her. She put the same question to her fellow students, and they didn't lie. They said, "No, it doesn't look like him." Actually, it looked like the top of a meringue pie, you know, with little peaks?

RM Did it look completely abstract?

MB It was not a face! But in her head, it was, and that convinced me on the spot of the non-primacy of vision. I owe that woman so much.

RM What was her reaction?

MB She came back to do some more. I thanked her and tried to explain how important it was, that this was the opening of an enormous area of investigation for a person working in a field as dominated by vision as art. It's like finding another door in a room—a big opening where you can pour all your energy and all your thirst for knowledge from other, parallel fields.

ment of her hips. I made this elaborate matrix in the studio and had her walk through it again and again and again, until I found the points in space that were just outside the swing of her hips. So she could step into it and walk the full sixteen-foot distance and never hit a thing, but if somebody else walked through it, they'd hit almost every one of the points. And, of course, the seat belt sculptures are much more global, because a two-year old infant or Shaq O'Neal can put one on and walk around.

And ever since, my practice has been to make the work accessible to anyone, regardless of size.

RM I like to think of your series of seat belt sculptures of 1968–71 as pieces that set you off in a different direction, another transformative moment.

The seat belt sculptures are all anchored to the floor. First of all, I see the pile of nylon straps and a belt with a buckle and then I strap the belt around my waist and move around the room, Even after removing the belt and moving freely, unbuckled, I experience physic-ally the way the sculpture made me feel. How do these pieces work within the development of your practice?

Mowry Baden *Instrument*, 1969. Aluminum and steel. 192 × 8 in. (487 × 20 cm), height variable. The Museum of Contemporary Art, Los Angeles. Gift of the artist

DAVID PAGEL What brought you to Pomona?

MICHAEL BREWSTER I had an aunt and uncle who lived in Ontario [California], and they said, "Go over and look at those campuses." I fell in love with a dormitory at Pomona called Clark Five. I thought, "Oh wow, I could come here and be monastic." The rooms were like cells for monks, with fireplaces and balconies around courtyards.

DP At that time you were in high school in Brazil?

MB In São Paulo, at an imitation American high school, so that I'd be fully prepped for American college. My family had been in Brazil for fourteen years. My twenty-six-year-old, D-Day master sergeant, chemical engineer father went there on a three-year contract in 1950, which turned into thirty-five years. He was doing well, much better than an engineer could do in the States.

DP That's where you began taking art classes?

MB I did theater work, actually, a lot of it. I was a bored sophomore when a drama teacher showed up at the school. He very quickly figured out that he could use me for a lot of stuff. So, my exchange with him was I would take a lot of theater classes if they could be taken on stage. I basically only sat in about two non-theater academic classes a semester. The rest of the time, I had all my classes and study halls on stage, and I built sets and aimed the lights. I thought I was going to be a set designer.

DP Who was the theater teacher?

MB His name was Jim Colby. There were many teachers in American foreign schools there, running from something in the States, we figured. Colby was running from some off-Broadway misadventure. He hadn't quite made it in New York. But he was really a good teacher, very enthusiastic and something of a brat himself, so he attracted all the brats in the school. We put on fabulous productions, *Androcles and the Lion*, complete with running water in the fountain and a rotating set on wheels. It was quite a piece of engineering. We also put on a full-fledged of *Guys and Dolls*, with giant, "practical" sets—meaning the actors moved over and through them.

DP And you were the set guy?

MB I was the tech director and the set guy. And it amuses me now, you know, because I do installations. It's not so different, except that, boy, now my sets are minimal.

DP Were you planning to major in theater?

MB No. I was going to be an English major. That's how you got into theater in a liberal arts college, as an English major. Drama. Art departments at liberal arts colleges didn't think about set designing. You'd have to go to a dedicated art school, and few of them actually had theater majors. So I ended up going to Pomona because Stanford was too huge and scared the hell out of me. I had fifty people in my high school class. The thought of going to a place that had thousands of students was pretty hard, especially because I was scared of American culture.

DP When did you leave English for art?

MB I switched to the art department in the second semester of my freshman year. During the first semester, I built a couple of sets and I thought, you know, we're all prima donnas here, and this prima donna's going to take his ball and go play by himself. I could do that in the art department.

DP Building sets for college theater wasn't as much fun as building them for high school productions?

MB Well, good ol' teacher Colby, director Colby, he'd say, "What do you think we should do here, Mike?" There was great freedom, like we were artists together. In college, it was more about doing the director's bidding: "Don't get any ideas. Just do the work." Your artistry is crushed.

DP Art majors had more freedom?

MB Not as much as I would have liked. Much of the program was regimented: go to class, do the assignment. I took Salvatore Grippi's deadly painting classes, where you had to paint bottles. But I also studied with John Mason for a while. He controlled the sculpture yard. There were kilns, but you couldn't make pots. You could make sculpture. John wasn't about to have a pot shop there. He was uncanny. The most effective non-verbal teacher I've met in my life. One semester, he said all of three words to me: "Pretty bizarre, Mike."

MICHAEL BREWSTER
INTERVIEWED
BY DAVID PAGEL

*Michael Brewster's studio, Venice, California,
June 2, 2010*

Michael Brewster *Configuration 010 Audio Activity*, 1970. Installation view at Pomona College Museum of Art

Michael Brewster *Configuration 010 Audio Activity*, 1970. De-installation of "clickers" from gallery wall at Pomona College Museum of Art

DP As a compliment?

MB No, not as a compliment. I insisted on doing these little figures, and he wanted me to blow past that antique notion of what sculpture was. I learned a lot that semester, but I don't know how. Pomona College has the ability to teach you whether you want to learn or not.

DP Who else made an impact?

MB John was replaced by David Gray. He was a good Minimalist and an effective teacher. More verbal than John. When I came up against David, he said, "No, I won't allow any of that work in my class. Period." So then I had to do these things that were, you know, kind of constructivist plastic things. David had a good effect on me, breaking me out of the figurative work. Although I didn't like it at the time. I fought him quite a bit. But then I was converted by the sculptures I started to build. And then Mowry Baden showed up and the dialogue went way up.

DP How so?

MB It just took off. Suddenly we were reading psychology and philosophy books. We hadn't been reading anything but art books. It was just go to art class, make the project and go home and do your other homework. But when Mowry showed up, and then Hal Glicksman, there was this big buzz. Suddenly

people were arguing, you know. We would go to Mowry's house, and we would get drunk and talk art. Amazing. Unbelievable. He so changed the tenor of the art department. He was kind of like a pied piper. A lot of people chased behind Mowry. He was unique. He was fuckin' terrific as an undergrad teacher, really inspirational, provocative. Always in the direction of *his* line of research. So instead of going to graduate school someplace else, I stayed at Pomona. In those days there was no formal graduate school home building, so I could continue working in the Pomona studios.

DP What was it like?

MB Well, you had the Scripps faction: a bunch of Soldnerites making pots, running around and partying, sometimes naked in Seal Court fountain. The whole contingent of graduate students numbered about fifteen. The graduate school was not centralized. Doug McClellan was the chairman of Scripps Art Department, and coincidentally chair of the graduate students. Originally, I think it had started out as a way to get Paul Soldner more sophisticated students. They made really interesting pots; it was the center of raku firing, quite famous you know. And in counterpoint was our group at Pomona, also entertaining each other but in different ways.

DP Who were the graduate students you hung out with?

MB When I was a sophomore, Bill Leavitt was a graduate student, a bit of a cipher; you never knew what the hell he was doing. Bas Jan Ader blew in and out of those studios. He was friends with Leavitt and Jerry Mahoney. Jerry made big sculptures that were kind of cool. In retrospect, they looked a lot like Star Wars spaceships. Peter Shelton was there and Chris Burden. Chris was very sophisticated in terms of the art world. He had bummed around Europe as a kid, so he was savvy about the mechanics of art doings and openings in a way that I wasn't. Like James Turrell, who was a senior when I was a freshman, Chris seemed to know how to become a legend. Judy Fiskin was also there in a painting studio. So, before 1969, we already had a group of upper classmen who were serious. They were going to be artists, much to their parents' consternation. We were part of "Wheaton's Folly," Dean Wheaton's ten-year admission policy that prized creativity.

And Hal's program at the Pomona College Museum of Art was really important. Hal was a great curator—

Michael Brewster *Configuration 010 Audio Activity*, 1970. Detail of "clicker" installed in gallery wall at Pomona College Museum of Art

truly a friend of the artist, an under-funded *mecenate*, like a patron/producer. Working with him was like being artists together, as it had been with Colby or, later, with [Count Giuseppe] Panza [di Biumo], who was a true *mecenate*. We had Lloyd Hamrol's installation and Michael Asher's remarkable piece. The gallery was open twenty-four hours a day during Asher's installation. It raised all sorts of interesting habitability issues. We learned a lot from that.

DP The intellectual atmosphere was lively?

MB There was a lot of enthusiasm. We felt like we were breaking ground in Claremont. In those days, we're talking 1964 to 1968, Ken Kesey was not yet famous, just a wacko hippie riding around in a bus with one goal: *Furthur*. That was the Zeitgeist, to find stuff out. Incredibly exploratory. It was hopeful. "Be Here Now." Yes, we thought, there's still stuff to find out.

DP Did you feel that as artists you were taken seriously by a larger public?

MB We didn't care. We were self-absorbed. We thought that the rest of them could catch up if they wanted to. The thing was, we were playing to a select audience. And everyone in the circle was going, "Yes, yes, more, and more." It was about the conversations that the pieces generated. And there was a lot of "fly on the wall" stuff. We wanted to watch each other do stuff. And so we were sort of pumping each other up in a great way. I was in art for the discovery of it, to expand consciousness. Art was for the experience. It was to generate insights, to instigate exploration. Process art came very obviously and very easily to us. There was no art market and that was really healthy for ideas, which flourished freely. The art magazines were echoing the ideas we were pursuing. It was exciting.

Michael Brewster *Configuration 010 Audio Activity*, 1970. Installation view at Pomona College Museum of Art

DP How did your work reflect that?

MB In 1969 I was doing pieces with little flashing lights, taking people out to the desert, not huge contingents, twelve to twenty people would drive halfway to Vegas, away from city lights, to deserted places where it actually got dark at night. You'd get this itinerary in the mail and follow the directions, like a road rally. You'd park by my car and a few other cars and walk out on a promontory and you'd stand and you'd look and you'd see almost nothing. When the sun went down, you'd start to see some flickering across the mudflat below, where I had arranged twenty-five flashing lights sixty feet apart in a grid that covered ninety thousand square feet of the desert. As it got darker, these lights would appear to get brighter and faster, going flash-flash-flash-flash. It took four hours. That was as much as I felt I could demand from my audience.

DP Times have changed. Today that sort of patience is in short supply.

MB Well, there were all sorts of refreshments and intoxicants and stuff. It was a party in the desert. And remember, this is back when we were having love-ins. Everything was actual experience. It was all about actual experience. You'd sit around, talk to each other, watch this happen, and when it was absolutely pitch black the lights went fucking wild!

DP Did the flashing speed up?

MB No. Just the perception of it. It was all perceptual. Perceptualism was a big deal then. We figured we knew truth because of the way we were wired. I'm still pretty much convinced that there's a truth out there that I have no ability to sense. You know, like gamma rays.

At the beginning of the piece, everything seemed really quiet and slow with the flashing lights just flickering because there was no contrast. They were just too dim. When it got dark enough, there was massive contrast. And the eye would take too long to adjust, so it would seem like the flashes were happening faster. And then the full moon would come up and the ambient light would make the flash rate seem to slow down to a flickering field.

DP How many flashing light pieces did you do?

MB They were called Configurations. I did about ten of them. Actually I did nine. Number ten was the sound piece, my MFA show. I set forty little, battery-operated mechanisms to click every four seconds and embedded them in the walls of Pomona's gallery. I covered the holes in the walls with model airplane paper and a couple of thin coats of paint. The illusion was pretty good. You couldn't see anything but white wall. This was the first of what I came to call the Clicker Drawings.

DP What led you from flashing lights to clicking sounds?

MB The whole problem with my desert piece was that it worked best from a distance, from the promontory. If in the middle of the dark period, you go, "Wow! This is so fucking cool!" and try to wrap it around yourself by walking down the hill and into the thing, you discover the experience is not as good. To fully appreciate that situation you had to remove yourself from it, and I thought that that was too much like telegraphic sex. I wanted to collapse that distance.

DP And with sound the audience is in the middle of it. The physical distance of being a viewer—or a spectator—is gone. Using sound was a breakthrough?

MB Oh, yes. For me, it was huge. The idea of using sound came to me just after I returned to my hideout in Claremont, a chicken coop I'd remodeled behind a small house on Sixth Street. It was fifty bucks a month and I split it with Peter Stephens. Anyway, I'm sitting at my dinner table and I hear a car go by. I knew it was a Volkswagen, because they have a characteristic sound. Moreover, I knew whose Volkswagen it was, because it was missing a tooth in third gear, and it just happened to shift in front of my house. So I knew it was Chris and that he was on his way to see [his future wife] Barbara because she lived in Upland, and he was going in that direction. And I could tell he was frustrated by the way he was shifting. All of this I knew with my back to the street—without seeing anything and in less time than it took to lift my fork to my mouth. I frontalized on nothing. I had a complete picture of what was happening, underlying motives and all, based on what I heard. It hit me like a ton of bricks: "Sound! Better sculpture!" Just BOOM! You know, lightning! Holy shit!

DP And that solved all the problems from the flashing light pieces.

MB It killed all the problems.

DP You had found your medium.

MB I thought so. From there on in, I never thought about doing anything except sound pieces. I broke the original clickers down. Rebuilt them several times. I changed the timings. I did all kinds of experiments with the pieces, and I found that different timings produced different responses. They had different percepts to them. I got really involved with that. I thought that it was really obvious. Not many others did.

DP Except for your cohorts?

MB Oh, the Pomona gang thought that they were way cool. Hal still talks about it as a major piece.

DP It seems user-friendly to me.

MB Audience engagement is very important to me. That was what attracted me to Mowry's ideas—the practicality of his work. You had to put it on, to wear it. You had to do something with it. You had to physicalize your interaction with it. And my training in theater had been from people who wanted to break the barrier at the proscenium. You know, grab the audience by the ears, really engage their senses, their whole bodies.

MB What about the market? Did you think about selling works to make a living?

MB No. I'm really a research artist. I do it for the fun of finding out. When it finally occurred to me that I was supposed to sell the stuff, I felt particularly stupid for having overlooked that factor. But the model I saw at Pomona was that you could make any kind of art you wanted if you could support it with a teaching job. This was the way around the art market. I hadn't anticipated that I personally had this exhibitionist tendency in me, that I wasn't content with just doing it for me.

DP That seems to be intrinsic to your work, from the beginning.

MB Well, I think it needs to be looked at, and it needs to have that kind of effect, an engagement with the world. But my work's stance was also stubbornly, "You couldn't buy me if you wanted to."

DP To avoid being a trophy or a souvenir or a precious collectible?

MB We were absolutely opposed to those sorts of things, as well as to the distance of documentation, photography, and reference. Our stance was: It's either the real thing or nothing. Be there or miss it. No surrogates, no substitutes, no facsimiles. And I still believe in that. I don't make drawings of my pieces because they're going to be looked at from the wrong standard. They're not meant to be works of graphic excellence. They're more like engineering plans. I probably would have done better if I had been a little savvier. I could have made a few collectibles...

DP But at the time, it wasn't even a consideration.

MB If you talked about the market, you would have been chided for it. None of our models were represented by galleries. We showed in college galleries. It was almost like an alternative circuit. As students, we thought that this was just how art is done. This was normalcy. It was a shock to find out that we were freaks. That we were exceptionally freakish because we were so enthusiastic about it, and moreover, that we had this absurd sense of mission, that quintessential American conceit where you're going to enlighten the unwashed. It was, "Hey man, come on down. I'm going to blow your mind with this one." There was a strong, blow-one-another's-mind factor. It was a heady time, but we thought it was just normal. We didn't know any better.

Michael Brewster *Configuration 010 Audio Activity*, 1970. Exterior view of installation at Pomona College Museum of Art

GLENN PHILLIPS How did you first visit Pomona, and how did you decide to go to school there?

CHRIS BURDEN I lived in Cambridge, Massachusetts. I spent the summer between my junior and senior years of high school in La Jolla [California] at the Scripps Oceanography Institute. I got a tiny National Science Foundation grant and took a Greyhound bus across the country. But when I was in La Jolla, I didn't link up with the scientists. I spent most of my time there developing and printing my art photos.

California was an eye-opener for me. I had my first taco, and I learned how to drive a motorcycle. The room I rented was right on La Jolla Shores beach, and the surfers wanted a place to store their surfboards. Their dads were in the air force and had brought back Honda motorcycles. Hondas hadn't been imported here yet. So the deal with these surfer guys was that if I let them store their surfboards in my room, then they'd let me teach myself how to drive their motorcycles.

I went to a prep school in Cambridge, and we were expected to have college interviews. On the way home, I drove back east with a couple of friends. Pomona College is on Route 66, so I ended up having an interview at Pomona, and subsequently ended up going there.

I started at Pomona as a pre-architecture student. That meant you signed up with the art department. You took art courses, physics, and advanced algebra concurrently. Well, the physics and algebra courses, especially the physics courses, were really hard at Pomona. So right away I started drifting towards art, because you'd have to spend forty hours a week on the math. It didn't seem interesting at all, and a lot of the physics was over my head. I really liked making things.

One summer, I think the second summer, I went back and worked in an architectural office, called Cambridge Seven Associates. At the time, it looked like you had to be fifty-five years old and a principal in the architectural firm before you got to make any decisions. I was the lowest of the gofers. There were ex-Harvard graduate students from the architectural program on the lower levels of the building, drawing toilets and blueprints, and I was the gofer of the gofers, organizing magazines in the sub-sub-basement. The principals were all on the top floor, so the hierarchy of this company was physically structured by the building. And I just went, "Man, I cannot go to college for four years, and then do four years of graduate school,

and then be sitting, working for somebody, drawing toilet bowls and blueprints, in the hopes that when I'm fifty-five, I'll be able to design a building!"

So I came back to college, and it was at that point that I decided to become a sculptor. I'll never forget going down and telling the chairman of the art department, Nick Cikovsky, that I didn't want to be a pre-architecture student anymore. I wanted to become an artist, and specifically I wanted to become a sculptor. And he said to me, "Oh, I don't know. It's bad enough to be a painter, but a sculptor, you're just committing financial suicide." He used those very words: "financial suicide." And I went, "Huh, well, we'll see about that."

GP You first studied sculpture at Pomona with John Mason. What was he like as a teacher?

CB John was a good teacher. This is going to sound kind of weird, but he would go in his office, and he was super grumpy and kind of intimidating for everybody to approach. The door would be open, and he would just sit there. And even as a student, I realized what the deal was—he didn't want to be there. He was doing time. Drive out from East L.A. twice a week, sit in the goddamn office from one to five, and he's done his job, right? If students want to come in and ask questions, they can. But I realized, he's an artist, you know, he doesn't want to be here! So in a way I kind of empathized with him.

GP You still have one of the sculptures you made in John's class.

CB I was having a debate with John about what constituted art. Could a design object be art? Could something that was utilitarian also be sculpture? John said no. We were talking about making some fiberglass luggage. Well, couldn't that be art? So I wanted to make this sculpture, this shape, which is sort of a three-sided Henry Moore. It was supposed to actually be a knife. On the sharp side, I was going to embed a razor, or a razor strip, so that it could be used as a chopper, a rocking chopper. I spent a lot of time making that thing, trying to get the perfect shape. I thought I could cast it solid. John didn't say a thing. I finally finish the whole thing—it's perfect—and then John says, "Oh, well you can't cast that as a solid. It has to have a core, and you have to cut it in half." Oh, crap. I had to start over. But you learn when you make a big mistake. John was a good teacher in that sense.

CHRIS BURDEN INTERVIEWED BY GLENN PHILLIPS

Chris Burden's studio, Topanga, California, May 18, 2010

Chris Burden *Untitled*, 1967. Oil on plywood.
72 × 72 × 72 in. (180 × 180 × 180 cm)

Ultimately, I never inserted the razor. By the time I got it done, it had been so much work, I just let it go as what it was, a beautiful shape. (*See back cover*)

GP And then John left.

CB John left and they hired a Minimalist named David Gray. He knew Tony DeLap, and Minimalism was kind of the hip thing. David came in and took all the clay and the foundry out, and he put white paper on all the tables and everybody had to make little cardboard cubes that were perfect. I dug it. It seemed like a breath of fresh air. That's when I started making that large, yellow and black, outdoor sculpture. I realized that no students went in after class to work on their projects, and David had bought forty or fifty sheets of plywood. Hmmm. Nobody else is using it. It's for the students. I'm a student. Guess what? It's all my free plywood! I get to make something huge!

There was a learning curve there, too. I wasn't told that plywood shrinks and expands. I spent months and months putting many layers of gray primer on, and then many, many layers of lacquer paint. Well, it wasn't steel or aluminum, so basically as the weather changed, all the stuff just cracked. In hindsight, that was okay. How do you learn? You learn by getting lost.

GP Were you thinking about those John McCracken finishes?

CB Absolutely, yes. It was the whole Finish Fetish kind of deal. But that piece was also very important because it was the beginning of my understanding of how sculpture was different than two-dimensional work. That piece acts as a sort of textbook example. In order to understand it, you need to see it from all sides. You can't look at it from one side and understand what you're looking at. It physically forces the viewer to take physical action, which two-dimensional work, in general, doesn't.

That became the basis for performance, actually, because how do you get the essence of sculpture? It's about body movement, right? Well, it's about performance. Just get rid of the sculpture, and try to distill it down to the essence.

GP Was that a lesson that you think David Gray tried to teach?

CB No, that was definitely Mowry Baden. He was into phenomenology, and he brought that out. But it was something that was already current before Mowry showed up. I remember writing in my art history class what I thought was a really clever paper about how the perspective would have been different when approaching Greek temples, and how it was a phenomenological experience. I was trying to figure out how the ancient Greek temples were part of that same idea. How you came down low and the columns would appear to you in a physical way. I just remember writing the paper and thinking, "God, I really figured something out." But—no you didn't! D-minus. The professor didn't like my approach at all.

GP Mowry seemed to liberate a lot of people's thinking.

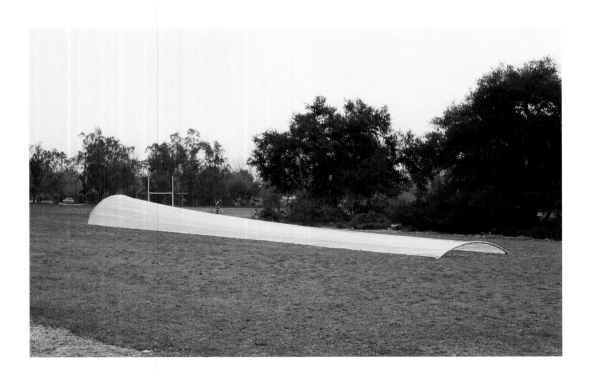

Chris Burden *Untitled*, 1969. Installation on Pomona College campus. Polyethylene sheeting, 2 in. pipe, and galvanized wire. 1152 × 144 in. (2926 × 365.7 cm); 24–78 in. (61–198 cm) variable height

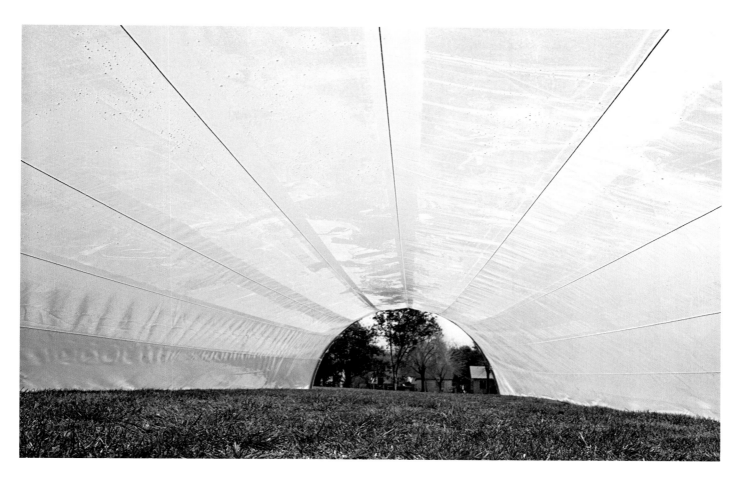

CB It was good, you know, we tried to figure out what art was and what sculpture was. It was a real inquiry; it wasn't just, "Let's draw some more still lifes" and "You need to improve your shading technique." There were real philosophical questions as to what constituted art, and how it tied into human physiology, and how the two were intertwined. That was an interesting line of inquiry, how perception is also a physiological phenomenon, not just an intellectual one. I think that was really important.

During this period, Pomona was going through a little—they were trying to re-adjust, be hipper. When I did my interview, I had long hair and I was all tan, and that wasn't a problem. I'll never forget, though, the first or second year that I was there. There were things called parietal hours; you were only allowed to have women in your rooms during certain hours. The door had to be open, all that kind of stuff. Well, the faculty wanted to liberalize those rules. And the student body vetoed the faculty! And I kind of went, where the fuck am I? This is like…weird. I grew up in Cambridge, where freshmen were dating high school girls because there were not enough women

to go around. So, where am I? What is this place? It came from a fundamentally very right-wing, conservative, Christian kind of ideal.

But I really enjoyed being in Claremont. I really liked California. I liked being able to work outside. I liked being able to hop on my motorcycle and drive up to Mt. Baldy in a flash, go exploring up there. I could sense the opportunity of the West or something out there. My friends were local kids who had grown up in the town of Pomona—not the college. And they had watched the rolling hills become housing tracts.

And you could sense that there was more action in California than there was in Boston. The contrast couldn't have been greater, to tell you the truth. Boston is basically a college town. I went to a day school, a private school, and I'd take my little bike, my green book bag, and go down to the Charles River. There's the Cabots' house. They've been there for three hundred years before the revolution, same house, same people. There's the Lodges'. You just feel the heavy weight of European history. And the weight of history here in California is light.

Chris Burden *Untitled*, 1969. Detail of installation on Pomona College campus, interior view. Polyethylene sheeting, 2 in. pipe and galvanized wire. 1152 × 144 in. (2926 × 365.7 cm); 24–78 in. (61–198 cm) variable height

When I applied for graduate school, I remember applying to a whole bunch of East Coast graduate schools. I got offers at Rutgers and Columbia, but I wanted to go to Irvine. I didn't want to go back to snow-covered New Jersey. I had been making sculptures outdoors in a soccer field at Pomona. You don't do that in the winter in New Jersey. And by then, I'd bought my first pick-up truck. Previously I'd had an old Volkswagen, and I was sticking twenty-foot pieces of pipe through the passenger door, and destroying the car in the process. But I bought my first Ford, a 1950 pick-up. It was $250, and all of a sudden I was in business. I could drive anywhere in Los Angeles and get stuff. It was a big deal.

As a graduate student, you were allowed to go to these surplus yards and buy stuff. I bought a huge chunk of aluminum. It was like a 500-pound slab of aluminum, four-inches thick. I drove it home to my studio in Santa Ana. The people next to me had a big machine shop. So, I took it in there. They cut it in half, and they gave me as much money as I'd paid for the whole chunk for half of it! So basically I got that thing for free, for the price of driving out to Fullerton! And then I realized that Los Angeles is a great place. Because of the aerospace and the aircraft industry, you had access to all this trickle-down stuff, the technologies and the people who knew how to do things.

GP Fabricators.

CB Fabricators! Next door to me in my shop, where I did those early body pieces in graduate school, were stainless steel people. I'd just go next door to the fabricator. He was a great stainless steel welder. Try

doing that in Boston! "A stainless steel guy?" "I don't know, there's one half way to New York." The idea of making things, and that things could be made, was something that felt truly Californian. You had access to a vast body of both material and knowledge.

GP You made two other large-scale pieces while you were at Pomona. They looked like huge tunnels or corridors.

CB Well, I was trying to blow up Minimal art, make it gigantic. The first piece was an attempt to make a work that you could enter upright and that would slowly force you to crawl out the back end; it was a hundred feet long. Somehow I got permission to use this abandoned soccer field [on campus], which was amazing. And then I went down, made myself a power auger, and started drilling holes. I got bags of cement, my pipe and plastic, cables and turnbuckles, and just started doing it. Things got swiped a couple of times, so I ended up just camping out there.

Then I did the long black piece, which was kind of a disaster. In my mind, it was a Minimalist wall, a long corridor. I didn't realize that the wind blew down that field from Mt. Baldy. The corridor was two-hundred feet long, and the wind would hit it as a surface. It would bow the side in and create turbulence, and then the opposite side would also bow somehow. But there was this phenomenon: if you ran through it, the air around your body would open it out in front of you and close it behind you, like running into a black hole. Nothing ever touched you. If you walked, it wouldn't work, but if you ran, it was enough air. You realized you had air around you that was pushing the stuff apart, so it

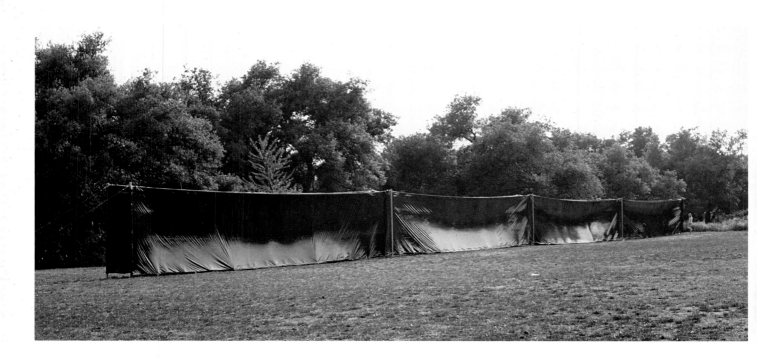

Chris Burden *Untitled*, 1969. Installation on Pomona College campus. Black polyethylene sheeting, 2 in. pipe, and galvanized wire. 2400 × 108 × 36 in. (6096 × 274.3 × 91.4 cm)

Chris Burden *Untitled*, 1969. Detail of installation on Pomona College campus, interior view. Black polyethylene sheeting, 2 in. pipe, and galvanized wire. 2400 × 108 × 36 in. (6096 × 274.3 × 91.4 cm)

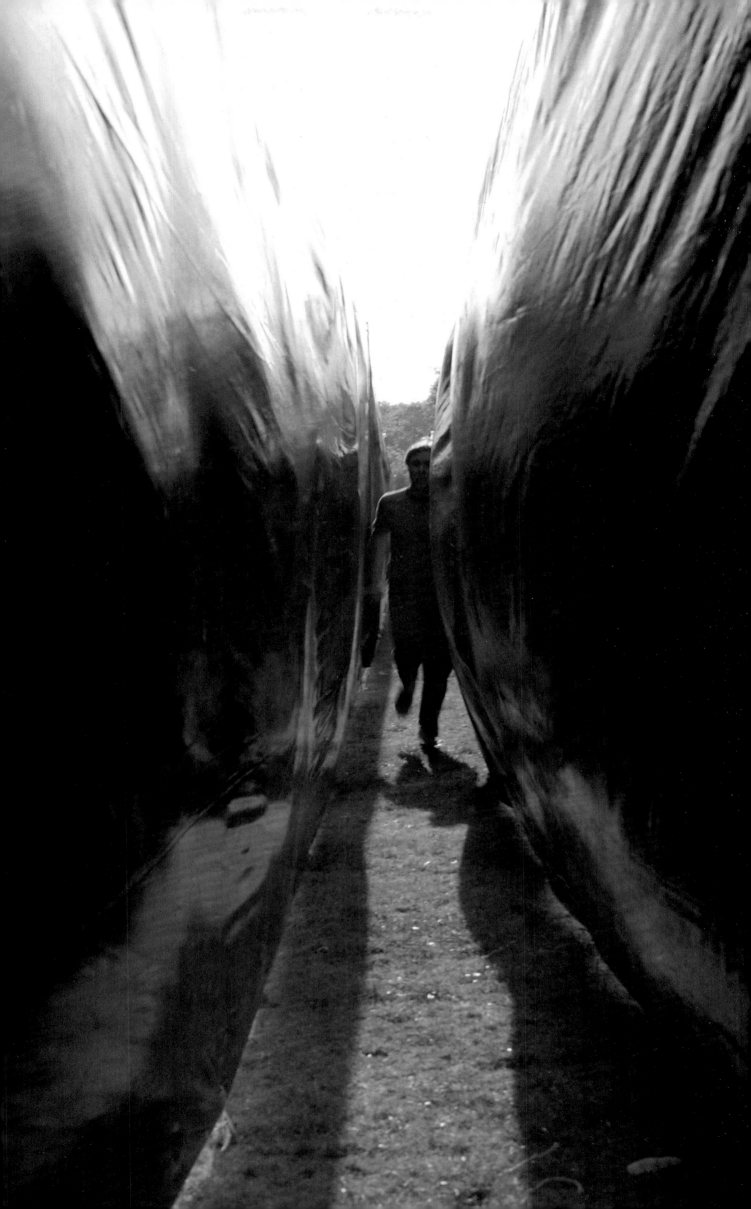

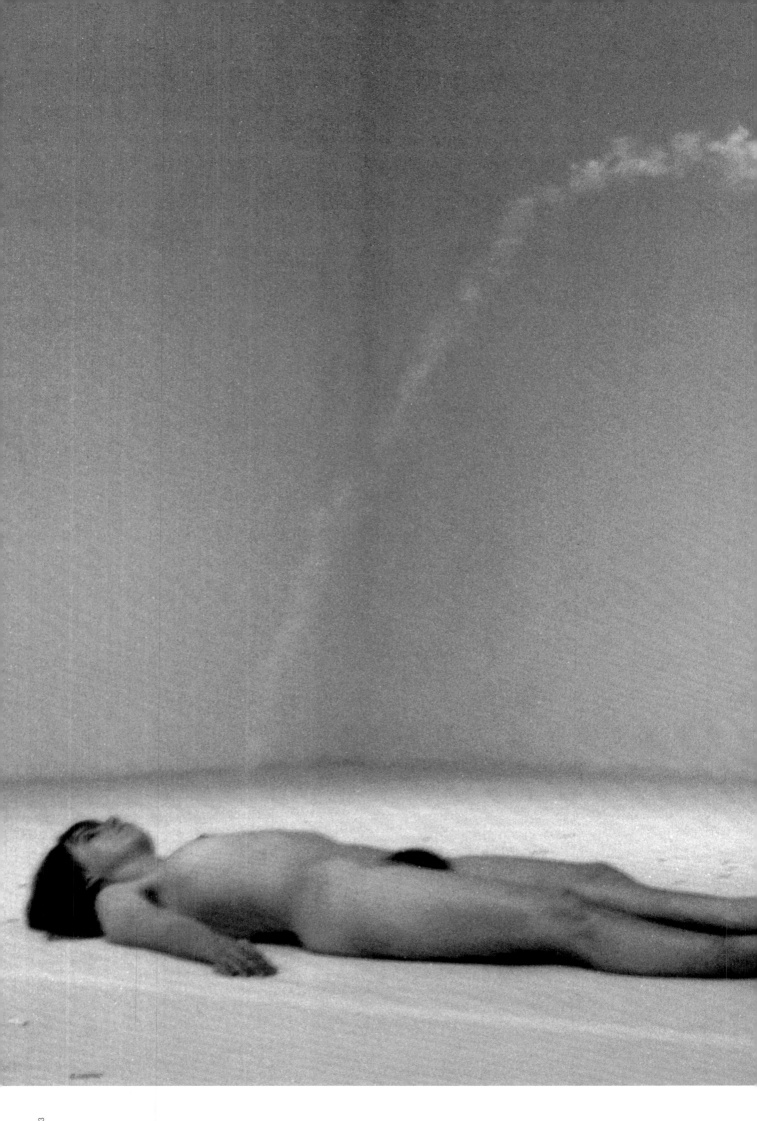

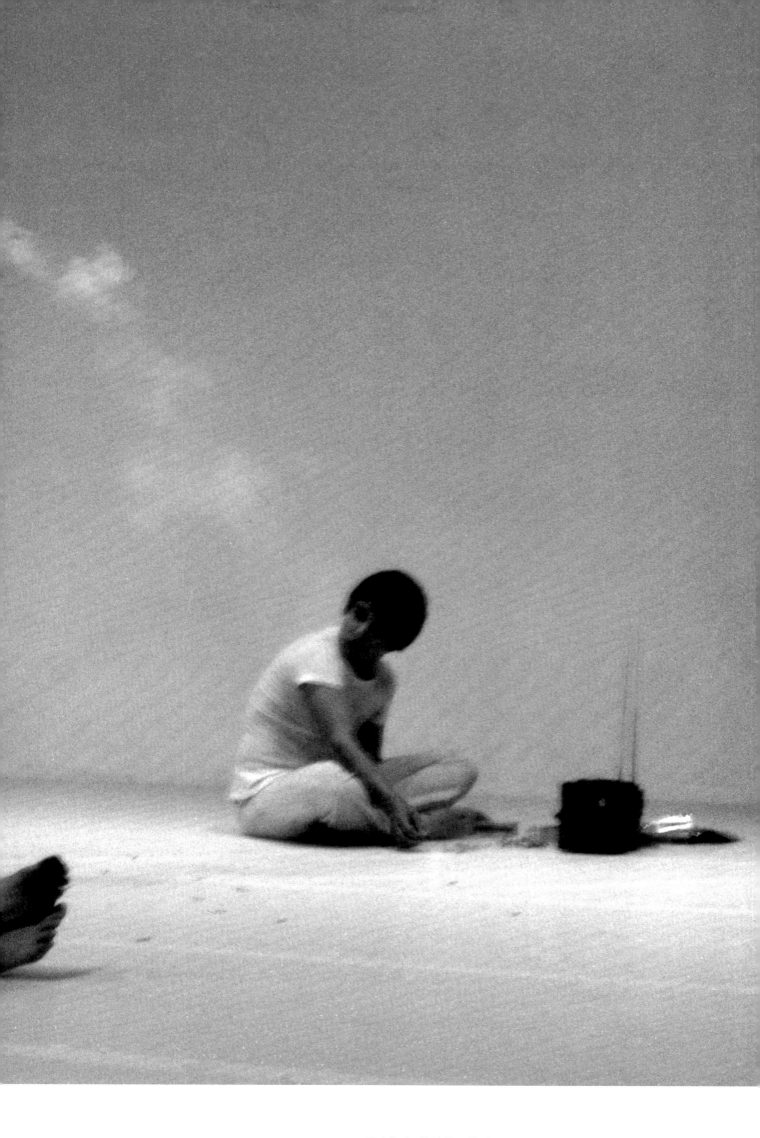

Chris Burden *Match Piece*, March 20, 1972.
Photograph of performance at Pomona
College Museum of Art

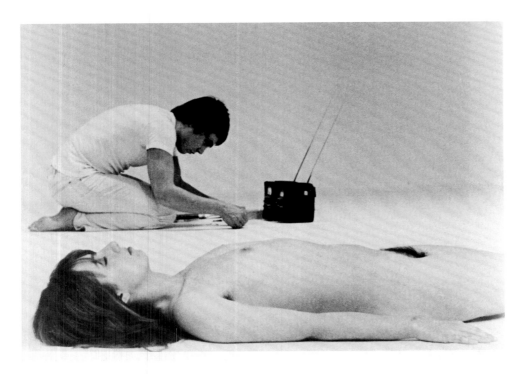

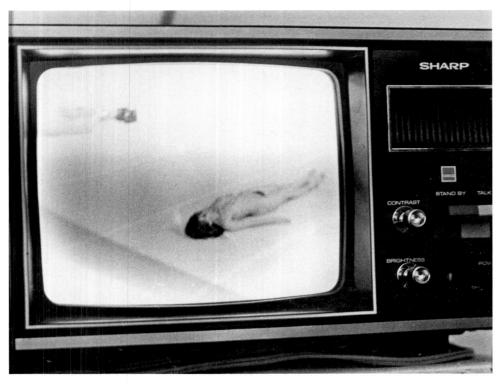

Chris Burden *Match Piece*, March 20, 1972. Photograph of performance at Pomona College Museum of Art. Typed text by Burden accompanying performance: "Two-thirds of the gallery floor was covered with white paper. A closed circuit television system was installed in the room. The monitor was placed so that the audience could watch the piece or see it in the monitor, but could not do both at once. I sat on the floor at the opposite end of the room. Two miniature TVs were placed so that I could view them while I made match rockets and shot them at a nude woman lying on the floor about fifteen feet from me. The rockets were made by wrapping the match head with foil and igniting it with another match. Range and accuracy were impossible to control. Some of the rockets landed on her body leaving small burns, others landed in the audience. The piece began before the audience arrived and ended when everyone had left, lasting about three hours."

Chris Burden *Match Piece*, March 20, 1972. Photograph of performance at Pomona College Museum of Art taken from the audience, which was relegated to the hallway

Chris Burden *Match Piece*, March 20, 1972. Photograph of view from video monitor of performance at Pomona College Museum of Art

would open up before you and then close behind you. None of this was anticipated in any form or fashion.

That was fine when it was just my buddies and two people that I knew. But unbeknownst to me, there was a giant concert out on the field where my sculpture was. I'd used these stakes that I had made out of aluminum tubes. There were hundreds of them. They were holding down the bottom of these long sheets that were hanging down. I had made them into little stakes by cutting them at an angle. Well, people were tripping, and they'd step on these things, and they would put giant, gaping holes in their feet. Because, of course, they were barefoot. And I felt, oh, my god. I had no idea they were coming. I don't know how many people got injured.

GP Was the piece a class project, or was it just something that you wanted to make?

CB I was probably in a class, but it was just something I wanted to do. That's what was great about Pomona. They had this field and they let me do it. It was a small college; if you made a request, and if they could in any way accommodate you, you got to do it.

I'm sure those cement foundations are still in there. I didn't take them out. When I took the piece down, I just cut the poles down with a torch, and then I put the pieces of turf back over the embedded concrete. I'm sure they're still there, somewhere.

GP You graduated from Pomona in 1969, and started grad school at Irvine the next fall. In the spring of 1972, you came back to Pomona to present a performance in the museum, called *Match Piece*. In that performance you fired little match rockets at your wife Barbara, who was lying on the ground. Could you describe that piece?

CB The work was about an artist and his model, and so in some symbolic way, the matches, the match rockets, were supposed to be sort of the creative muse and sperm at the same time. They weren't about impregnating the model, but about connecting, like a

fishhook, and getting it back. It doesn't make any sense when you talk about it. I had wanted to hire a professional model. Helene Winer tried to hire models. I'd interview them, and when they found out what I was going to be doing, they wanted no part of it. So my wife said that she'd stand in and be the model.

GP You also had a video camera set up in the space.

CB I was trying to talk about television. I had two little TVs that were hooked up to a camera. It wasn't recorded; it was just a live feed. What I was seeing on the monitors was a close-up of her. I think the crowd could see that, too. One of the monitors was facing the crowd.

GP The audience was standing in the adjacent space, looking through the doorway.

CB There was a certain space that they couldn't come in, so it was hard for them to see. The idea was to use media to give them access, which is something I used later on in a piece called *Velvet Water* (1974). You couldn't actually see the action; you had to see through the monitors.

GP Can you describe how to make a match rocket?

CB Sure. You take a little paper match. You can use wooden ones, but paper ones are actually better. And you wrap the head very tightly with tinfoil. And then you make a little launcher out of a paper clip. [Picks up a paper clip to demonstrate.] You put it like this, and the match with the aluminum foil on its head goes here. Then you take another match and you light it, and put the flame under the wrapped tinfoil. At some point, the match ignites.

REBECCA MCGREW You graduated from Pomona in 1966, which means you probably started at Pomona in 1962. How did you end up attending Pomona College?

JUDY FISKIN My mother took me to Stanford. There were just too many people in tennis sweaters roaming around the campus! [Laughs.] I didn't know who I was, but I knew I wasn't that person.

RM Was that in 1961?

JF Yes. My brother was at Pomona, so we went to see Pomona. It was very, very quiet, which freaked me out. But, it actually turned out to be a great place for me. The first two weeks I was there, I was very upset, because it was pretty conservative in those days. But it turned out that they had a dean who was letting in a certain percentage of people who were not so balanced in academics. He wanted to let in people who were tending in one direction—if you were really good in music or if you were really good in art, for instance. And of course, they tended to be more rebellious and arty. I found those people after about the second week.

RM Who was the dean?

JF Dean Wheaton. Wheaton's Folly, it was called. The class before me—that was Jim Turrell's—was also Wheaton's Folly. My husband-to-be, Jeffrey Fiskin, was part of that group. Once I fell in with them, I was fine, and started to understand who I was. I had already met this woman, Alice Higman, who's now Alice Reich. She wasn't in that group, but she was in my class. She was very salty and extremely smart. Once I met her, I felt things were going to be all right.

RM What do you mean?

JF She was not conservative. You know, people were dressed in little paisley dresses with gold circle pins and raffia belts; that is the best way I can explain it. And I was just on the cusp of being a beatnik or hippie. The minute I got out of my house, I let my hair grow, put on red lipstick, and wore all black.

RM So you started at Pomona in the fall of 1962. I've been hearing quite a bit about the tradition of the "weigh-in." All the freshman girls were measured and weighed, then the results were broadcast to the watching crowd of young men, and published in a little booklet. Did this happen to you?

JF Oh, the weigh-in! I felt the weigh-in was bizarre, but I was more concerned about how much I was going to actually weigh than the fact that the guys were allowed to weigh us.

RM How did it happen?

JF The first week of school, before classes, there were a bunch of activities geared towards freshman, like the weigh-in. Another one was a big tug-of-war in the Wash, and I really loved that. There was a Sunday night dinner at a faculty house. There was a lot of attention paid toward trying to integrate the freshmen, and bizarrely enough, the weigh-in was part of it. I liked the whole picture of the freshman orientation. I didn't like the weigh-in, but I didn't have a lot of feminist consciousness at that point, either. And I wasn't angry at men. So, it didn't make me angry in that way.

RM Kay Larson remembers arriving as a freshman in 1965, and getting out of her car, and being grabbed and pulled over to the weigh-in location.

JF I think I just showed up, like the army, you know. Drafted in. This is the next thing on the list of social activities. I was much more concerned with how conservative everybody was. I used to break the curfew rules, and I got caught one too many times. I had to be tried by the student court, by all these young women. And I just remember thinking, "Why do they want to do this? Why aren't they climbing over the back fence like I am?" I just really didn't understand those people. And they epitomized a very large group of the female contingent of the school at that point.

Pomona was a good place for me to be rebellious, because at Pomona I was ahead of the curve. If I had gone on to Berkeley, it would have been tough. For instance, I never took LSD. At Berkeley, everybody that I knew who went there was taking LSD. So, I could feel like I was being rebellious at Pomona, because it didn't take much.

RM You majored in art history. What do you remember about your art history classes at Pomona?

JF There are two requirements that I specifically remember. One was you had to take a drawing class. And John Mason was teaching the drawing classes. I loved studying with him. I absolutely have no aptitude for drawing. But there were basic drawing exercises that he gave at the beginning that I could do. There's

Judy Fiskin's home, Los Angeles, California, April 28, 2010

JUDY FISKIN INTERVIEWED BY REBECCA MCGREW

one exercise, which I'm sure they're still doing, in which you look at the model, put your pencil down to draw, and you never look at the paper, you just keep marking the paper. When I finished and looked at the drawing, I realized that it was good. And he came over, and I said, "I think this is good." And he said, "Yes, this is good." It wasn't so much that I had made a good drawing, but that I could recognize it and that he validated that. I respected him because he just radiated a kind of non-arrogant sureness. It made me feel that maybe I had an eye. The other really important class, which was also required, was Maurice Cope's connoisseurship course. It was basically trying to figure out what you were looking at, and talking about it in purely formal, visual terms.

RM Was that an art history class?

JF Yes, it was the first art history class I took. I think it was really important. I still believe in training your eye. I don't believe that's just a given. Maurice would bring things in that the Pomona College Museum owned. I remember one day he brought in an African sculpture that had a long, curving neck, and he asked us why they had done the neck that way. I remember everybody looking down at the table. There was no way to articulate that. And he never filled in. There was going to be silence until one of us said something. It was just such an important class. To start to be able to see how things were put together, and why they were put together the way they were. I remember taking all my classes with Maurice Cope, except the nineteenth-century French art course, which I took with Jim Demetrion. Cope was a fantastic teacher.

RM Do you remember any of the field trips with Cope?

JF He often would take us into Los Angeles to see the galleries, and then we'd go have a meal. He was teaching us Los Angeles and how to do the city. Even though I grew up here, I never did any of the things that we did with him. That was huge for me. It taught you curiosity about your environment, and it also started a big gallery- and museum-going habit.

My last year, they replaced Maurice Cope with Nick Cikovsky. We organized the art history majors and went to complain to the dean of students. Of course, they never explained why they did it, but I think it was because Cikovsky had a degree from Harvard, and Cope didn't. But Cikovsky just was not the right kind of teacher for that place. He didn't know enough, and he didn't have that kind of charisma.

We treated him very badly; now, as an adult, I feel sorry for the man. I'm sure it made him miserable. It wasn't his fault. But we were so attached to Cope. Jim Turrell felt that way about Cope, too. It was a really big loss.

RM Was it in graduate school at the University of California, Los Angeles (UCLA) that you began thinking about being an artist?

JF There was this kind of wild guy teaching modern and contemporary art at UCLA, and I ended up switching from medieval, which is what I had been doing at Berkeley, to modern, almost immediately when I got to UCLA.

RM So whom did you switch to work with?

JF Kurt von Meier from Princeton; he was really, really into contemporary art. And he was having us do Happenings. He wasn't calling them that, but that's what they were. In one of the seminars, right at the end, he had us borrow cameras, and each person was supposed to document a different symbol as it was used in popular culture. Somebody got an arrow, I got the heart. I borrowed a camera, and I just *immediately* went for it. The first time I put it up to my face, it was like, I could do this. I just felt that, right away.

RM Meanwhile, you're working on your art history degree.

JF Yes, I think it overlapped, but it was very much toward the end. And then I got a job with Richard Neutra. As soon as I graduated, I went to work for him part-time, and then I was photographing.

RM Did you ever take any photography classes?

JF I took one course at UCLA from Edmund Teske. He had flowing white hair. He wore a cape. Everybody in that basic class got an A, but I got a B. He liked to mount photographs on various layers of board, and I knew right away I didn't want to do that, so I just didn't, and I got in trouble for it. Otherwise, I never got a proper technical education in photography. I was heading in my own direction anyway, and it probably would have interfered if I had taken classes. I would have had a hard time getting the work as small as I finally made it, since all the trends, even at that time, were to get bigger, not smaller. But in any case, I was just allergic to being taught at that point.

RM The Stucco series, from 1972 to 1973, was your first major body of work. How did that series come about?

JF I had come across these books by The Museum of Modern Art. There was a big, really beautiful book of [Eugene] Atget. They also had reprinted Walker Evans's *American Photographs*. And those books together, that's really all I wanted to look at. I started out by trying to imitate Atget. I was photographing in any place that could look European. I did a lot in the parks of Beverly Hills because they had that nineteenth-century feel. After about a year, I could get that look. Then I realized, well, I can't keep doing this. I have to figure out my own work.

We lived in a little California bungalow, near Sunset and Fairfax. I was standing on the porch, looking across the street, thinking what would Atget be photographing if he lived here? And then I just looked around and said, "This stuff." I started photographing those bungalows. At the same time, I switched to a 4 x 5 camera, and the combination just didn't work. Somehow, from there, I went to the next era—the little stucco houses that were slightly younger than the wood bungalows. I started photographing them and went back to 35 mm. That really worked. I think it worked because, unlike the stucco houses, the bungalows had deep porches. The house's façade wasn't at the picture plane. Without knowing it, I really wanted to go towards something very flat, something that could be more abstract.

Judy Fiskin *Untitled,* from the Stucco series, 1972–73. Gelatin silver prints. 5 × 7 in. (12.7 × 17.8 cm). Pomona College Collection. Museum purchase with funds provided by the Estate of Walter and Elise Mosher

RM While you were developing this new work, were you aware of any contemporary photographers?

JF I knew of quite a few contemporary photographers, especially the ones in the Los Angeles area—JoAnn Callis, Eileen Cowin, Barbara Kasten, and Leland Rice, among others. I'm kind of surprised that by the time I was showing people my work, maybe in 1971 or 1972, I wasn't aware of Lewis Baltz. But, on the other hand, I don't think he had done the Irvine industrial parks yet. I remember after having shown my work and having twice gotten the comment, "Do you know the work of Lewis Baltz?" I was getting very pissed off about it. I went to a group show at Cal State [California State University] Northridge, not knowing what I was going to see. I walked in, and there was a

big array of his work in this one gallery. And my first spontaneous reaction was, "Who got a hold of my negatives?" It was that close. I was just astounded. And when I think back, I don't know why I hadn't seen his work before because I was certainly out looking at exhibitions. But it could be that he hadn't been shown that much by then.

RM Hal [Glicksman] gave Lewis his first show at Pomona in May 1970.

JF Yes, and I wouldn't have gone out to a Pomona exhibition. But, what's interesting is that one of the people who said that to me was Gretchen Glicksman, and she would have been aware of his work because she was still married to Hal then.

ABOVE / LEFT
Judy Fiskin *Untitled,* from the Stucco series, 1972–73. Gelatin silver print. 5 × 7 in. (12.7 × 17.8 cm). Pomona College Collection. Museum purchase with funds provided by the Estate of Walter and Elise Mosher

ABOVE / RIGHT
Judy Fiskin *Untitled,* from the Stucco series, 1972–73. Gelatin silver print. 5 × 7 in. (12.7 × 17.8 cm)

RM That's right. How did you know Gretchen?

JF Gretchen! I became the director of Womanspace for one year. Gretchen was on the board of Womanspace, and had been director before me. I met her when I went to apply for the job, and I worked with her after that.

RM When was that?

JF I think I was about twenty-six, so probably 1971.

RM You showed the Stucco series in an alumni show at Pomona in March 1973. Was that the first time you exhibited them?

JF I also showed them at the Woman's Building in 1972 or 1973. The first show would have either been at Pomona or the Woman's Building.

RM I would like to ask you about the "New Topographics" exhibition first presented at the International Museum of Photography at the George Eastman House in 1972. Had you heard about this exhibition, or were you considered for it?

JF I was well aware of it. And it is another interesting connection with Lewis [Baltz]. He actually came to see me, with his wife, because my name had been mentioned for consideration. Lewis was already going to be in the show. The curator [William Jenkins] was in Rochester, New York, and didn't have a travel budget, so he didn't come see me. Lewis came to see me instead. And Lewis's wife went after me because she felt that there was no reason that the photographs couldn't be any size. I don't think I even tried to explain it, it was just a decision I made. It's a legitimate decision. I don't think I could have said more than that then. I can now. But I just said, "No, they can't be bigger than this. This is the size they are." And she just wouldn't let go of it. And I don't know if that influenced him, or whether he had his own reasons, but I was not in that show. I was really disappointed and upset about it.

But you know even though Hilla Becher was in that show, she was part of a team. It was still a time when women in the art world mostly had to be attached to men in the art world. Right around that period was when that kind of thing stopped. I think it was probably one of those times when, if I'd have been a man, it would have been different.

I also think there is another major factor, and it may have to do with my being a woman. Again, at the time, I don't think I quite knew it yet, nor could I have articulated it, but if you look at the way my work developed, and you look at the way their work developed, you could see that I was really interested in taste, and they weren't. I was really interested in decoration, and they weren't. So when I was looking at these little stucco buildings, I was really interested in how people made decisions on how to decorate them. And that was not on their agenda. And I didn't have the political agenda that they had of showing the desecration of the landscape. But my interest in certain kinds of printing was very similar to theirs, and certainly really similar to Lewis's. There was an investment in the black-and-white print that went through all of the work exhibited in "New Topographics." I think I probably should have been in the show, because there was a certain look that work had that my work shared—a kind of emptiness and a high contrast.

RM And a Minimalist frontality and formality. So why did you choose the small size?

JF It wasn't even a choice. It was more of a development that had really started when I took that class with Edmund Teske. The whole point then was to start with an 8 x10 negative and try to make it into a good print that was bigger, to make it a 16 x 20. So while everybody else was trying to do that, I kept thinking, "This is gross. I'm going to go down to 5 x 7." And then I looked at that, and thought, "This is gross. I'm going down to 4 x 5." And then finally, sometime in that first year that I was learning to do this, I just cranked my enlarger down as far as I could go, and printed it at that size. I just had a taste for that. And I think that some of it also had to do with my taste for abstraction, a kind of radical abstraction that I didn't find very convincing in larger prints. Whereas in smaller prints, it just suited them.

It also made them look like drawings or etchings. It spoke to my wish to be able to draw. And so it satisfied me in that way. I was interested in things that you could do with a drawing that you usually didn't do in a photograph, which is to make a certain kind of abstraction—to make lines instead of volumes or instead of realistic representations.

And then, I was involved with a dollhouse for many, many years growing up. My mother had collections of miniatures, and she still does. So I also think that I just had a taste for the miniature.

RM I have to confess that I have always been really attracted to small artworks and objects. I first saw your work in the late 1980s, probably at MOCA [The Museum of Contemporary Art]. I loved how you really had to get close, inches from the image, to see it. It was like a little world. You could encompass the whole thing with just your gaze and your mind.

JF And when you're looking through a 35 mm-camera viewfinder, you get that same effect, where you lose your body and you've got just a pure image in front of you. It doesn't have a scale. It doesn't feel big or small. It's like a world that goes straight into you and you do lose your sense of your body. I wanted to translate that feeling into the photograph itself.

I think all of what you just said was at play for me. I know that boys played traditionally with toy soldiers, but in a sense they played at that larger scale where the armies of toy soldiers were standing all over a floor. They didn't have tiny houses filled with little furniture that you had to peer in at. With the soldiers, you had tactics and strategy, and looked at the bigger picture, whereas in a dollhouse, you really focused in on that little room.

RM How would you see the Stucco series fitting with other 1970s art movements like Conceptual art or Minimal art?

JF I could see the relationship to Minimal art, although I wasn't thinking of that at the time because I didn't like Minimal art. But on the other hand, I was struggling to understand Minimal art, and it certainly was one of the top art paradigms at the time. I felt I had to know about it and so it seeped in. A year or two after I completed the Stucco series, I could see it.

But Conceptual art, I'm not as sure. People say that about my work a lot. I was just in a big MOCA collection show called "California Conceptualism." I don't think of my work as being Conceptual. I think the concept of Conceptual art has expanded so far that now, if your work has an idea in it, that makes it Conceptual art. But, I really had an investment in aesthetics. That was the number one criterion. If I had a print of an interesting building that didn't look like the kind of print that I wanted it to look like, I just threw it out immediately. So, on those grounds, I think not.

RM Your work doesn't fit neatly into any specific category.

JF It's *sui generis*. I think that's right. After a certain amount of time, the New Topographics kind of just went away. I felt glad that I wasn't part of that group because I didn't want to be perceived as having gone away. And I did like being *sui generis*. But it made it hard, especially in the photo world, because for years they couldn't recognize what I was doing as legitimate photographic printing. And that's part of why I ended up showing in art galleries instead of photo galleries. They didn't have a preconceived notion of what a photographic print looked like, so they could really get what I was doing almost right away. But I could not crack the photo world. So, although I was kind of bitter about it, once I started getting attention in the art world. I thought, this is better, because it's more prestigious. Photographers were always battling with the question, is it even art? So to be taken up by the art world was much better for me.

Judy Fiskin *Untitled*, from the Stucco series, 1972–73. Gelatin silver print. 7 × 5 in. (17.8 × 12.7 cm). Pomona College Collection. Museum purchase with funds provided by the Estate of Walter and Elise Mosher

IN 1963, David Gray and his wife Joanna moved to Los Angeles from Madison, Wisconsin. No jobs awaited them and no family members lived in Southern California. The young couple simply up and left the Midwest because a friend in show business, John Simes, encouraged them to go West. Gray had earned his undergraduate and graduate degrees in art at the University of Wisconsin, Madison. He was beginning to make a name for himself as an artist, exhibiting welded metal sculptures at annuals in Milwaukee, Minneapolis, and Denver, as well as in solo shows in Madison, Chicago, and New York. These assemblages were pieced together from rusty tools and cast-off appliances Gray scavenged from junkyards and scrap heaps. His large, freestanding pieces combined the formal restraint of David Smith's early works and the narrative potential of Edward Kienholz's assemblages. His smaller pieces, often set on pedestals and tabletops, played off of the sensibility and structure of H. C. Westermann's solidly built sculptures. The main difference was that Gray worked in metal and Westermann wood. Gray's *Unpredictable (To H.C.W.)* (1962) explicitly acknowledges the woodworker's influence; its toggle switches, mirrored portholes, and boxy form recall the offbeat utilitarianism of Westermann's art.

In Los Angeles, the Grays rented a house in Echo Park, and he worked as a substitute teacher in various grade schools and high schools throughout the district. Gray immediately set up a studio in the garage and backyard. Almost as quickly, his art underwent a radical transformation. Although Gray did not stop using castoff metal objects to make his oddly elegant compositions, he did begin to use more neutral, less memory-laden materials, welding together abstract shapes and geometric forms from sheets of steel he purchased new and then cut with a torch. This allowed him to move away from the organic patina of rusted steel and weathered metal that had dominated his Midwestern works. He used automobile enamels to spray-paint his new sculptures, giving them a highly polished finish, often in bright colors and hard-edge patterns. Chrome made its way into his newly sleek works, along with the occasional mirrored surface. Preparatory drawings, sketches, and studies, which Gray hadn't used before, became an important part of his increasingly designed and Minimalist-oriented pieces, which often resembled abstract totems or stylized icons from the future. These streamlined compositions combined cubes and tubes, sometimes set on low pedestals. Gray often left two or three sides of his cube-shaped sculptures open, revealing

their interiors. He sometimes packed the interiors with welded clusters of scrap-picked castoffs and at other times left them empty, their flocked walls swallowing light in deep, velvety darkness.

Within a year, Gray was picked up by Feigen/Palmer Gallery, where his Los Angeles solo debut took place in 1965. That same year, he had a New York solo show at Richard Feigen Gallery and was included in a group exhibition at Ferus Gallery, in Los Angeles. A solo show at Ferus followed in 1966, along with his inclusion in the prestigious "Primary Structures" exhibition at The Jewish Museum in New York. John Coplans featured three of Gray's chrome and enameled-steel works, *L.A./1*, *L.A./4*, and *L.A./5*, alongside similarly cool sculptures by Larry Bell, Tony DeLap, John McCracken, and Ken Price, in "Five Los Angeles Sculptors" at the Art Gallery, University of California, Irvine. Later that year, Coplans added Billy Al Bengston, Joe Goode, Craig Kauffman, Charles Mattox, and Ed Ruscha to the original five sculptors for the roster of "Ten From Los Angeles" at the Seattle Art Museum, where Gray's *L.A./7* was shown. Gray then moved to Costa Mesa and taught with Coplans and DeLap at the University of California, Irvine, for a year. In 1967, his painted-aluminum and chrome-plated steel pieces, *Irvine 4* and *Unit Q,* were included in "American Sculpture of the 1960s," organized by Maurice Tuchman for the Los Angeles County Museum of Art. The next year, when John Mason left Pomona College's art department, Gray moved to Claremont and took the full-time position. As a teacher, Gray was popular and demanding, exacting from his students a level of seriousness and rigor that many found to be extremely challenging while they were in school, but later credited as being absolutely essential to their artistic development.

In 1970, Gray dislocated both of his hips when a student's earthwork collapsed on him. In 1972, he and his wife divorced. In 1973, after crashing his scooter on his way home from the Midway, a bar on Foothill Boulevard where faculty and students regularly gathered, Gray stopped teaching. He remained in Claremont, where he worked as a handyman. Without the large studio provided by the college, his works became smaller. He experimented with a variety of industrial materials and fabrics, including aluminum, shattered glass, resin, linoleum, Naugahyde, Plexiglas, and PVC, as well as lacquered, chromed, and flocked metal. He eventually turned to poetry, which he published in pamphlets.

David Pagel

David Gray *L.A./5,* 1965.
Welded steel, lacquer, chrome plate, and flock.
13½ × 9 × 9 in. (34.2 × 23 × 23 cm).
Pomona College Collection, Gift of Pam Gray and DJ Gray

Gray is best known for two series, both titled for the places he made them. The L.A. series, mentioned above, was made from 1965 to 1966. This group consisted of segmented steel sculptures, each composed of two kinds of components: enameled, glossy white geometric forms and shiny, chrome-plated cylinders. By varying the number, shape, and configuration of these elements, Gray created a modular sculptural format that put a peculiar, even idiosyncratic spin on Minimalism's serial structures. Regularity and repetition were rejected in favor of a disjuncture or shift in an object's constitutive elements that was initially disorienting but quickly gave way to an experience of surprise, delight, and wonder. The second series, Irvine, occupied Gray from 1966 to 1967. Its works were also comprised of two elements: a chrome-plated steel cylinder welded to an enameled aluminum sheet that Gray sometimes folded at a ninety-degree angle and always cut into a simple geometric shape, as if it were a straight-laced relative of Ellsworth Kelly's gracefully curved works.

A peculiar sort of discontinuity animates both series, and is the focus of all of Gray's mature works. Rather than aiming for seamlessness, resolution, and harmony, his part-by-part sculptures emphasize—and insist on—inconsistency and irregularity. Interruptions, even collisions, among incompatible materials, forms, and formats drive his pieces, which never come off as closed-off or self-contained. Instead, Gray's works have the presence of precise yet ambiguous structures assembled from a limited number of components, their parts linked and stacked in the manner of children's building blocks or Tinkertoys. At the same time that these works recall industrial objects, they evoke commercial products designed to be functional. Above all else, Gray's sculptures are comfortable with their place in the world of everyday activities and entities, at home among automotive paint shops, industrial steel suppliers, and the ductwork in modern buildings.

This workingman, salt-of-the-earth ordinariness has its roots in Gray's early assemblages. It also distinguishes his California sculptures from those of his contemporaries, including Michael Brewster, James Turrell, and Michael Asher, whose preoccupation with perception led to works that expanded from finite objects to borderless installations concerned with scale, site, and social context. In contrast, Gray remained dedicated to precisely manufactured objects that highlight design and emphasize the utilitarian potential of all things, including abstract ones.

David Gray *L.A./6*, 1966. Welded steel, lacquer, chrome plate, and flock. 52 × 38 × 14 in. (132 × 96.5 × 35.6 cm). Music Center | Performing Arts Center of Los Angeles County

TELL

If there were another way
To tell you
It would be a long way
To go and
You would have found
Another way

NEED

If there is needlessly
A need
Then let there be
A need

For less is more
Than needed
And what is
Needed
Is Necessary

The Necessity of a need
Has a priority
If the need is felt
And there are those
Who have not felt

Why don't you feel the feelings
Of those
Who have felt
Because of
The feelings
Of those
Who have not felt

There are needs
And there will be
Someone needing
And when a need
Is freed
There might be more
Than expected

4

5

Vacuum Packed, book of poems by **David Gray**,
1972. Pomona College Collection

ROCHELLE LEGRANDSAWYER Let's begin by talking about how you chose Pomona College.

PETER SHELTON I was born in Ohio but I grew up in Arizona. I was the kind of kid that was always making stuff. I don't know that I necessarily thought of it as art, but I was always intensely involved with building and making things. I was also the son of a disabled vet and a working secretary mother. They'd been educated at Oberlin College but had the shit kicked out of them by World War II. So the big emphasis was on education. Even though my father was a man of poetry and art, there wasn't much encouragement to be an actual artist. I loved anatomy as a kid, so my father would say, "You like art and like to draw, so maybe you should be a medical illustrator." And my mother's father was a small town doctor, so I ended up at Pomona as a premed student.

But there were so many distractions. In my freshman year in the fall of 1969, it was complete chaos. There were several antiwar moratoriums, and I watched students trashing Claremont Men's (McKenna) College's ROTC offices. The whole school kind of broke down at one point because of the antiwar stuff. It was really hard to keep focused on class, so kids just stopped going. The faculty got together and asked, "How are we going to get these students through it?" Basically, at the end of the second semester they switched everything to "Pass/Fail" because people simply weren't focused on school.

RLG Was protesting really significant for Pomona students at the time? What I found in *The Student Life* newspaper was very mixed—sometimes it seemed like students were rioting 24/7, and sometimes it seemed like everyone was sunbathing on the quad.

PS Honestly, I wouldn't say a majority of students were actively involved in protesting the war. There were some extreme people out there advocating destruction of school property, and many others who were marching and doing other things peacefully. But in some ways things just carried on Suzy Cream Cheese normal: there were fraternities, the football team, that sort of thing. But I also remember being part of a pile of people protesting in the middle of Frary [Dining Hall]. We had stained ourselves to look bloody, as if we were a pile of dead bodies. Some students actually came up and dumped peanut butter and jelly on us in contempt. What we were doing was a little intense, but on the other hand, it showed that not everybody held the same view. But now, in

retrospect, I wonder whether all people think they were a part of antiwar activities in some way.

RLG When did you get involved with the art department?

PS I started taking art classes right away at the same time as my premed classes. The very first semester I took a fundamentals class from Mowry Baden; I think it was called Issues in Art. Mowry basically went through periods of Modernism up to the present day and described the central values and interests of those eras. Then, we would all make something in the mode of those kinds of works. Second semester, I had Guy Williams for drawing. He had us making drawings with typewriters. No models! I ended up taking art classes all the way through college.

In my sophomore year, I went off to eastern Kentucky with a man named Guy Carawan, who was the folksinger in residence at Pitzer College. In the early days of the Civil Rights Movement, Guy and a couple other people were very involved with adapting new lyrics to what had previously been working or religious songs. For example, he is credited, along with folk singers Pete Seeger, Frank Hamilton, and Zilphia Horton, with the lyrics for "We Shall Overcome," which he taught to the young people of SNCC [Student Nonviolent Coordinating Committee], and it spread from there. Anyway, Guy put us in these home-stay situations; I lived with a couple of different coalminers way up in the mountains of Kentucky, where we learned about mountain culture, music, and politics.

In my junior year, I wanted to work in the theater department because it was really an amazing place then and the community of it appealed to me. I acted in Brecht's "Caucasian Chalk Circle" and designed a play for Stanley Crouch during my junior year. So after premed, I was briefly an anthropology major my sophomore year, a theater major my junior year, and I finally went back to the art department in my senior year.

RLG It doesn't sound like art was particularly central in structuring your Pomona experience.

PS Honestly, I think my education was the whole mix of things. Initially, I found my experience in the art department to be pretty dry. Mowry was a very articulate guy and a real character. He would show up wearing these funny jumpsuits that he got at Sears, with Beatle boots, his head shaved bald, wearing

Peter Shelton's studio, Los Angeles, California, May 13, 2010

PETER SHELTON INTERVIEWED BY ROCHELLE LEGRANDSAWYER

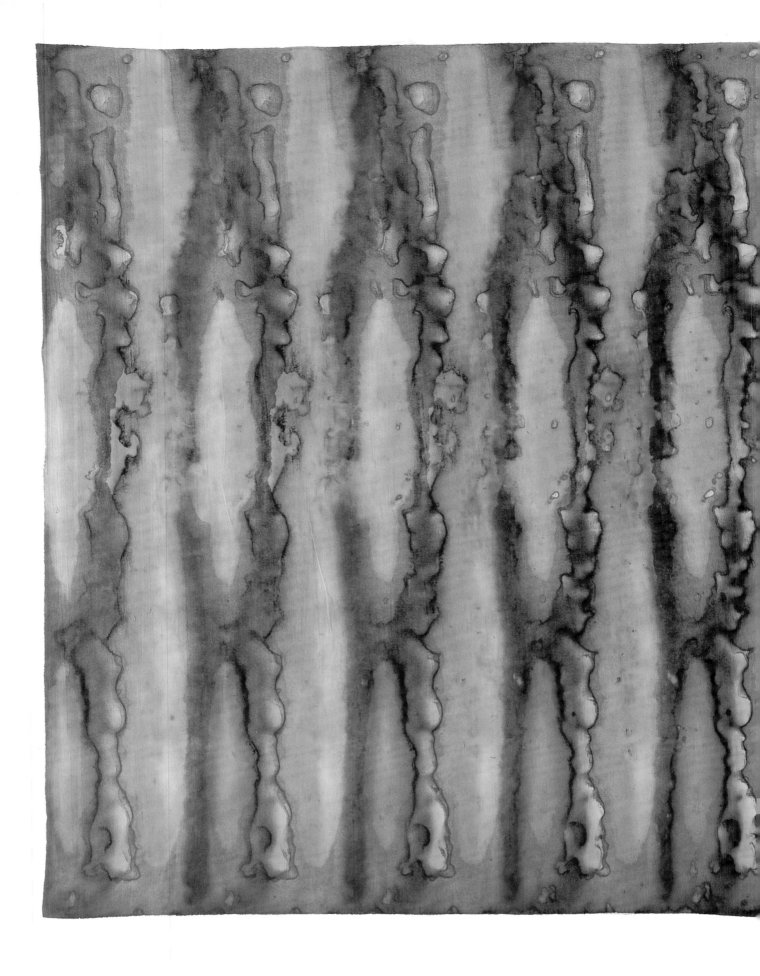

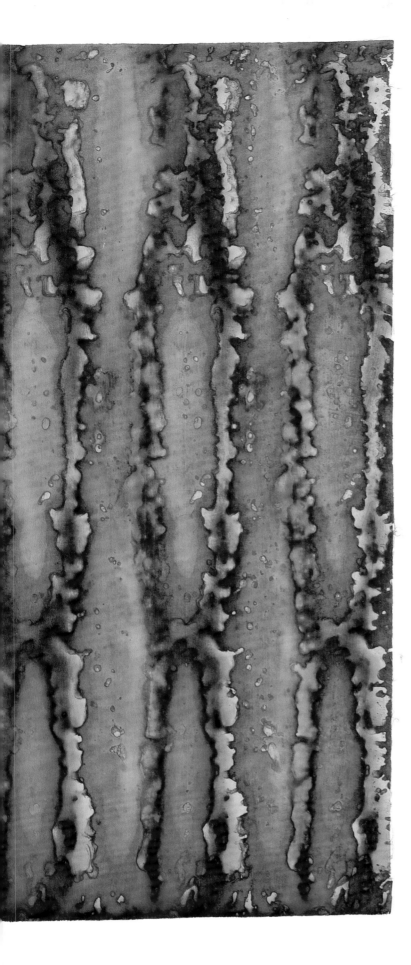

octagonal glasses, and smoking cigarettes in this very urbane way. He was a wonderfully provocative teacher with a personality that seemed a little tough to me at the beginning.

RLG Was that toughness characteristic of the whole department?

PS It was interesting because none of these guys considered themselves professional teachers. And they got in trouble for it. Mowry was the exception in that he was much more collegial, much more willing to play cards with the philosophy or English department professors. He was pretty comfortable with the role of being head of the department and engaging in the kind of social activity that a small college tends to expect. Everybody else was like, "I'm going back to my studio in the city. You got my few hours today, see you later." I don't think the college liked that particularly, but for me and the other students who were serious about art, it was our introduction to real, practicing artists and their business.

These guys were pretty rarified, pretty intense, and I was just this bumpkin kid from Arizona. I remember seeing Guy [Williams] my second semester and basically saying, "I hope you're not going to be an asshole like Baden." And Guy's response was, "It was probably good for you." There was this kind of tension there because I think Mowry and all those guys brought a very high-mindedness to what they were doing. They saw themselves on the edge. They were pros. They basically said: "Here's the deal, get serious or not." So, initially it wasn't very warm and fuzzy. I felt beat up by it and a little alienated, but I'm also the kind of person who took it as a challenge.

By the time I was a senior, there were probably only four or five art majors left standing. On the other hand, during my senior year there were like twenty-five people taking ceramics classes from Norm Hines. Norm came in and started teaching pottery, and all these football players and non-majors started throwing pots. This happened without the approval of the art faculty. No offense to Norm, but it caused a division, which created immense weirdness in the department: the crafty non-artists against the rest of us.

RLG Did Pomona College's museum play a role for you?

PS It was amazing. During Hal [Glicksman]'s programming, we spent an immense amount of time in

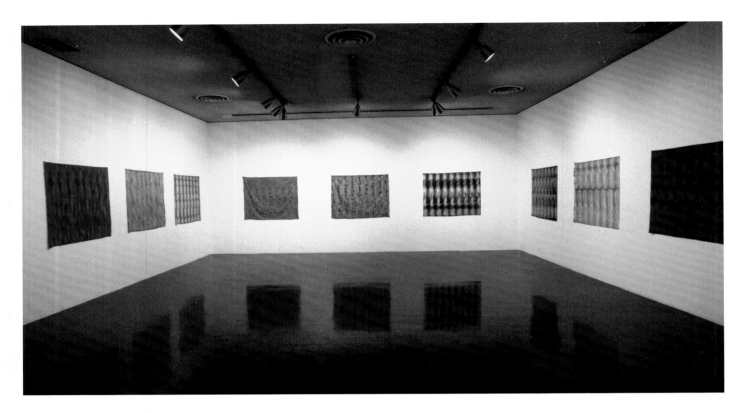

Michael Asher's piece, stoned as hell because it was open all night long. It was aurally and visually very exciting. It put you in a total environment. Most of Hal's programming was sensuous and visual, like the [Lloyd] Hamrol and the [Tom] Eatherton installations. But when Helene [Winer] came along, it was all really tough, conceptually based stuff, almost consistently except maybe her Ed Moses show. Bill Leavitt got his patio set up; Al Ruppersberg's show had a painting that said "Greetings from California" with the center of it burned away; and Bill Wegman put glop on his feet.

RLG What was your response to that?

PS Well, a typical response from me then was, "What is this shit?" Several friends and I took the seats off the dorm room toilets and fashioned these gunny-sack outfits that we wore to Al Ruppersberg's opening on Halloween. We went into the opening and sort of pumped up and down, like pistons in a car, going Ump-pa-pa, and had this little performance in the middle of Al's show. I don't know if we were antithetic to Al or whether we were just being foolishly absurd, but we certainly acted foolishly and absurdly.

RLG Speaking of theatrics, you said you were involved with the theater department. Do you remember Dick Barnes's production *The Death of Buster Quinine*?

PS Sure. I was very involved with *The Death of Buster Quinine*. The summer before my senior year, I actually got certified to handle fireworks by working for Red Devil, which is a company from Ontario [California] that worked on the Rose Bowl Fourth of July celebration. My goal was to be certified so I could interface with the fireworks company for *The Death of Buster Quinine*. I was in charge of the wall of fire or "Tunnel of Fire," where a student—heavily clad in an asbestos outfit and several pairs of water soaked jeans—walked through a kind of minefield and hallway of various kinds of explosions and fireworks. The event was down in the rock quarry with this huge crowd of people at night. And we rolled this big juggernaut-like cart that carried a Mexican firework *castillo* out amongst everyone. It unfurled itself, exploded, and spat sparks all over the place, and people were running out of the way. Dick just loved the whole thing.

Installation view of **Peter Shelton** exhibition
at Pomona College Museum of Art, 1973

RLG What kind of projects did you do as an art major?

PS You know, only when I had to do a senior thesis did I really begin to think of myself as an art person. I probably thought of myself as more of a sculptor, but I ended up making paintings because I had a good relationship with Guy Williams. Basically, I just decided, "I'm going to make paintings because Guy's here, and it'll be the strongest interaction that I could have."

Michael Brewster came in to replace David Gray my junior year. I got along well with Michael. We decided to build a student work gallery, so we framed up this room in the back area. The idea was that it was going to be a place where we could do experimental things. So I made a series of installation pieces my junior year. The first ones I did were composed with sheets of muslin dyed in cheap, scarlet Rit dye that were stretched like taut membranes with string between two walls in different configurations, or hung from the ceiling floating above the floor, or gathered in bunches.

For my senior show, I made a series of stain paintings that came out of fabric maps that I had found in Kentucky. I had found a rusty tube there with a bunch of rolled-up engineer's drawings of coal mines. On one side they were graphically quite interesting, with beautiful little black-ink drawings on this sized linen, but some were just stained to hell because they'd been rolled up and exposed to rusting steel. Two years later, I was looking for something I could work with for a painting project. At first I used the graphics from those maps to create paintings. But I wasn't sure if I was more interested in the inked graphics or the stains. Guy encouraged me to explore the stains, and I spent a lot of time rolling up, burying, and soaking fabric. I also spent a lot of time in the botany department trying to come up with little primitive formulas that I could use to develop the stains, for example, blackening steel by exposing it to tannic acid extracted from camphor leaves. I stuck some things in the orchid house. At some point, I figured out that I should actually roll the fabric *around* a steel tube, and if I used a

very fine fabric—cotton, not synthetic—that it would soak through, and I would get a strong clear print through many layers. At the same time, I was also experimenting with painting with coffee and tea. I even combined both. The chemical part of it was kind of amazing, which is also why I eventually stopped making those paintings. They kind of made themselves—almost pure nature—and they just had very little to do with me in the end.

RLG What do you mean?

PS The ethos at the time was the idea of the artist removing himself from his work in some way—it was a mix of the Minimalist ideal of a lack of personality and reference, and a sort of Zen-ful, "no ego" kind of thing. I felt very passive working in this kind of situation. It wasn't that I couldn't make lovely things. I made a bunch of them, and they were gorgeous, but they weren't very interactive for me. I felt like they were just impenetrable, almost like I was just executing an experiment using the scientific method to have the work make itself. I just could not work in that way.

RLG You don't think of your trajectory as a neat progression of artistic experiments?

PS Well, I think a lot of people tried to understand it that way. They only want to see it from the art point of view. But with Pomona, it was a little bit of everything. What I got was a whole approach, not a strictly focused activity in one medium. I got as much out of theater, my anatomy and histology classes, and going to eastern Kentucky, as I got out of my art classes. I've come to think of my work as much more of an ecology, like the way a garden grows. You start off being a very willful gardener when you are young but now I use my trowel here and there only as needed. I try to pay close attention and keep my mouth shut so the bugs don't fly in, but you give up control in the end anyway, and then shit just happens.

Peter Shelton's studio in Rembrandt Hall, 1973

REBECCA MCGREW You grew up in Portland, so how did you choose Pomona College?

HAP TIVEY My father lived in Santa Barbara, which was kind of a base for me during high school. The draw of Pomona was Southern California. I chose that instead of going to Brown, because I thought if I go to Brown, I'm going to be in this cold place with no surf. [Laughs.] Actually, Pomona offered a five-year plan where you'd go three years, either at Pomona or Cal Tech [California Institute of Technology], and do two years at the other institution. So you ended up with a bachelor of science and a bachelor of arts. I went intending to be a physicist.

RM When did you discover the art department?

HT In the middle of my sophomore year, I had classes with John Mason. That was really a turning point for me. Guy Williams was a big influence, too. But when Mowry Baden arrived, then everything really opened up. Los Angeles was opening up at the same time. There was all this energy coming out of the city and landing in Claremont. The art part of that seemed like the most important, vital way to be doing things at Pomona. The ability to design a show with Mowry, to design a thesis with Stephen Erickson in philosophy, and to carve out your own space was ideal. I really loved it. Mowry, and later Helene Winer (who was at Pomona when I was at Claremont Graduate School) played a big part because they brought the visual information into the community. Before John Coplans became the editor of *Artforum* he was the adjudicator for my senior show. Larry Bell and Coplans were the judges. Gus Blaisdell was on campus. Charles Bukowski and David Antin were there as well. Antin and Eleanor Antin were progenitors of this new kind of social involvement that was spinning out of Happenings. We always went to shows in Los Angeles. You'd see the minimal thing at Irving Blum's gallery, and Riko Mizuno and Coplans were supporting the light people. There was this sense of information filtering into the community and a sense of the presence of players. You didn't always have to go to Los Angeles; it came to Pomona, too.

RM Lewis Baltz said this era at Pomona College has assumed a mythic aura. Did it seem that way to you?

HT Well, I think there was certainly something happening. The other part of this mythic time was the politics. You'd be on the phone with somebody in Berkeley and hear that someone was killed. At Century Plaza, you had 125 people seriously injured or killed at the protests. And those kids were coming back to campus. There was no sense that this was an ordinary world any more. We were going to go get killed. What did we have to lose?

Another example was my graduation, the class of 1969. The valedictorian presentation was a poet, James E. Rosenberg, who read an epic poem. The metaphor was that America was a huge elephant driven by people from the inside, who couldn't see out, and they were crushing innocents all over the world. The audience of local people and the parents of the graduating class booed and booed. The class stood up, turned around, and was yelling at their own parents, "Fuck You!" There were no rules.

RM How did this connect with your senior art project?

HT Kay Larson and I began a program at Pomona called The Honors Project. The idea was that students would design their own senior year, where you would have two senior projects in two separate divisions. I worked with Fred Sontag and Stephen Erickson in philosophy, and I wrote a thesis on various philosophers, discussing how art changed due to a shift in philosophy. My artwork played off of [Robert] Irwin's discs and Richard Smith's shaped canvases.

There was a place, called Edwards Air Force Base, where you could get surplus stuff. I got a tank, which was a sphere. I opened the gas end of it, so you were looking into this completely perfect sphere. It was like looking into the sky.

I really liked what happened with that, but I also liked what happens with fabric and how you light fabric. So in my senior year, I made walk-in paintings that were a block ten-feet wide, seven-feet high, and four-feet deep, with a vertical cylinder removed from the center. All surfaces, including the cylinder, were stretched canvas, so they assumed a parabolic curve formed by the fabric tension. I was also thinking of Morris Louis. You walked into this central interior, and the inside of it was glowing. It was like you were standing in this vertical room, in this glowing space. You could walk into them and feel surrounded by light. I made two of those. One of them had a stain on it. And the second one was just canvas and light.

HAP TIVEY INTERVIEWED BY REBECCA MCGREW

Hap Tivey's home, New York, New York,
July 23, 2009

Hap Tivey *Sunpainting*, 1971. Window frame, paint, paper, tape, and incandescent light. 24 × 24 × 3 in. (61 × 61 × 7.6 cm)

RM Was that in 1969?

HT That was definitely in the fall of 1968 because what came *after* that was a whole series of shaped canvases. The pieces that I made for the senior show were combinations of lighting using just the gallery lights and fabric structures. Most were hyperboloid structures with fabric stretched from one end to the other. I made several versions of this, lit and backlit in different ways. But, you'd look through it. You wouldn't enter it. It was a painting with light. So you looked through this painting with light, and there was a floating, Plexiglas disc—sort of an Irwin rip-off—on the wall. But because you were looking at this surface first and focusing somewhere in here, the disc seemed to be floating in space. Instead of looking at the Irwin on the wall, floating in the shadows, this lit object was literally just floating in light. It was gold. It was gorgeous. It was like looking at a membrane. It had a really beautiful quality to it. And that was the most successful and dramatic of those pieces.

RM What was it like working with the faculty at Pomona?

HT It was great. You could feel it in their earnest approach to what they were doing, and you just absorbed it. One of the amazing things about the faculty was how open they were. You sensed that there was something that was monumental about what was happening. You would go over to Mowry's and babysit his kids! You'd see his drawings. Or you would have a long dinner with Guy [Williams] and Marcy Goodwin. They weren't a remote entity. You know, I probably learned more working in Jim's [Turrell] studio, helping build things, than I did in any art class.

RM James Turrell graduated from Pomona in 1965, a few years before you, and then came back in the fall of 1971 to teach at Pomona and to get his MFA at CGS. Would you clarify when you worked with Jim?

HT After I graduated in May 1969, I went to the draft office in Portland and got an alternative service. Then I went to Claremont Graduate School from 1971 to 1972 for an MFA, when Jim was teaching there. I was his teaching assistant. I actually did two degrees with Claremont Graduate School. The first was an MFA, and then I got an MA in photography with Duke

Hap Tivey *Galaxy*, 1971. White Plexiglas hemisphere, granite block, red laser, and ambient blue light. 36 × 36 × 60 in. (91.4 × 91.4 × 152.4 cm)

[Lewis] Baltz and Leland Rice. Around 1972, I moved to Pasadena and did the Pasadena Dayton Street studio until 1974. Then I went to a monastery in Japan.

RM What were you working on as a graduate student?

HT I was doing a series of fire tunnels with flares. To put that in context, I wanted to be an artist who didn't make something that would be commodified. The whole idea then was that art was not a thing, art was an experience. So I was the teaching assistant in Jim's light class and I was doing lots of experiments on my own and with the class. I'd been doing these tunnel pieces in the river channels all around Claremont and Montclair. I'd gather a bunch of people together, head to a tunnel with half a dozen flares, put up aluminum against the tunnel wall, stick the flare in clay, fire it off, and run back twenty feet. As you sat in front of it, it would gradually come closer and closer; smoke would obscure whatever the back flare was doing, and it would burn out. There was a telescopic space of light that was defined by the individual flare lines. They would collapse toward you until you were looking at one arc of light.

RM On October 21, 1972, a memorable theatrical performance took place in the quarry east of campus— Richard Barnes's *The Death of Buster Quinine*. Your fire tunnels became an element in his play. How did you get involved?

HT Dick Barnes was a wonderful medievalist and literature professor at Pomona. He had either seen or heard about the tunnels and some searchlight experiments I did with Jim's class outside, around Bridges Auditorium. The whole *Buster Quinine* deal evolved when Dick decided that he wanted to do something more dramatic at the quarry. The idea for doing the searchlights for *Buster Quinine* came from Jim's light class. Jim got a large budget for the light class, probably from Roland Reiss. We rented search-lights for the night. Since we were a class, we tried various things. We tried moving the lights close together, and doing them as parallel beams going up into the sky. We made an X in the sky that made a beautiful rainbow.

RM What exactly did you end up doing at the quarry for *Buster Quinine*?

Hap Tivey *Upper Dayton Street Studio— Newman Sequence*, 1972–74. Sunlight and incandescent light projected from outside the building through apertures. 96 × 84 × 240 in. (243.8 × 213.3 × 609.6 cm)

HT I told Dick I wanted to do a walk-through, giant version of one of those tunnels. I would need a hundred flares. Well, in those days, I had twenty dollars. A hundred flares was a big deal. Dick's budget paid for a whole bunch of stuff. It paid for the flares, and another hundred bucks went for the two searchlights for Jim's piece.

Dick staged the play down in a big pit. To get to the pit, you had to walk into the quarry. There was a dirt road that led you through this huge arch. I got a bunch of people to fire the flares off. It was the same thing I did in the little tunnels, except you had these aluminum sheets that would face the walls, and blow the light back up on the walls of the arch. The walls of the arch were about fifteen or twenty feet high. And then, at top, it was a half circle. It focused all of the sound of the flares directly on the people walking through it. It lasted about fifteen minutes. You walked through a shimmering red fire and heard the amplified sound of all those flares hissing. It was like walking through the entrance of hell! Two thousand people wandered through an atmosphere of churning red light with this huge blue bar behind it, which was Jim's two carbon-arc searchlights, facing each other. There was about half a mile of beam across the top of the pit.

RM When did you do your first Ganzfeld space?

HT In 1971. The flare work and the fire tunnels really related to the class at CGS. The big move for me at that point was building my first Ganzfeld that people would go inside. I first worked on these in Claremont in 1971 and 1972.

RM Was that in the Rembrandt building studios, next to the gallery?

HT Yes, the space was constructed with a very high-frequency, geodesic architecture. The floor curved up at the edges, into the sphere. You'd walk into this three-quarter sphere, close the door, sit on a small tatami mat, and the program would begin. The light came from the door behind the viewer. Every-thing was vaporous light. You would be looking for any kind of clue to build a sense of space. And usually the clue was just the spectrum; your own cortical information would play into that and start making it be something. It was like you were in the sky and there was no earth below you, other than your body and this platform. The light was choreographed. When you work in that kind of light, you can make space infinitely deep. You can put the space right on somebody's eyeballs. It was about constructing color and space.

RM How big were these pieces?

HT The dome itself was fourteen feet, fitting one person.

RM How did you manipulate the light?

HT Fluorescent lights beneath the platform mixed the light.

That was the beginning. It took me a long time to build that thing, but a patron saw it, and said, "I'll fund the studio." And that's how I got the Dayton Street studio.

RM In Pasadena, right?

HT Yes. That was an amazing place. The garden had one of the oldest silk floss trees in California. It was a green-skinned tree with thorns. When it flowers, they look like orchids. I slept outside in the garden, surrounded by jade plants, underneath a tree that dropped orchids on me continuously. After I'd made the first Ganzfeld room there, I invited people to visit. I'd meet people outside, after they saw the first room. I'd serve them tea, and they would tell me about what they were able to perceive, or if it scared them, or if they were bored. Then I would think, "OK, you can probably see more," and I'd take them to another room. People told me that they could hear, and see, the light. In fact, they were literally seeing what their mind was doing. So, for me, it was about providing an experience through which they experienced themselves.

While all that was going on, I started to go to intensive training sessions as a layperson at a California Buddhist monastery. Then I met the real deal from Japan and trained with them. They said, "Come and join us." I eventually did, going to Japan in 1974. Through all of that, I was making this artwork.

So, the work is always essentially some sort of meditative device. But at the time I created a Ganzfeld in 1971, all I wanted people to do was to look at themselves. I wanted them to see that they were seeing their minds. I didn't want them to see an object, and to think, "Oh, I know what that is." I didn't want them to look out and think, "I'm in a Ganzfeld." I wanted them to look out and get scared, get euphoric, get peaceful, or just be. I wanted them to *be*, and then reflect on what they were. That was my whole motivation then.

Hap Tivey *Fire Arch*, 1972. Made with **James Turrell** for Richard (Dick) Barnes's *The Death of Buster Quinine*. Red phosphorous flares and carbon arc searchlights

REBECCA MCGREW Since you've had many other interviews about your work over the last couple of decades, I thought that today we could talk specifically about your time at Pomona. Basically there were two periods: when you were an undergrad from 1961 to 1965, and then when you were a faculty member in the art department from 1971 to 1973. What was it like as a student at Pomona in the mid-sixties?

JAMES TURRELL The art department drew me in after I was already at Pomona College. I began in 1961. John Mason was the sculpture professor. Bates Lowry was there from 1959 to 1963. Salvatore Grippi was the painting professor. We also had visiting artists that lectured. Malcolm McClain and Peter Voulkos came through, and of course Paul Soldner was up at Scripps. So the curriculum for teaching sculpture was largely clay related. John Mason was really a wonderful teacher. He didn't have that much to say, but from the way he conducted himself, you really got a feeling of what it was to be an artist. He really was an artist. Of all those artisans who came out of California clay, he was the one who became the sculptor, even more than Voulkos. He created large clay sculptures, and then he made brick pieces, which were inspired by all of the kilns he had made to fire the large sculptural pieces. Of course, my interest was in light, and these guys had giant pug mills for clay, forges for bronze casting—it was manly art. If you think about it, now with *Roden Crater*, I have come full circle. The crater is one of the largest high-fire bowls!

RM When you started at Pomona, were you interested in art?

JT I wanted to work with clay.

RM But you majored in psychology and math. How did that happen? When you graduated, did you know that you were interested in going into art?

JT It's hard to explain. In a way, my work comes more out of painting than sculpture because I use a hypothetical space put into three dimensions. The traditions of portraying light come out of painting more than sculpture. But the problem is that in painting they're teaching the color wheel. If you mix blue and yellow to get green, it works in paint, but if you mix blue light and yellow light, you get white light. That means you have to learn the spectrum, which has a lot more to do with this other way of thinking. It's thinking about seeing, and it has to do with perception. I was very interested in [Maurice]

Merleau-Ponty, the Phenomenologists, and the English psychologists like James J. Gibson involved in the psychology of perception. I had a psychology professor, Graham Bell, who was very exciting. He was a very good psychology professor and quite a wonderful human being. He really helped me get through Pomona. I had some little scrapes when I landed my plane in the Quad.

RM I'm trying to imagine you landing a plane on Marston Quad. You came over Carnegie, and landed towards Big Bridges [Bridges Auditorium]?

JT Right in front of Bridges, and then I turned around and took off. I actually went back quite a ways, because I was worried about the take off; but that was no problem either. I did that with a Helio Courier, which I still have. I also still have the plane my father made at Pasadena Junior College, in Pasadena. A Number 1 Harlow.

RM Is that actually a Pomona yearbook on your desk?

JT Yes! From 1965. I'll show you what I looked like then. I was the art editor. Richard White was the overall editor. I wrote about the *Genesis* mural (1960) by Rico LeBrun.

RM So you were pretty actively involved on campus.

JT Yes, I was junior class president, and was art editor in the senior year. Here is a picture of John Mason with his work. Look at the clothes. It was a different time. You can't imagine how different it was. Here I am on my motorcycle. The Mods and the Rockers. [Laughs.] I had a Jaguar XK-120. (*See page 363*)

RM Why did you choose Pomona College?

JT I grew up in Pasadena. My family's Quaker, so I'd gone back to see Swarthmore and Haverford. But when I went back there, it was cold and all the women were wearing black stockings, plaid skirts, and sweaters. Well, it was very different from the culture of California. And I liked sailing and flying a lot. The other possibility was Stanford; my father went to Stanford, and it was easier to get into than Pomona at that time. Anyway, my worldview wasn't very large then, and Pomona looked pretty good. I liked it. In Southern California, it was the school that I thought was the best, and I still do.

JAMES TURRELL INTERVIEWED BY REBECCA MCGREW

James Turrell's ranch, Flagstaff, Arizona,
February 17, 2009

and students. The shows were very interesting, too, so furtive and fertile! Of course, Helene got fired for all that interest.

RM There are so many stories about why, or if, Helene got fired.

JT The faculty all resigned! *En masse*, to support her.

RM The human resources files all say that you resigned on June 30, 1973. But Helene had already left well before then.

JT Yes, it was actually earlier than that for us, too. They may have made it June 30. I stayed on, but Lewis Baltz would not. Baltz just left immediately. I stayed on to finish the grades for my students. And then that was it. I was out of there. But it was also the last of my thinking about teaching. My family, Quakers, were all teachers—brother, sister, brother-in-law, mother. So when I resigned at Pomona that really changed everything for me. David Alexander, the President, acted as he needed to act. Everyone played their role. It's one of those times when you realize that we come into this life and we have a role. It's best not to under-play it and not to overplay it. But certainly when you have your moments, you should speak your lines, and we all did. That was the moment of our resignations. We all stood before David Alexander.

RM As a group?

JT Yes, as a group. And we had our resignation letters. I was holding the letters in an envelope. And at some point, I put the envelope down on David Alexander's desk. And this made poor Guy Williams nervous. Guy really needed this job. And then Guy moved around me and was getting closer to picking it up. I realized that Guy was moving over so he could actually take back the envelope. Just before he was able to do that, David took the envelope and put it in his drawer and closed it.

RM Why did Guy want to take the envelope back? What happened?

JT This was a powerful statement—the whole studio department resigning—and we really thought it would change things. But I think Guy realized that it was not going to work. The students had published something in the newspaper and they were supporting Helene and the faculty. But as we were discussing this with David Alexander, we all realized that no change was going to happen. It was not going to go the way we had

I think it's largely about the peers that you go to school with; I think it's the peers that make the school, even more so than the faculty.

RM You can't predict that though when you're applying.

JT That's true, and that's why there are places like Black Mountain or a moment at UCLA [University of California, Los Angeles] in art, or even this time at Claremont. Those moments kind of come together. They're not very predictable.

RM There was a confluence of amazing work happening at Pomona during that time.

JT Mowry Baden had a lot to do with that. It was his coming into the department as a Pomona graduate. It was a pretty hot time. A great group of colleagues

James Turrell *Mendota Stoppage*, 1969.
Outside night lights into prepared space

James Turrell *Raemar Blue*, 1969.
Fluorescent-light installation and constructed
wall. Collection of Tate Museum, London

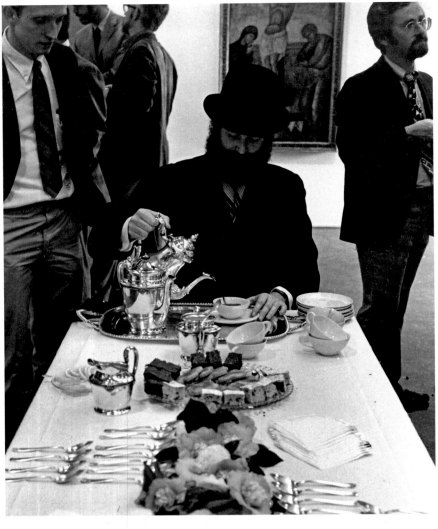

James Turrell pouring tea at Pomona College
Faculty Tea at Pomona College Musuem of Art,
c. 1971

felt it should go. In reality, it gave David Alexander
a clean slate to hire a faculty better suited for a more
standard vision of the mission of art in academia.

RM He was a relatively new president, dealing with a
complicated time.

JT Yes, he was new, and all of this had just come out.
First, Wolfgang Stoerchle had done his number,
pissing on the gallery rug, during his performance.

RM What do you remember of the Stoerchle piece?

JT I just remember leaving that evening and thinking,
"Wow, this is going to be something. I wonder how
the hell this is going to play." Mostly students were
there, but also [chuckles] the Rembrandt Club, they
would come to these things. I don't know how many
were there. But many of them were from Pilgrim's
Place [a Senior Independent Living housing develop-
ment]. And they were supporting art; they loved art
and architecture. What can I say? [Laughs.] You have
to remember that the Rembrandt Club had raised the
money to support these shows.

RM And then, all of a sudden, performance, the body.

JT Here come these Young Turks. Think about it. I've
made a career out of selling blue sky and colored air.
But it was a big thing in those days. The one thing about
performance is that you're standing there, and some-
times you're thinking, "My God, why am I here? This
is interminable and nothing's really happening." And
everyone's standing around on one foot and then
the other. But then you think, "I'm an artist, and so
I want to support this." In fact, I think that's how it was
for Helene, too. I mean, we all lost our jobs over this.

RM Over that performance.

JT Over that performance, yes. But in a way, it has
become something bigger in all of our minds than
it actually was. You have to remember what perfor-
mance was like then. It was a really wild time, and
how was this supposed to fit into academia? How art
fits into academia always causes trouble. Of course,
you have to realize with people like Chris Burden,
myself, Mowry Baden, Michael Brewster, and Peter
Shelton, what a huge change this was for Pomona.
When I was there as a student, it was Millard Sheets,
architecture, and chamber music. Everybody
came to listen to violin and viola. That was the idea
of art that architects liked to put forward. They
would like to have art neatly fit into their buildings.

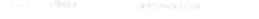

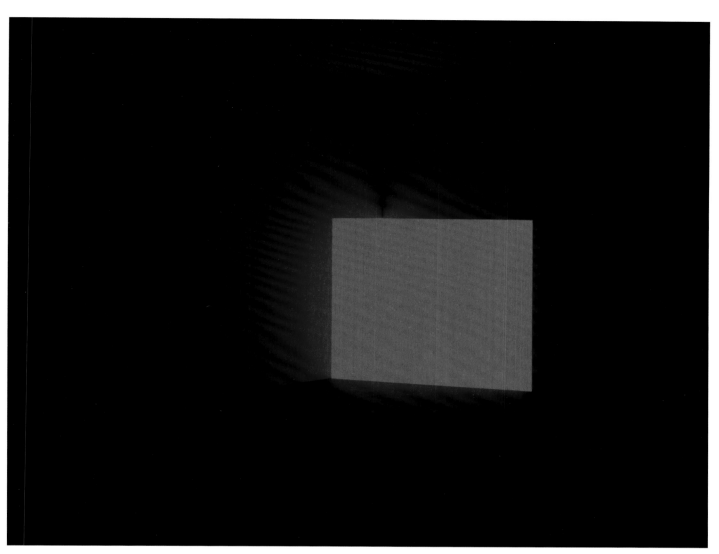

Our understanding of what art could be really turned over in that period, and part of that change was a dishonoring of those who had come before, which was difficult. It was difficult on the school, and particularly on the Rembrandt Club, which was sponsoring these exhibitions fiscally.

RM Art doesn't fit neatly into prescribed patterns, modes, and behaviors. And it must have been even more complicated then. After you all left, the department did go back to a more traditional approach to teaching art.

JT It worked out well for me, ultimately. I was not really in the teaching mood. I was just going to do art. I think it was a painful moment for everyone. Generally, I think everybody behaved well. I've made my peace with that whole period, and with David Alexander as well. We talked last year when I had the

exhibition and installed *Dividing the Light* [on the Pomona College campus, in 2007]. That was healing to have an exhibition [at the Pomona College Museum of Art] and that piece there. I really love the school because it was a great, formative experience for me. It changed my life. It was very exciting for me.

And a lot of it had to do with things we'd go to. Because Maurice Cope and Jim Demetrion would pack us off to Los Angeles for art field trips. We went to see the *Autobodies* performance by Claes Oldenburg [in the parking lot of the American Institute of Aeronautics and Astronautics].

RM That was in 1963 [December 9 and 10], right?

JT Yes. Allan Kaprow was doing Happenings and Oldenburg was, too. And the schools, all these artists were professors, teachers, and sometimes lecturers.

James Turrell *Acro Red*, 1968. Projected light onto prepared wall. Collection Almine Rech, Brussels

Everything was exploding at the same time. So how this all got handled at a school like Pomona, it was amazing. I have a great picture of me pouring tea, and President David Alexander standing over me.

RM Helene told me that story. She said that she was mortified when she got a call from David, maybe from his secretary, asking her to pour tea at a faculty meeting. And she just said, "No, I can't do that. That's not right."

JT Yes. So I did it. Helene and I did it. I poured the tea and it just outraged everybody. I was in full Quaker regalia, wearing a full, square-cut frock coat, and it just set off a firestorm.

RM Lets talk about the work you were doing at Pomona while you were teaching there.

JT I was doing some pieces with flares and also parachute flares, out of airplanes. You had things happening on the ground and light coming out from above.

RM You created some works in various spots on campus, right?

JT I did one piece called *Burning Bridges*. I did it with Hap Tivey and a group of students. I had sandboxes and put three flares in them and reflectors, and put them behind the columns of Big Bridges. They made an unbelievable amount of light. When the flares were set off, it just looked fantastic because it put the light right into the alcove space—behind the columns. It really looked like the building was on fire! We did it on two sides, the front side and the side down toward Renwick Gym. Well, of course, somebody reported that Big Bridges was on fire. They actually

James Turrell *Pullen White*, 1967. Projected light onto prepared wall. Collection Lannan Foundation, Santa Fe, New Mexico

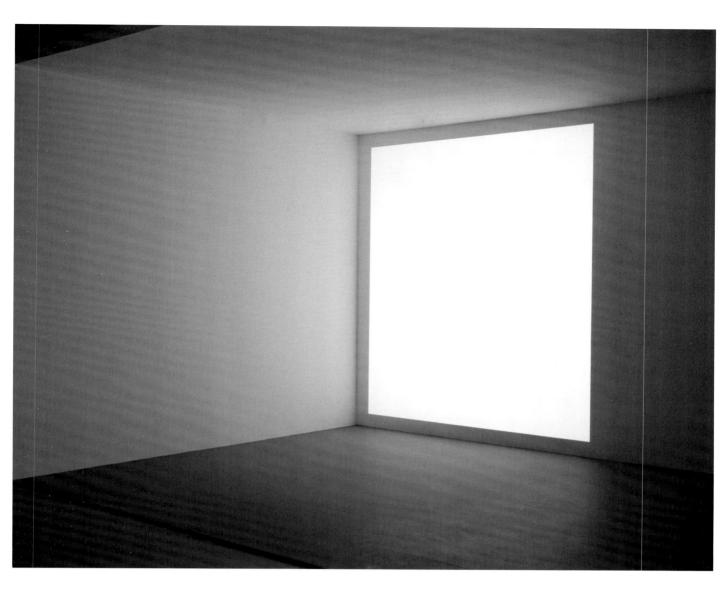

had the fire trucks come out. I had moved the crew to go to the next place and get it ready. When the fire trucks arrived, Roland Reiss was standing there, of course. He explained that it was an art piece. The next piece was in the tunnels that go underneath the playing field.

RM I've been in those.

JT Another piece was called *Silver Cord*. For that one, two bricks and flat plates with a brick between were placed on the floor of the tunnel. Then, Hap Tivey and I did the big flare and searchlight pieces with Dick Barnes for *The Death of Buster Quinine* performances at the quarry. These were huge productions with many people involved.

RM Were *Burning Bridges* and the other pieces created when you first started, in early 1971?

JT I remember it was right when Roland started. It was one of the first things he had to take care of, this problem with the fire and the police departments.

RM Do you have any documentation of these?

JT No, no. I was more into the happy merriment of creating them. I didn't worry about whether or how that was counted. Even though it happened in the early seventies, it was the sixties!

James Turrell *Jadito White*, 1967. Projected light onto prepared wall

TOP / BOTTOM

Guy Williams *Navy Street #25*, 1975. Acrylic
with paper and stencil on canvas. 45 × 78 ¼ in.
(114.3 × 198 cm). Collection of the Orange
County Museum of Art; Gift of Toni Gump

Guy Williams *Slamfoot Brown*, 1972.
Oil on canvas. 88 × 144 in. (223.5 × 366 cm).
Collection of David and Jeanne Carlson,
Rancho Mirage, California

1. Guy Williams, *Random Notes on Painting*, (Claremont: Pomona College, 1971). Exhibition brochure, unpaginated.

2. Peter Plagens, "From School-Painting to a School of Painting in Los Angeles," *Art in America* 61, no. 2 (March–April 1973): 36–41.

3. Williams later became a tenured professor at the University of California, Santa Barbara, where he was also highly influential.

4. Exhibition press release, Pomona College, April 12, 1971.

5. This series informally adopted many names, but was never officially identified by Williams, other than by some individual painting titles. For instance, the Navy Street paintings all belong to this series (titled after his Navy Street studio in Venice in the early 1970s), but other paintings in the series remain untitled. Works from this series have been referred to in print and otherwise as Hatch-Mark paintings, Color Bar paintings, All-Over Mark paintings, and Blip paintings. I have chosen the term Color Mark paintings, as this is how Williams referred to them in his Los Angeles Institute of Contemporary Art (LAICA) catalog interview. See Bob Smith, Marcia Traylor, and Guy Williams (interview), *Guy Williams* (Los Angeles: Los Angeles Institute of Contemporary Art, 1976).

6. Marcy Goodwin, email interview with the author, May 16, 2010.

7. Melinda Wortz, "Barbara Munger and Guy Williams," *Artweek* 7, no. 26 (July 31, 1976).

8. Judith L. Dunham, "Both Kinds: Contemporary L.A. Art (Group Exhibition) at UAM Berkeley," *Artweek* 6, no. 18 (May 3, 1975).

9. Carter Ratcliff, "The Whitney Annual," *Artforum* 10, no. 8 (April 1972), 28–32.

To understand these paintings is understanding, that when all is understood, there is nothing to understand.
—Guy Williams[1]

OUTSIDE THEIR ASSOCIATION with the major galleries in Los Angeles—Ferus, Nicholas Wilder, Dwan, Ceeje, Riko Mizuno, and others—in the 1960s and 1970s artists in Los Angeles were (and often still are) identified by where they taught. As Peter Plagens once wrote in his characteristically wry vernacular:

"Oh, him…where's he teach?" was the Southern California equivalent of "Does he still have that loft on Broome Street?" UCLA, Occidental ("Oxy"), Orange Coast, Pasadena City College ("Pee Cee Cee"), Pomona, Santa Monica City College, or, ninety miles into the boondocks, "Yew Cee" at Santa Barbara: that's where the artists hung out.[2]

Indeed, while New York had its neighborhood watering holes and studio buildings, Los Angeles had its wide-open spaces and its art schools. The schools were some of the primary places where artists came together, and where some of the most groundbreaking events occurred in the formative days of the region's contemporary art scene. At the time of his 1971 exhibition at Pomona College, Guy Williams was also making his mark in the school's art department, as its only faculty member in painting.[3] The opportunity to look back at Williams's exhibition and tenure at Pomona also provides an occasion to focus on the legacy of an artist whose career was challenged by a devastating setback in 1990, and cut short by his untimely death in 2004, at the age of seventy-two.

Williams's exhibition at the Pomona College Museum of Art featured a group of large paintings, "each occupying one wall of the main gallery,"[4] from what became known as the artist's Color Mark series.[5] The large, rectangular canvases in the exhibition were distributed with thousands of concise dashes of color that moved diagonally, from the upper left to the lower right corners of the canvas.

The paradox of these works exists as much in their making as in their reception. Beginning with a single field of color on canvas, the artist methodically hand-painted an average of 16,000 hash marks in a select color scheme through a specially devised template. The arrays of colored marks on the surface interact with each other, as well as with the background color, creating the effect of two paintings (or more) in one.

Recalling the process by which Williams hand-rendered this seemingly infinite number of identically shaped marks, Marcy Goodwin elaborated on the artist's "screen of specially made, die cut masking tape, that was applied to the canvas over every inch of the surface":

Guy's masking tape came from a special high tech firm that could take extra wide tape and then cut it with these special metal dies. So each strip of, let's say, 3-inch wide tape had a row of maybe 12–14 hash marks, each perfectly repeated (Guy called it "step and repeat") throughout the full length of the masking tape roll. It's important to consider that such technology had never been used. The visual source was punch cards—Hollerith-style computer punch cards. This was well before the personal computer era. Guy liked the idea of using the latest technology to create a "reproducible" image that was actually hand-wrought. Once the paintings were complete, they always appeared to have been made instantaneously in a single stroke.[6]

The visual effect of these works is quite remarkable, even mesmerizing. Up close, the focus lies on each individual mark and its distinctive color. A little farther away, the paintings are "a vibrant, moving field of colors, so optically balanced that each one reads equally strongly."[7] Viewed from a distance, they "fuse into a modulated field…The mutating quality of each painting suggests that on subsequent viewings the effect will be different."[8]

The critical response to works from this series was positive, gaining Williams entry into, among many other venues, the 1972 Whitney Annual. In his review of the Whitney exhibition, Carter Ratcliff described Williams's paintings as "a geometric depiction of texture."[9] Though brief, Ratcliff's account is an indication of the distinction these works held in the larger realm of painting, especially considering the divisions that had occurred in the previous decade between various forms of Post-Abstract Expressionist painting, namely Color Field and Hard-Edge. Williams's work was equally distinct in the sphere of Southern California Minimalist painters (i.e. the Dot paintings of Robert Irwin) and Hard-Edge (such as John McLaughlin).

Williams produced the Color Mark paintings from 1970 to 1975, representing just a fraction of time in his long-term pursuit of art and knowledge. But this work also represents his quest for something higher, and more (or perhaps less) specific. The artist often

GUY WILLIAMS

Julie Joyce

Guy Williams *Slamfoot Brown* (detail), 1972.
Oil on canvas. 88 × 144 in. (223.5 × 366 cm).
Collection of David and Jeanne Carlson,
Rancho Mirage, California

10. See Bob Smith, Marcia Traylor, and Guy Williams.
11. Ibid.
12. Some of these poems can be found in the brochure that accompanied the exhibition at Pomona College. See Guy Williams, *Random Notes on Painting*.
13. Ibid.
14. See Bob Smith, Marcia Traylor, and Guy Williams.
15. Ibid.
16. Peter Shelton, telephone interview with the author, May 20, 2010.
17. Goodwin.
18. Shelton.

expressed his deep interest in what Ludwig Wittgenstein described as the unsayable[10]—that which exists outside of the limits of language, wherein ethics and aesthetics take precedence. In an interview printed in a catalog that accompanied his sixteen-year survey exhibition at the Los Angeles Institute of Contemporary Art (LAICA) in 1976, Williams expressed that this was a search for the "gut-level things," those "leaving only silence."[11] It was a realm that encompassed not only his painting and the concrete poetry that he composed,[12] but also his interest in jazz and playing the piano, his persistent reading, and the card games he played with faculty members from Pomona's philosophy department. All of these influences lay at the core of Williams's practice as an artist and as a teacher.

For Williams, process and structure were the intellectual parts of his work, and color was the "'emotional' part."[13] He often masked this by speaking about color in intellectual terms. Later, in the same interview, Williams stated,

In each painting there was always an excuse for red, yellow or blue... There was always that consideration, that the primaries had to be there to make full color in the painting, and they were not just randomly chosen. Pink is red in a certain range, and brown is yellow in a certain range. Many people don't see those things.[14]

Yet he was much more interested in a balance between the intellectual and emotional, as he continues:

I wanted to delete any self-expression in my work, that apparent lack of self-expression may be what you call analytical. But at the same time, I was conscious of wanting to be quite intuitive about it, and letting that carry the momentum of the piece.[15]

Williams's engagement with color theory permeated not only his painting, but also his practice as a teacher. Former student Peter Shelton recalls that Williams's "favorite reference was Josef Albers's book, *Interaction of Color*, the famous 1963 volume with a folio of thirty-two silkscreened, color plates. Williams often brought the text to the classroom as a teaching aid."[16] This tome continues to be utilized in art schools even today; for Williams it evidenced not only his dedication to classroom rigor, but also his own exploration of color relationships through his work.

Williams's knowledge of painting was deep, ranging from his experience living and working in New York in the early 1960s, to his keen awareness and knowledge of art in California. As Goodwin recalls:

He demanded that his students function as full-on artists, in the tradition of Chouinard Art School, where I met him. The approach could also be found at one or two professional art schools around the country, but was not a common approach, especially in a liberal arts undergraduate college. He did not want the students to be "about art" nor to be kind of art-like, nor to emulate artists. He expected everyone to function as an artist and to take their work quite seriously as a full professional.[17]

Shelton confirms that Williams was difficult, but also extremely "generous...like a parent in a way, giving you the feeling that 'anything you do is great.'"[18]

Evaluating the legacy of Guy Williams is in some ways fraught with complication. His influence as a teacher is undeniably significant, evidenced in the abundant, thoughtful praise he receives from students and colleagues. His work, however, became less visible as his career continued, at first due to his move, in the early 1980s, to Santa Barbara, where he eventually grew disenfranchised from the success he had enjoyed during his active years in Los Angeles. And then, in 1990, much of his early work, including many of the Color Mark paintings, were destroyed in the disastrous Painted Cave Fire—an event that was devastating for him both personally and professionally. What remains today is the work that was acquired by public and private collections along the way.

Some who knew Williams suggest that his legacy lies in his most accomplished and provocative body of work—the Color Mark paintings. These have endured, as has Williams's influence, the latter of which can be found in places one might not suspect. It is unquestionably evident in the diagonal bar paintings by John M. Miller, one of Williams's students at Claremont and also one of his studio assistants (at his studio on Navy Street in Venice). A full re-examination of Williams's work would surely position him in a much more significant role in the development of painting in Southern California. Until this happens, however, it is most rewarding to simply stand in front of these works, and take each one in, silently. For in his resolute attempts to create a new paradigm for painting, Guy Williams invented something truly phenomenal.

The paintings are about surface and color without other impor-
tant contents; they are retinal—for the eyes. The paintings have
no meaning, but do not advocate meaninglessness; they have
no subject—they are themselves the subject.

•

Each painting contains approximately 16,000 marks in a system
of equal distribution. The mark (dash, broken line) is somewhat
incidental, the least offensive mark available—not as official as
formalized geometric figures—the circle being too pure, the
square too specific. The marks are ersatz brushstrokes.

•

A packed surface is dense like a blank canvas—with this dif-
ference: *the surface can be painted*. A uniform and regular
mark allows *getting into the center of the canvas*.

•

Complicated color possibilities within a predisposed system
become fugal, but not in a musical sense, only in a relational
painting sense.

•

The use of color is not an intellectual exercise, but a retinal
one; its application is based in part on whimsy, in part on
chance; its success or lack of success is measured by the eye,
not by scientific method.

•

The paintings were invented on the typewriter in 1961. Fifty
typewriter drawings called *Poems for Painters* were completed
at that time and then published privately in 1963. *Poems for
Painters* is a lightweight minor work, nevertheless it is the pri-
mary source for the current paintings. Several examples follow:

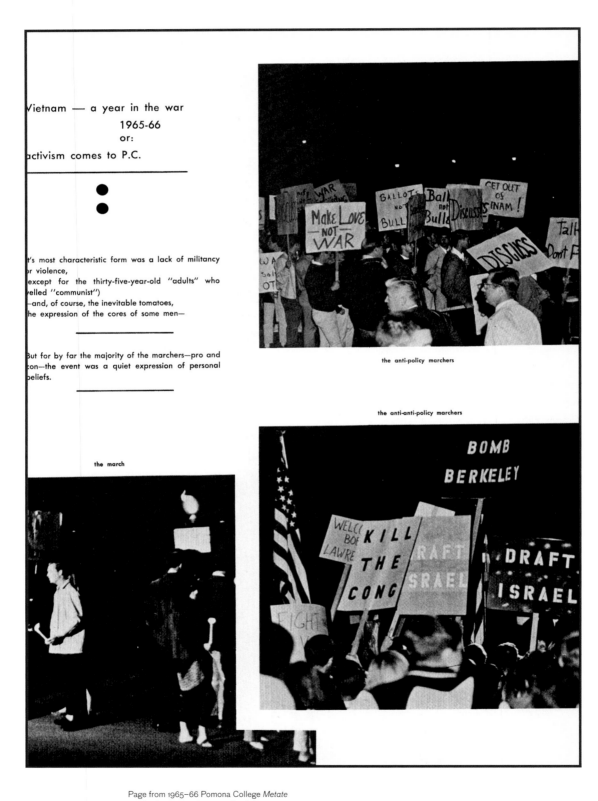

Vietnam — a year in the war

1965-66

or:

activism comes to P.C.

●
●

t's most characteristic form was a lack of militancy
or violence,
except for the thirty-five-year-old "adults" who
yelled "communist")
—and, of course, the inevitable tomatoes,
he expression of the cores of some men—

But for by far the majority of the marchers—pro and
con—the event was a quiet expression of personal
beliefs.

the anti-policy marchers

the anti-anti-policy marchers

the march

BOMB BERKELEY

Page from 1965–66 Pomona College *Metate*
yearbook, showing images of activism at
Pomona College. October 14, 1965,
International Days of Protest at the Claremont
Colleges. First anti-Vietnam War policy
protests (350 marchers) held; pro-Vietnam
War policy protests (850 marchers) held
in opposition. Pomona College Archives

SELECTED TIMELINE OF EVENTS FROM 1968 TO 1974

Compiled by Rochelle LeGrandsawyer

The following information that pertains to exhibitions and events at Pomona College and the Pomona College Museum of Art has been compiled through interviews and archival research, using exhibition announcements, press releases, catalogues, reviews, and other official printed matter. Quotes in the exhibition descriptions are taken directly from archival materials. Despite many inconsistencies in the historical documents, every effort has been made to ensure the accuracy of this information. Exhibitions that we were unable to verify are marked with an asterisk (*).

1968

02/21/68
Students demonstrate against the presence on campus of two Air Force recruiters.

Fall 1968
Pomona College hires Mowry Baden as Chairman of Art Department, Assistant Professor of Art, and Gallery Director.

Fall 1968
Dormitories are "coeducationalized" when fifty-nine men become residents of Blaisdell Hall and fifty-eight women live in Walker Hall.

09/30–10/31/68
"Faculty Show"
Recent work by the Pomona College faculty. Includes Mowry Baden, David Gray, and Guy Williams.

11/19–11/20/68
"American Comic Strips from the Turn of the Century"
A survey of comics including popular characters Buster Brown, the Yellow Kid, Krazy Kat, Jiggs, Snuffy Smith, Joe Palooka, and Snoopy. Includes comics from the collections of Stephen Longstreet and Murray Harris Organized by Dolores Mitchell, under the direction of Mowry Baden.

12/10/68
Black Panther Bobby Seale speaks at Bridges Auditorium, Pomona College.

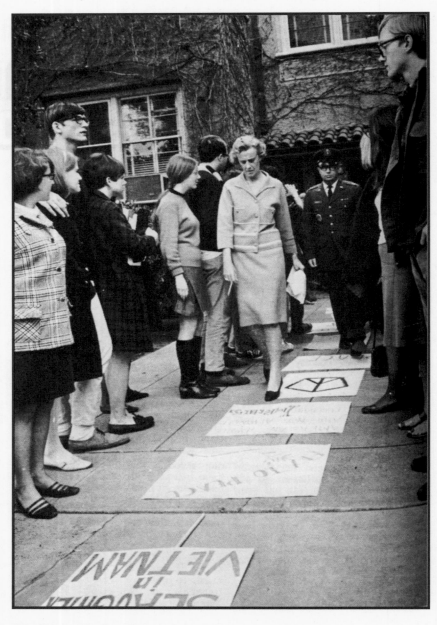

Congress passes the Civil Rights Act of 1968.
Major antiwar demonstrations at over 100 colleges and universities nationwide.
Tom Wolfe's *The Electric Kool-Aid Acid Test* published.
Laugh-In sketch-comedy television program runs for 140 episodes, January 22 through May 14, on NBC.
Robert F. Kennedy announces candidacy for presidency on March 16.

My Lai Massacre: U.S. soldiers kill 583 civilian Vietnamese women, men, and children on March 16.
Martin Luther King Jr. assassinated at the Lorraine Motel in Memphis, Tennessee on April 4.
Robert F. Kennedy is assassinated June 5 in Los Angeles after winning the California primary.

Photograph in *The Student Life*, February 27, 1968. Dean of Students Jean Walton leads Air Force recruiter from Sumner Hall through lines of demonstrators when recruiting session was halted because of obstruction by other students on February 21. Special Collections, Honnold/Mudd Library of the Claremont Colleges

1969

01/69
David Alexander announced as new president of Pomona College.

02/25/69
Pomona College's Carnegie Building is bombed.

03/10–04/06/69
"Yoruba Sculpture in Los Angeles Collections"
Selection of art made by Yoruba-speaking groups of southwestern Nigeria and adjacent parts of Dahomey (now known as the Republic of Benin). Organized by Danuta Batorska and Arnold Rubin.

04/14–05/02/69
"6 Attitudes"
Twelve works that deal with current critical, formal, and anti-formal problems. Includes David Deutsch, David Dixon, Scott Grieger, John Manno, Lindsay McDougal, and Stephen Sher. Organized by Mowry Baden.

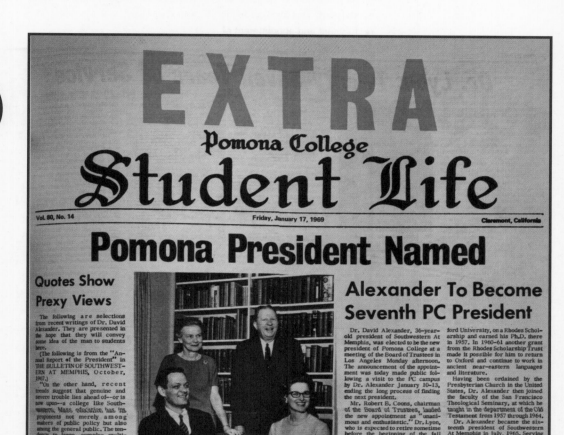

Hundreds of thousands in the U.S. protest Vietnam War; major campus protests nationwide.

Allen Ruppersberg holds his first solo show, "Location Piece," at Eugenia Butler Gallery.

Judy Chicago shows at Pasadena Art Museum.

Judy Chicago stages Atmosphere performances through 1974.

James Turrell creates *Mendota Stoppages* in the Mendota Hotel, Ocean Park, California, through 1974.

Richard Nixon becomes the 37th president of the United States on January 20.

On February 13 William Leavitt publishes first issue of *Landslide: A Quarterly Journal of Underground Art*, working out of the night registrar's office at Chouinard Art Institute. Bas Jan Ader joins as co-publisher after the first issue.

James Turrell and Sam Francis make sky drawing as part of "Easter Sunday in Brookside Park," organized by Oliver Andrews, Judy Chicago, and Lloyd Hamrol.

Neil Young (with band Crazy Horse) releases the album *Everyone Knows This Is Nowhere.*

Dennis Hopper receives the First Film Award for *Easyrider* at the Cannes Film Festival.

"The Appearing/Disappearing Image/Object" exhibition at Newport Harbor Art Museum Balboa Pavilion, featuring works by Michael Asher, John Baldessari, Ron Cooper, Doug Edge, Barry LeVa, Tim Rudnick, and Allen Ruppersberg, ran May 11 through June 28.

President Nixon and South Vietnamese President Nguyen Van Thieu meet June 8 at Midway Island. Nixon announces that 25,000 U.S. troops will be withdrawn by September.

"Pomona President Named," *The Student Life*, January 17, 1969, front page. Special Collections, Honnold/Mudd Library of the Claremont Colleges

1969

04/17–04/20/69
United Mexican-American Students host "The Chicano Movement: The Challenge of Urgency" conference at the Claremont Colleges.

05/69
The Black Studies Center (Black Student Union established in Fall 1967) and the Mexican-American Studies Center (later changed to the Chicano Student Center) of the Claremont Colleges are established. This also led to the recruitment and appointment of new faculty members, the introduction of new courses, and the creation of a special admissions program at Pomona College to encourage recruitment of qualified black and Chicano students.

05/20–05/26/69
"Pomona Student Show"
Senior thesis exhibition of Pomona College art majors. Includes Chris Burden, Linda Hassing, Kay Larson, Steve Ringle, Jill Roe, and Hap Tivey.

09/69
Hal Glicksman hired as Gallery Director and Assistant Professor of Art at Pomona College.

10/02–11/02/69
"An Exhibition of Archeological Artifacts"*
Exhibition presented in conjunction with the Claremont Graduate School Institute for Antiquity and Christianity. Organized by Hal Glicksman.

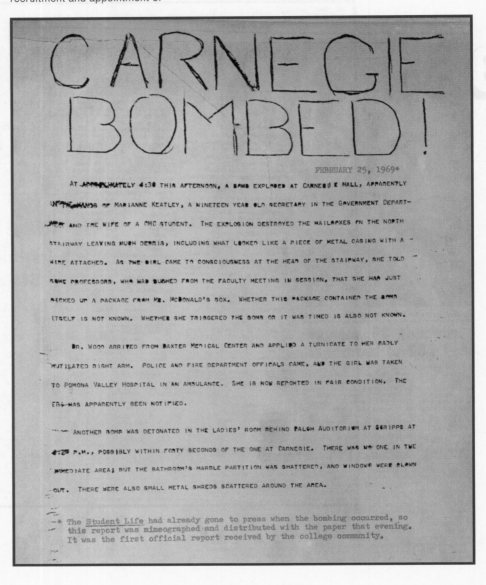

Stonewall riots in New York City on June 28 mark the start of the modern gay rights movement in the U.S.

Sharon Tate and four others are found dead in Los Angeles, in the first of a series of crimes known as the Manson Family Murders, headed by criminal cult-leader Charles Manson.

First U.S. troop withdrawals are made in the Vietnam War on July 8.

NASA Lunar Module, *The Eagle,* lands July 20 on the moon's surface and Neil Armstrong takes "one giant leap for mankind."

The Woodstock Festival is held in upstate New York August 15 through 18.

Allen Ruppersberg's *Al's Cafe,* a storefront installation at 1913 W. 6th Street, Los Angeles, is open October 9 through November 13.

First message is sent over ARPANET, the forerunner of the Internet, on October 29.

On November 9, Native Americans seize Alcatraz Island for nineteen months, triggering a wave of renewed Native American pride and government reform.

Pasadena Art Museum opens its new building on November 24.

U.S. holds a draft lottery on December 1 to determine order of call for induction in the U.S. Army.

Altamont Speedway Free Festival is held on December 6 in Northern California, featuring The Rolling Stones, Santana, Jefferson Airplane, The Flying Burrito Brothers, and Crosby, Stills, Nash & Young. Four audience members die and hundreds are injured after the festival erupts in violence and chaos.

Judy Chicago, Lloyd Hamrol, and Barbara Smith stage the performance work *Raymond Rose Ritual Environment* on December 3 in Pasadena.

"Carnegie Bombed," February 25, 1969, *The Student Life* press release. Special Collections, Honnold/Mudd Library of the Claremont Colleges

RIGHT
Exhibition flyer for "6 Attitudes," 1969. Pomona College Museum of Art Archives

6 ATTITUDES

POMONA COLLEGE ART GALLERY APRIL 14 TO MAY 2 OPENING AT 7:00 P.M.

DAVID DEUTSCH

THE EXPRESSION OF MATERIALS **PRO FORMA** HAS BEEN RE-GARDED AS A TENET OF MODERN ART, ESPECIALLY IN THE CASE OF MODERN PAINTING. THIS LOGIC STATES THAT MA-TERIALS ARE DESIGN — THEY CONSTITUTE PHYSICAL ORDERS ALREADY ESTABLISHED BY CERTAIN PROCESSES, NATURAL OR OTHERWISE. THUS, IF MATERIALS ARE CONTENT, FORM IS A FUNCTION OF CONTENT. BUT THIS THINKING IS CARRIED TO AN ILLOGICAL CONCLUSION IF IT IS SUGGESTED THAT MA-TERIALS (ESPECIALLY ONE MATERIAL ALONE) CAN CARRY THE BURDEN OF A NEW INTERPRETATION OF FORM OR FORMLESS-NESS. FOR HERE THERE IS ONLY A CHANCE TO "APPRECIATE" THE NATURE OF THE MATERIAL, AND FORM=F (CONTENT) BE-COMES THE EXTENT OF THE SYSTEM.

I WOULD SUGGEST A WIDER CONCEPT IN WHICH A SORT OF PARAMETRIC ORDER IS ESTABLISHED. FOR EXAMPLE, A DEVICE WHICH ESTABLISHES ITSELF AS A PARAMETER FOR A SET OF POSSIBILITIES CAN ALLUDE TO AN OPPOSITE NOTION TO THAT OF ITSELF AS A THING. IF SUCH A DEVICE ADJUSTS MECHAN-ICALLY AS IN THE CASE OF "AD HOC," MORE THAN ONE PARAMETER EXISTS SINCE VARIOUS DISTRIBUTIONS ARE POSSI-BLE. THE DISTRIBUTION, THEN, EXPANDS THE IDEA BEYOND THE LIMITATIONS OF PURE MATERIAL.

DAVID DIXON

SCOTT GRIEGER

TACTILITY BARS AND TACTILE STRIPS ARE PROVIDED FOR THE ACCUMULATION OF LINEAL INFORMATION THROUGH THE SENSE OF TOUCH. THEY ARE A SER-VICE AND THEIR USE IS INDETERMINATE.

JOHN MANNO

ALTERED LOGIC, RANDOM SYMBOLISM AND NONVIS-UALITY: AN ACCIDENTAL PROCESS.

RANDOM LOGIC, ALTERED SYMBOLISM AND ACCI-DENTAL VISUALITY: A NON-PROCESS.

NON-LOGIC, ACCIDENTAL SYMBOLISM AND RANDOM VISUALITY: AN ALTERED PROCESS.

ACCIDENTAL LOGIC, NON-SYMBOLISM AND ALTERED VISUALITY: A RANDOM PROCESS.

LINDSAY MCDOUGAL

STEPHEN SHER

I TRY TO AVOID TAKING MYSELF TOO SERIOUSLY. INCONGRUITY IS A PART OF MY PRESENT WORK.

10/15/69
National Moratorium Day observed at the Claremont Colleges.

10/20/69–06/06/70
"Robert Irwin"
"A single work of this Los Angeles artist [is] to remain on view for the entire year as a focus of contemplation and repose." Organized by Hal Glicksman.

10/25–11/02/69
"Lloyd Hamrol"
Inaugural exhibition of the Artist's Gallery program, which was "a series of exhibitions by artists who utilized the Pomona College Gallery to create different environmental situations." Organized by Hal Glicksman.

Pomona College
Student Life

1969

"In the name of all that is sacred, just, and honorable, let us go out not simply to proclaim the message of peace, but to do the work of peace. AMEN."

Chaplain James Joseph
Moratorium Day, October 15, 1969

Time to Oppose the War

Tomorrow, October 15, Claremont students and faculty will participate in the nationwide moratorium against the war in Vietnam. The Moratorium Coalition Committee and the Committee of Concerned Faculty will join together in presenting morning and afternoon teach-ins, "teach-outs" during the afternoon, and an evening march and rally.

Yet disagreements over tactics have pulled the two groups apart. The faculty group has withdrawn its support from the SDS-proposed noontime march against the ROTC, fearing disruptive or violent action when the march reaches its target, Bauer Center. The faculty also oppose the morning leafleting of the General Dynamics plant in Pomona.

In the articles to follow, the STUDENT LIFE presents a history of Claremont's moratorium and a view of the plans for it.

Students and faculty on nearly 1,000 college campuses across the United States will protest the war tomorrow. Seventeen senators and forty-seven congressmen have endorsed the day. Antiwar leaders such as John Kenneth Galbraith, Noam Chomsky, Hans Morgenthau, William Sloane Coffin and Benjamin Spock will participate.

ASPC President Eric Sundquist attended a conference at Stanford this summer where student body presidents agreed to join in the moratorium. As this school year began, Sundquist and Steve Powlesland joined with Jim Kulk of the Claremont SDS, former chaplain Doug Mitchell, the University Christian Movement, and the two-year old Committee of Concerned Faculty in making plans for October 15.

Pomona professors Joseph Ricapito and Frank Wyckoff became the Concerned Faculty's spokesmen. The faculty and the student groups held a joint meeting in Walker Lounge on October 1 where various activities were proposed and task forces began.

But the faculty group began to have apprehensions over the SDS's proposal to march on the ROTC at Bauer Center. At an SDS meeting on October 1, various forms of disruption at Bauer were proposed. Mike Ryan said he might enter the building and not leave until business was shut down; Ellen Mindell stated that if target practice was going on, she might stand in front of the targets; another girl said she might strip naked at Bauer.

On October 3 the faculty and the student leaders met separately to determine what kind of schedule they might be able to agree upon. The leaders met at Kenyon House the next day.

Options Open

At that meeting, Ricapito fought for a disavowal of the march on Bauer, or at least a guarantee of non-disruption. Jim Kulk said only that "Our options are open." Doug Mitchell said that no one could be held responsible for what certain people might do in the course of the ROTC demonstration. Finally, Ricapito gave in and those present at the meeting decided to form as individuals—and not as separate organizations—a central Moratorium Coalition Committee with Eric Sundquist as chairman.

Ricapito was roasted by many of the faculty for thinking that the October 4 agreement was a compromise acceptable to them. The Concerned Faculty group voted 21-15 on October 6 not to take cognizance of the SDS-proposed actions. The faculty decided to prepare its own schedule of moratorium events—a schedule which would, however, include faculty participation in most of the Coalition activities.

On October 5 the United Coun-

cil endorsed the moratorium. The ASPC Joint Session declared its support for the moratorium on October 7. "We call upon the various factions opposing the war to work within the coalition committee. Tactical differences should not be allowed to become more important than uniting in opposition to the Vietnam War," the Joint Session urged.

Universal Call

"While we are a group of individuals who are members of a variety of organizations, the Coalition is not officially related to any of these groups," the MCC said on October 7. "We call upon all students and faculty to embrace the concept of non-violence in all Moratorium activities," Jim Kulk, Mike Ryan, and various faculty members and students joined Sundquist, Powlesland and chaplains Joseph, Rouillard, and Mitchell in signing the statement.

The SDS met on October 9. Kulk urged persuasion, not confrontation, at the leafleting of General Dynamics. Kulk said that the SDS would be joined in their leafleting by a much larger group, numbering perhaps three hundred, headed by CMC student Greg O'Leary. With such a large group, Kulk reminded the SDS, "A crucial consideration will be not getting busted at 7:30 in the morning so that we can be around for the Bauer march." The SDS reaffirmed its desire to cooperate with the Coalition.

A petition signed by 83 Claremont professors and administrators as individuals was released by the Committee of Concerned Faculty on the 10th, urging the suspension of classes for the moratorium.

The Concerned Faculty also announced the schedule they had devised. "We have tried very hard," they said, "To accommodate as many students and student groups opposed to the war as possible: (a) We have altered our program to minimize conflicts with other planned activities for the day; (b) we have offered platforms in the teach-ins to students from each student group."

"Issues which are only marginally related to the war should not be emphasized," the faculty statement continued. "Further-

more, tactics which may well be offensive to people who are otherwise ready to join the anti-war movement should be avoided. The protest of ROTC at Bauer planned for October 15 is likely to have these undesirable side effects. For these reasons, the Committee of Concerned Faculty has made efforts to disassociate itself with the activity in Bauer Center."

At first the faculty had resisted the inclusion of a local SDS speaker in the morning teach-in because they did not want to provide a forum for the advocacy of the march on Bauer. But Jim Kulk has been invited to speak by the faculty tomorrow morning anyway.

"We had a long debate about what to do," says Concerned Faculty member Frank Wyckoff, "and we decided it would be best to leave it up to the students to decide what they want to do."

Steve Powlesland of the Coalition said last Sunday night that "the hope for a wide variety of alternatives for non-violent action in protest of the war" and "the desire to end the 'Claremont syndrome' (fighting one's friends harder than one fights the enemy)" are the things that have motivated the Coalition. "The Coalition," Steve added, "says 'We make no particular recommendations regarding the activities. We ask only that each individual participate in as much as he is able.'"

Teach-In

One highlight of the moratorium will be a "teach-out." Students and faculty will go out into the Claremont community to talk with businessmen and community leaders in an attempt to persuade them to oppose the war.

The "teach-out" teams' training session has been scheduled for tonight, October 14, at 8 o'clock in Walker Lounge on the Pomona campus.

The agenda for the training program includes a brief resume of the aims and reasons for the moratorium against the Vietnam War; an examination of the issues and the status of the Nixon administration's policy; small group discussions about the process of meeting and discussing the issues with Claremont business, religious, educational, and political leaders; and a concluding assignment of specific persons to be contacted by each two-or-three man team.

David Barry, a junior at Harvey Mudd College, has been in charge of the recruitment of students for the "teach-out" teams. Doug Mitchell, former assistant chaplain, currently studying in the graduate school's government department, has been working on the program for tonight's meeting.

morning teach-in

A crowd of several hundred students, faculty, and Claremont citizens sat on a wet lawn at College and Bonita to hear three hours of speeches at the morning teach-in yesterday. The speakers were Dr. Karem Monsour of the Counseling Center, ASPC President Eric Sundquist, Dr. Louis Benezet, President of CGS and UC, Dr. Arthur Ferraru of Pitzer, PC student John Harris, Jim Kulk of SDS, Dr. Joseph Platt, President of HMC, Physics Professor Jack Miller, and Dr. Harry Seifert of

"Groups of students clustered around television sets to watch the 6:00 news last night, feeling that they had in some way contributed to the news of the day. This feeling of solidarity was often repeated when Pomona students spoke of their involvement in the moratorium. With many, even the possibility of opposition to their ideals was forgotten in moments of estatic oneness."

the School of Theology. Professor Joseph Ricapito, a leader of the Concerned Faculty, acted as moderator.

Most of the speakers stressed the need to make policy more moral, to make moral considerations a basic part of our political thinking. The immorality of the present situation led them to emphasize the need for moral as well as rational analysis of political questions, and indeed our need for more self-examination as a nation.

Monsour, speaking from his perspective as a psychiatrist, stressed the need to keep the war from depriving us of "the remainder of our humanness." America, he said, must find ways to reaffirm, not to degrade and suppress, the human spirit and dignity of its citizens and the people its policies affect throughout the world. Hoping "to find every American rising to speak out against this degradation," he said, "It seems incomprehensible that Governor Reagan doesn't understand. . ."

Eric Sundquist spoke next, giving a brief but sharp talk on the absurdities that confront American youth at a time when "responsible" older people are continually urging "rationality" in expression of political beliefs. It is absurd above all, he said, to be having men kill their fellow men while Nixon is asking for 60 days of "peace and quiet so he can think." He found it absurd that he had to justify his religious beliefs to a board of old men who will pass on his C.O.

American youth will be congratulated for their faith in the established channels, but, he asked, can the usual channels be valid when they have gotten us into such a mess as Vietnam, and failed to get us out? Sundquist concluded, "I'm hoping we're going to scare Nixon, to stir his imagination, and I don't care whether that's rational or not."

President Benezet, alluding to his father's efforts in the struggle

to get the US into the League of Nations, said that Viet Nam has all but done to the UN what Lodge did to the League. Benezet wondered what effect the war will have on the children now growing up who cannot remember a time when there was no color-televised war every night.

Taking a more optimistic view than Sundquist, who saw increasing government suppression of dissent, Benezet hoped that the news exposure of the killing, the degradation, the graft and corruption of war would bring Americans to realize the full horror of the war. Benezet was encouraged with the awareness of today's students, and said that the academy can and should strive to revive discussion of the war, subject national policy to scientific study, especially in the area of the arms race, and act as a theater of debate on national goals.

As some elderly people from Claremont, one or two wearing peace buttons, drifted in, Dr. Ferraru discussed the increasing failure of people to control their institutions. People are forgotten as the purpose of an institution becomes self-preservation. And the war itself has become an institution, with its own needs, and even its own ethic. It has, he said, been sanctified like a crusade. Even disunity has been institutionalized by the rule of the contented over the discontented.

The doctrine of academic neutrality has become part of the

more ...

Thursday, October 16, 1969 Claremont, California

Articles in *The Student Life* about the October 15, 1969, Moratorium. Special Collections, Honnold/Mudd Library of the Claremont Colleges

teach-in II

The afternoon teach-in began at 1 o'clock and continued past 4:00. The first scheduled event was a performance of three anti-war plays by Andy Doe's Street Theatre. Entertainment continued as Guy Carawan and Chris Darrow sang. The Rev. Larry Rouillard followed with a speech on the Draft Counseling Center at McAlister.

The Street Theatre's first play was "Parable", a monologue accompanied by a pantomime. A peaceful forest scene was set. Wind and rain came and beat down on the trees; the trees trembled under the natural forces; some broke. The storm passed.

But the trouble was not over in the forest: man came and built towns and the towns grew into cities. And with the cities' growth then had differences, and in the city the differences became vast disagreements, and wars were fought over them, making it necessary to have soldiers. Out of wars came magnificent heroes! Unfortunately, the war destroyed the city, but no matter, for it grew up again. It was a peaceful city: nothing ever happened. Sometimes someone died, sometimes someone loved, and out of this love children were born, . . . and the cycle continues.

The second play concerned "Monroe", a four-year-old boy who (as four-year-old boys do) would not eat, would not sleep, and hated little girls. By some efficient bit of bureaucracy, Monroe was inducted into the army. Eventually Monroe tried to convince the officers that he was only four. The responses were less than satisfying (the sergeant: "Men of four are not required to serve in the armed forces, ergo you are not four." The psychiatrist: "You only think you are four." Etc.).

Finally, despite his searing desire to be patriotic, Monroe broke down and cried RIGHT IN THE MIDDLE OF THE PARADE FIELD. This time the army logic worked in Monroe's favor: "Men don't cry, only babies cry". . .ergo Monroe was only four. Immediately the army had him honorably discharged, given medals, sign a release. This, of course, made Monroe feel better. But henceforth, when Monroe refused to eat or sleep, his mother reminded him of the time he was in the army. . .

The third piece brought the assembly right into the training camp to show them that the army is not all that bad. Indeed, there are some very understanding fellows like "Sgt. Jackson", weapons instructor. The good sergeant discussed the "gas-operated, semi-automatic, clip fed, caliber .30 shoulder weapon," the M-1. He explained that "if you take care of your rifle, it will take care of you," and "if you LOVE your rifle, it will LOVE you". . .with all the Freudian implications.

availability of the Committee of Concerned Asian Scholars who were prepared to answer questions about the Vietnamese conflict. Stationery on which to write congressmen and SDS leaflets were also available.

Sundquist also announced the success of the moratorium, up to that point, in terms of participation. A representative of Claremont High School then announced that 1100 out of 2200 high school students had participated in a rally at CHS. Mrs. Patty Hall was the last speaker on the program, after which the assembly dispersed, some members remaining to form small discussion groups.

Guy Carawan and Chris Darrow followed the Street Theatre with fifteen minutes of songs, some for friends in prison.

The Reverend Larry Rouillard of McAlister Center spoke next, noting that Guy's and Chris' was a hard act to follow, but his first comment, that the Selective Service System was the largest violator of the law in the US today, drew applause from the large crowd. He said that the reason is that most draft board members DON'T KNOW THE LAWS, and thus the need for draft counselors and lawyers arises.

The two crucial times, the times that Rev. Rouillard is most emphatic in his advice to see a draft counselor, are at age 18--the first registration--and at the beginning of the fourth year of college--when one applies for a C.O. (probably). He stated that if you don't want to enter the army, you don't have to. To implement his advice, Rev.

"I don't think the colleges should associate in any way with institutions of war. I don't think any student has the right to learn the skills of war. No institution can afford the luxury of being silent when the military is such a strong and corrupting influence."

Eric Sundquist

Rouillard offered the services of the Draft Counseling Center at McAlister Center.

After Mr. Rouillard, Eric Sundquist, chairman of the Coalition Committee and ASPC president, announced a press conference to be held later in the day and the

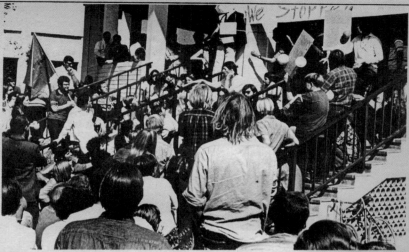

bauer

Shortly before 1 p.m. about 150 persons marched on a closed Bauer Hall. Prior to the march, Jim Kulk addressed the crowd, saying that the demonstration would be in celebration of ROTC's being closed that day, and in anticipation that ROTC would be closed two days in November and three days in December.

Some of the marchers carried balloons in celebration, many wore black armbands, and Kulk waved a brick. They moved out from College and Bonita six abreast, with

march

In a candlelit march through Claremont to a mass rally at Alumni Field, some 2000 people yesterday night expressed their opposition to the war in Vietnam.

Chanting "peace now" and singing "all we are asking is: give peace a chance," the orderly procession moved from the staging area at College and Bonita up Bonita to Yale, from Yale to Eighth, and then from Eighth to the field at College and Sixth.

Moratorium monitors guided the crowd: 12 Claremont Police officers directed traffic at all of the intersections. The marchers included 150 from Chaffey College, some of whom walked the eight miles to Claremont from a rally at Chaffey, and there was also a delegation which marched from the School of Theology at Claremont.

People watched the march from their home front porches and windows; a good number of community people participated, particularly high school students but also elderly couples and young couples with their children. A few dogs ran loose. Everyone had trouble keeping their candles from blowing out.

Finally the march reached the rally, where a few hundred people were waiting already. Signs such as "Nixon-Thieu in '72?" and "Swap Spiro for Peace" appeared; a more conservative person unfurled two banners on the bleachers, "Nixon Wants Peace Too" and "Help Bring PEACE Support the PRESIDENT."

Moratorium officials and two independent SL surveys estimated the marchers at 2000; a Claremont police officer suggested 5000.

Of course there were those who braved social ostracism to go to class. One such student commented, "In the long run I can do more if I go to class; parading around is fruitless." Another spoke resentfully of those who had asked a professor to cancel class. "They made my decision for me," he said. "Boycotting should be an individual thing, not something decided by 51 percent."

linked arms, intermittently chanting slogans such as "Stop ROTC, stop the war," "Ho, Ho, Ho Chi Minh, the SDS is going to win," and "Peace. . .Now."

There were a few pro-ROTC signs along the parade route, and fewer spectators. The onlookers had gathered at Bauer, where they watched the demonstrators march around the building and rally on the front steps.

Mike Ryan addressed the marchers, saying "That ROTC is closed today is due to our force. . .How

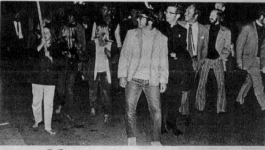

rally

"I must confess that I stand before you tonight not simply as an American who is indignant, but as a black American who is outraged. . .In the words of Langston Hughes, I must cry out: 'Oh yes, I say it plain, America never was America to me, and yet I swear this oath, America will be!'"

Thus Chaplain James Joseph concluded yesterday night's rally at Alumni Field protesting the war in Vietnam. The speakers at the rally included Methodist Bishop Gerald Kennedy, Jeremy Larner, a speech writer in Senator McCarthy's presidential campaign, Bill Gunther of Businessmen Move Toward Peace, Eric Sundquist, ASPC President, Joseph Platt, HMC President, and Lee C. McDonald, Pomona government professor. Tim Ryan and Chris Darrow sang peace songs.

Sundquist pointed out how opposition to the war had brought many together for the first time: "You businessmen here -- you may be holding the hand of an SDS member. And you SDS members here--you may be holding the hand of a businessman."

"I am a conscientious objector," Sundquist said, "I will not fight in any war. . .Maybe that sounds irrational, but what is rational anyway?. . .What's happening in America is not rational."

Jeremy Larner said of the McCarthy campaign: "We felt America would be hard to get to--I think we were wrong. . .We started a movement, a will in this country to save democracy and make it work."

"I think," Larner said, "That this country is big enough to say we lost. . .We're not Communists.

much to you want to change the political and economic structures of this country? Both the war and ROTC are tied to the political and economic structures of this country. . .ROTC isn't shut down for good. We aren't finished either."

He also said that they had not had to decide the question of whether of not to break the law. Then Eric Sundquist spoke, followed by Jim Kulk. During Kulk's speech, ex-President Benson of CMC was hung in effigy. The hanging was unimpressive.

Communism is a form of thought control--one thing we're against no matter where it's from."

Bishop Kennedy declared "I'm not a pacifist. . .Yet so far as this war is concerned I'd have to say if I were a young man I'd be a C.O. and I'd go to jail if necessary."

"Communism" said the Bishop, "is not monolithic--like I used to think the Catholic Church was . . . We do not have to interfere everywhere in the world. . .We have denied the American spirit in an experiment which can destroy us . . .But I am hopeful . . .Something is on the way that nobody can stop. I believe tonight that we might even penetrate into the White House."

Lee McDonald gave "a little bit of Claremont history," He recounted the 1965 and 1967 Claremont protest marches; "This year, a far larger group is here again. . . Our hope is not overpowering, yet we find some glimmers of hope. . . (Nixon) is very much affected by all that goes on today. . .The majority of people today oppose the war --and college students are primarily responsible for that change."

Rev. Joseph expressed his outrage at President Nixon's statements on the moratorium: ". . . today, we say to the President that when patriotism becomes an absolute, we must protest; not because we are unpatriotic but because we ask ourselves 'is it more patriotic to mourn a dead soldier than to honor a living conscience?'"

He prayed: "In the name of all that is sacred, just and honorable, let us go out not simply to proclaim the message of peace, but to do the work of peace. Amen."

11/04–11/30/69
"California Abstract Expressionism: Monte Factor Collection"
Exhibition includes John Altoon, Edward Kienholz, Frank Lobdell, Nathan Oliveira, Richards Ruben, Hassel Smith, and Emerson Woelffer. Organized by Hal Glicksman.

12/01/69–01/10/70
"Movie Palace Modern: Drawings of A. B. Heinsbergen"
Traveling exhibition of architectural renderings from the 1930s by the California designer A. B. Heinsbergen. Organized by Hal Glicksman with the Smithsonian Institution.

1969

MOVIE PALACE MODERN

Front cover of exhibition brochure for "Movie Palace Modern: Drawings of A. B. Heinsbergen," 1969. Pomona College Museum of Art Archives

12/12–12/20/69
"Ron Cooper"
Second exhibition of the
Artist's Gallery program.
Organized by Hal Glicksman.

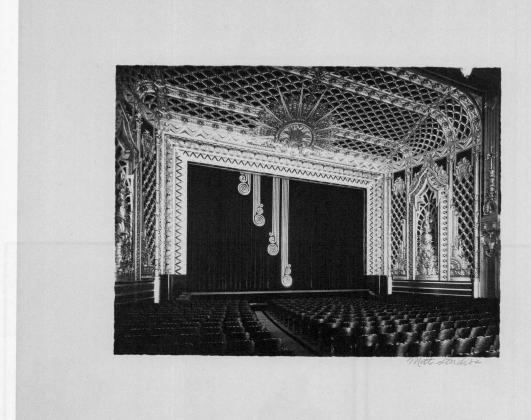

POMONA COLLEGE ART GALLERY

December Events 1969

MOVIE PALACE MODERN: A. B. HEINSBERGEN

December 1 - January 10

Decorative schemes for movie theaters and other major buildings of
the 1930's. A series of tempera and water-color drawings that served
as proposals and alternative color schemes. Excellent as works of art
in themselves, Heinsbergen's delicate drawings form a valuable doc-
ument of many buildings that have been destroyed or drastically altered.

ANNUAL PRINT SALE

December 6, Saturday, 9 - 5, Rembrandt Hall

Many new sources of graphic art are being utilized to increase the scope
and quality of the selection for this year. The work of Pomona College
art students will also be offered for the first time.

RON COOPER

December 13 - 20. Opening Friday, December 12, 7 - 10 p.m.

The result of Ron Cooper's residence with the gallery. Some of the
materials he has requested so far are glass, steel and giant rocks.

CONTINUING EVENTS

CALIFORNIA ABSTRACT EXPRESSIONISM from the Collection of
Mr. and Mrs. Monte Factor.
To November 30

ROBERT IRWIN

A single new work of this Los Angeles artist to remain on view for the
entire year as a focus of contemplation and repose.

The Gallery is located at College and Bonita Avenues in Claremont
Open Monday thru Friday 9 a.m.-5 p.m. — Saturday and Sunday 1-5 p.m.

Pomona College Art Gallery
Friday Dec. 12 7-10 P.M.
RON COOPER
spectacular ~~giant rocks~~
& glass smash

TOP
Motts Studios, *Photograph of Fox Wilshire
Theatre Auditorium, Beverly Hills, California*,
1930. 7 ⅛ × 9 ½ in. (18 × 24 cm). From
"Movie Palace Modern: Drawings of A. B.
Heinsbergen" exhibition, 1969. Pomona
College Collection, Gift of the Grinstein Family

BOTTOM LEFT
Poster for December 1969 events.
Pomona College Museum of Art Archives

BOTTOM RIGHT
Exhibition flyer for "Ron Cooper," 1969.
Pomona College Museum of Art Archives

02/13–03/08/70
"Michael Asher"
Third exhibition of the Artist's
Gallery program. Organized
by Hal Glicksman.

02/20/70
Artist Judy Chicago gives a
lecture at Pomona College.

02/22/70
Snow Atmosphere
An Atmosphere performance
by Judy Chicago at Mt. Baldy,
San Gabriel Mountains, California.
Organized by Hal Glicksman.

1970

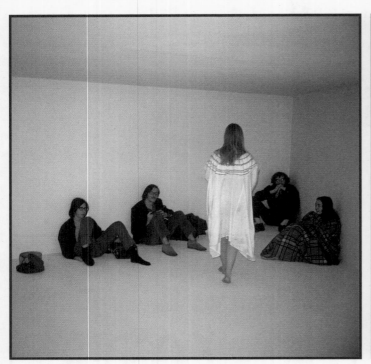
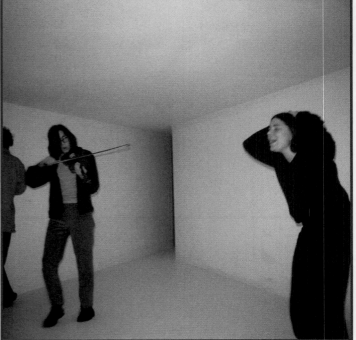

Students playing music and singing
in **Michael Asher** installation, February 1970.
Pomona College Museum of Art.
Gift of Hal Glicksman. The Getty Research
Institute, Los Angeles (2009.M.5)

03/31– 04/26/70
"Three Master Photographers:
Wynn Bullock, William R. Current,
Brett Weston"
Exhibition of photographs donated
to the museum's collection.
Organized by Hal Glicksman.

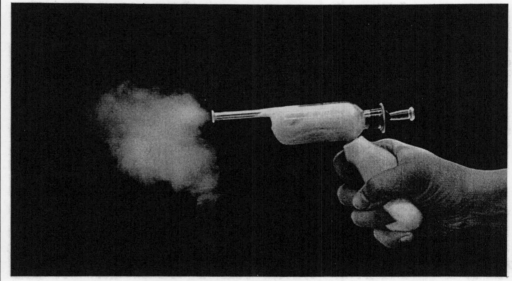

SNOW ATMOSPHERE

by

JUDY GEROWITZ

POMONA COLLEGE ART GALLERY

presents the 9th in a series

Sunday, February 22, 1970

Four P.M. Sharp

Allow about an hour from Claremont to the Falls because of expected heavy traffic. In case of inclement weather on February 22, the event will take place Sunday, March 1. Call (714) 626-8511, ext. 2241, if in doubt.

Over 400 U.S. universities and colleges are closed or on strike for antiwar protests.
Wave of bombings across country.
Joan Didion publishes the novel *Play It as It Lays*.
For his *Cremation Project*, John Baldessari cremates most of the paintings he made between 1953 and 1966.

Eugenia Butler Gallery presents William Leavitt's first solo show.
William Wegman moves to Los Angeles to teach at California State University, Long Beach.
Nuclear Non-Proliferation Treaty goes into effect March 5 after ratification by forty-three nations.
First Earth Day, April 22, founded as a national environmental teach-in day by Wisconsin Senator Gaylord Nelson.

U.S. invades Cambodia on April 29 in search of Viet Cong, triggering widespread antiwar protests in the U.S.
Four students killed on May 4 by National Guard at Kent State University in Ohio.
U.S. voting age lowered to eighteen on June 10.
Angela Davis becomes the third woman on the FBI's Most Wanted list in August.

Judy Chicago sets up the first Feminist Art Program at California State University, Fresno.
"Young Artist: Allen Ruppersberg" exhibition at the Pasadena Art Museum from September 22 to October 25.
Judy Gerowitz changes her name to Judy Chicago in October.

Exhibition flyer for **Judy Chicago's**
Snow Atmosphere, 1970. Pomona College
Museum of Art Archives

02/25–02/28/70
American Indian Conference
held at the Claremont Colleges.

04/13–04/20/70
"Steel Boxes"*
Thesis exhibition for George
Ketterl's MFA from Claremont
Graduate School. Organized
by Hal Glicksman.

05/01–05/27/70
"Tom Eatherton"
Fourth and final exhibition
of the Artist's Gallery program.
Organized by Hal Glicksman.

1970

GEORGE KETTERL STEEL BOXES

MONTGOMERY ART GALLERY
POMONA COLLEGE APRIL 13-20-70

NEXT PAGE TOP LEFT / TOP RIGHT
Front cover of exhibition brochure for
"Chicano Graffiti," 1970. Pomona College
Museum of Art Archives

Dorothy Townsend, "Chicano Graffiti:
Man Leaves his Mark," *Los Angeles Times*,
May 1, 1970. Article on "Chicano Graffiti"
exhibition. Gift of Hal Glicksman. The Getty
Research Institute, Los Angeles (2009.M.5)

NEXT PAGE BOTTOM
Exhibition photograph of graffiti artists
in front of their "clubhouse" in the "barrio"
of Claremont, from "Chicano Graffiti," 1970.
Gift of Hal Glicksman. The Getty Research
Institute, Los Angeles (2009.M.5)

Exhibition flyer for "Steel Boxes," 1970.
Pomona College Museum of Art Archives

"Chicano Graffiti"
Exhibition of photographs of the
"signatures and symbols of
Mexican American youth...taken
in Los Angeles barrios." Organized
by Bob Allikas and Hal Glicksman.

Chicano Graffiti

The Signatures and Symbols of Mexican-American Youth

An exhibit organized by Bob Allikas and Hal Glicksman

May 1 to May 31

The Pomona College Gallery, located in the Montgomery Art Center, is at the corner of
Bonita and College Avenues, Claremont. Hours are 9-5 daily, 1-5 Saturday and Sunday.

Los Angeles Times

EDITORIALS

CC PART II—15 17

FRIDAY, MAY 1, 1970

COLLECTORS' ITEMS—Display of graffiti at Pomona College
Art Gallery is shown by Hal Glicksman, top, director, and Robert
Allikas, a collector of Chicano wall-writing. At left is an scandal
jail bed, its underside decorated over the years by many inmates.
Times photo by John Nelson

Chicano Graffiti: Man Leaves His Mark

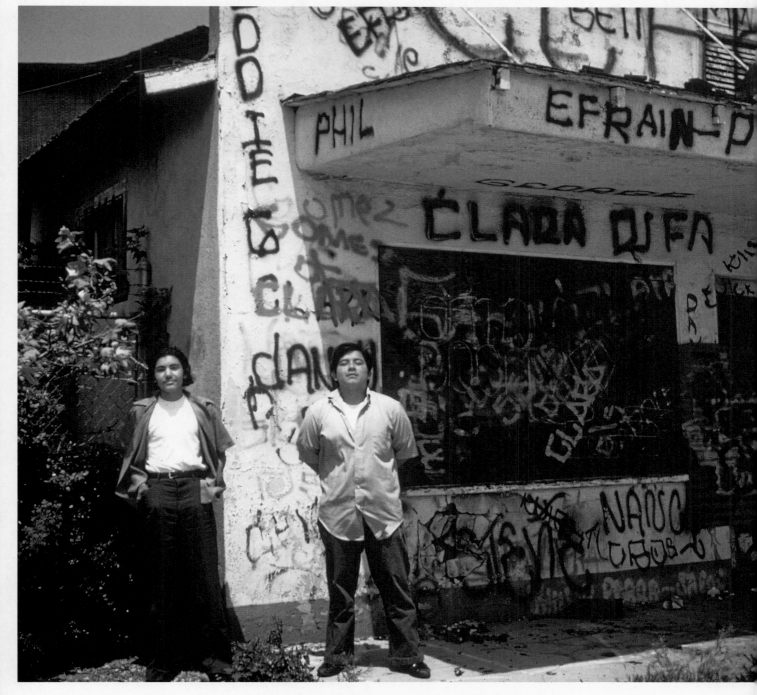

1970

05/04/70
Antiwar protest at Claremont McKenna College's Bauer Hall.

05/25–06/01/70
"Lewis Baltz"
Exhibition of photographs from the Prototypes series. Organized by Hal Glicksman.

05/29–05/31/70
"Configuration 010 Audio Activity" Thesis exhibition for Michael Brewster's MFA from Claremont Graduate School. Organized by Hal Glicksman.

Fall 1970
Helene Winer hired as Gallery Director and Assistant Professor of Art at Pomona College.

10/23/70
Richard (Dick) Barnes organizes theater performance *The Eighth Avatar* at Pomona College.

C. Lewis Baltz will show thirty photographs at the Montgomery Art Center, Pomona College, (College at Bonita Street) Claremont, Ca., from May 25 through June 1. The gallery is open from 9 – 5 weekdays and 1–5 Saturday.

Exhibition poster for "Lewis Baltz," 1970

11/05–11/29/70
"Milford Zornes"
Exhibition of watercolor, ink, and mixed media works.

12/05–12/26/70
"Lithographs"
Lithographs loaned by Gemini G.E.L., Los Angeles. Includes Josef Albers, Ellsworth Kelly, and Frank Stella. Organized by Helene Winer.

12/05–12/26/70
"Monoprints"
"Original work that can, in a loose interpretation of the term, be considered a print." Includes John Baldessari, Billy Al Bengston, Ron Cooper, Joe Goode, David Gray, Sol LeWitt, Ed Ruscha, and De Wain Valentine. Organized by Helene Winer.

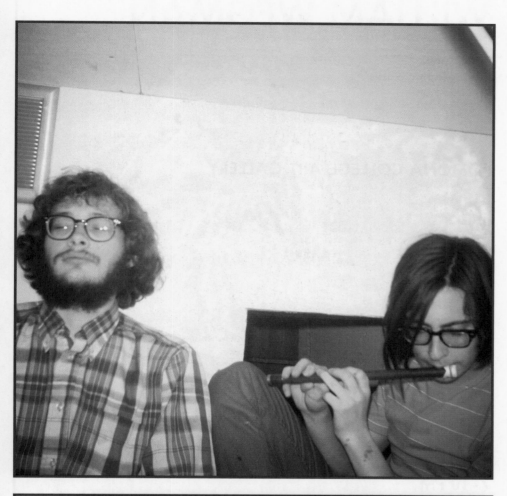

Photographs of students in a hidden, secret room below college dormitories. Gift of Hal Glicksman. The Getty Research Institute, Los Angeles (2009.M.5)

Eric Orr and John McCracken create performance sculpture *Blood Shadow* in Venice.

Reyner Banham publishes *Los Angeles: The Architecture of Four Ecologies*.

"Young Artist: Ron Cooper" exhibition at Pasadena Art Museum from January 19 to February 28.

NASDAQ stock index debuts on February 8.

The Ed Sullivan Show airs its final episode on March 3.

"Studio Show" in Jack Goldstein's Figueroa Street studio from April 4 through 24. Artists: Goldstein, Bas Jan Ader, Ger van Elk, William Leavitt, Allen Ruppersberg, and Wolfgang Stoerchle.

Charles Manson is sentenced to death on April 19; sentence commuted to life-imprisonment in 1972.

Chris Burden performs *Five Day Locker Piece* at University of California, Irvine from April 26 to 30.

Allen Ruppersberg's *Al's Grand Hotel* runs May 7 through June 12 at 7175 Sunset Boulevard, Hollywood. The hotel is open to guests on Friday and Saturday nights.

"24 Young L.A. Artists" exhibition at the Los Angeles County Museum of Art (LACMA) from May 11 through July 4, curated by Jane Livingston ('65) and Maurice Tuchman. Includes Michael Asher, Jack Goldstein, Allen Ruppersberg, Wolfgang Stoerchle, William Wegman, and John M. White.

Exhibition announcement for "William Wegman," 1971. Pomona College Museum of Art Archives

01/07–01/31/71
"William Wegman"
"An exhibition of videotapes, photographic work, and arrangements."
Organized by Helene Winer.

02/09–03/07/71
"Wall Reliefs"
"Five relief staircases designed and constructed especially for Pomona College by Joe Goode." Organized by Helene Winer.

02/10–03/07/71
"John McCracken: Wall Pieces"
An exhibition of three painted-wood wall sculptures. Organized by Helene Winer.

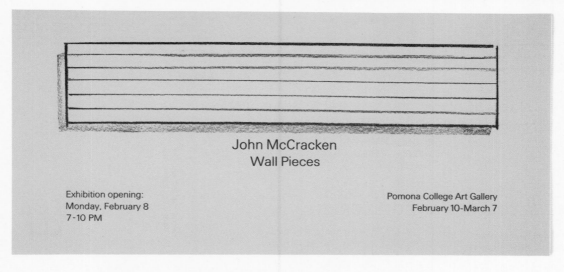

John McCracken
Wall Pieces

Exhibition opening:
Monday, February 8
7-10 PM

Pomona College Art Gallery
February 10-March 7

"Art & Technology" exhibition at LACMA, from May 11 through August 29; curated by Maurice Tuchman.

U.S. ends its trade embargo on China on June 10.

In the trial New York Times Co. v. United States, the U.S. Supreme Court rules on June 30 that the Pentagon Papers may be published.

Judy Chicago brings the Feminist Art Program to California Institute of the Arts in the fall, where she co-teaches with Miriam Schapiro.

"11 Los Angeles Artists" exhibition at the Hayward Gallery in London, from September 30 through November 7, includes Robert Irwin and William Wegman.

Lewis Baltz shows Tract Houses as his Claremont Graduate School MFA thesis exhibition in December at Castelli Graphics, New York.

TOP LEFT / TOP RIGHT
Cover of **William Wegman** exhibition catalogue, 1971. Pomona College Museum of Art Archives

Cover of exhibition catalogue for **Joe Goode's** "Wall Reliefs," 1971. Pomona College Museum of Art Archives

BOTTOM
Exhibition announcement for "John McCracken: Wall Pieces," 1971. Pomona College Museum of Art Archives

03/29–04/16/71
"John M. White"
"Sculpture of non–traditional materials such as tape, paper, sand, cardboard, and wood." White also presented two performances: *Preparation F* and *Wooded Path*. Organized by Helene Winer.

04/17–05/30/71
"MFA Exhibition"
Thesis exhibition for the MFA candidates at Claremont Graduate School. Includes Steve Davis, Marcy Goodwin, Owen Holder, David Smith, Peter Tkacheff, and Paul Waszink.

1971

JOHN M. WHITE

three rooms of :

notes	March 29 - April 16
drawings	
pallets	
bags	
towels	
tape	
rugs	
sand	
pins	
paper	
wood	Monday - Friday 9-5
ladder	Saturday and Sunday 1-5
string	*closed Easter Sunday*

POMONA COLLEGE ART GALLERY

Bonita and College Avenue
Claremont, California 91711

4/20/71

PRESS RELEASE

Four graduate art students will be exhibiting their work in the gallery during April and May. The exhibitions will alter throughout that period. David Smith has constructed a room in which he creates environments (April 17 - May 16). Steve Davis and Paul Waszink will do work during the following week, followed by watercolors by Marcie Goodwin, painting by Peter Tkacheff, a graduating senior, and sculpture by Owen Holder.

Helene Winer
Gallery Director

LEFT / RIGHT
Exhibition poster for "John M. White," 1971. Pomona College Museum of Art Archives

Press release for "MFA Exhibition," April 20, 1971. Pomona College Museum of Art Archives

04/20–05/16/71
"Recent Paintings by Guy Williams"
Exhibition of paintings. Organized
by Helene Winer.

09/23–11/04/71
"Permanent Collection"
Exhibition of nineteenth- and
twentieth-century art from
the museum's collection.
Organized by Helene Winer.

11/16–12/17/71
"Edward Moses: some early
work, some recent work, some
work in progress"
Survey of works from the 1950s to
1971. Organized by Helene Winer.

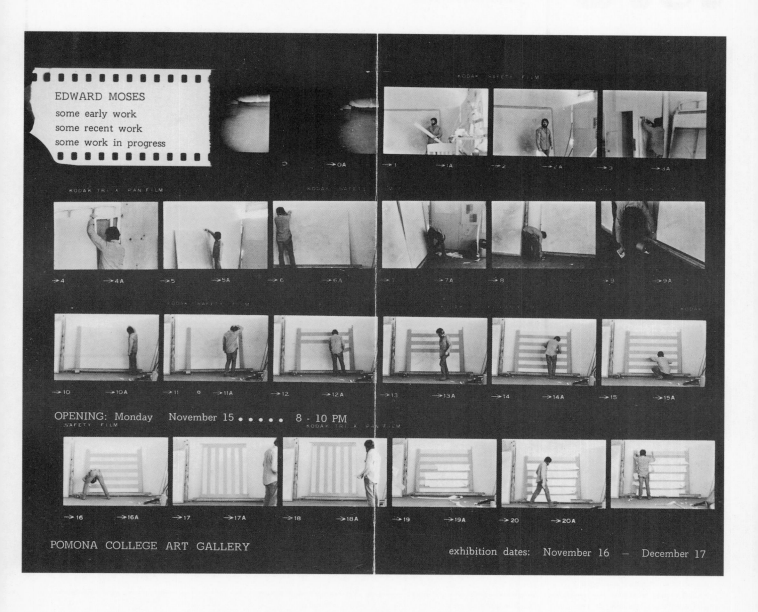

Exhibition announcement for "Edward
Moses: some early work, some recent
work, some work in progress," 1971.
Pomona College Museum of Art Archives

01/18–02/20/72
"Bas Jan Ader, William Leavitt,
Ger van Elk"
Exhibition of recent works
by the artists. Organized by
Helene Winer.

1972

BAS JAN ADER

WILLIAM LEAVITT

Opening: Monday, January 17, 8-10 PM

GER VAN ELK

Pomona College Art Gallery January 18 - February 20

Alex Comfort publishes the bestselling manual *The Joy of Sex*.

Bas Jan Ader begins teaching at Immaculate Heart College in Los Angeles.

Womanhouse, the first woman-centered art installation, is created in Los Angeles by Judy Chicago and Miriam Schapiro with their students in the Feminist Art Program.

President Nixon makes an unprecedented eight-day visit, February 21 through 28, to the People's Republic of China and meets with Mao Zedong.

The U.S. and the U.S.S.R. join some seventy nations in signing the Biological Weapons Convention, an agreement to ban biological warfare on April 10.

Okinawa is returned to Japan on May 16 after twenty-seven years of U.S. military occupation.

Angela Davis is found "not guilty" of murder on June 4.

Watergate break-in June 17 at Democratic National Committee headquarters, Washington, D.C.

President Nixon and White House chief of staff H. R. Haldeman are taped talking about using the CIA to obstruct the FBI's investigation into the Watergate break-ins on June 23.

President Nixon announces June 28 that no new draftees will be sent to Vietnam.

Exhibition announcement for "Bas Jan Ader, William Leavitt, Ger van Elk," 1972. Pomona College Museum of Art Archives

03/06/72, 03/13/72, and 03/20/72
"Performance Series"
Series of performances by three
Los Angeles artists: Hirokazu
Kosaka (March 6), Wolfgang
Stoerchle (March 13), and Chris
Burden (March 20). Organized
by Helene Winer.

04/72
Poet and writer David Antin
performs "Talking at Pomona,"
an improvisational "talk piece,"
at Pomona College.

04/05–05/03/72
"Los Angeles Painters of the
Nineteen Twenties"
Exhibition of forty artists active
in Los Angeles during the
1920s. Organized by Nancy Moure
and Helene Winer.

04/18/72
Ronald Reagan speaks at
the Athenaeum, Claremont Men's
(McKenna) College.

HIRO KOSAKA
Monday, March 6, 8 PM

WOLFGANG STOERCHLE
Monday, March 13, 8 PM

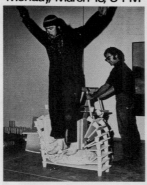

CHRIS BURDEN
Monday, March 20, 8 PM

ARTIST'S FILMS,
Thursday, March 2, 7 PM

**ARTIST'S PERFORMANCES
POMONA COLLEGE ART GALLERY**

LOS ANGELES PAINTERS
OF THE
NINETEEN TWENTIES

OPENING: 7-9 PM Wednesday, April 5

POMONA COLLEGE
ART GALLERY

APRIL 5 to MAY 3

Munich Massacre occurs during the 1972
 Summer Olympics in Munich, West
 Germany, August 26 through September
 11. Members of the Israeli Olympic team
 are taken hostage and eventually murdered
 by terrorist group Black September.
Hirokazu Kosaka performs at Mori's Form,
 Los Angeles on Sepember 1.

"Joe Goode" exhibition at Nicholas Wilder
 Gallery, Los Angeles from September
 2 to 30.
Bob Barker hosts the first episode of
 The Price Is Right September 4 on CBS.
"Ed Moses" exhibition at Nicholas Wilder
 Gallery, Los Angeles from October 3 to 21.

First female FBI agents are hired on
 October 25.
Chris Burden performs *Deadman* on
 November 12 opposite the Riko Mizuno
 Gallery. He is arrested and taken
 to court; Helene Winer later testifies
 on his behalf.
The Christmas bombing of North Vietnam
 leads to widespread international
 criticism of the U.S. and President Nixon.

LEFT / RIGHT
Poster for performance series with
Chris Burden, Hirokazu Kosaka,
and **Wolfgang Stoerchle,** March 1972.
Pomona College Museum of Art Archives

Exhibition announcement for "Los Angeles
Painters of the Nineteen Twenties," 1972.
Pomona College Museum of Art Archives

1972

Fall 1972
A faculty commission on the Education of Women is appointed, chaired by Jean Walton, Dean of Students. The Commission's deliberations lead to the introduction in the curriculum of a multidisciplinary course in women's studies and the establishment of an Office of Women's Studies.

09/72
Pomona College bans the annual weigh-in ceremony for all first-year women.

10/02–10/22/72
"Jim Morphesis Paintings"* Exhibition of recent paintings. Organized by Helene Winer.

10/05–10/22/72
"The Art of Greece and Rome" Exhibition of 52 pieces of Cypriot, Greek, Etruscan, and Roman sculpture, ceramics, coinage, and minor arts. Organized by Harry J. Carroll Jr.

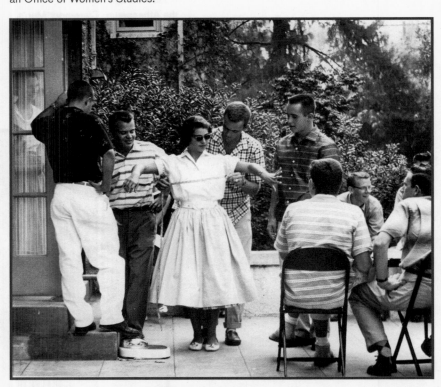

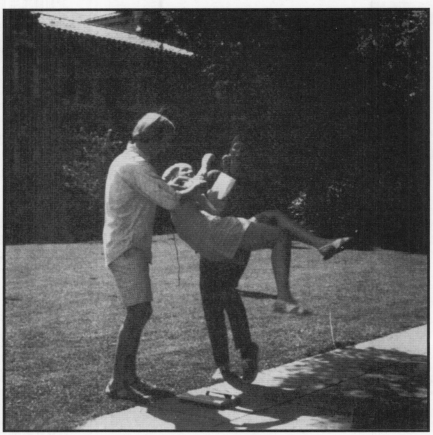

TOP / BOTTOM
Photograph of 1962 weigh-in of first-year woman by second-year men in *Claremont Courier*, September 27, 1962. Pomona College Photo Archives, Special Collections, Honnold/ Mudd Library of the Claremont Colleges

Photograph of woman resisting annual weigh-in, *The Student Life*, October 1, 1968. Pomona College Photo Archives, Special Collections, Honnold/Mudd Library of the Claremont Colleges

Richard (Dick) Barnes *The Death of Buster Quinine* performance, 1972. Dick Barnes Collections, Special Collections, Honnold/ Mudd Library of the Claremont Colleges

Richard (Dick) Barnes organizes
The Death of Buster Quinine,
an original play based on
medieval mystery plays, staged
east of the Claremont Colleges
in a rock quarry.

1972

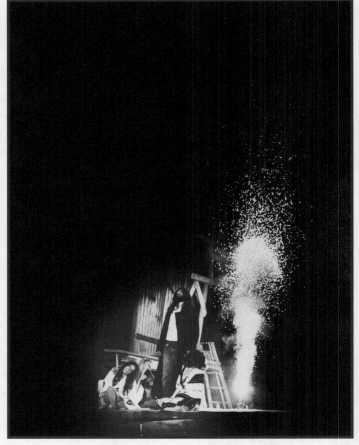

Richard (Dick) Barnes *The Death of Buster
Quinine* performance, 1972. Dick Barnes
Collections, Special Collections, Honnold/
Mudd Library of the Claremont Colleges

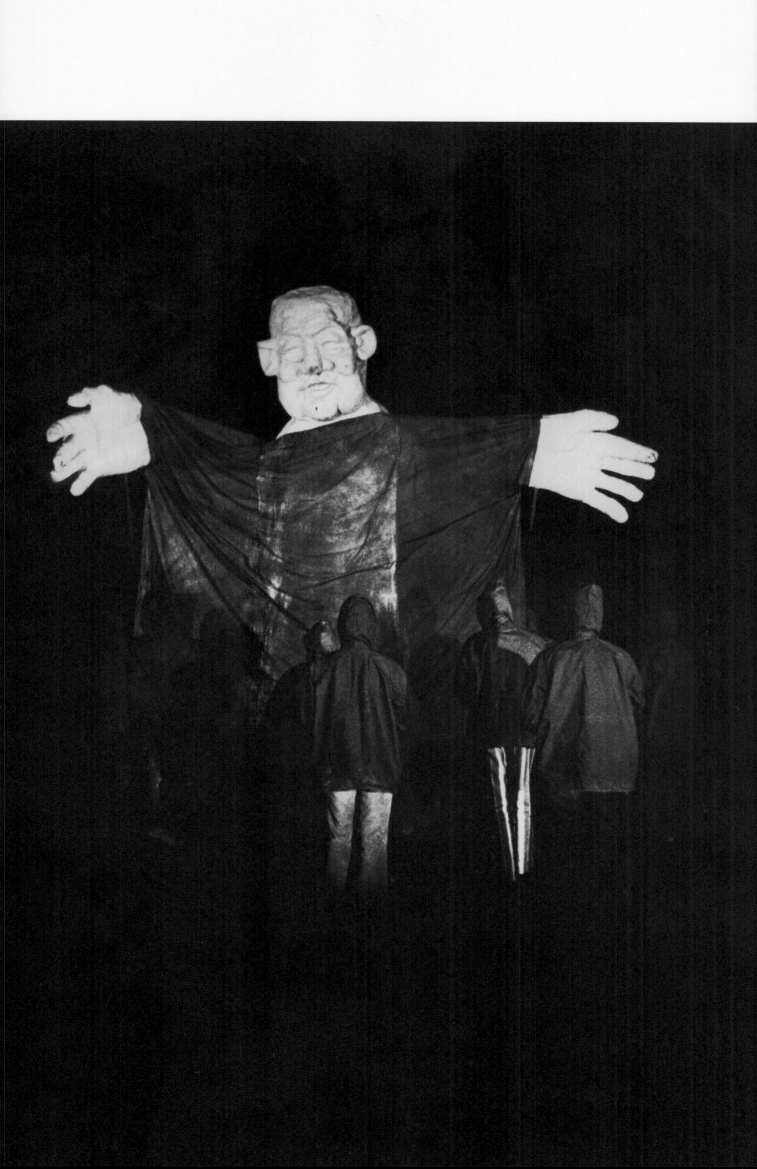

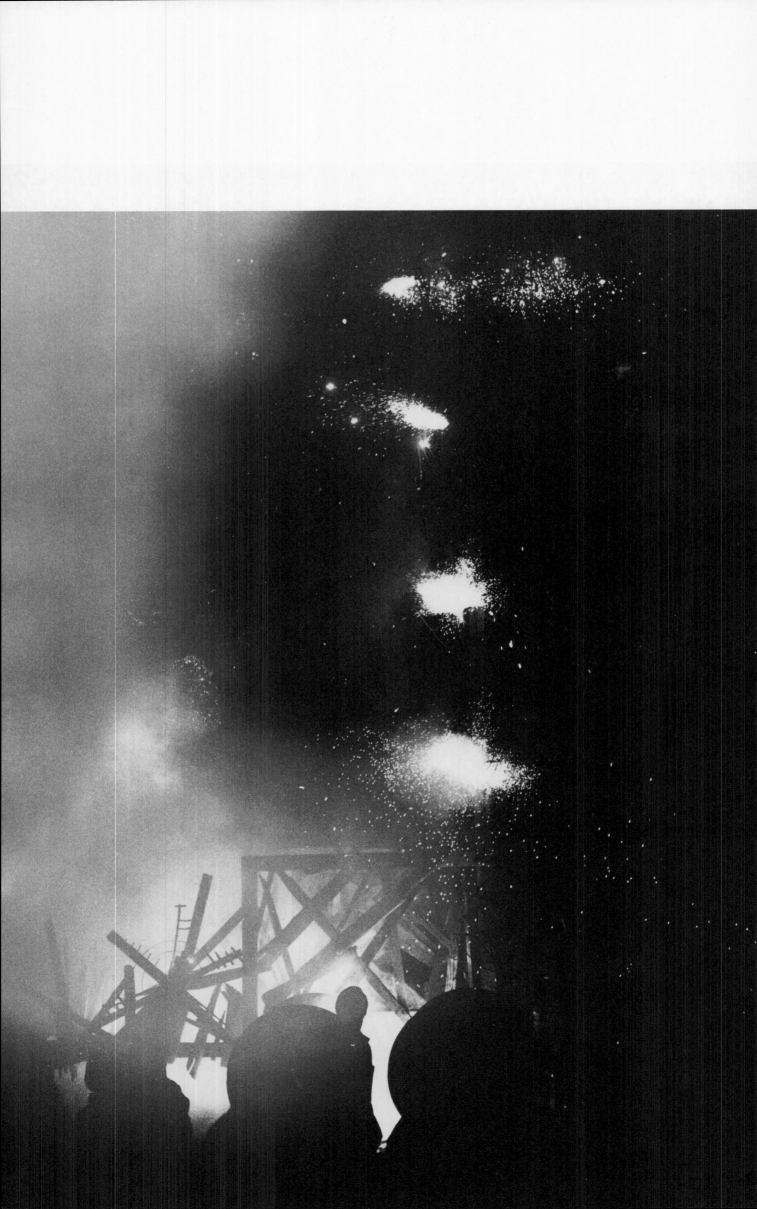

Richard (Dick) Barnes *The Death of Buster
Quinine* performance, 1972. Dick Barnes
Collections, Special Collections, Honnold/
Mudd Library of the Claremont Colleges

Allen Ruppersberg *Disappearing
Chinese Theater*, 1972. Postcards

1973

01/08–03/11/73

"Revolution in a Box from 1839:
A Historical Survey of Photo-
graphica in Two Parts"
An exhibition of approximately
200 photos, co-sponsored with
University of California, Riverside.
Part 1: Photographs; Part 2: Photo-
graphic equipment. Organized
by James Turrell and Leland Rice.

03/19–04/13/73

"Alumni Exhibition"*
Exhibition featuring James
Strombotne '56, Richard
White '56, Judy Fiskin '66, Bob
Bass '66, Norman Hines
'61, Jonathon Stokesbary '58,
and Sheldon Kaganoff '59.
Organized by Tom Horowitz.

The Woman's Building is founded by Judy
Chicago, art historian Arlene Raven,
and designer Sheila Levrant de Bretteville.
The building hosts feminist organizations,
businesses, art galleries, and the Feminist
Studio Workshop, the first independent
feminist art school.

Thomas Pynchon publishes the landmark
postmodern novel *Gravity's Rainbow*.

President Nixon is inaugurated for his
second term on January 20.

U.S. Supreme Court overturns state bans
on abortion in *Roe v. Wade* on January 22.

U.S. involvement in the Vietnam War
ends with the signing of the Paris Peace
Accords January 27.

The American Indian Movement occupies
the Pine Ridge Reservation on
February 27 at Wounded Knee, South
Dakota, for seventy days.

Last U.S. soldier leaves Vietnam on March 29.

LexisNexis computerized legal research
service debuts on April 2.

First handheld cellular phone call is made on
April 3 by Martin Cooper in New York City.

A seventy-one-day standoff between federal
authorities and American Indian Movement
activists occupying the Pine Ridge
Reservation at Wounded Knee ends with
the surrender of the militants on May 8.

Skylab, the first U.S. space station, is launched
on May 14.

U.S. bombing of Cambodia ends on August 15
after twelve years of combat activity in
Southeast Asia.

Claire Copley Gallery opens in October in
Los Angeles with the inaugural exhibition,
"William Wegman."

Poster for "Revolution in a Box from 1839:
A Historical Survey of Photographica
in Two Parts," 1973. Pomona College Museum
of Art Archives

04/23–05/11/73

"Artforms Abstract Activities Ideas: Exhibition of Conceptual Art." Exhibition at Pomona College Museum of Art and the Libra Gallery of Claremont Graduate School. Includes Eleanor Antin, John Baldessari, Ken Friedman, Douglas Huebler, Joseph Kosuth, Sol LeWitt, Tom Marioni, George Miller, Adrian Piper, Ed Ruscha, Wolfgang Stoerchle, and Lawrence Weiner. Organized by Tom Horowitz.

MONTGOMERY ART CENTER
of Pomona College

THE LIBRA GALLERY
of the Claremont Graduate School

PRESENT
AN EXHIBITION – SYMPOSIUM

ARTFORMS ABSTRACT ACTIVITIES IDEAS

EXHIBITING ARTISTS

John Baldessari
Ken Friedman
Douglas Huebler
George Miller
Sol LeWitt
Eleanor Antin

Tom Marioni
Joseph Kosuth
Adrian Piper
Lawrence Weiner
Edward Ruscha
Wolf Storchle

OPENINGS & LECTURES

Opening – Montgomery Art Center
April 23 to May 6 8:00 p.m.

Opening – Libra Gallery
April 30 to May 11 7:30 p.m.
Location – Galileo Hall

Moira Roth
Art Historian
Duchamp and Recent Art

Peter Plagens
Artist Critic
The Interesting

May 3 7:30 p.m. to 9:30 p.m.
Location – Rembrandt Hall
Gerald Ackerman
Chairman, Fine Art Dept., Pomona College
Ideas, Objects, & Art since the Renaissance

Stephen Erickson
Chairman, Philosophy Dept., Pomona College
Art & Philosophy

May 2 1:00 p.m.
Tom Marioni
Conceptual Art

Ken Friedman
The Fluxus Group

George Miller
Word & Object

May 4 1:00 p.m.
Theme- The Aesthetics of Ideas as the Interesting

Allen Kaprow
Associate Dean, Cal Arts

David Antin
Chairman, Fine Arts Dept., U C S D

John Baldessari
Cal Arts
Panel Discusion

John M. White creates the "Watts Performances" series for the Watts Community Housing Corporation.

Spiro T. Agnew resigns as vice president of the United States on October 10.

Arab Oil Embargo triggers an energy crisis.

American Psychiatric Association removes homosexuality from its official list of mental disorders on December 15.

Exhibition and symposium poster for "Artforms Abstract Activities Ideas," organized by the Libra Gallery at Claremont Graduate School, 1973. Pomona College Museum of Art Archives

1973

05/09–05/30/73
"Bravely Splashing Reds and Blues"
Exhibition of contemporary
Chinese art from Taiwan. Includes
Chuang Che, Chiang Han-Tung,
Wu Hao, Li Hsien–Kuang,
Ma Pai-Sui, Lee Shi-Che, Lung
Ssu-Liang, Chen Ting-Shih,
Lee Wen-Han, and Sun Ying.
Organized by Gerald Ackerman
and John Haeger.

05/30–06/10/73
"Senior Art Show"*
Senior thesis exhibition of Pomona
College art majors. Includes
Louise Bowler, Harold Feldman,
Cecile de Ford, Peter Shelton,
and Sandra Waine.

MAY 30–JUNE 10
art students
AT
pomona college—
a showing

HAROLD FELDMAN
PETER SHELTON
de FORD
SANDRA WARNE
LOUISE BOWLES
W/ A FILM BY RICK VOGT

MONTGOMERY ART GALLERY
POMONA COLLEGE –BONITA + COLLEGE AVE.
reception – WED. MAY 30, 8:00–10:00 P.M.

FILM SHOWN AT 7:45 P.M., REMBRANDT LECT. RM.

Exhibition announcement for "Senior
Art Show," 1973. Collection of the artist
[Peter Shelton]

Pasadena Art Museum becomes the Norton
Simon Museum.
President Nixon announces his resignation
on August 9.
President Gerald Ford announces clemency
program for draft evaders and deserters
on September 16.

"Wanted: Used White Bed Sheets," *Ad-Visor*,
April 19, 1973. Ad placed by **Peter Shelton**
to locate materials for his artwork. Collection
of the artist

ARTIST BIOGRAPHIES AND EXHIBITION CHECKLIST

Compiled by Carrie Dedon and Hai Minh Nguyen

BAS JAN ADER

Born: 1942, Winschoten, The Netherlands. Disappeared: 1975, Atlantic Ocean between Cape Cod, Massachusetts, and Falmouth, England

Education: 1965 BFA, Otis Art Institute, Los Angeles; 1967 MFA, Claremont Graduate School (CGS), Claremont, California

Selected Exhibitions: "In Search of the Miraculous: A Homage to Bas Jan Ader," Villandry, London, 1994; "Reconsidering the Object of Art: 1965–75," The Museum of Contemporary Art, Los Angeles, 1995; " Bas Jan Ader," Centre National d'Art, Grenoble, France, 1996; "Bas Jan Ader: Filme, Fotograpfien, Projektionen, Videos und Zeichnungen aus den Jahren, 1967–75," Kunstverein Braunschweig, Braunschweig, Germany (traveling), 2000; "Bas Jan Ader, Thoughts Unsaid, Then Forgotten," Museum Het Domein, Sittard, The Netherlands, 2001; Patrick Painter Inc., Santa Monica, California, 2002; "Index," The Swedish Contemporary Art Foundation, Stockholm, 2003; "The Last Picture Show: Artists Using Photography, 1960–1982," Walker Art Center, Minneapolis (traveling), 2003; "Open Systems—Rethinking Art c. 1970," Tate Modern, London, 2005; "All Is Falling," Camden Arts Center, London, 2006; "Into Me/Out of Me," KW Institute for Contemporary Art, Berlin, 2006; "Fall," Kunsthalle, Basel, 2007; "Color Chart: Reinventing Color, 1950 to Today," The Museum of Modern Art, New York, 2008; "In & Out of Amsterdam," The Museum of Modern Art, New York, 2009; "Suspended Between Laughter and Tears," Pitzer College Art Gallery, Claremont, California, 2010

Selected Bibliography: Helene Winer, *Bas Jan Ader, Ger van Elk, William Leavitt*, Pomona College Museum of Art, 1972; Bas Jan Ader, "In Search of the Miraculous (Songs for the North Atlantic July 1975)," *Art & Project Bulletin* 89, Amsterdam, July 1975; Liza Béar and Willoughby Sharp, "A Telephone Conversation with Mary Sue Ader, Los Angeles, May 28, 1976," *Avalanche* 13, Summer 1976; James Roberts, "Bas Jan Ader: The Artist Who Fell from Grace with the Sea," *Frieze* 17, June–August 1994; Thomas Crow, *Modern Art in the Common Culture*, Yale University Press, London, 1996; Brad Spence, ed., *Bas Jan Ader*, The Art Gallery, University of California, Irvine, 1999; *The Last Picture Show: Artists Using Photography, 1960–1982*, Walker Art Center, Minneapolis, 2003; Jan Verwoert, *Bas Jan Ader: In Search of the Miraculous*, Afterall Books, London, 2006; *Bas Jan Ader: Please Don't Leave Me*, Museum Boijmans Van Beuningen, Rotterdam, 2006; Rivas, Pilar Tompkins. *Bas Jan Ader: Suspended Between Laughter and Tears.* Claremont, Calif.: Pitzer College, 2010

Checklist:

I'm Too Sad to Tell You, 1971
Black-and-white, 16 mm film transferred to DVD, silent
3 min. 34 sec.
Edition of 3
Courtesy of the Bas Jan Ader Estate and Patrick Painter Editions

Untitled (Sweden), 1971
Projection of two color slides
Courtesy of the Bas Jan Ader Estate and Patrick Painter Editions

MICHAEL ASHER

Born: 1943, Los Angeles

Selected Exhibitions: "Enter the Work of Michael Asher," La Jolla Museum of Art, La Jolla, California, 1969; "Anti-Illusion: Procedures/Materials," Whitney Museum of Art, New York, 1969; "Spaces," The Museum of Modern Art, New York, 1969; "Documenta 5," Kassel, Germany, 1972; Claire Copley Gallery, Los Angeles, 1974; Otis Art Institute, Los Angeles, 1975; "Ambiente Arte," Venice Biennale, Venice 1976; "Skulptur Projekte Münster," Münster, Germany, 1977 (1987, 1997, 2007); "73rd American Exhibition," The Art Institute of Chicago, 1979; "Documenta 7," Kassel, Germany, 1982; "In Context," The Museum of Contemporary Art, Los Angeles, 1983; "Michael Asher," Musée National d'Arte Moderne, Centre Georges Pompidou, Paris, 1991; "Reconsidering the Object of Art: 1965–1975," The Museum of Contemporary Art, Los Angeles, 1995; "Made in California: Art, Image and Identity 1900–2000," Los Angeles County Museum of Art, Los Angeles, 2005; "Focus: Michael Asher," The Art Institute of Chicago, 2008; "Michael Asher," Santa Monica Museum of Art, Santa Monica, California, 2008; "2010 Biennial Exhibition," Whitney Museum of American Art, New York, 2010

Selected Bibliography: Munger, Barbara. "Michael Asher: An Environmental Project." *Studio International* 180, no. 926 (October 1970): 160–62; *Michael Asher: Exhibitions in Europe, 1972–1977*, Stedelijk Van Abbemuseum, Eindhoven, The Netherlands, 1980; Benjamin H. D. Buchloh and Michael Asher, *Writings 1973–1983 on Works 1969–1979*, The Press of the Nova Scotia College of Art and Design, Halifax, and The Museum of Contemporary Art, Los Angeles, 1983; Fred Leen, *Michael Asher*, Le Nouveau Musée, Villeurbanne, France, 1991; Birgit Pelzer, *Michael Asher*, Musée National d'Arte Moderne, Centre Georges Pompidou, Paris, 1991; Allan Sekula, "Michael Asher: Down to Earth," *Afterall*, Autumn/Winter 2000; Moeller, Whitney, and Anne Rorimer. *Michael Asher: George Washington at the Art Institute of Chicago, 1979 and 2005*. Chicago: Art Institute of Chicago, 2006; Longhauser, Elsa. *Michael Asher.* Santa Monica: Santa Monica Museum of Art, 2008; Miwon Kwon, "Approaching Architecture: The Case of Richard Serra and Michael Asher," *Yale University Art Gallery Bulletin*, 2010; Kirsi Peltomäki, *Situation Aesthetics: The Work of Michael Asher*, The MIT Press, Cambridge, Massachusetts, 2010

Checklist:

No Title, 2011
This work temporarily reconfigures the usual hours that the Pomona College Museum of Art is open to the public. Rather than being closed evenings, mornings, and one full day per week, the Museum will be open to visitors twenty-four hours a day from August 30 through November 6, 2011. Courtesy of the artist

MOWRY BADEN

Born: 1936, Los Angeles

Education: 1958 BA, Pomona College; 1965 MA, Stanford University, Palo Alto, California

Selected Exhibitions: "New Talent," The Museum of Modern Art, New York, 1960; Chouinard Art Institute, Los Angeles, 1969; "Mowry Baden," Otis Art Institute, Los Angeles, 1975; "Mowry Baden," San Francisco Art Institute, 1976; "Art Stories," Libra Gallery, CGS, Claremont, California, 1977; "Artwords and Bookworks," Los Angeles Institute of Contemporary Art, 1978; "Pluralities," The National Gallery, Ottawa, Ontario, 1980; "Mowry Baden," Artists Space, New York, 1983; "Mowry Baden: Maquettes and Other Preparatory Work, 1967–1980," Art Gallery of Greater Victoria, Victoria, British Columbia, 1985; "Mowry Baden," San Diego Museum of Art, San Diego, California, 1991; "Un-natural Traces," Barbican Gallery, London, 1991; "Out of Actions: Between Performance and the Object, 1949–1979," The Museum of Contemporary Art, Los Angeles, 1998; "Freckled Gyres," Pomona College Museum of Art, 2001; "Mowry Baden and Roland Brener: Thirty Years in Victoria," Art Gallery of Greater Victoria, Victoria, British Columbia, 2006

Selected Bibliography: Jack Burnham, "On Being Sculpture," *Artforum*, May 1969; "Kinesthetic Challenges, Time Continuums: The Participatory Art of Mowry Baden and Dan Graham," *Art News*, November 1975; *Mise En Scene*, Vancouver Art Gallery, Vancouver, British Columbia, 1982; *Social Space*, Walter Phillips Gallery, Banff Center, Banff, 1983; *Mowry Baden: Maquettes and Other Preparatory Work 1967–1980*, Art Gallery of Greater Victoria, Victoria, British Columbia, 1985; *Mowry Baden: Task-Oriented Sculptures*, Mercer Union, A Centre for Contemporary Art, Toronto, Ontario, 1987; "Un-Natural Traces," Barbican Gallery, London, 1991; Davis, Todd A. *Mowry Baden: A Choreography of the Ordinary.* Victoria: Open Space, 1998; "Mowry Baden: Stage Fright," *Sculpture Magazine*, September 2003; Baldissera, Lisa. *Mowry Baden and Roland Brener: Thirty Years in Victoria.* Victoria: Art Gallery of Greater Victoria

Checklist:

Delivery Suite, 1965
Steel and fibered polyester resin
49 × 77 × 75 in. (124 × 195 × 190 cm)
Collection Theresa Britschgi, Seattle, Washington

Instrument, 1969
Aluminum and steel
192 × 8 in. (487 × 20 cm), height variable
The Museum of Contemporary Art, Los Angeles
Gift of the artist

K Walk, 1969
Aluminum
116 × 24 × 35 in. (294 × 60 × 88 cm)
Pomona College Collection. Museum purchase with funds provided by the Estate of Walter and Elise Mosher

Shortall, 1969
Aluminum and steel
26 × 166 × 89 in. (66 × 422 × 225 cm)
Collection of the artist, Victoria, British Columbia

Seat Belt Three Points, 1970
Steel and nylon
168 in. (426 cm) diameter × height of viewer
Collection of Steve C. Young, Lopez, Washington

JOHN BALDESSARI

Born: 1931, National City, California

Education: 1953 BA, San Diego State College, San Diego, California; 1957 MA, San Diego State College, San Diego, California

Selected Exhibitions: "Information," The Museum of Modern Art, New York, 1970; "John Baldessari: I Will Not Make Any More Boring Art," Nova Scotia College of Art and Design, Halifax, Canada, 1971; "Whitney Biennial," Whitney Museum of American Art, New York, 1971; "Venice Biennale," Venice, 1972; "Documenta 5," Kassel, Germany, 1972; "John Baldessari: Recent Work," Stedelijk Museum, Amsterdam, 1975; "John Baldessari: Matrix 32," Wadsworth Atheneum, Hartford, Connecticut, 1975; "Baldessari: New Films," Whitney Museum of American Art, New York, 1978; "John Baldessari: Work 1966–1980," New Museum, New York, 1981; "Documenta 7," Kassel, Germany, 1982; "Ni por Ésas/Not Even So: John Baldessari," Museo Nacional Centro de Arte Reina Sofia, Madrid, 1989; "John Baldessari," The Museum of Contemporary Art, Los Angeles (traveling), 1990; "Baldessari: 4RMS W VU: Wallpaper, Lamps, and Plants," Witte de With, Center for Contemporary Art, Rotterdam, The Netherlands, 1998; "John Baldessari: A Different Kind of Order (Works 1962–1984)," Museum Moderner Kunst Stiftung Ludwig Wien, Vienna, 2005; "John Baldessari: Life's Balance (Works 1984–2004)," Kunsthaus Graz am Landesmuseum, Joanneum, Graz, Austria, 2005; "Pipe, Glass, Bottle of Rum: The Art of Appropriation," The Museum of Modern Art, New York, 2008; "California Video," J. Paul Getty Museum, Los Angeles, 2008; "Whitney Biennial," Whitney Museum of American Art, New York, 2008; "Venice Biennale," Venice, 2009; "The Pictures Generation: 1974–1984," Metropolitan Museum of Art, New York, 2009; "Waiting for Video: Works from the 1960s to Today," The National Museum of Modern Art, Tokyo, 2009; "John Baldessari: Pure Beauty," Tate Modern, London (traveling), 2009–10

Selected Bibliography: Marcia Tucker, et al., *John Baldessari*, New Museum, New York, 1981; Coosje van Bruggen, *John Baldessari*, Rizzoli International, New York, 1990; Kirk Varnedoe, "An Interview with John Baldessari," *MoMA* 16, Winter/Spring 1994; Jeremy Gilbert-Rolfe, et al., *Baldessari: 4RMS W VU: Wallpaper, Lamps, and Plants (NEW)*, Museum für Gegenwartskunst, Zurich, 1998; Meg Cranston, et al., *Baldessari: While Something is Happening Here, Something Else is Happening There: Works 1965–2001*, Reykjavik Art Museum, 2001; Russell Ferguson, et al., *John Baldessari: Somewhere Between Almost Right and Not Quite (With Orange)*, 2004; Sidra Stich, "Conceptual Alchemy: A Conversation with John Baldessari," *American Art* 19:1, Spring 2005; Rainer Fuchs, ed., *John Baldessari: A Different Kind of Order (Works 1962–1984)*, Walther König, Cologne, 2005; John Baldessari, *John Baldessari: From Life*, Carré d'Art Musée, Paris, 2005; Sharon Coplan Hurowitz and Wendy Weitman, *John Baldessari: A Catalogue Raisonné of Prints and Multiples, 1971–2007*, Hudson Hills Press, Manchester, Vermont, 2009; Martin Hentschel and John C. Welchman, *John Baldessari: Brick Bldg, Lg Windows W/xlent Views, Partially Furnished, Renowned Architect*, Kerber Verlag, Bielefeld, Germany, 2009; John Baldessari and Hans Ulrich Obrist, *Conversation Series 18: John Baldessari, Hans Ulrich Obrist*, Walther König, Cologne, 2009; Jessica Morgan and Leslie Jones, *John Baldessari: Pure Beauty*, Prestel Publishing, New York, 2009

Checklist:

Evidence: A Potential Print, 1970/2011
Typed text, ashes
Installation of ashes, dimensions variable
Typed text: 12 × 9½ in. (29.8 × 24.1 cm)
Collection of the artist

Evidence: Bowl Handed to Helene Winer Dec. 1, 70, 1970. Typed text, bowl, tape, and lamp black (bowl was later destroyed)
Photodocumentation: black-and-white photograph, 8 × 10¼ in. (20.3 × 25.4 cm).
Collection of the artist

LEWIS BALTZ

Born: 1945, Newport Beach, California

Education: 1969 BFA, San Francisco Art Institute; 1971 MFA, CGS, Claremont, California

Selected Exhibitions: "Lewis Baltz," Corcoran Gallery of Art, Washington, D.C., 1974; "New Topographics: Photographs of a Man-Altered Landscape," George Eastman House, Rochester, New York (traveling), 1975; "Lewis Baltz," Newport Harbor Art Museum, Newport, California, 1986; "Lewis Baltz," The Institute of Contemporary Art, Boston, 1991; "Lewis Baltz," P.S. 1, New York, 1991; "Lewis Baltz: Rule Without Exception," Des Moines Art Center, Des Moines, Iowa (traveling), 1991; "Spectacles of Surveillance," Centre Pompidou, Paris, 1992; "Lewis Baltz: Five Projects, 1983–1988," Stedelijk Museum, Amsterdam, 1992; "La Ronde de Nuit," Lillehammer Art Museum, Lillehammer, Norway (traveling), 1992; "Works 1979–1994," Louisiana Museum of Modern Art, Humlebaek, Denmark, 1995; "Lewis Baltz: the politics of bacteria, docile bodies, ronde de nuit," The Museum of Contemporary Art, Los Angeles, 1998; Norton Simon Museum, Pasadena, California, 2001; Princeton University Art Museum, Princeton, New Jersey, 2002; Canadian Centre for Architecture, Montreal, 2002; Kunstverein Bremerhaven, Bremerhaven, Germany, 2006; Museo Civici di Modena, Italy, 2007; California Museum of Photography, University of California at Riverside, 2009; "New Topographics: Photographs of a Man-Altered Landscape," Los Angeles County Museum of Art, Los Angeles, 2009; "Lewis Baltz: In the Desert," Nevada Museum of Art, Reno, Nevada, 2010; "Lewis Baltz, Prototypes/Ronde de Nuit," The Art Institute of Chicago, 2010

Selected Bibliography: *IXe Biennale de Paris a Nice*, La Galerie des Ponchettes et de la Galerie de la Marine, Nice, France, 1976; *Mirrors and Windows: American Photography Since 1960*, The Museum of Modern Art, New York, 1978; *American Images*, Corcoran Gallery of Art, Washington, D.C., 1979; *A Sense of Place: The American Landscape in Recent Art*, Hampshire College Art Gallery, Amherst, Massachusetts, 1980; Lewis Baltz, *Rule Without Exception*, University of New Mexico Press, Albuquerque, 1991; Lewis Baltz, *Five Projects, 1983–1988*, Amsterdam: Stedelijk Museum, 1992; Lewis Baltz, *Ronde de Nuit*, Centre Regional de la Photographie, Nord Pas-de-Calais, 1992; Lewis Baltz and Bernard Lamarche-Vadel, *Lewis Baltz*, Editions de la Difference, Paris, 1993; Lewis Baltz, *The Deaths in Newport*, Paradox, Houston, 1995; Anneli Fuchs, et al., *Lewis Baltz*, Louisiana Museum, Denmark, 1995; Butler, Cornelia H. *Lewis Baltz: The Politics of Bacteria, Ronde de Nuit, Docile Bodies.* Los Angeles: The Museum of Contemporary Art, 1998; *Lewis Baltz*, Whitney Museum of American Art, New York, 2005; Lewis Baltz, *The Tract Houses, The Prototype Works, The New Industrial Parks Near Irvine, California*, Steidl, Göttingen, Germany, 2005; Britt Salvesen, *New Topographics*, Steidl, Göttingen, Germany, 2009; Jane Livingston, *Lewis Baltz: Maryland 1976*, Steidl, Göttingen, Germany, 2010; Robert Sobieszek, *Lewis Baltz: Nevada 1977*, Steidl, Göttingen, Germany, 2010; Mathew Witkovsky, *Lewis Baltz: The Prototype Works*, Steidl, Göttingen, Germany, 2010

Checklist:

"Part 1: Hal Glicksman at Pomona"

Works from the Prototype series:

Embarcadero Center B 1967
Gelatin silver print
5⁹⁄₁₆ × 8⁷⁄₁₆ in. (13.5 × 21.4 cm)
Pomona College Collection

Gilroy 1967
Gelatin silver print
5 × 7¹⁵⁄₁₆ in. (12.7 × 20.1 cm)
Pomona College Collection

Monterey 1967
Gelatin silver print
5¼ × 7¹¹⁄₁₆ in. (13.4 × 19.5 cm)
Pomona College Collection

Greenbrae 1968
Gelatin silver print
5½ × 8⅜ in. (13.9 × 21.2 cm)
Pomona College Collection

Irvine Ranch 1968
Gelatin silver print
5¼ × 8⁹⁄₁₆ in. (13.3 × 21.7 cm)
Pomona College Collection

Laguna Beach 1968
Gelatin silver print
4⅜ × 7¾ in. (11.11 × 19.69 cm.)
Pomona College Collection

Sausalito 1968
Gelatin silver print
5⁹⁄₁₆ × 7⅜ in. (13.1 × 18.7 cm)
Pomona College Collection

Laguna Beach 1970
Gelatin silver print
5⁹⁄₁₆ × 8½ in. (14.13 × 21.59 cm)
Pomona College Collection

Laguna Niguel 1970
Gelatin silver print
5¹³⁄₁₆ × 21¹¹⁄₁₆ in. (14.7 × 55.12 cm)
Pomona College Collection

"Part 3: At Pomona"

The complete Tract House series

Tract House #1–#25, 1971
Gelatin silver prints
Each 6 × 9 in. (15.24 × 23 cm), mounted on 11 × 11 in. (28 × 28 cm) archival board
Norton Simon Museum, Gift of the artist.
© Lewis Baltz

MICHAEL BREWSTER

Born: 1946, Eugene, Oregon

Education: 1968 BA, Pomona College; 1970 MFA, Sculpture, CGS, Claremont, California

Selected Exhibitions: "Los Angeles in the Seventies," Fort Worth Art Museum, Fort Worth, Texas, 1977; "Sound Show," Los Angeles Institute of Contemporary Art, 1979; "1981 Biennial Exhibition," Whitney Museum of American Art, New York, 1981; "The Museum as Site," Los Angeles County Museum of Art, Los Angeles, 1981; "A Decade of New Art," Artists Space, New York, 1984; "Sight and Sound," San Francisco Art Institute, 1985; "New Music America '85," The Museum of Contemporary Art, Los Angeles, 1985; "World Wide Sound Sculpture," De Appel, Amsterdam, 1986; "Impossible Objects, Invisible Cities," Art Gallery of New South Wales, Sydney, Australia, 1991; "Means to an End: An Exploration of Drawing," Pomona College Museum of Art, 1999; "allAROUNDyou," Orange County Museum of Art, Newport Beach, California, 1999; "See Hear Now: A Sonic Drawing and Five Acoustic Sculptures," Los Angeles Contemporary Exhibitions, 2002; "From America," Museum of Contemporary Art, Minsk, Belarus, 2006

Selected Bibliography: *Soundings*, Neuberger Museum, Purchase College, State University of New York, 1981; Christopher Miles, "Jane Hart, T. Friedman, and Michael Brewster Interviewed," *Artweek*, February 1997; Barry Schwabsky, "Sounding Spaces," *ARTBYTE* 1:3, 1998; Michael Brewster, "Where, There, or Here?" in *Site of Sound: Of Architecture and the Ear*, Brandon LaBelle and Steve Roden, eds., Errant Bodies Press with Smart Art Press, Santa Monica, California, 1999; Michael Brewster, *See Hear Now: A Sonic Drawing and Five Acoustic Sculptures*, Los Angeles Contemporary Exhibitions, 2002; Brandon Labelle, "Other Architectures: Michael Brewster, Maryanne Amacher, and Bernhard Leitner," in *Background Noise*, Continuum, New York, 2006

Checklist:

Configuration 010 Audio Activity, 1970/2012 "Clickers" sound installation Dimensions variable Courtesy of the artist

CHRIS BURDEN

Born: 1946, Boston

Education: 1969 BA, Pomona College; 1971 MFA, University of California, Irvine, California

Selected Exhibitions: "Documenta 6," Kassel, Germany, 1977; "Whitney Biennial," Whitney Museum of American Art, New York, 1977; "Chris Burden: A Twenty Year Survey," Newport Harbor Art Museum, Newport Beach, California (traveling), 1988; "Whitney Biennial," Whitney Museum of American Art, New York, 1989; "Dislocations," The Museum of Modern Art, New York, 1991; "Helter Skelter: L.A. Art of the 1990s," The Museum of Contemporary Art, Los Angeles, 1992; "Biennial," Whitney Museum of American Art, New York, 1993; "Chris Burden," Centre d'Art Santa Mònica, Barcelona, Spain, 1995; "Chris Burden: Beyond the Limits," MAK-Austrian Museum of Applied Arts, Vienna, 1996; "Whitney Biennial," Whitney Museum of American Art, New York, 1997; "Sunshine & Noir," Louisiana Museum of Modern Art, Humlebaek, Denmark, 1997; "Out of Actions: Between Performance and the Object, 1949–1979," The Museum of Contemporary Art, Los Angeles, 1998; "48ᵗʰ Venice Biennale," Venice, 1999; "When Robots Rule: The Two-Minute Airplane Factory," Tate Gallery, London, 1999; "Made in California: Art, Image and Identity, 1900–2000," Los Angeles County Museum of Art, Los Angeles, 2000; "Chris Burden," Museum Moderner Kunst, Vienna, 2002; "Chris Burden," Los Angeles Contemporary Exhibitions, 2003; "Concrete Art," European Cultural Capital, Graz, Austria, 2003; "Los Angeles 1955–1985: Birth of an Art Capital," Centre Pompidou, Paris, 2006; "Chris Burden," Center for Contemporary Art, Kitakyushu, Japan, 2006; "Chris Burden," Middelheimmuseum, Antwerp, Belgium, 2009

Selected Bibliography: Chris Burden, *Chris Burden, 71–73*, Los Angeles, 1974; Chris Burden, *Chris Burden, 74–77*, Los Angeles, 1978; *Chris Burden: The Artist and His Models*, Lowe Art Museum, Miami, Florida, 1986; *Chris Burden: A Twenty Year Survey*, Newport Harbor Art Museum, Newport Beach, California, 1988; Peter Noever, ed., *Chris Burden: Beyond the Limits*, MAK-Austrian Museum of Applied Arts, Vienna, 1996; *When Robots Rule: The Two-Minute Airplane Factory*, Tate Gallery Publishing, London, 1999; Frazer Ward, "Gray Zone: Watching 'Shoot,'" *October 95*, Winter 2001; *Chris Burden: Early Work*, Zwirner and Wirth, New York, 2004; Fred Hoffman, ed., *Chris Burden*, Locus+ Publishing, Newcastle-upon-Tyne, England, 2007

Checklist:

On view August 30, 2011, through May 13, 2012:

Untitled sculpture, 1967/2011 Lacquer paint on aluminum 72 × 72 × 72 in. (180 × 180 × 180 cm) Pomona College Collection

"Part 2: Helene Winer at Pomona":

Match Piece, 1972 Documentation of performance, March 20, 1972 Pomona College Museum of Art Two 8 × 10 in. (20.3 × 25.4 cm) photographs and text mounted on board, 20 × 27 ½ in. (51 × 70 cm) Courtesy of the artist

"Part 3: At Pomona":

Untitled, 1966 Bronze 6 ½ × 5 in. (16.5 × 12.7 cm) Courtesy of the artist

JUDY CHICAGO

Born: 1939, Chicago

Education: 1962 BA, University of California, Los Angeles; 1964 MA, University of California, Los Angeles

Selected Exhibitions: Pasadena Museum of Art, Pasadena, California, 1969; "The Dinner Party," San Francisco Museum of Modern Art, 1979; "The Birth Project," Artisans Gallery, Mill Valley, California, 1982; "Holocaust Project: From Darkness Into Light," Spertus Museum, Chicago (traveling), 1994; "Sexual Politics, Judy Chicago's Dinner Party in Feminist Art History," UCLA Armand Hammer Museum and Cultural Center, Los Angeles, 1996; "Trials and Tributes," Museum of Fine Arts, Florida State University, Tallahassee (traveling), 1999; "Resolutions: A Stitch In Time," American Craft Museum, New York (traveling), 2000; "Judy Chicago," National Museum of Women in the Arts, Washington, D.C., 2002; "Judy Chicago: Fragments from the Delta of Venus and Other Femmerotica: A Thirty-five Year Survey," ACA Galleries, New York, 2004; "Judy Chicago: Jewish Identity," Hebrew Union College Art Museum, New York (traveling), 2007; "When Women Rule the World: Judy Chicago in Thread," Textile Museum of Canada, Toronto, Canada (traveling), 2009; "Judy Chicago," Art Museum of South Texas, Corpus Christi, 2010; "Judy Chicago," Musée des Maîtres et Artisans du Québec, Montreal, 2010

Selected Bibliography: Judy Chicago, *Through the Flower: My Struggle as a Woman Artist*, Doubleday, New York, 1975; Judy Chicago, *Holocaust Project: From Darkness into Light*, Viking/Penguin Press, New York, 1993; Amelia Jones, ed., *Sexual Politics: Judy Chicago's Dinner Party in Feminist Art History*, University of California Press, Berkeley and Los Angeles, 1996; Judy Chicago, *Beyond the Flower: The Autobiography of a Feminist Artist*, Viking/Penguin, New York, 1996; Edward Lucie-Smith, *Judy Chicago: An American Vision*, Watson-Guptill Publications, New York, 2000; Lucy Lippard, et al., *Judy Chicago*, National Museum of Women of the Arts, Washington, D.C., 2002; Judy Chicago, et al., *Judy Chicago*, Watson-Guptill Publications, New York, 2002; Jenni Sorkin, *Judy Chicago: Minimalism, 1965–1973*, LewAllen Contemporary, Santa Fe, New Mexico, 2004; Judy Chicago and Donald Woodman, *The Dinner Party: From Creation to Preservation*, Merrell Publishing, 2006; Catherine Grenier, ed., *Los Angeles 1955–1985*, Centre Pompidou, Paris, 2006; Klaus Biesenbach, ed., *Into Me/Out of Me*, P.S.1 Contemporary Art Center, New York, 2006; Gail Levin, *Becoming Judy Chicago: A Biography of the Artist*, Harmony Books, New York, 2007; Cornelia Butler, *WACK! Art and the Feminist Revolution*, The Museum of Contemporary Art, Los Angeles, 2007; Lars Nittve and Lena Essling, eds., *Time & Place: Los Angeles 1957–1968*, Moderna Museet, Stockholm, 2008

Checklist:

Snow Atmosphere, 1970 Documentation of performance, February 22, 1970 Mt. Baldy, San Gabriel Mountains, California Fifteen digital prints from slides, 30 × 44 in. (76 × 112 cm) each Courtesy of Through the Flower Archive

A Butterfly for Pomona, January 21, 2012 Performance of fireworks and road flares Merritt Field, Pomona College Courtesy of the artist

RON COOPER

Born: 1943, New York

Education: 1963 attended Chouinard Art Institute, Los Angeles

Selected Exhibitions: "Prospect '69," Düsseldorf, Germany, 1969; "Art and Technology," Los Angeles County Museum of Art, Los Angeles, 1971; "Ron Cooper," Pasadena Art Museum, Pasadena, California, 1971; "Ron Cooper," La Jolla Museum of Contemporary Art, La Jolla, California, 1973; "SoCal: Southern California Art of the 1960s and '70s from LACMA's Collection," Los Angeles County Museum of Art, Los Angeles, 2008; "Hopper Curates: Larry Bell, Ron Cooper, Ronald Davis, Ken Price and Robert Dean Stockwell," Harwood Museum of Art, Taos, New Mexico, 2009

Selected Bibliography: Maurice Tuchman, *Art & Technology: A Report on the Art & Technology Program of the Los Angeles County Museum of Art, 1967–1971*, Los Angeles County Museum of Art, Los Angeles, 1971; *Five recent works by Larry Bell, John McCracken, DeWain Valentine, Ron Cooper and Peter Alexander*, Edmonton Art Gallery, Edmonton, Canada, 1971; *Ron Cooper*, La Jolla Museum of Contemporary Art, La Jolla, California, 1973; *Recent Works: Ron Cooper, Laddie John Dill, Charles Arnoldi*, Sena Galleries West, Santa Fe, New Mexico, 1987

Checklist:

Ball Drop, 1969 16 mm film transferred to DVD 8 min., 30 sec. Collection of the University Art Museum Art Video Archive, California State University, Long Beach

Head On, 1969/2010 Laminated safety glass/automotive windshield 23 × 66 × 12 in. (58.4 × 167.6 × 30.5 cm) Courtesy of the artist

Dead Center, 1969/2010 Laminated safety glass/automotive windshield 18 × 57 × 12 in. (46 × 145 × 30.5 cm) Courtesy of the artist

TOM EATHERTON

Born: 1934, Los Angeles

Education: 1957 BA, University of California, Los Angeles

Selected Exhibitions: "Move: Southern California Directions," Pasadena Art Museum, Pasadena, California, 1972; "Point, Rise and Trip," Percept Gallery, Los Angeles, 1981; "Point," Institute for Contemporary Art, Boston, 1983; "Blue Light and Universe: Visual Silences Exhibition," Marc Richards Gallery, Los Angeles, 1988; "Square Intersections," Santa Monica Museum of Art, Santa Monica, California, 2001; "Tom Eatherton: Time," Cardwell Jimmerson Contemporary Art, Culver City, California, 2008

Selected Bibliography: Peter Plagens, Review of Pomona College Museum of Art Exhibition, *Artforum* 9, September 1970; Peter Plagens, *Sunshine Muse: Art on the West Coast, 1945–1970*, University of California Press, Berkeley, 1974; *Point*, ARCO Center for the Visual Arts, Los Angeles, 1981; Peter Clothier, *Visual Silences*, Marc Richards Gallery, Los Angeles, 1988; Jan Butterfield, *The Art of Light and Space*, Abbeville Press, New York, 1996

Checklist:

Rise, 1970/2011
Light environment consisting of incandescent bulbs, two layers of nylon diffusion material, and wooden support structure
Dimensions variable
Collection of the artist

GER VAN ELK

Born: 1941, Amsterdam

Education: 1959–61, Institute for Applied Arts, Amsterdam, 1961–63, Immaculate Heart College, Los Angeles; 1965–66 University of Groningen, The Netherlands

Selected Exhibitions: "When Attitudes Become Form," Kunsthalle, Bern, Switzerland, 1969; "Three works by Ger van Elk Made this Spring in California," art & project, Amsterdam, 1971; "Documenta 5," Kassel, Germany, 1972; "The 39th Venice Biennale," Venice, 1972; "Europe in the Seventies," The Art Institute of Chicago, 1977; "Documenta 6," Kassel, Germany, 1977; "Documenta 7," Kassel, Germany, 1982; "An International Survey of Recent Painting and Sculpture," The Museum of Modern Art, New York, 1984; "On the Nature of Genres," le Magasin, Centre National d'Art Contemporain de Grenoble, Grenoble, France, 1988; "Reconsidering the Object of Art: 1965–1975," The Museum of Contemporary Art, Los Angeles, 1995; "Ger van Elk: The Cadillac and the Nun," Stedelijk van Abbemuseum, Eindhoven, The Netherlands, 1999; "Conceptuel kunst 1965–1975 uit Nederlandse en Belgische collecties," Stedelijk Museum, Amsterdam, 2002; "A farewell, a moving point on the horizon," Galerie m Bochum, Bochum, Germany, 2004; "In & Out of Amsterdam: Travels in Conceptual Art, 1960–1976," The Museum of Modern Art, New York, 2009

Selected Bibliography: Germano Celant, *Arte Povera: Earthworks/Impossible Art/Actual Art/Conceptual Art*, Praeger, New York, 1969; Helene Winer, *Bas Jan Ader, William Leavitt, Ger van Elk*, Pomona College Museum of Art, 1972; R. H. Fuchs, *Ger van Elk*, Stedelijk Museum, Amsterdam, 1974; Richard Francis "Ger van Elk at the Boymans Museum," *The Burlington Magazine* 123:937, April 1981; Richard Stone, "London: Dibbets and van Elk," *The Burlington Magazine* 124:949, April 1982; Ron Kaal, *Ger van Elk: The Cadillac and the Nun*, NAi Publishers / Stedelijk van Abbemuseum, Eindhoven, The Netherlands, 1999; *The Last Picture Show: Artists Using Photography, 1960–1982*, Walker Art Center, Minneapolis, 2003; Anne Rorimer, *Ger van Elk: Monograph*, Thieme Art, Amsterdam, 2009

Checklist:

The Return of Pierre Bonnard, 1971
Two color photographs between Plexiglas and mirror in wooden frame
Photographs: 24 × 28 in. (60 × 70.4 cm); mirror: 21 × 24 in. (53 × 60.5 cm)
Courtesy of the artist

JUDY FISKIN

Born: 1945, Chicago

Education: 1966 BA, Pomona College; 1969 MA, University of California, Los Angeles

Selected Exhibitions: "Some Aesthetic Decisions," The New Museum, New York, 1986; "Judy Fiskin: Some Photographs, 1973–1992," The Museum of Contemporary Art, Los Angeles, 1992; "New Photographs," Curt Marcus Gallery, New York, 1994; "After Art: Rethinking 150 Years of Photography," Friends of Photography, Ansel Adams Center, San Francisco (traveling), 1995; "Made in California: Art, Image and Identity 1900–2000," Los Angeles County Museum of Art, Los Angeles, 2000; "Los Angeles 1955–1985: Birth of an Art Capital," Musée National d'Arte Moderne, Centre Georges Pompidou, Paris, 2006; "Index: Conceptual Art in California from the Permanent Collection," The Museum of Contemporary Art, Los Angeles, 2008; "The View From Here," San Francisco Museum of Modern Art, 2009

Selected Bibliography: William Bartman, ed., *Judy Fiskin*, Los Angeles: A.R.T. Press, 1988; Robert L. Pincus, "Judy Fiskin: Some Questions of Aesthetics," *Visions*, Winter 1989; Susan Kandel, "The Tiny Photographs of Judy Fiskin," *Art Issues*, February/March 1991; Judy Fiskin, *Some More Art*, The Museum of Contemporary Art, Los Angeles, 1992; Christopher Knight, "Taxonomic Dingbats," in *Last Chance for Eden*, Art Issues Press, Los Angeles, 1995; William Bartman, ed., *Judy Fiskin*, A.R.T. Press, Los Angeles, 1998; Catherine Grenier, ed., *Los Angeles 1955–1985: Birth of an Art Capital*, Musée National d'Arte Moderne, Centre Georges Pompidou, Paris, 2006

Checklist:

Untitled, from the Stucco series, 1972–73
Gelatin silver print
5 × 7 in. (12.7 × 17.8 cm)
Pomona College Collection.
Museum purchase with funds provided by the Estate of Walter and Elise Mosher

Untitled, from the Stucco series, 1972–73
Gelatin silver print
7 × 5 in. (17.8 × 12.7 cm)
Pomona College Collection.
Museum purchase with funds provided by the Estate of Walter and Elise Mosher

Untitled, from the Stucco series, 1972–73
Gelatin silver print
5 × 7 in. (12.7 × 17.8 cm)
Pomona College Collection.
Museum purchase with funds provided by the Estate of Walter and Elise Mosher

Untitled, from the Stucco series, 1972–73
Gelatin silver print
5 × 7 in. (12.7 × 17.8 cm)
Pomona College Collection.
Museum purchase with funds provided by the Estate of Walter and Elise Mosher

Untitled, from the Stucco series, 1972–73
Gelatin silver print
5 × 7 in. (12.7 × 17.8 cm)
Collection of the artist
Courtesy Angles Gallery, Los Angeles

Untitled, from the Stucco series, 1972–73
Gelatin silver print
5 × 7 in. (12.7 × 17.8 cm)
Collection of the artist
Courtesy Angles Gallery, Los Angeles

Untitled, from the Stucco series, 1972–73
Gelatin silver print
5 × 7 in. (12.7 × 17.8 cm)
Collection of the artist
Courtesy Angles Gallery, Los Angeles

Untitled, from the Stucco series, 1972–73
Gelatin silver print
5 × 7 in. (12.7 × 17.8 cm)
Collection of the artist
Courtesy Angles Gallery, Los Angeles

Untitled, from the Stucco series, 1972–73
Gelatin silver print
5 × 7 in. (12.7 × 17.8 cm)
Collection of the artist
Courtesy Angles Gallery, Los Angeles

Untitled, from the Stucco series, 1972–73
Gelatin silver print
5 × 7 in. (12.7 × 17.8 cm)
Collection of the artist
Courtesy Angles Gallery, Los Angeles

Untitled, from the Stucco series, 1972–73/2006
Gelatin silver print
5 × 7 in. (12.7 × 17.8 cm)
Collection of the artist
Courtesy Angles Gallery, Los Angeles

Untitled, from the Stucco series, 1972–73/2006
Gelatin silver print
5 × 7 in. (12.7 × 17.8 cm)
Collection of the artist
Courtesy Angles Gallery, Los Angeles

JACK GOLDSTEIN

Born: 1945, Montreal, Quebec, Canada. Died: 2003, San Bernardino, California

Education: 1970 BFA, Chouinard Art Institute, Los Angeles; 1972 MFA, California Institute of the Arts, Valencia, California

Selected Exhibitions: "Twenty-Four Young Los Angeles Artists," Los Angeles County Museum of Art, Los Angeles, 1971; "Pictures," Artists Space, New York, 1977; "Jack Goldstein," Centre d'Art Contemporain, Geneva, Switzerland, 1981; "74th American Exhibition," The Art Institute of Chicago, 1982; "Image Scavengers: Painting," Institute of Contemporary Art, Philadelphia, 1982; "New Art at the Tate Gallery," Tate Gallery, London, 1983; "Whitney Biennial," Whitney Museum of American Art, New York, 1985; "Documenta 8," Kassel, Germany, 1987; "A Forest of Signs," The Museum of Contemporary Art, Los Angeles, 1989; "Jack Goldstein," Mendel Art Gallery and Civic Conservatory, Saskatoon, Canada (traveling), 1991; "Jack Goldstein," Whitney Museum of American Art, New York, 2002; "Jack Goldstein," Magasin, Centre National D'Art de Grenoble, Grenoble, France (traveling), 2002; "Whitney Biennial," Whitney Museum of American Art, New York, 2004; "Los Angeles 1955–1985: Birth of an Art Capital," Musée National d'Art Contemporain, Centre Georges Pompidou, Paris, 2006; "Jack Goldstein," Museum für Moderne Kunst, Frankfurt, Germany, 2009

Selected Bibliography: Helene Winer, "How Los Angeles Looks Today," Studio International 183:937, October 1971; Morgan Fisher, "Talking to Jack Goldstein," LAICA Journal 14, Los Angeles Institute of Contemporary Art, April/May 1977; Germano Celant, "The Record as Artwork from Futurism to Conceptual Art," Fort Worth Art Museum, Fort Worth, Texas, 1977; David Salle, Jack Goldstein: Distance Equals Control, Hallwalls, Buffalo, New York, 1978; Thomas Lawson, "The Uses of Representation: Making Some Distinctions," Flash Art 88/89, March/April 1979; Paul Schimmel, et al., Shift, LA/NY, Newport Harbor Art Museum, Newport Beach, California, 1982; Jean Fisher, "Jack Goldstein: The Trace of Absence," Artforum 22:3, November 1983; Philip Pocock, "Jack Goldstein," Journal of Contemporary Art 1:1, Spring 1988; Meg Cranston, "Haunted by the Ghost: Jack Goldstein Then and Now," Artext 75, November/January 2001; Jean Fisher and Stella Santacatterina, "Figuring Difference—The work of Jack Goldstein," Afterall 4, 2001; Aupetitallot, Yves, and Lionel Bovier. Jack Goldstein. Grenoble, France: Le Magasin, Centre National de l'Art Contemporain, 2002; Richard Hertz, Jack Goldstein and the CalArts Mafia, Minneola Press, Ojai, California, 2003; Buchholz, Daniel, and Christopher Müller, eds. Jack Goldstein: Films, Records, Performances and Aphorisms 1971–1984. Cologne: Walther König, 2003; Jack Goldstein, Museum für Moderne Kunst, Frankfurt, Germany, 2009; Chrissie Iles and Shepard Steiner, Jack Goldstein, Walther König, Cologne, Germany, 2010

Checklist:

Untitled, 1969–71/2011
Wood
101½ × 24 × 21¾ in. (257.8 × 61 × 55.2 cm)
Courtesy of The Estate of Jack Goldstein and 1301PE, Los Angeles

Untitled, 1969–71/2011
Wood
101½ × 24 × 25¾ in. (257.8 × 61 × 65.4 cm)
Courtesy of The Estate of Jack Goldstein and 1301PE, Los Angeles

JOE GOODE

Born: 1937, Oklahoma City, Oklahoma

Education: 1959–61 Chouinard Art Institute, Los Angeles

Selected Exhibitions: "Joe Goode: Work Until Now," Modern Art Museum, Fort Worth, Texas, 1972; "Art in Los Angeles: Seventeen Artists in the Sixties," Los Angeles County Museum of Art, Los Angeles, 1981; "Laboratory: Joe Goode Tornado Triptych," Los Angeles County Museum of Art, Los Angeles, 1992; "Hand-Painted Pop: American Art in Transition, 1955–62," The Museum of Contemporary Art, Los Angeles (traveling), 1992; "Joe Goode," Orange County Museum of Art, Newport Beach, California, 1997; "Sunshine & Noir: Art in L.A., 1960–1997," Louisiana Museum of Modern Art, Humlebaek, Denmark (traveling), 1997; "Made in California: Art, Image and Identity 1900–2000," Los Angeles County Museum of Art, Los Angeles, 2000; "California Modern," Orange County Museum of Art, Newport Beach, California, 2006; "Los Angeles 1955–1985: Birth of an Art Capital," Musée National d'Arte Moderne, Centre Georges Pompidou, Paris, 2006; "Time and Place: Los Angeles, 1958–1968," Moderna Museet, Stockholm, 2008; "Joe Goode: Clouds, Paintings and Drawings from the '60s and '70s," Franklin Parrasch Gallery, New York, 2009

Selected Bibliography: John Coplans, "The New Paintings of Common Objects," Artforum, October 1962; Philip Leider, "Joe Goode and The Common Object," Artforum, March 1966; Henry T. Hopkins, Joe Goode, Edward Ruscha, Fine Arts Patrons of Newport Harbor, Balboa, California, 1968; Helene Winer, Joe Goode: Wall Reliefs, Pomona College Museum of Art, 1971; Henry T. Hopkins, "Bengston, Grieger, Goode: 3 Interviews," Art in America, March–April 1973; Sue Scott, Joe Goode, Jerry McMillan, Edward Ruscha, Oklahoma Art Museum, Oklahoma City, Oklahoma, 1989; Nora Halpern Brougher, Joe Goode Waterfall Paintings, James Corcoran Gallery, Santa Monica, California, 1990; Leah Ollman, "Seeing Through Nature," Art in America, October 1997; Michael Duncan, Joe Goode, Orange County Museum of Art, Newport Beach, California, 1997; Michael Duncan, "Joe Goode at L.A. Louver," Art in America, November 1998; Duncan, Michael, and Joe Goode. Joe Goode: The Cloud Paintings. Los Angeles: Manny Silverman Gallery, 2001; Catherine Grenier, ed., Los Angeles 1955–1985: Birth of an Art Capital, Musée National d'Arte Moderne, Centre Georges Pompidou, Paris, 2006

Checklist:

Untitled (Staircase Series II), 1971
Wood and carpet
64¼ × 64¼ × 8¾ in. (163.2 × 163.2 × 22.2 cm)
Collection of Ed Ruscha

DAVID GRAY

Born: 1927, Waukesha, Wisconsin. Died: 2001, Claremont, California

Education: 1952 BS, University of Wisconsin, Madison; 1958 MA, University of Wisconsin, Madison

Selected Exhibitions: Art Directions Gallery, New York, 1959; Kasha Heman Gallery, Chicago, 1961; "David Gray," Milwaukee Art Center, Milwaukee, Wisconsin, 1964; "Whitney Biennial," Whitney Museum of American Art, New York, 1964; "David Gray," Feigen/Palmer Gallery, Los Angeles, 1965; "David Gray," Richard Feigen Gallery, New York, 1965; "Five Los Angeles Sculptors / Sculptors Drawings: Los Angeles / New York," Art Gallery, University of California, Irvine, 1966; "Primary Structures: Younger American and British Sculptors," The Jewish Museum, New York, 1966; "American Sculptures of the Sixties," Los Angeles County Museum of Art, Los Angeles (traveling), 1967; "Contemporary American Sculpture," Whitney Museum of American Art, New York, 1969

Selected Bibliography: Tracy Atkinson, David Gray, Milwaukee Art Center, Milwaukee, Wisconsin, 1964; Whitney Museum of American Art Sculpture Annual, Whitney Museum of American Art, New York, 1964; Five Los Angeles Sculptors / Sculptors Drawings: Los Angeles / New York, Art Gallery, University of California, Irvine, 1966; California Painting and Sculpture, La Jolla Museum of Art, La Jolla, California, 1965; Primary Structures: Younger American and British Sculptors, The Jewish Museum, New York, 1966; Maurice Tuchman, ed., American Sculptures of the Sixties, Los Angeles County Museum of Art, Los Angeles, 1967

Checklist:

L.A./5, 1965
Welded steel, lacquer, chrome plate and flock
13½ × 9 × 9 in. (34.2 × 23 × 23 cm)
Pomona College Collection, Gift of Pam Gray and DJ Gray

L.A./6, 1966
Welded steel, lacquer, chrome plate, and flock
52 × 38 × 14 in. (132 × 96.5 × 35.6 cm)
The Music Center / Performing Arts Center of Los Angeles County

LLOYD HAMROL

Born: 1937, San Francisco

Education: 1959 BFA, University of California, Los Angeles; 1963 MFA, University of California, Los Angeles

Selected Exhibitions: "Lloyd Hamrol," Rolf Nelson Gallery, Los Angeles, 1966; "American Sculpture of the '60s," Los Angeles County Museum of Art, Los Angeles, 1967; "Lloyd Hamrol," La Jolla Museum of Art, La Jolla, California, 1968; "The West Coast Now," Portland Art Museum, Portland, Oregon, 1968; "Drawings: Exhibition of Contemporary American Drawings," Fort Worth Art Center, Fort Worth, Texas, 1969; "Lloyd Hamrol," California State University, Fullerton, California, 1970; "Painting and Sculpture in California: The Modern Era," San Francisco Museum of Modern Art and Smithsonian Institute, Washington, D.C., 1976; "Lloyd Hamrol: Works, Projects, Proposals," Los Angeles Municipal Gallery, Los Angeles, 1986; "Lloyd Hamrol," Cardwell Jimmerson Contemporary Art, Culver City, California, 2010

Selected Bibliography: Lawrence Alloway, American Sculpture of the '60s, Los Angeles County Museum of Art, Los Angeles, 1967; George Neubert and John Hightower, Public Sculpture/Urban Environment, Oakland Museum, Oakland, California, 1974; Stephen Prokopoff, Four Los Angeles Sculptors, Chicago Museum of Contemporary Art, Chicago, 1974; Douglas Bullis, ed., 50 West Coast Artists, Chronicle Books, San Francisco, 1981; Henry Hopkins, Lloyd Hamrol: Works, Projects, Proposal, Los Angeles Municipal Gallery, Los Angeles, 1986

Checklist:

Situational Construction for Pomona College, 1969/2011
Balloons, lead wire, plastic sheeting, water, and colored light
Dimensions variable
Courtesy of the artist

ROBERT IRWIN

Born: 1928, Long Beach, California

Education: 1948–50 Otis Art Institute, Los Angeles; 1951 Jepson Art Institute, Los Angeles; 1952–54 Chouinard Art Institute, Los Angeles

Selected Exhibitions: "Robert Irwin," Pasadena Art Museum, Pasadena, California, 1960; "Robert Irwin—Kenneth Price," Los Angeles County Museum of Art, Los Angeles, 1966; "Gene Davis, Robert Irwin, Richard Smith," The Jewish Museum, New York, 1968; "Robert Irwin," Pasadena Art Museum, Pasadena, California, 1968; "Robert Irwin," The Museum of Modern Art, New York, 1970; "Robert Irwin," Museum of Contemporary Art, Chicago, 1975; "Robert Irwin," Walker Art Center, Minneapolis, 1976; "Robert Irwin," Whitney Museum of American Art, New York, 1977; "Robert Irwin," San Francisco Museum of Modern Art, 1977; "Robert Irwin," The Museum of Contemporary Art, Los Angeles (traveling), 1993; "Robert Irwin," Musée d'Art Moderne de la Ville, Paris, 1994; "Robert Irwin," Museo Nacional Centro de Arte Reina Sofía, Madrid, 1995; "Sunshine & Noir: Art in L.A., 1960–1997," Louisiana Museum of Modern Art, Humlebaek, Denmark (traveling), 1997; "Robert Irwin," Musée d'Art Contemporain de Lyon, Lyon, France, 1998; "Robert Irwin: Primaries and Secondaries," Museum of Contemporary Art, San Diego, California, 2007

Selected Bibliography: Frederick S. Wight, "An Interview with Robert Irwin," *Transparency Reflection Light Space: Four Artists*, University of California Los Angeles Art Galleries, 1971; Jan Butterfield, "Robert Irwin: On the Periphery of Knowing," *Arts Magazine*, 46:8, February 1976; Roberta Smith, "Robert Irwin: The Subject is Sight," *Art in America* 64:2, March/April 1976; Thomas Albright, "Robert Irwin: 'Everything I've Done in the Last Five Years Doesn't Exist," *ARTnews* 76:6, Summer 1977; *Robert Irwin*, Whitney Museum of American Art, New York, 1977; Lawrence Weschler, *Seeing is forgetting the name of the thing one sees: a life of contemporary artist Robert Irwin*, University of California Press, Berkeley, 1982; Robert Irwin, *Being and Circumstance: Notes Toward a Conditional Art*, Lapis Press, Larkspur Landing, California, 1985; Irwin, Robert. *Robert Irwin: A Selection of Works 1958 to 1970*. New York: PaceWildenstein, 1998; *Robert Irwin*, The Museum of Contemporary Art, Los Angeles, 1993; Hugh M. Davies and Robert Irwin, *Robert Irwin: Primaries and Secondaries*, Museum of Contemporary Art, San Diego, California, 2008

Checklist:

Untitled, 1968–69
Acrylic lacquer on formed acrylic plastic
Diameter: 54 in. (137.2 cm)
The Museum of Contemporary Art, Los Angeles
Gift of Lannan Foundation
97.56

HIROKAZU KOSAKA

Born: 1948, Wakayama, Japan

Education: 1970 BFA, Chouinard Art Institute, Los Angeles

Selected Exhibitions: "Amerika Maru," Japanese American Cultural and Community Center, Los Angeles, 1990; "Hirokazu Kosaka: In the Mood," The Museum of Contemporary Art, Los Angeles, 1994; "Silkroad," J. Paul Getty Center, Los Angeles, 2000; "Made in California: Art, Image and Identity 1900–2000," Los Angeles County Museum of Art, Los Angeles, 2000; "Hatsutabi," Noguchi Plaza, Japanese American Cultural and Community Center, Los Angeles, 2005; "Buffer Zone," Indianapolis Art Museum, Indianapolis, Indiana, 2005

Selected Bibliography: Russell Ferguson, ed., *Hirokazu Kosaka: In the Mood*, The Museum of Contemporary Art, Los Angeles, 1994; Kosaka, Hirokazu. *Hirokazu Kosaka*. Japan: IKKYU, 1998; Jacquelynn Baas and Mary Jane Jacob, *Buddha Mind in Contemporary Art*, University of California Press, Berkeley and Los Angeles, 2004; *Art in Action: Nature, Creativity, and Our Collective Future*, Natural World Museum, Earth Aware Editions, San Rafael, California, 2007

Checklist:

Untitled, 1972
Documentation of performance, March 6, 1972
Pomona College Museum of Art
Four black-and-white photographs,
8 × 10 in. (20.3 × 25.4 cm)
9⅜ × 7½ in. (22.9 × 17.8 cm)
7½ × 9½ in. (17.8 × 22.9 cm)
7½ × 9½ in. (17.8 × 22.9 cm)
Courtesy of the artist

WILLIAM LEAVITT

Born: 1941, Washington, D.C.

Education: 1963 BFA, University of Colorado, Boulder; 1967 MFA, CGS, Claremont, California

Selected Exhibitions: Art & Project Gallery, Amsterdam, 1972; Kabinett für aktuelle Kunst, Bremerhaven, Germany, 1973; "Video Projects," The Museum of Modern Art, New York, 1976; "William Leavitt," Long Beach Museum of Art, Long Beach, California, 1978; "Narrative Art," Contemporary Art Museum, Houston, Texas, 1978; "William Leavitt," Artists Space, New York, 1979; "Tableau," Los Angeles Institute of Contemporary Art, 1980; "Tableaux: Nine Contemporary Sculptors," Contemporary Art Center, Cincinnati, Ohio, 1982; "Reconsidering the Object of Art: 1965–1975," The Museum of Contemporary Art, Los Angeles, 1995; "Los Angeles, 1955–1985: Birth of an Art Capital," Musée National d'Arte Moderne, Centre Georges Pompidou, Paris, 2006; "Index: Conceptual Art in California from the Permanent Collection," The Museum of Contemporary Art, Los Angeles, 2008; "William Leavitt: Warp Engines," LA > < ART, Culver City, California, 2009; "William Leavitt: A Show of Cards," Jancar Jones Gallery, San Francisco, California, 2010; "William Leavitt: New Prints," Cirrus Gallery, Los Angeles, 2010; "William Leavitt," The Museum of Contemporary Art, Los Angeles, 2011

Selected Bibliography: Helene Winer, *Bas Jan Ader, Ger van Elk, William Leavitt*, Pomona College Museum of Art, 1972; Helene Winer, "Scenarios/Documents/Images I," *Art in America*, March 1973; Tom Lawson "Every Picture Tells a Story Don't It," *Real Life* 2, 1979; Connie Butler, "West of Everything," *Parkett* 57, December 1998; David Schafer, "William Leavitt," *Art Papers*, January/February 2000; Erik Bluhm, "Minimalism's Rubble: On William Leavitt's and Bas Jan Ader's *Landslide* (1969–70)," *artUS* 10, October/November 2005; William Leavitt, "Organism (a theatrical habitat)," *X-TRA* 8.1, Fall 2005; Carole Ann Klonarides, "William Leavitt, Allen Ruppersberg, and Mungo Thomson," *X-TRA* 10.3, Spring 2008; *William Leavitt*, The Museum of Contemporary Art, Los Angeles, 2011

Checklist:

California Patio, 1972
Mixed media construction
Dimensions variable
Collection of the Stedelijk Museum, Amsterdam

JOHN MCCRACKEN

Born: 1934, Berkeley, California
Died: 2011, New York

Education: 1957–62, 1964–65 California College of Arts and Crafts, Oakland, California

Selected Exhibitions: "Geometric Abstraction and Minimalism in America," Solomon R. Guggenheim Museum, New York, 1989; "Carnegie International," Carnegie Museum of Art, Pittsburgh, 1991; "John McCracken," Kunsthalle, Basel, 1995; "Skulptur Projekte Münster," Münster, Germany, 1997; "Sunshine & Noir: Art in L.A., 1960–1997," Louisiana Museum of Modern Art, Humlebaek, Denmark, 1997; "Heroic Stance: The Sculpture of John McCracken," P.S.1 Contemporary Art Center, Long Island City, New York (traveling), 1986; Municipal Museum of Contemporary Art, Ghent, Belgium, 2004; "Singular Forms (Sometimes Repeated): Art From 1951 to the Present," Solomon R. Guggenheim Museum, New York, 2004; "A Minimal Future? Art as Object 1958–1968," The Museum of Contemporary Art, Los Angeles, 2004; "John McCracken," Stedelijk Museum, Amsterdam, 2004; "Summer of Love: Art of the Psychedelic Era," Tate Liverpool, Liverpool, England (traveling), 2005; "John McCracken/Paul McCarthy," Galerie Hauser & Wirth Zürich, Zurich, Switzerland, 2005; "Los Angeles 1955–1985: Birth of an Art Capital," Musée National d'Arte Moderne, Centre Georges Pompidou, Paris, 2006; "SoCal: Southern California Art of the 1960s and '70s from LACMA's Collection," Los Angeles County Museum of Art, Los Angeles, 2007; "The Shapes of Space," Solomon R. Guggenheim Museum, New York, 2007; "Documenta 12," Kassel, Germany, 2007; "Time and Place: Los Angeles, 1958–1968," Moderna Museet, Stockholm, 2008; "John McCracken: A Retrospective," Castello di Rivoli, Turin, Italy, 2010

Selected Bibliography: *John McCracken: Sculpture 1965–1969*, Art Gallery of Ontario, Toronto, 1969; Susan C. Larsen, "John McCracken," *California: 5 Footnotes to Modern Art History*, Los Angeles County Museum of Art, Los Angeles, 1977; *McCracken: Heroic Stance: The Sculpture of John McCracken, 1965–1986*, Newport Harbor Art Museum, Newport Beach, California, 1987; *John McCracken*, Galerie Froment and Putman, Paris, 1991; Dan Cameron, *John McCracken*, Galerie Art & Public, Geneva, 1994; *John McCracken*, Kunsthalle Basel, Basel, Switzerland, 1995; Patricia Bickers, "UFO Technology," *Art Monthly* 204, March 1997; Frances Colpitt, "Between Two Worlds," *Art in America*, 86:4, April 1998; Giovanni Intra, "John McCracken: Alienbait," *Artext* 73, July–August 2001; Kristine Bell, Greg Lulay, and Alexandra Whitney, eds. *Early Sculptures: John McCracken*, Zwirner & Wirth, New York, 2005; *John McCracken Sketch Book*, Radius Books, Santa Fe, and David Zwirner, New York, 2008

Checklist:

Black Resin Painting I, 1974
Polyester resin on plywood
32¼ × 48¼ × 2⅜ in. (81.9 × 122 × 6 cm)
Collection of Orange County Museum of Art; Gift of Mr. and Mrs. M. A. Gribin

ED MOSES

Born: 1926, Long Beach, California

Education: 1955 BA, University of California, Los Angeles; 1958 MA, University of California, Los Angeles.

Selected Exhibitions: "Fifty California Artists," Whitney Museum of American Art, New York (traveling), 1962; "The Late Fifties at Ferus," Los Angeles County Museum of Art, Los Angeles, 1968; "West Coast 1945–1969," Pasadena Art Museum, Pasadena, California, 1969; "Documenta 5," Kassel, Germany, 1972; "34th Biennial of Contemporary American Painting," Corcoran Gallery of Art, Washington, D.C., 1975; "The Last Time I Saw Ferus, 1957–66," Newport Harbor Museum, Newport Beach, California, 1976; "Painting and Sculpture in California: The Modern Era," San Francisco Museum of Modern Art, 1976; "Ed Moses," High Museum of Art, Atlanta, 1980; "International Invitational," The Museum of Contemporary Art, Los Angeles, 1986; "Whitney Biennial," Whitney Museum of American Art, New York, 1991; "Choice Encounters," Long Beach Museum of Art, Long Beach, California, 1992; "Ed Moses: A Retrospective of the Paintings and Drawings, 1951–1996," The Museum of Contemporary Art, Los Angeles, 1996; "Made in America: Contemporary Paintings and Sculpture from the Norton Simon Museum," Norton Simon Museum and Armory Center for the Arts, Pasadena, California, 1999; Frank Lloyd Gallery, Santa Monica, California, 2010; "Ed Moses: Paintings," Greenfield Sacks Gallery, Santa Monica, California, 2010

Selected Bibliography: Joseph Mashek, *Ed Moses Drawings 1958–1976*, Frederick S. Wight Gallery, University of California, Los Angeles, 1976; Stephanie Barron, *Ed Moses: New Paintings*, Los Angeles County Museum of Art, Los Angeles, 1976; *Ed Moses*, Louver Gallery, New York, 1989; *Ed Moses: Abstraction & Apparition*, L.A. Louver, Venice, California, 1990; John Yau, *Ed Moses: A Retrospective of the Paintings and Drawings, 1951–1996*, The Museum of Contemporary Art, Los Angeles, 1996; Barbara Haskell, *Ed Moses*, Radius Books, Santa Fe, New Mexico, 2009

Checklist:

ILL. 245 B, 1971
Resin and powdered pigment on canvas
96 × 132 in. (244 × 335.3 cm)
Collection of the artist

ALLEN RUPPERSBERG

Born: 1944, Cleveland, Ohio

Education: 1967 BFA, Chouinard Art Institute, Los Angeles

Selected Exhibitions: "When Attitudes Become Form," Kunsthalle, Bern, Switzerland, 1969; "1970 Annual Exhibition: Contemporary American Sculpture," Whitney Museum of American Art, New York, 1970; "Young Artist: Allen Ruppersberg," Pasadena Art Museum, Pasadena, California, 1970; "24 Young Artists," Los Angeles County Museum of Art, Los Angeles, 1971; "Pier 18," The Museum of Modern Art, New York, 1971; "Documenta 5," Kassel, Germany, 1972; "73rd American Exhibition," The Art Institute of Chicago, 1979; "Stay Tuned," New Museum, New York, 1981; "Shift, LA/NY," Newport Harbor Art Museum, Newport Beach, California, 1981; "Allen Ruppersberg/ The Secret of Life and Death," The Museum of Contemporary Art, Los Angeles, 1985; "L.A. Hot & Cool," MIT List Visual Arts Center, Cambridge, Massachusetts, 1987; "Whitney Biennial," Whitney Museum of American Art, New York, 1991; "Hall of Mirrors: Art and Film Since 1945," The Museum of Contemporary Art, Los Angeles (traveling), 1996; "Sunshine & Noir: Art in L.A. 1960–1997," Louisiana Museum of Modern Art, Humlebaek, Denmark, 1997; "Allen Ruppersberg: One of Many—Origins and Variants," Kunsthalle Düsseldorf, Düsseldorf, Germany (traveling), 2005; "Los Angeles 1955–1985: Birth of an Art Capital," Musée National d'Arte Moderne, Centre Georges Pompidou, Paris, 2006; "Photography on Photography: Reflections on the Medium Since 1960," Metropolitan Museum of Art, New York, 2008; "You and me or the art of give and take," Santa Monica Museum of Art, Santa Monica, California, 2009; "In & Out of Amsterdam: Travels in Conceptual Art, 1960–1976," The Museum of Modern Art, New York, 2009.

Selected Bibliography: Helene Winer, *Allen Ruppersberg*, Pomona College Museum of Art, 1972; *Allen Ruppersberg*, Stedelijk Museum, Amsterdam, 1973; Allen Ruppersberg, "Notes for Progress, Not Adventure," *LAICA Journal*, Los Angeles Institute of Contemporary Art, 1978; Allen Ruppersberg, *The Secret of Life and Death*, The Museum of Contemporary Art and Black Sparrow Press, Los Angeles, 1985; Dirk van Weelden, "The Nighthawk," *Western / Allen Ruppersberg: A Different Kind of Never-Never-Land*, De Appel Foundation, Amsterdam, 1992; Sandra Leonard Starr, *Lost and Found in California: Four Decades of Assemblage Art*, James Corcoran Gallery, Los Angeles, 1988; Daniel Levine, "Allen Ruppersberg" (interview), *Journal of Contemporary Art*, Fall 1992; Jerry Saltz, "Let Us Now Praise Artist's Artists," *Art & Auction*, April 1993; *Where's Al?: Allen Ruppersberg*, Magasin, Centre National D'Art Contemporain, Grenoble, France, 1996; David Joselit, "Object Lessons," *Art in America*, February 1997; Allan McCollum, *Allen Ruppersberg: Books, Inc.*, Le Fonds Régional d'Art Contemporain, Limoges, France, 1999; Ann Goldstein, et al., *Allen Ruppersberg: One of Many—Origins and Variants*, Walther König, Cologne, 2005

Checklist:

100 MPH, 1972
Five color photographs, 8 × 10 in. (20.3 × 25.4 cm) each
Edition of 3
Courtesy of Margo Leavin Gallery, Los Angeles

Missing You, 1972
Five magic tables, four books, one 14 × 11 in. (35.5 × 28 cm) color photograph
Courtesy of Margo Leavin Gallery, Los Angeles

Summer Days, 1971
Three black-and-white photographs, 8 × 10 in. (20.3 × 25.4 cm) each
Three pieces of bond paper with text, 11 × 8½ in. (28 × 22 cm) each
Edition of 3
Pomona College Collection. Museum purchase with funds provided by the Estate of Walter and Elise Mosher

The Disappearing Chinese Theatre, 1972
Three black-and-white photographs, 11 × 14 in. (28 × 36 cm) each
Edition of 3
Courtesy of Marc Selwyn Fine Art

Where's Al?, 1972
110 typed index cards, 3 × 5 in. (7.6 × 12.7 cm) each
160 instamatic prints, 3½ × 3½ in. (9 × 9 cm) each
Edition of 3
Collection of Jill and Peter Kraus, New York

PETER SHELTON

Born: 1951, Troy, Ohio

Education: 1973 BA, Pomona College; 1974 trade certifications, Hobart School of Welding Technology, Troy, Ohio; 1979 MFA, University of California, Los Angeles

Selected Exhibitions: "With More than One Sense," Los Angeles County Museum of Art, Los Angeles, 1981, "white roundhead," Artists Space, New York, 1982; "Aperto '84, Venice Biennale," Venice, 1984; "Elements: Five Installations," Whitney Museum of American Art, New York, 1987; "Avant-Garde in the Eighties," Los Angeles County Museum of Art, Los Angeles, 1987; "BLACKVAULT falloffstone: Sculpture Inside Outside," Walker Art Center, Minneapolis, 1988; "Peter Shelton: Waxworks," Museum of Contemporary Art, La Jolla, California (traveling), 1989; "bottlesbonesandthingsgetwet," Los Angeles County Museum of Art, Los Angeles, 1994; "oldwetbrickhouse," Museum of Contemporary Art, San Diego, California, 1997; "godspipes," Irish Museum of Modern Art, Dublin, 1998; "sixtyslippers," University of California, Berkeley Art Museum (traveling), 1998; "Panza: The Legacy of a Collector," The Museum of Contemporary Art, Los Angeles, 2000; "Los Angeles 1955–1985: Birth of an Art Capital," Musée National d'Arte Moderne, Centre Georges Pompidou, Paris, 2006; "Highlights from the Permanent Collection, 1980–2005," The Museum of Contemporary Art, Los Angeles, 2008

Selected Bibliography: Christopher Knight, *Peter Shelton Sculpture*, Open Space Gallery, Victoria, British Columbia, 1982; Sandy Ballatore, "The Body Architecture of Peter Shelton," *Artspace*, September/October 1989; Nancy Princenthal, "The Body in Question," *Sculpture*, September/October 1989; *bottlesbonesandthingsgetwet*, Los Angeles County Museum of Art, Los Angeles, 1994; Mary Davis MacNaughton, *Body, Mind, and Spirit: Eight Sculptors*, Ruth Chandler Williamson Gallery, Scripps College, Claremont, California, 1995; *sixtyslippers*, University of California, Berkeley Art Museum, Berkeley, 1998; Christopher Knight, *Peter Shelton*, Henry Moore Sculpture Trust, Halifax, England, and Irish Museum of Modern Art, Dublin, 1998; Susan Landauer, *The Not-So-Still Life: A Century of California Painting and Sculpture*, University of California Press, Berkeley and Los Angeles, 2003; Barbara Rose, "Monocromos de Malevich al presente," Museo Centro de Arte Reina Sofia, Madrid, 2004

Checklist:

Roll #14, 1973
Chemical stain, pigment, and black tea on percale cotton
44 × 59 in. (112 × 150 cm)
Collection of the artist

Spread #4, 1973
Coffee stain on polished cotton
44 × 59 in. (112 × 150 cm)
Collection of the artist

Roll #30, 1975
Chemical stain, pigment, and coffee on percale cotton
44 × 59 in. (112 × 150 cm)
Collection of the artist

WOLFGANG STOERCHLE

Born: 1944, Neustadt, Germany. Died: 1976, Santa Fe, New Mexico

Education: 1968 BA, University of Oklahoma, Norman; 1970 MFA, University of California, Santa Barbara

Selected Exhibitions: "24 Young Artists," Los Angeles County Museum of Art, Los Angeles, 1971; "Richard Dunlap, Sam Erenberg, Wolfgang Stoerchle," Wright State University, Dayton, Ohio, 1979; "And Gravity: Works by Bas Jan Ader, Guy de Cointet, Wolfgang Stoerchle," Magasin, Centre National D'Art Contemporain, Grenoble, France, 1996; "California Video," J. Paul Getty Museum, Los Angeles, 2008; "RECORD > AGAIN!: 40yearsvideoart.de – Part 2," ZKM Center for Art and Media, Karlsruhe, Germany, 2009. "Exposed: Voyeurism, Surveillance, and the Camera Since 1870," San Francisco Museum of Modern Art, and Tate Modern, London (traveling), 2010

Selected Bibliography: *And Gravity: Works by Bas Jan Ader, Guy de Cointet, Wolfgang Stoerchle*, Magasin Centre National D'Art Contemporain, Grenoble, France, 1996; Richard Hertz, *Jack Goldstein and the CalArts Mafia*, Minneola Press, Ojai, California, 2003; Jenni Sorkin "Envisioning High Performance," *Art Journal* 62:2, Summer 2003; Miles Varner, "Wolfgang Stoerchle," reprinted in *California Video: Artists and Histories*, Glenn Phillips, ed., J. Paul Getty Museum and Getty Research Institute, Los Angeles, 2008. *Exposed: Voyeurism, Surveillance, and the Camera Since 1870*, San Francisco Museum of Modern Art, and Tate Modern, London, 2010

Checklist:

Untitled, 1972
Documentation of performance,
March 13, 1972
Pomona College Museum of Art
Photo collage, 20 × 13 in. (51 × 33 cm)
Private collection, Santa Barbara

Untitled (Video fragment from rehearsal of performance), 1972
Black-and-white video, sound
The Getty Research Institute, Los Angeles
(2009.M.16)

HAP TIVEY

Born: 1947, Portland, Oregon

Education: 1969 BA, Pomona College; 1972 MA, CGS, Claremont, California; 1973 MFA, CGS; 1974–75 Hofuku-ji Monastery, Soja, Japan; 1978, 2002 Tofuku-ji Monastery, Kyoto, Japan

Selected Exhibitions: "Hap Tivey: Fourth Situation," Fine Arts Gallery, University of California, Irvine, 1976; "Shift, LA/NY," Newport Harbor Art Museum, Newport Beach, California, 1982; "Luminous: Light as Material, Medium and Metaphor," Bellevue Art Museum, Bellevue, Washington, 2001; Santa Barbara Contemporary Arts Forum, Santa Barbara, California, 2004; "Hap Tivey: Leukos Transit," Elizabeth Leach Gallery, Portland, Oregon, 2005; "Electric Lab," Exit Art, New York, 2007; "Hap Tivey: Sands of the Ganges," Elizabeth Leach Gallery, Portland, Oregon, 2008

Selected Bibliography: Hap Tivey and Melinda Wortz, *Hap Tivey: Fourth Situation*, Fine Arts Gallery, University of California, Irvine, 1976; Gerald Marzorati, "Hap Tivey, Making Light," *Soho News*, October 1978; Paul Schimmel, et al., *Shift, LA/NY*, Newport Harbor Art Museum, Newport Beach, California, 1982; Brian Libby, "Light as Path to Infinity," *The Oregonian*, February 1, 2008

Checklist:

Spring 69, 1969/2012
Wood, canvas, acrylic, and oil paint
Dimensions variable
Courtesy of the artist

JAMES TURRELL

Born: 1943, Los Angeles

Education: 1965 BA, Pomona College; 1965–66 University of California, Irvine; 1973 MA, CGS, Claremont, California

Selected Exhibitions: Stedelijk Museum, Amsterdam, 1976; "James Turrell," Whitney Museum of American Art, New York, 1980; "Occluded Front James Turrell," The Museum of Contemporary Art, Los Angeles, 1986; "Sunshine & Noir: Art in L.A. 1960–1997," Louisiana Museum of Modern Art, Humlebaek, Denmark, 1997; "The American Century: Art and Culture 1900–2000," Whitney Museum of American Art, New York, 2000; "James Turrell: Into the Light," Mattress Factory, Pittsburgh, 2003; "Singular Forms (Sometimes Repeated): Art from 1951 to the Present," Solomon R. Guggenheim Museum, New York, 2004; "James Turrell at Pomona College," Pomona College Museum of Art, 2007; "Time and Place: Los Angeles 1958–1968," Moderna Museet, Stockholm, 2008; "Sites," Whitney Museum of American Art, New York, 2009; "James Turrell: Large Holograms," PaceWildenstein, New York, 2009; "The Wolfsburg Project," Kunstmuseum Wolfsburg, Germany, 2009; "James Turrell," Guggenheim Museum, New York (traveling), 2012

Selected Bibliography: Julia Brown, ed., *Occluded Front: James Turrell*, The Museum of Contemporary Art, Los Angeles, and Fellows of Contemporary Art, and Lapis Press, 1985; Craig Adcock, *James Turrell: The Art of Light and Space*, University of California Press, Berkeley, 1990; Daniel Birnbaum, et al., *James Turrell: The Other Horizon*, MAK Vienna and Hatje Cantz Verlag, Berlin, 1999; Maurice Merleau-Ponty, et al., *James Turrell: Eclipse*, Hatje Cantz, Ostfildern, Germany, 2000; *Into the Light*, Mattress Factory, Pittsburgh, 2002; *James Turrell: Projection Works 1967–69*, Albion, London, 2004; Markus Bruderlin, et al., *James Turrell: The Wolfsburg Project*, Hatje Cantz, Ostfildern, Germany, 2010

Checklist:

Burning Bridges, 1971/January 21, 2012
Flare performance
Bridges Auditorium, Pomona College
Courtesy of the artist

WILLIAM WEGMAN

Born: 1943, Holyoke, Massachusetts

Education: 1965 BFA, Massachusetts College of Art, Boston; 1967 MFA, University of Illinois, Champaign–Urbana

Selected Exhibitions: "When Attitudes Become Form," Kunsthalle, Bern, Switzerland, 1969; "Documenta 5," Kassel, Germany, 1972; "Video Art: An Overview," San Francisco Museum of Modern Art, 1976; "Biennial," Whitney Museum of American Art, New York, 1981; "Aperto '82, Venice Biennale," Venice, 1982; "Image World," Whitney Museum of American Art, New York, 1989; "Biennial," Whitney Museum of American Art, New York, 1989; "William Wegman: Paintings, Drawings, Photographs, Videotapes 1970–1990," Kunstmuseum, Lucerne, Switzerland (traveling), 1990; "Photography Until Now," The Museum of Modern Art, New York, 1990; "William Wegman's Cinderella," The Museum of Modern Art, New York, 1993; "Reconsidering the Object of Art: 1965–1975," The Museum of Contemporary Art, Los Angeles, 1995; "William Wegman: Photography, Video, Drawing and Painting, 1970–2000," The Fabric Workshop and Museum, Philadelphia, 2002; "William Wegman," Printed Matter, New York, 2002; "The First Decade: Video from the EAI Archives," The Museum of Modern Art, New York, 2002; "The Last Picture Show: Artists Using Photography, 1960–1982," Walker Art Center, Minneapolis (traveling), 2003; "Evidence of Impact: Art and Photography 1963–1978," Whitney Museum of American Art, New York, 2004; "William Wegman: Funney/Strange," Addison Gallery of American Art, Andover, Massachusetts (traveling), 2007; "California Video," J. Paul Getty Museum, Los Angeles, 2008; "William Wegman: Paintings, Photographs, Video," Chang Art, Beijing, China, 2010

Selected Bibliography: Helene Winer, *William Wegman: Video Tapes, Photographic Works, Arrangements*, Pomona College Museum of Art, 1971; Lisa Lyons, *Wegman's World*, Walker Art Center, Minneapolis, 1982; Craig Owens, "William Wegman's Psychoanalytic Vaudeville," in *Beyond Recognition: Representation, Power, and Culture*, University of California Press, Berkeley, 1992; *Wegmanology*, Hyperion, New York, 2001; *How Do You Get to MoMAQNS?*, The Museum of Modern Art, New York, 2002; *William Wegman: Polaroids*, Harry N. Abrams, New York, 2002; Joan Simon and William Wegman, *William Wegman: Funney/Strange*, Yale University Press, New Haven, Connecticut, 2006

JOHN M. WHITE

GUY WILLIAMS

Checklist:

Basic Shapes in Nature, 1970
Gelatin silver prints
Three panels, 10¾ × 10⅞ in.
(27.3 × 27.6 cm) each
Courtesy of the artist

Big and Little, 1970
Gelatin silver print
8 × 8¾ in. (20.3 × 22.2 cm)
Collection of Atlas Wegman

Chip and Dip Set, 1970
Gelatin silver prints
Two panels, 17½ × 30½ in. (44.4 × 77.5 cm) each
Courtesy of the artist

Duck/Crow, 1970
Gelatin silver print
12 × 11 in. (30.5 × 28 cm)
Pomona College Collection. Museum
purchase with funds provided by the Estate
of Walter and Elise Mosher

Milk/Floor, 1970
Gelatin silver prints
Two panels, 7 × 7 in. (18 × 18 cm) each
Collection of Lola Wegman

Photos, 1970
Gelatin silver print
16¼ × 23 in. (41.3 × 58.4 cm)
Pomona College Collection. Museum
purchase with funds provided by the Estate
of Walter and Elise Mosher

Pool Party, 1970
Gelatin silver prints
Two panels, 10 × 8 in. (25.4 × 20.3 cm) each
Pomona College Collection. Museum
purchase with funds provided by the Estate
of Walter and Elise Mosher

Scar, 1970
Gelatin silver prints
Two panels, 13 × 10½ in. (33 × 26.7 cm) each
Collection of William Wegman

Single and Double Studio, 1970
Gelatin silver print
Work in two parts
11 × 11 in. (28 × 28 cm)
Sonnabend Gallery, NY

Selection of videos from *Spit Sandwich,* 1970
Muscles, 0:34
Crane Art, 1:02
Twins, 1:03
Alex, Bart, and Bill, 0:55
Tortoise and Hare, 0:25
Mixer, 0:22
Studio Work, 0:30
Recorded on Sony CV half-inch open reel
to reel
San Pedro, CA
Re-mastered February 2005
Courtesy of the artist

Selection of videos from *Reel 1,* 1970–71
Microphone, 0:47
Pocketbook Man, 1:19
Randy's Sick, 0:16
Milk/Floor, 1:02
William Wegman in Chinese, 0:36
Recorded on Sony CV half-inch open reel
to reel
San Pedro, CA, and Santa Monica, CA
Re-mastered February 2005
Courtesy of the artist

Born: 1937, San Francisco

Education: 1962–64 Patri School of Art
Fundamentals, San Francisco; 1965–69 BFA,
MFA, Otis Art Institute, Los Angeles

Selected Exhibitions: "Three Los Angeles
Artists," San Francisco Art Institute, 1972; "24
Young Artists," Los Angeles County Museum
of Art, Los Angeles, 1972; "Four L.A. Sculptors,"
Museum of Contemporary Art, Chicago, 1973;
"Autobiographical Fantasies," Los Angeles
Institute of Contemporary Art, 1976; "19
Artists, Emergent Americans," Solomon R.
Guggenheim Museum, New York, 1981; "20
Years of New Talent," Los Angeles County
Museum of Art, Los Angeles, 1983; Orange
County Center for Contemporary Art,
Newport Beach, California, 1986; "John M.
White," Total Art Museum, Seoul, Korea,
1993; "Out of Actions: Between Performance
and the Object, 1949–1979," The Museum
of Contemporary Art, Los Angeles, 1998;
Ventura County Museum of Art, Ventura,
California, 2009; "Lifelines: John M. White
Retrospective," Armory Center for the
Arts, Pasadena, California, 2011

Selected Bibliography: Moira Roth, "Toward
a History of California Performance Art, Part
II," *Arts,* June 1978; Anne Nequette, "John
White: Grinning in Space," *High Performance,*
Fall/Winter 1980; Peter Frank, *19 Artists,
Emergent Americans,* Solomon R.
Guggenheim Museum, New York, 1981; Lynn
Zelevansky, "Is There Life After Performance
Artists," *Artweek,* February 15, 1982; Fidel
Danieli, "John White: A Most Complete
Artist," *Artweek,* May 14, 1983; Peter Frank,
John White: Selected Works, 1968–1983, Los
Angeles Municipal Art Gallery, Los Angeles,
1983; Steve Durland, "John White, Second
Stories," *High Performance* #34, Vol. IX, No. 2,
1986; Linda Burnham, "John White, Second
Stories," *Artforum,* October 1986; Jacki Apple,
"Performance Art is Dead, Long Live
Performance Art," *High Performance,* #66, Vol.
XVII, No. 2, 1994; John M. White, "A Course
in Performance Art," *Performance Art Journal,*
May/September 1995; Betty Brown, *Lifelines:
John M. White Retrospective,* Armory Center
for the Arts, Pasadena, California, 2011

Checklist:

Preparation F, 1971
Documentation of performance, April 16, 1971
Pomona College Campus Center
Two digital prints from slides,
10 × 14 in. (25.4 × 35.6 cm) each
Courtesy of the artist

Wooded Path, 1971
Documentation of performance, April 16, 1971
Pomona College Campus Center
Two digital prints from slides,
10 × 14 in. (25.4 × 35.6 cm) each
Courtesy of the artist

Preparation F, January 21, 2012
Performance
Memorial Gymnasium, Pomona College
Courtesy of the artist

Born: 1932, San Diego, California. Died: 2004,
Santa Barbara, California

Selected Exhibitions: "New Modes in
California Painting and Sculpture," La Jolla
Museum of Contemporary Art, La Jolla,
California, 1966; "Whitney Biennial," Whitney
Museum of American Art, New York, 1972;
"Southern California: Attitudes," Pasadena
Art Museum, Pasadena, California, 1972;
"Current Concerns," Los Angeles Institute
of Contemporary Art, 1975; "Guy Williams:
A Selection of Works, 1960–1976," Los Angeles
Institute of Contemporary Art, 1976; "Los
Angeles Painting: The Decade," Art Center
College of Design, Pasadena, California, 1981;
"Guy Williams: Selected Works, 1976–1982,"
Los Angeles Municipal Art Gallery, Los
Angeles, 1982; "Guy Williams," Santa Barbara
Museum of Art, Santa Barbara, California,
1985; "Recent Paintings," Jan Baum Gallery,
Los Angeles, 1986; "The Stamp of Impulse,"
Cleveland Museum of Art, Cleveland, Ohio,
2001; Kiyo Higashi Gallery, Los Angeles, 2004

Selected Bibliography: *Random Notes on
Painting,* Pomona College Museum of Art,
1971; *Guy Williams: A Selection of Works
1960–1976,* Los Angeles Institute of
Contemporary Art, 1976; *Guy Williams: (The)
Paper Works,* University Art Museum,
University of California, Santa Barbara, 1977;
Gus Blaisdell, *Guy Williams: Selected Works
1976–1982,* Los Angeles Municipal Art Gallery,
Los Angeles, 1982; *Guy Williams,* Santa
Barbara Museum of Art, Santa Barbara,
California, 1986

Checklist:

Navy Street #16, 1974
Acrylic with paper and stencil on canvas
45 × 78¼ in. (114.3 × 198 cm)
Collection of Marc Williams

Slamfoot Brown, 1972
Oil on canvas
88 × 144 in. (223.5 × 366 cm)
Collection of David and Jeanne Carlson,
Rancho Mirage, California

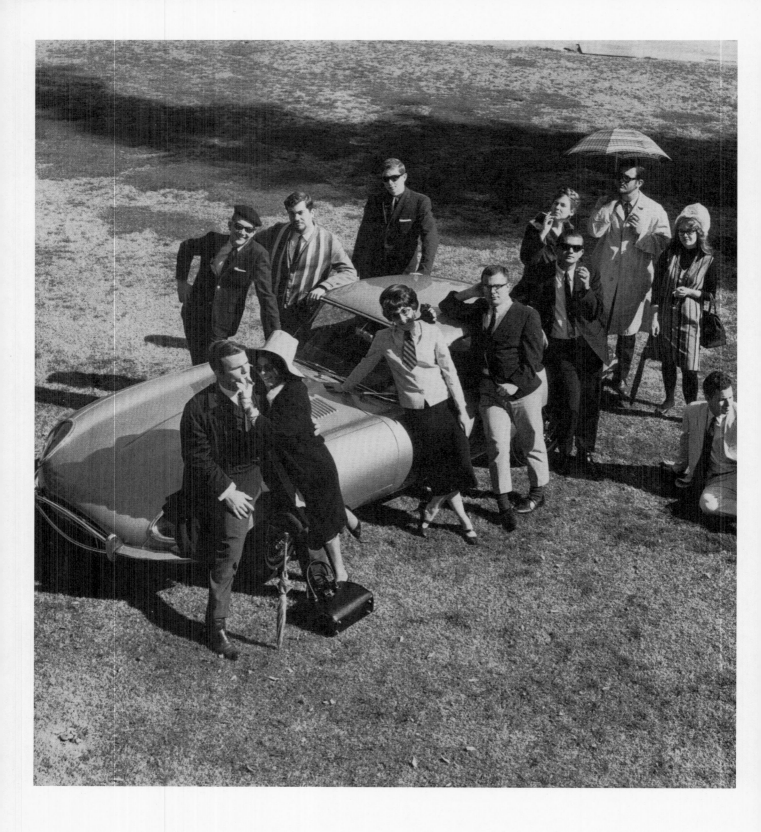

Photograph of the "Mods" (left) and "Rockers"
(right), the *Metate* yearbook staff, in the
1964–65 *Metate* yearbook, edited by James
Turrell, p. 158. Pomona College Archives

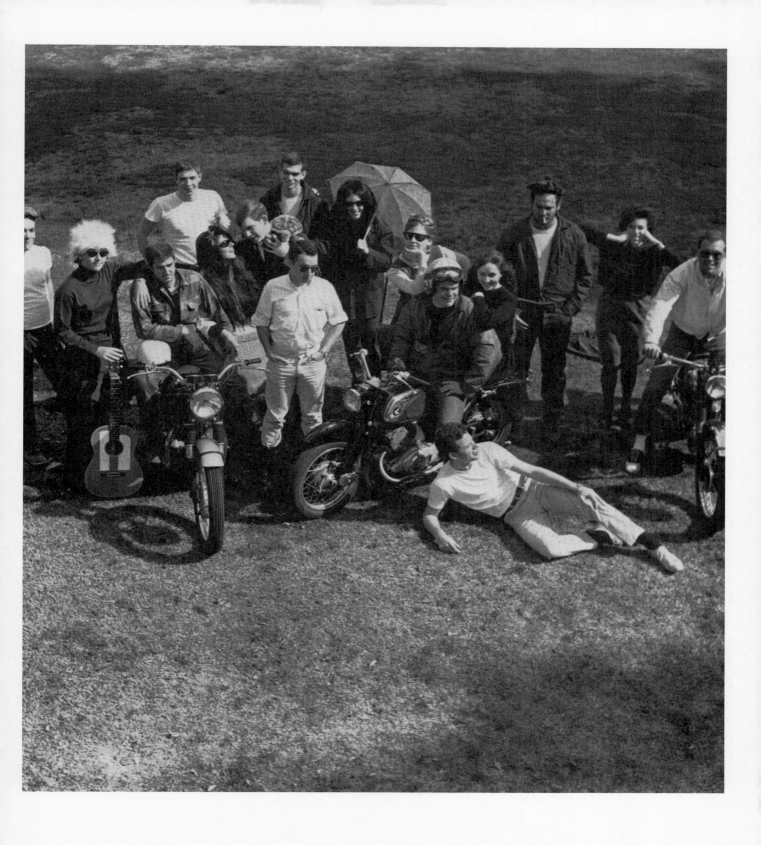

SELECTED POMONA COLLEGE ART DEPARTMENT FACULTY

GERALD ACKERMAN
1970–89
Associate Professor of Art (1970–76), Professor of Art (1976–89), Emeritus (1989 to present)
Art History

MOWRY BADEN
April 1968–71
Assistant Professor of Art, Acting Chair of the Art Department (1968–69), Director of Gallery (1968–69)
Pomona alumnus, 1958
Studio Art

LEWIS BALTZ
1970–73
Part-time Faculty in Photography (1970–71), Assistant Professor (1971–73)
Claremont Graduate School (CGS) alumnus, 1971
Studio Art

DANUTA BATORSKA
1968–69
Instructor in Art
Art History

MICHAEL BREWSTER
1971–73
Assistant Professor of Art (1971–73), Professor of Art, CGS (1973 to present)
Pomona alumnus, 1968; CGS alumnus, 1970
Studio Art

HARRY JOSEPH CARROLL, JR.
1948–85
Edwin Clarence Norton Professor of Classics
Art History

NICOLAI CIKOVSKY, JR.
1964–68
Director of Gallery, Assistant Professor of Art (1964–67), Associate Professor of Art (1967–68)
Art History

MAURICE E. COPE
1961–65
Assistant Professor of Art
Art History

JIM DEMETRION
1963–64
Instructor in Art
Art History

JUDSON EMERICK
1973 to present
Instructor in Art (1973–75), Assistant Professor of Art (1975–81), Associate Professor of Art (1981–97), Professor of Art History (1997–2003), Loren Barton Babcock Miller Professor in Fine Arts and Professor of Art History (2003 to present)
Art History

TERESA GRACE FRISCH
1969–70, 1972–74
Visiting Professor of Art, Mellon Visiting Professor of Art
Art History

HAROLD (HAL) L. GLICKSMAN
1969–70
Assistant Professor of Art, Director of Museum
Art History

DAVID GRAY
1967–73
Assistant Professor of Art
Studio Art

SALVATORE GRIPPI
1962–68
Associate Professor of Art
Studio Art

NORMAN HINES
1969–2000
Instructor in Physical Education for Men (1962–64), Assistant Dean of Admissions (1969–73), Part-time Faculty in Ceramics (1969–73), Assistant Professor of Art (1973–75), Associate Professor of Art (1975–88), Professor of Art (1988–2000)
Pomona alumnus, 1961; CGS alumnus, 1963
Studio Art

ANN T. LEVEQUE
1973–77
Part-time Faculty (1973–76), Lecturer (1976–77)
Art History

BATES LOWRY
1959–64
Associate Professor of Art
Art History

JOHN MASON
1962–67
Assistant Professor of Art
Studio Art

MALCOLM A. MCCLAIN
1964–65
Visiting Assistant Professor of Art
Pomona alumnus, 1955
Studio Art

JAMES MCGILVRAY
1968–73
Assistant Professor of Philosophy
Art History

DAVID MERRILL
1969–73
Associate Professor of Art, Chair of Art Department
Art History

DOLORES MITCHELL
1968–69
Instructor in Art
Art History

LELAND RICE
1973–79
Lecturer in Photography
Studio Art

PETER SELZ
1955–59
Art History

DAVID STEADMAN
1974–80
Assistant Professor of Art, Director of the Galleries of the Claremont Colleges
Art History

JAMES TURRELL
1971–73
Visiting Artist / Assistant Professor of Art
Pomona alumnus, 1965; CGS alumnus, 1973
Studio Art

PETER S. WALCH
1966–68
Instructor in Art
Art History

GUY WILLIAMS
1967–74
Part-time Faculty in Painting (1967–68), Instructor in Art (1968–71), Assistant Professor of Art (1971–74)
Studio Art

HELENE WINER
1970–72
Assistant Professor of Art, Director of Museum
Art History

STEVEN C. YOUNG
1967–2004
Professor of English, Dr. Mary Ann Vanderzyl Reynolds Professorship in the Humanities
Art History

Art

Danuta Batorska

David Gray

Dolores Mitchell *Mowry Baden*

Guy Williams *Linda Ann Hassing*

Saskia Cornelia Paap *Scottie Dunshee*

Stephen Ringle

POMONA COLLEGE ART DEPARTMENT MAJORS, ALUMNI 1965-73

1965
Echeverri, Janet
Holland, Katherine Church
Livingston, Jane
Plummer, Kathleen Church
Rony, Ellen O.
[Turrell, James, Psychology major]
Webb, Stephen L.
Wilson, Mark

1966
Alexander, Robin R.
Fiskin, Jeffrey A.
Fiskin, Judith
Hamilton, Paul J.
Oldham, Sarah
Sedlock, Marilen H.
Ware, John A.

1967
Anders, Cynthia
Kohler, Prudence (Prudy) J.
Kotrozo, Carol A.
Reich, Philip G.
Westen, Elizabeth W.

1968
Brewster, Michael L.
Kawaichi, Byron
Kenton, Mary Jean
Krupp, Robin Rector
Margolis, Barbara E.
Price-Glynn, Cynthia H.
Puryear, Kathryn A.
Stephens, Peter H.
Wood, Jonathan F.

1969
Beavon, Constance
Bennett, Mary Jill Alice
Burden, Christopher L.
[Crow, Thomas E., Government major]
Dunshee, Susan
Harwin, Sylvie A.
Hassing, Linda Ann
Ringle, Stephen
Tivey, Harold (Hap) M.
Withee, Diana

1970
Crosby, Christina
Doughty, Philip S.
Harper, Rebecca R.
Katra, Jane E.
Phillips, George Lee
Price, Patricia A.
Schreiner-Nylund, Margaret E.
Stump, Cary J.
Svien, Karen
Waszink, Paul H.
Young, Elizabeth J.

1971
Bendheim, Paul E.
Drake, Kristin H.
Duncan, J. Lansing
Elgin, Mary Jane
Frieder, David S.
Kleinberg, Susan L.
Mendenhall, Richard S.
Miller, Eugene T.
Moore, Elizabeth
Moore, Robert D., Jr.
Price, David A.
Reed, Jerry L.
Robbs, Philip C.
Tkacheff, Peter V.
Turner, Stephanie
Winer, Jody

1972
Allis, Daniel M.
Chapman, Christopher P.
Crespy, Leigh
McMahon, Paul W.
Price, R. Bret
Rosenbaum, Chiao-Ling Tung
Sciarra, Lorraine A.
Snyder, Chrystal K.
Wechsler, Peter F.
Young, Elizabeth F.

1973
Brustein, Caren B.
De Ford, Cecile
Gregory, Margo
Hunter, E. Jeffrey
Perez-Rodriguez, Carolyn D.
Shelton, Peter T.
Welsh, Elizabeth

42

Thomas Crow

Patrice Smith

Anthony H. Anderson

Bonnie Anderson

Charlie David Calvin

Thomas Crow's senior photograph in the 1969 *Metate*, p. 42. Pomona College Archives

Peter Shelton

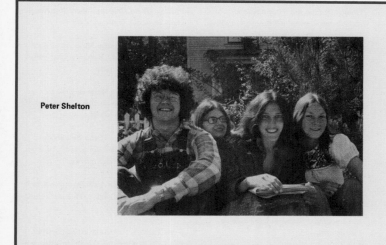

Judith Watson

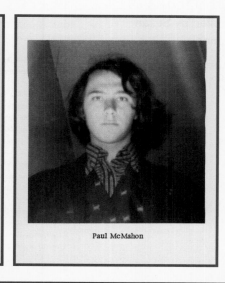

Paul McMahon

Margaret Tennant
German
Oakland

Alan Thomas
Physics
Chicago, Ill.

Kenneth Thomas
Philosophy
Temple City

James Turrell
Psychology
Claremont

William Upholt
Chemistry
Silver Spring, Md.

Barbara Wallace
Psychology
Menlo Park

Stephen Webb
Art-Practice
Montclair

Janet Welch
English Writing
Palo Alto

Celia Williams
English Writing
Ogden, Utah

Janet Williams
Sociology
Denver, Colo.

Carl Wulfestieg
Chemistry
Huntington Park

Mark Yamazaki
Zoology
Los Angeles

Gary York
Music-Applied
Glendale

27

Ivan L. Breed

Richard Earl Brewer

Michael L. Brewster

David Harvey Brown

Alison Howard Campbell

Thomas G. Carne

Thomas L. Carter

Adele Mae Chue

Frank Joseph Clemenza

John C. Clemons

SELECTED BIBLIOGRAPHY

Compiled by Susan Debonne

See also individual artist biographies from pages 353–363

Alberro, Alexander, and Sabeth Buchmann, eds. *Art After Conceptual Art*. Cambridge, Mass.: The MIT Press, 2006.

Allan, Ken. "The Cool School." *X-TRA* 10, no. 3 (Spring 2008): 44–48.

Antin, David. *Talking*. Champaign, Ill.: Dalkey Archive Press, 2001.

Armstrong, Elizabeth. *Birth of the Cool: California Art, Design, and Culture at Midcentury*. Newport Beach, Calif.: Orange County Museum of Art and Prestel Publishing, 2007.

Barron, Stephanie. *Art in Los Angeles: The Museum as Site: Sixteen Projects*. Los Angeles: Los Angeles County Museum of Art, 1981.

———. *Reading California: Art, Image, and Identity, 1900–2000*. Berkeley: University of California Press, Los Angeles County Museum of Art, 2000.

Beebe, Marjorie Harth. *Art at Pomona 1887–1997: A Centennial Celebration*. Claremont, Calif.: Trustees of Pomona College, 1988.

Bell, Kristine, and Tim Nye. *Primary Atmospheres: Works from California 1960–1970*. New York: David Zwirner, and Göttingen, Germany: Steidl Verlag, 2010.

Belloli, Jay, Michelle Deziel, Stephen Nowlin, and Jeff von der Schmidt. *Radical Past: Contemporary Art & Music in Pasadena, 1960–1974*. Pasadena: Armory Center for the Arts, 1999.

Bourriand, Nicolas. *Relational Aesthetics*. Dijon, France: Les Presses du RÉEL, 2002.

Cherix, Christophe. *In & Out of Amsterdam: Travels in Conceptual Art, 1960–1976*. New York: The Museum of Modern Art, 2009.

Clary, William W. *The Claremont Colleges: A History of the Development of the Claremont Group Plan*. Claremont, Calif.: Claremont University Center, 1970.

Crimp, Douglas. "Pictures." *October* 8 (1979): 75–88.

———. *Pictures*. New York: Artists Space and Committee for the Visual Arts, Inc. 1977.

Crow, Thomas. *Modern Art in the Common Culture*. New Haven, Conn.: Yale University Press, 1996.

———. *The Rise of the Sixties*. New Haven, Conn.: Yale University Press, 1996.

Daalder, Rene, and Aaron Ohlmann. *Here Is Always Somewhere Else: The Disappearance of Bas Jan Ader*. Los Angeles: Cult Epics, 2008. DVD, 144 min.

Deverell, William F., Victoria Dailey, Michael Dawson, and Natalie Shivers. *LA's Early Moderns*. Los Angeles: Balcony Press, 2003.

Drouin-Brisebois, Josée. *Caught in the Act: The Viewer as Performer*. Ottawa: National Gallery of Canada, 2008.

Eklund, Douglas. *The Pictures Generation, 1974–1984*. New York: The Metropolitan Museum of Art, 2009.

Goldstein, Ann, and Anne Rorimer. *Reconsidering the Object of Art: 1965–1975*. Los Angeles: The Museum of Contemporary Art; Cambridge, Mass.: The MIT Press, 1995.

Goldwater, Marge, ed. *Los Angeles in the Seventies*. Fort Worth: Fort Worth Art Museum, 1977.

Gould, Claudia, and Valerie Smith. *5000 Artists Return to Artists Space: 25 Years*. New York: Artists Space, 1998.

Grässlin, Karola, ed. *Kunst aus Los Angeles der 60er bis 90er Jahre*. Braunschweig, Germany: Kunstverein Braunschweig e.V.

Grenier, Catherine, ed. *Catalog L.A.: Birth of an Art Capital, 1955–1985*. San Francisco: Chronicle Books, 2007.

Hertz, Richard. *Jack Goldstein and the CalArts Mafia*. Ojai, Calif.: Minneloa Press, 2003.

Jenkins, William. *New Topographics: Photographs of a Man-Altered Landscape*. Rochester, N.Y.: International Museum of Photography at the George Eastman House, 1975.

Kienholz, Lyn. *L.A. Rising: SoCal Artists Before 1980*. Los Angeles: The California/International Arts Foundation, 2010.

Klein, Norman M. *The History of Forgetting: Los Angeles and the Erasure of Memory*. London and New York: Verso, 2008.

Kraus, Chris, Jan Tumlir, Jane McFadden, Oriana Fix, and Catherine Grant. *L.A. Artland: Contemporary Art from Los Angeles*. London: Black Dog Publishing, 2005.

Krauss, Rosalind. "Overcoming the Limits of Minimalism." In *Studies in Modern Art 1*, edited by James Leggio and Susan Weiley, 123–41. New York: The Museum of Modern Art, 1991.

Krull, Craig. *Photographing the L.A. Art Scene, 1955–1975*. Santa Monica: Smart Art Press, 1996.

Kwon, Miwon. "Approaching Architecture: The Cases of Richard Serra and Michael Asher." *Yale University Art Gallery Bulletin*. New Haven, Conn.: Yale University Art Gallery, 2009. 44–55.

Lawson, Thomas. *Mining for Gold: Selected Writings (1979–1996)*. Zurich/Dijon: JRP Ringier & Les Presses du RÉEL, 2004.

Lippard, Lucy. *Six Years: The Dematerialization of the Art Object from 1966 to 1972*. Berkeley: University of California Press, 1997.

Meyer, Laura, ed. *A Studio of Their Own: The Legacy of the Fresno Feminist Experiment*. Fresno: Press at California State University, 2009.

Muchnic, Suzanne. *Odd Man In: Norton Simon and the Pursuit of Culture*. Berkeley: University of California Press, 1998.

Morgan Neville. *The Cool School: How L.A. Learned to Love Modern Art*. Los Angeles: New Video Group, 2007. DVD, 90 min.

Newman, Amy. *Challenging Art: Artforum 1962–1974*. New York: Soho Press, 2000.

Nittve, Lars. *Sunshine and Noir: Art in L.A. 1960–1997*. Humlebaek, Denmark: Louisiana Museum of Modern Art, 1997.

———. *Time and Place: Los Angeles 1957–1968*. Göttingen, Germany: Steidl Verlag and Moderna Museet, 2008.

Osborne, Peter, ed. *Conceptual Art*. London: Phaidon Press, 2002.

Perlstein, Rick. *Nixonland: The Rise of a President and the Fracturing of America*. New York: Scribner, 2008.

Phillips, Glenn. *California Video*. Los Angeles: Getty Research Institute, 2008.

Plagens, Peter. *Sunshine Muse: Art on the West Coast, 1945–1970*. Berkeley: University of California Press, 1974.

Reiss, Julie H. *From Margin to Center: The Spaces of Installation Art*. Cambridge, Mass.: The MIT Press, 1999.

Rimanelli, David, and Scott Rothkopf. "'80s Redux: 'Pictures' Reframed." *Artforum* 40, no. 2 (October 2001): 130–34.

Rorimer, Anne. *New Art in the 60s and 70s: Redefining Reality*. London: Thames & Hudson, 2001.

Rose, Barbara. "Los Angeles: The Second City." *Art in America* 54 (January–February 1966): 110–15.

Ross, David A. *Southland Video Anthology, 1976–77*, Long Beach, Calif.: Long Beach Museum of Art, 1977.

Rugoff, Ralph. *Scene of the Crime*. Cambridge, Mass.: The MIT Press, 1997.

Salvesen, Britt. *New Topographics*. Tucson: Center for Creative Photography, University of Arizona; Rochester N.Y.: George Eastman House International Museum of Photography and Film; and Göttingen, Germany: Steidl Verlag, 2009.

Schapp, Rebecca M. *Eye on the Sixties: Vision, Body, and Soul: Selections from the Collection of Harry W. and Mary Margaret Anderson*. Santa Clara, Calif.: de Saisset Museum, Santa Clara University, 2008.

Schimmel, Paul. *Shift: L.A./N.Y.* Newport Beach, Calif.: Newport Harbor Art Museum, 1982.

Siegel, Katy. *High Times Hard Times: New York Painting 1967–1975*. New York: Independent Curators International and D.A.P., 2006.

Singerman, Howard. "The Myth of Criticism in the 1980s." *X-TRA* 8, no. 1 (Fall 2005).

Solnit, Rebecca. *Secret Exhibition: Six California Artists of the Cold War Era*. San Francisco: City Lights Books, 1990.

Starr, Sandra Leonard. *Lost and Found in California: Four Decades of Assemblage Art*. Santa Monica: James Corcoran Gallery, Shoshana Wayne Gallery, and Pence Gallery, 1988.

Steadman, David W. *The Claremont Colleges Faculty Exhibition*. Claremont, Calif.: Trustees of Scripps College, 1976.

Tuchman, Maurice. *American Sculpture of the Sixties*. Los Angeles: Los Angeles County Museum of Art, 1967.

Whiting, Cécile. *Pop L.A.: Art and the City in the 1960s*. Berkeley: University of California Press, 2006.

ACKNOWLEDGEMENTS

When this project first took root in conversations with Mowry Baden more than ten years ago, it was impossible to imagine how large it would become, with twenty-nine artists taking over the entire Pomona College Museum of Art for an academic year. A project of this scale owes its existence to the good will and efforts of many individuals and institutions. We have been extremely fortunate in the assistance we have received throughout the project.

First and foremost, we extend our deepest gratitude to the artists in the exhibition, whose work has been its impetus, and whose generosity has been instrumental in realizing the project. We thank them for sharing their time, memories, images, and material from their archives. We thank the Pomona College artist alumni who not only inspired this long journey, but who willingly gave their time to talk about Pomona College, their memories of their time at Pomona, and their art: Mowry Baden, Michael Brewster, Chris Burden, Judy Fiskin, Peter Shelton, Hap Tivey, and James Turrell. Many of the artists would not be in this exhibition if it had not been for the brilliant curatorial visions of both Hal Glicksman and Helene Winer. Both Hal and Helene indefatigably and patiently offered insight, memories, time, and expertise at all stages of this long and complex project. Thomas Crow also offered invaluable guidance and input—generously participating in multiple team meetings and writing a major new essay for this book. We thank everyone for their generosity, patience, and keen insight.

In addition to team members Crow, Glicksman, and Winer, we owe a tremendous debt to Marie Shurkus, who joined the team in 2008, and proved vital with her unparalleled scholarship, editing, and writing, and to research assistant Rochelle LeGrandsawyer, who expertly and patiently worked for over three years on a myriad of curatorial and research tasks including locating a key Guy Williams painting, editing and writing catalogue texts, compiling the timeline, and managing the continuously evolving checklist. Research assistants Carrie Dedon, who also wrote two artist essays, and Hai Minh Nguyen ('09) ably tackled a range of esoteric projects including compiling the list of Pomona College alumni in the arts and biographical material on all the artists. All their contributions have greatly enriched the scholarship of this project and cannot be underestimated.

In so many ways, this project would not have been realized without the crucial and far-reaching support of the Getty Foundation. Beginning with the vote of confidence in the project signaled by the award of a Getty Curatorial Research Fellowship to Rebecca McGrew in 2008, Foundation staff members Deborah Marrow, director; Joan Weinstein, interim director; and Angie Kim, program officer, are owed a debt of gratitude for their support of the project in its earliest stages. Nancy Micklewright, senior program officer, provided invaluable support at all stages of both Pacific Standard Time grants. Katie Underwood and Andrea Cajucom are also due many thanks. Gloria Gerace offered tremendous assistance as the managing director of the Pacific Standard Time initiative at the Getty. It has been a pleasure to work with all of them, and Pomona College is eternally grateful to the Getty Foundation for making this project a reality.

In addition to all the artists who have given of their time and lent work to this exhibition, we thank the many individual and institutional lenders to the exhibition and the publication. This exhibition could not have been organized without their participation and generosity. In alphabetical order by artist we thank: Gabriela Corchada at Patrick Painter Editions for assistance with the Bas Jan Ader estate; Michael Asher and Yoko Kanayama; Mowry Baden and Judith McDowell, and Theresa Britschgi, Steve Young, and the Museum of Contemporary Art, Los Angeles, for lending artwork; John Baldessari, Kim Schoenstadt, Rashell George, and Phil Curtis of the Baldessari Studio; Lewis Baltz, Theresa Luisotti, Jeff Schwartz and the Norton Simon Museum for lending artwork; Michael Brewster; Chris Burden, Katy Lucas of the Burden Studio, and Nigel Briand for helping realize Burden's 1967 sculpture; Judy Chicago and Donald Woodman; Ron Cooper, Jennifer Lynch, and Angela Barker of the University Art Museum of California State University Long Beach; Tom Eatherton; Ger van Elk, Ann Goldstein, Catharina van Daalen at the Stedelijk Museum, Amsterdam; Judy Fiskin and Nowell Karten of Angles Gallery, Los Angeles; Brian Butler and Isha West at 1301 PE, Los Angeles, and Rebecca Donelson for assistance with the Jack Goldstein estate; Joe Goode and Ed Ruscha for lending artwork; Mónica Hidrovo-Halperin and Howard Sherman at the Music Center|Performing Arts Center of Los Angeles County for lending David Gray artwork; Lloyd Hamrol; Robert Irwin and the Museum of Contemporary Art, Los Angeles, for lending artwork; Hirokazu Kosaka; William Leavitt, the Margo Leavin Gallery, and the Stedelijk Museum, Amsterdam, for lending artwork; John McCracken, Hanna Schouwink and Haley Shaw at David Zwirner, New York, and Sharon Robinson and Dianna M. Santillano at the Orange County Museum of Art for lending artwork; Ed Moses, Carol Lewis, and the staff at the Moses Studio; Allen Ruppersberg, Margo Leavin, Wendy Brandow, Elizabeth James, and Sarah Hymes at the Margo Leavin Gallery, Jill and Peter Kraus, and Marc Selwyn and Joshua Holzmann at Marc Selwyn Fine Art for lending artwork; Peter Shelton; Carol Lingham for lending Wolfgang Stoerchle artwork; Hap Tivey; James Turrell and Kyung Turrell; William Wegman, Christine Burgin, and Emily Helck; John White and Sylvia White; and David and Jeanne Carlson and Marc Williams for lending Guy Williams's artwork.

We would also like to thank numerous other individuals who offered advice and suggestions, who answered research queries, who opened their archives, and who helped in a variety of other ways: Christine Burgin, Sara Campbell, Robin Clark, Claire Copley, Mary Dean, Kirk Delman, Andrew Doe, Ciara Ennis, Angela Escobar, Jonathan Furmanski, Ann Goldstein, Marcy Goodwin, Bruce Grenville, Richard Hertz, Tom Jimmerson, Philipp Kaiser, Anne Lindley, Carol Lingham, Meg Linton, Mary MacNaughton, Alberta Mayo, Leta Ming, Rebecca Morse, Karen Moss, Suzanne Muchnic, Kristina Newhouse, Helen Pashgian, Andrew Perchuk, Vicki Phung at Frank Lloyd Gallery, Leland Rice, Paul Schimmel, Bennett Simpson, Stephanie Soldner Sullivan, Arden Reed, Sue Ann Robinson, Naomi Sawelson-Gorse, Matthew Simms, Rani Singh, Catherine Taft, John Tain, Pilar Tompkins, Maurice Tuchman, Ted Walbye, Matthew S. Witkovsky, and James Woodward at Metro Pictures.

The publication has been a massive endeavor, and could not have been realized without the major resources of a large group of creative, hardworking, and dedicated people. Lorraine Wild and Xiaoqing Wang at Green Dragon Office created a beautiful document to support and unify the disparate threads of the three-part exhibition, the curatorial voices of Hal Glicksman and Helene Winer, and the work of the twenty-

nine artists in the exhibition. We thank all the catalogue's contributing authors as well: Thomas Crow and Marie Shurkus for major new scholarship; and Carrie Dedon, Julie Joyce, Rochelle LeGrandsawyer, and David Pagel for their artist essays and interviews. We thank Alberta Mayo for her thoroughness and patience in transcribing all the interviews. We are grateful to Judy Chicago for allowing us to publish for the first time a lecture she gave at Pomona College in 1970 and to Paul McMahon for granting us permission to reprint his Wolfgang Stoerchle article, first published in *The Student Life* in 1972. David Antin and *Artforum* generously granted us permission to reprint Antin's seminal "Talking at Pomona" and the Press of the Nova Scotia College of Art and Design graciously granted permission to reprint Michael Asher's text.

As publication manager, Stephanie Emerson seamlessly and skillfully managed the production of this very complex project. Elizabeth Pulsinelli tirelessly and painstakingly tackled the enormous process of editing the tens of thousands of words in this book. The collection of hundreds of images for this publication was a massive endeavor, and we are indebted to Susan Amorde, photo researcher, for this task. The inclusion of many new images was due to the careful photographic work and flexibility of Robert Wedemeyer in Los Angeles, Rick Pharaoh in Carmel, and Florian Holzherr in Germany. We are fortunate to be able to include many original installation images courtesy of the Frank J. Thomas Archive, in Sierra Madre. We thank Kenneth M. Bernstein ('70) for the use of the cover image. In Claremont, we are grateful to Pomona College for allowing many reprints of period images and to Carrie Marsh and Lisa Crane at Special Collections, Honnold/Mudd Library of the Claremont Colleges. We thank Todd Bradway, Jane Brown, and Sharon Helgason Gallagher of D.A.P./ Distributed Art Publishers, Inc. for distributing this publication.

Rebecca McGrew's essay in this book was aided tremendously by interviews and conversations with many other Pomona alumni, former faculty, and administrators who thoughtfully gave hours of their time to reminisce about their college years and to answer pointed questions about certain stories. McGrew would like to especially acknowledge former Pomona College President David Alexander (1932–2010). Starting in 1969, he created an environment that ultimately led to an extremely fertile period in the arts. His willingness to entertain often-uncomfortable questions was both generous and inspiring. McGrew is also grateful to: Gerry Ackerman, Catharine Alexander, Scott Brastow and his family, Thomas Crow, Marjorie Harth, Norm Hines, Kay Larson, Denise Marika, Paul McMahon, Robb Scott, David Steadman, Robert Taplin, and Paul Waszink. She also thanks Mary Jill Alice Bennett, Kathleen Dimmick, Susan Kleinberg, Susan Levy Perry, Greg Van Velsir, and David Warren for sending material.

At Pomona College, this project would not have gotten off the ground if President David Oxtoby had not put his support behind it from inception through every stage of planning and fundraising. The project benefited from the generous support of friends of Pomona College: Janet Inskeep Benton ('79), Louise and John Bryson, Richard N. ('46) and Mary Alice Frank, David ('73) and Emily ('06) Horowitz, and The Dr. Lucille Paris Estate. We are also grateful to the Carleton and Laura Seaver Fund, the Eva Cole and Clyde Alan Matson Memorial Fund, and the Edwin A. and Margaret K. Phillips Fund to Support the Museum. In the advancement office, Vice President Chris Ponce, Assistant Vice President John Norton, Director of Alumni Relations Nancy Treser-Osgood and Office Manager of Alumni Relations Faye Epps, Director of Foundation and Corporate Relations Martina Ebert, Director of Donor

Relations Donald Pattison, Regional Director Robin Flynn, and Regional Director Jenifer Gilio have all supported this project enthusiastically and devoted resources to help the Museum realize it. In the communications office, Senior Director Mark Wood, Director of Media Relations Cynthia Peters, Associate Director/Web Manager Whitney Hengesbach, and Assistant Director Mary Marvin have also recognized the importance of this huge undertaking and helped in myriad ways to bring this project to new audiences. Colleagues in the Art and Art History Department have helped with support and research, and we particularly thank Mark Allen, Lisa Anne Auerbach, Judson Emerick, George Gorse, Sandeep Mukherjee, Michael O'Malley, Sheila Pinkel, Frances Pohl, and Mercedes Teixido.

The Rembrandt Club of Pomona College was founded in 1905 to support the arts in Claremont. This year, the Club is generously sponsoring the presentation of Michael Asher's new work for the exhibition. We are grateful to the Pasadena Art Alliance for its generous support of the exhibition. The Pasadena Art Alliance has underwritten the realization of the timeline presented during the exhibition, a version of which is also on view in this catalogue. In addition, we are indebted to Lauri Firstenberg of LA×ART and the Getty Foundation for supporting the "Performance at Pomona" project as part of the Pacific Standard Time Performance Art and Public Art Festival. We also thank Nancy Berman and The Philip and Muriel Berman Foundation for supporting Judy Chicago's restaging of *A Butterfly for Pomona* during the Performance Art and Public Art Festival.

As always, the staff of the Pomona College Museum of Art rose to the occasion with the highest standards of professionalism and commitment and tackled this massive, unprecedentedly large project with forbearance and skill. Kathleen Howe offered critical guidance and encouragement throughout the complex and varied stages of exhibition planning, and she provided unwavering support as the project grew in scope and scale. Assistant director and registrar Steve Comba handled the unusually large amount of registrarial work with ease and supported this project from its inception, helping in all matters, no matter how trivial. Museum coordinator Jessica Wimbley juggled a wide range of tasks with efficiency, including media requests, web management, and exhibition tours. Deborah Wilson handily supported all other elements of the project, from the simplest to the most complex, always willing to tackle each new development. Curator of academic programs Marie Shurkus designed and developed innovative programming to complement this project. Curatorial associate Susan Debonne joined the team in the thick of pulling this publication together, and we thank her profusely for her hard work, commitment, initiative, and good cheer. We also thank Diya León for providing assistance on a huge range of curatorial and preparatorial tasks. Carolyn Campbell and Susan Martin of Campbell Communications created successful media links. Finally, Rebecca extends very special thanks to Gary Murphy, whose extraordinary expertise in the fabrication of objects and the supervision of the installation has been crucial; and whose generosity, patience, and support as a partner have been considerable throughout this project. Likewise, Glenn would like to thank his partner Robert Fontenot for his unending patience and advice throughout the development of Pacific Standard Time.

Rebecca McGrew
Senior Curator
Pomona College Museum of Art

Glenn Phillips
Principal Project Specialist and Consulting Curator
Department of Architecture and Contemporary Art
Getty Research Institute

CONTRIBUTORS

THOMAS CROW is an art historian and art critic, best known for his influential writing on the role of art in society and culture from the eighteenth century to the present. Crow received a BA from Pomona College in 1969, a MA in 1975, and PhD in 1978, both from the University of California, Los Angeles. Most recently, his work has focused on modern and contemporary art and includes *The Rise of the Sixties: American and European Art in the Era of Dissent (1996)*, *Modern Art in the Common Culture (1996)*, and *The Intelligence of Art* (1999). Crow has held teaching positions at the California Institute of the Arts, the University of Chicago, Princeton University, the University of Michigan, the University of Sussex, Yale University, and the University of Southern California. He served as director of the Getty Research Institute from 2000 to 2007. He currently is the Rosalie Solow Professor of Modern Art at New York University's Institute of Fine Arts. Crow is a contributing editor to *Artforum*.

CARRIE DEDON received a BA from Pomona College in 2010, where she was the first Kilsby Museum Intern at the Pomona College Museum of Art. Her research is in modern and contemporary art with a focus in contemporary Czech art. She is currently living in Boston and pursuing a PhD in Art History.

HAL GLICKSMAN grew up in Los Angeles. He received a BA in Art History from UCLA in 1959. He worked in the arts in a variety of capacities, serving as curator and/or director of Percept in Los Angeles; Otis Art Institute in Los Angeles; University of California, Irvine, Art Gallery; the Corcoran Gallery of Art, Washington, D.C., and Pomona College Museum of Art from 1969–70. In 1969 he was a Guest Curator for the groundbreaking "Art and Technology" exhibition at the Los Angeles County Museum of Art after serving as Exhibition Designer for Walter Hopps at the Pasadena Art Museum.

JULIE JOYCE is Curator of Contemporary Art at the Santa Barbara Museum of Art, and served as Gallery Director/Curator of the Luckman Fine Arts Complex at California State University, Los Angeles from 1998–2008. Joyce's in-depth knowledge of art in Los Angeles has shaped critically acclaimed exhibitions for artists such as Charles Garabedian, Jack Goldstein, Kim Jones, Marnie Weber, and many others. She received her MA in Art History and Museum Studies at the University of Southern California, contributed to *Art Issues* magazine, and has written essays published by The MIT Press, The Studio Museum in Harlem, the Corcoran Gallery of Art, and others.

ROCHELLE LEGRANDSAWYER is a doctoral student in the Department of Art History at the University of California, Los Angeles. Her current research focuses on issues of temporality in contemporary African art. Her publications and curatorial work have dealt with a wide range of topics surrounding the contemporary art of Southern California. She received an MA from the University of California, Los Angeles, and BA from Pomona College in 2008.

REBECCA MCGREW (Pomona College BA 1985) is senior curator at the Pomona College Museum of Art. McGrew has organized over thirty exhibitions, including "Steve Roden: when words become forms," "Hunches, Geometrics, Organics: Paintings by Frederick Hammersley," "Ed Ruscha/ Raymond Pettibon: The Holy Bible and THE END," and "The 21st Century Odyssey Part II: The Performances of Barbara T. Smith." She curates the Project Series, devoted to artists from Southern California, including Mark Allen and Machine Projects, Edgar Arceneaux, Mark Bradford, Karen Carson, Katie Grinnan, Evan Holloway, Dinh Q. Le, Sandeep Mukherjee, Kaz Oshiro, Steve Roden, Amanda Ross-Ho, and Shirley Tse, among others.

DAVID PAGEL is an art critic who writes regularly for the *Los Angeles Times*. He is an associate professor of art theory and history at Claremont Graduate University and chair of the art department. He is also an adjunct curator at the Parrish Art Museum in Southampton, New York, and two-time winner of the California Triple Crown.

GLENN PHILLIPS is Principal Project Specialist and Consulting Curator in the Department of Architecture and Contemporary Art at the Getty Research Institute in Los Angeles. His exhibition "California Video" at the J. Paul Getty Museum won the International Association of Art Critics award for best exhibition of digital media, video, or film in 2008. His other exhibitions include "Time/Space, Gravity and Light," "Marking Time," "Evidence of Movement," "Reckless Behavior," "Pioneers of Brazilian Video Art 1973–1983," and "Radical Communication: Japanese Video Art 1968–88."

MARIE B. SHURKUS is a Los Angeles-based contemporary art historian and theorist. She teaches at Vermont College of the Fine Arts and is the Curator of Academic Programs at the Pomona College Museum of Art. Her research and teaching interests focus on the intersection of contemporary art and philosophy. She has lectured and written essays about affect and performative models of art practice. She has received fellowships from the Mellon Foundation and Concordia University, where she completed her doctorate.

HELENE WINER lives in New York City. She is from Los Angeles and received a BA in Art History from the University of Southern California in 1966, followed by a period as a curatorial assistant at LACMA. She was in London at The Whitechapel Gallery as Assistant Director in the late 1960s, returning to Los Angeles in 1970 as the Gallery Director/Curator at Pomona College. After Pomona, she wrote briefly for the *Los Angeles Times* before moving to New York, where she did freelance projects before becoming Director of Artists Space in 1975. In 1980 Winer, in partnership with Janelle Reiring, started Metro Pictures.

LENDERS TO
THE EXHIBITION

Bas Jan Ader Estate and
Patrick Painter Editions

Michael Asher

Mowry Baden

John Baldessari

Michael Brewster

Theresa Britschgi, Seattle, Washington

Chris Burden

David and Jeanne Carlson,
Rancho Mirage, California

Judy Chicago and Through the Flower Archive

Ron Cooper

Tom Eatherton

Ger van Elk

Judy Fiskin and Angles Gallery, Los Angeles

Getty Research Institute

Jack Goldstein Estate and 1301 PE,
Los Angeles

Lloyd Hamrol

Hirokazu Kosaka

Jill and Peter Kraus, New York

Carol Lingham, Santa Barbara

The Museum of Contemporary Art,
Los Angeles

Margo Leavin Gallery, Los Angeles

Ed Moses

Music Center | Performing Arts Center
of Los Angeles County

Norton Simon Museum

Orange County Museum of Art

Ed Ruscha

Marc Selwyn Fine Art

Peter Shelton

Sonnabend Gallery

Stedelijk Museum, Amsterdam

Hap Tivey

University Art Museum, California State
University Long Beach

Atlas Wegman

Lola Wegman

William Wegman

Marc Williams

John M. White

Steve C. Young, Lopez, Washington

CREDITS

Every effort has been made by the publisher to credit organizations and individuals with regard to copyright and the supply of photographs. Please notify the publisher regarding corrections.

Page 3: Smith, Powell, and Morgridge Architects, Rembrandt Hall Addition, 1957. Gouache on paper. Pomona College Collection. Photograph by Robert Wedemeyer; pp. 4–5: Michael Asher, installation, 1970. Viewing out of gallery toward street from small triangular area. © Michael Asher. Photograph courtesy of the Frank J. Thomas Archives; pp. 6, 152, 154, 155, 156, 157: Installation © Lloyd Hamrol. Photograph © Hal Glicksman. Photographs courtesy of the Getty Research Institute; pp. 8, 323 (left), 326, 327 (all), 336, 337 (bottom), 338 (left), 340, 341 (left, right), 348, 349: Photographs by Robert Wedemeyer; p. 19 (top): Photograph by Lewis Baltz. Photograph courtesy of Marcy Goodwin; p. 19 (bottom): Photograph by Marcy Goodwin with the enlightened guidance of Lewis Baltz. Photograph courtesy of Marcy Goodwin; pp. 35, 258, 260 (all), 261, 262 (all), 263, 265: © Mowry Baden. Photographs courtesy of the artist; p. 37: Photo by Sheedy and Long. Photo courtesy of Scripps College. Reproduced with permission from Stephanie Soldner Sullivan and Paul Soldner Estate; p. 38: Photographer unknown. Photo courtesy of Stephanie Soldner Sullivan and Paul Soldner Estate; pp. 40–41: © John Mason. Photography by Anthony Cuñha. Courtesy of the artist and Frank Lloyd Gallery; p. 42: © Mowry Baden. Photograph courtesy of Museum of Contemporary Art San Diego; pp. 43, 305: © James Turrell. Photograph by James Turrell; pp. 48, 273 (all), 274, 275, 276, 277, 278–279, 280 (all): © Chris Burden. Photographs courtesy of the artist; p. 51: Courtesy of the artist and Christine Burgin; pp. 53, 55, 56, 57 (all), 58, 60, 61 (all), 62, 63, 65, 67, 68, 69, 70, 71, 228, 230–231(all): © 2009 J. Paul Getty Trust. Photographs courtesy of the Getty Research Institute; pp. 73, 223, 224–225: © Allen Ruppersberg. Photographs courtesy Margo Leavin Gallery; p. 74, 91, 92, 93, 94, 95, 347: © Allen Ruppersberg. Photographs courtesy of the artist; pp. 77, 79: Photographs courtesy of Thomas Lawson and Susan Morgan; pp. 80, 81, 190, 192, 193, 195: © The Estate of Jack Goldstein and 1301PE Gallery, Los Angeles. Photographs courtesy of The Estate of Jack Goldstein and 1301PE Gallery, Los Angeles; pp. 87, 207: Photos courtesy of William Leavitt; p. 89: Courtesy of the artist and Metro Pictures; pp. 99, 103 (top), 113 (top, bottom), 335 (all): Photographs courtesy of the Getty Research Institute; pp. 102, 328 (all): installation © Michael Asher. Photograph © Hal Glicksman. Photographs courtesy of the Getty Research Institute; pp. 103 (bottom), 105 (all), 110, 113 (all), 331 (bottom): © Hal Glicksman. Photographs courtesy of the Getty Research Institute; pp. 109 (all), 140, 141, 143: Artwork © Ron Cooper. Photograph © Hal Glicksman. Photographs courtesy of the Getty Research Institute; pp. 115, 119, 120 (top, bottom), 121 (top, bottom): © Michael Asher. Photographs courtesy Frank J. Thomas Archives; p. 117: © L. Kenny. Reproduced from Halifax: Press of the Nova Scotia College of Art and Design; Los Angeles: The Museum of Contemporary Art, Los Angeles, 1983, pp. 35–36; pp. 124 (all): © Lewis Baltz. Photographs by Robert Wedemeyer; pp. 126, 127: © Lewis Baltz; pp. 128, 132–133, 135: Photographs courtesy of Judy Chicago and Through the Flower Archive; p. 138: © Ron Cooper. Photograph courtesy of the artist; p. 142: © Ron Cooper. Photograph courtesy

of the Frank J. Thomas Archives; p. 145 (all): Artwork © Tom Eatherton. Photograph © Hal Glicksman. Photographs courtesy of the Getty Research Institute; pp. 146–147, 150: © Tom Eatherton. Photographs courtesy of the Frank J. Thomas Archives; pp. 159, 161: © Robert Irwin. Photos courtesy of The Museum of Contemporary Art, Los Angeles; p. 165: Photo by Helene Winer. Courtesy of Paul McMahon; p. 168: Photograph by Gary Krueger. Courtesy of Allen Ruppersberg; pp. 169 (all), 233, 234, 235, 237: © William Wegman. Photos courtesy of William Wegman; p. 171: Photograph by and courtesy of Helene Winer; pp. 172 (all), 308 (all): Courtesy of Helene Winer; p. 174: Photograph by James Turrell. Courtesy of Helene Winer; pp. 177, 178–179, 180 (all): © The Bas Jan Ader Estate and Patrick Painter Editions. Courtesy of the Bas Jan Ader Estate and Patrick Painter Editions; pp. 182, 183, 185: ©John Baldessari. Photographs courtesy of John Baldessari; pp. 187, 188, 189: © Ger van Elk. Courtesy Stedelijk Museum, Amsterdam; pp. 197, 198 (top, bottom), 199: © Joe Goode. Photographs courtesy of the Frank J. Thomas Archives; pp. 201, 202, 203: ©Hirokazu Kosaka. Photos courtesy of the artist; pp. 207, 209 (all): © William Leavitt. Photos courtesy of William Leavitt; p. 211: © William Leavitt; p. 213: © John McCracken. Photographs by Robert Wedemeyer; p. 214: © John McCracken. Photograph courtesy of the Frank J. Thomas Archives; p. 215: © John McCracken. Courtesy of the artist and David Zwirner, New York; pp. 217, 218–219: © Ed Moses. Photographs by Robert Wedemeyer; p. 220: © Ed Moses. Photo courtesy of the artist; p. 226: © Allen Ruppersberg; p. 227: © Allen Ruppersberg. Photo by Gary Krueger. Image courtesy of the artist; pp. 239, 240 (all), 241, 242, 243 (all): Photos by Gary Krueger. Photo courtesy of the artist; pp. 248–257: © Artforum, September 1972 [spreads, pp. 38–47]. Courtesy of David Antin. Author's note: The *Artforum* version was squeezed with difficulty into the three column format, while the correct format can be seen in either the 1972 "Kulture" book or the 2001 "Talking" published by Dalkey Archive; pp. 267 (top, bottom), 268, 269, 271: © Michael Brewster. Photos by and courtesy of Michael Brewster; pp. 284, 285 (right, left), 287 (right, left): © Judy Fiskin. Photos courtesy of Judy Fiskin and Angeles Gallery; pp. 289, 290, 291 (all): © Estate of David Gray. Photographs by Robert Wedemeyer; pp. 292 (all), 294–295: © Peter Shelton. Photographs by Robert Wedemeyer; pp. 296, 297: © Peter Shelton. Photographs courtesy of the artist; pp. 299, 300, 301: © Hap Tivey. Photos courtesy of Hap Tivey; p. 303 © Hap Tivey and James Turrell. Photo courtesy of Hap Tivey; pp. 306–307, 309, 310, 311: © James Turrell. Photographs by Florian Holzherr; p. 312 (top): © Estate of Guy Williams. Photo by Robert Wedemeyer; pp. 312 (bottom), 314–315: © Estate of Guy Williams. Photo by Rick Pharoah Photography; p. 331 (top right): © Los Angeles Times. Reprinted with permission. Photograph courtesy the Getty Research Institute; pp. 332–333: Photograph courtesy of the Frank J. Thomas Archives; p. 336: Courtesy of John Counter; pp. 350, 351: Photographs by Robert Wedemeyer. Courtesy of Peter Shelton.

Published on
the occasion
of the exhibition
*It Happened
at Pomona:
Art at the Edge
of Los Angeles
1969–1973*
August 30, 2011–
May 13, 2012

In three parts:
*Part 1:
Hal Glicksman
at Pomona*
August 30–
November 6, 2011
*Part 2:
Helene Winer
at Pomona*
December 3,
2011–February
19, 2012
*Part 3:
At Pomona*
March 10–
May 13, 2012

Curated by
Rebecca McGrew
and Glenn Phillips

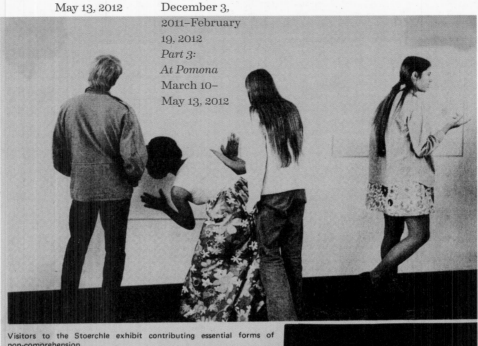

Visitors to the Stoerchle exhibit contributing essential forms of non-comprehension.

Pomona College Museum of Art
Montgomery Art Center
333 North College Way
Claremont, CA 91711
www.pomona.edu/museum
Tel: 909-621-8283

© Trustees of Pomona College

All rights reserved. No part
of this book may be reproduced
in any form without the written
permission of the publisher.

Available through D.A.P. /
Distributed Art Publishers, Inc.
155 Sixth Avenue
New York, NY 10013
www.artbook.com

Publication Manager
Stephanie Emerson

Copyeditor
Elizabeth Pulsinelli

Indexer
Harvey L. Gable, Jr.

Designers
Lorraine Wild
and Xiaoqing Wang
with Joe Potts
Green Dragon Office

Photo Researcher
Susan Amorde

Printing and binding
CS Graphics Pte Ltd., Singapore

Typefaces
Bau, designed by Christian
Schwartz, and Eames
Century Modern, designed
by House Industries

Printed in Singapore

ISBN: 978-0-9818955-8-1

COVER
Kenneth M. Bernstein's ('70) photograph
of Peter Shelton ('73, center), Richard
Voght ('73, right), James Michaelson
('73, left) in Michael Asher's installation at
Pomona College Museum of Art. Installation
© Michael Asher. Photograph © Kenneth
M. Bernstein. Photograph by and courtesy
of Kenneth M. Bernstein.

FRONT FLAP
William Wilson, "This is Art—These
People Are Artists," *Los Angeles Times*,
March 24, 1972. © 1972 *Los Angeles
Times*. Reprinted with permission.
Photograph by Robert Wedemeyer.

BACK FLAP
Flyer for "Pomona Student Show," 1969.
Pomona College Museum of Art Archives

BACK COVER
Chris Burden, *Untitled*, 1966.
Bronze. 6 ½ × 5 in. (16.5 × 12.7 cm)
Collection of the artist. © Chris Burden.
Photograph courtesy of the artist.

TITLE PAGE
Smith, Powell, and Morgridge Architects,
Rembrandt Hall Addition, 1957. Gouache
on paper. Pomona College Collection.
Photograph by Robert Wedemeyer.

CONTENTS
Michael Asher, installation, 1970. Viewing
out of gallery toward street from small
triangular area, Pomona College Museum
of Art. © Michael Asher. Photograph
courtesy of the Frank J. Thomas Archives.

*It Happened at Pomona: Art at the Edge
of Los Angeles 1969–1973*, is part of Pacific
Standard Time. This unprecedented
collaboration, initiated by the Getty, brings
together more than sixty cultural institutions
from across Southern California for six
months, beginning October 2011 to tell
the story of the birth of the L.A. art scene.

Pacific Standard Time is an initiative
of the Getty. The presenting sponsor
is Bank of America.

 Presenting Sponsors The Getty Bank of America

Additional exhibition support provided by the Pasadena Art Alliance.